MAGNUM

PHOTOBOOK

MAGNUM

PHOTOBOOK

THE CATALOGUE RAISONNÉ

Texts by Fred Ritchin
& Carole Naggar

Questions, Hidden by the Answers

by Fred Ritchin

'The purpose of art is to lay bare the questions that have been hidden by the answers.'
James Baldwin

On the disposition of a city, from Michael Christopher Brown's *Libyan Sugar* (2016):

```
Sender:                    Sender:
Daniel                     Daniel
Twitter says               But according to
sirt has fallen            twitter it has
Sent:                      also not fallen
Oct-12-2011                Sent:
14:46                      Oct-12-2011
                           15:00
```

The seventy-year arc of Magnum Photos describes an exceptionally vibrant and perilously fragile trajectory since its founding two years after the end of World War II. Its first members – Robert Capa, Henri Cartier-Bresson, David 'Chim' Seymour and George Rodger – had begun their photographic careers during the previous two decades supported by the introduction of highly disruptive technologies: the portable small- and medium-format cameras combined with the more light-sensitive films that gave photographers enormous mobility and flexibility in engaging with their subjects, as well as the mass-circulation, large-format picture magazines such as *Vu, Regards, LIFE, Look* and *Picture Post* that provided an effective means of photographic reproduction and widespread distribution in numerous countries.

These early innovations not only permitted the up-close, intimate coverage of war as it unfolded – an endeavour in which Magnum's founders excelled during both the Spanish Civil War and World War II – but would also allow conflict and its victims to be turned into a spectacle, a trend against which succeeding generations of Magnum photographers have rebelled. (In 1951 Werner Bischof was already complaining of the short attention span of the media, while insisting on the integrity of his own vision. After photographing a famine in India that had moved him deeply, Bischof articulated a refrain that would become commonplace among the agency's photographers: 'I am powerless against the great magazines – I am an artist, and I will always be that.')

Given its relative autonomy, the photographic book or, as it is now called, the photobook, soon emerged as a potential counterbalance to the tendency of the mass media to subsume individual voices. The photobook not only allowed photographers to report more extensively on a particular subject, but also enabled them to articulate nuanced, developed, at times dissonant points of view. These sometimes experimental strategies could then influence the more predictable ones of the conventional media. This trend accelerated as photographers took on greater responsibility for the design, layout, picture selection and text of their own books, becoming fully fledged

1 'Robert Capa' by Gerda Taro in *Picture Post*, vol.1, no. 10, 3 December 1938.
2 'Le peuple russe' by Henri Cartier-Bresson, *Paris Match*, no. 305, 1955.

1

2

Hôtel Ukraine à l'heure de lapause : le fox-trot des ouvriers

authors rather than simply providing the imagery for others to contextualize and present. Philip Jones Griffiths's 1971 classic *Vietnam Inc.* is a prime example of this assertive exercise of authorship that in recent years has become much more the norm (pp. 50–1).

In the last quarter-century a newer round of transformative technologies has profoundly disrupted photography. The introduction of image-manipulation software has increased public scepticism as to the photograph's recording function, and the invention of the mobile phone with an embedded camera has both allowed and encouraged billions of people to cheaply photograph, modify, distribute and publish their own imagery. This democratization of image-making and presentation, while a boon for individual expression, has significantly challenged the role of the professional photographer. Due to the billions of cameras in people's pockets and purses, it is much more likely that one of their owners would be on the scene of a critical event rather than one of the relatively scarce professionals. Furthermore, the enormous, chaotic streams of photographs that result express a multitude of competing narratives that are both promiscuous and frequently decontextualized, undercutting the ability of the professional to assert a coherent, nuanced point of view, and making it harder for anyone to charge adequately for published photographs.

It is no surprise then that the book, whether published conventionally or self-published, has become an increasingly desirable vehicle for extended photographic exploration and commentary, less encumbered by the media chaos rampant elsewhere. And whereas in the past working for a prestigious publication brought a photographer an elevated authority, given the eroded status of conventional journalism a photographer's name on the cover of a book may now have more credibility, at least in some circles.

At Magnum Photos the struggle for the photographer's right to an independent vision began at its inception. Battling publishing standards, its founders not only created a photographer-owned cooperative but also insisted on the novel step of retaining copyright to their images, rather than granting it to the publications that commissioned the assignments. This did much to enable the members' financial survival and, in turn, helped protect their independence. Magnum's photographers thus had more flexibility in accepting commissioned work, and its staff in reselling photographs to publications in other countries and languages. Photographs made for the US-based *LIFE* magazine, for example, might then appear in *Paris Match* in France and in *Stern* in Germany, providing extra income to help bankroll personal projects. Images in the agency's archive could be licensed for re-publication decades later. In the current digital era these empowering strategies, while more problematic fiscally, still underline the tradition of a photographer's right to assert authorship over his or her own imagery.

Even in the 1930s the book was an option for a photojournalist. When in 1938 the British magazine *Picture Post* published eleven pages of the twenty-five-year-old Robert Capa's 'This is War!' – revelling in his startling imagery ('These men crouching beneath the ledge feel the shock of every shell-burst. They know that a better aim will bring their own piece of rock down on top of them. They know that in a minute's time they may be ordered forward over the shell-swept ground....') while at the same time disingenuously calling the pictures 'simply a record of modern war from the inside' – the photographer was able to also publish a more personalized account. Asserting his own perspective on the Spanish Civil War, Capa's *Death in the Making* (1938) was

3 Robert Capa's photo essay 'This is War!', in *Picture Post*, vol. 1, no. 10, 3 December 1938.
4 Robert Capa's book, *Death in the Making*, Covici-Friede, New York, 1938.

3

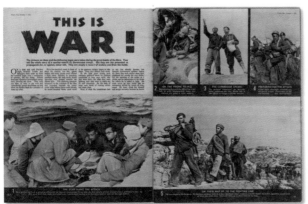

4

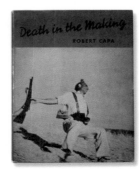
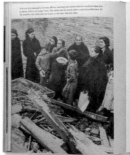
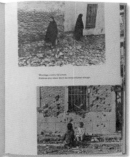

dedicated to the memory of his companion, the photographer Gerda Taro, and, rather than 'simply a record of modern war', emphatically advocated for the anti-Fascist cause in both its use of image and text (pp. 18–19).

With the famous photograph of the 'Falling Soldier' on its cover, *Death in the Making* can read as both a family album – about 'us' rather than 'them' – and a political screed: 'Life in a city besieged is not easy. Whole mornings you stand in line for food and when you go home, home is no longer there. The shells and the bombs show a special predilection for the humble – the shells and the bombs or the men who aim them.' Or it can read like a poem, as on the facing page with two of his photographs: 'Wreckage clutters the streets. Children play where death has lately whistled through.'

Later generations of Magnum photographers, asserting their own independence as witnesses, would further interrogate the underpinnings of armed conflict and express their own strong points of view. In *Vietnam Inc.* (1971), Philip Jones Griffiths's sardonic and outraged volume, he eviscerated a war that was officially being waged to support democracy, characterizing it instead as a short-sighted attempt at a massive corporate takeover (pp. 50–1). A decade later, Susan Meiselas's *Nicaragua: June 1978–July 1979* (1981; pp. 80–1) narrated and contextualized the vicissitudes of a popular revolution from insurrection to liberation, with interviews, news reports and colour photographs (challenging the more traditional and sombre use of black and white to cover war).

Gilles Peress's *The Silence* (1994), a quasi-forensic, novelistic indictment of the world's catastrophic indifference to Rwanda's internal genocide, comes with a removable booklet containing a chronology of events and an excerpt from a UN report detailing how international law can be applied to the situation there. The volume is divided into three sections – 'The Sin', 'Purgatory' and 'The Judgment' – and begins with words that appear like lines of poetry: 'rwanda/kabuga 27 may 1994/16h:15/a prisoner, a killer is presented to us,/ it is a moment of confusion, of fear,/of prepared stories./he has a moment to himself.' Then the first photograph in the book appears: a man staring straight ahead. Reaching the end, some 150 pages later, is another image of this man, now looking at the camera – but only three minutes have passed: 'rwanda/kabuga 27 may 1994, 16h:18/ as I look at him he looks at me.' It is horror as stream of consciousness, and horror as memory. *The Silence* is part of Peress's larger project on internecine conflicts, 'Hate Thy Brother'.

More recently, in 2008, Alec Soth's trenchant and somewhat morose newsprint publication, *The Last Days of W* ('as President Bush once said, "One of the great things about books is, sometimes there are some fantastic pictures"'), marks the end of an apocalyptic era with Soth's laconic imagery from various parts of the United States. Peter van Agtmael's *Disco Night Sept. 11* (2014; p. 183) presents a hybrid first- and third-person account in which war's brutality, even on a global scale, has been largely calcified into a set of displaced signifiers for all but those directly involved, including the words on a neon sign which became the book's title. (A May 2016 *New York Times* article, in line with *Disco Night's* thesis, points out that the perpetual state of war in which the United States now finds itself has been re-codified by the Obama administration as 'a chronic and manageable security challenge rather than an all-consuming national campaign'.) Van Agtmael's self-insertion is his attempt at partial redress: 'By making myself, for better or

5 Philip Jones Griffiths, *Vietnam Inc.*, Collier Books, New York, 1971.
6 Raymond Depardon, *Correspondance New-yorkaise*, Editions de l'Etoile, Paris, 1981.
7 Michael Christopher Brown, *Libyan Sugar*, Twin Palms Publishers, Sante Fe, 2016.

5

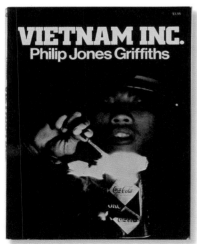

6

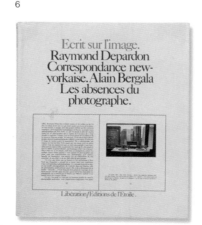

7

worse, a part of the story – folks identify with the experience, which might enable them to better understand war.'

As in these books, it is the articulation of a personal point of view rather than a reliance on the mechanical fidelity of the camera or on any institutional affiliation that propels much of the best work, as well as a combining of the journalistic with the artistic, the 'out there' and the 'in here'. Cartier-Bresson's reference to photojournalism as 'keeping a journal with a camera' foreshadows today's increasing acceptance of hybrid first- and third-person journalism. So, too, does Raymond Depardon's *Correspondances New-yorkaise* (Editions de l'Etoile, 1981), a compilation of a stint in the summer of 1981 for the French newspaper *Libération* in which a photograph of almost anything in New York (girls skipping rope in Harlem, rain falling on the Staten Island ferry, the ladies' room at *Geo* magazine) would be published on a foreign affairs page along with a short personal text expressing the photographer's own thoughts and feelings.

Under a photograph of girls happily skipping rope, for example, Depardon's text reads in part: 'It's the first time that I go to Harlem. I am 39 years old today. We leave the subway, people look at us, the police organize games for children in the streets. Several minutes later we run to a fire 100 meters away ... no victims'. There is a sizeable echo in Depardon's project of the famous 'New Journalism' practiced by writers such as Truman Capote, Gay Talese, Norman Mailer and Tom Wolfe, in which they speculated upon the inner thoughts of their subjects, the observer would insert himself as a protagonist, and reporting included conventions from fiction.

Making it even more personal, Michael Christopher Brown's *Libyan Sugar* (2016) – described somewhat cavalierly by the publisher as 'a road trip through a war zone' – combines a diaristic confrontation with the Libyan revolution, the first war Brown had witnessed, and a reflection upon his own life (p. 192). ('There are points in life when we are given opportunities to test ourselves in ways, and for me it was going to war,' Brown told CNN.) Photographing with an iPhone (his camera had broken), compiling journal entries and text messages, and linked by Skype and Facebook with far-away family and friends, Brown touches on, among other subjects, what might be called the quantum indeterminacy of social media: 'Twitter says sirt has fallen,' Daniel messages him (referring to the Libyan city), and then, fourteen minutes later, adds (or subtracts), 'But according to twitter it has also not fallen.'

Libyan Sugar also limns the photographer's transition from a world of seeming cause and effect to a bewildering one in which various points of view may seem both correct and without substance: 'In the desert there would sometimes only be a smell of metal, of smoking scraps of tanks or rockets, and there would sometimes be a feeling that at any moment the place where one stood might vanish.' A similar theme of contrasting, distorting connections was introduced by Tim Hetherington in his 2010 short video *Diary*, about the kaleidoscopic prism through which he strained to depict violence abroad while attempting to preserve his connections to his life at home. The following year, the forty-year-old Hetherington – whose photographs are now distributed by Magnum (he became a member posthumously) – was killed in Misrata, Libya, by an artillery explosion. The thirty-three-year-old Brown was next to Hetherington and was himself severely wounded; as a professional, Hetherington had a significant influence on Brown, among many others.

8 Peter van Agtmael, *Disco Night Sept. 11*, Red Hook Editions, New York, 2014.

8

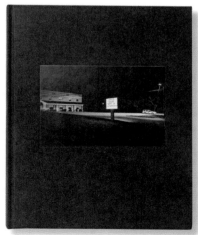
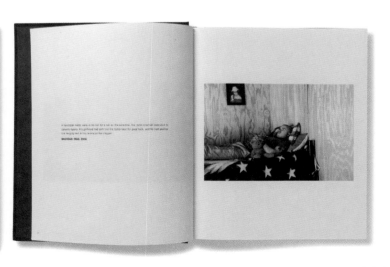

The disorienting experiences of younger photographers such as Soth, van Agtmael and Brown echo those of Magnum's founders, who had also lived through periods of turmoil and war. Chim's parents were killed by the Nazis, and he lost other family and friends in World War II; Capa's girlfriend Gerda Taro was run over by a Republican tank and died during the Spanish Civil War; Cartier-Bresson escaped from prisoner-of-war camps three times and in 1943 created a documentary film unit to collaborate with the French Resistance; and Rodger photographed in more than sixty countries in Europe, Africa and the Pacific during World War II, and was one of the first people to enter the concentration camp of Bergen-Belsen upon its liberation. However, given the seismic transformation of political and media systems over the last seven decades, the takeaways of these two generations as to the efficacy of their societal roles as photographers has been significantly different.

For example, in the words of former New York bureau chief Lee Jones, in the early days of Magnum 'people really believed you could make the world a better place'. It was as if there was a competition among photographers to find a worse wrong to right. One could be expected to transcend personal preoccupations for the larger good of both the newborn agency and the world struggling to re-emerge after the war – even if one had previously self-defined as an artist. 'Back in France, I was completely lost,' Cartier-Bresson told *Le Monde*, describing his experience after World War II. 'At the time of the liberation, the world having been disconnected, people had a new curiosity ... I had been engaged in looking for the photo for itself, a little like one does with a poem. With Magnum was born the necessity for telling a story. Capa said to me: "Don't keep the label of a surrealist photographer. Be a photojournalist. If not you will fall into mannerism. Keep surrealism in your little heart, my dear. Don't fidget. Get moving!" This advice enlarged my field of vision.'

For early members of Magnum, exploring the outside world and communicating what they discovered was essential. After World War II Cartier-Bresson's work became less abstract and more journalistic, as in the latter sections of *The Decisive Moment* (1952), with dramatic photographs of events in China and India, and as in *The Europeans* (1955), an affectionate, even hopeful look at a civilization in recovery. (Eerily, a previous 'posthumous' volume about Cartier-Bresson's imagery prefigured a profoundly different kind of 'decisive moment', this one historic and fatal. A catalogue of the photographer's solo exhibition at New York's Museum of Modern Art – planned when it was thought that Cartier-Bresson had been killed during World War II – was published in 1947. The following year, after having been introduced to Mahatma Gandhi in India, Cartier-Bresson showed him the small book. Sitting cross-legged on the ground, Gandhi carefully turned the pages. He is said to have remained silent until he came upon a photograph of a man looking at a fancy hearse, when he asked: 'What is the meaning of this picture?' Cartier-Bresson responded, 'That's Paul Claudel, a Catholic poet very much concerned with the spiritual issues of life and death.' Gandhi, reflecting for a moment, then uttered just three words: 'Death. Death. Death.' Fifteen minutes later, after Cartier-Bresson had bicycled away, Gandhi was assassinated.)

Another Magnum co-founder, Chim was known for his photographs of artists and intellectuals ('Chim was a philosopher, a chess player, a man who though not religious at all carried the burden

9 David 'Chim' Seymour, *Enfants d'Europe* (Children of Europe), Unesco, Paris, 1949.
10 Sebastião Salgado, *Sahel: L'Homme en détresse*, Prisma Presse, Lyon and Médecins sans Frontières, 1986.

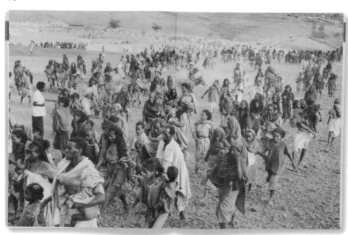

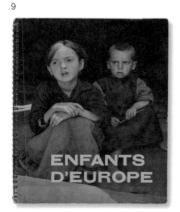

of being Jewish within him as a kind of sadness,' Cartier-Bresson once remarked). His book *Enfants d'Europe* (Children of Europe), published in 1949 by UNESCO, told the story of some of the millions of orphans and other children who had barely survived World War II to help draw attention to their plight (p. 21). The book begins with an eight-page 'Letter to a Grownup', written in the first person as if from a child speaking on behalf of the '13,000,000 abandoned children of Europe'. Chim's photographs explore the lives of children enduring severe psychological and physical injuries, learning in schools, roaming ravaged cities and, in one memorable case, trying on, with amazement, a first pair of shoes.

Later re-edited as *Children of War*, Chim's book was also a highly personal endeavour: having lost family and friends in the war, in the course of photographing for the project he learnt to his surprise that his own family's country residence in Otwock had been transformed into a home for Jewish orphans. And with its direct advocacy for the work of the newly founded United Nations, *Children of Europe* foreshadowed the humanitarian work of later photographers such as Sebastião Salgado's *Sahel: L'Homme en détresse* (Man in Distress, 1986), on the famine in the Sahel region of Africa, published in collaboration with Médecins Sans Frontières, an NGO that was later awarded the Nobel Prize for Peace.

Like *Children of Europe*, George Rodger's *Le Village des Noubas* (The Village of the Nubas, 1955) – an empathetic, curious and respectful study of a Sudanese tribe that had never been previously seen by a Westerner (Rodger had the permission of the local authorities) – was an attempt to come up with a constructive response to the ravages of the just-concluded war (p. 29). Rodger, who in April 1945 had been severely traumatized by his experience documenting the liberated Bergen-Belsen concentration camp, subsequently terminated his career as a war photographer. Instead he travelled with his first wife Cicely for two years over 45,000 kilometres (28,000 miles) in Africa largely motivated by a need 'to get away where the world was clean'.

Le Village des Noubas, a compact, diaristic image-text volume published in France by Robert Delpire, was among the first photobooks to acknowledge the tensions of a documentary photographer living the experiences that he is simultaneously trying to convey (Sergio Larrain's *Valparaiso* and Sebastião Salgado's *Other Americas* would take on more pronounced meditative stances, pp. 94–7 and p. 88). Three years later Delpire would publish Robert Frank's ironic, controversial documentary classic, *Les Américains* (The Americans, 1958). It was followed by other seminal volumes from Delpire such as René Burri's *Les Allemands* (1963, published the previous year as *Die Deutschen*, pp. 38–9), on the youthful optimism of the post-war generation in Germany, and Josef Koudelka's *Gitans: La Fin du Voyage* (1975, published as *Gypsies* in the United States), depicting far-flung Roma communities within an impassioned, at times nearly magical, ethos (pp. 64–5).

Many other Magnum photographers would similarly author their own books concerning various groups, ranging from broad studies of nations and peoples (such as *Afghanistan, Algeria, Congo, The English, El Salvador, The Europeans, The Face of North Vietnam, The Italians, Morocco, Wales*) to specific religions (*Allah O Akbar, The Faces of Christianity, God Inc., The Mennonites*), and racial issues (*Black in America, Black in White America, Living Apart*).

11 George Rodger, *Le Village des Noubas*, Robert Delpire, Paris, 1955.
12 Bruce Davidson, *Brooklyn Gang: Summer of 1959*, Twin Palms Publishers, Santa Fe, 1998.
13 Paul Fusco, *RFK Funeral Train*, Magnum Photos and The Photographers' Gallery, London, 1999.

12

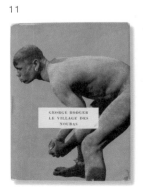

11

13

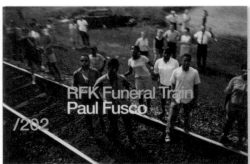

Some explored smaller groups and communities (*Brooklyn Gang*, *Central Park*, *Pleine Mer* (Men at Sea), *Police Work*, *The Teds*), and a few photographed institutions such as prisons and psychiatric hospitals (*Beaufort West*, *Conversations with the Dead*, *Leros*, *San Clemente*, *Zona*, and Chien-Chi Chang's accordion book on patients linked by force, *The Chain*). While diverse in their style and approaches, these books generally strive to explore societal dynamics at deeper, more intuitive levels, rather than diminish them, as all too frequently occurs in photographic books to fit an exoticized template.

A few books by Magnum photographers were stridently activist, in particular Aileen and W. Eugene Smith's pioneering *Minamata* (1975), a blistering exposé of industrial pollution and the crippling effect of mercury on humans, including children born almost helpless with severe neurological impairment and contorted limbs, as well as the excruciating process required to claim reparations from corporate powers (pp. 66–7). Like *Minamata*, other books are also deeply participatory, minimizing the distance between the observer and those observed, such as Jim Goldberg's *Raised by Wolves* (1995), a multi-year, multi-media, hands-on documentary that propels the reader into the precarious, at times desperate, situations of young homeless people as they are sidelined into a debilitating mire of dead ends, drugs and the occasional gesture of hope (pp. 104–5). As one young woman wrote about her situation, 'It's not like you can go home and watch TV.' *Raised by Wolves* followed Goldberg's equally successful, *Rich and Poor* (1985), featuring photographic portraits in which the San Francisco subjects, in their own lodgings, express handwritten feelings and expectations alongside the image itself, revealing their particular outlooks both as individuals and as members of quite divergent socio-economic classes. As Linda Banbo writes, 'This picture says that we are a very emotional & tight family, like the three musketeers [sic]. Poverty sucks, but it brings us closer together.' And Countess Vivianna de Blomville asserts on the book's cover: 'I keep thinking where we went wrong. We have no one to talk to now, however, I will not allow this loneliness to destroy me. I STILL HAVE MY DREAMS. I would like an elegant home, a loving husband and the wealth I am used to.'

Other photographers, breaking with Magnum's traditional baseline of empathy, have taken an outsider point of view in their books and wage a sardonic attack against aspects of society. They include Martin Parr, a prolific bookmaker whose biting, mordantly humorous colour photographs skew consumerism and tourism, including his *Last Resort* (1986) on working-class vacationers in New Brighton, England, and *The Cost of Living*, on Thatcher-era yuppies. Others include Bruce Gilden's *Go* (2000), on Japan's dark underbelly of mobsters and street people (pp. 134–5), and Chris Anderson's *Stump* (2014), a coruscating takedown of campaigning politicians that is scarily reminiscent of John Heartfield's anti-Nazi collages from the 1930s (p. 180).

Several photographers in pursuit of the autobiographical chose the form of the photobook, such as Raymond Depardon's *La Ferme du Garet* (The Farm at Le Garet, 1995), revisiting his rural youth (p. 106); Eugene Richards's ambivalent and incisive return to his Boston neighbourhood in *Dorchester Days* (1978; p. 72); Patrick Zachmann's contested reflections on his Jewish roots in *Enquête d'Identité* (Search for Identity, 1987); Antoine d'Agata's nightmarish, spiralling descent

14 Jim Goldberg, *Rich and Poor*, Random House, New York, 1985.
15 Patrick Zachmann, *Enquête d'Identité: Un Juif à la recherche de sa mémoire*, Editions Contrejour, Paris, 1987.

14

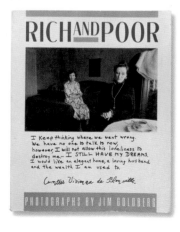
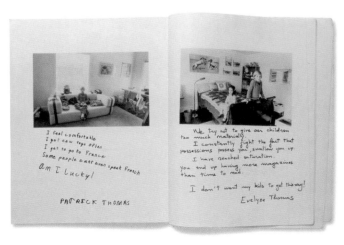

15

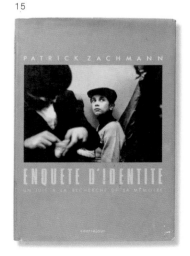

into drugs in *Ice* (2012); and Abigail Heyman's self-searching *Growing Up Female: A Personal Photojournal* (1974; pp. 62–3).

Some of these books, like Heyman's, are notable for their texts. She begins, in a typeface meant to resemble handwriting: 'This book is about women, and their lives as women, from one feminist's point of view. It is about what women are doing, and what they are feeling, and how they are relating to their mates, their children, their friends, their work, their interests, and themselves.' She continues with a statement at odds with the aggressiveness often attributed to her profession: 'This book is about myself. I looked at people and events long before I owned a camera, more as a silent observer than as a participant, sensing this was a woman's place. It is no longer my place as a woman, but it remains my style as a photographer.'

Heyman depicts her own abortion with a stark photograph and writes, 'Nothing ever made me feel like more of a sex object than going through an abortion alone', and also photographs another woman giving birth. She adds her own voice: 'At first I didn't want my husband in the delivery room because I didn't want him to see me that exposed. And I was afraid he would never want to make love with me again.' As in Charles Harbutt's *Travelog* (p. 60), published the previous year, containing his own images to which Harbutt had responded, 'Yes, life's like that' while referencing James Joyce's *Ulysses*, Heyman selects photographs from her own archive, employing them as reference points to help define her own stance as female.

Despite what has long been a dominantly male culture at the agency, several other books have also been published by women at Magnum that, in different ways, sharply articulate critical issues surrounding gender: among them, Eve Arnold's *The Unretouched Woman* (1976), Susan Meiselas's *Carnival Strippers* (1976), Mary Ellen Mark's *Ward 81* (1979) and *Falkland Road* (1981), Alessandra Sanguinetti's *The Adventures of Guille and Belinda and the Enigmatic Meaning of their Dreams* (2010) and Lise Sarfati's *She* (2012). However, three of the photographers – Mark, Heyman and Sarfati – remained at the agency only briefly: a claim for a sustained feminist outlook among Magnum's bookmakers would be difficult to assert.

The aesthetics of colour as a formal strategy to voice ideas that would be difficult or impossible to articulate in black and white has been a preoccupation of a number of Magnum photographers since well before the use of colour photography became commonplace. Ernst Haas, one of the agency's first members, was an innovator in photographic abstraction who quickly took to colour, culminating his search with the poetic, expressionistic, somewhat mystical 1971 bestseller *The Creation*, with its inspirational religious texts (p. 52). Others also experimented with the possibilities of colour to express different kinds of ideas, including Alex Webb's disquieting, hallucinatory *Hot Light/Half-Made Worlds* (1986), which used the interplay of intense colours from the Tropics to amplify and simultaneously call into question the act of seeing and, by extension, the possibilities of knowing (p. 89).

Costa Manos, after his exquisitely rendered, spare depiction of traditional lives in black and white in *A Greek Portfolio* (1972), switched films and his attention to a bemused, sharply ironic look at modern social dynamics in *American Color* (1995; p. 109) and *American Color 2* (2010).

16 Abigail Heyman, *Growing Up Female: A Personal Photojournal*, Holt, Rinehart, and Winston, New York, 1974.
17 Susan Meiselas, *Carnival Strippers*, Farrar, Strauss & Giroux, New York, 1976.

16

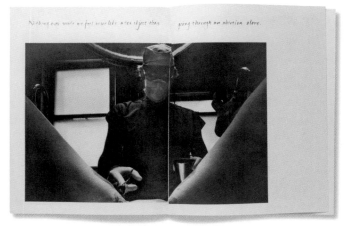

17

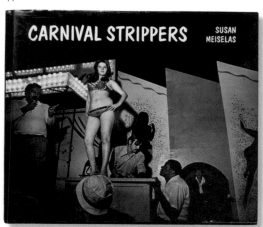

These two books use colour to evoke an affectedness and disquieting plasticity that parallels, to some extent, Martin Parr's more sarcastic skewing of contemporary mores (pp. 126–8). Harry Gruyaert's jarring interrogation of the visual language of colour television in his 1972 *TV Shots* (p. 164), and his luminous use of colour in other volumes, picture worlds discordant and serenely magical, eliciting overlapping harmonies in ways that are resonant of some of Bruno Barbey's radiant colour work in his books, including *Passages* (2015). Miguel Rio Branco's visceral, drenched colours depict aspects of his native Brazil in *Silent Book* (2012; p. 114) and *Dulce Sudor Amargo* (1985), evoking strong emotions that can be intuited more than understood.

As a predominantly documentary strategy, Mary Ellen Mark's vivid use of colour portraying Indian sex workers in *Falkland Road* (1981; p. 79), like Susan Meiselas's *Nicaragua* or Paul Fusco's *Funeral Train*, the latter showing people mourning the death of Robert F. Kennedy, challenged a *de facto* standard that certain subject matter – particularly involving victimization, marginalization and the gore of war – should be represented in shades of grey (colour seemed both too unseemly and too upsetting). While Mark lived with the sex workers for some time, and contextualizes their individual lives within the social dynamics of the brothel and the street, her intense use of colour was construed by some as underlining the women's exoticism to a Western audience without doing sufficient justice to their oppressed status as sex workers.

The Indian photographer Ragubir Singh, who died in 1999, expressed a perspective that is pertinent to the controversy over *Falkland Road*, while also arguing against assumptions that photography is a universal language: 'The fundamental condition of the West is one of guilt', Singh wrote, 'linked to death – from which black is inseparable. The fundamental condition of India, however, is the cycle of rebirth, in which colour is … a deep inner source.' Now that colour photography has largely become the digital default, such discussions have faded.

Rather than revelation, Bieke Depoorter's book of colour photographs, *I Am About to Call it a Day* (2014) – a large-format, cardboard-covered experiment in not really looking at the strangers in whose homes she stayed overnight – makes a much more subdued argument, casting the dilemma of empathy and engagement as nearly irrelevant (p. 182). 'We are immersed in obscurity,' it states on the back of the book. 'We find ourselves scarcely scratching the surface of these unpolished and unvarnished images. A surreal breeze drifts through the portraits and landscapes in this book despite their documentary nature, while the visual idiom inclines towards the cinematographic. Maybe these images were not meant to be fathomed; rather, the photographer is acutely aware of the inarticulate and the ineffable, melting away into thin air ever so easily….' The ability of the photograph to record is not in question, but its ability to reveal may no longer always be, in 2014, a realistic expectation.

In a more experimental vein, Thomas Dworzak's series of Instagram books, culled from social media via hashtags, acknowledges that some fascinating activities are beyond the purview of the professional photographer (pp. 184–5). His books, each published in an edition of only five, plug into a visual stream of consciousness that is replete with social-media surprises, from adolescent girls waging a campaign to free Boston Marathon bomber Dzhokhar Tsarnaev, apparently because of his

18 Martin Parr, *The Last Resort: Photographs of New Brighton*, Promenade Press, Wallasey, 1986.
19 Constantine Manos, *American Color 2*, W.W. Norton & Company, New York, 2009.

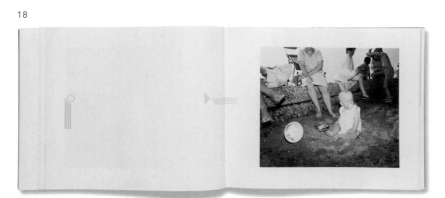

18

19

looks rather than his politics (#freejahar), to numerous images of pets dressed in papal style upon the election of Pope Francis (#habemuspapam). 'What are you going to do? Hire 12 photographers, then see if anyone is planning on dressing up their pets in the next 25 minutes, and go take pictures? It wouldn't work,' Dworzak remarked. The extensive panoply of imagery available from social media, curated in clever and detailed ways, may eventually reveal considerably more of the idiosyncratic complexities of cultures than do many photographic monographs.

Like Dworzak's series, compilations of imagery from numerous contributors have a long tradition at Magnum. One of the more innovative examples is a 1969 collection of gripping photographs of key moments, issues and personalities in Charles Harbutt and Lee Jones's *America in Crisis*, expressing the high-minded hope that 'Taking its measure may be a step toward surmounting [the crisis] and toward making all citizens eligible to share the dream.' More recently, the 2015 *Postcards from America* – an eclectic catalogue of imagery from Magnum photographers travelling from place to place, creating pop-up shows as they go – looks for another kind of community engagement that is less top down (pp. 176–7). Earlier, the ascension of a new president was celebrated in *Let Us Begin: The First One Hundred Days of the Kennedy Administration* (1961). Spearheaded by Cornell Capa, the book utilized the work of ten photographers, including Henri Cartier-Bresson, Elliott Erwitt, Burt Glinn, Inge Morath and Marc Riboud. From a more activist perspective, *Access to Life*, a 2009 coffee table-like book featuring the work of eight photographers, was published as part of a collaboration with The Global Fund that, with an accompanying exhibition, helped raise one billion dollars for the purchase of anti-retroviral medicine to treat HIV. *Access to Life* was a case of photographers being enlisted to help solve a problem, not just witness it – in the same way as Chim's collaboration with the United Nations in *Children of Europe* exactly six decades before.

A number of photographers also have had significant impact as editors or publishers outside Magnum, privileging other voices as well as sometimes including their own. They include Wayne Miller, who in 1955 assisted Edward Steichen on his landmark exhibition and book *The Family of Man*, an immensely influential 503-photograph ode to humanity, and Cornell Capa, whose provocative *Concerned Photographer* series (1968–73) highlighted the work of Werner Bischof, Ernst Haas, Lewis Hine, Marc Riboud, Gordon Parks, 'Chim' Seymour, Dan Weiner and Cornell's brother Robert, among others considered to have demonstrated a humanitarian impulse to use their pictures to educate and change the world rather than simply record it. Susan Meiselas's collaborations as an editor resulted in *El Salvador: The Work of Thirty Photographers* (with Harry Mattison and Fae Rubenstein, 1983), an attempt to create a more nuanced portrait of the embattled country than presented in mass media; *Chile from Within* (1990), on events after the overthrow of the Allende government; as well as *aka Kurdistan*, a multi-year project to establish a visual legacy for a people without a country via photography, crowdsourcing and archival research.

Among younger photographers, both Alec Soth (Little Brown Mushroom) and Olivia Arthur (Fishbar) have run independent publishing ventures, two of the hundreds that have emerged in recent years. They have published distinctive, idiosyncratic books (including their own),

20 Cornell Capa (ed.), *The Concerned Photographer*, Grossman Publishers, New York, 1968; photographs by Werner Bischof, Robert Capa, André Kertész, David 'Chim' Seymour, Leonard Freed and Dan Weiner.

20

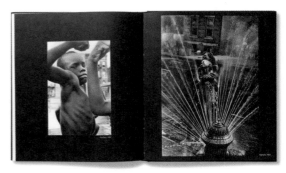

such as the imagined experiences of a 1961 shipwreck survivor returning fifty years later to Dubai depicted on the translucent pages of Arthur's *Stranger* (2015; pp.186–7), the beguiling 2011 *Conductors of the Moving World* by Brad Zellar – on Zen, traffic control and cultural misperceptions (Little Brown Mushroom) – and *Sudden Flowers* (2014) by Eric Gottesman, about the disrupted lives of Ethiopian children who express their grief and trauma after their parents' deaths from AIDS (Fishbar). The photographer who has probably impacted the perception of the photobook the most is Martin Parr who, with Gerry Badger, produced the three-volume *The Photobook: A History* (2004, 2006 and 2014), galvanizing the largely neglected evolution of the photographic book into an enlarged focus for scholars and collectors alike, with a resulting increase in the prestige of the photobook as well as the prices of many limited-edition and hard-to-find volumes.

Following the rapid disappearance of print periodicals and the inability of most online ones to finance sustained photographic reportage, the book has become more of a primary strategy for the photographer as author. Contrasted with the current absence of sufficiently complex screen-based strategies for photographers, books allow for greater creative control and encourage a slower, more concentrated and tactile engagement by the reader. As more photographers are dependent upon print sales, the book can also help to promote an individual's visual style and strategies while generating an increased following among aficionados. What the book does less well, of course, is reach out to the general public quickly and *en masse*.

Over Magnum's long history, there is an enormous distance between the stance expressed in Robert Capa's passionately anti-Fascist *Death in the Making* and Alec Soth's reflective *The Last Days of W* (2008), or Michael Christopher Brown's *Libyan Sugar* (2016). Whereas in previous generations Capa was advocating for profound political change, Cartier-Bresson was acknowledging 'the necessity for telling a story' and Abigail Heyman was promoting a movement, many younger photographers today spend more of their energy critiquing the circumstances that already exist or, as in the case of Depoorter, struggling with the mediation itself, asserting that 'maybe these images were not meant to be fathomed'.

It is of course a different world today, a more precarious and confusing one, in which image has largely trumped substance, the front page has nearly vanished and voices have become exceedingly personal and antagonistic in an attempt to claim authenticity, if not credibility. In the contemporary era the photobook can and does fill a critical need, offering the expanded potentials of image-text authorship and a space for reflection. Even if books are initially seen by smaller audiences, excerpts and reviews often appear in other media outlets, including blogs, while the books frequently are accompanied by exhibitions. They are also taught in classrooms worldwide.

Magnum Photos, with its long tradition of encouraging independence among its members, has many who are well positioned to pursue the photobook's diverse and untapped potentials. It is critical that in a world submerged by pictures and data, deeply uncertain of its next steps, Magnum photographers and their peers continue to experiment, aiming to make books that in their complexity and originality 'bare the questions that have been hidden by the answers'.

21 Alec Soth, *The Last Days of W*, Little Brown Mushroom, Minnesota, 2008.
22 Bieke Depoorter, *I Am About to Call It a Day*, Edition Patrick Frey, Zurich and Hannibal, Veurne, 2014.

21

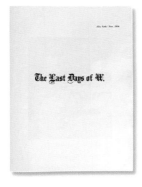 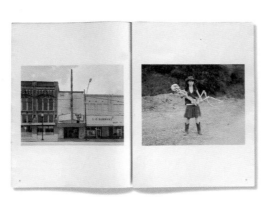

22

The Photobooks: In Detail
1938-2016

Texts by Fred Ritchin and Carole Naggar

Robert Capa
Death in the Making

Covici-Friede,
New York, 1938

285 x 210 mm
(11 ¼ x 8 ½ in), 98 pp

Hardback with full beige
cloth cover and jacket

148 b&w photographs

Preface by Jay Allen;
photographs by Robert Capa
and Gerda Taro; captions
by Robert Capa; arrangement
by André Kertész

The outbreak of the Spanish Civil War in 1936 began soon after the introduction of small, portable cameras that, combined with more light-sensitive films, allowed the photographer considerable flexibility in covering fleeting events. Photographers were no longer confined to static, safe situations far from the front lines or to depicting the residue of war after the battle was over. Robert Capa – whose oft-cited motto was, 'If your pictures aren't good enough, you aren't close enough' – took full advantage of these new possibilities. When combined with the emergence of serious and popular picture magazines, they transformed the ways in which much of the public would experience war.

Death in the Making, a riveting, action-packed, partisan volume about the Spanish Civil War (1936–9), included photographs by Capa and Gerda Taro, to whom the book is dedicated: 'For Gerda Taro. Who spent one year at the Spanish front. And who stayed on. R.C.' Taro was killed there by a tank. She was Capa's girlfriend. (Although uncredited, a number of photographs were made by David Seymour, who would, like Capa, become a co-founder of Magnum.)

Acccording to the book's credits, the photographs of civilians and soldiers were arranged by André Kertész, Capa's countryman, himself an extraordinary photographer. The cover image is the famous one that claimed to show a man at the moment of death, frequently referred to as 'The Falling Soldier'. The photographs, often three or four per spread, are positioned in various sizes; most of them bled to the edges, creating a visual rhythm that accelerates the reader's circuit through the book. Montaged almost like a film, the images are often placed so that the action on one side of the spread spills over into the other. The imagery appears proximate and direct, favouring content over formal constraints, minimizing a sense of mediation.

The captions are said to be by Capa. On the book's penultimate page he writes empathically: 'But the best blood of Spain spills in torrents over the yellow land. Is spilled wantonly. Spills generously. The blood of men and women and boys, of worker, student, lawyer, peasant, mechanic, miner. But the ranks are ceaselessly replenished and each death, each replenishment, tightens the bond. In Spain a new army *has been forged*. In Spain a new nation *is being forged* … '

The preface, by journalist Ted Allen, is vivid. 'Ah Madrid!' he writes. 'Lucky those who have seen it all! You have got to have seen it all, the first weeks of elation when the generals rose and brought down the Old Spain in ruins – or so it seemed – and then the new factors from without, the setbacks, the confusion, the bewilderment, the blood and then – after Toledo – the miraculous rebirth with the Moors already in the suburbs … ' He ends by commenting optimistically on the book's title: '*Death in the Making*. He might have called it *Life in the Making* with as much truth.'

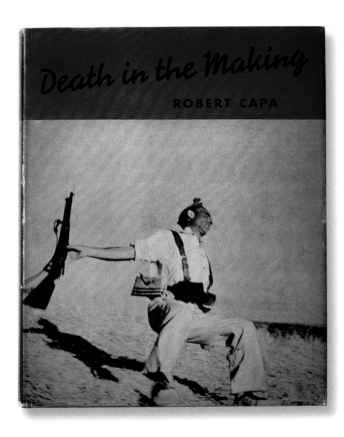

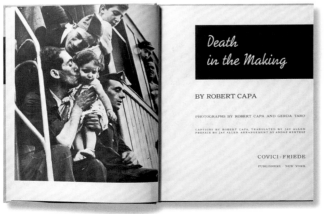

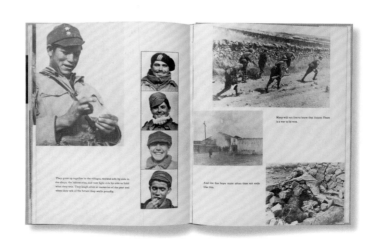

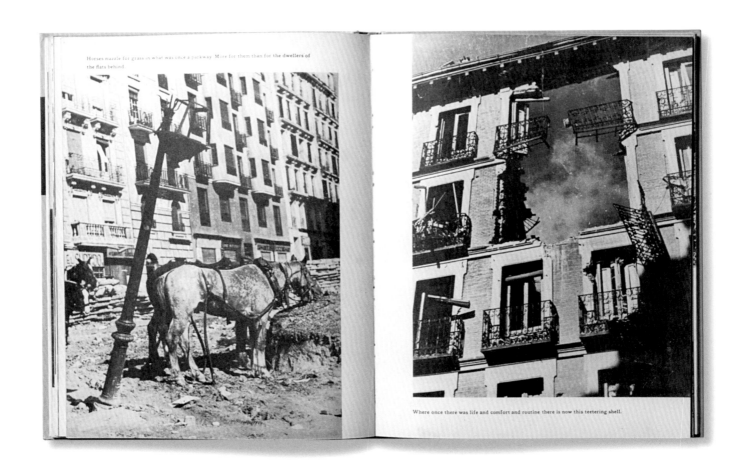

Horses nuzzle for grass in what was once a parkway. More for them than for the dwellers of the flats behind.

Where once there was life and comfort and routine there is now this teetering shell.

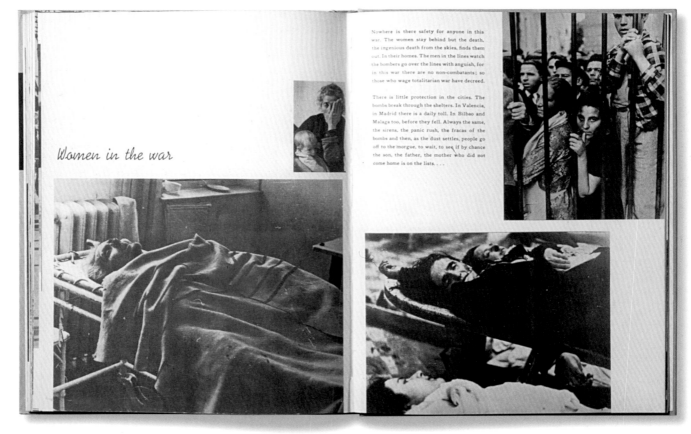

Women in the war

Nowhere is there safety for anyone in this war. The women stay behind but the death, the ingenious death from the skies, finds them out. In their homes. The men in the lines watch the bombers go over the lines with anguish, for in this war there are no non-combatants; so those who wage totalitarian war have decreed.

There is little protection in the cities. The bombs break through the shelters. In Valencia, in Madrid there is a daily toll. In Bilbao and Malaga too, before they fell. Always the same, the sirens, the panic rush, the fracas of the bombs and then, as the dust settles, people go off to the morgue, to wait, to see if by chance the son, the father, the mother who did not come home is on the lists. . . .

Werner Bischof
24 Photos

L.M. Kohler, Bern, 1946

305 x 236 mm (12 ¼ x 9 ¼ in),
46 pp

Hardback portfolio with
loose photographs

24 b&w photographs

Introduction by
Manuel Gasser

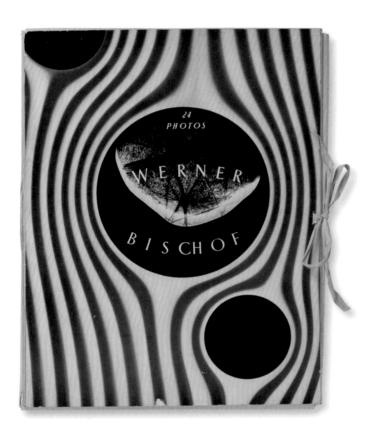

In 1945, aged just twenty-nine years, the Swiss photographer Werner Bischof prepared a selection of his work for publication. A portfolio with cloth ties, *24 Photos* (1946) is a suite of twenty-three loose black-and-white photographs printed full-bleed on photo stock paper, with the twenty-fourth image, 'Abstraktion', mounted on the folio cover and a four-page booklet of text inside.

Bischof trained as a painter before working as a freelance photographer for several magazines, where his artistic eye helped him establish himself as a studio photographer in Zurich. In 1945 he gained international recognition when he documented the devastation caused by World War II – the reportage was published in *Du* magazine. In 1949 he became the first photographer to join Magnum Photos after its founding.

24 Photos displays the whole array of the work of the first part of Bischof's career; the photographs were taken during his school days at the Kunstgewerbeschule in Zurich, and after he opened his first studio on Spielweg, later in Zurich-Leimbach, dedicated to fashion and publicity. They include abstraction, photomontage, nude, still life, fashion, nature photography (e.g. images of animals photographed in a precise but romantic spirit), as well as light projections and photograms in the spirit of the Bauhaus. Some photographs had been previously published in two issues of *Du*, a new magazine directed by Arnold Kübler.

24 Photos also contains two photographs, 'Spanish Boy' (1941) and 'Italian Refugee Child, Tessin' (1945), that testify to Bischof's new interest in photojournalism: he had started taking assignments from *Du*, becoming more radical politically and turning his sights on the world. In his preface to *24 Photos*, Manuel Gasser writes: 'This man who … investigated – as only a poet and dreamer could – the most delicate and fragile of objects, one day pushed aside everything he knew and had achieved, got in a Jeep, and drove off into the world laid waste and despoiled by war – to Germany, to Holland, to Northern Italy. To photograph. To express in a new way something new.'

Printed with extreme care – Bischof supervised its production – *24 Photos* represents both a milestone in Bischof's career and his goodbye to the studio. By the time the portfolio was published in 1946, he had become a photojournalist – but, ambivalent about the profession, always considered himself an artist.

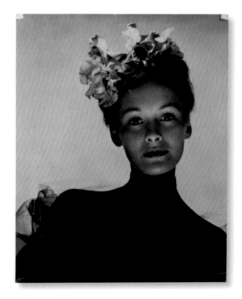

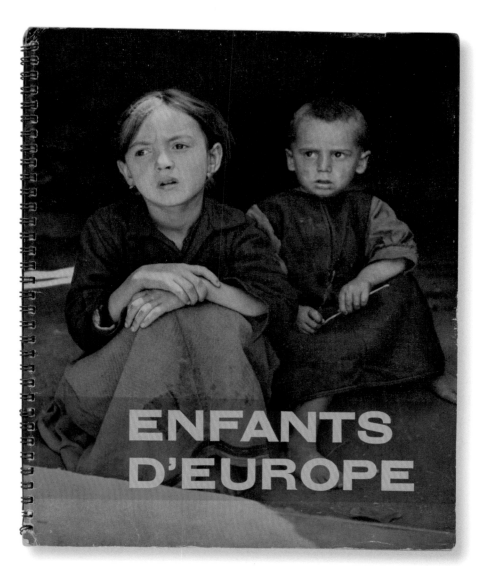

David 'Chim' Seymour
Enfants d'Europe (Children of Europe)

UNESCO, Paris, 1949 (also published in English and Spanish)

224 x 180 mm (8 ¾ x 7 in), 60 pp

Spiral-bound paperback

54 b&w photographs

Introduction by David 'Chim' Seymour; captions in French, English and Spanish

On 10 March 1948, David Seymour – always known as 'Chim' – received a telegram from John Grierson, then deputy director of the United Nations Children's Emergency Fund (UNICEF): 'when are you returning paris. most anxious discuss immediate photographic journey to eastern European countries Grierson.' Grierson hired Chim as a 'special consultant' to photograph the condition of young European survivors of World War II and to show UNICEF in action as it provided 13 million children with necessities such as powdered milk, soup and shoes, as well as vaccinations against tuberculosis and other diseases.

A year earlier, in the aftermath of the war, Chim had joined Robert Capa, Henri Cartier-Bresson and George Rodger to found Magnum to allow photographers to work outside the constraints of magazine journalism. Now the UNICEF assignment became a labour of love: instead of his usual $100-a-day fee, Chim accepted $2,600 for a job that lasted over six months and took him to six countries (Austria, Greece, Germany, Hungary, Italy and Poland).

Children of Europe was published by the United Nations Educational, Scientific and Cultural Organization in 1949 in English, French and Spanish in a small, spiral-bound paperback format that resembled a child's school notebook. It contains 54 photographs, a very small portion of the 257 rolls of film Chim had shot with Rollei and 35mm cameras. (A new edition, *Chim's Children of War*, was published by Umbrage Editions in New York in 2013, with rare or unseen photographs selected by Carole Naggar.) >>

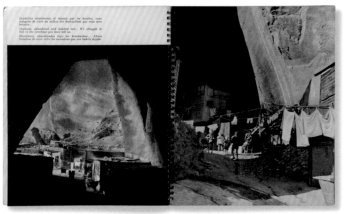

>> Printed in Paris by Magnum's printer Pierre Gassman, the pictures are laid out on single or double pages and represent situations that highlight UNICEF's intervention: meals and vaccinations, schools and hospitals. They are contrasted with harsher images — juvenile courts, orphanages, penitentiaries, makeshift sleeping and living conditions, refugee camps from the Greek Civil War and children maimed by shrapnel. The second half of the book shows the children taking control of their lives: games, studies, gymnastics, dance, music, clearing of street rubble, and reconstruction of schools. The book's opening preface — written by Chim or by the UNICEF team — is an eight-page 'Letter to a grown-up' written in the voice of a child speaking on behalf of Europe's abandoned children, and each image is captioned underneath.

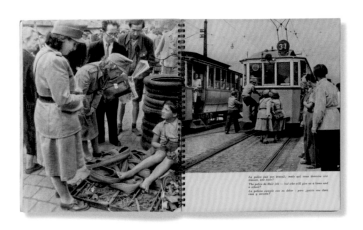

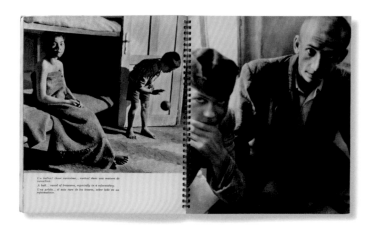

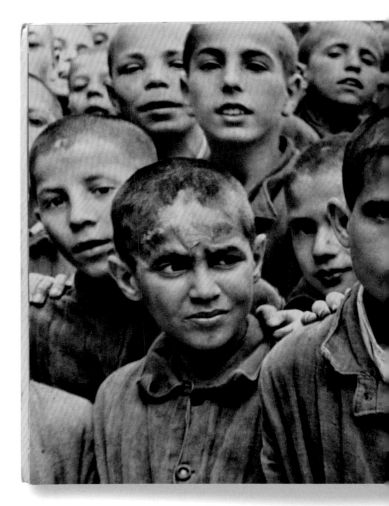

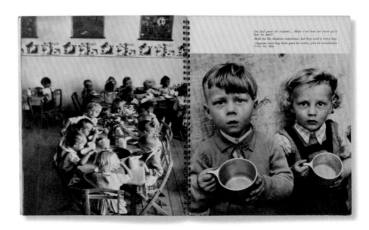

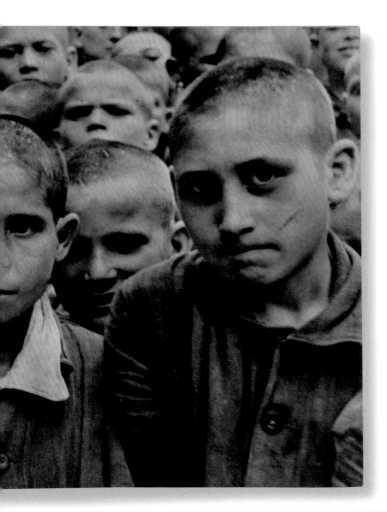

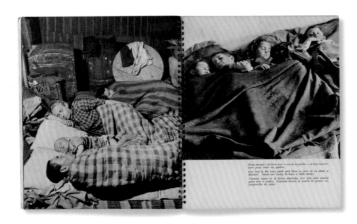

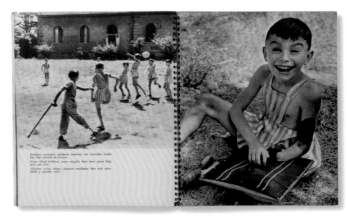

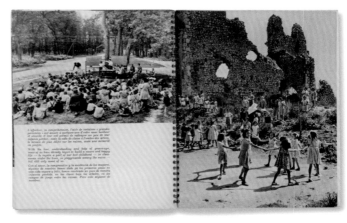

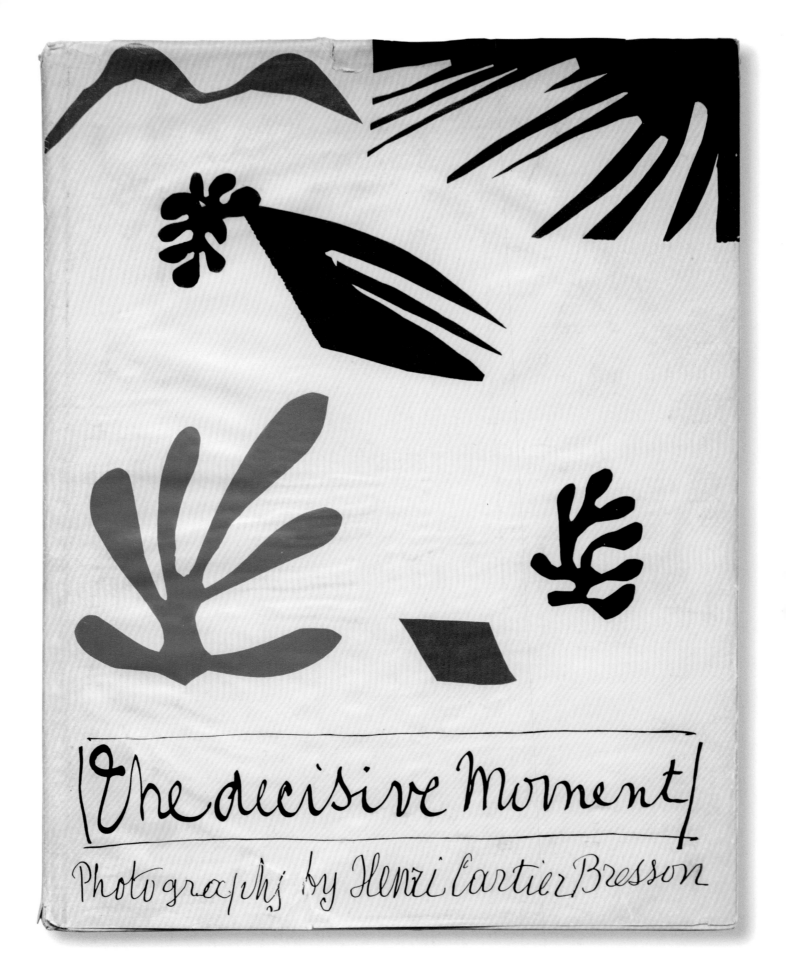

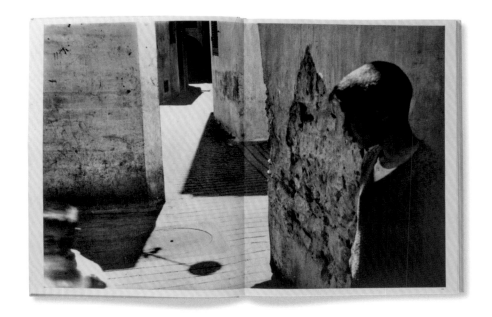

Henri Cartier-Bresson
The Decisive Moment

Simon & Schuster, New York,
in collaboration with
Editions Verve as *Images
à la Sauvette*, Paris,1952
(facsimile edition in
slipcase published by Steidl,
Göttingen, 2014)

370 x 274 mm (14 ½ x 10 ¾ in),
158 pp

Hardback with illustrated
cover and jacket and 12-pp
caption booklet

126 b&w photographs

Introduction by Henri
Cartier-Bresson; afterword
by Richard Simon; cover
illustration by Henri Matisse

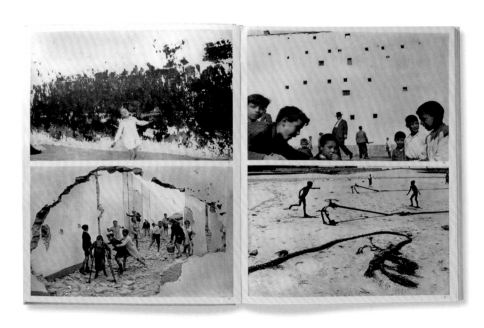

The Decisive Moment, published on 15 October 1952 in the United States and simultaneously in France as *Images à la Sauvette* (which translates roughly as 'Images on the Sly'), may have been the most important photographic book of the last century. Its elegantly simple large-format design and the rich tones produced by the heliogravure printing that showcased the pointed, exquisite formal quality of so many of the French photographer Henri Cartier-Bresson's 126 35-millimetre photographs, made the book an emphatic statement of complex, independent seeing by a pioneer of photographic language.

The cover, designed by Henri Matisse, reflects the photographer's early affinity for painting. The imagery within straddles the line between artist and photojournalist, a synergy that he engaged for much of his career. And a well-formulated text reveals, among other insights, Cartier-Bresson's oft-quoted theory of the 'decisive moment': 'To me, photography is the simultaneous recognition, in a fraction of a second, of the significance of an event as well as of a precise organization of forms which give that event its proper expression.'

The Decisive Moment was Magnum co-founder Cartier-Bresson's first book and, according to a letter he addressed to his colleague, Marc Riboud, it was the publishing medium that he had come to prefer: 'Magazines end up wrapping French fries or being thrown in the bin,' he wrote, 'while books remain.' Conceived and composed by the Parisian publisher Tériade with the collaboration of Marguerite Lang, *The Decisive Moment* allows each image to nearly touch the edge of the page, and includes a caption booklet so as not to interrupt the visual flow. The book primarily displays two vertical images on facing pages, or two-page spreads with one large horizontal image (these are usually placed in the middle of the signatures to ensure the least disruption at the spine), along with a number of double-pages of three images and only two spreads with four photographs displayed.

The Decisive Moment is a modest, even ambivalent book. As the photographer cautions the reader: 'These photographs taken at random by a wandering camera do not in any way attempt to give a general picture of any of the countries in which that camera has been at large.'

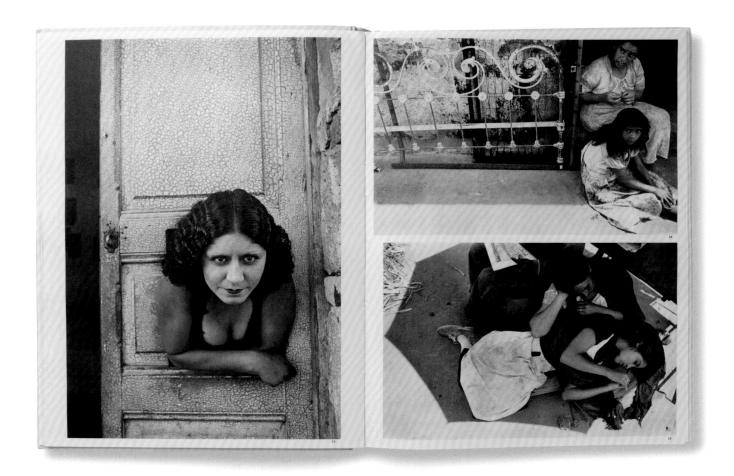

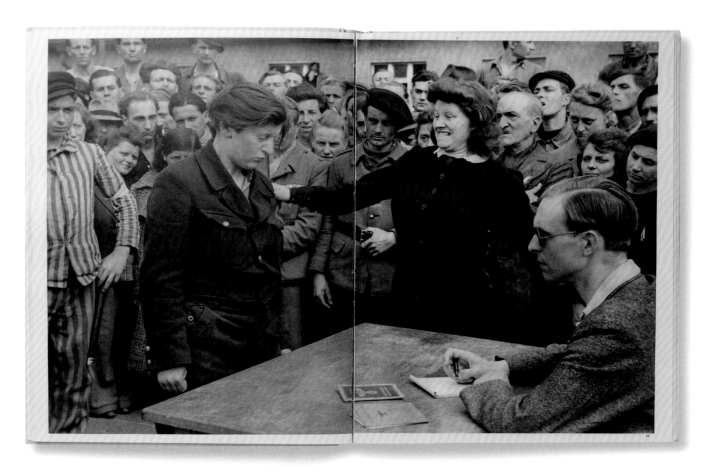

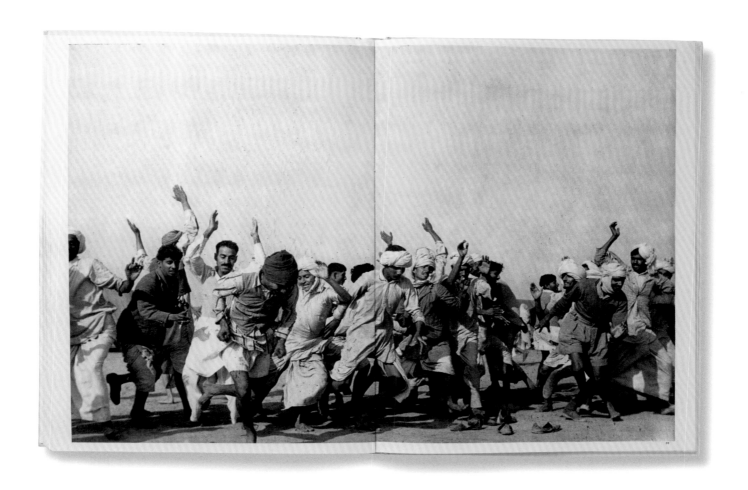

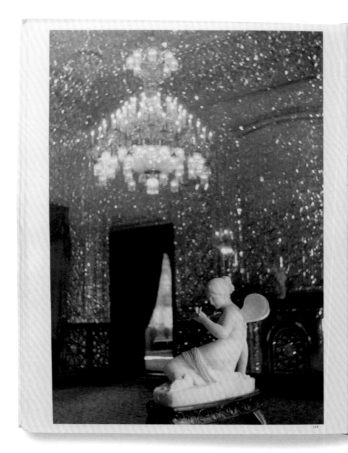

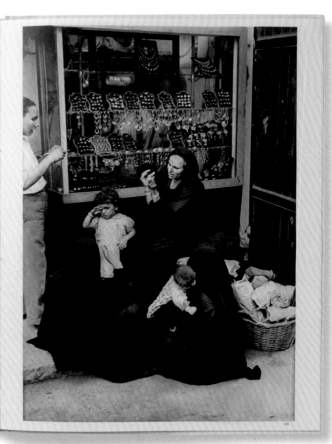

With a text by archaeologist Walter-Herwig Schuchhardt and photographs taken on the Greek mainland and islands, including Athens, Corinth, Delos, Delphi, Meteora Island, Sounion and Crete, *Licht über Hellas* is an oversize book with 159 black-and-white photographs taken from 1936 to 1938 by German photographer Herbert List. List, who had studied art history before becoming a photographer, abandoned his middle-class livelihood as a coffee importer in Hamburg and moved first to London then to Paris. From there he made trips lasting several months to Greece, twice accompanied by his friend and colleague, the fashion photographer George Hoyningen-Huene.

The book has a complicated backstory: its concept and design were developed in 1938, when it was commissioned by Jérôme Peignot, the editor of *Arts et Métiers Graphiques*. At the time, fifteen of List's early Greece pictures had already been published in the periodical *Le Voyage en Grèce – Cahiers Périodiques*, Paris (issue no.9, summer 1938) – List's first major publication – as well as in *Verve* and the yearbook *Photographie*.

In January 1939, List signed a contract for the book to be published in English, French, German and Italian; shortly after, printing plates were sent to Magdeburg, Germany. World War II broke out in September and interrupted the book's printing. List was living and working in Athens, and when German troops attacked Greece in the spring of 1941, he had to return to Munich. His Jewish ancestry meant he was not allowed to pursue the project and publish the book in the following years.

It was only in 1949 that some of the unbound sheets for the book could be secured. Some photographs and negatives left in Paris were never recovered. A reduced print run of *Licht über Hellas* finally came out in Munich in 1953, using the unbound printed pages along with newly printed pages, with 159 images and a text by Walter-Herwig Schuchhardt. Years later, the book was republished. The 1993 volume is a reconstruction of the original book project, preserving the basic format, style, and division into chapters, each with a text by a classical poet selected by List.

List's formal images represent ruins, sculptures and reliefs (photographed under wide skies like stone portraits), together with daily scenes of Greek life, landscapes, portraits of shepherds and local boys. The presence of the Mediterranean is strong. Rather than classical, the images are imbued with a surrealist atmosphere often recalling de Chirico's paintings. According to List, *Licht über Hellas* captures 'the magical essence inhabiting and animating the world of appearances'.

Herbert List
Licht über Hellas
(Light Over Hellas:
A Symphony in Images)

Georg D.W. Callwey, Munich,
1953

360 x 295 mm (14 ⅛ x 11 ⅝ in),
244 pp

Hardback with grey cloth
case and jacket

159 b&w photographs

Introduction by Walter-
Herwig Schuchhardt

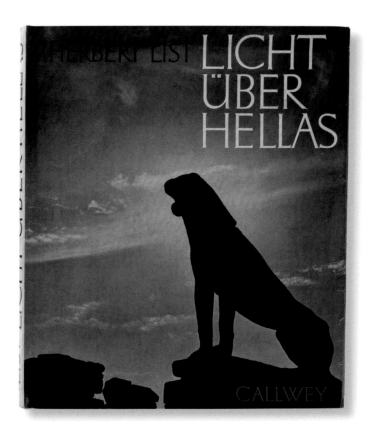

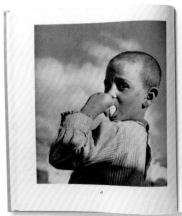

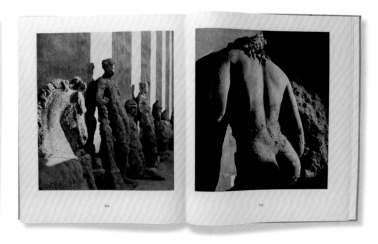

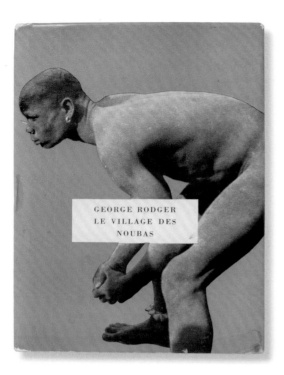

George Rodger
Le Village des Noubas
(The Village of the Nubas)

Delpire, Paris, 1955
(English language and French
editions published by
Phaidon Press, London,1999)

178 x 128 mm (7 x 5 in),
124 pp

Hardback with jacket
with flaps

38 b&w photographs

Text by George Rodger

Le Village des Noubas (The Village of the Nubas) by British
photographer George Rodger, one of the founders of Magnum
in 1947, is the third volume of the *Collection Huit*,
conceived by French publisher and editor Robert Delpire
and designed by Pierre Faucheux. It was printed in Paris
on 4 February 1955. The book became a classic and was
republished in a facsimile form in 1999 by Phaidon Press.

Rodger first visited Africa early in his career, when
LIFE magazine sent him to cover fighting between Axis and
Allied forces in North Africa in 1941. Having also visited
Iran, Burma and Italy, in April 1945 he was the first
photographer to enter Bergen-Belsen concentration camp.
Traumatized by what he had seen at Belsen, Rodger vowed
never to photograph war again and returned to Africa as
part of a 45,000-kilometre (28,000-mile), two-year journey
from Cape Town to Cairo.

The Nuba story originated from *National Geographic*, where
Rodger's pictures were published in February 1951 (they
were first published by *Weekly Illustrated* on 22 October
1949); the assignment was approved while Rodger and his
wife Cicely were in southeastern Sudan, photographing the
Latuka tribe. In February 1949 they started their journey
to Kordofan province where 300,000 Nuba were living in
isolation. With permission from the District Commissioner,
Jack Thompson, and the Jebel sheikhs, Rodger spent time
with the Nuba and became the first photographer to
witness their wrestling tournaments. Working with a Leica
rangefinder for the action shots and a Rolleiflex 2 ¼ inch
for prospective magazine covers, Rodger shot both in colour
and in black and white.

Le Village des Noubas gives equal importance to text
and images. It is divided into chapters, and each image
sequence is preceded by a text based on Rodger's diary.
The cover and back cover use cutouts of a single image
of the Nuba fighters floating on an acid green background.
Inside the text is printed on off-white matte paper and
the photographs on shiny white paper; they are mostly
reproduced full-bleed, either on single or on double pages.
Rodger's photograph of the Nuba victor, his body rubbed
with white ashes, sitting on his adversary's shoulders,
became one of his most famous pictures.

A year after their trip, Cicely died in childbirth, and
the book is dedicated to 'the memory of my wife Cicely,
for whom that trip was the last'.

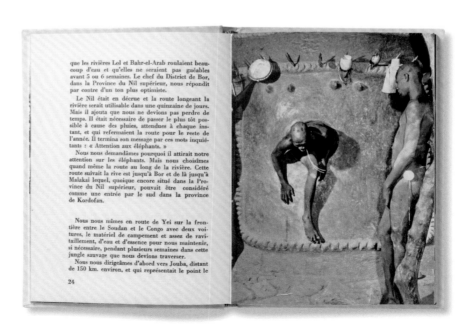

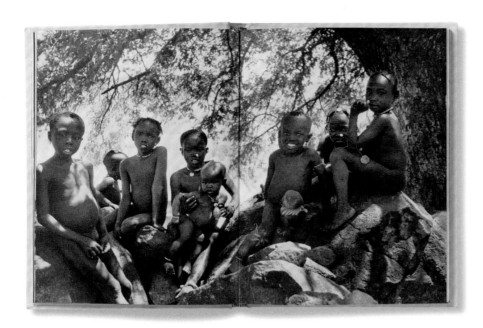

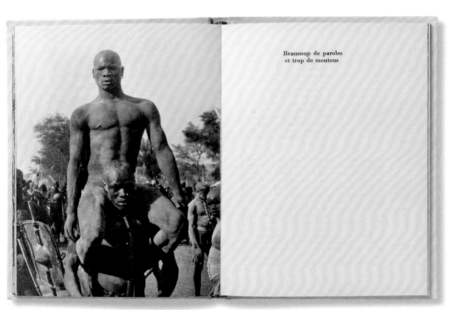

Beaucoup de paroles
et trop de moutons

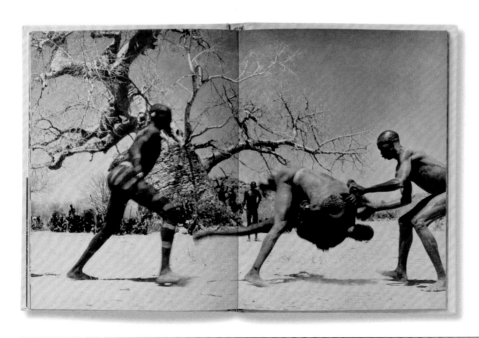

Dennis Stock
Portraits of a Young Man,
James Dean

Kadokawa Shoten, Tokyo, 1956

252 x 180 mm (10 x 7 in),
82 pp

Paperback with jacket

65 b&w photographs

Text in English and Japanese

In 1951, Dennis Stock joined Magnum. In January 1955,
film director Nicholas Ray invited him to a soirée in his
Hollywood bungalow in the grounds of the Château Marmont
Hotel, where he introduced Stock to a rising young actor:
James Dean. Stock had a long conversation with Dean
and attended a sneak preview of his film *East of Eden*
at a Santa Monica theatre. Mesmerized, Stock mentally
photographed Dean's repertoire of gestures. He was deeply
impressed by Dean's acting and sensed that the charismatic
young man would soon join Marlon Brando and Paul Newman
as a major film star of his generation. Stock decided then
and there to shoot a story about Dean and he received a
two-day guarantee from *LIFE* magazine – $150 a day. He would
work for two months. *LIFE* ran a number of the pictures in
its 7 March 1955 issue, under the headline 'Moody New Star'.

The encounter between Dean and Stock also resulted in
the book *Portrait of a Young Man, James Dean*. Stock
photographed Dean on a journey to his hometown, Fairmount,
Indiana, where he had grown up on a farm with his aunt and
uncle; they then went to New York City, before returning
to Hollywood, as Dean started work on Ray's film *Rebel
Without a Cause*. In a Fairmount picture, the actor is shown
posing with a huge white sow, his hand resting on the
animal's flank. Frame number nineteen on one of Stock's
contact sheets is a portrait that would become world-
famous: hunched over, cigarette dangling from his mouth,
hands in pockets of a Chief Petty Officer's Navy bridge
coat bought at an army surplus store, it shows Dean on his >>

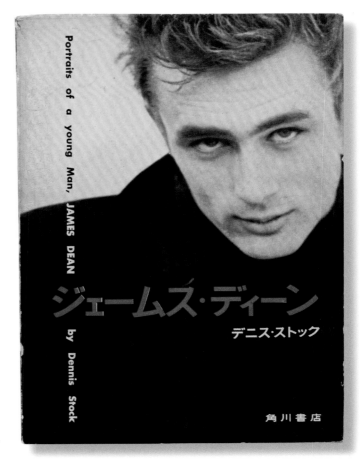

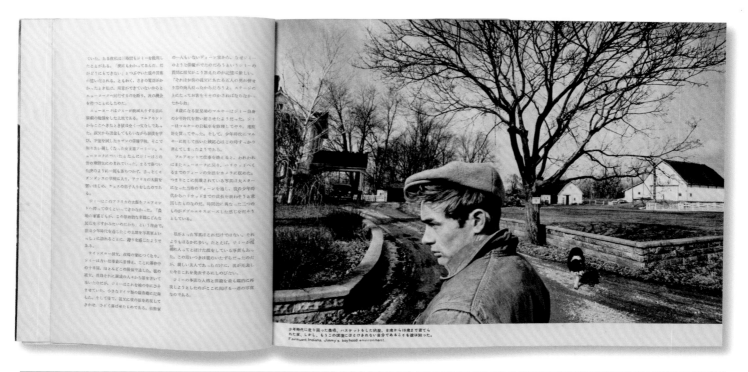

少年時代に走り回った農場、バスケットをした納屋、8歳から19歳まで育てられた家。しかし、もうこの映像にはとけ込まれない自分であることを彼は知った。
Fairmount, Indiana. Jimmy's boyhood environment.

way to the Actors Studio in New York. He appears as a sombre figure seen from a distance and reflected in a puddle, walking towards the photographer in a drizzly, misty Times Square. The surroundings of billboards and movie marquees take on as much importance as the person, illustrating the actor's milieu as well as his dreams.

'What I was specifically trying to illustrate was the concept of "you can't go home again",' Stock explained. 'I wanted to create a visual biography, which was unheard of … so we were making in stills a little movie'. This is Dennis Stock's first book, and demonstrates his skill as an editor and designer of his own photographs. As in his next book *Jazz Street* (1960), the image sequence is tight, filmic, dynamic and surprisingly modern. It is accompanied by a text Stock wrote about his story and his relationship to James Dean, who would never see the book published: he died in a car crash in February 1955.

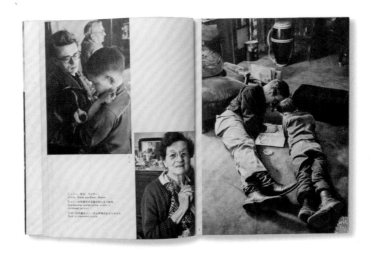

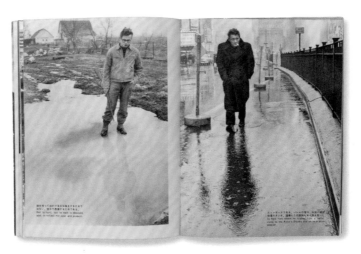

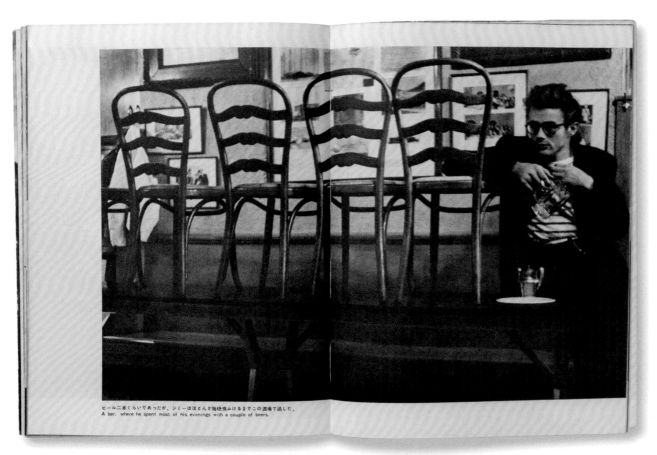

Micha Bar-Am
Across Sinai

Hakibbutz Hameuchad
Publishing House and
Lamerhav, Tel Aviv, 1957

234 x 212 mm (9 ¼ x 8 ¼ in),
80 pp

Hardback with cloth spine

57 b&w photographs

Photographs by Micha
Bar-Am and Azaria Alon;
introduction by Yohanan
Aharoni with accompanying
remarks by Azaria Alon;
layout and cover design
by Dan Gelbart

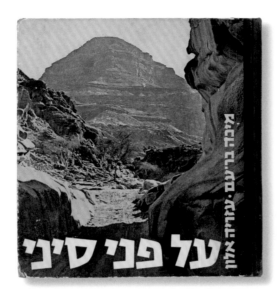

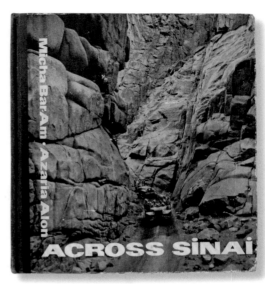

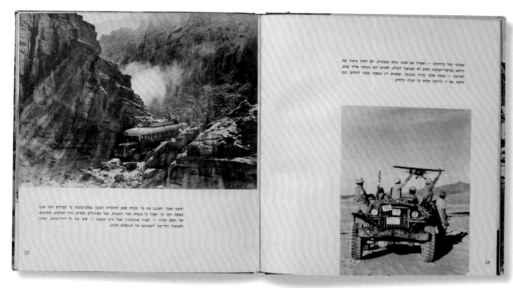

Born in Berlin in 1930, Micha Bar-Am arrived in Israel (then Palestine) with his family in 1936, later becoming involved in the Jewish underground, working on kibbutzim and, after the creation of the State of Israel in 1948, serving as a conscript in the Arab-Israeli War. He also began documenting kibbutz life and archaeological sites using borrowed cameras: 'I had an interest in biblical archaeology and joined expeditions in search of remnants of the Dead Sea Scrolls in the Judean Desert. With a camera borrowed from a friend I managed to publish my first story in a major magazine.'

After his military service, Bar-Am began to photograph with awareness, covering the 1956 Suez Crisis, when Israel invaded the Egyptian Sinai after President Nasser's decision to nationalize the Suez Canal and French and British troops intervened to try to take control of the waterway. (Magnum co-founder 'Chim' Seymour was killed in the conflict.) Eager to cover the action, Bar-Am bought a Leica and borrowed a few rolls of black-and-white film and one roll of colour. Disguised as a troupe of entertainers, he hitchhiked with two companions from Beer-Sheva to the Sinai, following the advancing troops, until he was able to join a reconnaissance unit to the Gulf of Suez. The fighting lasted only 100 hours, leaving Britain and France humiliated and Israel occupying the Sinai, which became

a pilgrimage of sorts for Israelis eager to see the biblical desert across which Moses had led the Israelites in the Book of Exodus.

The public appetite for images of the Sinai led to the publication of *Across Sinai*, a book in a modest format, featuring fifty-seven black-and-white images by Bar-Am and Azaria Alon – an established natural history photographer whose involvement in the project was requested by the publisher – comments by Alon and an introduction by archaeologist Yohanan Aharoni. The images are a combination of landscapes (desert monasteries and fortresses, sand dunes and palm groves) and portraits (a Sinai Bedouin, an Arab boy picking dates, soldiers round the campfire) organized in a loose sequence. Bar-Am recalls: 'This Sinai is no strange and desolate land, without any roots in our history, as might appear to some ostensibly observer or scholar. This is the historic Sinai, and it was seen like this by two of the Children of Israel.'

Across Sinai, Bar-Am's first book, achieved an edition of 20,000 copies and prompted the Israeli Army magazine *Bamachane* to hire him as a photographer in 1957, launching his career (he would become a Magnum correspondent in 1968). Also in 1957, Israel was forced to withdraw from the Sinai because of strong international diplomatic pressure.

Magnum Photographers
Children's World

Heibonsha, Tokyo, Japan, 1957

245 x 180 mm (9 ¾ x 7 in),
56 pp

Hardback with jacket

59 b&w photographs

Texts by Kryn Taconis,
David Seymour, George
Rodger, Henri Cartier-
Bresson, Eve Arnold,
Inge Morath, Cornell Capa
and Elliott Erwitt

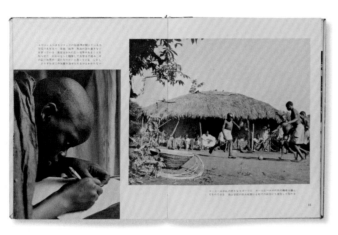

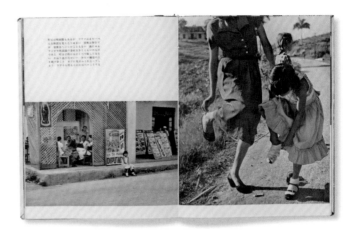

Magnum Photos' first collective book, *Children's World* features images by eight Magnum photographers chosen from the project *Generation Children*, conceived by Robert Capa in early 1954 (he died before the project was finished) and assigned by John Morris. The project, meant to picture children all over the world, was a sequel to *Generation X* (about children born after World War II) and *Generation Women*. With a portrait of a Peruvian boy by Cornell Capa on its green cover, the small book features a preface followed by eight short portfolios, with one or two black-and-white images per page, sequenced with no separation between photographers.

As Robert Capa had intended, each photographer found a subject in the part of the world where he or she usually worked. Magnum founding member George Rodger stumbled upon his subject while shooting his story, *King of Bunyoro*, in Uganda. Emanuel was the son of the Keeper of the Sacred Shield in Bunyoro's royal household. Rodger photographed him at court, but also working with his mother in the manioc fields and hunting a water buffalo with a spear, noting the boy's 'naturalness and unselfconsciousness'.

Kryn Taconis, a member of Magnum since 1950 (he left the agency in 1960), documented the harsh, nomadic life of Iisak Henryk Magga, a young Sami boy, while he and his family followed the migration of their reindeer herd across Lapland's desolate tundra. Two newcomers to Magnum – Inge Morath and Cornell Capa – chose Europe and South America, respectively. Morath photographed Ian MacPherson, a six-year-old English boy attending a privileged prep school, whom she shows at home, at school, at the barbershop and being driven by his father in the family's sports car. Capa, who joined Magnum after his brother Robert's death, photographed ten-year-old Mario Tito Meseco, a Quechua

Indian shepherd living in an adobe house with his family in Huila, in the Andean sierra.

Eve Arnold, also new to the agency, photographed nine-year-old Juana Chambrot from Cayo Carenero, Cuba, whose parents were fishers who were so poor that they begged Arnold to adopt Juana to save her from a life of poverty. Deeply touched, Arnold would go back to see Juana in 1997. In North America, meanwhile, Elliott Erwitt photographed ten-year-old Gary Carlstrom in his tough, physical and practical world in North Park, Colorado, playing baseball and helping on his father's ranch.

Magnum founder Henri Cartier-Bresson explored a contrasting type of physicality in his images of Arlette Rémy, a young *petit rat* (apprentice ballerina) with the Paris Opera. David 'Chim' Seymour, another founder member, also chose a European subject. Then living in Italy, he photographed a young boy from Orvieto, Roberto Moncelsi, who served as a guide in front of his parents' restaurant, explaining to tourists in fluent English and French the history of the neighbouring Gothic cathedral.

In the spirit of 'Family of Man', which opened at New York's Museum of Modern Art in 1955, *Children's World* is an attempt to record and understand the lives of children the world over. Even when the children photographed come from poor backgrounds, there is a sense that the photographers strive towards a vision of shared traditions and harmony and want to emphasize resemblances rather than differences in that world. Such an endeavour was very much in the spirit of Magnum, and other organizations such as the United Nations and UNICEF, founded after the war. The pictures were also published as a three-part series in *Holiday* magazine in December 1955 and January and February 1956.

Inge Morath
De la Perse à L'Iran

Delpire, Paris, 1958
(published in English by
The Viking Press, New York,
1960 and in paperback by
Nouvel Observateur/Delpire,
Paris, 1980)

279 x 220 mm (11 x 8 ⅝ in),
138 pp

Hardback with grey cloth
and jacket

25 colour and 37 b&w
photographs and 1 map

Edited by Robert Delpire;
text by Edouard Sablier;
photographs by Inge Morath

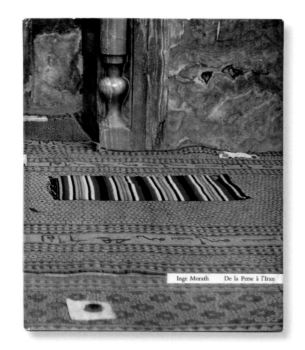

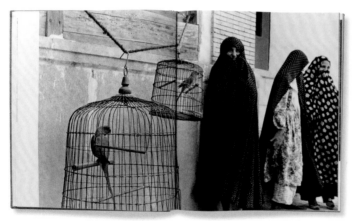

Invited to join the newly founded Magnum agency in 1954 as an editor and researcher, Inge Morath — then a journalist — began photographing during the early 1950s, submitting her pictures to agencies under the pseudonym of Egni Thoram (an anagram of her name) until she had established her reputation as a photographer more widely. She became a Magnum associate in 1953, while assisting Cartier-Bresson, and a full member in 1954 becoming one of the first women to join the all-male cooperative along with Eve Arnold.

During March and April of 1955, Morath made a five-week journey to Iran with the publisher Robert Delpire to work on her second monograph. *Holiday* had also asked her to photograph the carpets and mosques of Isfahan, and she had assignments for the Pepsi-Cola Corporation in Tehran and for Standard Oil in Abadan. For Magnum distribution, meanwhile, she documented the Shah's celebration of Nowruz, the Persian New Year and the Golestan Palace. However, most of the images Morath shot for *De la Perse à l'Iran* (From Persia to Iran) were self-assigned. Carrying two cameras, she made more than 5,000 exposures: one hundred rolls of black-and-white and about forty rolls of colour film. She also carried a Polaroid camera, and gave the portraits she took to her nomad subjects, who had probably never been photographed before.

Beneath its jacketed cover featuring a full-bleed detail of a colour photograph of Iranian carpets, with the title set

like a fax in the corner, *De la Perse à l'Iran* is printed on off-white paper and is divided into eleven thematic chapters mixing black-and-white and colour photographs, with captions at the end of each chapter and a historic text by Edouard Sablier. Though Morath had not planned it that way, colour photographs are predominant in the book because a light leak damaged the black-and-white film in one of her cameras, which she discovered only upon her return to Paris.

Morath's graceful and empathetic photographs capture beautiful archaeological sites in Persepolis but mostly focus on the great variety of human subjects she was able to approach: a Kurdish shepherd in the plain, street musicians, a boy carrying a tower of suitcases in the bazaar, Empress Soraya in her palace, small girls knotting carpets … Attracted particularly to women and children, she often makes ironic, bitter-sweet social commentaries on their situation: pairing veiled women with caged cockatoos in the Shiraz market, for instance, or contrasting the tiny stature of girls weaving carpets with the gigantic size of the looms, a statement on child labour. *De la Perse à l'Iran* lies somewhere between anthropology and diary. It does not express decisive moments but, rather, the complex layering of history and modernity within a culture in transition: 'What interests me', Morath wrote, 'is the continuity — or lack of it — between past and present. This is what is expressed in the title of my book *From Persia to Iran*.'

When he said 'Jump!' they all did: Groucho Marx and Bob Hope, Marilyn Monroe and Richard Nixon, the Duke and Duchess of Windsor, Jerry Lewis and Dean Martin, Sophia Loren, Audrey Hepburn, Brigitte Bardot and even the Ford matriarch, Mrs Edsel Ford. (One subject refused, and when asked why, tilted his chin and said he had no reason to explain his refusal. Click, Halsman went.) And we all know his picture *Dalí Atomicus* of 1948, where a crazed-looking Salvador Dalí is suspended in mid-air together with three lunging cats, a chair and a long, S-shaped stream of water. Halsman was nothing if not persistent: the picture took twenty-eight tries. 'When you ask a person to jump,' he said, 'his attention is mostly directed toward the act of jumping and the mask falls so that the real person appears.'

Halsman, who was Jewish, had immigrated to New York in 1940. His breakthrough came when he photographed a young model resting on the American flag: she became the face of Elizabeth Arden's *Victory Red* lipstick. More than a hundred Halsman covers for *LIFE* magazine followed, featuring portraits of celebrities, intellectuals and politicians. In 1951, the founding members of Magnum – Chim, Capa,

Rodger and Cartier-Bresson – asked Halsman to become a contributor so that they could syndicate his work outside the United States.

Under a white cover featuring red, stacked-up typography and a portrait of comedian Danny Kaye jumping with his cane, not much bigger than the letters, *Philippe Halsman's Jump Book* features 197 black-and-white photographs. The beginning of the book showcases images in the margin alongside Halsman's commentaries and analysis of the act of jumping. The dedication of the book reads: 'To my subjects who defied gravity'. This is followed by a long series of various personalities jumping – some full page, some organized in sequences on the same page – with short comments by Halsman.

About the *Jump Book* and the art of portraiture in general, Halsman explained: 'Most people stiffen with self-consciousness when they pose for a photograph. Lighting and fine camera equipment are useless if the photographer cannot make them drop the mask, at least for a moment, so he can capture on his film their real, undistorted personality and character.'

Philippe Halsman
Philippe Halsman's Jump Book

Simon and Schuster, New York, 1959 (paperback published by Abrams, 1986; revised hardback edition published by Damiani, 2015; French edition by Editions de La Martinière, 2015)

178 x 210 mm (7 x 8 ¼ in), 96 pp

Hardback with paper cover, cloth spine and jacket

197 b&w photographs

Preface 'Jumpology' by Philippe Halsman

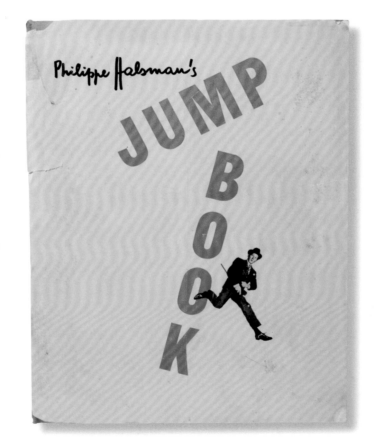

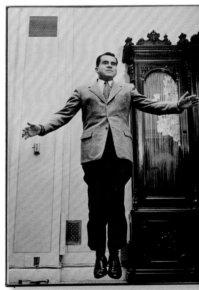

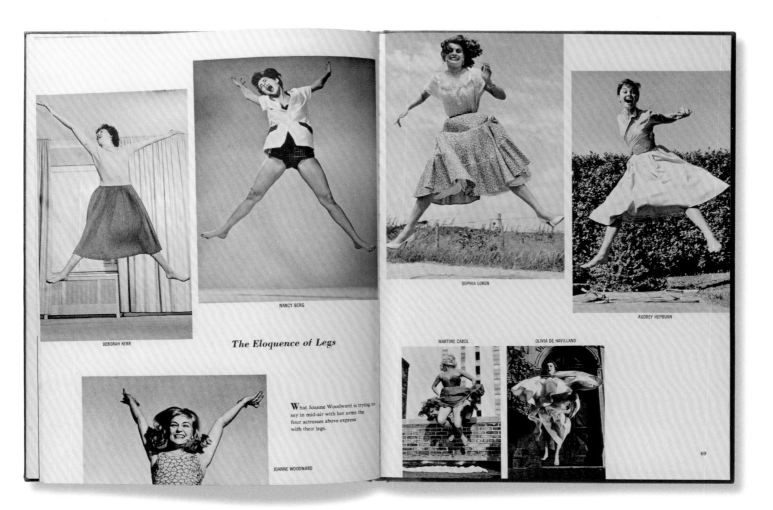

DEBORAH KERR

NANCY BERG

The Eloquence of Legs

What Joanne Woodward is trying to say in mid-air with her arms the four actresses above express with their legs.

JOANNE WOODWARD

SOPHIA LOREN

AUDREY HEPBURN

MARTINE CAROL

OLIVIA DE HAVILLAND

69

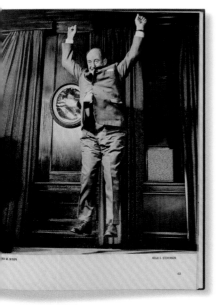

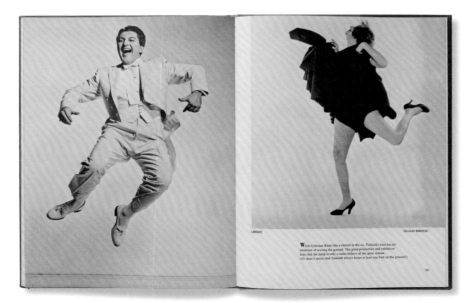

LIBERACE

TALLULAH BANKHEAD

While Liberace floats like a cherub in the air, Tallulah's foot has no intention of leaving the ground. The great projectors and exhibitors hide that the jump is only a make-believe of the great actress. (Or don't it mean that Tallulah always keeps at least one foot on the ground?)

René Burri
Die Deutschen (The Germans)

Fretz & Wasmuth Verlag,
Zurich/Stuttgart, 1962
(published in French as
Les Allemands, Delpire,
Paris, 1963; revised
editions published in 1986,
1990 and 1999)

185 x 210 mm (7¼ x 8¼ in),
168 pp

Hardback with full linen
cover and jacket

80 b&w photographs

Texts edited by Hans Bender;
text extracts by Heinrich
Böll, Bertolt Brecht,
Max Frisch, Wolfgang
Koeppen, Friedrich Sieburg,
Diether Stolze and others

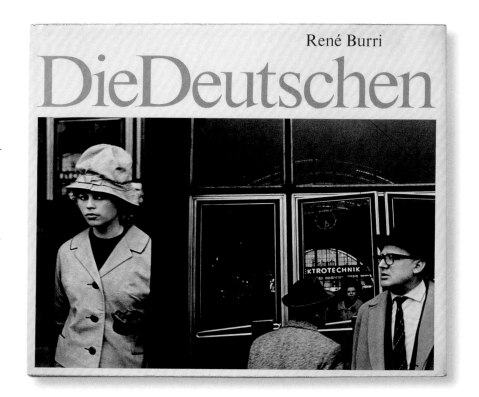

Although *Die Deutschen* was a commercial failure when it was published in 1962, it has since become a classic of postwar European documentary photography. Intended as a counterpart to Robert Frank's *Les Américains* (1958), also published by Delpire and similar in design, *Die Deutschen* is now seen as the definitive portrait of a complex, changing nation struggling to shake off the legacy of World War II and redefine itself.

The Swiss photographer René Burri – one of Magnum's early members, joining the agency in 1955 and becoming a full member in 1959 – spent three years working on his first book. It is a book of history more than geography, although it does not describe the big issues, but rather everyday life. Burri's neutrality – he called himself 'The Swiss in the world' – and his command of the German language enabled him to approach people easily and to photograph in both West and East Germany: he portrayed both with an unprejudiced eye, sometimes serious, sometimes humorous.

The layout of *Die Deutschen* can seem repetitive – picture on the right, caption on the left – but ultimately this very repetition helps to highlight differences and details in the sequence of eighty black-and-white images. The hardback cover of the first French edition is a black background sprinkled with signatures from German artists in green and purple; the German edition featured one of Burri's striking photographs, beautifully framed yet casual in its composition.

Children saluting a tank in West Berlin, a solitary man in a tramway, a speeding Volkswagen on a highway, the Oktoberfest in Munich, the first postwar factories, a Lunapark, a school, street children, mannequins in evening dress … Burri records them all. One image of a zigzag iron staircase, taken in Berlin in 1957, is a mass of striated shadows and half-tones, where one silhouetted figure is walking up, another down, while one hesitates on a landing, foreshadowing Burri's famous photograph taken on a building's roof in Brazil. 'What counts', Burri said, 'is putting the intensity that you yourself have experienced into the picture. Otherwise it is just a document.'

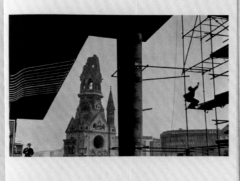

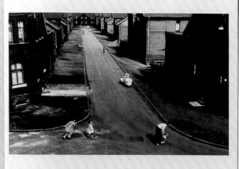

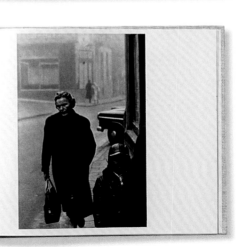

Ferdinando Scianna
& Leonardo Sciascia
Feste religiose in Sicilia
(Religious Festivals in
Sicily)

Leonardo da Vinci Editrice,
Bari, 1965 (large format
edition with slipcase also
published by L'Immagine
Editrice, Palermo, 1987)

186 x 128 mm (7 ¼ x 5 in),
224 pp

Hardback with natural cloth
and jacket

106 b&w photographs

Text by Leonardo Sciascia;
photographs by Ferdinando
Scianna

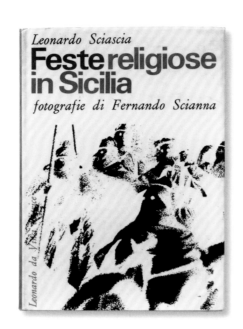

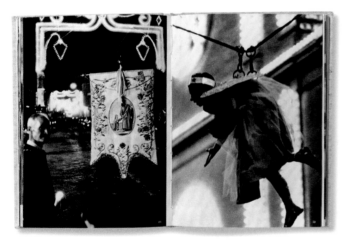

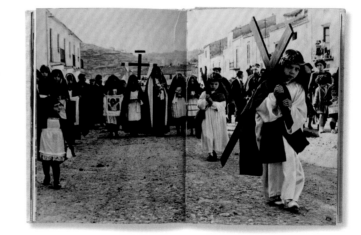

Feste Religiose in Sicilia was published when Sicilian photographer Ferdinando Scianna was only twenty-two, years before he met Henri Cartier-Bresson and subsequently joined Magnum in 1982. Under an off-white cover where the photograph of a procession appears as mysterious, ghost-like shapes, the book is novel-sized with an immersive layout of images printed full bleed on a single page or on double pages.

The religious rituals of his native island (he was born in Bagheria) have been a life-long interest for Scianna, who started photographing them while he was studying literature, philosophy and art history in Palermo in the early 1960s. His interests led him to specialize in anthropology, but rather than study faraway countries, he decided to focus on Sicily, witnessing religious holidays – which he calls 'existential explosions' – in towns and remote villages all over Sicily. Often taken at night, using the natural light of candles and no flash, the photographs offer dramatic light contrasts as well as complex compositions. Scianna's photographs go beyond documentary. Although he is not a religious person, neither is he a dispassionate observer. He plunges into the crowds and becomes part of festivals that unite people in shared rituals. He calls his attitude one of compassionate curiosity.

The book is divided into the different festivals that Scianna covered from 1961 to the end of 1964 (in 1963 he

started collaborating with writer Leonardo Sciascia, who would write texts for several of Scianna's books, including this one). The festivals include *La Madonna del Monte* in Racalmuto, *L'Assunta* in Aspra, *Santa Rosalia* in Palermo. In Missilmeri, for the feast of San Giuseppe, children dressed as flying angels are suspended from wires; in Prizzi, a crowd of devils with papier-mâché masks congregate; in the final images of the book, made during Good Friday in Enna, ghost-like characters, their heads covered in sheets, walk in procession holding swords and crosses. Grainy and fuzzy, the images allude to the ultimate mystery of the religious festivals. 'A photograph is not created by a photographer,' said Scianna. 'What it does is just to open a little window and capture it. The world then writes itself on the film. The act of the photographer is closer to reading than it is to writing. They are the readers of the world.' The world that Scianna photographed has all but disappeared, as religious festivals have become commercialized as a form of folklore intended for tourists.

Feste Religiose in Sicilia won the prestigious Prix Nadar in France in 1966 at a time when neither photography nor photography books were recognized. Like Sergio Larrain's *Valparaiso* (1991), it is a great example of collaboration between writer and photographer. Its spare yet lyrical design and its emphasis on the photographer as subjective witness have made it a classic.

Marc Riboud
The Three Banners of China

Macmillan, New York, 1966
(published in French by
Robert Laffont, Paris, and
in German by Helmut Kossodo,
Geneva)

260 x 211 mm (10 ¼ x 8 ¼ in),
216 pp

Hardback with grey linen
cloth and jacket

109 b&w images and
39 colour images

Text by Marc Riboud

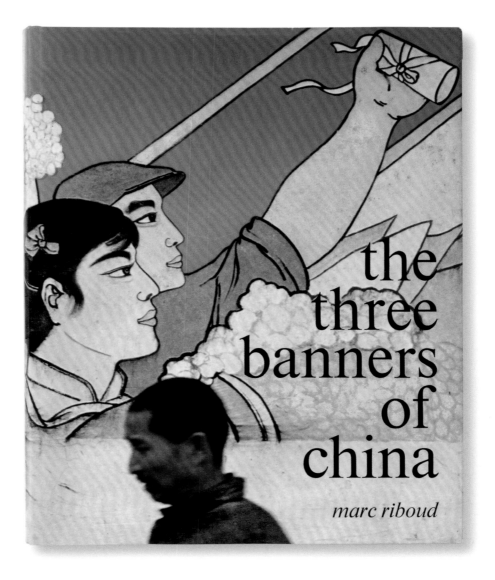

In the early 1950s the French photographer Marc Riboud moved from Lyon to Paris, where he met the founders of Magnum Photos – Henri Cartier-Bresson, Robert Capa, George Rodger and David Seymour. By 1953 he was a member of the organization (he left in 1979) and he began travelling in the Middle East and Asia, as suggested by Cartier-Bresson: 'You should go to China and have a look, it is a totally different world from ours.'

In 1957 Riboud was one of the first Western photographers to enter China, making the first of more than twenty visits to the country. He returned in 1965 for a second time: a four-month stay with K.S. Karol, a French journalist from *Le Nouvel Observateur*. They had to wait a year for their visa. Their visit coincided with the Hundred Flowers Campaign – a rare moment when Chairman Mao Zedong encouraged open political debate – and the start of the Cultural Revolution, which stifled that debate. The Cultural Revolution was based on what the Chinese called the 'three banners', or paths – which also provided Riboud's three chapters for the book: the agricultural communes; the industrial expansion of the Great Leap Forward; and the organization of daily life by the Communist Party. Riboud noted: 'I had remained obsessed with the desire to return and see again what I had seen once. I wanted to try and see more, and to see more clearly. Since my first journey, developments of considerable importance had taken place … which seem to have transformed both China and world's opinion on China.'

Sometimes accompanied by an interpreter, Riboud and Karol travelled by train, taxi or bus more than 20,000 kilometres (12,500 miles), crossing twelve of the eighteen Chinese provinces. Photographing schools and universities, family life, literacy campaigns, workshops and factories and everyday peasant life, Riboud was usually welcomed. He did not find many obstacles in photographing people, and nobody tried to conceal poverty. He recorded a society in a state of transition: 'The work I have done in China does not have a beginning and an end. I have never thought of it as a story, not even as history.'

National Geographic had offered Lee Jones, then an editor at Magnum New York, an $8,000 guarantee for the story, but Riboud, who wanted to remain independent, turned it down. When he came back, *LOOK* magazine ran his story on a cover and eighteen pages – the largest story they had ever published – and his pictures had many simultaneous publications in Europe. As a book, *The Three Banners of China* features thirty-nine colour photographs and over one hundred in black and white, each with a caption, interspersed with writings by Riboud. The images vary in size, ranging from single pages to double pages and smaller sizes, mixing colour and black and white. In this loose travelogue, Riboud does not impose his ideas on China, but collects telling instants and details, building with fragments a chronicle of the country's history.

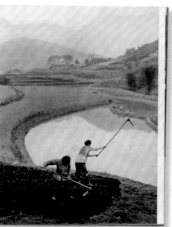

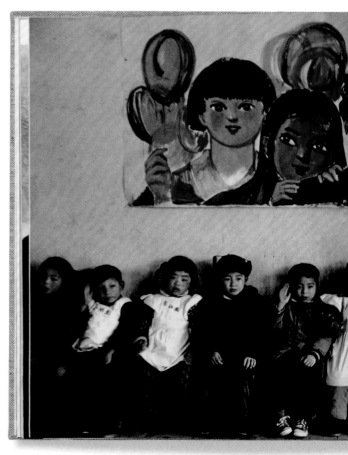

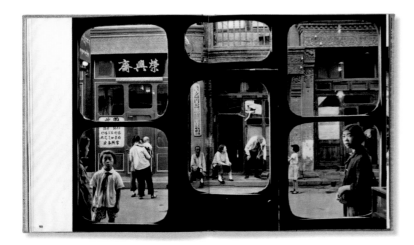

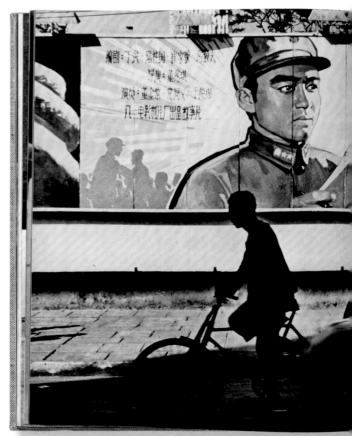

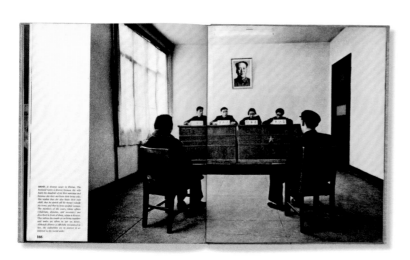

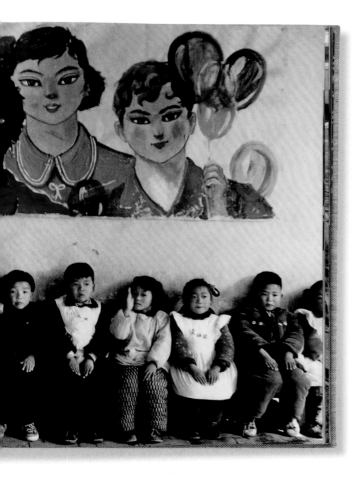

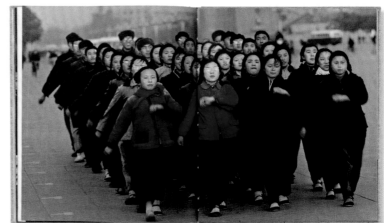

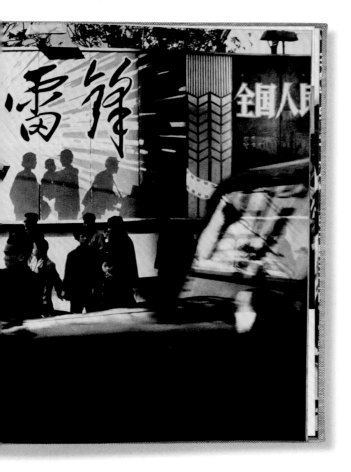

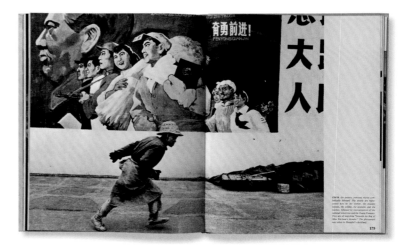

Burt Glinn
*A Portrait of all the
Russias*

The Hogarth Press, London,
1967

277 x 206 mm (11 x 8 in),
176 pp

Hardback with full red cloth
and jacket

56 colour photographs

Text by Laurens van
der Post

Burt Glinn joined Magnum as an associate in 1951, the same year as Dennis Stock and Eve Arnold, and in 1954 he became a full member, one of only three Americans. Some of his best-known works were the colour travel essays he produced for the American travel magazine *Holiday* in the 1960s, including entire issues devoted to such places as the South Seas, Japan, Mexico, Russia and California. Two of these essays grew into books: *A Portrait of all the Russias* (1967) and *A Portrait of Japan* (1968, also published by Hogarth Press).

A technical perfectionist, particularly in relatively early colour processes, Glinn worked at a time when travel photography was still closely connected to anthropological investigation of other cultures. Laurens van der Post, a renowned Afrikaner anthropologist, wrote the text for *A Portrait of all the Russias*. Sections of Van der Post's text, printed on off-white matte paper, are followed by sequences of colour images (fifty-six in total) reproduced on shiny paper. Each section is devoted to a different geographical area of the Soviet Union, hence the title of the book.

Glinn photographed the expected – Red Square, for instance – but also travelled in much lesser known parts of the Soviet Union, such as Central Asia, Georgia, Ukraine, Siberia, Riga and Leningrad, shooting unposed images of everyday life: a picnic, little girls in pink outfits and high hats, babushkas in flowered kerchiefs, a heroine of Soviet labour, a chest covered in medals, a Ukrainian farmer, three Jews in the only remaining synagogue in Bukhara, a miners' sanatorium in Sochi … When Glinn visited Russia, few photographers, except for his colleague Eve Arnold, had been there and given as much access. Adept at portraiture as well as landscapes, Burt Glinn demonstrated in this book that he could approach people from all walks of life, from politicians to artists, workers, nomads, children and peasants. He once said: 'What is important is not what I make happen, but what happens to me … I think that what you've got to do is discover the essential truth of the situation, and have a point of view about it.'

Magnum Photographers
America in Crisis

Michael Joseph Ltd, London,
and Holt, Rinehart and
Winston, New York, 1969

292 x 210 mm (11 ½ x 8 ¼ in),
192 pp

Hardback with cloth cover
and jacket

171 b&w photographs

Photographs by various
photographers and edited
by Charles Harbutt and
Lee Jones; foreword
by the editors; text
by Mitchel Levitas

'Our crisis today,' begins the foreword to *America in Crisis*, 'is the clash between the nation's traditional vision of itself – the American dream – and the hard, discordant realities it lives with.' The book, the reader is then told, 'is an effort to examine the dream and the reality. In text and pictures it seeks to identify the events, the trends, and the feelings involved in this crucial period of the American experience.'

But the book's editors have something more startling in mind as well: 'Because so much of what is happening is subjective, much of the crisis is interpreted in pictures.' It used to be said, of course, that 'the camera never lies', and one could rely on a photograph for a seemingly objective version of events, but as of 1969 photographers, or more specifically photojournalists, particularly of the Magnum variety, could be considered to have their own, individualized points of view, at least when dealing with 'much of what is happening'. (While John Szarkowski's 'New Documents' exhibition, featuring the work of Diane Arbus, Lee Friedlander and Garry Winogrand at New York's Museum of Modern Art two years earlier posited a similar hypothesis concerning documentary photographers, it is only in recent years that the interpretive qualities of the photograph have been widely accepted.)

America in Crisis, divided into eight thematic sections concentrating on the United States in 1968, was edited by Magnum photographer Charles Harbutt and New York >>

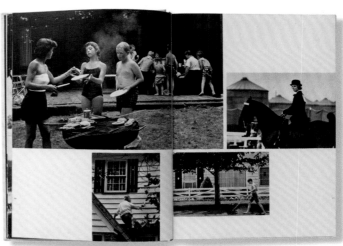

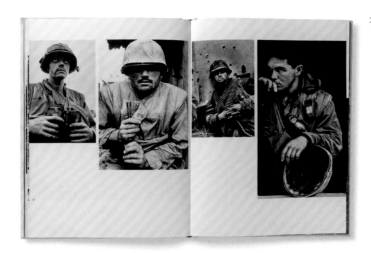

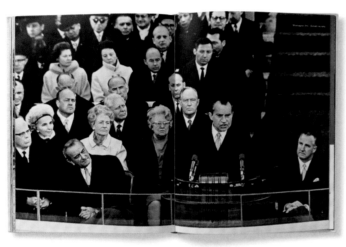

>> bureau chief Lee Jones, and featured the work of eighteen photographers who were only credited for individual images at the back of the volume (the authorship of small photo essays was acknowledged near the pictures),including one on North Carolina sharecroppers by Constantine Manos, and another on the 'Kennedy Magic' by Burt Glinn and Cornell Capa. The captions are minimal, and some of the spreads are jarring, like an image of a young woman in hair curlers tending to a cow across from one of a radiant beauty queen wearing a crown, or a photograph of energetic black men protesting in front of the Washington Monument facing a dark, haunting image of two Ku Klux Klan members standing in front of a little girl. A spread depicting three grieving widows – Mrs John F. Kennedy, Mrs Martin Luther King, Jr and Mrs Robert F. Kennedy – is poignant with grief and society's failures.

Harbutt also devised an idiosyncratic mode of presentation for the work when it was exhibited: the viewer pulled a lever attached to three projectors, each showing individual pictures from the project so that, like a slot machine, images would line up in differing sequences each time, the juxtapositions creating different meanings. The projection was set up so that the only time three images would match was if they were all the same photograph: a mask of President Richard Nixon with a dollar sign drawn across his forehead.

Why explore an America in crisis? The reasoning was noble, if tentative: 'Taking its measure may be a step toward surmounting it and toward making all citizens eligible to share the dream.' Sadly enough, one is left with the sense that a similar, angrier project must be done again, questioning how a crisis explored nearly fifty years ago has been allowed to so cruelly metastasize.

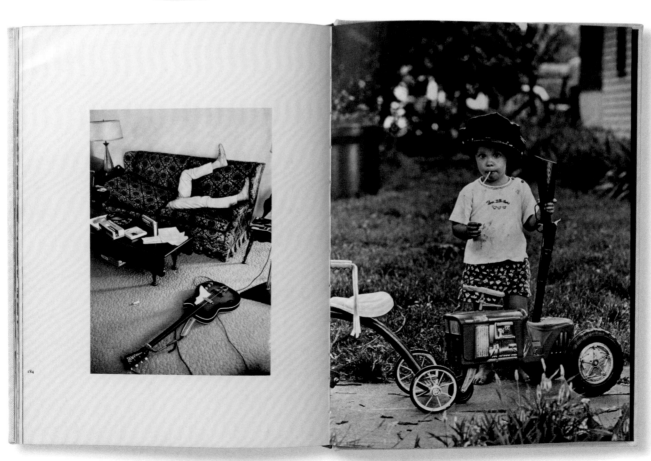

Bruce Davidson
East 100th Street

Harvard University Press,
Cambridge, Massachusetts,
1970

277 x 230 mm (11 x 9 in),
130 pp

Hardback with linen cover
and inset photograph

123 b&w photographs

Introduction and edited
by Bruce Davidson; design
by Elton Robinson

In 1966, Magnum's librarian Sam Holmes alerted Bruce Davidson to a story: East 100th Street in Spanish Harlem was said to be the worst block in New York City. 'At that point in American history,' Davidson once said, 'we were sending rockets to the moon and waging a futile war in Vietnam. I felt the need to explore the space of our inner cities and document both the problems and the potential there.'

Davidson – a full member of Magnum since 1958 – presented himself at the Metro North Citizen's Association with a portfolio to obtain permission to photograph. Once accepted, he returned with a 4 x 5 large format view camera and a big bellows placed on a tripod, from which a black cloth went over the photographer's head. He also carried a powerful strobe light. This was an unusual setup for a documentary photographer, who would generally work with a portable 35mm camera, but Davidson wanted to be seen as a professional, as someone who did not steal images.

For two years, he photographed not only on the streets of the neighbourhood but, having gained the occupants' trust, also inside their apartments. Early on, a woman stopped Davidson on the street and asked what he was doing. When he replied that he was photographing the ghetto, she said, 'What you call a ghetto, I call my home.' He understood her point and tried to convey in his photographs the combination of dignity and degradation of the neighbourhood, showing not only run-down tenements

and garbage-strewn streets but also stately portraits of the people in their church best – and their bare-bones apartments, with pictures of Jesus hanging on the walls. In 1967 he received the first grant the National Endowment for the Arts had ever awarded for photography, and used it to continue his work in East Harlem until 1968.

East 100th Street was published in 1970 in a large format, in rich, dark tones, with each photograph appearing on a generous matte background. With its simple, classic sequence, the book was a groundbreaking object – the first time a documentary project presented itself as art. While photographers loved it, polemics raged in the media. Critics A.D.Coleman and Philip Dante, for instance, thought that the photographs were too beautiful, too artistic for their subject matter. Dante thought that Davidson had depicted his subjects as victims. The controversy about photography of the disadvantaged continues to this day.

In March 1969, a portfolio of *East 100th Street* was published in *Du* magazine, with an interview of Davidson by Barney Simon, a South African writer and director. Following this, in 1970, the project was shown at the Museum of Modern Art in New York; many of the project's subjects, to whom Davidson had given their portraits, came to the opening. No one had ever photographed East Harlem as intimately as Davidson did in *East 100th Street*, or with such a sense of collaboration from the subjects.

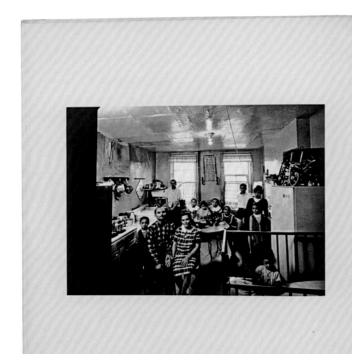

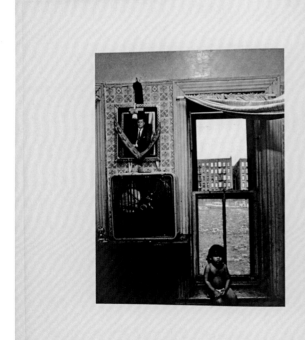

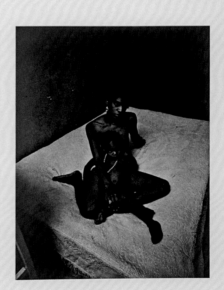

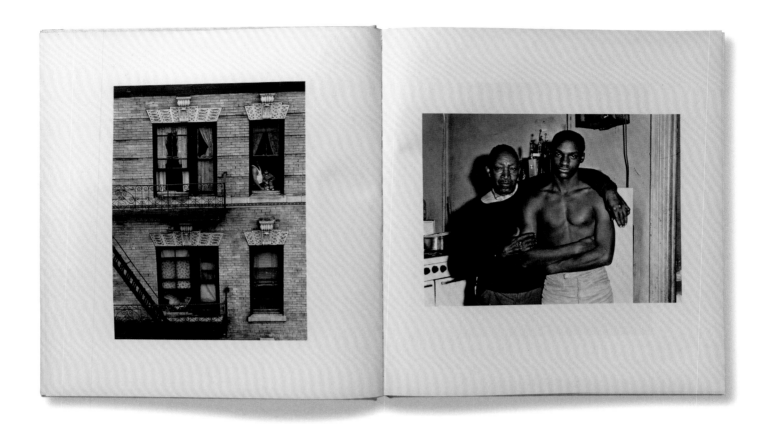

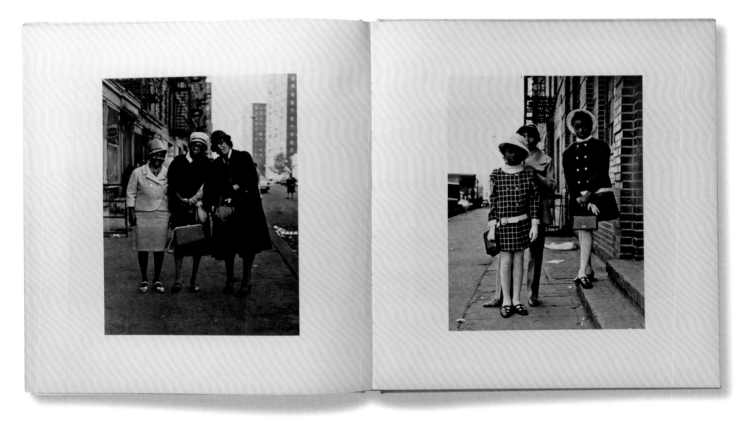

Philip Jones Griffiths
Vietnam Inc.

Collier Books, New York
and Collier-Macmillan Ltd,
London, 1971 (also published
in paperback, 1971;
re-published by Phaidon
Press, London, 2001,
with an introduction by
Noam Chomsky)

280 x 202 mm (11 x 8 in),
224 pp

Hardback

266 b&w photographs

Photography, text and design
by Philip Jones Griffiths

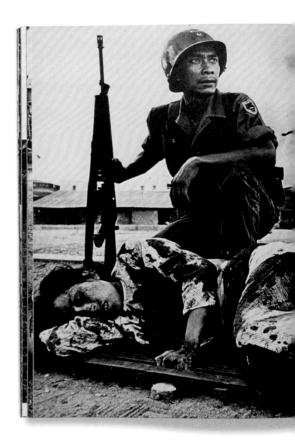

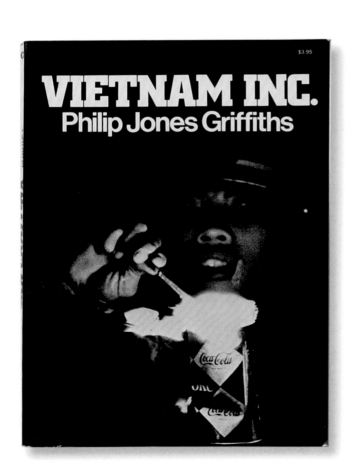

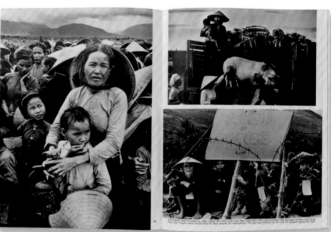

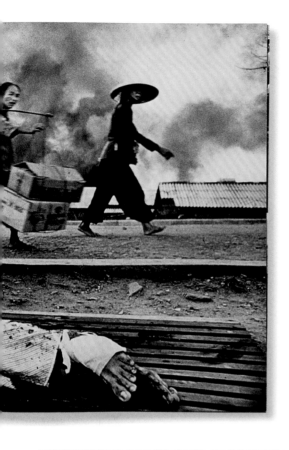

The Welsh photojournalist Philip Jones Griffiths'
1971 volume *Vietnam Inc.* was produced after two-
and-a-half years of photographing in the field with
only several days of actual assignments. It asserts
an approach that is explicit in its abandonment of
traditional, liberal empathy for everyone involved in war
as its inevitable victims. Instead it becomes a searing,
angry indictment of US involvement.

Griffiths presents some of the expected images
of heroism, but they are purposefully undermined
by the photographer's critical juxtapositions of
his photographs as well as by his highly sardonic
captions: 'US combat troops arrive, outnumbering the
enemy 3 to 1 and possessing the most sophisticated
military hardware; the job seemed easy. Earlier,
spirits were high among the troops, intoxicated as
much by the spectacle of their own strength as by
the cold beer delivered to them daily.'

Two images of uniformed Vietnamese children in a ward full
of American wounded are captioned: 'Orphans visit a United
States Army hospital to sing and dance for the wounded men
whose predecessors were responsible for these children's
parentless status.' Even a photograph of US soldiers at
rest (one sprawls, bare-chested, while reading a 1970
Plymouth catalogue) is captioned to emphasize a sense of
the surrounding war's many-levelled insanity. 'Salesmen
used to follow GIs into the field to make a "sale" so that
the boys will have a real reason for wanting to get home
in one piece. Today they find it safer to have the GI
choose his car's trim and upholstery by mail order!'

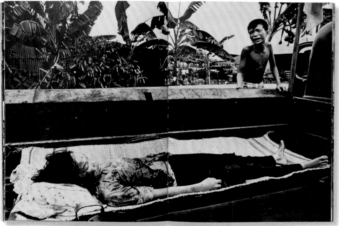

Other images assign responsibility where it has not often
been assigned photographically, such as in a photograph
of soldiers surrounding a printout from the 'the computer
that "proves" the war is being won'. Or, quite simply,
the helmeted face of an American pilot is put opposite
a photograph of a civilian burned by napalm. In Vietnam,
where many eyewitnesses could not agree with the policies
of the US government, the role of society's reliable
photographic witness was becoming that of revulsed critic,
and the photo-reporter was becoming an author with an
individualized point of view.

Vietnam Inc., remaindered shortly after its
publication, was acknowledged as a classic decades
later – one of the first books of photojournalism
in which the photographer effectively contextualized
and re-contextualized his imagery through his own
editing, page design and text.

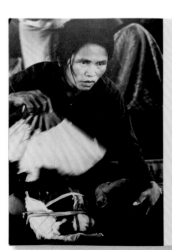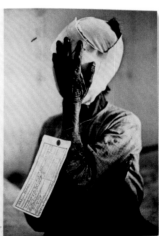

Ernst Haas
The Creation

A Studio Book, Viking
Press, New York, 1971 (also
published in French as *La
Création* by Editions Denoël,
Paris, 1971 and in paperback
by Penguin Press, London,
1976; revised edition
published by Viking Press,
New York, 1983)

190 x 280 mm (7 ½ x 11 in),
160 pp

Hardback with brown cloth
and black spine and jacket

106 colour photographs

At the invitation of Magnum co-founder Robert Capa, the
Austrian photographer Ernst Haas joined the agency in
1949, developing close associations with Capa, Henri
Cartier-Bresson and Werner Bischof. Haas moved to the
United States in 1951, where he became a pioneer of colour
photography, using Kodachrome film, and taking photographs
– particularly of nature and the elements – that bridged
the gap between photojournalism and photography as an
expressive medium. Haas was the first photographer
to have a long colour feature published in *LIFE* magazine
– a twenty-four page photo essay on New York City in
1953 – and the first to have an exhibition of colour
photography at New York's Museum of Modern Art in 1962.

In the late 1960s, a lab assistant named Michelangelo
compiled a number of Haas's slides in a projector in the
photographer's absence: geological forms, landscapes,
wildlife, plants, the elements, close-ups. When Haas
returned, he started to project the photographs, telling
Haas: 'Do you realize what you have photographed? You have
photographed the creation of the world.' Haas continued
to refine the collection until 1970. He then organized his
photographs into the three sections that make up the book,
each representing the dawn of the world as described in the
Book of Genesis: The Elements, The Seasons, The Creatures.

Using Leicas 3 and M4 and a Pentax camera with Micro-Nikkor
55mm lens for close-ups, Haas developed a new pictorial
language based on several techniques: shooting close-ups
at unexpected angles, cropping, double exposure or moving
the camera during exposure to give a sense of motion. Haas
has been called a poet photographer. In *The Creation*, a
book that soon became a classic (reprinting many times and
in numerous editions) and inspired a number of contemporary
photographers, his language is lyrical and evocative,
transforming reality into a more subjective vision. 'Without
touching my subject,' he wrote, 'I want to come to the
moment when, through pure concentration of seeing, the
composed picture becomes more made than taken. Without
a descriptive caption to justify its existence, it will
speak for itself – less descriptive, more creative; less
informative, more suggestive; less prose, more poetry.'

Danny Lyon
Conversations with the Dead: Photographs of Prison Life with the Letters and Drawings of Billy McCune #122054

Holt, Rinehart and Winston, New York, 1971 (republished with a new afterword by Danny Lyon by Phaidon Press, London, 2015)

—————————

205 x 279 mm (8 x 11 in), 196 pp

Hardback with grey cloth and jacket

—————————

75 b&w photographs, 5 colour illustrations and 6 b&w identity photographs

—————————

Foreword by Danny Lyon; introduction, letters and drawings by Billy McCune; design by Danny Lyon and Martin Stephen Moskof

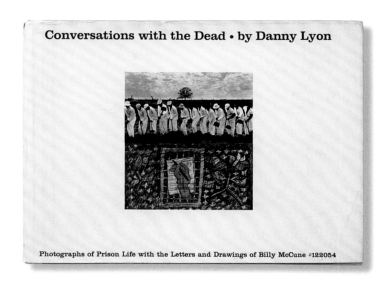

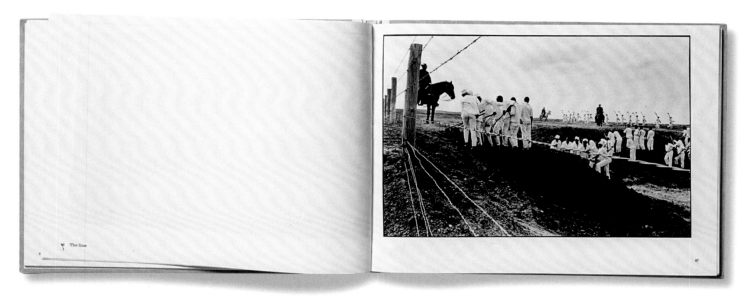

In 1967, Danny Lyon was invited by Dr George Beto of the Texas Department of Corrections to photograph inside the state's prisons. Lyon spent fourteen months inside six Texas penitentiaries, where he was given access to enter at any time, unprecedented for a photographer. The result was *Conversations with the Dead*, a book where Lyon was no objective witness but an active participant in the style of New Journalism: with no pretension to objectivity, he became immersed in the life of his subjects. This has been the case with all of his books, such as *The Bikeriders* (1968) when he became a member of the Chicago Outlaws motorcycle club, travelling with them and sharing their lifestyle in the Midwest from 1963 to 1967.

Besides photographing every aspect of the inmates' life, Lyon recorded their personal testimonies, which are also featured in the book, among which the drawings and texts of inmate Billy McCune are prominent. Lyon's meetings with Billy unleashed 'a torrent of writing and drawing', and as a result *Conversations with the Dead* is probably the first photobook where writing and drawing play an equal role to pictures: one of McCune's drawings features on the cover beneath one of Lyon's photographs. Lyon writes: 'I did not believe that I could convey the reality of the prisons through my own writing alone. I wanted to drag the reader in with me. I also wanted the text to be beautiful to look at … so I made my text from mug shots, reports, telegrams and letters.' Originally, Lyon wanted to produce the book inside the prison. Instead, he made a portfolio, 'Born to Lose', in the print shop of The Walls, a penitentiary in Huntsville – the printing was supervised by James Renton, an inmate who had learnt lithography and offset printing.

Groundbreaking at the time, *Conversations with the Dead* remains relevant to this day. In Texas, Lyon photographed a world of 12,500 men and women. Within a generation, that world had increased to 200,000 – the second highest rate in the world, with about 22 per cent of the world's prisoners.

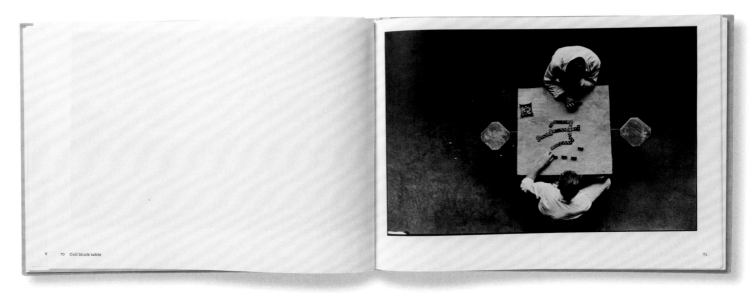

You asked if there was any thing I needed. Well, the
most immediat thing I can think of is freedom.
How much of that can you spare?

We now have a new Governor "Preston Smith".
The state legislature is now asking that all people
serving life sentences, do at least 20 years flat
before they are eligable for parole. Right now
I come up for parole in 1975. If they pass it, do
you realize I wouldn't even come up until 1985.
I have really got to start working on a writ.

Enough about down here & my self. I'm glad
for you, that you are getting something done
for yourself on your looks. I've been reading
about you & your intentions on mines. Hope
something breaks for you soon.

Well, I guess I'll close.

Your Friend
Curt

Letter Received November 1, 1969[1]

Dear Danny,

In your last interview or visit with me a few days ago, I asked you to write me and you
said you would. I have not received a letter from you as yet, so I am writing you so you'll be
reminded of me and be assured that I always truly appreciate and enjoy reading and re-reading all
you write to me.

As you know, I am no longer in the treatment center. I am assigned to what is called the
Hoe squad. The four hoe. I work outdoors. So far in the fields. I know how to use an aggie or a hoe.
We all make one line of men and all move across the field, chopping or cutting down weeds. So far I've
only worked two half days and one morning. All the squads wandered or sat around on an old junk
yard or field. But I've worked hard twice so far. Nobody may stop and rest but must keep moving.
And keep that aggie swinging. I have blisters on my left hand but eventually my soft hands will get
used to holding an aggie. We wear to work better looking clothes than we are allowed to see you in.
You said you were moving to New Mexico. As you know, the only address I know is the one in
New York. Robert's place. Be sure to let me know the address you will have in New Mexico.
Remember, I am thinking of you when I am in my cell or in the fields working. You are
the best friend I have. And I am very thankful for the privilege of having you interested in me. As
there are so many convicts, and I am very lucky that you preferred me out of so many. Danny, I
still have the picture painted from the photograph you sent. What shall I do. How may I get it to
you. Do you have any suggestions. Let me know.
Unfortunately, I have not received the painting material you spoke of when you were here.
I will let you know when I receive it. I am well and doing ok. Tell Robert, Mary, June hello for me.

Your friend, Billy McC.

*1. In November of 1969 Billy McCone was transferred out of the row for psychotics in the Treatment Centre
and assigned to a regular job in a hoe squad that works on the prison grounds. D. L.*

Letter Received December 3, 1969

Hi Danny,

You would have heard from me sooner but it was kicked back to me by our Wynne
censor because it was written on oblong paper. The attached note read use state stationery only.
What I tried to send you in that envelope was page one and two of my Ft. Worth memoirs. If I
re-write what I have on this kind of stationery it will be a long time to get the work to you.[2] But
you know the score and did long before you set eyes on me in Major Pack's office.
How is all our friends getting along. Mark. Robert. Mary. Their daughter. your parents.
June Leaf. And Mary the secretary at Magnum incorporated. Needless for me to say. No body writes
me except you. I have not heard from Barbara in over six months. No letter or post card has been
given me but the ones you sent me.
I have shelled alot of peanuts and cut a lot of weeds and grass since I last saw you. But I

Elliott Erwitt
*Photographs and
Anti-Photographs*

The New York Graphic Society,
New York, 1972

235 x 290 mm (9 ¼ x 11 ⅜ in),
128 pp

Hardback with full black
cloth and jacket

112 b&w photographs

Introduction by John
Szarkowski; essay by Sam
Holmes; edited and designed
by Ray Ripper

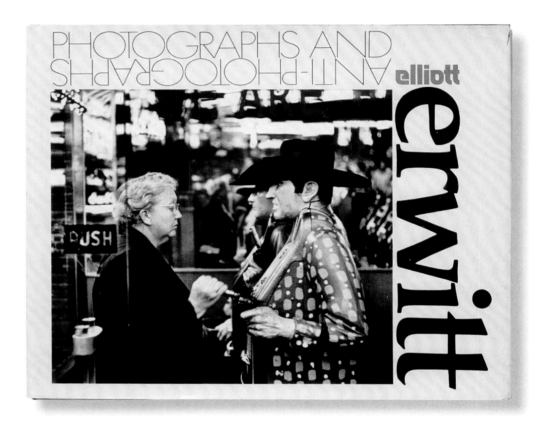

If Henri Cartier-Bresson famously championed the 'decisive moment' in photography, his countryman Elliott Erwitt is more concerned with what the noted photography curator John Szarkowski calls in his introduction to *Photographs and Anti-Photographs* 'the anti-climactic non-event'. Szarkowski goes on, 'His subjects seem the patient victims of unspecified misunderstandings … Over their inactivity hangs the premonition of a pratfall. From these unmemorable occasions Erwitt has distilled, with wit and clarity and grace, the indecisive moment.'

Erwitt, who joined Magnum in 1953 with Robert Capa's encouragement, has divided his life between commercial and news photography and more personal shots, 112 of which are assembled in *Photographs and Anti-Photographs*. While it is true that his moments do not resemble Henri Cartier-Bresson's, they are far from indecisive. Instead, although their understated tone mimics that of amateur snapshots, they represent the small, everyday epiphanies that Erwitt has patiently tracked down. 'It's like fishing,' he says. 'Sometimes you catch one. You lay in wait for something to happen – sometimes it happens, sometimes it doesn't.'

Some of the pictures in the book are poignant, others are surreal; most are imbued with humour. Erwitt's famous image of the so-called Kitchen Debate, taken during an argument between Soviet Premier Nikita Khrushchev and

US Vice President Richard Nixon in Moscow in July 1959, with Nixon jabbing at Krushchev with his pointed index finger, shows how Erwitt turned a news assignment into a far more personal photograph. 'But how pictures can lie,' Erwitt later commented. 'The illusion is one of Nixon standing up to the Soviets, where the reality is an argument about cabbage soup versus red meat.' A 1963 picture taken at an amusement park, meanwhile, has a quietly disturbing aura: it shows two women who stand on either side of a park bench, looking in different directions. A third sits between them with a large baby sprawled on her lap. A sign posted on the wire fence behind them announces 'Lost Persons Area'.

Some of the images in *Photographs and Anti-Photographs* strike a more serious or melancholy tone, such as the black man drinking from a sink marked 'Colored', the nearby sink marked 'White' remaining conspicuously empty; or the boy in a car where the star-shaped impact left by a bullet aligns precisely with his eye. A classic photobook, Erwitt's *Photographs and Anti-Photographs*, with its unpretentious feel and terse captions, has the feel of an intimate diary where the use of black and white has boiled down the images to their essentials: light, story, form, emotion and information.

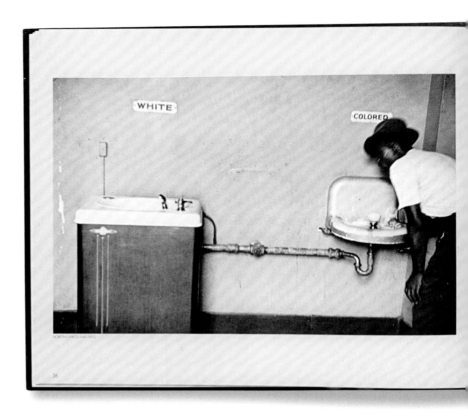

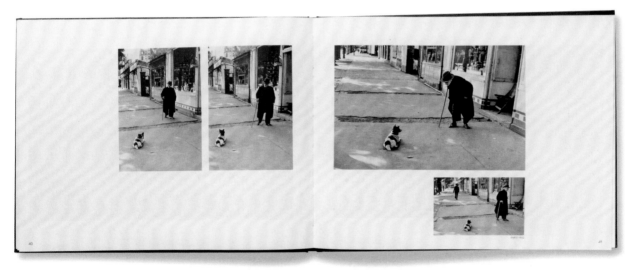

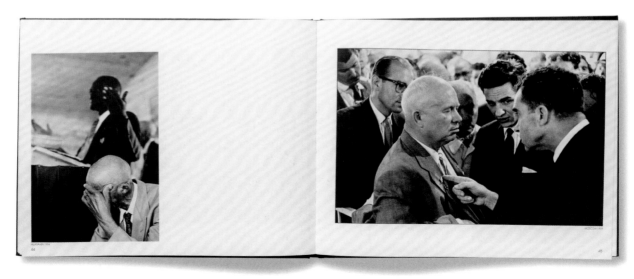

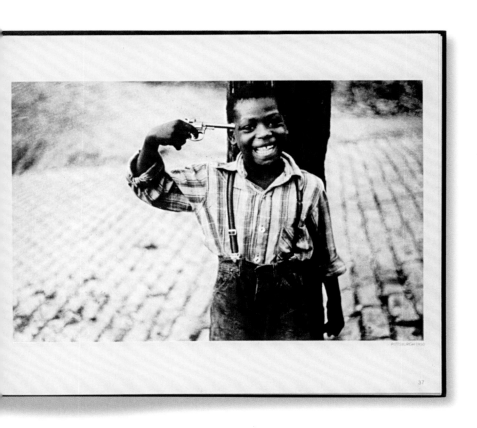

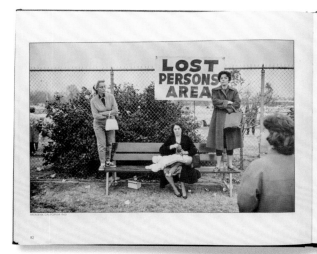

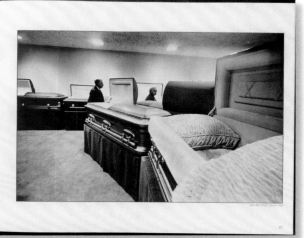

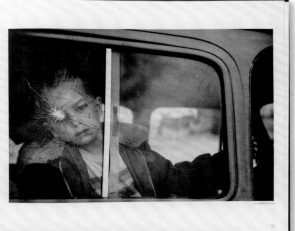

Burk Uzzle
Landscapes

Magnum Photos/Light
Impressions Corp.,
New York, 1973

203 x 228 mm (8 x 9 in),
96 pp

Paperback

87 b&w photographs

Introduction by Ron Bailey;
design by Arnold Saks Inc.

Born in North Carolina, Burk Uzzle began working at
the age of fourteen, got his first full-time job as a
photographer at age seventeen and became *LIFE*'s youngest
contract photographer at age twenty-three. He has lived
a nomadic existence, travelling all over America, Europe
and East Asia. 'I don't like sitting in one place', he
says, 'physically, geographically, or artistically. You
just have to be hungry.' Alongside his personal work,
Uzzle has worked regularly as a photojournalist and made
some of the most striking images of Woodstock, the Civil
Rights Movement (such as his images of Martin Luther King's
assassination and funeral) and the Cambodian War (1967–75).
Uzzle was a member of Magnum from 1967 to 1982. When he
joined, Henri Cartier-Bresson advised him to study the
Quattrocento painters, advice Uzzle says opened his eyes
to the play of planes 'to head me into confusion, riot and
the camera's gluttony and the simultaneous distraction of
the world'.

As a book, *Landscapes* may be unpretentious in size and
simple in its one-image-per-page layout, but it constitutes
a complex emotional reaction to America's reality. Uzzle
focuses on small towns, ordinary places, unobtrusive
moments and strange perspectives: a wrecked car seems to
grow out of a tree, as if the tree had tried to eat it;
on a beach, an aluminium reflector multiplies a woman's
face; a man's leg kicks out of a car, inexplicably sliced
in half; rows of tyres form an impeccable geometrical
composition in front of painted walls; three tuba players
walk down some steps, their faces hidden by their
instruments' mouths; darkly dressed, a prone man hurtles
mysteriously down the slope of a garage. These are
challenging, graphic, visually complex images – sometimes
menacing or lonely, sometimes humorous – not immediately
readable. They make us stop, reflect and wonder.

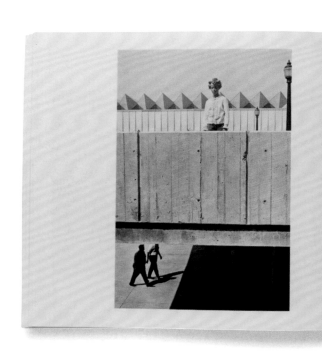

As Uzzle says: 'These photographs are an appreciation
of America. Their structure, like that of America itself,
evokes a melody of movement and collage – not an explanation.
Unlike documents, they play tag with layers of reality,
both interior and exterior. America is like that,
conditioning us to zigzag and change with its constant,
energetic barrage of many and various realities. But there
is a melody in all the movement, and I can only feel it
in America.'

The Photobooks: In Detail 1938–2016

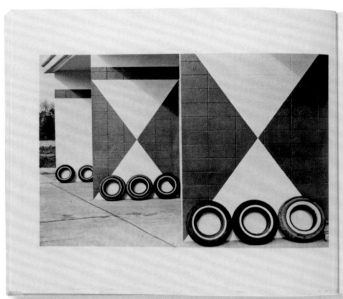

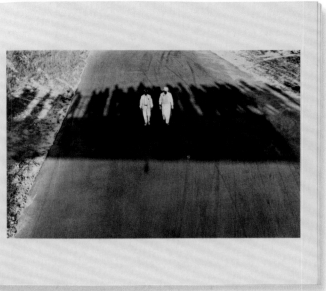

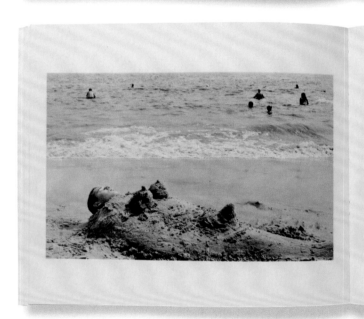

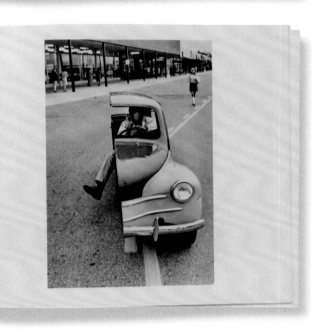

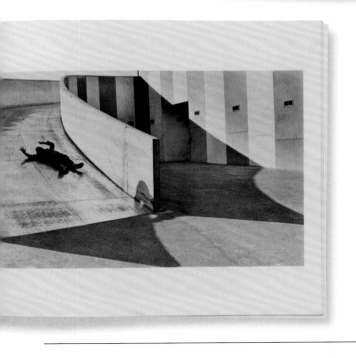

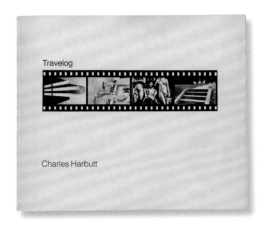

Charles Harbutt

Travelog

MIT Press, Cambridge,
Massachusetts and London,
1973

203 x 230 mm (8 x 9 in),
144 pp

Hardback (also published
in paperback)

110 b&w photographs

Introduction and epilogue
by Charles Harbutt

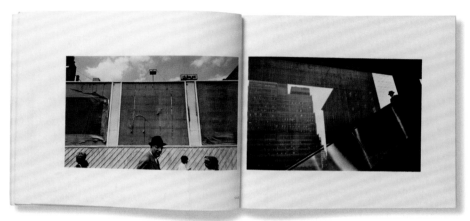

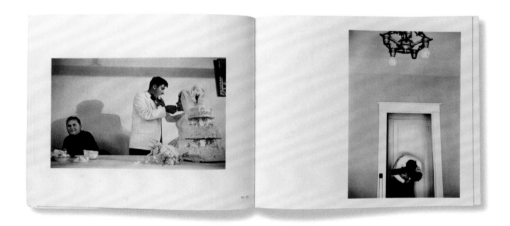

'The specter of Leopold Bloom haunts this book,' writes the American photographer Charles Harbutt in the introduction to *Travelog*, which was divided into chapters entitled 'The World', 'The Flesh', 'The Devil' and 'Home'. Harbutt maintains that by selecting from an array of his own black-and-white photographs those to which he responded 'Yes, life's like that', he emerged with 'a record of late-blooming adolescence, or perhaps more accurately, new-blooming middle age'.

Although his images are from many parts of the world, Harbutt, who began his career as a writer and joined Magnum in 1963, remaining until 1981, equates his wider voyage in *Travelog* with the one-day odyssey through Dublin of James Joyce's protagonist in *Ulysses*, almost seventy years before: 'I go out into the alien world: hard, fearful, lonely,' Harbutt writes. 'My afternoon stroll passes Sandymount strand: lustful, yearning, fleshy. I descend into a blasphemous, bedeviled Nighttown: horror, insanity, and laughing death. And then I wander home to witness Molly's acceptance and integration of the terrors and to spring free from my depressed sleepwalk.' Hauntingly, the book's introduction concludes: 'The ecstasy of this freedom is my prayer.' In the considerably longer and equally eloquent epilogue,

excerpted from a public talk he had delivered the previous year, Harbutt broadly explores photographic meaning (the book's cover contains four photographs displayed as if on the same piece of film). After asserting photography's uniqueness in its ability to serve as a two-dimensional visual record 'of the real world', Harbutt argues, more radically: 'Photography is causing images to be made by reality.' He adds, 'None of this is to deny the reality of the imagination, of the subconscious, or of the dream.' And in the next paragraph he signals a challenge and a provocation: 'Photography is not art. Atget had the right idea when he refused to exhibit his photographs in an art gallery. He had a little sign on his door saying, "*Documents pour artistes*".'

Travelog is more of an internal journey than an external one. Its documentary-style photographs of the putatively real – 'Backyard chairs', 'Two chairs', 'Side street', 'Robe in closet' and 'Woman' are the titles of the first five images in the 'Home' series – barely disguise the author's restless desire to photograph as a way of better comprehending himself. Like the Surrealists before him, Harbutt successfully invited the unconscious to speak.

Cornell Capa
Margin of Life

Grossman Publishers Inc.,
New York, 1974

240 x 200 mm (9 ½ x 7 ¾ in),
192 pp

Paperback

139 b&w photographs

Text by J. Mayone Stycos

Margin of Life is authored by two complementary voices:
J. Mayone Stycos, director of the Cornell University
International Population Program, who wrote the text,
and Cornell Capa who, the year of the book's publication,
transformed his International Fund for Concerned
Photography into the International Center of Photography,
a pioneering institution dedicated to the exhibition and
teaching of the medium.

The book focuses upon two small countries in Central
America, El Salvador and Honduras, because 'they had the
main ingredients we were interested in: rapid population
increase, poverty, and painfully slow progress in improving
the lot of the average citizen'. But there was another
proactive reason: ' … we chose them because they had just
had a war whose roots were in poverty and population, and
we wished to show that if it could happen to these small
sister nations, larger ones might not be far behind'.

The photographs tend to be direct, warm and empathetic,
acknowledging the poverty and struggles of those depicted,
as well as their bonds as families and communities. With
sections including 'Jobs, Houses, and Schools' and 'New
Hopes for Agriculture', the book is a broadly sociological
study interspersed with quotes from various protagonists
and reports. Facing a full-page photograph of smiling boys
holding newspapers and above a small one of a boy who
appears to be asking a man for money (there are no captions),
a statement appears in bold type: 'The deficit of boys
appears in the fourth grade when the average child would be
eleven or twelve – an ideal age for selling papers, guarding
cars, shining shoes, and selling chiclets [gum].'

Margin of Life ends with a sequence of Capa's more militant
photographs from Bolivia, Brazil and Peru, as well as El
Salvador and Honduras. Although perhaps lesser known, Capa's
book presages the work in Latin America of Magnum colleagues
such as Susan Meiselas and Sebastião Salgado. And it
affirms, as Capa has written, an essential difference with
the work of his brother Robert: 'One war photographer was
enough for my family; I was to be a photographer for peace.'

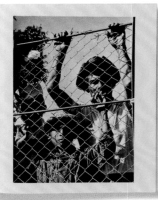

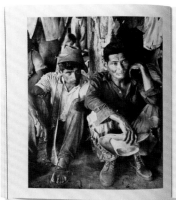

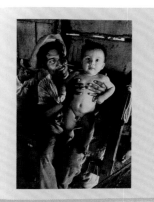

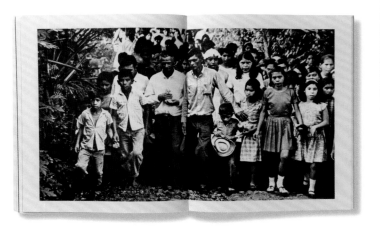

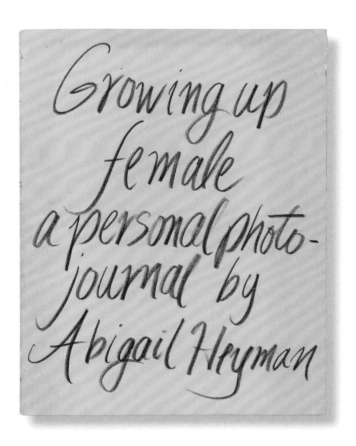

Abigail Heyman
Growing Up Female:
A Personal Photojournal

Holt, Rinehart and Winston,
New York, 1974

240 x 182 mm (9 ½ x 7 ¼ in),
120 pp

Paperback

81 b&w photographs

Introduction by Abigail
Heyman; design by Arnold
Skolnick

While Magnum Photos has had very few female members throughout its nearly seventy-year history, *Growing Up Female: A Personal Photojournal* is a direct and articulate exploration by Abigail Heyman of a feminist's own nuanced struggle in defining herself. Published in 1974, during Heyman's years with Magnum (she left the agency in 1981 to form Archive Pictures with a number of other photographers, including Charles Harbutt and Mary Ellen Mark), the book emerged from an era in which the roles of women and girls were beginning to evolve in the United States. Rather than looking at a movement, *Growing Up Female* explores it, and the photographer's life, from within.

Reproducing actual handwriting, the text – excerpts from Heyman's own journals – emanates from her own intense attempts at consciousness-raising as a woman, but also reflects the experience of all women. The uncaptioned black-and-white photographs, one or two on each spread, range from an image of a woman spreading her legs in a strip joint to another of a woman in childbirth and one of a young woman surrounded by others while acting as the subject in a gynaecological self-help group. There is also an apparently first-person photograph of an abortion, the doctor looming above, with a text stating, 'Nothing ever made me feel like more of a sex object than going through an abortion alone.'

A photograph of a cheerleader is across from another of a woman in jeans and a well-worn T-shirt holding a football, and there is another of a mother sitting on the carpet comforting her three children while her husband, seated at a dining table in the background, eats a slice of a melon. There is also an image of a young woman facing the camera in front of shelves of documents with text on the facing page stating, 'I no longer feel flattered when men tell me I don't think like a woman.' And a double-page flash photograph depicts young people at a dance holding onto each other in various forms of a clinch, somewhat unsure as to how to proceed.

'This book is about women, and their lives as women, from one feminist's point of view,' Heyman writes to introduce the book. She also asserts, 'This book is about myself. I looked at people and events long before I owned a camera, more as a silent observer than a participant, sensing this was a woman's place. It is no longer my place as a woman, but it remains my style as a photographer.' *Growing Up Female*, which Heyman worked on 'for the past thirty-one years' (she was born in 1942), ends optimistically: 'I value women. I value myself. I don't reject being female anymore. I can become the woman I want to be, and I can help to develop a new society that will value her.'

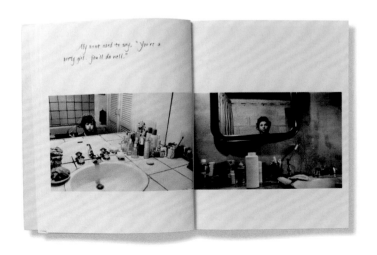

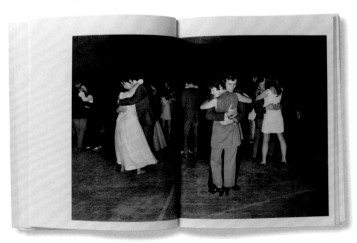

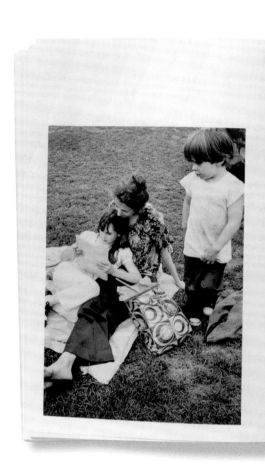

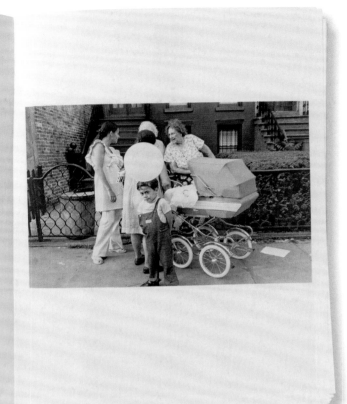

Dave and I do share the housework. Sometimes that scares me. If he doesn't need me for that, I'm afraid maybe soon he won't need me at all.

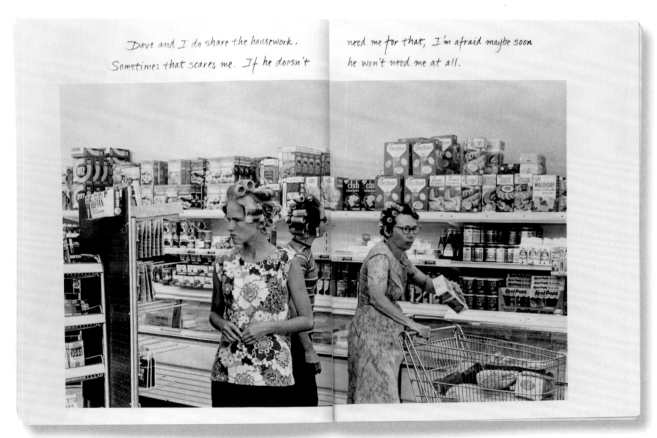

Josef Koudelka
Gypsies

Aperture, Inc., Millerton, New York, 1975 (special paperback edition for the Museum of Modern Art published in 1975; also published in French as *Gitans: la fin du voyage*, 1977)

270 x 295 mm (10 ½ x 11 ½ in), 136 pp

Hardback with full black cloth and jacket

60 b&w photographs

Text by Willy Guy, John Szarkowski and Anna Fárová; (text by Robert Delpire and Willy Guy in French edition); design by Robert Delpire

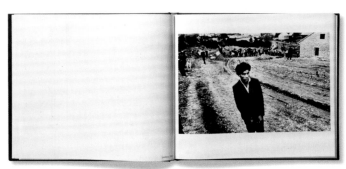

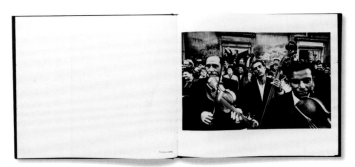

Gypsies

Aperture, Inc., New York, 2011

320 x 240 mm (12 ⅝ x 9 ½ in), 224 pp (including 8 gatefolds)

Hardback with full black cloth and jacket

109 b&w photographs

Text by Willy Guy; photographs and layout by Josef Koudelka; design by Aleš Najbrt and Josef Koudelka

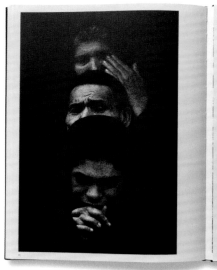

In 1961 Josef Koudelka started to take photographs of gypsies in his native Czechoslovakia. His gypsy photographs were first exhibited in a Prague theatre lobby, 'Divadlo za Branou', in 1967 and a portfolio of *Gypsies* was also published by Allan Porter in *Camera* in November 1967. In 1968 Koudelka photographed the Soviet invasion of Prague. He left Czechoslovakia in 1970 and became stateless. After he obtained political asylum in England, he became a Magnum associate in 1971. He later said, 'Becoming associated with Magnum brought me a certain security. I discovered that I belonged to one of the best organizations for photographers that exist in the world.'

While in Prague, Koudelka and designer Milan Kopřiva had prepared a dummy of *Gypsies* with seventy-eight pictures for publication by Mladá Fronta. A second, identical dummy was taken to Magnum Paris by Charles Harbutt in 1969 and sent to Magnum New York. It was lost in transit back to Paris, however, so Koudelka then produced a third dummy, with corrections to the original layout.

From 1973, Koudelka and Robert Delpire worked on a selection of sixty photographs taken in various gypsy settlements in Czechoslovakia. The pictures were published in 1975 by Aperture as *Gypsies*. The book, with a classic design – each image set on the right page with a white, framelike background and a caption on the left page – was issued in France in 1977 as *Gitans: la fin du voyage*. The book received the prestigious Prix Nadar award in 1978.

The original dummy, meanwhile, which had been left with the Czech publisher Mladá Fronta, was displayed in 1989 in the Manes Gallery in Prague in the exhibition 'What is Photography? 150 Years of Photography'. Following the exhibition, it too went missing.

Koudelka still planned to publish *Gypsies* according to his original concept. He finally did so in 2011, fifty years after the project began, with 109 pictures instead of 60, taken in Czechoslovakia, France, Hungary, Romania and Spain. The cover bears only Koudelka's name and the title, without an image. Appearing in six languages, the new book was lavishly printed in offset quadrotone, lending it a rich tonality close to the photogravure used in Czechoslovakia in the 1950s and 1960s. The layout alternates vertical and horizontal pictures with double-page spreads and foldouts. In this new publication it is clear that Koudelka has chosen to photograph the gypsies in order to articulate a statement about human life in general.

In his classic depiction of the gypsies, Koudelka never yielded to the temptation of the exotic. As John Szarkowski writes, 'Koudelka's pictures seem to concern themselves with prototypical rituals, and a theater of ancient and unchangeable fables. Their motive is perhaps not psychological but religious. Perhaps they describe not the small and cherished differences that distinguish each of us from all others, but the prevailing circumstance that encloses us.'

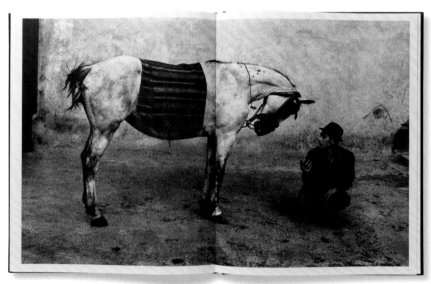
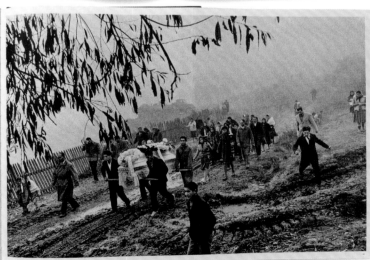
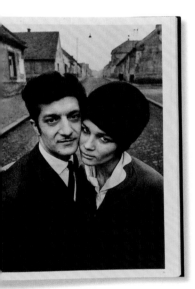

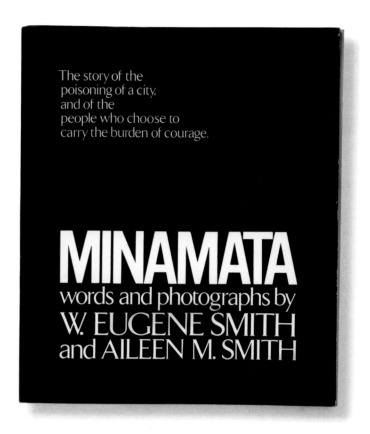

The story of the
poisoning of a city,
and of the
people who choose to
carry the burden of courage.

MINAMATA
words and photographs by
W. EUGENE SMITH
and AILEEN M. SMITH

W. Eugene Smith
& Aileen M. Smith
Minamata

Holt, Rinehart and Winston,
New York, 1975

293 x 238 mm (11 ⅝ x
9 ⅜ in), 192 pp

Paperback

150 b&w photographs

Words and photographs
by W. Eugene Smith and
Aileen M. Smith; prologue
by W. Eugene Smith,
January 1975; jacket
design by Carole Thomas;
with design consultancy
by Philip Kaplan

Minamata 'is not an objective book,' Gene Smith asserts in its prologue: 'The first word I would remove from the folklore of journalism is the word objective. That would be a giant step toward truth in the "free" press. And perhaps "free" should be the second word removed. Freed of these two distortions, the journalist and photographer could get to his real responsibilities.' What are they? 'My belief is that my responsibilities within journalism are two. My first responsibility is to my subjects. My second responsibility is to my readers.' Then, referring to his conflicts with editors at *LIFE* magazine: 'I believe that if I fulfill those two responsibilities I will automatically have fulfilled my responsibilities to the magazine.'

Minamata is the result of the Smiths' determination to tell as complete a story as they could of how industrial pollution can devastate a community. It is about a community in Japan protesting against the mercury waste released from a nearby factory into the bay that has poisoned their waters and fish, in turn poisoning many of them and their children, causing a horrifically debilitating neurological disease. And it is about the courage of those who had the stubbornness and courage to protest, and about the guilty verdict delivered on the Chisso Corporation and its promise to make restitution.

Gene and Aileen (whose mother was Japanese) lived in this fishing community for three years, during which time Gene was severely beaten by employees of Chisso. The book isn't chronological, but sets the stage by showing those fishing and the fish themselves, then images of victims of the disease being attended to, and then a spread with a photograph on the left focused upon the distorted hand – nearly a claw – of someone with 'Minamata disease', facing another photograph of a pipe discharging into the water. The book also includes Gene Smith's famous gently lit, Pietà-like photograph of 'Tomoko Uemura in Her Bath', showing a severely ill child being bathed by her attentive mother. In 1997, twenty years after Tomoko had died at the age of twenty-one from foetal mercury poisoning, Aileen Smith asked that the image not be published, given the wishes of the family that the suffering of their child no longer be on public display.

Minamata has become a classic of photography about the environment, revealing not only the victimization caused by catastrophic pollution but also the social and economic system that allowed it to happen. The book ends with a chronology and medical report on 'Minamata Disease'. 'To cause awareness is our only strength,' declared Gene Smith. He would die the year after Tomoko Uemura.

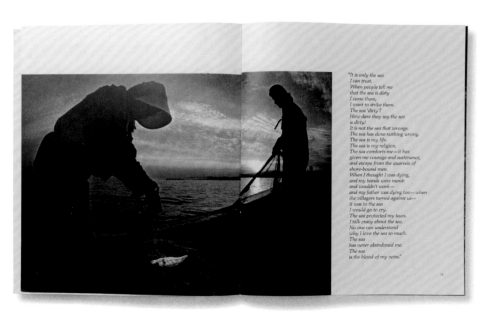

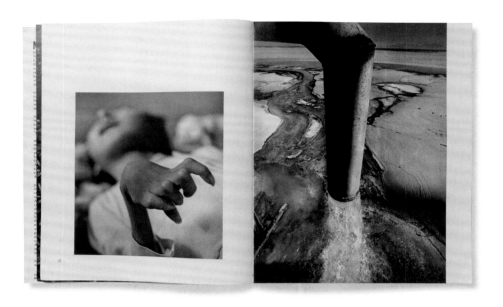

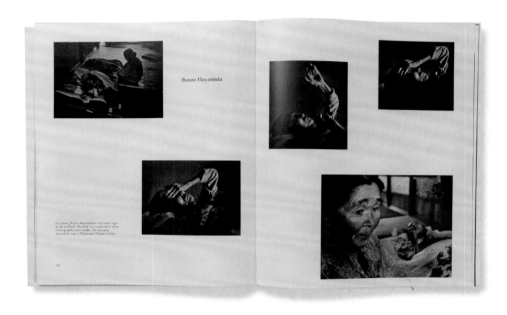

Bunzo Hayashida

For years, Bunzo Hayashida's wife kept vigil at his sickbed. He died two weeks after these photographs were made. An autopsy proved he was a Minamata Disease victim.

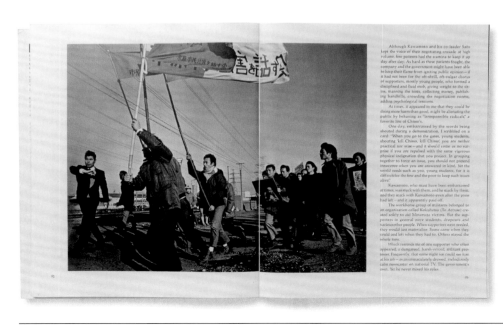

Although Kawamoto and his co-leader Sato kept the voice of their negotiating crusade at high volume, few patients had the stamina to keep it up day after day. As hard as these patients fought, the company and the government might have been able to keep their flame from igniting public opinion—if it had not been for the oft-shrill, oft-vulgar chorus of supporters, mostly young people, who formed a disciplined and fluid mob, giving weight to the sit-ins, manning the tents, collecting money, publishing handbills, crowding the negotiation rooms, adding psychological tensions.

At times, it appeared to me that they could be doing more harm than good, might be alienating the public by behaving as "irresponsible radicals," a favorite line of Chisso's.

One day, embarrassed by the words being shouted during a demonstration, I scribbled on a card: "When you go to the gates, young students, shouting 'kill Chisso, kill Chisso', you are neither practical nor wise—and it should come as no surprise if you are repulsed with the same vigorous physical indignation that you project. In grouping together to force an issue, you should not pretend innocence when you are answered in kind. Yet the world needs such as you, young students, for it is difficult for the few and the poor to keep such issues alive."

Kawamoto, who must have been embarrassed at times, was stuck with them, and he stuck by them, and they stuck with Kawamoto even after the press had left—and it apparently paid off.

The workhorse group of militants belonged to an organization called Kokuhatsu (To Accuse) created solely to aid Minamata victims. But the supporters in general were students, dropouts and various other people. When supporters were needed, they would just materialize. Some came when they could and left when they had to. Others stayed the whole time.

Which reminds me of one supporter who often appeared; a shaggy-maned, harsh-voiced, militant protester. Frequently, that same night we could see him at his job—as an immaculately dressed, melodiously calm newscaster on national TV. The government's own. Yet he never mixed his roles.

Eve Arnold

The Unretouched Woman

Alfred A. Knopf, New York, 1976

280 x 230 mm (11 x 9 in), 200 pp

Hardback with black cloth and jacket

111 b&w and 44 colour photographs

Text by Eve Arnold; design by Barney Wan

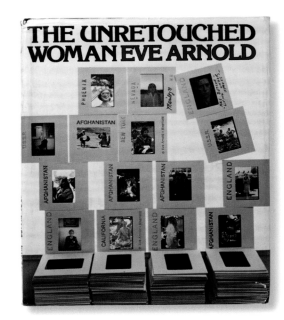

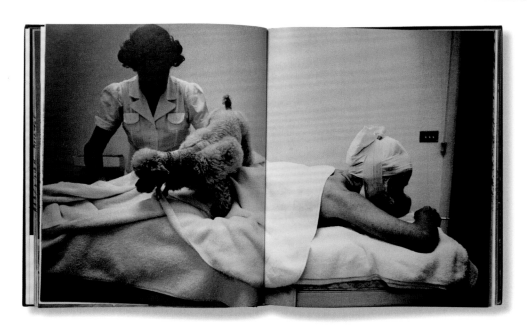

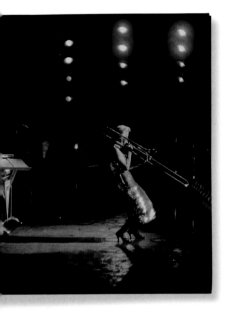

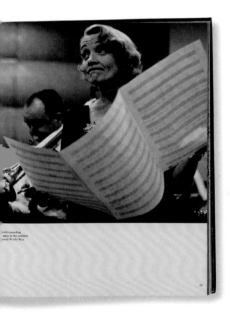

New York-born Eve Arnold was already in her sixties when she decided to publish her first book, and she was clear about its subject: 'This is a book about how it feels to be a woman, seen through the eyes and the camera of one woman – images unretouched, for the most part unposed, and unembellished.' *The Unretouched Woman* took shape over several trips to New York, London and Mexico. Arnold set up a darkroom and started printing images from a career that spanned twenty-five years of photographing women.

The book features Arnold's first reportage, about a behind-the-scenes fashion show of black women in Harlem in 1950, a story that led to her association with Magnum in 1951. (She became a full member in 1957, one of the first women, along with Inge Morath, to join the cooperative.) Equally at ease photographing potato pickers in Long Island and the Queen of England, Arnold selected subjects ranging from a nomad bride in the Hindu Kush to Zulu women in a South African hospital, harems in Abu Dhabi, barmaids in Cuba, a fencing mistress in a British school, African American women marching for civil rights in Virginia, and her famous portraits of Marilyn Monroe. The book's cover depicts four neat piles of colour slides arranged in front of a lightbox on which further slides are illuminated, while a simple interior layout features Arnold's texts (written on a veranda in Cuernavaca, Mexico) alternating with a mix of black-and-white and colour images, which together build a circuitous narrative through diverse countries and social classes.

Arnold worked with her publisher, Bob Gottlieb, editor-in-chief at Alfred A. Knopf, on the picture editing and monitored the printing of the final selection. *The Unretouched Woman* was published in the United States in late 1976 and a few months later in Great Britain to considerable attention, including interviews, reviews, a twenty-five minute film for the BBC, and excerpts in the *Sunday Times Magazine*. While she edited the material for *The Unretouched Woman*, Arnold had realized that she could mine her material for more books, and over the next few years she published *Flashback! The 50s* (1978) and *In Britain* (1991). Bob Gottlieb would go on to publish six of Eve Arnold's books and become one of her closest friends; books became an essential part of Arnold's creative life, giving her a way to reflect and assess her work.

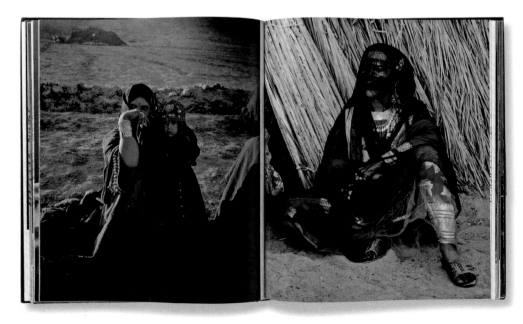

Guy Le Querrec
Quelque part

Contrejour, Paris, 1977

240 x 204 mm (9 ½ x 8 in),
72 pp

Paperback with illustrated
jacket featuring game of
Jeu de l'oie

68 b&w photographs

Introductory texts by Arnaud
Claass and Roméo Martinez

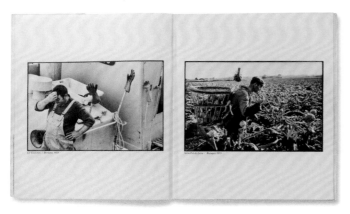

Quelque part, the fifth photography book from the recently founded Contrejour publishing house, came out a year after Guy joined Magnum. 'This book was my passport to join Magnum,' says Le Querrec. Born into a modest family from Brittany, Le Querrec had first worked for the magazine *Jeune Afrique* before he co-founded the cooperative photoagency Viva in 1972, with Hervé Gloaguen, Martine Franck, Claude Raimond-Dityvon, François Hers and Alain Dagbert, with the support of William Klein.

Quelque part features a loose sequence of sixty-eight images, one or two per page, each framed with a thin black line and set on a white background. The pictures come from Le Querrec's reportages – assigned and voluntary – in Portugal, India and mostly France. Several are from the Viva-assigned group projects, 'Families in France' and 'The French on Holiday', and from the first project ever funded by the French organization Fondation Nationale de la Photographie, 'The French on Holidays'. Among many striking or humorous moments, Le Querrec captured a bride's lifted veil surprising a passer-by; the millisecond when a worker, aiming for a basket, throws the artichoke he just picked; the boisterous joy of sailors who have just finished a period of military service; or a lazy adult son, slouching, hands in pocket, as he watches as his mother paint his room.

Quelque part's jacket is a picture biography in sixty-three images in the shape of a game of *Jeu de l'oie* (the French equivalent of Snakes and Ladders). The *Jeu de l'oie* game was created by Le Querrec 'with scissors and glue', together with his friends the French designers Loup and Barbe. It features the important moments of his life and work: his family, an exhibition at the Bibliothèque Nationale, his first camera – a Rolleiflex – his encounter with jazz and, finally, his acceptance by Magnum in 1976. In addition to the image portfolio and the game, *Quelque part* features a separate insert which contains a grid of the book's images with explanatory captions, a text by noted photography historian Roméo Martinez who Le Querrec admired and a preface by Arnaud Claass, then a young member of the Contrejour collective, together with an inset with a text by Le Querrec: 'For me, the camera must not be a separating element between the photographer and the others. To be sure that the camera is forgotten, you have to try and integrate it into the space where it moves. It has to move with the photographer and be one with him. … The viewfinder must not be a skylight for the voyeur but a wide open window, allowing in the emotions and shapes produced by others.'

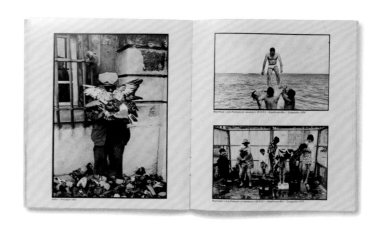

Ian Berry
The English

Allen Lane, Penguin Books
Ltd, London, 1978

245 x 225 mm (9 ⅝ x 8 ⅞ in),
112 pp

Hardback with blue case
and jacket

100 b&w photographs

Foreword by Ian Berry

The English was Ian Berry's first book. He felt it was important to assert his style in the form of a book, as many Magnum members had. He had been invited by Henri Cartier-Bresson to join Magnum Photos in 1962; five years later he became a full member. Berry started working on *The English* in 1974–5 after returning from living abroad. He felt like an outsider, knowing very little about his own country: he wanted to see things while his eye was still fresh. The project was conceived as 'a personal exploration of English life' and was funded by the first Arts Council Photography Bursary and the Whitechapel Art Gallery, which allowed Berry to work without the restrictions of an assignment.

For three months he travelled the length and breadth of the country, using Leica cameras with 28, 35 and 50mm lenses and black-and-white Ilford film. His personal exploration features the English at work and at play – though Berry admits that photographing 'the so-called upper class' can be much trickier than photographing the lower classes: 'They always insist on putting a damned horse in the background.' *The English* features some grim landscapes, such as Newcastle or Ashington with its rows of council houses, but also country fairs and parades, pop festivals and picnicking, a motorcycle show and a couple dancing in a pub.

Peter Bastow, an editor at the *Sunday Times Magazine*, created the first design for the book. As Berry recalls, however: 'When I brought the dummy to Allen Lane at Penguin Books, they said that it was too left wing for them. You did not have power then over the publisher. … Their in-house designer sat down and re-laid it out, taking out some images. I did not even think of taking back my old layout with me. Later, a review suggested that I might have been a fascist to do such a book. The BBC called me a communist! But in fact I did not try to grind any political sense at all.' Forty years later, *The English*, with its simple layout of one captioned image per page, stands as a vivid and tender time capsule of an England that is no more.

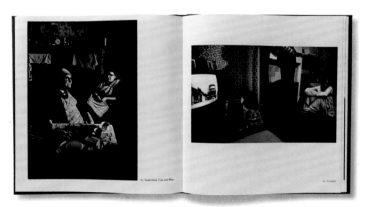

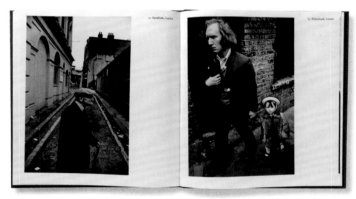

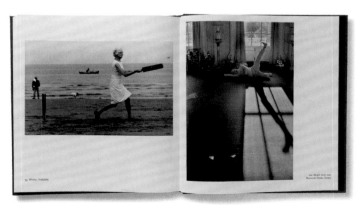

Eugene Richards
Dorchester Days

Many Voices Press,
Wollaston, Massachusetts,
1978 (limited edition
of 1,000 copies; also
republished by Phaidon
Press in an expanded
and redesigned edition,
London, 2000)

305 x 227 mm (12 x 9 in),
64 pp

Paperback

76 b&w photographs

Text by Eugene Richards;
postscript by Dorothea
Lynch; design by Guy Russell

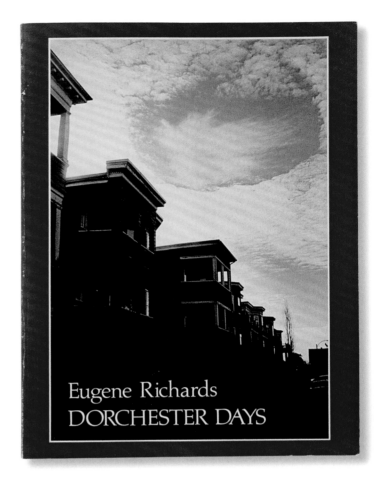

Dorchester Days is about going back, and about the
fractures that become evident when one tries. Referring
to those he depicts in his raw, elegiacal, in-your-face
photographs, Eugene Richards writes, 'A few are people
I wish I didn't have to confront, except in someone else's
photographs, so that their pain and rage would remain
inaccessible to me.'

Dorchester Days, confronting both the past and the present
in the inner-city Boston neighbourhood, where Richards had
grown up, was initially self-published in 1978, with money
borrowed from friends, 'printed on a press that had been
utilized in the manufacture of jam jar labels'. Richards,
who had been a news reporter and social worker for several
years in the South, describes himself as returning broke
to his old, changing, racially charged neighbourhood, from
where many had moved away and new groups of people had
moved in. 'There is a wariness and sometimes anger on the
faces in front of me,' he notes. 'Boastful kids call this
their neighbourhood and I call it mine. Mine, not yours.'

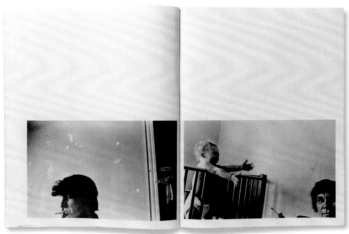

Richards contextualizes a spread of three horizontal
photographs of children, many of them dressed for church:
'Iris, a ten-year-old, demands recognition for being so
beautiful, and Angel has cut off someone's finger with his
knife. So it's hard for me now to think of children as
blessed beings.' His photographs are made from within the
personal space of those he encounters, or seem to bounce
off their often strong, sometimes violent emotions. He
credits photographers Gene Smith, Robert Frank and Leonard
Freed for inspiration, but one might also add the writers
Allen Ginsberg and Jack Kerouac for their kindred embrace
of twisted spirits.

Dorchester Days features a poetic Postscript from
Richards's partner, Dorothea Lynch. She writes of Sing-
Sing, said by Richards to be the best street thief in
the neighbourhood, who has just flashed a bare rear end
to the camera of a departing film crew which had visited
the neighbourhood. '"You know", Gene says, "nothing's
ever completely what it seems at first. Sing-Sing can
be crude. But he can also be pretty sweet. During last
year's ice storm he brought all the pigeons he could find
into LaSalle's [the local bar]. Their wing feathers were
frozen, so he warmed them up on top of the radiators."'
The book's visceral, honest first-person stance represented
a deepening, and perhaps even a coarsening, of the
documentary embrace for the photographic agency.

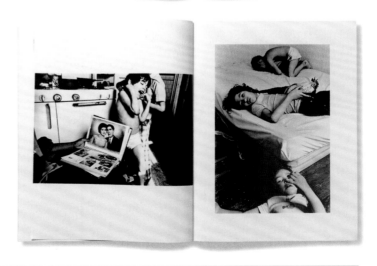

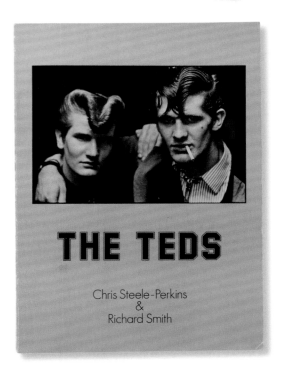

THE TEDS

Chris Steele-Perkins
&
Richard Smith

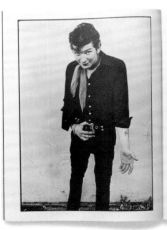

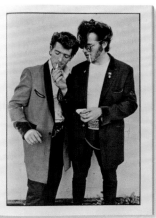

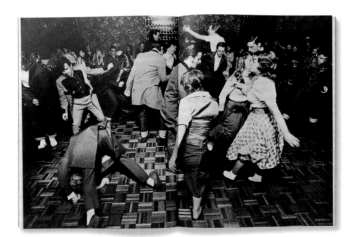

Chris Steele-Perkins
& Richard Smith
The Teds

Travelling Light/Exit,
London, 1979 (reissued by
Dewi Lewis, London, 2002)

229 x 201 mm (9 x 8 in),
128 pp

Paperback

74 b&w photographs

Photographs by Chris
Steele-Perkins; text
by Richard Smith

In the 1950s, Teddy Boys had been the first mass expression of rebellion by working-class youth in England. When they made a comeback in the 1970s, their looks were Edwardian: drapey velvet-collared jackets, vests and drainpipe trousers worn with crepe-soled shoes. The music was American: rock 'n' roll. And the hair was surreal: Elvis-inspired quiffs, heavily greased with Brylcream, helmets divided into rolling waves or horn-like points and pulled back into a 'duck's arse'.

In the 1970s, *New Society* magazine commissioned British photographer Chris Steele-Perkins and the writer Richard Smith to do a piece on the Teddy Boy revival. The pair soon agreed that the subject deserved more than two pictures in a magazine and in 1977 they decided to make a book.

Shot in black and white in London, Derby, Newcastle and Portsmouth, in pubs, nightclubs, streets and homes, *The Teds* has the spontaneity of a family album. The chapters follow a loose narrative and each has its particular rhythm. The book starts slowly and tenderly, with portraits of Kenny, Stan and others, some combing their hair or checking their outfits in the mirror; it accelerates into sometimes frantic concert and dance scenes, with a few Teds showing off breasts or genitals, and leads into a sequence of more formal vertical portraits of couples or trios. A chapter devoted to music and dancing – sometimes acrobatic – takes on an accelerated and intense rhythm, while another sequence of pictures, shot in square format, features the Teds in their homes, some of them with their families. The book ends with alternating portraits and group scenes, many in the resort of Southend or elsewhere at the seaside, and the mood is relaxed.

'The layout was done entirely by myself,' Steele-Perkins comments. 'I was influenced by the layout designs of the good reportage magazines, like the *Sunday Times Magazine* which allowed for strong double spreads and big verticals. I wanted the text and photographs to be distinct and stand on their own as complementing each other rather than one being subservient to the other.' When he photographed the Teds, Chris Steel-Perkins was not much older than they were. They were revolting against a straight-laced society, while he came from a rigid background, with his father in the military.

The Teds, Steele-Perkins's first book, was instrumental in his joining Magnum in 1979: 'It defined how I really wanted to work, which is to be in control of my work and the way it was shown.' Since its first printing, *The Teds* has remained a cult book and a prime example of a very personal, relaxed and colloquial documentary style. The glee, the kitsch, the machismo and energy jump out of the page. Leafing through the book, we can almost hear the music.

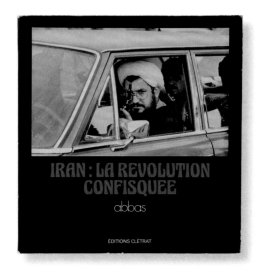

Abbas

*Iran: La Révolution
Confisquée*

Editions Clétrat, Paris,
1980

245 x 250 mm (9 ⅝ x 9 ⅞ in),
96 pp

Paperback

70 b&w photographs

Interview by Jean-Pierre
Séréni

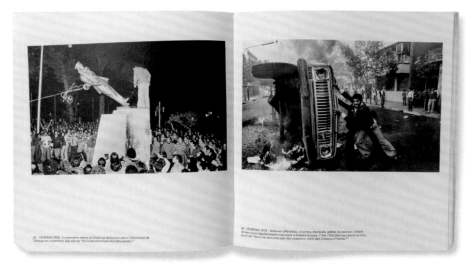

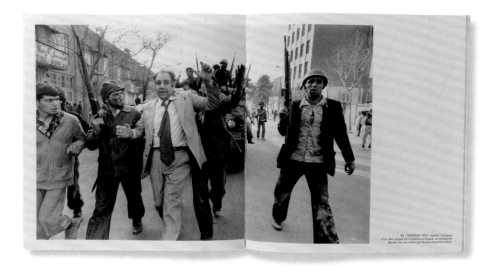

Born in Iran in 1944, Abbas and his family emigrated to
Algeria. Returning to his home country in the 1970s, he
had the sense that the autocratic rule of the Shah could
not continue unchallenged and, after the revolution broke
out in earnest, he had the discernment to immediately
declare it to have been hijacked. In his 1980 book *Iran:
La Révolution Confisquée* (which came out soon after
Ayatollah Khomeini had officially taken power as Supreme
Leader), with its enigmatic black-and-white cover photograph
of a bespectacled mullah holding a pistol and gazing out
from the driver's seat of a car, seemingly on the verge
of taking aim and firing, the revolution has already been
declared to have moved from its moment of exhilaration to
a future of ominous violence and constraint.

There are relatively few women in the book, but a
photograph of an older woman, believed to be a steadfast
supporter of the departed Shah, being hurried down a city
street by a mob of younger men attacking her, acutely
underlines one of the many social ruptures enabled by
over-reaching fervour. There is a photograph of the bodies
of four generals on steel drawers in the morgue, executed
after a hasty and secret 'Islamic' trial; another of a
statue of the Shah being pulled down; one of men happily

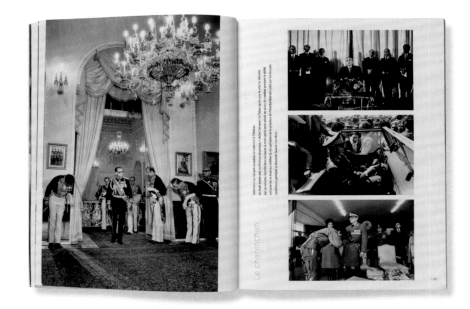

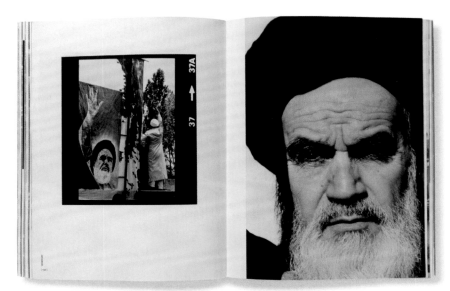

IranDiary 1971–2002

Editions Autrement, Paris, 2002 (also published in Italian by Il Saggiatore, Milan, 2005)

250 x 190 mm (9 ¾ x 7 ½ in), 240 pp

Paperback

268 b&w photographs and reproduced letters and magazine covers

Text by Abbas; artistic direction by Kamy Pakdel

spilling out bottles of alcoholic beverages found in a large hotel; a photo of a demonstrator brandishing his shoes in front of soldiers and yelling, 'Soldier my brother, why kill your brother?'; and another of a child with a gun seen from the back using a picture of the former Empress, Farah Pahlavi, as a target while other children watch. Divided into four chapters – 'Why the Revolution?', 'A People Revolting', 'The Revolution Confiscated' and a last chapter of only one photograph, 'A President for the Revolution', the book makes visible the underpinnings of a faith-based revolution that took the West by surprise.

While *Iran: La Révolution Confisquée* was made when Abbas was a member of the Gamma photo agency, *IranDiary 1971–2002* is a personalized and extended expansion of the previous book by Abbas as a Magnum member, with photographs and short texts relating to both everyday and more traumatic events. Included are photographs of theatre, the making of a film, music, weekend amusements and other signs of a less militant way of life. The book ends with a black-and-white photograph of a highway, a desolate, flat landscape and a bus moving ahead with three letters inscribed on its back: GOD.

Leonard Freed
Police Work

Simon and Schuster,
New York, 1980

278 x 215 mm (10 ¾ x 8 ½ in),
126 pp

Paperback

124 b&w photographs

Foreword by Studs Terkel;
cover design by Barry
Littmann

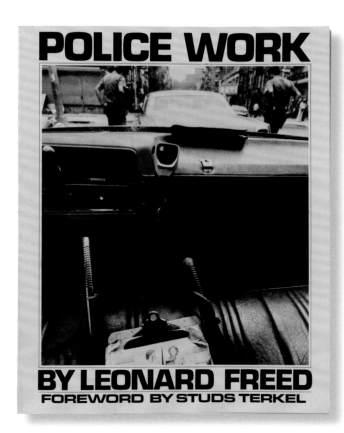

The American photographer Leonard Freed was well-known for his photographs of the Civil Rights movement from the 1960s when, in 1972 (the year he also joined Magnum), *The Sunday Times* in London commissioned him to photograph the New York Police Department (NYPD). The resulting article was provocatively titled 'Thugs, Mugs, Drugs: City in Terror' – and it provoked an uproar among New York politicians and media. Freed was less interested in what he called the 'blood and gore', explaining 'I was more interested in who the police were … I wanted to get involved in their lives.' After the *Sunday Times* article, further assignments from *Stern* and *Paris Match* allowed Freed to pursue his work with the police. His 1973 exhibition *Spectre of Violence* at the Photographer's Gallery in London, inspired by the book, created a sensation at the time.

Freed accompanied NYPD officers during drug busts, protests and murder investigations, but he also showed the complexity of their lives: a policewoman playing with neighbourhood kids or an African-American woman hugging a white officer. He showed officers 'on the beat' and negotiating tough situations, as well as demonstrating camaraderie with each other and spending time at home with their families. At a time before the ubiquity of cop shows on TV, Freed's images offered many Americans their first glimpse of what life was like behind the scenes for 'New York's Finest'.

Freed photographed the police for nearly a decade before eventually publishing 124 black-and-white images as *Police Work*. He edited the pictures and did the layout himself – he had studied design with renowned art director Alexey Brodovitch of *Harper's Bazaar* in 1955. 'I chose this title [*Police Work*]', Freed said, 'because the police are workers, they are not in command, they are not the mayor, they are not the lawyers. They are ordinary working people.' Long out of print, *Police Work*'s unassuming and empathetic style has inspired other Magnum photographers such as Bruce Davidson, Chris Steele-Perkins and Patrick Zachmann. More than forty years after its publication, the book remains a classic, an extraordinary example of what black-and-white photography can achieve and a symbol of 'Concerned Photography'.

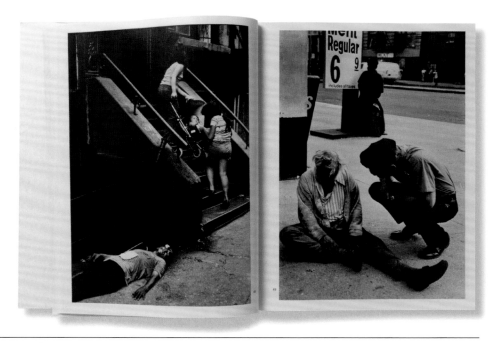

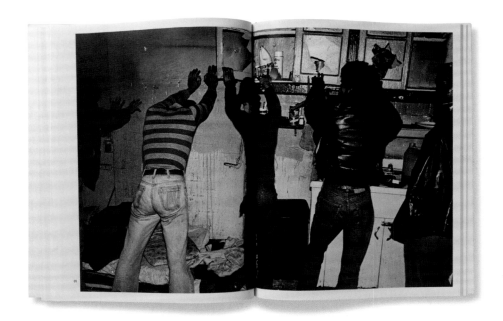

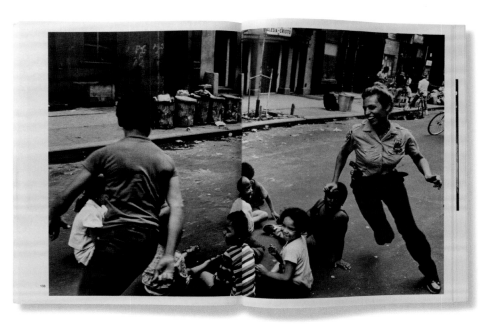

123. Central booking at night. An officer entertains with a puppet show.
The puppet shoots those who do not give satisfactory answers to
his "questions."

124. A police officer patiently waits in the hospital emergency ward for
a victim, shot in the leg, to say what happened.

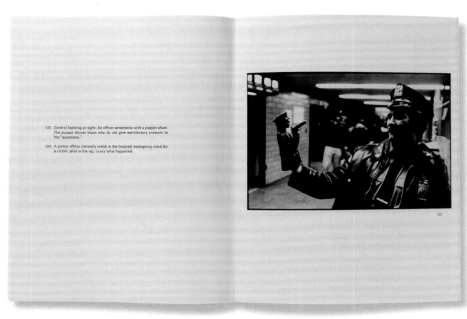

**Thomas Hoepker
& Eva Windmöller**

Leben in der DDR

Ein STERN-Buch, Wilhelm
Goldmann Verlag, Hamburg,
1980 (second hardback
edition published by Gruner
& Jahr, Hamburg, 1985)

185 x 125 mm (7 ¼ x 4 ¾ in),
224 pp

Paperback

113 b&w photographs

Text by Eva Windmöller

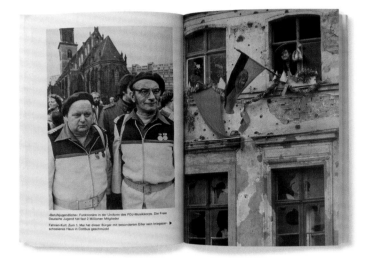

Thomas Hoepker, the son of a West German political journalist, was assigned a story on East Germany in 1974 by *Stern* magazine, where he was then a staff photographer, married to journalist Eva Windmöller. *Stern* published their story in installments from 1974 to 1976. It was the height of the Cold War and the relations between the two Germanys were frozen – but the West German Chancellor Willy Brandt negotiated a treaty, the Grundvertrag, part of which covered arrangements for an exchange of journalists. 'Stern's editor saw it as an opportunity to understand the nature of everyday life in the East', says Hoepker. 'By that time, we had discovered the world, we had been to Fiji and Namibia, but we had never been across the border to East Germany.'

Hoepker and Windmöller moved into one of the socialist prefab housing estates of East Berlin, equipped with official press passes as foreign correspondents that allowed them to move around the country. However, they quickly became disillusioned: they had to ask permission to photograph anything, and by the time permission was granted, all they had access to was a fake facade. They

finally got access to genuine family life through contacts with a group of East Berlin freelance photographers.

Leben in der DDR – more a collection of photographs than a picture story – features a classic layout in a small paperback format, looking like an illustrated novel (a larger format, hardback edition was published in 1985); text and captions were written by Windmöller, with a photographic sequence where subjects range from children playing along the Berlin Wall, party rallies, propaganda posters, old facades from the Imperial era, new apartment blocks, home interiors, Sunday outings and empty supermarket display cases.

Hoepker, a member of Magnum since 1989, comments: 'It was a hellish assignment, boring and tough at the same time. But I think I got pictures that show this weird mix of a state that was officially proletarian, a workers' state, but in reality extremely bourgeois. Everyone was in the business of getting a little house, or a nice apartment, with good curtains and china on the table. They were after good clothing and good food. It was very materialistic.'

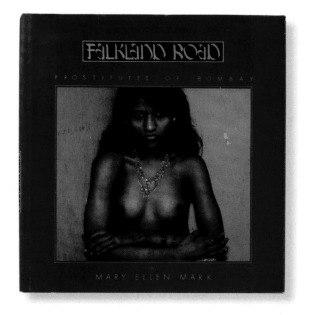

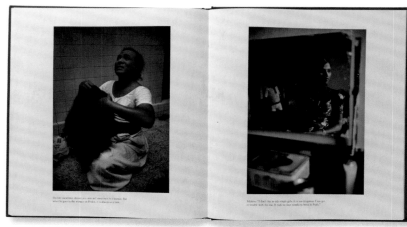

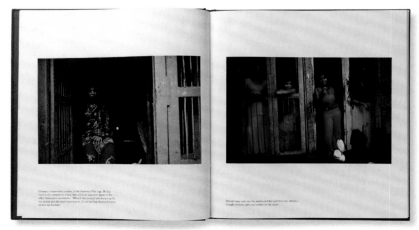

Mary Ellen Mark
*Falkland Road: Prostitutes
of Bombay*

Alfred A. Knopf, New York
and Thames & Hudson, London,
1981 (also published in
paperback; second edition
by Steidl, Göttingen, 2005)

276 x 254 mm (10 ¾ x 10 in),
124 pp

Hardback with blue cloth
and jacket

65 colour photographs

Edited and sequenced
by Joan Liftin; designed
by Diana Haas

Known for her penetrating portraiture of people ranging
from film stars to, in this case, sex workers, Mary Ellen
Mark was also known as a dedicated social documentarian,
particularly attracted to communities that were difficult
to enter. And, as a woman who received her Masters in
photojournalism in 1964, she was a trailblazer in a
profession then composed mostly of men.

Falkland Road, published in 1981 (the year she left Magnum
after five years), was Mark's third book, preceded by
Passport (1974), a collection of her early photographs, and
Ward 81 (1981), about a woman's psychiatric ward in Oregon.
Falkland Road, about a community of prostitutes in Bombay,
was Mark's first book in colour, and the imagery's strong,
visceral hues challenged the prejudice within the social
documentary field that the victimized and marginalized
should only be seen in tones of grey.

'I took the photographs on Falkland Road in the late
1970s,' she wrote in the afterword to the 2005 edition.
'Documentary photography in magazines was different then.
Certain magazines acted almost as sponsors supporting
serious photography. I suggested Falkland Road to Geo
magazine. They sent me to Bombay for three months. In the
end, the photographs were not published in Geo because the
editors thought they were too explicit for the American
market. Their sister magazine in Germany, *Stern*, published
13 pages instead.' Mark then expresses her disappointment

with contemporary editorial photography, including the
replacement of authenticity by spectacle. 'Today, no
magazine would sponsor a project like Falkland Road. The
real everyday world is – for the most part – no longer seen
in magazines. The only documentary photography we see is
of war, disaster and conflict. Most has been replaced by
fashion and celebrity photography.'

Falkland Road begins with a photograph in muted tones of
a twelve-year-old Lata seen from above, lying half-nude
in a small room, and ends with a colourful photograph of
Putla, a thirteen-year-old prostitute who is said to have
come from a small village, staring at the camera, frowning
and disconcerted, against a blue wall (the same image is
on the book's cover). There are photographs of families,
the street, moments of relaxation, prostitutes disconsolate
in the café, madams with their employees, customers (they
'range in age from thirteen to seventy-five. Some handsome
and some grotesque'), all composing a threaded narrative
exploring the complex dynamics of a place that previously
had been off limits to foreigners.

'For ten years', Mark wrote, 'I tried to take photographs
on Falkland Road and each time met with hostility and
aggression. The women threw garbage and water and pinched
me. Crowds of men would gather around me. Once a pickpocket
took my address book … Needless to say, I never managed
to take very good photographs.' But finally she did.

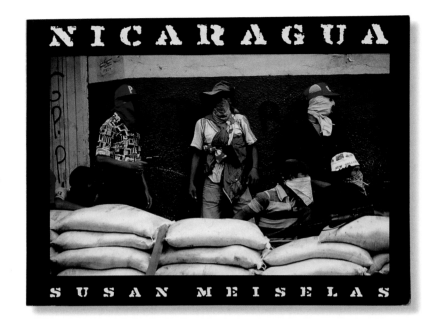

Susan Meiselas

Nicaragua: June 1978–July 1979

Pantheon Books, New York, 1981 (also published in paperback and in French and Spanish; reissued edition with DVD published by Aperture/ICP, New York, 2008)

215 x 175 mm (11 x 8 ½ in), 120 pp

Hardback with black cloth and jacket

71 b&w photographs and 1 map

Text by various authors; edited with Claire Rosenberg; design by Susan Mitchell

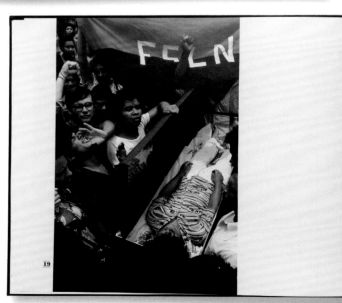

Nicaragua was Susan Meiselas's second monograph, after *Carnival Strippers* (1976), and the first in colour. In a series of uncaptioned photographs printed one on a page, it chronicles life in Nicaragua under the dictatorship of Anastasio Somoza Debayle and the Sandinista insurrection that toppled it in July 1979. The captions and thumbnails of the photographs follow the stream of images of what might be called the daily life of war, along with a variety of short texts primarily by civilians and insurgents that provide context and counterpoint. There is also a chronology of important moments in Nicaragua's history.

The book was made, Meiselas announces at its beginning, 'so that we remember'. It is also a commentary on the many small moments that make up both a dictatorship and a revolution, most of them unrecorded: 'NICARAGUA. A year of news, as if nothing had happened before, as if the roots were not there, and the victory not earned. 'The book was edited so that two photographs are usually facing each other on opposite pages. Many of them are vividly graphic, such as a young woman in a pink dress holding a frying pan and a pot surrounded by a bombed house; or the *muchachos*, young revolutionaries, wearing colourful masks and handkerchiefs to protect their identities as they fight on the streets; or a white-suited President Somoza in bright sunlight on the street in a row with other white-suited men, a dark car and soldiers lined up behind, coming to open a new session of the National Congress. Soon after this last image there is also a cautionary landscape photograph of a lush

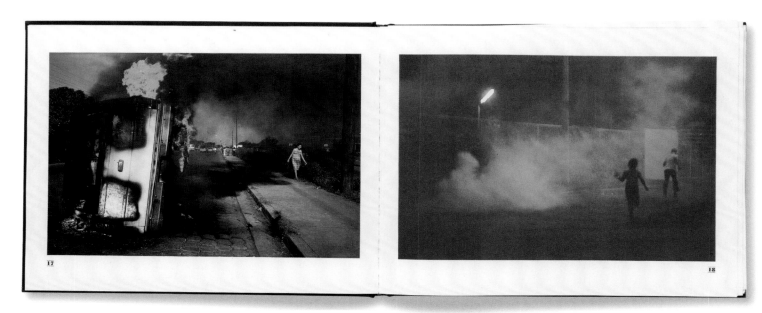

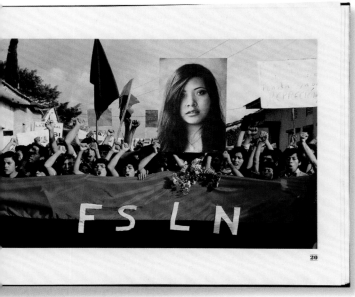

hillside outside Managua with a lake in the background, placed by itself on a right-hand page, that shows the bottom half of the body of someone still wearing blue jeans, prone on the ground with part of their spine sticking out. (The caption later informs us that this was a 'well known site of many assassinations carried out by the National Guard. People searched here daily for missing persons'.)

Meiselas, who joined Magnum in 1976 and became a full member in 1980, was a pioneer in the use of colour to photograph armed conflict. Although journalists knew the value of images of death and injury – 'It leads if it bleeds' was a common slogan – there was also a fear that depicting the red of blood and the vividness of gore (rather than rendering both as grey) would repulse readers. Meiselas, although just beginning to work in colour, used her wider palette to probe and highlight the intensity of the struggle she witnessed without treating it as spectacle. The victory that emerged seems, as a result, more real.

Several of the photographs had appeared in the 23 July 1978 cover story in *The New York Times Magazine*, making a somewhat obscure revolution considerably more visible and important in the West (the photographs also appeared in *Time* magazine and elsewhere). The book, with its sense of intimacy and respect for those involved in a violent struggle for their own futures, as well as its attention to a contextualizing historical record, has become a singular benchmark in the photography of conflict.

The Photobooks: In Detail 1938—2016

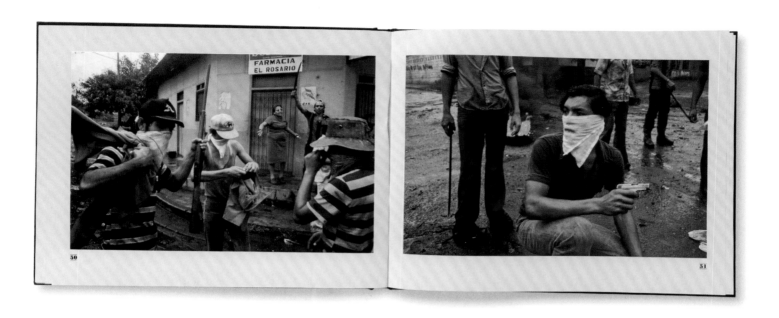

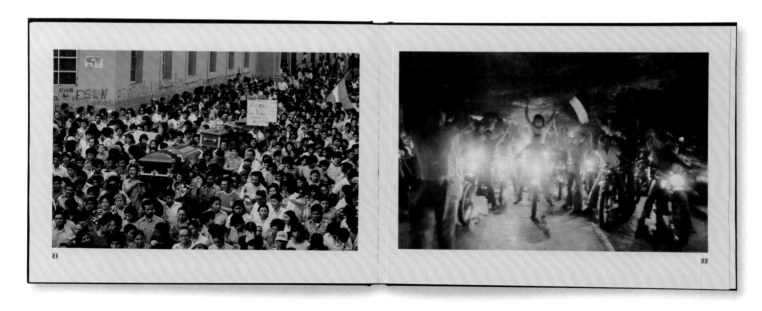

Gilles Peress
Telex Persan (Telex Iran)

Contrejour, Paris, 1984
(also published as *Telex
Iran: In the Name of
Revolution* by Aperture,
Millerton, New York, 1984;
republished in hardback
by Scalo, New York, 1997)

378 x 266 mm (15 x 10 ½ in),
104 pp

Paperback

100 b&w photographs

Introduction by Carole
Kismaric; essay by
Gholam-Hossein Sa'edi;
epigraphs from Roland
Barthes and Jorge Luis
Borges; design by Gilles
Peress and Claude Nori

The cover of *Telex Persan* (Telex Iran: In the Name of
Revolution) displays a single black-and-white photograph
that wraps around the book from front to back, fragmented,
playing with scale (a large head on the front, a large
poster on the back, groups of men gathered at different
distances in the background). Before even opening the book
there seem to be too many places the reader must look.

Gilles Peress went to Iran during the US Embassy siege
in Tehran that followed the Islamic Revolution led by
Ayatollah Khomeini, who months earlier had toppled the
Shah. Peress includes a photograph of his desk in New York
covered with frightening tabloid headlines: 'Khomeini's
Cowards Humiliate Hostage', 'Mideast Madness', '100,000
Shriek Hatred'.

On the initial pages of *Telex Iran* — including a page-and-
a-half photograph of graffiti in Persian — Peress asserts,
much like Henri Cartier-Bresson did in *The Decisive Moment*
(1952): 'These photographs, made during a five-week period
from December 1979 to January 1980, do not represent a
complete picture of Iran or a final record of that time.'
As Peress's Magnum colleague Cornell Capa states on the
book's back cover, '*Telex Iran* is a modern nightmare, an
urgent visual and telexed textual communication.' The
oversized book is, Capa notes, too big for any bookshelf —
making it more difficult to ignore.

One of the book's epigraphs is a disquieting, cautionary
quotation from Roland Barthes: 'All those young
photographers who are at work around the world determined
upon the capture of actuality do not know that they
are agents of Death … '. And then from Jorge Luis Borges:
'Islam asserts that on the unappealable Day of Judgment
every perpetrator of the image of a living creature
will be raised from the dead with his works, and he will
be commanded to bring them to life, and he will fail,
and be cast out with them into the fires of punishment.'
Further on, two successive images of Iran's barren, quiet
landscape, shown within the black frames of the original
roll of film, argue that any photographic reality is
a highly mediated one. The telexes beneath read first,
in French, 'MAGNUM PARIS WHERE IS GILLES?' and then
in English, somewhat ominously, 'DONT KNOW'.

Instead of captions, telexes between Peress and Magnum
appear throughout the book. They are there, in part,
to make it explicit that the photographer is a kind of
self-described mercenary representing the West, making
these pictures to sell, via his agency, to foreign
publications. The photographs are interrogations of
an emergent reality as yet not understood — the Islamic
Revolution — the reverberations of which still echo in
the region and the world today. Peress's first book, *Telex
Iran*, has emerged to become a classic redefinition of
the photo reporter as the curious, assertive person with
a camera, trying to figure out, transparently, what might
be going on.

Hiroshi Hamaya
Nyonin Rekijitu 1948–1950
(Calendar days of Asaya
Hamaya 1948–1950)

Self-published, Ōiso,
Kanagawa, 1985 (privately
published in a limited
edition of 1,000 copies on
the occasion of Hamaya's
wife's funeral)

300 x 211 mm (11 ¾ x 8 ¼ in),
28 pp

Hardback portfolio with
24 loose pages/photographic
plates (each individually
mounted) and one folded leaf
of printed text

24 b&w photographs

Text by Hiroshi Hamaya

In the late 1950s, Marc Riboud took a copy of Hiroshi Hamaya's *Snow Country* (1956) to the Magnum office in Paris. We do not know if it is this classic book, an ethnographic study of traditional agricultural life in the northeast of Japan, or the 1960 publication in *LIFE* magazine of Hamaya's photograph of Michiko Kanba, a left-wing activist beaten to death by the police during protests against the US military presence in Japan and the Security Treaty between Japan and the United States, that introduced Hamaya to Magnum in 1960 – the first Japanese photographer to join the agency. He was an associate member until his death in 1999. In his later career, Hamaya continued to focus on traditional life in Japan, but also produced black-and-white portraits of artists and writers, and extraordinary colour photographs of the natural world. His famous night photograph 'Boy Singing Songs to Drive Evil Birds Away', taken in the 1940s, was included in the exhibition 'The Family of Man' in 1955, and in 1972, Hamaya's photographs were included by Cornell Capa in the second volume of the collection *The Concerned Photographer*.

Calendar Days of Asa Hamaya is a self-published portfolio of prints and two presentation and title sheets that Hamaya put together in 1985 as a moving memorial to the recent death of his wife Asa, which he presented to friends at her funeral. Taken between 1948 and 1950, the soulful, intimate images of Asa – who was a master of the tea ceremony – follow the *ukiyo-e* tradition of woodblock print series known as *bijin-ga*, a term that refers to the portraits that were traditionally made to illustrate beautiful women. Hamaya admired such traditions, which he felt were under siege in modern Japan.

The elegant red Japanese colophon set in *gyosho* (semi-cursive) calligraphy on the cover is the only colour in a black-and-white series of twenty-four portraits of a young Asa preparing the tools for the tea ceremony, standing near a pond, getting her hair done, reading, folding a kimono, walking in a bamboo garden or lighting a lamp at dusk. Set in the centre of off-white pages, the spontaneous images of this exquisite portfolio are like the leaves of a family album, a discrete and restrained homage full of restrained emotion and nostalgia for the couple's days of youth.

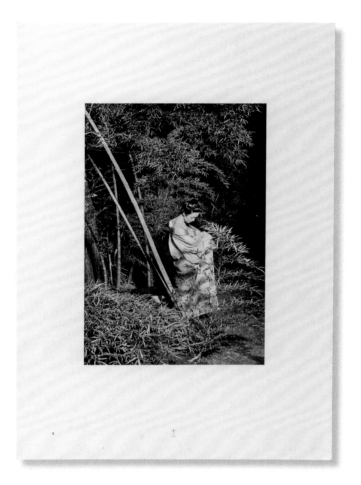

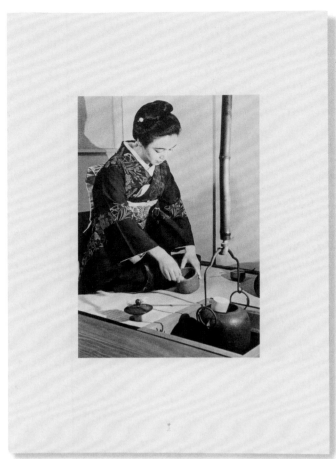

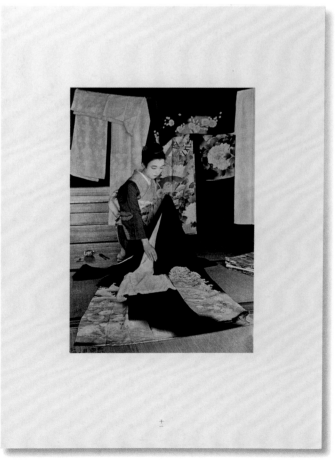

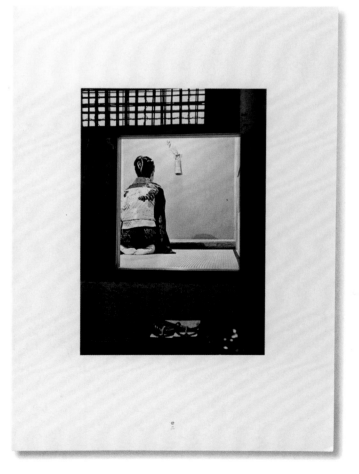

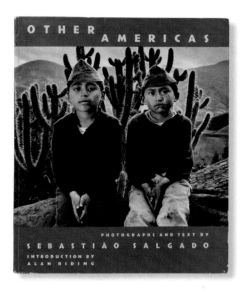

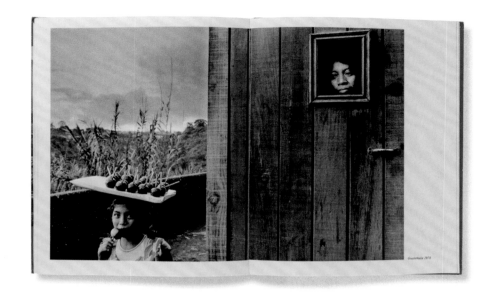

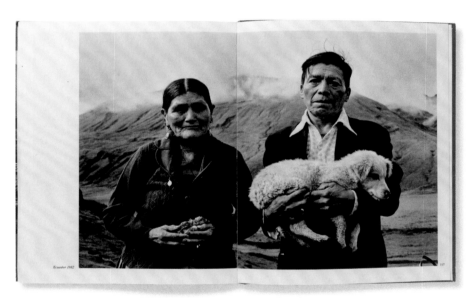

Sebastião Salgado
Other Americas

Pantheon Books, New York,
1986 (also published in
French, Portuguese and
Spanish; reissued in
hardback by Aperture,
New York, 2015)

300 x 240 mm (11 ¾ x 9 ½ in),
112 pp

Paperback

48 b&w photographs

Introduction by Alan Riding;
preface and photographs by
Sebastião Salgado; design
by Lélia Wanick Salgado
and Sophie Monterde; cover
design by Louise Fili

'The seven years spent making these images', Sebastião Salgado asserts in the preface to *Other Americas*, his first book, 'were like a trip seven centuries back in time to observe, unrolling before me, at a slow, utterly sluggish pace – which marks the passage of time in this region – all the flow of different cultures, so similar in their beliefs, losses, and sufferings.'

Salgado had relocated to Europe after fleeing the military dictatorship in his native Brazil, with his wife Lélia. *Other Americas* is an exploration of the cultures he had left behind, an attempt not to deal with the anguish and despair of those swarming into cities and their proliferating slums, but to articulate the strength of those who remained within the parameters into which they had been born. The book's title is meant to indicate the double otherness of Latin America and its rural people – first, because the USA has appropriated 'America' for itself, and second because those in the countryside are considered the 'other' even in their own countries, where they endure far outside the circles of power.

Reflecting its meditative stance, the book is laid out with almost every photograph across two pages, captioned only with the name of the country and the year it was made. The people depicted in the black-and-white pictures inhabit a weighty quietude that greatly differs from the noisy materialism of the North – the photographer turns the tables, able to show those in the United States and Europe, his primary audience, how the everyday spiritual wealth of the South may outweigh their material riches. (The book was initially published in English, French and Spanish, with three remarkably different cover photographs.)

In Latin America, 'Every mountain was an adventure.' Salgado walked for days to get to one village, was only the second outsider ever to arrive in another and in a third was considered a god. In one locale he unintentionally changed the way its denizens thought about a nearby river. When he explained that it eventually flowed into the Amazon and then into the Atlantic Ocean, they began to feel sorry for it and the long way it had to go.

Alex Webb

*Hot Light/Half-Made Worlds:
Photographs from the Tropics*

Thames & Hudson, London and
New York, 1986

267 x 305 mm (10 ½ x 12 in),
96 pp

Hardback with full black
cloth and jacket

76 colour photographs

Epigraph by Carlos Fuentes,
'The Hydra Head'; design
by Janet Doyle

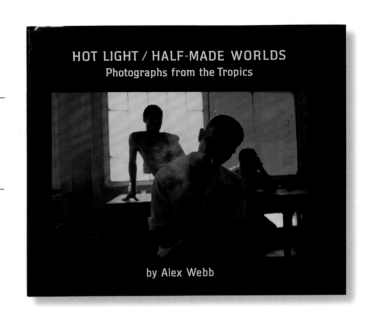

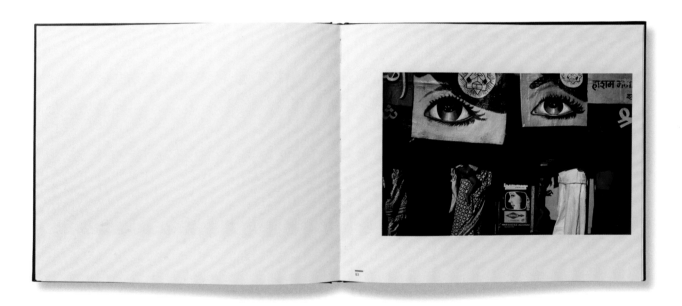

Hot Light/Half-Made Worlds was the first of San Francisco-born Alex Webb's fourteen books, and as such was both a personal milestone and a marker for a career working with intense, vibrant colour. Webb, who studied literature, sees the book in literary terms: 'The structure of this book owes a debt to Joseph Conrad's *Heart of Darkness*. Later on, working in the Amazon and in Paraguay, I have often felt that I've stepped into the magic-realist worlds of Garcia Marquez, Vargas Llosa, and Roa Bastos.'

Webb was feeling that his work in black and white covered territories already explored by others and realizing the importance of colour in the worlds he was photographing, his use of colour became 'the most significant obsession' of his career in the early 1980s, soon after joining Magnum in 1979. Originally, he thought the book might be about the Caribbean before he decided to broaden its geographical range: 'As I looked at my images from the Caribbean alongside those from Mexico, Latin America, and Africa I realized that despite the huge historical and cultural differences between these various places somehow the photographs seemed to be part of the same project.

There were emotional and sensory links – atmospheric links – connecting the photographs that encouraged me to put them together as a single body of work.'

Webb's images are complex and crowded with details. Shadows play an important role: the projected shadow of a jumper, of an arch or of trees drawing shapes on a plaster wall, the zigzag of a roof projected on the ground. Sometimes shadows invade almost the whole image, as in a photograph taken in Cuernavaca in 1982, or create a grid that seems to enclose people, as in a 1983 Mexico picture. The images are often bisected by a wall or window, creating a division between inside and outside or a sense of illusion, as if the street was a theatre set.

In *Hot Light/Half-Made World*, Webb portrays the tropics as a hybrid land where new and old mix, where natural beauty and human desperation coexist A sense of mystery pervades this lyrical and poetic book. *Hot Light/Half-Made Worlds* reads like a kind of journey, visual as well as metaphysical, from lightness to dark, from the tranquility of the tropics to something more disturbing.

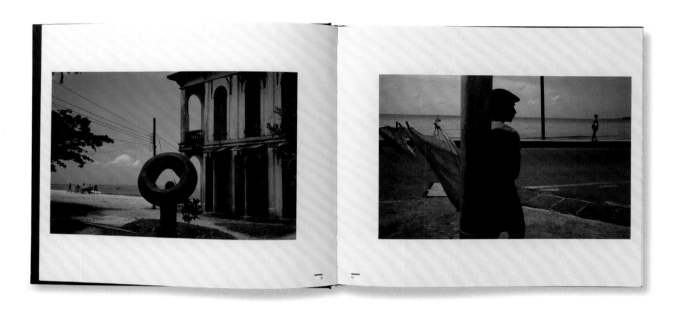

Marilyn Silverstone
*The Black Hat Dances:
Two Buddhist Boys in
the Himalayas*

Dodd, Mead & Company,
New York, 1987

227 x 188 mm (9 x 7 ½ in),
86 pp

Hardback with black cloth
spine and yellow paper cover
with jacket

52 b&w photographs

Text by Luree Miller;
jacket design by Jay Taylor

The Black Hat Dances is one of three children's books
published by American photographer Marilyn Silverstone
during her long career. One of only a few women members
of Magnum, she began working as a photojournalist in 1955,
becoming an associate of Magnum in 1964 and a full member
from 1967 to 1975. During this time, the agency distributed
her work from Iran, Israel, India, Sikkim, Bhutan, Nepal
and Japan, among other countries, until after over twenty
years' of photography Silverstone retired her camera in
order to become a Buddhist nun in Nepal.

Accompanied by Luree Miller's text, *The Black Hat Dances*
was conceived as an introduction to Buddhism for children
and teens, told through the lives of two eleven-year-
old Buddhist boys living in Sikkim, in the northeastern
corner of India. Tashi lives on a small family farm 80
kilometres (50 miles) from the regional capital. His best
friend, Samdup, lives in a monastery and is studying to
be a monk. The book's title refers to the black hat dances
that are performed in Sikkim, Dharamsala and Ladakh during
cultural and religious festivals, such as the yearly
festival at Pemagantse.

Opening with images of the Himalayan peaks and a historical
introduction by Miller, the book proceeds with portraits
of the two boys: Tashi's mischievous smile contrasts with
Samdup's serious expression as he stands in his monk's
robes. A series of images, either one or two per page with
explanatory captions, follow the two boys through their
everyday lives – one at his parents' farm, the other at the
Pemagantse Monastery, where he has lived for the last four
years. Both hold as many responsibilities as adults, but
Tashi has more time to play. The black-and-white images are
intimate in spirit, almost like family snapshots.

The book's sixth chapter documents the dances at the yearly
festival, which are performed around an enormous prayer
flag. Through a ritual dance accompanied by chanting and
music, the lama, dressed in a brocaded gown and a huge black
hat and surrounded by other monks wearing animal masks, must
destroy the evil to purify the world. The book ends the day
after the festival, when the two boys take a walk together
through the forest, talking about their lives. 'A photograph
is a subjective impression,' Silverstone once said. 'It is
what the photographer sees. No matter how hard we try to get
into the skin, into the feeling of the subject or situation,
however much we empathize, it is still what we see that
comes out in the images, it is our reaction to the subject
and, in the end, the whole corpus of our work becomes a
portrait of ourselves.'

Hiroji Kubota

Chosen Sanju Hachidosen no Kita (North of the 38th Parallel)

Kyoikusha, Tokyo, 1988

210 x 150 mm (8 ¼ x 5 ¾ in), 224 pp with two gatefolds

Paperback with jacket

106 colour photographs

The Japanese photographer Hiroji Kubota had his first contact with Magnum as a student, when he met a handful of photographers – René Burri, Burt Glinn and Elliott Erwitt – during a trip to Japan. Kubota became a full-time photographer in 1965, having moved to the United States, but two years later returned to Japan and began focusing on Asian subjects, including the Vietnam War. Drawn by places with little or no access to outsiders, Kubota – a Magnum associate since 1971 and a full member since 1986 – started working in North Korea on assignment for *Sekai*, a Tokyo magazine: the editor had been invited to North Korea and Kubota accompanied him in October 1978, the first Japanese photographer allowed to photograph in the country. Says Kubota: 'I was immediately convinced that I needed to make many trips there and luckily with the connections I had at that point I was able to go back, spending in total nine months there over a series of thirteen visits.'

In this xenophobic country addicted to personality cults, Kubota travelled to all the provinces, covering all four seasons and a variety of subjects: traditional houses in Kaesong, crowds queuing at the Korean Revolutionary Museum, a locomotive factory, a ping-pong game, little dancers at a model kindergarden, construction workers, a resort beach in Wonsan City, giant, Soviet-like panels of dignitaries. There are, however, few photographs of North Korean interiors – Kubota was probably not allowed to share families' lives. The beauty of his colour photographs is in sharp contrast with their regimented content, creating a surreal juxtaposition for the viewer. >>

>> 'The only way I could photograph,' Kubota explains, 'was to show things the North Korean – or rather the Party and Government – are proud of, but of course these things have a different message for me. The incredible regimentation of their military parades and mass games – imagine 50,000 children doing something together without one of them making a motion out of place. You just feel overwhelmed; it's like something out of a dream, and very scary. So I do not show anything the North Koreans don't want to show, but I like it, because what they want to show is so interesting.' Images of military parades and mass gymnastic displays prominently featured in the book may be what the North Koreans want to show of themselves, but as outside observers, what we perceive is probably not what they had in mind to convey.

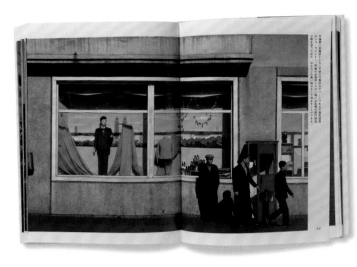

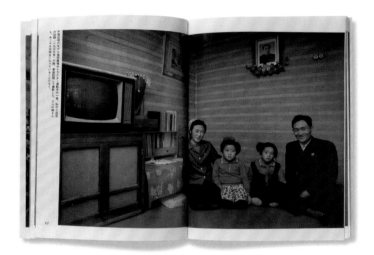

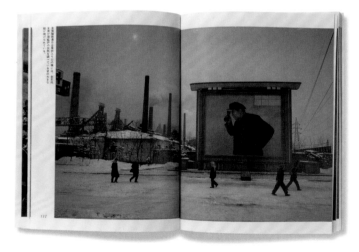

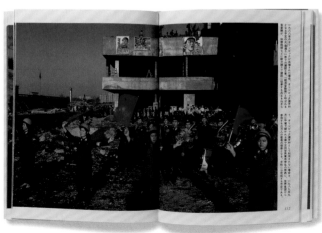

Cristina García Rodero
España Oculta

Lunwerg Editores, Barcelona,
1989

290 x 290 mm (11 ⅜ x 11 ⅜ in),
134 pp

Hardback with full black
cover and jacket

126 b&w photographs

Foreword by Julio Caro Baroja

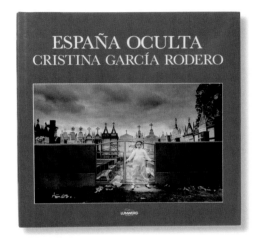

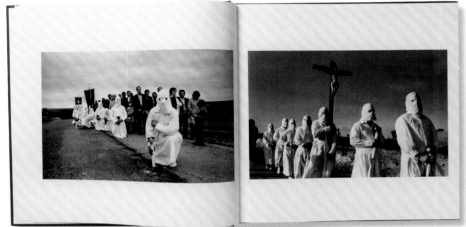

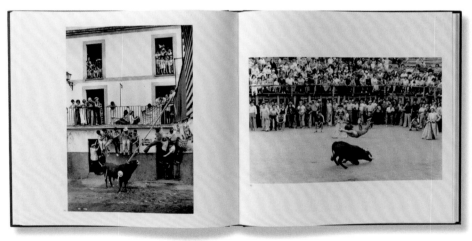

The Spanish photographer Cristina García Rodero has spent much of her career photographing cultural traditions around the world. From 1973 to 1988 she spent fifteen years researching and photographing popular and traditional festivities – religious and pagan – principally in her home country but also across Mediterranean Europe. As part of the project, which culminated in her book *España Oculta* in 1989, García Rodero went far off the beaten track, moving from village to village when she heard about a saint festival, a small *corrida*, a carnival or a rogation Sunday. Some of the festivals she has photographed have now disappeared, yet her book goes much beyond an anthropological interest.

The Spain we see in the pages of *España Oculta* is a mysterious, surreal world that evokes Francisco Goya or Luis Buñuel, with masked figures in costumes, old women in a trance, processions with banners, penitents carrying wooden crosses … Situations weave together the obscene and mystical, the quotidian and ritual. Sometimes modernity clashes with ritual, such as in a somewhat humorous image where, in front of hooded processioners, a woman consults

her watch. Garcia-Rodero's sense of humour is also present in her photograph of a man joyfully peeing in the street during a carnival in Galicia.

España Oculta follows a simple layout, one image per page with blank pages separating short picture sequences, and no captions. At the end of the book the pictures are identified by poetic titles such as The Kiss, A Sick Heart, The Horse that Neighed, the Transvestite… The book won 'Book of the Year Award' at the Rencontres d'Arles in 1989. The same year García-Rodero won the Eugene W. Smith Award for Humanistic Photography.

In her preface, García Rodero explains: 'I tried to photograph the mysterious, true and magical soul of popular Spain in all its passion, love, humour, tenderness, rage, pain, in all its truth; and the fullest and most intense moments in the lives of these characters as simple as they are irresistible, with all their inner strength, in a personal challenge that gave me strength and understanding and in which I poured all my heart.'

Sergio Larrain
Valparaiso

Editions Hazan, Paris, 1991

234 x 164 mm (9 ¼ x 6 ½ in),
64 pp

Paperback with flaps

38 b&w photographs

Essay by Pablo Neruda;
edited by Agnès Sire;
design by Xavier Barral

Chilean photographer Sergio Larrain's first photographs of the port city of Valparaiso were taken between 1952 and 1957, when he shot his famous image of two little girls descending a staircase. In 1958, Larrain received a grant from the British Council to go to London and Magnum co-founder Henri Cartier-Bresson saw Larrain's photographs of street children and suggested that he work for the agency: Larrain became an associate in 1959 and a full member in 1961. In January 1959, he published a photo essay on Valparaiso entitled 'The Town Suspended in the Hills', in *O Cruzeiro*, a weekly magazine published in Rio de Janeiro.

Years later, in April 1965, Larrain wrote to Cartier-Bresson: 'I have started the immense project of doing a story on a subject that is close to my heart, dedicating to it all my energy, without counting time or money. I have worked for two years in Valparaiso – a great harbour, miserable and magnificent. The result is a collection of very strong photographs.' Larrain's colleague René Burri introduced him to *Du* magazine, which published a portfolio of his Valparaiso photographs in 1965. But it was only in 1991 that the photographs were collected in a book, published in France, accompanied by an evocative text – also originally from *Du* – written by Larrain's friend and poet Pablo Neruda.

Larrain's fascination with Valparaiso went back to his childhood and the discovery in his father's library of books about the city dating back to the beginning of the twentieth century. Throughout the 1960s he walked the city's streets, often joined by his wife, Paquita Truel, and Pablo Neruda. They explored stores selling old books or ancient, surreal-looking deep-sea diving suits. *Valparaiso*'s iconic photographs feature people (often street children living on the banks of the Mapocho River) shot from the back or at low angles, in full sun with strong projected shadows; tilting or blurring objects, crowding the edges of the frame, as if following the sinuous perspectives of Valparaiso's concrete staircases. Presence and absence, reality and unreality: the themes are juxtaposed in Larrain's images, which he likened to the Buddhist state of *satori*, made in a hallucinatory state of grace, with childlike wonder. The image sequence is loose: as if we were following Larrain in his endless, meandering walks up and down the city's hills, into the shops, bars and nightclubs, and into the harbour, facing the open sea.

During his life, *Valparaiso* was one of seven books Larrain made – in 1966 he also made *Una casa en la arena*, a book about Pablo Neruda's house. From 1968, Larrain became a recluse, dedicating himself to meditation, yoga and painting and taking photographs only occasionally until his death in 2012. For its modern and poetic feel, close to Cartier-Bresson's first images taken in Mexico, and the extraordinary association between Neruda and Larrain, *Valparaiso* remains a unique book in the history of photography. In a letter to his nephew, Larrain once wrote, 'The game is to let go, to let the adventure begin. Like a sailboat dropping sails.'

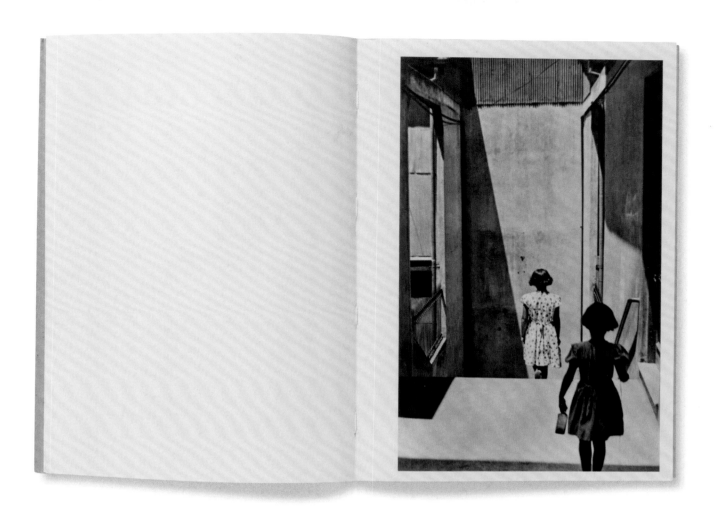

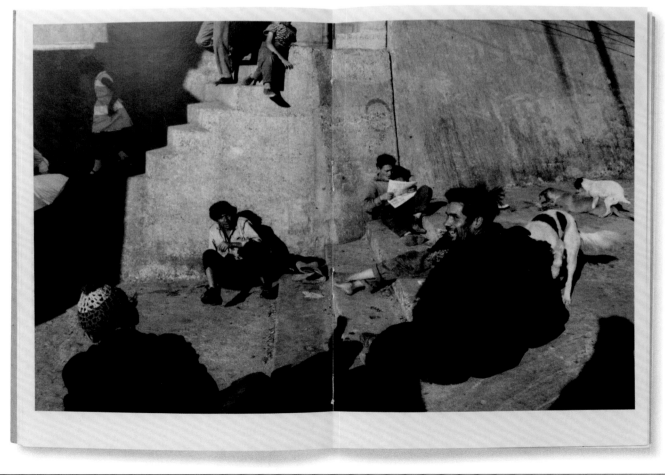

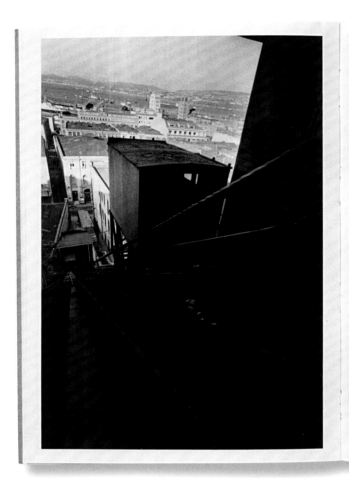

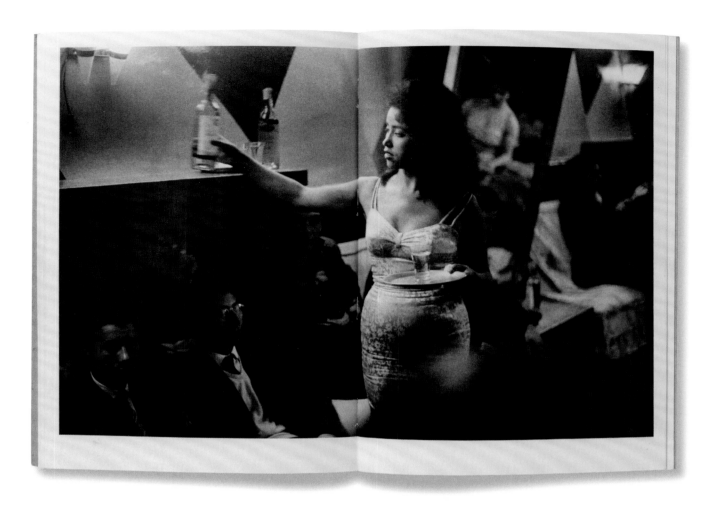

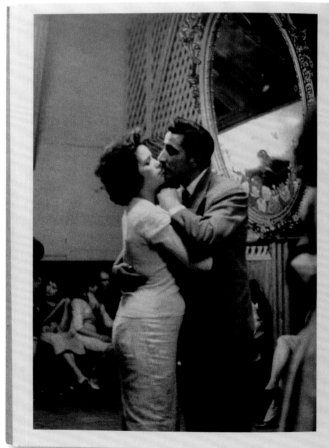

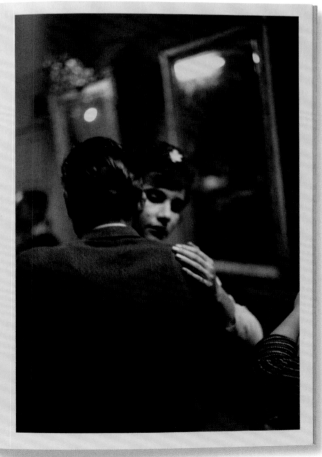

Lu Nan
Wasure Rareta Hitobito (The Forgotten People: The State of Chinese Psychiatric Wards)

Daisan Shokan, Tokyo, 1993 (bilingual English and Chinese edition published by China Tushu Publishing Ltd, Hong Kong, 2008)

210 x 300 (8¼ x 11¾ in), 136 pp

Hardback with jacket

63 b&w images

Text in Japanese by Ma Xiaohu and Zhang Dake

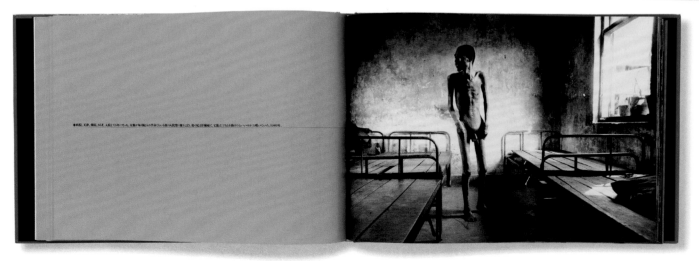

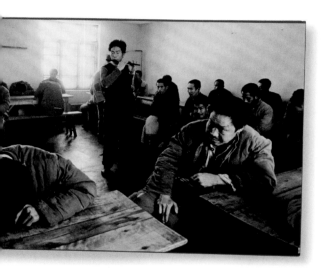

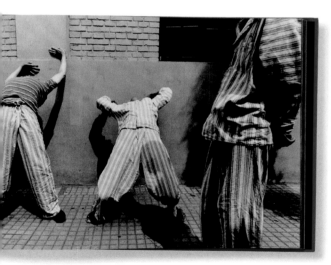

In 1989, the Chinese photographer Lu Nan started to work
on a project, which would eventually result in his first
book, *The Forgotten People*, which was completed in 1990.
A searing indictment of China's psychiatric wards, the
photographs could not be shown in China, so publishing the
book abroad was Lu's only recourse. *The Forgotten People*
is the first of Lu's 'Trilogy' series – documenting some
of Asia's most unfortunate communities – which took fifteen
years to complete and includes a total of 225 pictures.

The Forgotten People is a compelling and powerful testament
to the lives of patients held within wards across China,
from Beijing and Guizhou to Heilongjiang, Sichuan, Shanxi,
Yunnan and Tianjin. Lu Nan also visited mental patients
who remained at home when their families had no money
for hospitalization. We see some tied up with rope or
chained to their beds or a tree, while a homeless man
Lu encountered in Sichuan camps out near a river.

The Chinese wards resemble concentration camps rather
than hospitals. Often naked, dressed in rags or wrapped
only in woollen blankets, the patients are left alone,
helpless and with nobody to care for them. Malnutrition
is rampant and, as there are no special facilities for them,
children share rooms with adults. Photographed in black
and white with dramatic chiaroscuros, the heartbreaking
and lyrical pictures in *The Forgotten People* articulate
a powerful narrative through their sheer accumulation.
All the images are laid out full bleed on the right page,
with the opposite page blank. The photographs' visions of
horror contrast with the beautiful paper on which they are
printed in large format.

Like Chien-Chi Chang's *The Chain* (2002), though with a very
different style, *The Forgotten People* succeeds in drawing
the viewer into the closed, hopeless universe of the wards
and making us acutely uncomfortable. It is unclear how, in
the censored world of China in the 1980s, Lu Nan obtained
permission to photograph these scenes. It certainly was a
high-risk endeavour. 'As we all know,' says Lu Nan 'a book
has lots of advantages. To me, book is just like an old
friend that you can take out and talk to at any time and
it will never complain.'

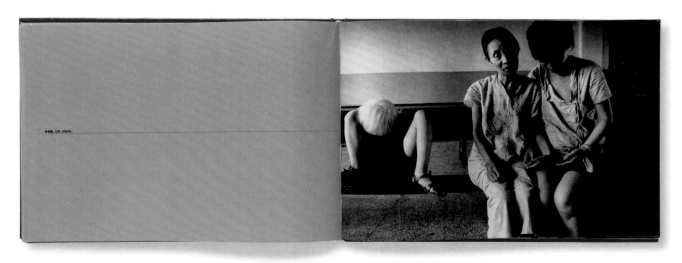

Peter Marlow
*Liverpool: Looking Out
to Sea*

Jonathan Cape, London,
1993 (also published in
paperback)

244 x 330 mm (9 ⅝ x 13 in),
112 pp

Hardback with grey linen
cover and jacket

85 b&w photographs

Introduction by Ian Jack;
design by Johnson Naylor
and Peter Dyer

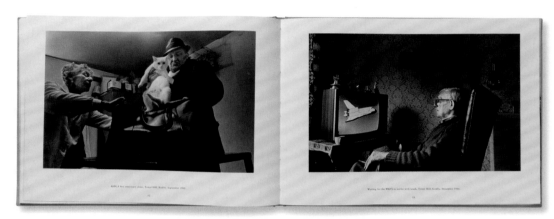

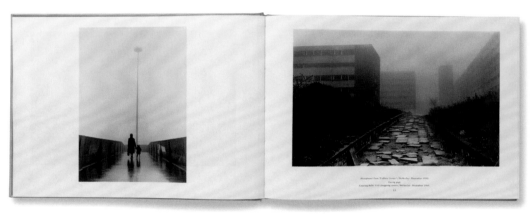

In 1986, British photographer Peter Marlow was increasingly aware that, despite his success as a photojournalist in the mainstream media, he had not yet authored an original body of work in his own style. Having returned to the UK from overseas assignments, Marlow decided to investigate the consequences of Thatcherism on the inner cities of northern of England, which had been bypassed by the economic reforms of the period, leaving a landscape of joblessness, devastation and despair. Marlow hoped to discover a story of hope and the resourcefulness of human beings. Eventually he settled on the city of Liverpool, which seemed to him 'like an island surrounded by the dreams of the Thatcherite nation'. He spent one week every month in the city until 1992, sometimes travelling with *Sunday Times* journalist Ian Jack, who wrote the book's preface.

Marlow's view of Liverpool is largely a record of an inner city in decline, with its shipping and manufacturing industries gone and the mythology of the 1960s' 'Mersey Beat' eclipsed by political arguments and social decay. The book features black-and-white images, laid out mostly full page with a small white frame. Marlow photographed scavengers at Bidston Moss searching for anything sellable, wearable or eatable; an unemployed couple sitting in their children's bedroom; abandoned apartment buildings; burned-out playgrounds; a job centre. But he also included more optimistic images of shoppers, boxing clubs and discos, or people on their way to work.

Marlow explains: 'This book was showing the work that I wanted presented, every aspect of it, the shooting, the interviews and the editing was all controlled by me. It was my first experience of having complete responsibility for a body of work – there could be no one else to blame for poor editing or cropping. And it was going to be "permanent".'

Nikos Economopoulos
In The Balkans

Harry N. Abrams Inc.,
New York and Libro, Athens,
1995

298 x 235 mm (11 ¾ x 9 ¼ in),
126 pp

Hardback with red cloth
and jacket

74 b&w photographs

Introduction by Frank Viviano

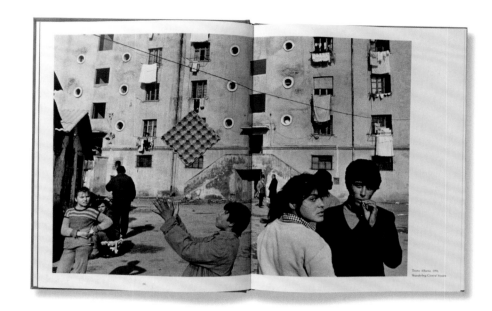

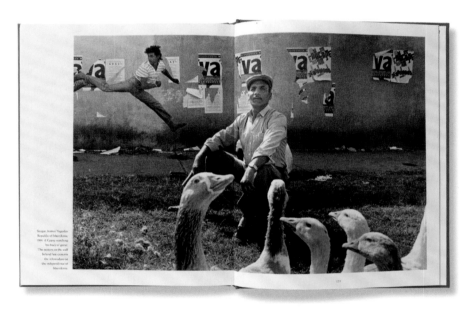

The Greek photographer Nikos Economopoulos joined Magnum in 1990, at the time when he started travelling and photographing extensively around the Balkans, then in the throes of ethnic wars in former Yugoslavia. His work in progress on the region won the *Mother Jones Award* in San Francisco, and the finished Balkans project eventually got him full membership into Magnum in 1994 – the year before *In the Balkans* was published. Economopoulos had been told that the Balkan people were enemies of Greece: 'When I first went to Turkey, however, instead of finding myself in a hostile country, I felt entirely at home. Everything seemed somehow familiar.' So he began exploring other Balkan countries to find a thread linking them: 'I found myself weaving together a common identity in an area infamous for its historical differences.'

Economopoulos does not view *In the Balkans* as a journalistic work. To him, making these photographs was intensely personal. In his classic book, shot in black and white with a Leica in 35mm – Economopoulos believes in being spare with his tools – he shows us how the people of the Balkans carry on with the business of living: marriages and funerals, farming and street games, village celebrations and markets. Economopoulos shot scenes in a psychiatric ward in Albania, a horse-breeding farm in Turkey, a Muslim refugee camp in Mostar, the gypsy community, the toppled statue of a Communist leader in Bulgaria and the foggy streets of Bucharest days after the Romanian regime was overthrown. Except for pictures shot during the war in former Yugoslavia, and those of Greek refugees arriving in Thrace, Greece, from the former Soviet Union, his photographs, organized in a quiet, unassuming sequence, are mostly classic and timeless.

Intuitive in their composition, they possess a fragile poetry, and tell us not only of what is, but of what could be. 'Being on the road,' Economopoulos says, 'travelling without a predetermined purpose, looking around me with visual curiosity and being surprised by what I encounter. While shooting, somehow, thinking is suspended. It is like playing a game with reality.'

Erich Hartmann
In the Camps

W.W. Norton & Company,
New York and London, 1995
(also published in French,
Italian and German)

277 x 252 mm (10 ¾ x 9 ¾ in),
112 pp

Hardback with full black
cloth and jacket

76 b&w photographs

Text by Erich Hartmann;
journal entry in Afterword
by Ruth Bains Hartmann;
quotes by Arthur Miller;
jacket design by Nathan
Garland

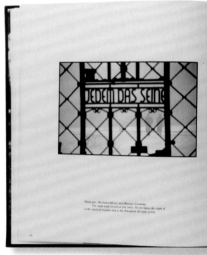

Erich Hartmann, who joined Magnum in 1952, pursued many long-term personal projects during his career, but *In the Camps* was especially important to him, as he felt obligated to those who were not as fortunate as he was. As a sixteen-year-old refugee from Nazi Germany, Hartmann had emigrated to America in 1938. Over the years, he thought more about the fate of European Jews that he had escaped. In 1994 he set out to photograph thirty concentration camps – empty, quiet and crumbling – before they were transformed into museums and memorials. *In the Camps* was eventually published as a book, coinciding with the fiftieth anniversary of the end of World War II in Europe.

For eight weeks or so, Hartmann and his wife Ruth undertook a winter journey to photograph the remains of the camps throughout Europe. Working with a 35mm reflex camera, without flash, Hartmann was determined to take only black-and-white photographs and to capture only what he saw immediately on arriving. He returned to New York with 120 rolls of film, from which he made a first edit of 300 photographs and a final selection of only 74 frames. Book-ended with images of barbed wire, starting and finishing with smaller images of a black crow in Majdanek in Poland, the book, with its sober design, takes us on a silent,

melancholy journey beneath overcast skies, with snow on the ground. Even after these many years, the camps, Hartmann writes, are still inhabited by 'the echoes of the dark and bitter past'.

Hartmann wanted to make descriptive images of the camps to bear witness and to express what the landscapes, architecture and abandoned buildings said to him about the past. And indeed, these places are haunted, from the railroad ramp at Buchenwald to the staircase of death at Mauthausen. When Hartmann focuses his attention on objects, he takes heartbreaking photographs of the accumulation of shoes, artificial limbs or children's clothing in Auschwitz's glass cases or the dissection tables in Sachsenhausen camp.

'If I have learned any lesson from having been in the remains of the camps,' Hartmann wrote, 'it is that thinking or living for oneself alone has become an unaffordable luxury … I am not an optimist, but I believe that if we decide that we must link our lives inextricably – that "me" and "them" must be replaced by "us" – we may manage to make a life in which gas chambers will not be used again anywhere and a future in which children, including my granddaughters, will not know what they are.'

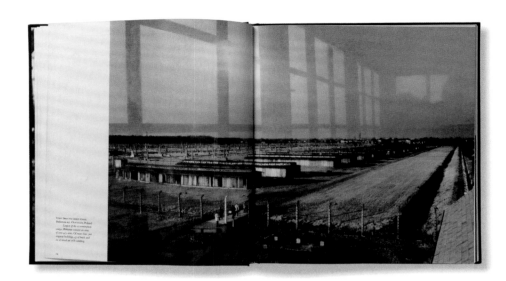

View from the watchtower, Birkenau 42, Oświęcim, Poland
Layout of the concentration camp. Birkenau covered 425 acres of some 425 acres. Of more than 300 original buildings, 45 of brick and 22 of wood are still standing.

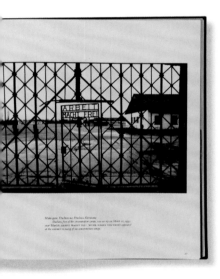

Main gate, Dachau 62, Dachau, Germany
Dachau, first of the concentration camps, was set up on March 22, 1933, near Munich. ARBEIT MACHT FREI (WORK MAKES YOU FREE) appeared at the entrance to many of the concentration camps.

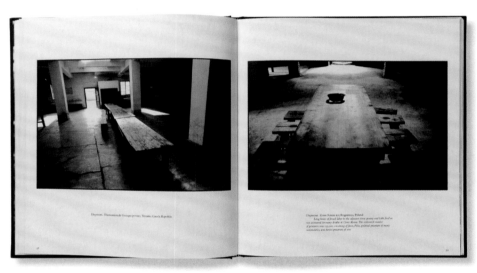

Dayroom, Theresienstadt Gestapo prison, Terezín, Czech Republic.

Dayroom, Gross Rosen 612, Rogoźnica, Poland
Long rows of bread laden the adjacent stone quarry and kilns fired at vast underground for many deaths at Gross Rosen. The estimated number of prisoners was 125,000, consisting of Jews, Poles, political prisoners of many nationalities, and Soviet prisoners of war.

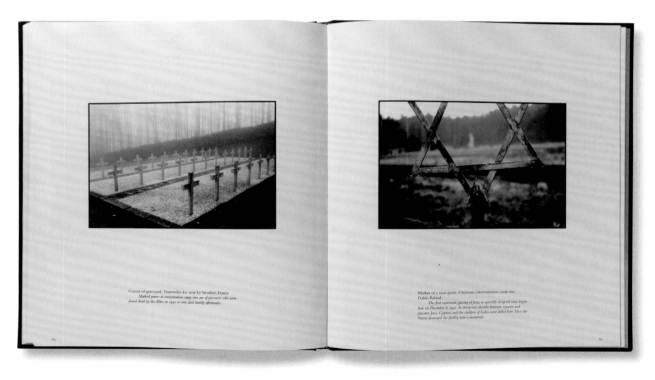

Corner of graveyard, Natzweiler 812, near En Struthof, France
Marked graves at concentration camp sites are of prisoners who were found dead by the Allies in 1945 or who died shortly afterwards.

Marker of a mass grave, Chełmno extermination camp site, Dabie, Poland
The first systematic gassing of Jews, in specially designed vans, began here on December 8, 1941. In thirty-two months between 150,000 and 320,000 Jews, Gypsies, and the children of Lidice were killed here. Then the Nazis destroyed the facility, now a memorial.

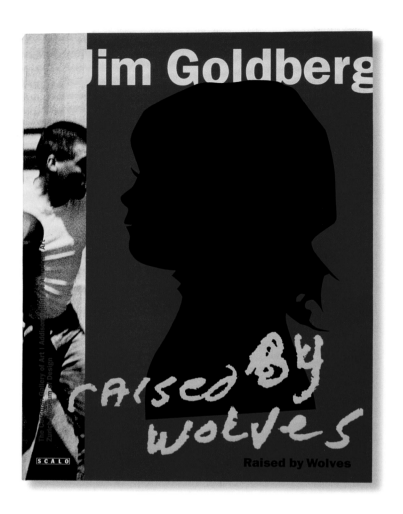

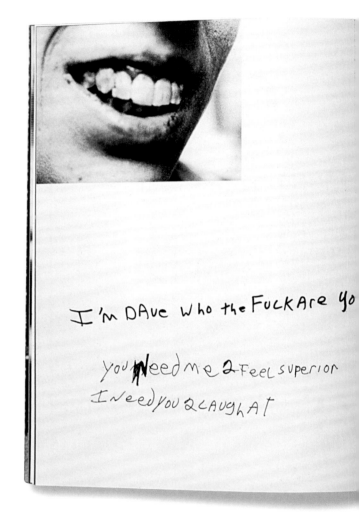

Jim Goldberg
Raised by Wolves

Scalo Publishing, Zurich,
1995

305 x 228 mm (12 x 9 in),
320 pp

Paperback

177 b&w and
53 colour photographs

Text by Jim Goldberg;
handwritten text by homeless
youths living on the
streets of San Francisco
and Hollywood, California;
designed in collaboration
with Philip Brookman

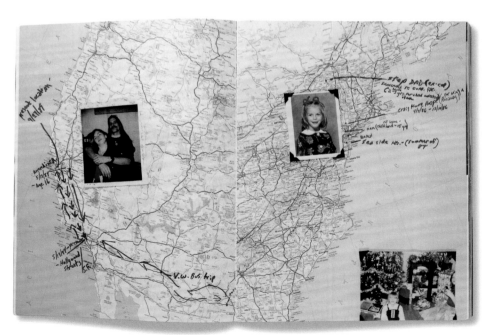

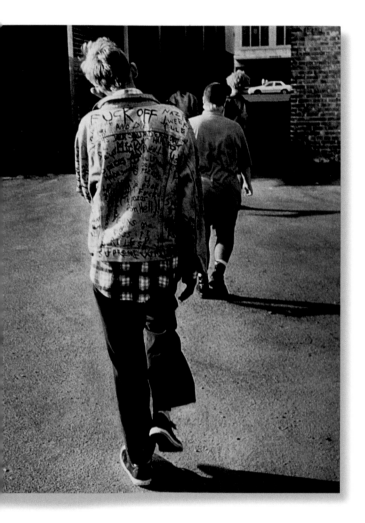

Jim Goldberg's mixed-media book, *Raised by Wolves*, is a large-format, several hundred-page, multi-year exploration of the lives on young people living on the streets of Hollywood and San Francisco. Among a host of others, the main protagonists include Echo, previously called Beth, who first ran away from home at the age of thirteen after being molested by her stepfather, a policeman, as well as Tweeky Dave, her seriously ill, love-struck friend who, early in the book, tells Goldberg that his own drug-dealing, abusive, rapist father told him as a young child, 'I hate everybody, why should you be any different?'

A third protagonist is Goldberg himself, who frequently writes about what he sees in front of him, asks questions of the confused adolescents, tries to help by giving them food, clothing and housing, checks in with adults who are supposed to be assisting – and eventually arranges for Tweeky Dave's funeral when his family will not. As Dave deteriorates, Goldberg describes an encounter with him in a café: 'Dave has no teeth so he sticks his fingers into the bowl of blue cheese dressing, leaving the fries for me. I show Dave the dummy for my book. He reads every bit of writing, looks at every picture, and asks no questions. When he's done, he wipes his hands on the dummy.'

Raised by Wolves does not conform to the model of the detached eyewitness documenting the horrific circumstances of his subjects in order that society immediately respond to somehow try and save them. It is instead a rather lonely, harrowing odyssey that hardly glorifies the results of empathy or compassion offered by the photographer-outsider. Self-destruction is rampant, and the pain is explicit. But where the book succeeds, as Echo puts it on the back cover, is in confronting these young people as they are: 'So many people try to become a part of these kids' lives, and then turn them into whatever they think they should be. I have never known you to do that.' Following on from Goldberg's previous book, *Rich and Poor* (1985), which had its subjects write directly on the photographic portraits to further describe their lives, *Raised by Wolves* presents a mix of hand-written statements ('It's not like you can go home and watch TV'), official documents, images from home movies, snapshots and Goldberg's photographs, many of them full bleed. They show the often unforgiving rawness of life on the street interspersed with occasional moments of grace.

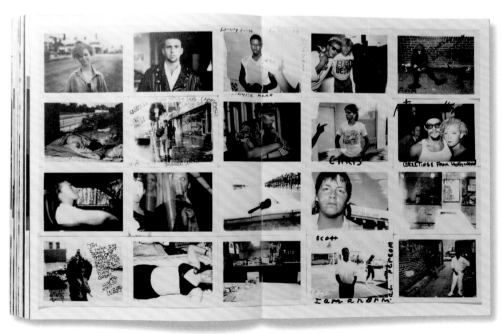

Raymond Depardon
La Ferme du Garet
(The Garet Farm)

Editions Carré, Paris, 1995

200 x 152 mm (8 x 6 in),
320 pp

Paperback with flaps

246 b&w and 37 colour
photographs and numerous
illustrations & ephemera

Text by Raymond Depardon;
design by Xavier Barral

Born to a farming family in Villefranche-sur Saône, just north of Lyon, Raymond Depardon grew up to become not a farmer but one of the most celebrated of twentieth-century French photographers, joining Magnum in 1978. *La Ferme du Garet* uses the family farmhouse as the heart of a narrative exploring Depardon's background, life and work. Beginning with a family picture from 1870 showing his mother as a baby on her mother's knees and a written account of his grandparents' life, the narrative closes over a century later.

Part autobiography, part reflection, the book is a skilful collage from different periods: black-and-white images taken by a teenage Depardon on the farm, when he photographed the animals and set up a darkroom in the cellar; ephemera from family pictures to Depardon's first press card and self-portraits as a child or a young journalist …); and colour pictures done with an 8 x 10 camera when, in 1995, he photographed landscapes around the farm for a group project financed by the DATAR (Délégation à l'aménagement du territoire et à l'action régionale). Loosely interspersed with the images are Depardon's own writings: 'I spent long afternoons in my parents' kitchen … I was able to write about my childhood in a way that I had never been able to do in Paris – the light, the sounds, memories of physical things, it all came back to me.'

As a photographer and filmmaker, Depardon has travelled the world over – notably in war zones of Biafra, Chad and Libya – but in recent years he has chosen to focus on the everyday in France and in the peasant world with books such as *Paris Journal* (2004), *La Terre des Paysans* (2008), *Paysans* (2009) and his long-term project on France in colour, shot with a 20 x 25 cm camera from 2004 to 2010, as well as his recent film *Les Habitants* (2016).

Printed in a small, intimate format like other books by Depardon such as *Le Désert américain* or *Afrique(s)*, *La Ferme du Garet* gives out a feeling of silence and slowness that approximates the pace of the peasant world. In a style close to that of Walker Evans, Depardon describes a world where routine reigns. 'Going back to the farm,' he writes, 'was partly because of a fear of forgetting. I wanted to pay homage to my parents, and also I wanted to show that it is not obligatory to go to the other side of the world to take photographs.' In the end, *La Ferme du Garet* demonstrates that the past cannot be recaptured: Depardon's parents are dead, and the world he knew as a child has died, too. 'I preferred to go around the world,' he says 'and when I became conscious of this farm's value, everything had disappeared.'

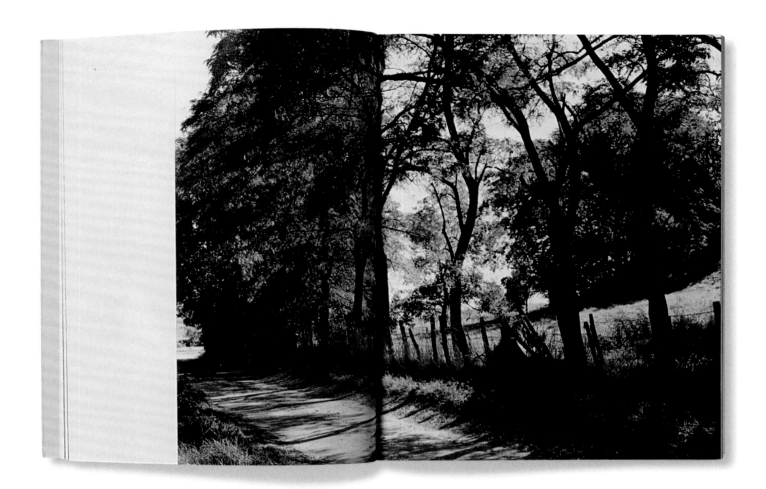

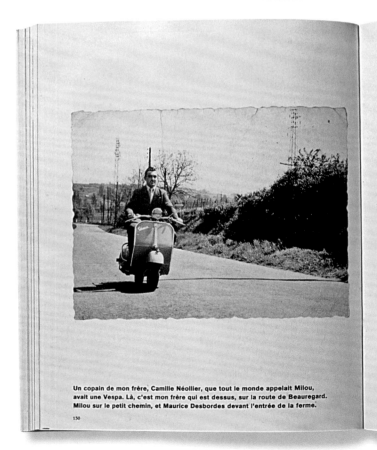

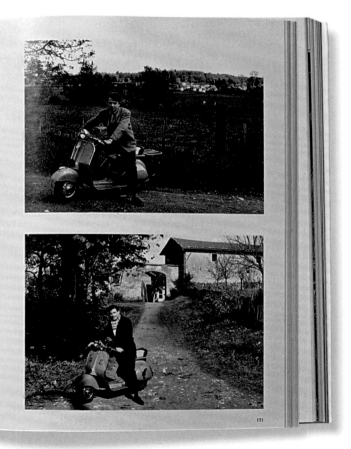

Un copain de mon frère, Camille Néollier, que tout le monde appelait Milou, avait une Vespa. Là, c'est mon frère qui est dessus, sur la route de Beauregard. Milou sur le petit chemin, et Maurice Desbordes devant l'entrée de la ferme.

130

131

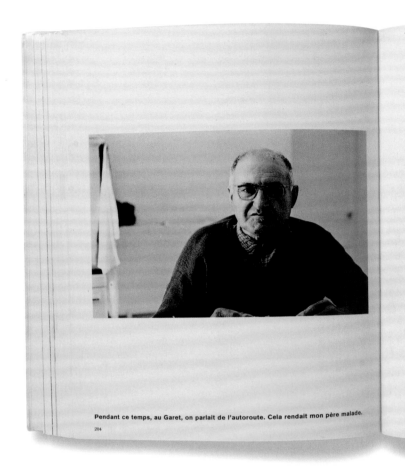

Pendant ce temps, au Garet, on parlait de l'autoroute. Cela rendait mon père malade.

Villefranche s/Saône le 26-12-61

M. Depardon Antoine
Cultivateur au Garet
à Villefranche (Rhône)
j'autorise mon fils Raymond
Reporter photographe âgée de 19 Ans
à louer une voiture pour les besoins
de son travail

Depardon

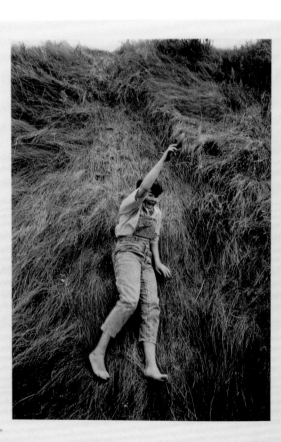

Près de la voie ferrée qui longe la ferme, Sophie faisait un terrain de jeux dans les grandes herbes. Nathalie avait grandi ; nous allions faire du vélo dans les petits chemins qui longent la Saône.

Constantine Manos
American Color

W.W. Norton & Company,
New York, 1995

227 x 300 mm (8 ⅞ x 11 ¾ in),
96 pp

Hardback with red cover
and jacket

93 colour photographs

Photographs and text
by Constantine Manos;
introduction by Brooks Johnson

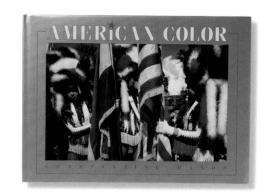

Constantine Manos's photographic career began when he was thirteen, in the school camera club in South Carolina; in 1953 he was hired as the official photographer of the Boston Symphony Orchestra, which culminated in the publication of his first book, *Portrait of a Symphony* in 1961. Moving to New York, Manos later worked for a number of illustrated magazines, before travelling to Greece where he lived and worked from 1961 to 1963, the year he also joined Magnum. From 1982, settling in Boston, Manos began fitting in short personal trips between his assignments in the United States, and over time it became clear that his real subject was colour: he published a collection of this work in 1995 as *American Color*, for which he received the Leica Medal of Excellence in 2003 (a second volume, *American Color 2*, was published in 2010).

Under a cover picturing an American Indian festival, *American Color*'s complex and beautiful images are presented in a continuous sequence, without captions, leaving questions and answers to the viewer. Manos likes to keep his equipment to a minimum: a Leica M6 with two lenses and Kodachrome 64, which he likes for its combination of vivid colour, sharpness and archival quality. The pictures in the book do not represent a general statement about the United States; they are more like a series of charged,

fleeting moments. Manos says that he sees images in his mind and when he's out on the streets, he looks out for these situations.

The situations are mostly public ones: motorcycles riders and mobile homes dwellers, fast-food counters and beauty queens, football games, state fairs, pageants and parades, the Daytona Beach bike festival, Coney Island, Venice Beach … Manos likes places that are chock-full of people, yet where no one looks directly into the camera. Manos thinks the United States – where he was born to Greek immigrant parents – is the most exotic country in the world and the public rituals under his scrutiny seem almost surreal. His images are complex and filled with information up to the edges of the frame; background and middle ground are just as important as the foreground. Bright tones and complex shapes impart a sense of lively energy. Manos explains: 'The flow of people in a setting, their changing relationships to each other and their environment, and their constantly changing expressions and movements – all combine to create dynamic situations that provide the photographer with limitless choices of when to push the button. By choosing a precise intersection between subject and time, he may transform the ordinary into the extraordinary and the real into the surreal.'

Patrick Zachmann
W. ou l'oeil d'un long-nez
(W. Or The Eye of a Long
Nose)

Marval, France, 1995
(bilingual edition with
text in French, English
and Chinese)

270 x 190 mm (10 ⅝ x 7 ½ in),
248 pp

Hardback with red cloth
and jacket

250 colour and b&w
photographs

Introduction and photographs
by Patrick Zachmann; design
by Gérard Paris-Clavel

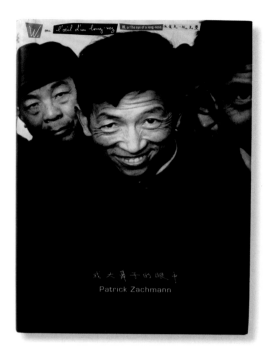

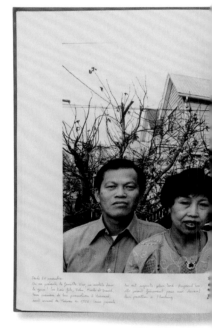

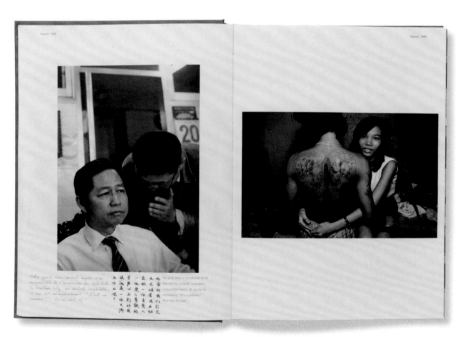

Patrick Zachmann has dedicated himself to long-term projects on cultural identity, memory and immigration in different communities. *W ou l'oeil d'un long-nez* (W. Or The Eye of a Long Nose) is his investigation of the Chinese diaspora and Chinese living in other cultures (the 'long nose' of the title refers to Chinese slang for Westerners). Zachmann's trips to China started in 1982 and he went back many times for the next eight years. His 1989 reportage on Tiananmen Square was published extensively. Fractions of *W* were published in a number of American and European magazines, and in 1986, Zachmann received the *Prix de la Villa Medicis Hors les Murs* to pursue his enquiry on the Chinese diaspora.

The final book — the result of ten years' work — gives text as much importance as Zachmann's photographs. The texts are laid out in three columns: in handwriting in Zachmann's native French, in Chinese characters and typeset in English. The book's format is modest, somewhere between a mystery novel and illustrated book. Printed on matte paper, the design alternates verticals and horizontals set on single pages with double-page spreads. *W ou l'oeil d'un long-nez* is not typical photojournalism: the book mixes authentic experiences with fictitious episodes. Zachmann found it a paradox that it was easier to photograph the Chinese in China than in New York's Chinatown, where he met with a lot of hostility: 'I have never met with so many refusals to take photos, even in the most harmless situations.' Going on patrol with the maritime police, Zachmann photographs the illegal emigrants fleeing China for Hong-Kong, follows the anti-Triad brigade on their raids on nightclubs controlled by the Triads, shoots everyday scenes at a barber, a butcher and a school, and the president of the stock exchange.

While Zachmann's black-and-white photographs often have the feeling of a *film noir*, a central colour section in-between black-and-white sections mimics the shiny aesthetics of tourist postcards, with photographs taken in Hong Kong, San Francisco, South China, Indonesia, Mali, Paris, London, Shanghai, Tahiti, Singapore and Thailand. The mysterious W., Zachmann's guide finally disappears, leaving the photographer with many unanswered questions. Says Zachmann: 'I gradually moved away from a traditional photojournalistic approach to one which was personal and entirely subjective … My photographic work presents a particular artistic vision in which most Chinese would clearly not recognize themselves.'

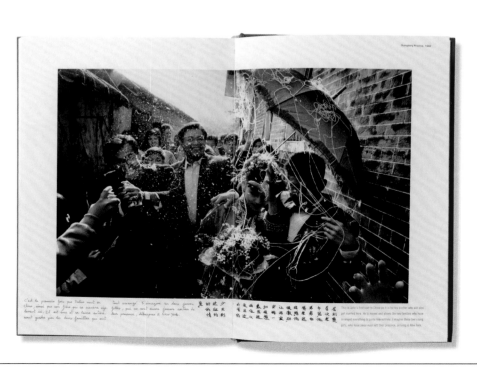

Eli Reed
Black in America

W.W. Norton & Company, Inc.,
New York/London, 1997

278 x 248 mm (11 x 9 ¾ in),
176 pp

Hardback with grey cloth and
jacket

174 b&w photographs

Foreword by Gordon Parks;
design by Debra Morton Holt

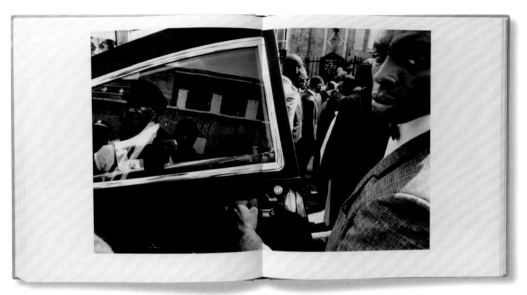

Eli Reed has been documenting the African-American experience in the United States for more than thirty years. Having worked for newspapers such as *Detroit News* in the early 1970s, Reed became tired of the smiley face clichés supposedly representing black life. He felt compelled to document the ups and downs of ordinary black Americans in a more truthful way, working specifically on this subject from the 1970s through the 1990s. Among Reed's other works are a study on the effect of poverty on American children, which became a film narrated by Maya Angelou (1988) and an acclaimed book (*Beirut: City of Regrets*, 1988), as well as more topical reportages on Haiti, the US military action in Panama and Hong Kong.

The idea of making a book only came about when Magnum (Reed became the agency's first black full member in 1988) connected him with Jim Mairs, an editor at Norton, who suggested they make *Black in America*. Norton's in-house designer put together a classic layout – a single picture to a page, sometimes two or three, and only two double-page spreads – which also featured several of Eli Reed's poems. The pictures are not organized chronologically but rather are paired and sequenced thematically. Reed explains that at the time he did not know much about book design: he was just happy that the book was published, seeing it as a very important moment for him. And Reed's book, a classic,

remains to this day the only one by a black photographer to cover the American black experience with such breadth and depth.

Reed's photographs capture a range of subjects: intimate family moments, the Los Angeles riots, the Million Man March in Washington, weddings and funerals, daycare centres and proms, beauty salons and gospel singers, a boxing centre, poor communities in Georgia or Mississippi … The images cover a lot of ground socially, geographically and politically, but always with empathy and compassion, truth and sometimes anger. He photographed some well-known figures, such as baseball great Hank Aaron, Mayor Marion Barry, Reverend Al Sharpton and famous artists such as Toni Morrison or Maya Angelou, but most of his subjects were anonymous African-Americans.

'This book,' Reed writes, 'deals with life for black Americans now and reaching into the next century. It is, in a large sense, about spirit and substance, about successes and failures, and social intercourse between the races, particularly blacks and whites. This project has not been easy for me. At times I wanted to turn away in disgust. But there were moments of joy and encouragement. The situation in the United States isn't good but I'm still an optimist.'

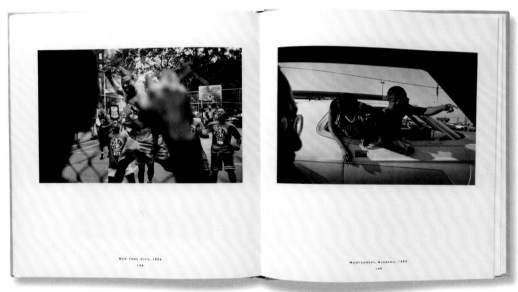

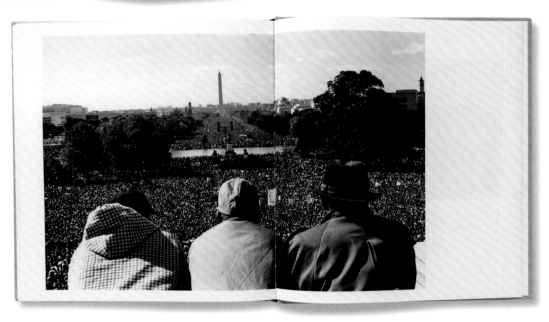

Miguel Rio Branco
Silent Book

Cosac & Naify Editions,
São Paulo, 1997

190 x 190 mm (7 ½ x 7 ½ in),
92 pp

Hardback

75 colour photographs,
including 3 gatefolds

Design by Jean Yves Cousseau

Silent Book was published in São Paulo in 1997. A hardcover
square Octavo with Japanese binding, designed by Jean Yves
Cousseau, it contains seventy-five colour plates and three
gatefolds. The endpapers are dark grey and black, and beyond
some biographical details about the photographer, it has no
captions or text to shape the viewer's interpretation of
the images. *Silent Book* is not a classic reportage. It is,
rather, conceived as a mysterious travel or a quest through
symbolic images of people, places and objects, echoing
Roman Catholic artistic tradition. A large portion of the
book was shot around the gymnasium of the Santa Rosa Boxing
Academy in Rio de Janeiro, but other pictures were shot in
Cuba, Spain and the Languedoc-Roussillon region of France.

Leafing through *Silent Book*, it is evident that Brazilian
photographer Rio Branco is also a painter and a filmmaker.
The logic of the book's sequence is poetic and dreamlike:
based on free association, it unwinds like a slow-motion
movie. When he photographs people, Rio Branco often does
it from the back – even when he does not, faces are mostly
hidden by hats or entirely cut off, leaving only the torso.
The dominant hues are deep reds and browns, with dark
blues at the end to echo the first page showing a closed
door. The light is that of dusk. Objects and still lifes –
a pavement with a few scattered red flowers, a painting of
hell with women kidnapped by demons, a dusty row of bottles
that seem left over after a natural disaster, a knife
on bloody ground – are given as much of a role as scenes
featuring people. Full of sweat, blood and tears, both the
boxing ring and bullfighting arena seem like the realms of
a regulated violence that contain and exorcise men's urges.
'My work has a lot to do with skin, for that is the surface
connecting us to the world, in pleasure as much as in pain.
Skin is a dialogue between outside and inside, a separation
that is also a connection,' says Rio Branco. He has been
a Magnum associate since 1980.

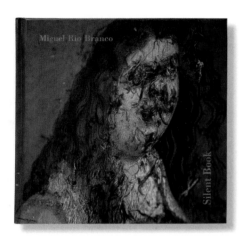

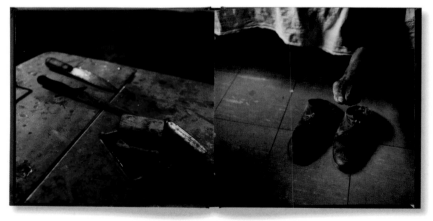

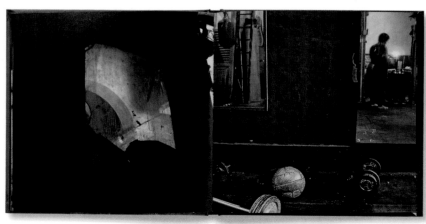

Martine Franck
D'un jour, l'autre

Editions du Seuil / Maison
Européenne de la Photographie,
Paris, 1998 (English edition
published by Thames & Hudson,
London)

270 x 215 mm (10 ¾ x 8 ½ in),
168 pp

Hardback with full black
cloth and jacket

104 b&w photographs

Foreword of fax correspondence
between John Berger and
Martine Franck; design by
Robert Delpire

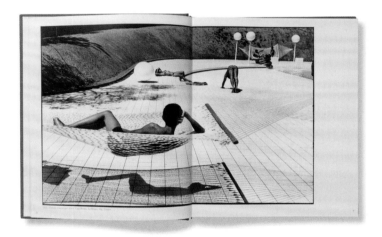

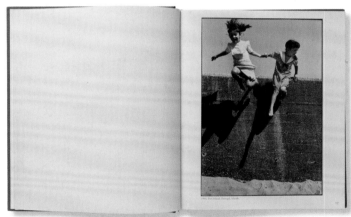

The Belgian photographer Martine Franck did not consider *D'un jour l'autre* as a retrospective monograph, but 'a visual choice of my favourite photographs grouped by themes: childhood, theatre, the Orient, old age, portraits, museums, landscapes … To me, they are inexhaustible themes.' *D'un jour l'autre* possesses the loose, unpretentious directness and simplicity of a visual diary. The layout uses a single picture as a chapter opener, followed by a sequence of full-frame images. The black line framing each image and the large white space around give them breathing space, as if they are hanging on the wall of Franck's imaginary museum.

'Your photographs are zipping like arrows,' John Berger comments in a preface composed of a fax exchange. This is the perfect description for the recurring image of two children jumping: over a wall in Tory Island, Ireland; over a dune at La Grande Motte in France; or again on the Puri beach in Orissa, India. Portraits of known figures – Henri Cartier-Bresson staring intently at a Goya painting, Albert Cohen, Marc Chagall, Paul Strand hugging his box camera, Sam Szafran in his studio, dwarfed by a giant

plant, Avigdor Arikha with his painted double – alternate with others of unknown, often older people: an old lady mimicking Franck's picture-taking at the Hospice d'Ivry or Mademoiselle Evelyne LaLiberté with her parents' portrait in Quebec.

D'un jour l'autre also features magnificent landscapes of the Lubéron in Provence, where Franck spent her summers, a tempest at Tory Island and a stormy sky in Bergen, Norway. Franck, who joined Magnum in 1980, was a shy woman ill at ease in social situations but was capable of forgetting herself to be receptive to the other. This Buddhist stance, coupled with her sense of humour, served her well when she went to photograph the *tulku*, the young monks of Tibet: 'I went into his room where he was studying with his tutor, Lhagyel. I crouched in a corner in order to be as inconspicuous as possible. All of a sudden, to my delight and that of the young tulku, a pigeon landed on his tutor's head.' Martine Franck clicked the shutter. When they all burst out laughing, she stopped being an observer and became a participant.

Gueorgui Pinkhassov
Sightwalk

Phaidon Press, London, 1998

280 x 295 mm (11 x 11 ⅝ in),
40 pp

Hardback with purple
leatherette cover and
translucent paper inserts

25 colour photographs

Design by Thomas Manss &
Company

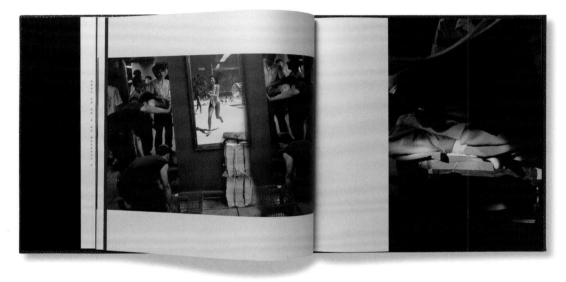

The Russian-born French photographer Gueorgui Pinkhassov published his first book, *Sightwalk*, ten years after joining Magnum in 1988. The project stemmed from a 1996 assignment by the European Union Japan Fest: he and a small group of photographers who had not previously been to Tokyo, were asked to record their impressions of the city.

Sightwalk is a large book, almost square; its presence is both precious and inviting. It is bound in a grainy leatherette, much like an old photo album. The fragile-looking binding is Japanese-style, sewn with thin red thread. The first twenty-five images are arranged as thumbnails in a square mosaic pattern on the first page, with the title, Tokyo. The same mosaic grid then appears with the image boxes in semi-transparent paper, followed by one image per page on a lustrous, light silver paper. Each 'chapter' opener repeats the motif and sequence. The semi-transparent grid that opens each 'chapter' invites the reader to 'see through' to the images beyond, linking the chapters like hidden compartments.

Our expectations of Tokyo are probably that of a metropolis filled with crowds and modernity, but *Sightwalk* proposes a different view. It is a dreamlike, intimate, impressionistic walk through the city, going from light to dark, dawn to dusk, and ending with the vision of three women with umbrellas on a bridge that recall Japanese woodblock prints by Hiroshige. Pinkhassov's vision is intense and singular. His images, shot in temples or on the tube, in parks or at the market, deliberately confuse foreground and background. Droplets of rain and reflections create a dappled, fragmented pattern of light and shadows. Their style seems close to Saul Leiter's semi-abstract colour photographs or to the work of film-maker Andrei Tarkovsky. *Sightwalk* does not have a narrative, but it conveys a strong emotion. 'Good photos have come when I least controlled the situation,' says Pinkhassov. 'The process reminds me of fishing … Sometimes I have not even recognized my own photographs. I have even hesitated to call them my own. But the editing is mine. Whoever controls the editing of a photographer controls his fate.'

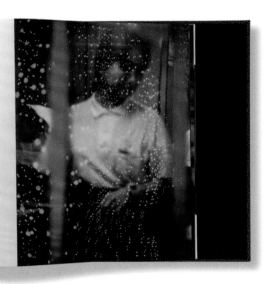
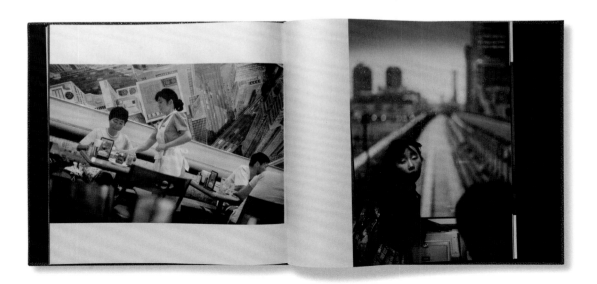

Paul Fusco
RFK Funeral Train

Magnum Photos with The
Photographers' Gallery, London,
1999 (artist's edition; first
edition published by Umbrage
Editions, New York, 2001;
revised edition published
by Aperture, New York, 2008)

167 x 250 mm (6 ½ x 9 ¾ in),
148 pp

Paperback with 9 different
covers, individually numbered

68 colour photographs

Introduction by Norman Mailer;
design by Cartildge Levene

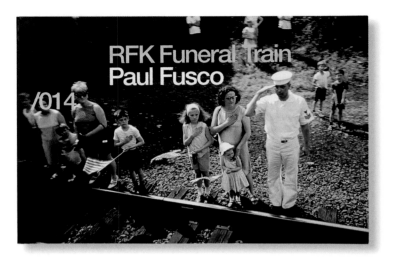

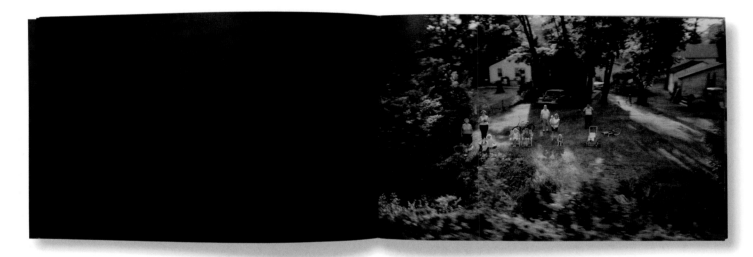

On 8 June 1968, Paul Fusco was a young photographer for *LOOK* magazine (he only joined Magnum in 1974) when his editor assigned him to accompany the train carrying Senator Robert F. Kennedy's body from New York to Arlington National Cemetery, following his assassination in the lobby of the Ambassador Hotel in Los Angeles two days earlier. 'He didn't say anything about what he wanted,' says Fusco. 'He just said: get on that train.'

Kennedy's coffin was placed in the last of twenty-two cars and elevated so that it was visible through the observation windows. For eight hours, Fusco stood at an open window on the train, taking 2,000 photographs of the mourners who flocked in their thousands to pay their respects as the train passed slowly by. They included people from every section of society, in large groups and on their own.

LOOK, however, was not due out until a week after its competitor, *LIFE*, which in the meantime dedicated its entire issue to coverage of the assassination. *LOOK*'s editors decided to drop Fusco's photographs, instead releasing a retrospective album on RFK. Fusco's images would have remained in the files unseen had it not been for Natasha Lunn, a photo editor at Magnum, who was shown the work in 1998. The pictures were then exhibited at The Photographer's Gallery, London, in November 1999, and with the support of Xerox were made available as a limited edition of 350 print-on-demand paperback books, with nine

different covers, the photos appearing full bleed on the page, a simple composition and layout that adds to the cinematic quality of the sequence. Only 200 copies were actually printed. A year later the book was reprinted in a more traditional hardback format by Umbrage Editions with a print run of 2,000 copies, then again by Aperture in 2008, with extra images from the cache of 1,800 images now held at the Library of Congress.

The photographs in *RFK's Funeral Train* seem guided by Fusco's instinctive response to an emotional moment. Each picture is filled with subtle gestures and body language that prevent the book from being repetitive: a man with crutches waves one crutch in the air; a black woman kneels in the dirt, her hands locked in prayer; and a mother holds the hands of two children.

'I could not change my view, I could not change my perspective,' says Fusco. He shot with Kodachrome, avoiding super-fast shutter speeds, so that as the light slowly fades during the journey, the crowd seems to dissolve into a swirl of purple blue as the train reaches its destination. As Fusco observes, 'The motion emphasizes the breaking up of a society emotionally. 'Everyone was there, America came out to mourn, to weep, to show their respect and love for a leader, someone they believed in, someone who promised a better future and the saw hope pass by, in a train.'

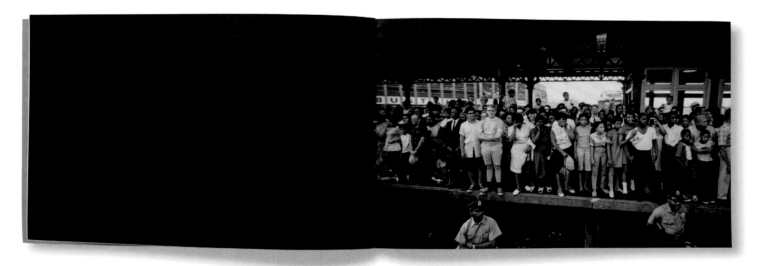

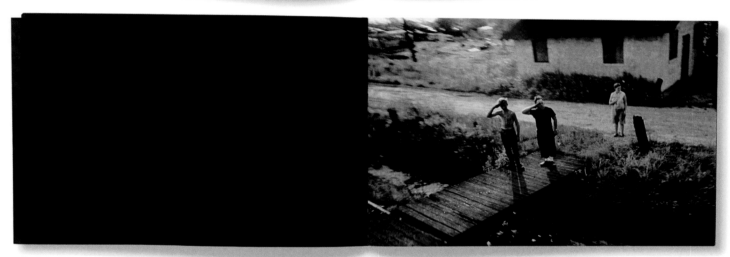

James Nachtwey
Inferno

Phaidon Press, London, 1999
(also published in French
and German)

380 x 275 mm (15 x 10 ¾ in),
480 pp

Hardback with full black
cloth

382 tritone photographs

Introduction by Luc Sante;
afterword by James Nachtwey;
design by Stuart Smith

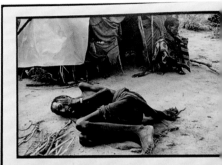

James Nachtwey, who began working for *Time* magazine as
a contract photographer in 1984, describes *Inferno* as both
a compilation and extension of his work for the press.
It is a chronicle of 'a personal journey through the dark
reaches of the last decade of the twentieth century',
as well as his 'attempt to go beyond the so-called "best
pictures" and to replace it with a sense of the flow of
events: ongoing, real, existing beyond the presence of
a photographer'.

The severe, graphic, disturbingly resonant black-and-
white photographs in this enormous volume chronicle a
descent into various levels of hell. The regions Nachtwey
photographed are listed on the contents page, every name
centred one below the other: Romania, Somalia, India,
Sudan, Bosnia, Rwanda, Zaire, Chechnya, Kosovo. Each
section has a short text contextualizing the misery. An
excerpt from Dante Alighieri's *The Divine Comedy: Inferno*
is cited as the book begins: 'There sighs, lamentations
and loud wailings resounded through the starless air, so
that from the beginning it made me weep.'

There is little redemption here, divine or otherwise.
Photographs of terrified, crazed, severely abused Romanian
orphans begin the book in a sequence of dire misery.
Images of dead bodies being picked up by bulldozers in
Rwanda are included, as are photographs of agonizingly
skeletal people dying during a famine in Sudan and others
in Somalia. There are depictions of devastated ruins in
Kosovo, and of a small portion of India's two hundred
million Dalits, or 'untouchables', who have been forced
into the most menial jobs. One can randomly leaf through
the book's 480 pages and expect to be frequently shocked,
horrified and rendered almost mute with despair.

But Nachtwey has another goal: 'My job is to help reach
a broad base of people who translate their feelings into
an articulate stance, then through the mechanisms of
political and humanitarian organizations bring pressure
to bear on the process of change.' As Luc Sante says in
the introduction, Nachtwey no longer considers himself a
war photographer but an anti-war photographer. And, all the
evidence to the contrary that he so ably shows, Nachtwey
continues to believe in humanity: 'I have witnessed people
who have had everything taken from them – their homes,
their families, their arms and legs, their sanity. And
yet,' he writes in the book's last sentence, 'each one still
possessed dignity, the irreducible element of being human.'

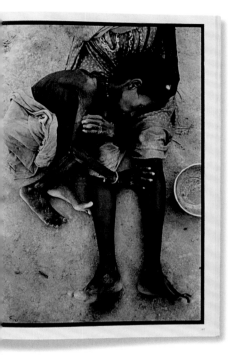

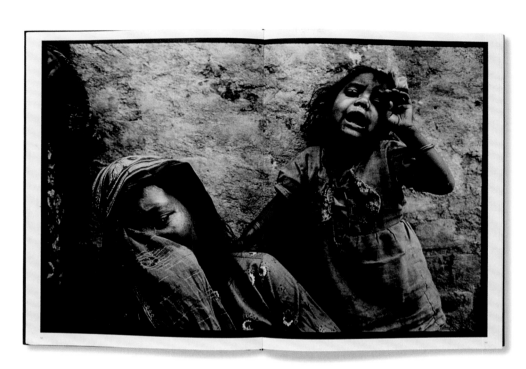

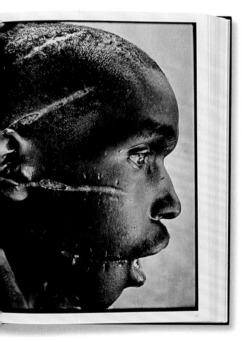

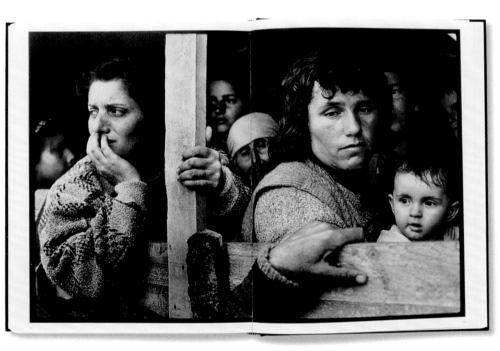

Trent Parke

Dream/Life

Hot Chilli Press, Sydney, 1999

244 x 289 mm (9 ½ x 11 ⅜ in), 144 pp

Hardback with full black cloth and jacket

104 b&w photographs

Dream/Life is Australian photographer Trent Parke's poetic tribute to Sydney. The book was first published as a small edition of 500 copies for News Limited, before this second edition was published with a different cover photograph. Without text, the book's photographs convey feelings of both loneliness and intimacy; the beach, the subway, the outback, the suburbs and Sydney's inhabitants all become part of Parke's story. Printed in a large format on cream paper, with deep black tones, the book's first group of photographs is set against a white background, which then shifts to black and back to white again, as if we were moving constantly from day to night or life to dream, from time to timeless. The captions at the end of the book list only dates (from 1995 to 1998) and places.

In *Dream/Life*, banal, everyday occurrences such as children at play, lonely figures on benches, people on their way to work, sailors on a ferry, a beggar or a couple embracing are transformed into surreal visions. Parke plays with scale, contrasting faces of passers-by with giant posters or photographing people from up high, focusing on their elongated shadows. He captures the scenes in grainy, moody photographs, trembling with raindrops and mist, doubled by reflections in glass or puddles and striated by shadows. Rather than building a narrative, the spontaneous photographs' sequence instead recalls the free associations of a jazz improvization.

Dream/Life brings to mind Robert Frank's *The Americans* (1959) or Dave Heath's *A Dialogue with Solitude* (1965); the book may be about the present, but it is haunted by memories heavy as clouds, underscoring Parke's emotional connection to the city. 'That searing light that is very much part of Sydney,' Parke said ' … it just down the streets. So I used these strong shadows to obliterate a lot of the advertising and make the scene blacker and more dramatic. I wanted to suggest a dream world. Light does that, changing something everyday into something magical.'

Magnum Photographers
Magnum°

Phaidon Press, London, 2000
(also published in French,
Spanish, German and Italian;
paperback edition published
in 2003)

250 x 250 mm (9 ¾ x 9 ¾ in),
536 pp

Hardback

175 colour and 345
b&w photographs

Introduction by Michael
Ignatieff; additional
texts by texts by various
Magnum photographers;
design by Julia Hasting

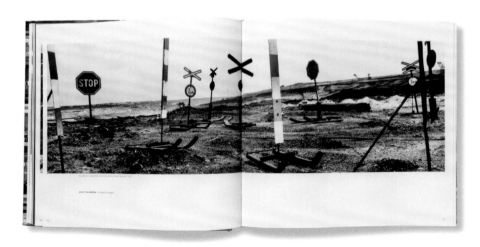

Published on the occasion of Magnum's fiftieth anniversary, *Magnum°* ('Magnum Degrees') features five hundred colour and black-and-white photographs introduced by the photographers themselves. In his postface, photographer Chris Steele-Perkins explains: 'It was our intention from the beginning that the project reflect a new era, rooted in two events that took place on either side of the planet: the massacre of Tiananmen Square and the fall of the Berlin Wall. The photo essays and individual images of the photographers would fill in a mosaic of history and observation from these events to the present.' Some of the reportages were produced especially for the publication, with financing from Canon Inc., Dai Nippon Printing Co. and Kodak. In 2000, the book won several awards — the Merit award from the New York Art Directors Club, Kodak Fotobuch Preis, and the *ID* magazine annual design review.

Opening with a single picture by each photographer, followed by a historical text by Michael Ignatieff, *Magnum°* is divided into nine 'chapters' that cover loose themes and subjects such as revolution, Euro watching, wars, the Middle East, refugees, Asia, Latin America, USA, religion and tourists. The last section ends with a series of collages by René Burri. Within each chapter, the photographs are shown as individual images or in short sequences. Throughout the dense layout places colour and black-and-white pictures on alternating white and black backgrounds.

The density of the images — some very explicit, others full of joy — is almost overwhelming, echoed by the design of the cover, which features thin slices of photographs stacked up horizontally, as if shredded. As Ignatieff writes, the images show us 'what we cannot see with our eyes alone. So if photography has a redeeming or cleansing effect on our vision, it is because it seems to restore both the reality of the world and its essential elusiveness.' Ignatieff also wonders if there will be another anniversary of Magnum in the future: will the cooperative that grew out of World War II survive?

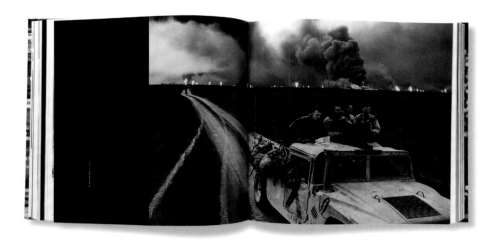

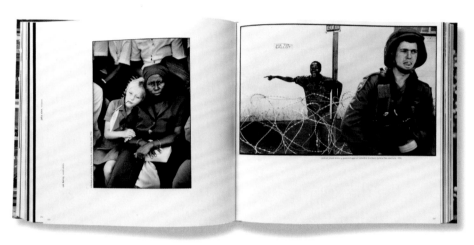

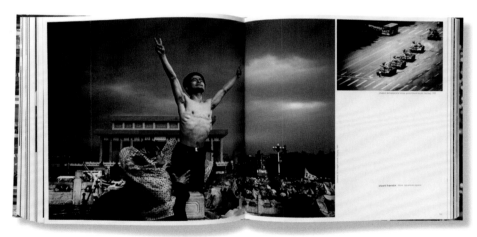

Martin Parr
Common Sense

Dewi Lewis Publishing,
Stockport, 1999

203 x 292 mm (8 x 11 ½ in),
160 pp

Hardback

158 colour photographs

Design by Dewi Lewis
Publishing

Martin Parr made his series of photographs entitled 'Common Sense' between 1995 and 1999, shortly after he became a full member of Magnum in 1994. It was at this time that Parr first started using a macro lens with a ring flash, a technique usually associated with medical photography, with the intention of coming in much closer to his subject matter. He started to explore British food and then worked on a commission for Bradford exploring the visual clichés surrounding Europe (the project was entitled 'Oh La La'), looking at themes of leisure, consumption and communication. *Common Sense* is the culmination of this work, the subject matter and themes of which have continued to inform Parr's photographic practice ever since. Both an exhibition at over forty venues worldwide and a book, *Common Sense* explores the concept of consumer culture around the world by describing in close-up and in lurid colours the minutiae of contemporary everyday life: hamburgers, cigarette butts, tacky gifts and dime-store combs. The accompanying show was produced as a set of lasers and shown simultaneously at galleries all around the world (for which Parr won a *Guinness Book of World Records* entry).

Parr, who is a book collector and an expert on photobooks, mostly conceives of his projects in book form, as evidenced by the more than eighty published books to his name. He rarely produces or shows individual photographs. Landscape in format and with no text, *Common Sense* contains 158 images laid out in full bleed, including on the book's endpapers. Eliminating all white space and text was a key consideration in the book's design and production. The cover shows a map of the world on a metal globe with a rusty slot for accepting coins: the planet is seen as a giant money box, a visual pun but also a view of the world confirmed by the images inside the book. Each double-page spread forms a diptych of sorts, with one photograph playing off against another. Sometimes images are grouped by colour — peas and carrots on one side, orangey snails with green stuffing on the other — or form an ironic pair, such as a man's sun-burned torso facing a slab of meat hanging from hooks, or a dog in pink, round, candy-like sunglasses facing an array of multicoloured glazed lollipops.

The subject matter, as well as the over-the-top colour — a result of using low ISO colour film (always with flash), which has a naturally high colour saturation — combine to create a sequence that is simultaneously strange, repulsive and weirdly attractive. *Common Sense* make us feel as if an alien had visited the planet and tried to make sense of what he or she saw. 'Initially I was photographing classic situations,' says Parr, 'English eccentrics, the English at leisure. Gradually the idea grew that I should photograph things that other people weren't photographing. I would think of subjects that were so obvious that I couldn't understand why no one else was doing them. This is what led me to photograph the middle classes, tourists and our consumer society.'

Alex Majoli
Leros

Westzone Publishing,
London, 1999 (revised
edition published by
Trolley Books, London, 2002)

210 x 155 mm (8 ¼ x 6 ⅛ in),
96 pp

Paperback

47 b&w photographs

Foreword by Laura Facchi
and text by Alex Majoli

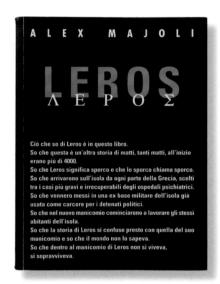

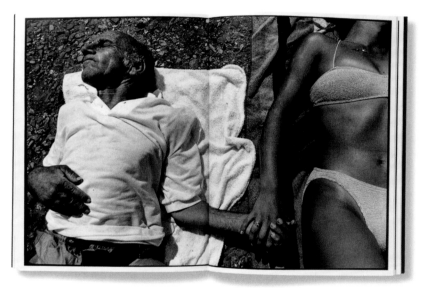

The Greek island of Leros was for more than twenty years the site of the world's most notorious and brutal asylum for the insane. The patients were housed in a former military base on the island, which had previously been used as a jail for political prisoners. Alex Majoli's book *Leros* – published first in paperback in 1999, and then in a hardback landscape format in 2002 by Trolley Books, the larger format giving added drama and intensity to the images – is an unflinching chronicle of the asylum's desperate patients, left naked or dressed in rags, forced to eat with their hands and sleep on beds that had been improvised from wooden pallets without sheets or blankets. The photographs reveal a nightmare world with no psychiatrists and local islanders used as nurses and guards with no medical training – they used to be herding goats. The guards quickly degenerated into thugs, who sought to control the patients with brute force and terror: patients were systematically beaten, even tortured.

Included in the book is a letter written by a group of Italian psychiatrists from the Trieste clinic of the mental health pioneer Franco Basaglia urging the authorities to close the asylum, which they called 'a desperate Hades for human masses'. They ultimately succeeded in reintegrating the patients into the world, and Majoli's photographs show how, after the closure of the pavilion, the patients lived four or five to an apartment, looked after by care workers instead of guards. Majoli's *Leros* opens with a text by Laura Facchi about the history of the island and the hospital. It continues with sequences alternating between portraits and group shots, sometimes taken from on high, sometimes in close-up or at low level when the patients are sitting on the ground.

Alex Majoli and his publisher Gigi Giannuzzi of Westzone worked together to edit and design the book. 'We approached the design by using black pages and spot varnish. Combined they give the feeling of being forgotten, faded in the darkness, like the inmates,' says Majoli, who joined Magnum in 1996 and became a full member in 2001. 'I know that "Leros" means dirty and that they came to this island from all over Greece, chosen from among the worst cases, the ones they'd given up on in the psychiatric hospitals … I know that inside the asylum you didn't live, you survived.'

Wayne F. Miller
*Chicago's South Side,
1946–1948*

University of California
Press, Berkeley, 2000,
in association with
the Graduate School
of Journalism, Center
for Photography

280 x 252 mm (11 x 10 in),
112 pp

Hardback with black cover
and jacket

103 b&w photographs

Foreword by Orville Schell;
commentaries by Gordon Parks
and Robert B. Stepto; design
by Nola Burger

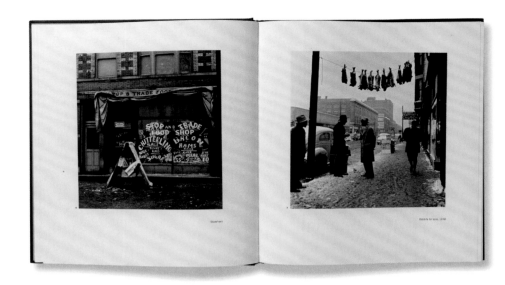

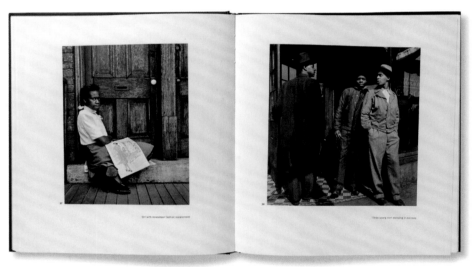

In 1946 Wayne Miller had just returned from his stint as a World War II Navy combat photographer in the Naval Aviation Photographic Unit under the direction of Edward Steichen when he received two Guggenheim fellowships to study African-Americans in his home city, Chicago. Miller had seen segregation in the war in the Pacific: African-Americans providing officers on the ships with clean laundry and good food, making ammunition and packing up stores. Now he wanted to focus on the great migration of some of the thousands who had moved to Chicago from the South during the war, when stockyards, steel mills and factories had relied on their labour.

Over the course of three years, Miller shot the images that would later become his classic book, *Chicago's South Side, 1946–1948* (some of the images were first published in *Ebony* magazine in December 1951). When the project began, Miller says: 'I had no idea what I was going to do; which way I was going to point my camera. I just had the desire to know the people that I saw and to try to express how they were feeling about their daily lives and their families. Strangely enough it worked out very well.' At the Parkway Community House, Miller was introduced by the director to a wealth of contacts. He also met Ben Burns, the editor of *Ebony*, who assigned him 'stories I could never have

discovered on my own. I saw and photographed things that would otherwise remained invisible or inaccessible.'

Armed with his Rolleiflex, Miller (who joined Magnum in 1958) took intimate and empathetic photographs of Chicagoans and their city: parades and beauty shops, storefronts, a storyteller around a fire a street piano, pool halls, the Maxwell flea market, a striker on picket line, a debutante ball, slaughterhouse workers, nightclubs, a few jazz stars such as Ella Fitzgerald and Duke Ellington. He photographed a girl in a doorway reading a fashion magazine, knowing she wanted something she might not be able to obtain. 'There are people who make pictures and people who take them. I take them,' Miller asserted.

With its simple layout, mostly one image per page with a caption, the book's sequence unravels from dawn till night like a slow motion film. In an essay Robert Stepto contextualizes Chicago's South Side in the history of the postwar city, while Gordon Parks describes 'those garbaged alleys and wintry streets where snowflakes fell like tears' in a poetic preface. In these classic photographs Miller, a sensitive but unsentimental witness, sought to explore the race division within American society. His work on African-Americans in Chicago remains unique.

Steve McCurry
South Southeast

Phaidon Press, London, 2000

380 x 275 mm (15 x 10 ¾ in),
156 pp

Hardback with black cover
and jacket

67 colour photographs

Text by Steve McCurry

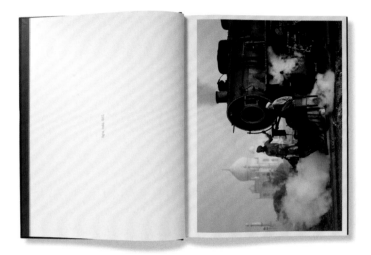

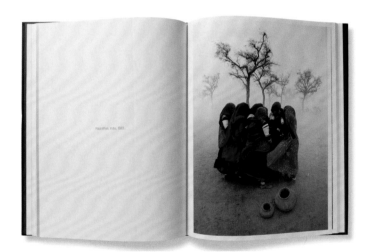

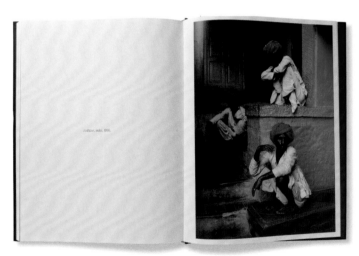

Steve McCurry first travelled to India in 1968, and since then has devoted much of his career, with dozens of visits, to photographing the subcontinent and Southeast Asia. He knows the region intimately: 'It was the vibrant colour of Asia that taught me to see and write in light,' he says.

South Southeast showcases some of McCurry's finest and now iconic colour pictures, taken during his travels in Afghanistan, Pakistan, India, Sri Lanka, Burma, Cambodia, Thailand and Tibet. In this large-format book, the size of a portfolio or a nineteenth-century album, snippets of diary-like texts are interspersed within the flow of images, recalling some of McCurry's experiences and noting memorable moments associated with the photographs. Each image is presented almost full bleed on the page, horizontal or vertical, so that it stands on its own as well as being part of the book's sequence: 'I strive for individual pictures that will burn in peoples' memories,' he once said.

McCurry has shot in monsoons and dust storms, and in the midst of wars and their aftermath, but some of his most famous photographs involve contemplation rather than action, and they are often serendipitous. He likes to shoot in muted light to minimize colour contrast, and his images vary in their perspective and topics – from sweeping crowd scenes to close-ups such as his portrait of a Bombay boy with kohled eyes and painted face. In this striking image of the pensive boy during Holi, a festival celebrating the arrival of spring, the red makeup accentuates the whiteness of the eyes and is made more intense by the contrast with an emerald-green plastered pillar against which he leans.

For McCurry, photography is less about the decisive moment than about patience: 'You take a trip, you take notes, you observe,' he explains. 'At first you don't see anything, but as time goes on, things reveal themselves. As the journey progresses, you start to pickup on the rhythm of a place, and suddenly you see things that were invisible before.'

Luc Delahaye
Winterreise

Phaidon Press, London, 2000
(also published in French;
paperback edition published
in 2003)

178 x 131 mm (7 x 5 ⅛ in),
232 pp

Hardback with full black
cloth and jacket

144 colour photographs

Text and design by
Luc Delahaye

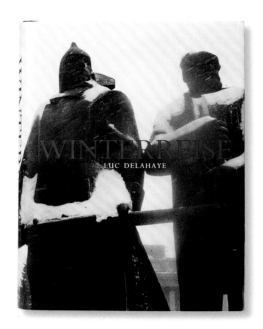

In the winter of 1998, Luc Delahaye journeyed with a translator by train for four months across post-Soviet Russia, from Moscow to Vladivostok. Along the way he stopped in several smaller cities: Perm, Ekaterinburg, Omsk, Obgaz and Norilsk. The previous summer, the rouble had crashed, and Delahaye wanted to photograph the social consequences of Russia's ensuing economic crisis. The idea had been suggested by his colleague, photographer Gilles Peress. Delahaye started with just a title, *Winterreise*, a reference to Franz Schubert's song cycle about a traveller on a winter journey.

A small book, the size of a novel, *Winterreise* was designed by Delahaye himself. It has no explanatory text and only a few, terse captions to guide the reader, such as 'overdose'. The flow of photographs has a filmic quality – the combination of a fast film and no flash results in grainy, moody images – and Delahaye creates a sense of unease by contrasting bleak backgrounds and subject matter with gorgeous colour. 'It's a country where the sky is gray, the buildings gray, but inside there is a delirium of colour,' he says.

Ending with a sequence of beautiful views of forests and lakes – a respite from the bleaker earlier images – *Winterreise* records the lives of people living on the edge of society: a scavenger searching a huge pile of rubbish; a homeless man dead in a basement; a stripper in a nightclub; a crowd of weary travellers in a railway station; a psychiatric patient with a bruised face; a sick man in bed; a housewife with no food to cook. These subjects have been incredibly accepting, taking Delahaye into their lives, but the backgrounds to their portraits are old factories, squalid bedrooms with disintegrating wallpaper or desolate, snowy landscapes.

Winterreise is indeed a poetic book – beautiful and melancholy at the same time. It does not pass political judgement but leaves room for interpretation. 'I want it to be comprehensible to everyone and at the same time fundamentally mysterious,' Delahaye says. 'The reader should have space to use his imagination.'

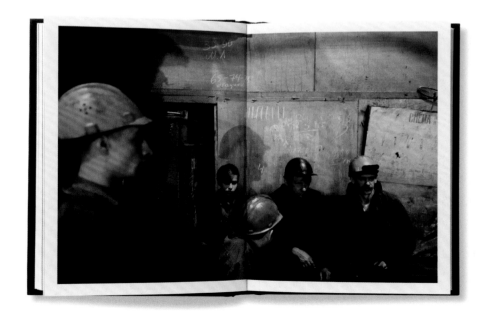

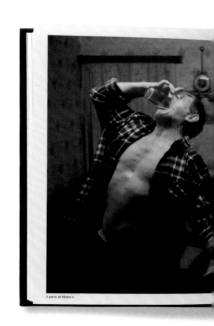

A party at Micha's

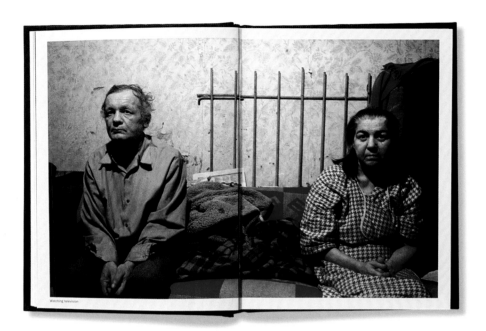

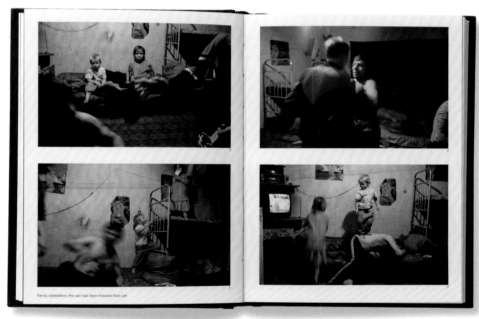

Family celebration; the son has been released from jail

Bruce Gilden
Go

Trebruk, London, 2000
(edition of 3,000 copies,
of which 100 copies have a
slipcase and a signed silver
gelatin print)

330 x 220 mm (13 x 8 ⅝ in),
96 pp

Hardback with embossed
red cloth and black cloth
slipcase

63 duotone photographs,
3 manga illustrations
and 1 b&w illustration

Interview with Sophie
Darmaillacq and Bruce
Gilden; manga illustrations
by Shonengahosa & CSJ;
design by Browns

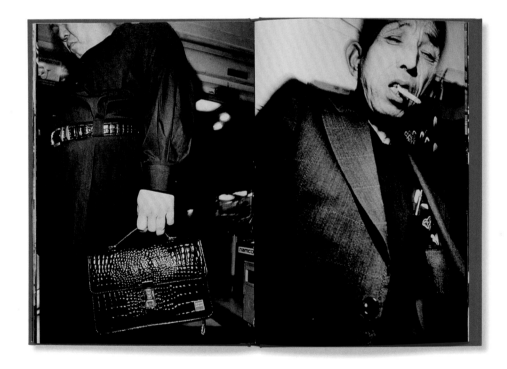

Bruce Gilden's fascination with Japan goes back to 1974, when he saw an exhibition at New York's Museum of Modern Art entitled 'New Japanese Photography'. But it was twenty years before Gilden was able to go to Japan, with grants from the French government and the Japan Foundation. He made three or four trips, working in Japan for a total of around nine months. The result was Go.

Designed by Jonathan Ellery from the publisher Browns, Go is a strong, vibrant book. The title can refer to being on the go or to the game Go that some are playing in the portraits, with its mix of spontaneity and calculation.

Go is bursting with energy, from the red colour of its cover and endpapers (the back cover is embossed with a Japanese decorative motif) to the intensity of the in-the-face portraits of Tokyo's inhabitants, in the spirit of a modern Weegee, all reproduced full frame and full bleed. Ellery has interspersed the photographs with Japanese manga, several on red backgrounds that echo the cover. When you open the book, each image appears framed by the red colour of the endpapers.

The portraits of Tokyo dwellers are from all backgrounds — from Go players to drinkers, Yakuza bosses (the Japanese

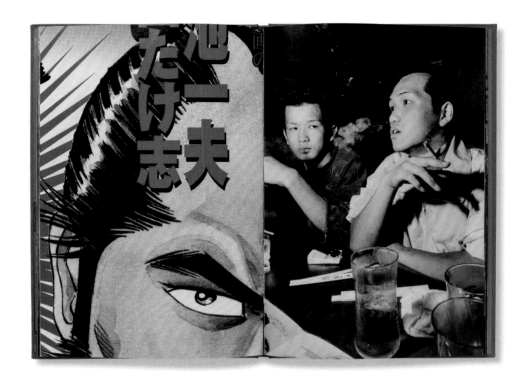

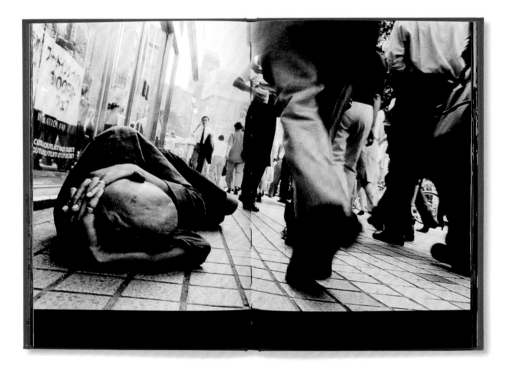

Mafia), beggars, taxi drivers, right-wing nationalists, and a woman bearing her breast. A man getting his hair dyed looks like a murder victim because the dye has pooled on the floor like blood. The images literally pop out of the page. Gilden is going for physicality and emotional intensity; he wants to pull the viewer in. But there is also a sense of mystery in the book, and Japan remains ultimately a foreign land that a foreigner cannot penetrate. Gilden has chosen not to add captions to the photographs (instead placing them at the back on the last page of the book), adding to the sense of mystery for the reader.

One of the only books by Gilden not having New York as a subject, Go stands out in the photographer's career. As we leaf through the book, the pages go from light to dark — a progression that often happens in Gilden's books — day to night, the end feeling being that of *film noir*. 'I work to create personal essays,' says Gilden. 'The pictures are always made for the wall for exhibition purposes, and the culmination of the project is the book. In the end, since I have a singular type of vision, the work comes together and you have a book that looks relatively cohesive. [Go] is an important book for me.'

David Hurn
Wales, Land of my Father

Thames & Hudson, London,
2000

228 x 240 mm (9 x 9 ½ in),
120 pp

Hardback with full red cloth
and jacket

92 b&w photographs

Introduction by
Patrick Hannan

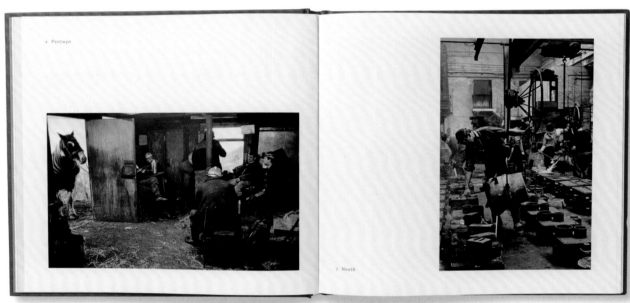

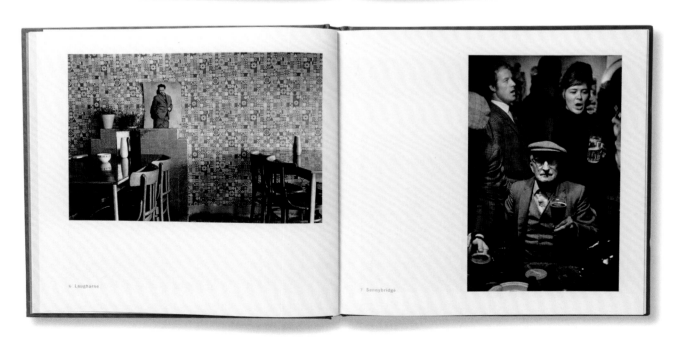

Born in England but with a Welsh father, the self-taught photographer David Hurn felt both like an insider and an outsider in Wales. In the early seventies, soon after becoming a Magnum associate in 1965 and a full member in 1967, Hurn set out to rediscover Wales in a project that lasted twenty years, supported by grants from the Arts Council Wales Bursary.

Wandering around the country with no preexisting agenda except an 'intensity of attention and the search for beauty', Hurn photographed whatever he felt attracted to, attempting to fit the pictures together in a way that would help him understand what people meant when they spoke of Welsh culture. Over time, he came to focus on the metamorphosis that was taking place in Wales as its traditional economy was rapidly modernized.

Full of tenderness and humour, Hurn's photographs depict a wide range of situations and social classes. They show traditional scenes — elderly men sunning at the beach, mine workers with pit ponies, ballroom dancing

championships, holiday camps, day-trippers on the beach, horse fairs, brass bands — but also more modern aspects of Wales: Japanese factories producing microchips and computers, Asian tourists, hamburger stalls, discos, male strippers.

For *Wales, Land of my Father*, which contains ninety-two duotone photographs, Hurn has chosen a light grey background and a classic layout design. The pictures stand on their own, so that the reader can view them without initially knowing what they show (the captions are all at the start of the book). 'My idea of Wales is that it's one of the very few places that you can see change happening at a pace that is really comprehensible,' says Hurn. 'If you look at differences between the generations — going from mining families to families that are headed up by people who work in a microchip factory to a family which has children growing up never having known anyone who has been in full-time employment — it's a fantastic rate of change and those pressures can create some extraordinary scenes.'

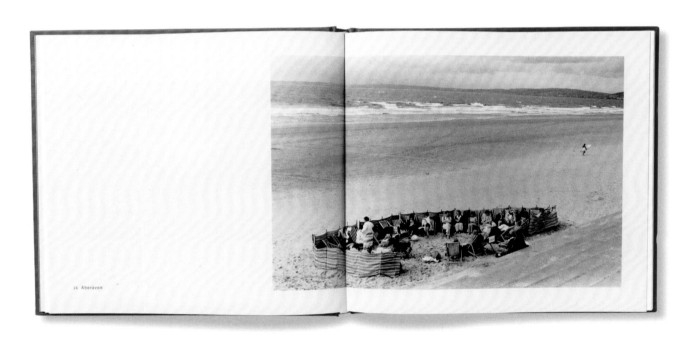

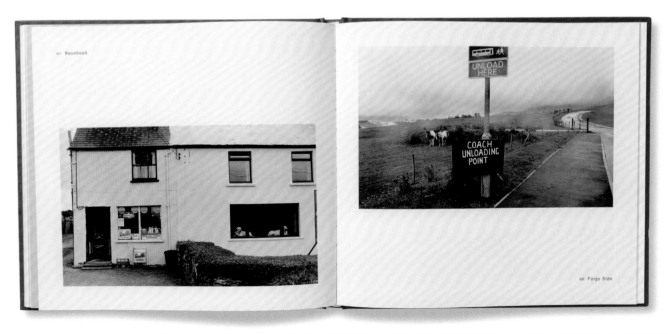

Larry Towell
The Mennonites

Phaidon Press, London, 2000

250 x 190 mm (9 ¾ x 7 ½ in),
292 pp

Hardback with full black
cloth and jacket in black
cloth slipcase (not shown)

119 b&w photographs

Text and concept by Larry
Towell; design by Atelier
Works

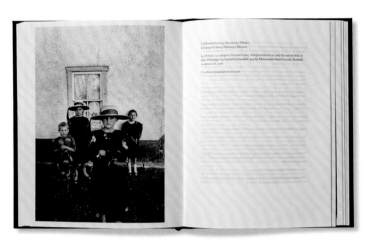

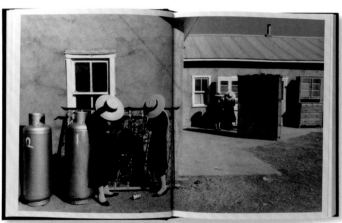

As befits someone whose business card reads 'Human Being', Canadian photographer Larry Towell has spent his career photographing the dispossessed, the exiled and those without a home in order to champion their cause. Towell – an artist, writer and folk musician, as well as a photographer – became a Magnum nominee in 1988 and a full member in 1993: 'I needed a community,' he once said, 'Magnum gave me that.'

Towell first encountered the Mennonites, a Protestant religious sect related to the Amish, near his home in Ontario, Canada, where he owns and sharecrops a small farm. The Mennonite faith does not usually permit photography, but through his friendship with migrant families and a shared sense of their lives as an agrarian community, Towell was gradually able to meet the wider group, photographing Mennonites in Canada and Mexico for over ten years. *The Mennonites*, which received the 2001 D&AD (Design and Art Direction) design award, includes photographs taken from 1990 to 1999.

Taken with beautiful chiaroscuro, the book's intimate photographs establish a world of textures reminiscent of early André Kertész pictures. Often poetic and evocative, Towell's images tend towards the abstract rather than illustrative, capturing the shadows projected on the side

of a caravan or La Batea colony in Mexico glimpsed through the slit of an outhouse wall. There are images of the Mennonites' hard work but also joyful images, such as that of children in their Sunday best running around in a field. Towell also made tender portraits, such as that of a girl holding a puppy at the Santa Rita colony in Mexico, and striking ones, like the image of a kitchen table, with its polished surface reflecting the faces of children and their parents as they look towards the photographer. Towell's photographs, which make visible the harshness and poverty of the Mennonites' rural existence and the discipline and contradictions of their religion, at the same time reveal their hunger for land and work and their struggle to keep the modern world at bay.

The book's preface draws a history of the Mennonites and includes maps of their travels and settlements. The design is based on that of a slip-cased Mennonite hymnal, with the text printed on a thin, off-white Bible paper. Says Towell: 'The text is a train of thought composed of flashbacks and fixations drawn from diary notes and the silt of memory.' He adds: 'Like literature, photography is best when it looks at ordinary things rather than sensational ones. This gets close to the truth, just like ordinary people are closer to the truth than politicians and heroes.'

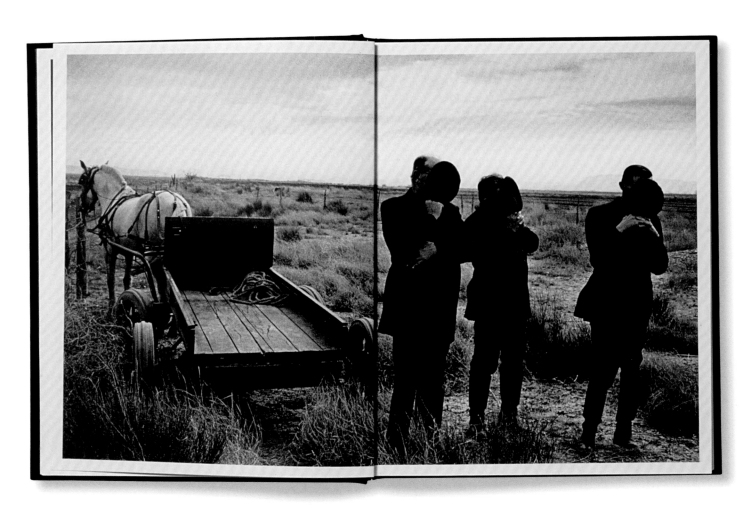

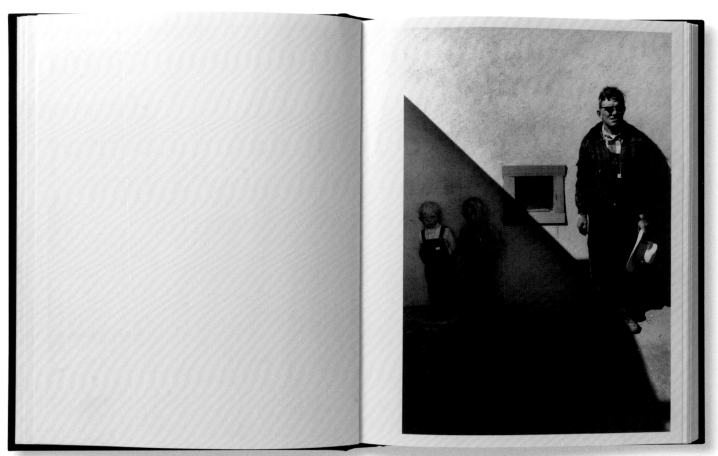

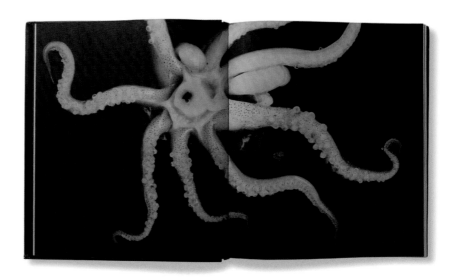

Jean Gaumy
Pleine Mer (Men at Sea)

Editions de La Martinière,
Paris, 2001 (also published
as *Men at Sea*, Harry N.
Abrams, Inc., New York;
as *Mare Aperto*, Contrasto,
Rome; and *Auf Hoher See*,
Knesebeck, Germany, 2002)

288 x 238 mm (11 ¼ x 9 ¼ in),
128 pp

Hardback

98 b&w and 7 blue-toned
photographs, 5 contact
sheets and 1 illustration

Text by Jean Gaumy;
design by Xavier Barral
and Anne Chevry

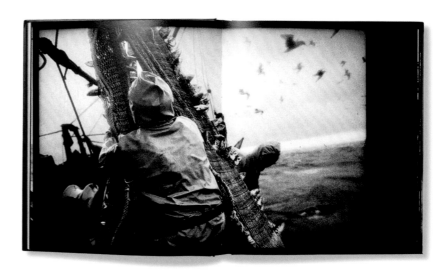

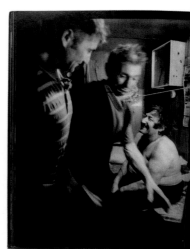

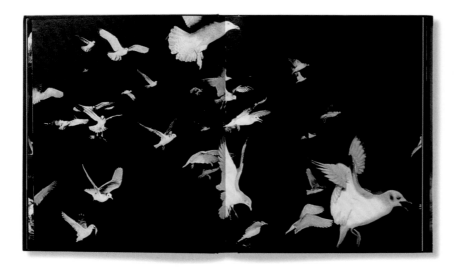

In 1984 the French photographer Jean Gaumy began the first of four winter sea voyages that would take him aboard so-called 'classic' trawlers across the Atlantic Ocean and the North Sea. Continuing until 1998, his voyages covered a period of profound change in traditional sea fishing and ultimately led to the publication of his book, *Pleine Mer*.

Gaumy – who joined Magnum in 1977 – had been fascinated by the ocean since his childhood. At an early age, he began fishing and looking at books with etchings of tempests. Years later, when watching the documentary film, *Man of Aran*, by Robert Flaherty on a visit to the Isle of Man, Gaumy got the idea for the layout and sequencing of his book, realizing that the photographs needed to be presented in a filmic way and sequence that would echo the spirit of film. Working closely with his designer, Xavier Barral, together they realized the book's design concept.

Indeed, *Pleine Mer* has something of the cinematic about it, with a beautiful design in which large double-page spreads show a complete frame as well as a part of the next. The 120 pictures are interspersed with blue-toned pages of

Gaumy's handwritten diary, lists of fish taken in by a crew – the ink running from water stains – lists of picture edits and several contact sheets. Pictures of whole scenes alternate with details shot in close-up, such as fish heads or gulls.

Like the sailors, Gaumy was on deck for up to fifteen hours a day, forever waiting for a moment of grace, with the 'rotten weather … anthracite clouds' that he liked best and the moments of dusk when the light was about to disappear. The images in *Pleine Mer* tell the story from within: it is as if the viewer is caught between the waves and clouds, thrown into a blurred chaos of movement. The trawlers on which Gaumy sailed were among the last boats with open bridges, and the images hold lyricism as well as melancholy for a way of life that will soon disappear. The photographer looks for 'an epic fusion of the elements' and avoids heroic images, instead highlighting man's fragility when confronted by the elements. 'To photograph', he writes in *Pleine Mer*, 'is like fishing or writing. It is pulling out an unknown that resists and refuses to come into the light.'

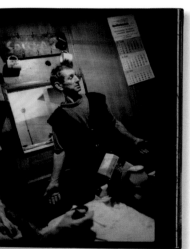

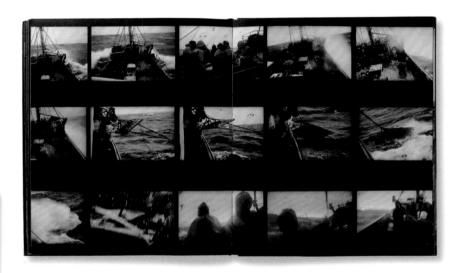

Magnum Photographers
New York September 11

Powerhouse Books,
New York, 2001

318 x 223 mm (12 ½ x 8 ⅝ in),
144 pp

Hardback

74 colour and
20 b&w photographs

Introduction by David
Halberstam; epigraph by
W.H. Auden, 'September 1,
1939'; photographs by various
Magnum photographers;
additional photographs by
Evan Fairbanks, Adam Wiseman
and Anne-Marie Conlon;
design by Yolanda Cuomo

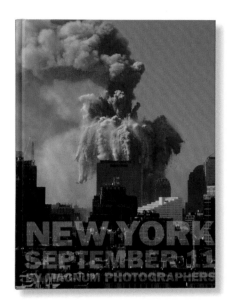

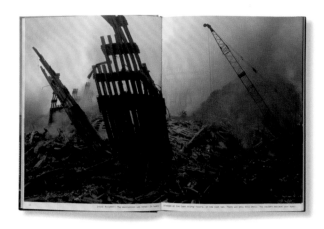

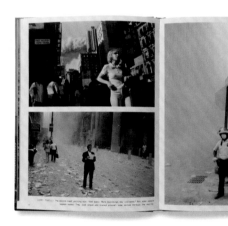

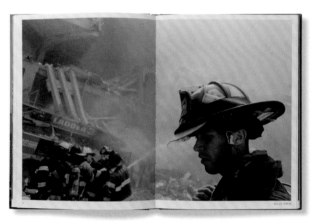

On September 11, 2001, two planes, American Airlines Flight 11 and United Airlines Flight 175 were crashed by al-Qaeda terrorists into the towers of the World Trade Center. Both 110-storey towers collapsed, as well as all other buildings in the complex, causing more than 3,000 deaths.

By chance, several members of Magnum — Steve McCurry, Susan Meiselas, Larry Towell, Gilles Peress, Thomas Hoepker, Alex Webb, Paul Fusco, Eli Reed, David Alan Harvey, Chien-Chi Chang, Burt Glinn, Richard Kalvar, Josef Koudelka and Raymond Depardon — were in Manhattan for their regular meeting. They dispersed to document events as they unfolded on 9/11 and over successive days. *New York September 11* assembles their work and their comments in colour and black-and-white pictures in double-spreads, full pages or sequences on white backgrounds. Bruce Gilden also contributed photographs; he shot the aftermath on his return to the city a week or so after the attacks. The photographers' varied vantage points transport the viewer to Ground Zero and terrified people fleeing from falling debris and to later scenes of rescue workers and fire fighters, as well as the mourners who gathered in the street and the impromptu memorials they erected.

The photographers did not seek out clever artistic compositions: their purpose was to bear witness. The book documents the shells of the fallen towers, the mountains of debris, strange monochromatic streets filled with dust,

Lower Manhattan disappearing under a veil of black smoke, the utterly silent lobby of 2 World Financial Center … Some of the strongest images are those that symbolize rather than represent: flag vendors, candle-lit street shrines, a collage of missing people photographs on a mailbox, a statue sitting on a bench near the World Trade Center holding a briefcase: 'It seemed to stand for all of those who were gone,' says Meiselas.

The book is prefaced by W.H. Auden's poem 'September 1, 1939', which contains the words 'The unmentionable odour of death / Offends the September night.' In the introduction, American historian David Halberstam refers to 'Dates which seem to separate yesterday from today, and then from now'. As if to reinforcing the point, the large-format book includes a few images of the World Trade Center before the events.

On September 11, 2001, Americans' collective sense of immunity ended. Photojournalists who in the past had photographed disasters far from home were confronted by an attack on their own city: what happened was personal. Coming together to photograph the event was thus of extreme importance to the photographers. As Thomas Hoepker explains in the book: 'Magnum was founded as a group of documentary photographers. That is our tradition. With a terrible event like this, we understand all over again the importance of our heritage.'

Bruno Barbey
Les Italiens

Editions de La Martinière,
Paris, 2002 (published in
English by Harry N. Abrams,
New York, 2002; revised
edition by Contrasto, Rome,
2015)

285 x 285 mm (11 ¼ x 11 ¼ in),
120 pp

Hardback with full black
cloth and jacket

96 b&w images

Texts by Tahar Ben Jelloun

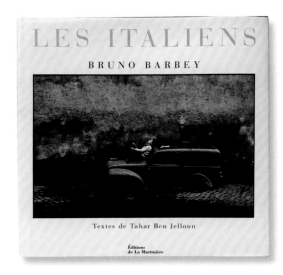

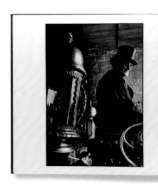
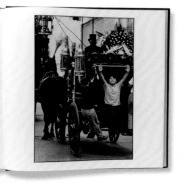

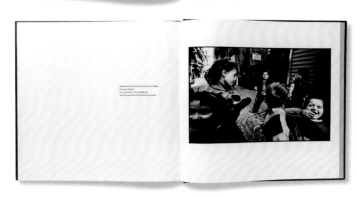

In 1962, Bruno Barbey was at l'Ecole des Arts et Métiers in Vevey, Switzerland, bored by his studies. He travelled to Italy, photographing there for the first time; he wanted to capture the spirit of the place and was fascinated by the emerging filmmakers of the Italian Neorealism movement.

Barbey regularly showed his work to French publisher and designer Robert Delpire – by the end of the project he had shot between three and four hundred rolls of film – and Delpire, planning on publishing the photographs as a book in the same series as Robert Frank's seminal *Les Américains* (1958) and René Burri's *Les Allemands* (1963), designed a simple layout: seventy full-page images in numbered sequences with blank pages opposite. In 1966 Delpire also financed the creation of beautiful 30 x 40 cm (11 ¾ x 15 ¾ in) prints of Barbey's work by Jules Steinmetz. But in the end Delpire could not publish *Les Italiens* because, having just produced the film *Polly Magoo*, he was bankrupt.

However, the portfolio opened the doors for Barbey to Magnum Photos, and he joined the still-small organization in 1966. During the following years his project on the

Italians was put to one side while he travelled the world, but almost forty years later Barbey finally published *Les Italiens* (with a text by Tahar Ben Jelloun) in French and English editions by publishers Editions de La Martinière and Abrams.

In the 1960s Barbey did not yet think in terms of story-telling, and *Les Italiens* is more of a sequence of individual pictures and a mosaic of portraits, fresh and energetic in spirit, than a piece of reportage: *ragazzi*, nuns, aristocrats, *carabinieri*, priests, beggars, prostitutes and old *Mafiosi*. Many of the photographs were published in *Du* magazine in 1964 – the first time Barbey was published – and then again in *Camera* in 1966.

As a book, *Les Italiens* remains unique in Barbey's long career: later on, he became especially known for his subtle use of colour, especially in his books about Morocco, where he spent his childhood and adolescence, as well as his books on Poland and China. When he photographed mosques in Uzbekistan in 2000, his images became even almost abstract, reduced to a few minimal elements.

Chien-Chi Chang
The Chain

Trolley Books, London, 2002

188 x 127 mm (7 ½ x 5 in),
104 pp

Hardcover leporello book
in a steel box

48 b&w photographs

Text by Cheryl Lai; design
by Martin Bell

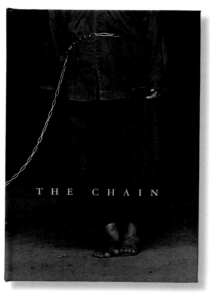

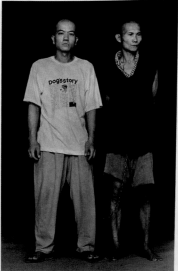

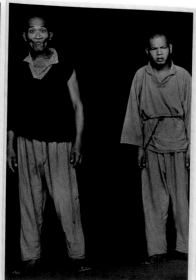

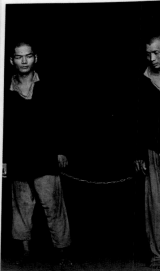

In 1993, Chien-Chi Chang visited the Long Fa Tang (the Temple of the Dragon), an asylum in Kaohsiung, Taiwan, where 700 mental patients lived and worked. Chained together in pairs during the day, the patients ate, slept and bathed together, and were put to work as labourers on one of Taiwan's largest chicken farms. The owner, abbot Shih Kai-feng, firmly believed he was taking care of the patients and was helping to alleviate the burden on their families. Over the next six years, Chang – who joined Magnum in 1995 and became a full member in 2001 – went back over and over again before he was finally given permission to photograph the patients in a warehouse as they paused in the light of an open door. 'When I pressed the shutter, I thought that I was in control. But looking back, they were, too. When they wanted to walk off, they walked. In some frames you can see one partner tugging at the chain to rein in the other. The light reflected off the concrete ground. It hangs across the sheet because the clouds and sun moved in the course of the two or so hours I was there shooting nine and a half rolls of film.'

Chien Chi-Chiang's *The Chain* is a rare book where format and subject matter are completely fitted to each other. In his work, Chang continues to explore the themes of alienation, such as in his book *I do I do I do* (2001) about grooms and brides in Taiwan, and *Double Happiness* (2005), a depiction of the business of selling brides in Vietnam, and his current long-term project about Chinese immigrants, their divided experience mirroring his own.

Unsettling and unforgettable, *The Chain* features forty-eight dual portraits of the patients, all richly printed in duotone as part of one long accordion-pleated 'page' which, when fully opened, extends 6 metres long by 20 centimetres high (20 feet by 8 inches). The camera always remains at the same distance from the subjects, whose responses to it vary: some are proud, others are dejected, angry, resigned, grinning or crying, their soiled uniforms hanging on their bodies as they strain against the chain, stare at the photographer or try to walk away.

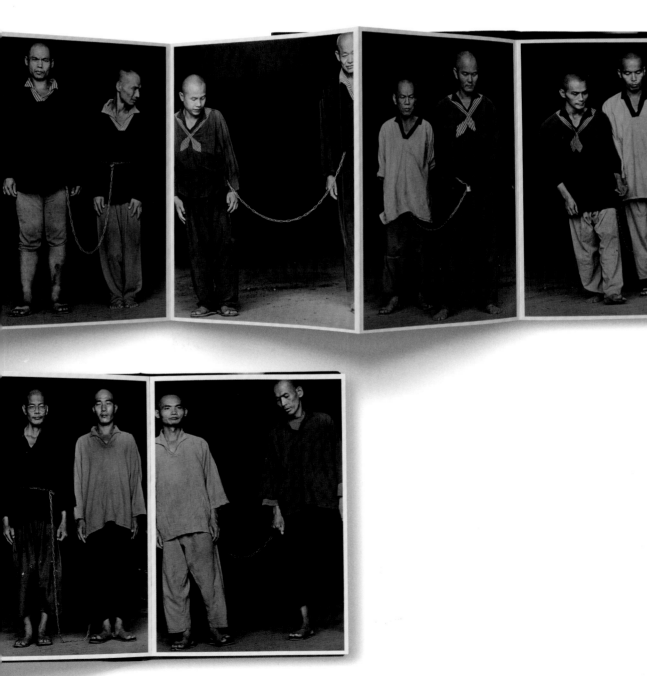

Carl De Keyzer
Zona: Siberian Prison Camps

Trolley Books, London, 2003

220 x 305 mm (8 ½ x 12 in),
160 pp

Hardback with paper cover
and jacket

90 colour photographs

Text by Carl De Keyzer;
design by Martin Bell and
Wai Hung Young/Fruitmachine

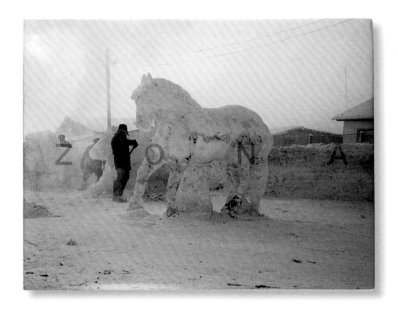

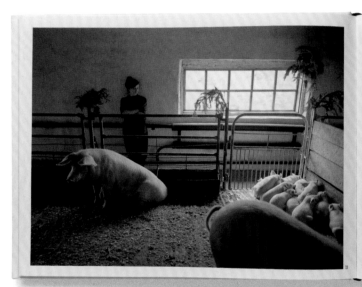

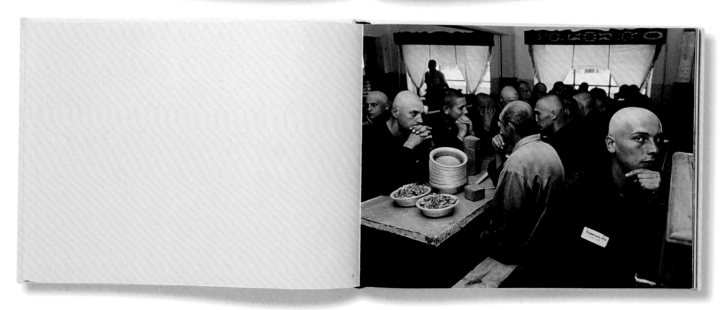

In 2000, Belgian photographer Carl De Keyzer was in Siberia for a workshop when he discovered that some 130 former Russian gulags – camps built by Stalin in the 1930s to hold political prisoners – were still being used as prisons for criminals (there were more than 300 camps in Russia during this period, housing nearly a million prisoners). De Keyzer was fascinated by Camp 27, a model camp that functions as a propaganda tool for the post-Soviet penal system, shown to visiting ambassadors and Western media crews. Self-assigned, he spent two years photographing the camps, all near the city of Krasnoyarsk and known as *Zona* after the local slang for prison. Not only did he have to jump through bureaucratic hoops to gain permission to photograph; he also had little choice but to accept official proscriptions about what he could and could not feature. De Keyzer decided to turn this to his advantage, exploring the facade the Russians wanted to present.

The resulting pictures were first published as an essay in *Courrier International*, Paris (29 August 2002), before becoming the book *Zona*. De Keyzer expected hell. Instead, the first camp he visited was rather like a cheap Disneyland painted in bright colours with wooden and metal ornaments, murals depicting glorious moments of USSR history and sleek black prisoners'uniforms. Another camp seemed like the set for a cowboy movie, surrounded by forests where prisoners worked as log-cutters, while another was a complete village where inmates farmed and their families were allowed to live with them – an echo of life in the gulags. The unlikely juxtaposition of inmates in army uniforms posed by Russian militia guards against a Disney-esque backdrop of cartoon-like statuary, ice statues and vividly painted fairytales of knights and gladiators makes for surreal photographs. In one of the pictures, two inmates play tennis without a ball, a setup that evokes the film *Blowup*. The contrast between the cheery colours of the environment and the tired faces of the inmates is disquieting.

De Keyzer – a Magnum nominee in 1990 and a full member since 1994 – explains that the images in *Zona*, which he shot in vivid colour using flash and in a straightforward manner are 'quite unlike the images people have in their minds when the think of prison camps. It's a mind game in a way, to play with images that way. There's always this double layer in my work: what you see is real, but at the same time it's not real.' In *Zona*, De Keyzer questions the world of appearances, and photography's role in depicting it.

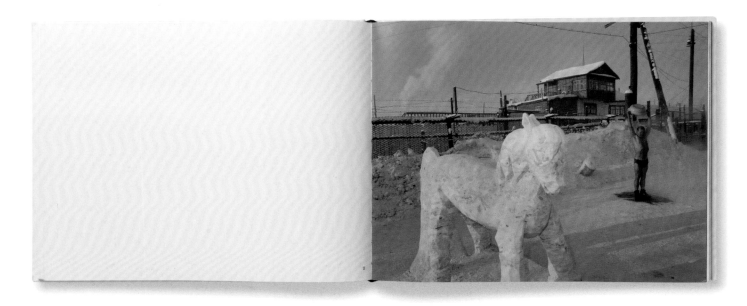

Paolo Pellegrin
Kosovo, 1999–2000:
The Flight of Reason

Trolley Books, London, 2002

235 x 235 mm (9 ¼ x 9 ¼ in),
148 pp

Hardback with black cloth
and jacket

60 b&w photographs

Text by Paolo Pellegrin,
Tim Judah and Thomas Rees;
design by Fruitmachine;
produced with the support
of the Olof Palme
International Center

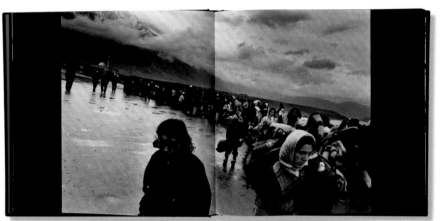

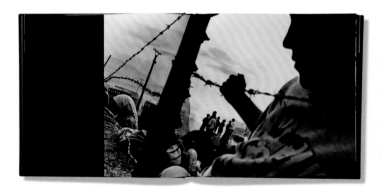

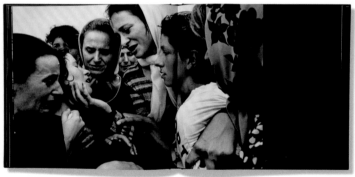

In 1998, the savage violence of war and ethnic cleansing erupted in Kosovo, a largely Albanian enclave in Serbia. By the end of the war the following year, almost 850,000 people out of a total population of two million had been displaced and countless thousands more had been killed: graves remain undiscovered to this day. When the Albanians returned to Kosovo, their homes had been sacked and burned, their villages bombed to rubble.

Kosovo, 1999–2000: The Flight of Reason is a self-assigned project, but Paolo Pellegrin received some help from the Olof Palme International Center. Working in the region for two years during the atrocities and after NATO took over at the end of the conflict, he describes the plight of the refugees and their long walk through the countryside of a ravaged land. The cover picture, which wraps around the book, is a stark, almost abstract image of crows flying in an obscure sky over the Pristina cemetery. Sombre and grainy, Pellegrin's images seem to mimic the confusion and fragmentation of war itself. The strong layout of the book, well adapted to its topic, features three-quarter page

horizontals bleeding into a black background. Captions are not beneath the images but follow each section of the book.

Pellegrin's images are not illustrative. Their language is lyrical, at times surreal: he cites Ralph Eugene Meatyard's 'hallucinations and deranged depictions of everyday life' as a strong influence. He wanted to document, to transmit information – but also to strike an emotional chord.

Pellegrin's book was eventually published while the Serb leader Slobodan Milosevic was charged with war crimes and crimes against humanity at the International Tribunal in The Hague. As Pellegrin – who joined Magnum in 2001 – explains: 'In my work, I am exposed to others' suffering, their loss, sometimes even their death; I feel I am a witness. I feel that my role – my responsibility – is to create an archive of our collective memory. I think this is partly due to a sense of responsibility. Maybe we only ever become aware that these people exist in their moment of suffering, and that this moment invalidates our excuse. We can no longer say that we did not know.'

Alec Soth
Sleeping by the Mississippi

Self-published, Minneapolis,
Minnesota, 2003 (artist's
edition of 30 copies and
limited edition of 25 copies)

275 x 212 mm (10 ¾ x 8 ¼ in),
60 pp

Hardback with full brown
cloth and inset photograph

45 colour photographs

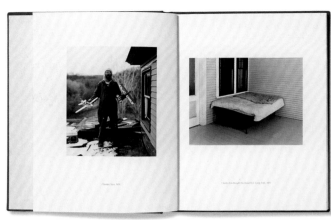

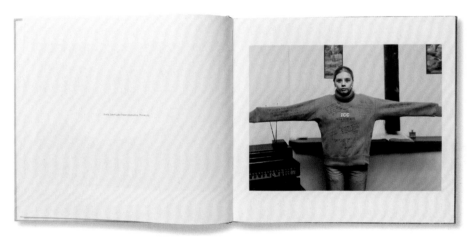

Sleeping by the Mississippi

Steidl, Göttingen, 2004
(first edition; second
edition, also 2004; third
edition published
by Steidl, 2008)

275 x 285 mm (10 ¾ x 11 in),
118 pp

Hardback

46 colour photographs

Essays by Patricia Hampl
and Anne Wilkes Tucker;
design by Steidl Design

The work of Minneapolis-based Alec Soth — a nominee of
Magnum Photos since 2004 and a full member since 2008
— is rooted in the American tradition of 'on-the-road
photography' developed by Walker Evans, Robert Frank and
Stephen Shore. Soth made his first river-road adventure
from Minneapolis to Memphis when he was still in college,
and the magic of that trip remained with him.

Sleeping by the Mississippi documents a series of road
trips made over four years during which Soth followed
the Mississippi River from north to south, cold weather
to warm, restrained to open. In Soth's first book, the
idea was that one image would lead to the next, as if
in a dream's free association (Soth says that the making
of the book was itself the fulfilment of a dream). The
Mississippi, whether present or not in the pictures,
functions as a sort of metaphor. The book alternates
portraits, often of marginalized or dispossessed subjects,
with landscapes and views of interiors made with a large
format, 8 x 10 camera, as Soth meanders from church to
marina, hospital to diners and brothels, cemetery to >>

>> marshes, talking to his subjects and sometimes asking them
to write down their dreams. Images of empty beds function
as a leitmotiv through the book and a metaphor
for dreaming.

Sleeping by the Mississippi was first produced as two
handmade artist's editions of 30 copies and 25 copies
respectively, where the images are paired one per page.
Upon seeing the book, publisher Gerhard Steidl decided
to publish a large-format, trade edition, following a
different but equally simple design, spare and clean
like the design of Walker Evans's *American Photographs*:
pictures on the right, captions on the left. The endnotes
contain more information about some of the forty-six
sumptuous colour images that were taken in Minnesota, Iowa,
Wisconsin, Kentucky, Missouri, Mississippi, Tennessee,
Illinois, Arkansas and Louisiana. Soth did not intend
for the book to be read as reportage, although he always
conceives of his work in terms of photobooks: 'Work like
mine is more lyrical than documentary,' he explains. 'Like
poetry, it's pretty much useless. Anyone can take a great
picture … but it is incredibly difficult to put these
fragments together in a meaningful way. This is my goal.'

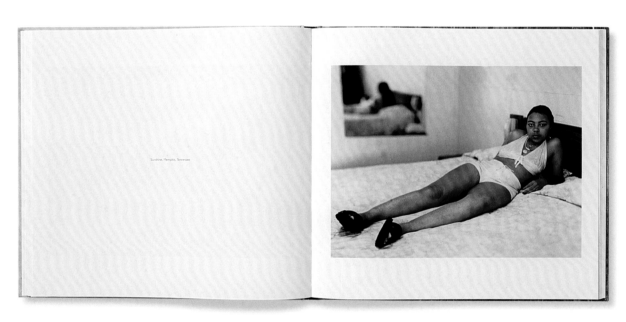

Sunshine, Memphis, Tennessee

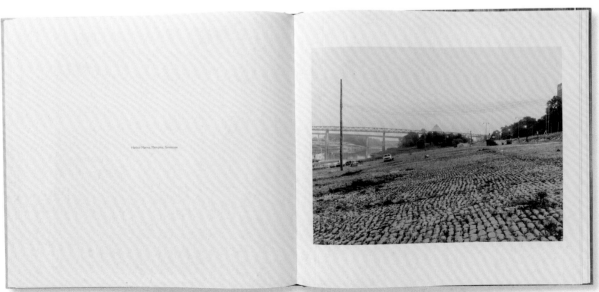

Harbor Marina, Memphis, Tennessee

John Vink
*Peuples d'en Haut: Laos,
Guatemala, Géorgie, la
montagne est leur royaume*

Editions Autrement, Paris,
2004

248 x 189 mm (9 ¾ x 7 ⅜ in),
208 pp

Paperback with flaps

141 b&w photographs

Text by Christian Culas,
Jesús García Ruiz,
Bernard Outtier and
John Vink; artistic
direction Kamy Pakdel

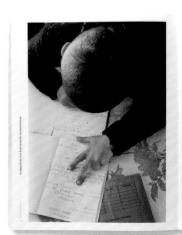

'There is always a mountain somewhere,' says a Hmong proverb. In 1993 the Belgian photographer John Vink, who had previously worked on the subject of refugees, decided to chronicle the life of the Hmong in Laos, the Mam in Guatemala and the Svanes in Georgia. The results of his enquiry, which lasted for seven years – during which he also became a full member of Magnum in 1997 – is the book *Peuples d'en Haut* ('Peoples of the Highlands').

Series of Vink's beautiful photographs, grouped by chapters, are interspersed both with his texts and texts by three anthropologists that discuss the history, customs and beliefs of the respective mountain peoples – three communities who have never been integrated in the rest of their countries' populations and who try to survive in precarious conditions. In his text, Vink stresses how the mountains have built strong people aware of their cultural identity.

Vink's images, like the contrasting ethnological and diary-like texts, fall into two categories: factual still lifes in square formats represent local architecture, agricultural instruments, animal drinking troughs, bamboo used for construction, foods, embroidered fabrics, ceremonial hats and so on, while very personal, poetic images, taken with a Leica, show people's daily lives: bathing, forest clearing, sowing and harvest, gathering leaves for a roof, children at school, villagers at the market and musicians.

Vink observes: 'Linking three different communities which live in different areas on three different continents, with both their specificities and similarities, contains a complexity no other medium but a book could possibly integrate … I want to accompany my photographs as far as I can (during the editing, by properly captioning, by controlling the layout, the distribution, etc …). With photography and in the book's layout we create a fiction, we build a tension between reality and its representation. Photography is really a way of writing … I work with certain ethics, which give the reader some guarantee that he can trust what I say or show.'

Jacob Aue Sobol
Sabine

Politiken, Copenhagen,
2004 (Danish edition of
700 copies and Greenlandic
edition of 200 copies;
also self-published English
edition of 200 copies)

228 x 336 mm (9 x 13 ½ in),
112 pp

Hardback with cloth spine
and CD (not shown)

55 b&w photographs

Foreword by Finn Thrane;
text by Jacob Aue Sobol;
design by Camilla Jorgensen

As a boy, the Danish photographer Jacob Aue Sobol (now among the youngest full members of Magnum) read *Grølandske Dagbogsblade* (The Diary of a Hunter) by Thomas Frederiksen, a book about the Inuit of Greenland. He first visited Greenland in autumn 1999, but when he returned to Copenhagen he felt profoundly dissatisfied with the hundreds of pictures he had taken. Tiniteqilaaq ('The strait that runs dry at low tide'), a settlement on the Greenland's eastern coast, continued to exert a hold on his imagination, and he returned in early 2000. Sobol was twenty-three when he took lodgings with Hans, the local Inuit priest, and fell in love with nineteen-year-old Sabine, Hans's cousin. He wrote in his diary: 'I want to be a hunter. Shoot seals and catch fish. Learn the language.' He stopped taking photographs and only resumed four months later, after the Inuit hunters had trained him: 'When I picked up the camera again, I was part of a community.'

Like Larry Clark's *Tulsa* (1971) and Richard Billingham's *Ray's a Laugh* (2000), and like the work of photographer Anders Petersen, *Sabine* is narrated by an insider with no pretence of objectivity. The images in *Sabine* weave together a sequence of dramatic landscapes of ice storms, fishing parties, ice holes … with intimate 'inside pictures' that have Sabine as their subject, alternately passionate, childlike, tender, jealous or sad. On the cover, Sabine playfully bends her fingers to form a heart-shaped window. The written part of the book consists of terse excerpts from Sobol's diary and a preface by Danish writer Finn Thrane, who places the work into a historical context. Its publication was marked by an exhibition at Frederik's Bastion in Denmark, and it was nominated for the Deutsche Börse Photography Prize in 2005. *Sabine* also attracted Magnum's attention, and Sobol became a nominee in 2007.

Ultimately, after two and a half years, Sobol and Sabine's love story failed: he could not stay in Greenland; she could not live in Copenhagen. Sobol's *Sabine* is a unique photobook, beautiful and poignant, that memorializes their story, and bridges in words and pictures a gap that could not be surmounted in real life.

Donovan Wylie
The Maze

Granta Books, London, 2004
(revised two-volume edition
published by Steidl, 2010)

229 x 277 mm (9 x 11 in),
110 pp including two
gatefolds

Hardback with full grey
cover and jacket

81 colour photographs

Introduction by Donovan
Wylie; essay by Louise
Purbrick; edited by Liz
Jobey and Donovan Wylie;
design by Donovan Wylie,
Liz Jobey and Bernard
Fischer

The Maze prison is ten miles outside Belfast in Northern
Ireland, where Northen Irish photographer Donovan Wylie was
born in 1971. It was opened in 1976 as a maximum-security
prison for political prisoners, and became synonymous with
the political conflict in Northern Ireland and one of its
most potent symbols. Wylie had joined Magnum as a nominee
in 1992 before becoming a full member in 1998, and much of
his work evolves around the political and social landscape
of his homeland.

Commissioned by the Faculty of Arts and Architecture at
the University of Brighton, National Media Museum and
Granta Books, Wylie started his project at the Maze in
November 2002, two years after the last inmates had been
released in 2000. Between November 2002 and October 2003,
he made fourteen trips to the prison, spending about
100 days shooting through the four seasons. Even though
Wylie photographed for so long, he never stopped feeling
disoriented by the prison, a feeling created by the
geography of the place, which, though clear and functional,
is also repetitive and confusing. The feel of this
concentration camp-like place is strongly conveyed in the
book. In three sequences interspersed with text, full-page
photos display deserted concrete blocks invaded by wild
grass. A fold-out of three images reconstructs a panorama
of the yard and a block. Wylie has also photographed the

inside of twenty-four cells, clinically impeccable with
their stacked pillows, folded sheets and drawn curtains.
All the cells are eerily similar except for the print on
the curtains.

Says Wylie: 'What I found striking about the Maze after
my first visit was the prison's scale — there's 300 acres
of it — and the relentless sense of repetition it had.
When inside you can become very quickly disorientated.
It was the architectural structure I was attracted to,
not the artefacts or things that remained from when the
prisoners were there.' Late in the project, he made an
important decision that contributes to the strength of his
book: 'I decided that instead of me personally choosing
a position from which to take a picture, I would start
working following the prison's own logic. In other words,
I was guided by the prison's system of geography as opposed
to my own.'

Throughout the book, the bleached out colours under grey
skies echo the numb feelings we get as a reader — it is
as if we become prisoners of the book, as inmates were of
the prison; the desolate emptiness of the space speaks of
the recent past and a fragile peace after the Good Friday
agreement, but also the menace of a possible future when
the Maze could be in use all over again.

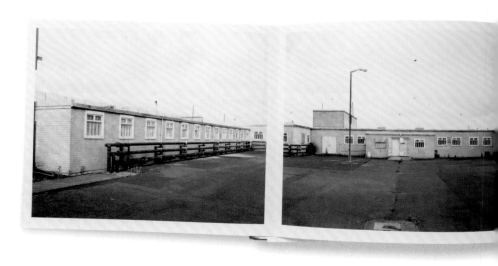

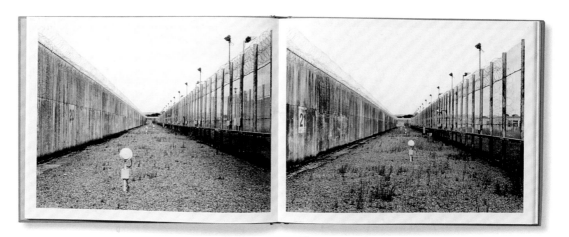

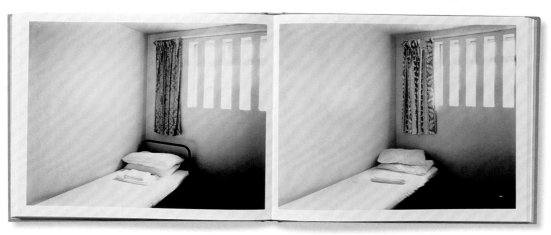

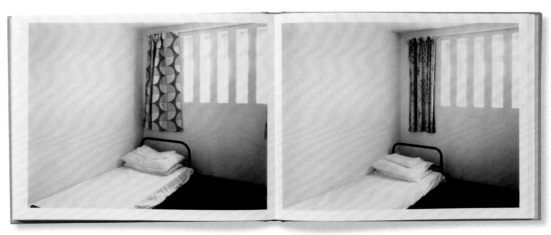

Jonas Bendiksen
*Satellites: Photographs
from the fringes of the
former Soviet Union*

Aperture, New York, 2006
(also published in French,
Dutch and Italian)

235 x 176 mm (9 ¼ x 7 ½ in),
152 pp

Hardback with cover image
from the series Spaceship
Crash Zones, 2000

62 colour photographs
on black pages

Text by Jonas Bendiksen

The Norwegian photographer Jonas Bendiksen was a nineteen-
year-old intern in Magnum's London office when he decided
to explore his family's past – his great grandparents
had immigrated to New York from Eastern Europe. Bendiksen
moved to Russia, but after he was expelled in 2000 over
a bureaucratic misstep, he spent much of the next five
years – during which he became a Magnum associate member
– travelling through the fringes of the former Soviet
empire. He visited 'forgotten enclaves and restless
territories' once held in orbit by Moscow's gravity,
from Transdniester, Abkhazia and Nagorno Karabakh in the
Caucasus to the Fergana Valley of Central Asia, the Jewish
Autonomous Oblast on the border with China and the steppes
of Kazakhstan, where the booster stages of Russia's space
rockets fall after take-off.

Satellites was not originally conceived as a project
until it was nearly finished – Bendiksen looked at his
pictures and realized that he was always photographing
the same things. The book is divided into six chapters,
all variations on the idea of enclave and isolation. The
countries that Bendiksen photographed do not really exist
– yet they have their own passports, flags, currencies:
they are countries of the mind and the memory that have
been left behind by the currents of global history.

Satellites features sequences of colour photographs on
a black background; each of the chapters is preceded by
a text printed in white on a grey background. Uncertainty,
vulnerability and isolation echo through the pages. An old
lady returns to her bullet-scarred apartment block; a lone
drinker in a bar sits under portraits of Marx and Stalin;
a lone man walks through a deserted street; and, on the
cover, a cloud of white butterflies circles a crashed Soyuz
space rocket that local children are gutting for scrap
metal – a surreal photograph. The beautiful, saturated
colours of Bendiksen's sixty-two pictures, often taken at
dusk or at night, contrasts with the coldness and emptiness
in his subjects. *Satellites* is a book where no one smiles.

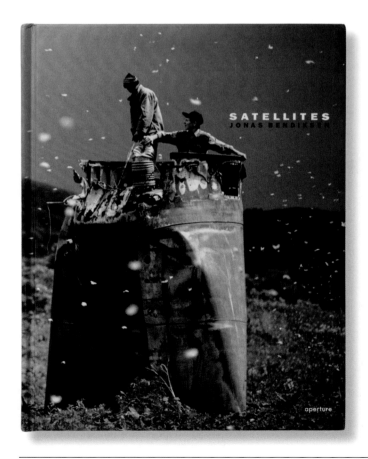

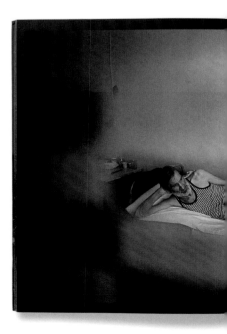

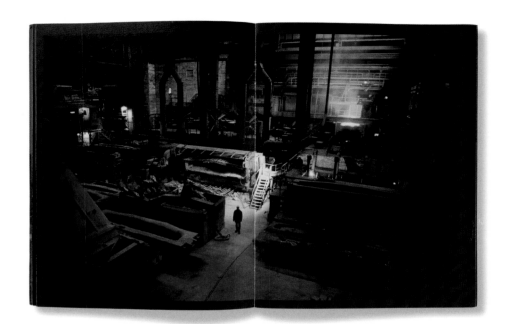

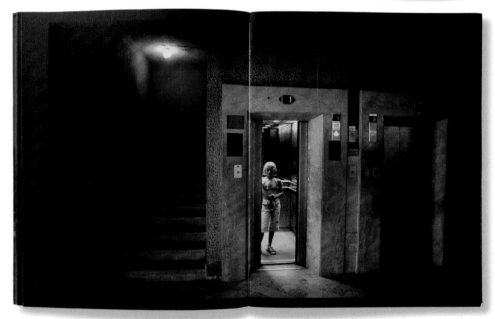

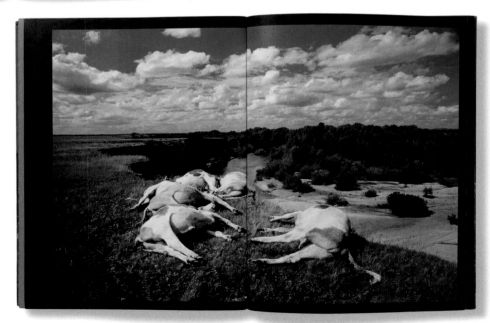

Erich Lessing
Budapest 1956 – La Révolution

Biro Éditeur, Paris,
2006 (also published in
English, German, Italian
and Hungarian, 2006)

310 x 310 mm (12 ⅛ x 12 ⅛ in),
148 pp

Hardback with jacket

190 b&w photographs

Texts by Erich Lessing,
François Fejtö, György Konrád
and Nicolas Bauquet

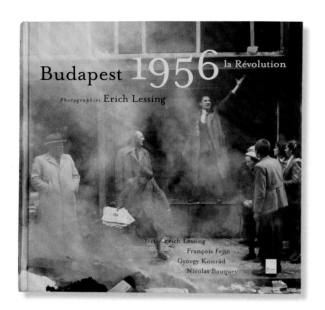

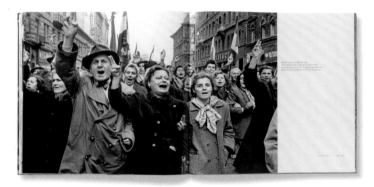

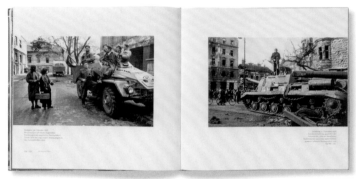

Invited to join Magnum Photos by co-founder David 'Chim' Seymour in 1951, the Austrian photographer Erich Lessing accepted, becoming a full member in 1955. A year later, Lessing published his first photographs of the Hungarian revolution, when Hungarians rose up against their Soviet-controlled government in October 1956, in *Paris Match*.

The photographs of the uprising are the subject of his photobook *Budapest 1956*. Although the story was self-assigned, Lessing had spent most of 1955 and 1956 in Eastern Europe working for *LIFE* magazine, to which he had suggested that he should cover the region. Lessing had been in and out of Hungary in spring and summer 1956, and from attending meetings at the Petöfi Club led by former Prime Minister Imre Nagy, he knew the revolution was going to happen. On October 23, he heard the news that it had begun: 'As soon as I heard that a battle had started on the streets, I jumped on the first plane to Vienna and got myself a car and drove to Budapest.'

Students had staged a demonstration demanding the withdrawal of Soviet troops, the formation of a multi-party system and the institution of free elections. When Hungarian security police fired on a crowd trying to occupy the radio building, four days of battles were fought on the street between students on one side and the police and their Russian reinforcements on the other until the Russian tanks retreated. The manoeuvre was a trick: the Russians halted and on November 4 attacked Budapest and ended the uprising. The Kremlin-installed government imprisoned 25,000 people and executed 230 revolutionaries, including Nagy.

In *Budapest 1956* Lessing is sympathetic to the Revolution in the way he captured happy crowds burning pictures of Communist leaders and propaganda material. He achieves a difficult balance: conveying empathy with his characters but also managing to step back from the scene into dispassionate contemplation. Seemingly spontaneous, Lessing's compositions are notable for the way he positions himself and his ability to project several steps ahead in a situation. For instance, when photographing a soldier standing on a tank, he stepped back to include a larger context: the onlookers standing near their bikes, and a view of a Budapest building.

Lessing's images of the Hungarian Revolution made him famous. A particularly chilling image is that of a lynched member of the AOV Budapest Secret Police, whose body hangs from a tree like meat from a butcher's hook. Other images go beyond the political and the anecdotal and become a meditation on time, as in the twin pictures of the Stalin monument in Budapest taken in summer and October of 1956. In the second image, the garlands and the statue itself have been torn down – the resulting two photographs sum up the Hungarian Revolution better than any action shots. Disappointed that the world seemed to pay so little attention to the Hungarian political situation, and disenchanted with the lack of impact of photojournalism in general, Lessing gradually shifted his professional focus to cultural and artistic subjects, museum photography, landscape and science.

Brian Brake
Monsoon

David Bateman, Albany,
New Zealand, 2007

252 x 250 mm (10 x 9 ¼ in),
184 pp

Hardback with black cover
and jacket

132 colour photographs, with
eight motion shots included
on two gatefolds

Foreword by Sir Edmund
Hillary; afterword by Asoke
Roy Chowdhury; design
by Trevor Newman

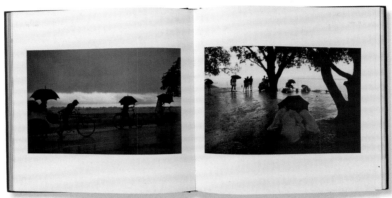

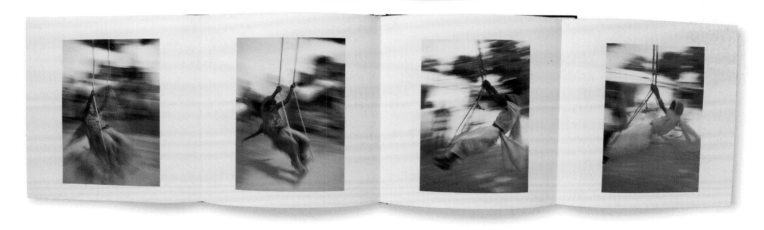

New Zealand-born photojournalist Brian Brake, a member of Magnum from 1955 until 1967, decided to photograph the Indian monsoon in the late 1950s, over a decade after Robert Capa had first suggested it. It wasn't until 1960, however, that Brake convinced *LIFE* magazine to support the project. After a few research visits, he travelled across India for nine months in 1960 and 1961, shooting the 132 colour images that make up his classic photo essay, which first appeared in the 8 September 1961 issue of *LIFE*, followed by portfolios in *Epoca*, *Paris Match* and *Queen*.

The monsoon story presented the worst possible conditions for photography – scorching heat, extreme humidity, the deluge of water and life-threatening floods – but Brake, who was admired at Magnum for his technical skills, was up to the challenge. Crisscrossing northern India, he chased the phases of the monsoon from Punjab in the west to West Bengal in the east, concentrating on rural and village life rather than on big cities, and working with slow (25 ASA) Kodachrome to shoot eighty-five rolls of film in total.

From the very beginning, Brake had envisioned his work as a book. Printed from digital scans of the original slides and designed by Trevor Newman, *Monsoon* is very well produced. The book opens with an aerial photograph of a patchwork of rural landscape, and the following images are spread through seven chapters, ending with a picture of a man praying near the Ganges.

Monsoon is a documentary essay, but 'Monsoon Girl' – the best-known image of the series and the cover of the book – was debated all over the world because the shot was staged. Although it appeared that Brake had captured a young Indian woman revelling in the feel of the rain on her face, in fact he had got the fourteen-year-old actress Aparna Sen to stand on a terrace as his assistant poured water over her face from a watering can. Despite the controversy, like Ernst Haas's colour work, *Monsoon* has a romantic and lyrical quality, and the filmic flow of captionless images helps give it a timeless feel.

Magnum Photographers
The Image to Come:
How Cinema Inspires
Photographers

Steidl, Göttingen, 2007

204 x 280 mm (8 x 11 in),
280 pp

Hardback with cloth-bound
spine and printed cover

406 colour and b&w
photographs, 44
illustrations

Text by Serge Toubiana
and Diane Dufour

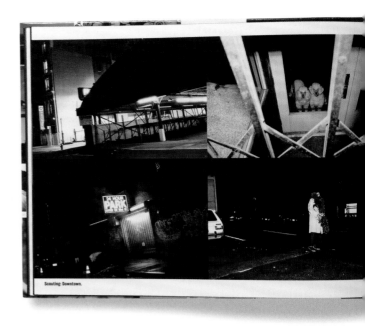

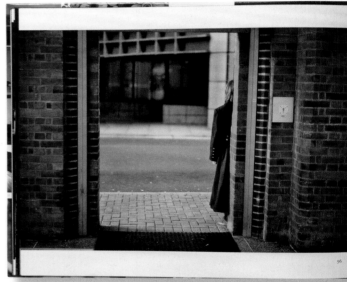

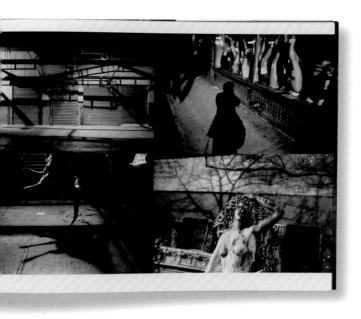

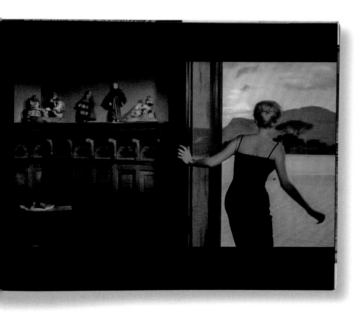

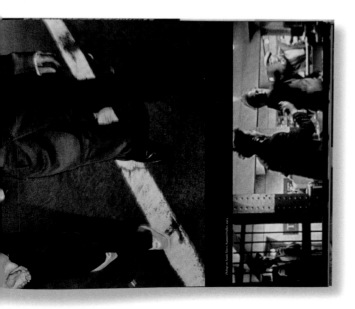

'The Image to Come' is an expression coined by Henri Cartier-Bresson to define filmmaking as opposed to photography. Through the work of ten photographers, *The Image to Come* explores the relationship between the two arts and was published to coincide with an exhibition at the Cinémathèque Français in Paris in 2007. Curator Serge Toubiana asks a pointed question: 'Is there a "no-man's land" between photography and film, an imaginary grey area where photos and film shots can co-exist, touch, and assess each other, rival each other even, in a sort of incestuous aesthetic relationship?' His question was put to each of the participating photographers, who between them represent various generations and trends in documentary photography: what does their imagination owe to the experience of cinema?

Abbas was bowled over when he first saw Roberto Rossellini's Italian Neorealist war drama film *Paisa* in the 1960s, during the Algeria war. He parallels his black-and-white images from the 1979 Iranian Revolution, seen from the inside and set in sequences like film strips with stills from *Paisa*. Fascinated by the universe of *In the Realm of the Senses* (1979) by Nagisa Oshima, Antoine d'Agata chose to immerse himself in nighttime Japan for several months and filmed his own descent into the nocturnal, creating a synopsis of sorts with text from his notebooks superimposed on images. Making use of the distortion of the closeup Bruce Gilden interspersed his own images images with stills from American *film noir* of the 1950s and 60s by Dassin, Fuller, Hitchcock, Nicholas Ray and Orson Welles. Harry Gruyaert parallels his colour and black-and-white images – such as portraits of an old girlfriend – with scenes from Michelangelo Antonioni's films, moments of pause, silence or doubt. Gueorgui Pinkhassov closely parallels his own pictures and contact sheets – portraits of Tarkowsky, still lifes and snow landscapes – with stills from Tarkowsky's *Stalker* (1979). Using the idea of a *carnet de répérage* (location scouting notebook) for a movie not yet written, Gilles Peress creates a mosaic of images shot in downtown Manhattan and the Bowery, with his friend Frankie as a subject.

In 2004, Mark Power watched Krysztof Kieslowski's film *Camera Buff* (1979) and never forgot it. His dreamlike colour pictures – including some amateur snapshots taken by his father and some 8mm film stills – were made in Leicester after his mother died, and signal the shift also present in Kieslowski's movie from documentary to personal memories. Alec Soth, inspired by Wim Wender's *Kings of the Road*, a lyrical road movie from 1976, photographed thirty-three movie theatres and a funeral home in the small town of his childhood. Most of the theatres are now vacant. Inspired by *Elephant*, a 1989 short film directed by Alan Clarke about Northern Ireland, Donovan Wylie returned to his native Belfast and created a mosaic of newspaper clippings, scrapbook images, film stills and family photographs about the 'troubles'. Patrick Zachmann, inspired by Shanghai's cinema of the 1930s, interspersed film stills of the period with his images of a China full of 'the seedy nocturnal atmospheres of gambling and opium dens'.

Published to celebrate the sixtieth anniversary of Magnum Photos, *The Image to Come* succeeds in imagining a hybrid world where the destinies of the two genres, film and photography, intertwine in a kind of labyrinth of images, as reflected in the complex layout.

Stuart Franklin
Hotel Afrique

Dewi Lewis Publishing,
Stockport, 2007 (paperback
edition published by
Black Sun)

328 x 240 mm (12 x 9 in),
48 pp

Hardback

48 colour photographs

Foreword by Mark Sealy;
edited by Paul Edison;
design and artwork
by Black Sun

In *Hotel Afrique* – a book of forty-eight square and rectangular colour images under an ochre cover with a chequered design – the British photographer Stuart Franklin sets out to portray the complex condition of African modernity through images of hotels. In his pictures, old and new Africa exist simultaneously: luxury hotels are, according to Franklin, 'the hybrid space between global culture and Africa's past and present identity'. In sharp contrast with the usual representation of Africa through images of war, disease and famine, these hotels exist in even the most poverty-stricken regions of Africa.

Franklin, who was invited to join Magnum in 1985 after sharing a flat in Khartoum with Sebastião Salgado and became a full member four years later, travelled to Angola, Cameroon, Democratic Republic of Congo, Ethiopia, Ghana, Ivory Coast, Kenya, Libya, Mali, Mozambique, Niger, South Africa, Tanzania and Zambia. He collected views of lounges, pools, business centres, conference rooms, presidential suites, bars and lobbies, and photographed both hotel workers and guests – business people, visitors and tourists.

The hotels are complex spaces. The interiors are decorated in a hybrid style, combining local artefacts (African woodcarvings or paintings) and international design. Even though they are wealthy enclaves, they have also become objects of desire for the proud workers Franklin depicts – hotel wages are higher than in other jobs and guarantee an income for the employee's entire family – and are sought after among local people as venues for receptions, weddings and conferences.

Hotel Afrique combines the beauty of a perfectly photographed and designed visual object with the complexity of an ethnographic record of a changing Africa. Franklin explains: 'I wanted there to be a tension between the inside of the hotel – often plush, and set out according to international standards – with the locally specific exterior. Sometimes these tensions collide, as in the photograph of the English-style armchairs in a tent in the Serengeti.'

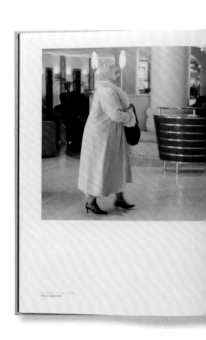

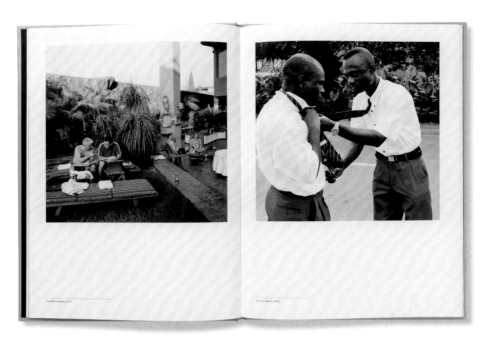

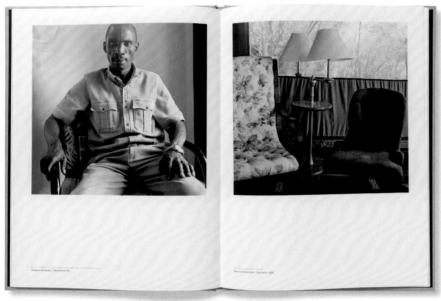

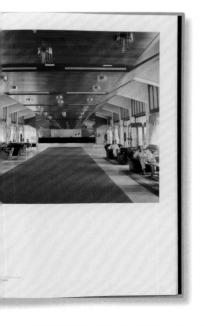

Harry Gruyaert
TV Shots

Steidl, Göttingen, 2007

284 x 192 mm (11 ¼ x
7 ½ in), 152 pp

Flexibound with matte
plastic vinyl and varnished
image on front and back
cover

104 colour photographs

Text in French by
Jean-Philippe Toussaint;
extract from 'La Télévision'
in French and English;
English translation by
Jordan Stump and Laura
Beilby; design by Harry
Gruyaert, Olivier Beer,
Gerhard Steidl and Jonas
Wettre

The body of work published in Harry Gruyaert's book *TV Shots* was shot by the Belgian photographer in Great Britain and France between 1969 and 1972, several years before Gruyaert joined Magnum in 1981 (he was the first member with an art background rather than a journalistic one). The series *TV Shots* was also an exhibition – the prints for the book and the exhibition were made by Charles Goossens, a key collaborator on the project.

Living in London at the end of the 1960s, Gruyaert became aware of the brainwashing power of television, which was then in transition from black-and-white to colour broadcasts. He decided to experiment with photographing a TV screen, cropping in and deliberately altering the tuning to achieve saturated colours and distortion. 'In London,' he recalls, 'I happened to find a TV set that, by fiddling with the controls, the wires and the antenna, gave me a fantastic variety of colours. They came out very strange and the structure of the image on the screen – the dots – was more interesting at that time than it would be with today's technology … I photographed the Apollo 10 flight, which was the first space mission photographed in colour.'

For Gruyaert, paradoxically, the series was 'one of the most journalistic things I've done … It was all done live: I missed the image or I had it'. The photographs included game shows, interviews, adverts, sitcoms, soap operas – and real news events. During the 1972 Munich Olympics, when Palestinian terrorists took Israeli athletes hostage, Gruyaert sat for two weeks in front of the screen, with a friend who adjusted the TV controls. 'In my room, I could participate by photographing those events … which I could not have done had I been physically present in Munich.'

TV Shots was first published as a portfolio in *Zoom* magazine in 1973, then shown at the Delpire Gallery in Paris in 1974. In the book, published thirty years later, the image sequence alternates full-bleed double-page horizontal images with full-bleed horizontal images placed sideways so the book has to be turned to see them. The plastic vinyl front and back covers are varnished, resembling a TV screen, while the flexibound format means one reads the book like a magazine or flip book, also reinforcing the effect of animation and the moving image. Verging on the abstract and painterly in effect, ranging from surreal and beautiful to strangely frightening, the series foreshadows Gruyaert's later work, and his explorations in the realm of colour in Belgium, Egypt, India, Morocco and the United States.

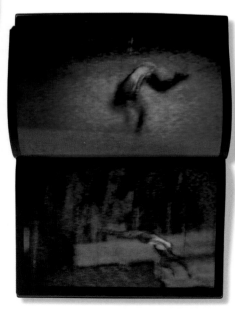

Richard Kalvar
Earthlings

Flammarion, Paris, 2007
(also published in French
as *Terriens*)

310 x 238 mm (12 ¼ x 9 ⅜ in),
192 pp

Hardback with full black
paper cover and jacket

88 b&w photographs

Preface by Seloua Luste
Boulbina; design by
Richard Kalvar

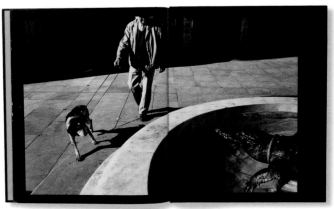

With its orange endpapers and preface on shiny grey paper, Richard Kalvar's *Earthlings* delivers punch. The book's photographs, which were taken during his travels from Rome to Paris, New York to Warsaw and San Francisco to Tokyo, bear no captions on the page (these appear at the back of the book) and their sequence resists a narrative story line, instead following on from one another as a series of free associations.

Kalvar portrays everyday life on Earth, but his pictures seem to come from a parallel universe. As the book's title suggests, he views the inhabitants of the planet as an alien species — see for instance his photograph of two mustachioed, bespectacled men wearing enormous flower-shaped hats during a Belgian carnival which appears on the book's cover. His perspective is fresh, at times funny, at times darker and touched with derision. Kalvar has an exceptional eye and a talent for catching moments when societal behaviour becomes humorous or shifts into the absurd. He does not follow an intellectual concept: to him, a photograph that is just an idea but is not composed cannot touch people and involve them emotionally. And although the aesthetic element is important to him, Kalvar never poses pictures and he works by intuition, feeling the flow in a situation and reacting to what is happening.

Modest in appearance, Kalvar's photographs ask deep questions from the viewer: what is the difference between photography and reality? Once a moment is captured, is it still reality? Or are successful pictures plays in which the actors do not know that they are actors? With *Earthlings* — his first monograph — Kalvar, like Alice in Wonderland, seems to have travelled to the other side of the mirror. A member of Magnum since 1975, he says: 'I'm trying to create little dramas that lead people to think, to feel, to dream, to fantasize, to smile … It's more than just catching beautiful moments; I want to fascinate, to hypnotize, to move my viewers. Making greater statements about the world is not my thing. I think there's a coherence in the work that comes not from an overriding philosophy but from a consistent way of looking and feeling.'

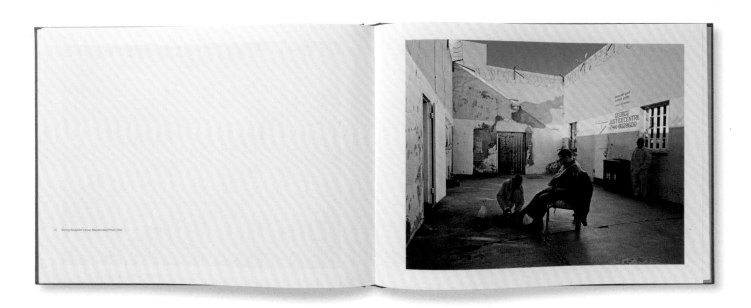

Mikhael Subotzky
Beaufort West

Chris Boot Ltd, London, 2008

280 x 350 mm (11 x 13 ¾ in),
80 pp

Hardback with full
grey cloth

45 colour photographs

Afterword by Jonny
Steinberg; commentary by
Mikhael Subotzky; design
by Untitled

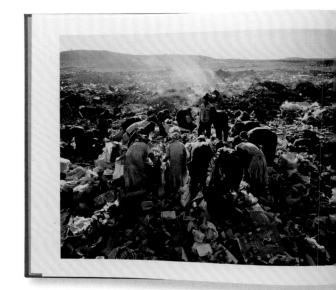

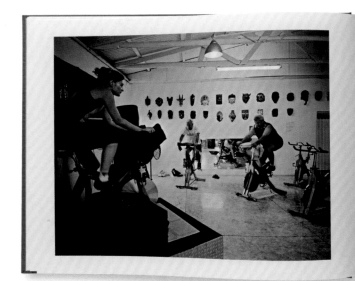

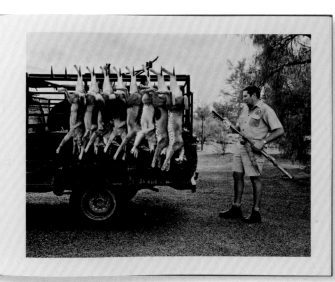

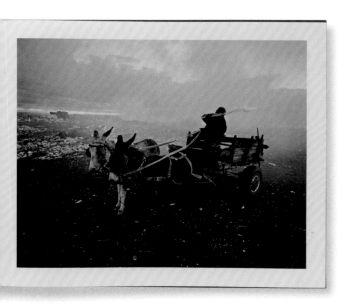

Born in Cape Town, South Africa, Mikhael Subotzky began his first book, *Beaufort West*, in 2006, describing a small town set halfway between Cape Town and Johannesburg, along South Africa's N1 highway. With a prison in the middle of town, on an island encircled by the highway, it is a surreal road stop that offers everything a traveller might want: food, fuel, a place to stay, an hour of sex. With an essay by writer Jonny Steinberg and Subotzky's own commentary on the photographs, the book examines the town, its characters and social landscapes. As did his previous work, the series *Die Vier Hoeke*, shown as an installation in Nelson Mandela's former prison cell, they serve as a prism to examine the contemporary issues of his country.

In *Beaufort West*, Subotzky documents the world outside the prison as well as the conditions within: a young prostitute leans over the side of a client's truck; a hospital escapee roams the streets with a knife in one hand and an IV drip attached to the other; a police flashlight illuminates the face of the victim of a beating. Haunting photographs of the Vaalkoppies rubbish dump, a sprawling wasteland, show scavengers combing the piles for food scraps. In a surreal photograph, one wears a Spider-Man mask, while inside the prison a black prisoner buffs the boots of a white guard.

'I wanted to make a contemporary version of David Goldblatt's iconic book *In Boksburg* (1982),' says Subotzy, who became Magnum's youngest nominee in 2007. 'Although my book ended up looking very different, the initial trigger was an attempt to do something similar in contemporary South Africa. Initially I thought of the work in traditional documentary terms. However, as I spent time in situ, I began to think of the work more broadly and contemplatively.'

Tim Hetherington
Infidel

Chris Boot Ltd, London, 2010

208 x 150 mm (8 ¼ x 6 in),
240 pp

Paperback with stiffened
black vinyl cover

148 colour photographs and
29 text illustrations

Introduction by Sebastian
Junger; text and photographs
by Tim Hetherington; design
by Heijdens Karwei

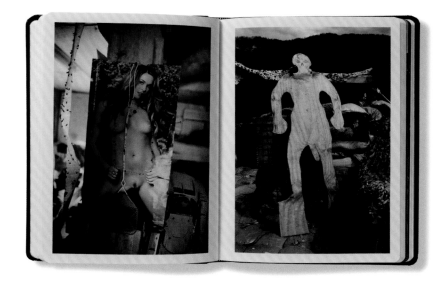

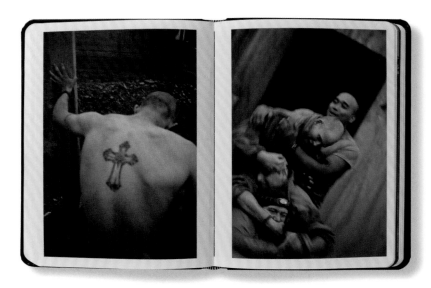

Infidel reads like a field manual, a diary, a hymnal and a family album. The introduction was written by Sebastian Junger, an American journalist who accompanied the British photographer Tim Hetherington during much of the five months they each spent in the Korengal Valley in Afghanistan, at a remote, fly-infested outpost with a single platoon. (The award-winning film they co-directed in 2010, *Restrepo*, is based on the same experiences.) 'Infidel' was the name given to the American troops by their Afghan enemies – but many soldiers then assumed it as a badge of honour.

The book begins with landscape photographs, a sequence that ends with a surreal image of a single soldier winding up a golf club to drive a ball into the valley below. There are identity photographs of the men, informal portraits, a section on their tattoos, images of firefights and a sequence of the soldiers as they sleep ('When they're asleep they look like little boys,' Hetherington said. 'They look the way their mothers probably remember them.'). Junger's take on the sleeping men was different: 'I remember sitting there thinking that this was hell on earth: twenty guys trapped on a hilltop with the heat, dust and tarantulas, and nothing to do but wait for someone to kill them.'

There are also trenchant interviews. 'Opening your mail in Afghanistan is the greatest thing ever,' says a soldier

named Steiner. 'Even if you sent yourself something and you know it's coming, it's still awesome, because you get to run around telling everybody about what you ordered three weeks ago and now it's actually here.' Or: 'Bullets are strange,' says another named Rice, who was shot in the back with a bullet that exited through his stomach. 'They have their own path and they'll do their own thing.'

The outpost was a dangerous place. 'For a while almost a fifth of the combat in all of Afghanistan was taking place in the Korengal Valley,' Junger reports. 'Once when we were there, the outpost was in four firefights in one day. The record was thirteen. Every man out there was nearly killed and every man had lost a friend. It's deeply unnatural for the young to have to make accommodations for their own death and these men did that every day for over a year.'

What was Hetherington's purpose? 'I want to record world events, big History told in the form of a small history,' he commented, 'the personal perspective that gives my life meaning and significance.' An extraordinarily talented journalist, photographer, filmmaker and human rights advocate, Hetherington's sudden death while covering another war the year after this book was published, aged just forty, shadows its every reading.

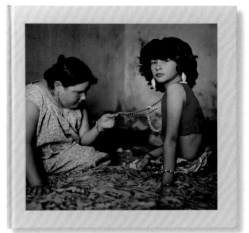

Alessandra Sanguinetti
*The Adventures of Guille
and Belinda and the
Enigmatic Meaning of
their Dreams*

Nazraeli Press, Portland,
Oregon, 2010 (edition of
2,000 copies)

277 x 277 mm (11 x 11 in),
120 pp

Hardbound with white cloth
and inset colour photograph

60 colour photographs

Design and layout by
Alessandra Sanguinetti
and Martin Weber

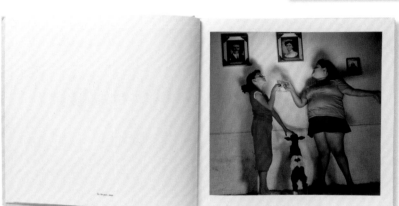

New York-born Alessandra Sanguinetti grew up in Argentina, and it was there that she met the subjects of her book *The Adventures of Guille and Belinda and the Enigmatic Meaning of their Dreams*. While working on her first book, *On the Sixth Day* (2006), a fable-like tale on farm animals, Sanguinetti would visit her family's farm south of Buenos Aires, where she met Juana, a friend of her father's, and her grown-up daughters Pachi and Chicha, whose own daughters Sanguinetti started photographing when they were nine and ten.

The images were made with the girls' active participation and the resulting book is a collaborative chronicle depicting their changes in mind and body over a period of time. Beautifully printed, *The Adventures of Guille and Belinda and the Enigmatic Meaning of their Dreams* is a large-format square book with a simple layout of one colour picture per page on a white background. Sanguinetti records the girls playing dress-up, pretending to be Ophelias,

mothers, the Virgin Mary with an angel, cuddling with the farm animals, swimming in a pond: fleeting moments which fade as the girls grow up and become more self-conscious and introverted. The accumulation of images and their sequence builds a novel of sorts – a narrative of the girls' existence and dreams. With empathy and sensibility, in joyful improvised scenes created in collaboration with her subjects, Sanguinetti has managed to capture the fleeting mystery and the magic that defines childhood.

Sanguinetti explains: 'My intention is to delve into Guille and Belinda's psychological and physical transformations as they become women, being aware of how their particular circumstances determine this coming of age. The time when their dreams, fantasies and fears would fuse seamlessly with real day to day life are ending, and these photographs both capture and crystallize this rapidly disappearing very personal and free space.'

Mark Power

The Sound of Two Songs

Photoworks, Brighton, UK in
association with Photomonth
Kraków, Poland, 2010
(edition of 2,000 copies)

310 x 250 mm (12 ¼ x 10 in),
168 pp

Hardback with red cloth and
screen-printed bird motif
on front cover

73 colour photographs

Text by Gerry Badger,
Wojciech Nowicki, Marek
Bieńczyk and Mark Power;
design by Stuart Smith

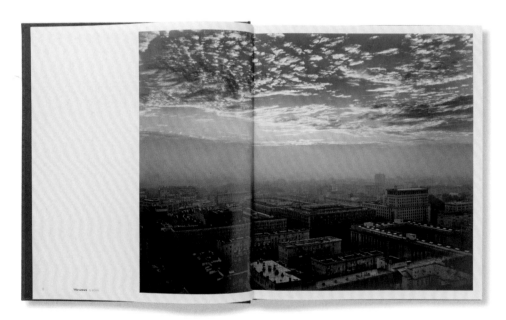

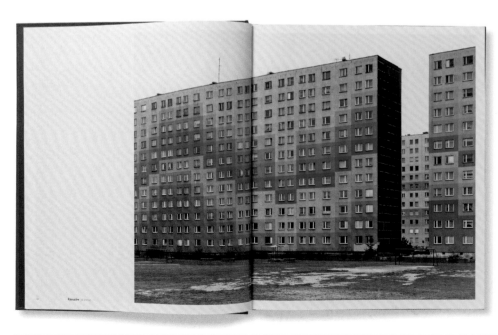

In September 2004, having been a nominee of Magnum for two years, the British photographer Mark Power undertook a one-month commission in which ten photographers each visited a new member of the European Union. Power chose Poland, and became fascinated by a country he had first visited on a holiday with his partner in 1989. After the commission ended, he returned more than twenty times over the next five years at his own expense, trekking around Poland with a local guide. Power made 2,000 contemplative colour images with a large-format 5 x 4 camera and a tripod, seventy-three of which are collected in his book *The Sound of Two Songs*.

While many of the pictures are made to stand alone, they are carefully sequenced in the book in order to investigate a number of themes, each merging into the next. This way of working has become standard for Power, and the photobook has since become his prime interest. *The Sound of Two Songs* records a country in a state of change, conveying its psychological state with the slight detachment that came from Power's outsider view of Poland as an exotic location. The book opens with a picture of Warsaw at dawn – an epic cityscape in two parts. In the lower half the grey streets are shrouded in a mist or smog. In the upper half wisps of cloud are illuminated by intense sunlight. Further on is a mysterious image taken at dusk: an uplighter in the street that a passerby has covered with mud before drawing a cross. It was taken on the day Pope John Paul II died. Other images highlight the juxtapositions of a changing nation: city and country; old and new; crumbling communist inner-city estates and colourful new apartment blocks or gleaming shopping centres. The last image, a cross on a hilltop in a snowy landscape seen from a distance, makes us feel that even though Poland is increasingly secularized, the power of the Catholic Church still looms over it.

Although the concentration camps are not photographed, a section of the book deals with the holocaust. Power finds its echoes everywhere: the romantic landscapes of deep silver birch forests in winter evoke the landscapes of Auschwitz; a limestone quarry references the entrance to a camp; a pile of discarded tubes in a factory echoes familiar pictures of clothing, shoes or glasses collected in the Auschwitz Holocaust Museum. Power's image of Kazimierz, the former Jewish quarter of Kraków, faces a picture of the window of an ordinary high-street photographer which recalls the rows of anonymous faces found in museums at the death camps.

Power intersperses the photographs of landscapes and urban scenes with portraits: a woman in boots and a fur coat, or a man wearing a boiler suit shown against the backdrop of the former Lenin shipyards in Gdańsk, the birthplace of Solidarnosc, the Solidarity trade union that led the campaign for liberation from communism. An especially beautiful image, 'Patryk, Natalia, Damian Zabrze 11/2004', is paired with an image of a path leading into a forest in an echo of the type of dark Eastern European fairytales Power recalls from his early childhood. Of the 'two songs' of the book's title, Power writes: 'Poland is a beautiful country. Poland is an ugly country. And, just as its ugliness can be profoundly beautiful, so its beauty, or that which we might be encouraged to appreciate as such, can be downright unsightly. It is a land bursting with visual contradictions. There is a form of philosophy that describes what happens when one listens to two or more pieces of music at the same time: it becomes impossible to hear one clearly. On reading this, it struck me this was what Poland looked like: layers of history jumbled up together so that it was almost impossible for an outsider – me, in other words – to make sense of it.'

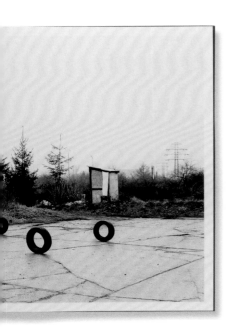

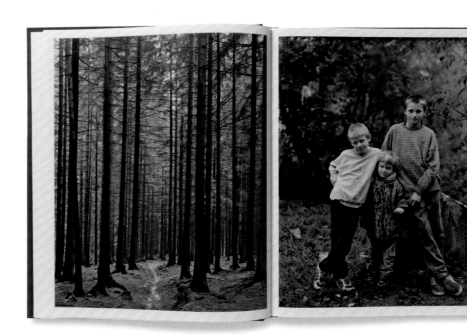

Antoine D'Agata
Ice

Images en Manoeuvres
Editions, Marseille, 2012

226 x 168 mm (8 ⅞ x 6 ¼ in),
288 pp

Hardback

151 colour and
b&w photographs

Text by Antoine D'Agata;
edited by Rafael Garido

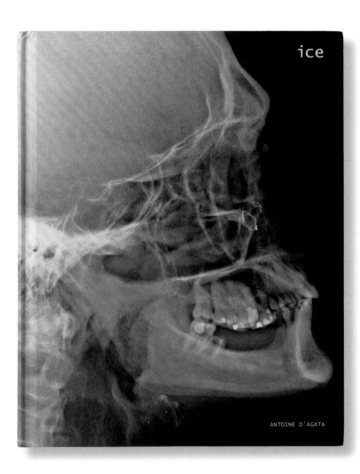

The French photographer Antoine d'Agata arrived in Cambodia in December 2007, three years after joining Magnum. While in Phnom Penh he fell in love with Ka, a Vietnamese prostitute who was also a drug dealer. In January 2008, they started living together. This was the beginning of a terrifying journey through sex and drugs that took d'Agata to São Paulo, Bangkok, Kuala Lumpur, Bombay and Manila, and saw the descent into addiction chronicled over five years in *Ice* – his own, as well as other people's. By exploring his body's limits in the realms of pure sensation, d'Agata courted death through unprotected sex and drug abuse.

D'Agata, who studied with Nan Goldin and Larry Clark, does not believe in photographic objectivity. In *Ice*, he is both witness to and participant in the events that he photographs, seeing this as the only possible way to capture the truth of a situation: 'The consciousness of life's extreme possibilities passes, in my practice, through the troubled transcript of heartrending experiences, the necessity to cross the limits of transgression, to explore the slopes of evil, and to witness, in constraint, real trials. I look at that found image and I feel vertigo. I am a spectator, thus an accomplice. But I share the thickness of the night with the victim.'

Ice features a series of blurry, grainy figures of prostitutes, clients and drug-pushers engaged in sex and drug-taking, their white bodies emerging from black backgrounds. With their mouths open as if in a silent scream, they evoke the paintings of Francis Bacon. Page after page of full-bleed images – there are more than 150 photographs in all – alternate with contact sheets and extracts from d'Agata's diary and emails. 'I use photography as a weapon,' d'Agata once said. Indeed, his honest book leaves the reader profoundly exposed, unsettled and wounded, uncertain of where reality and fiction meet.

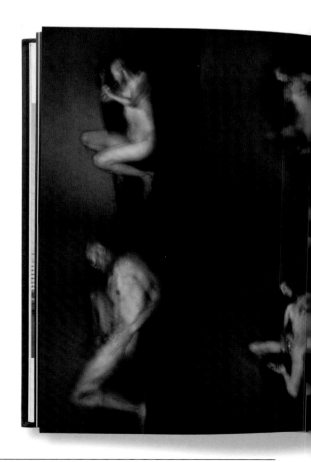

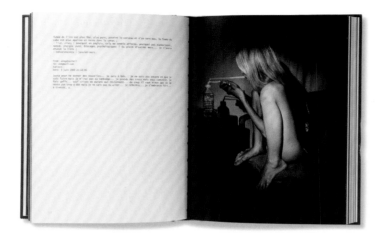

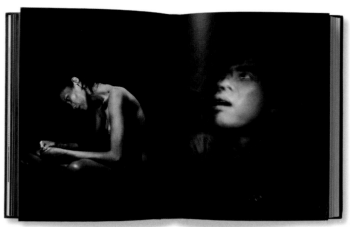

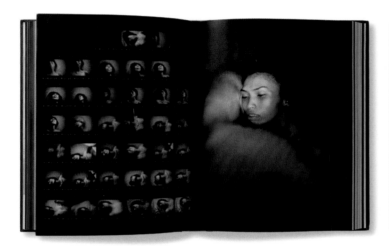

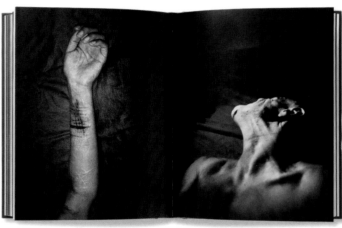

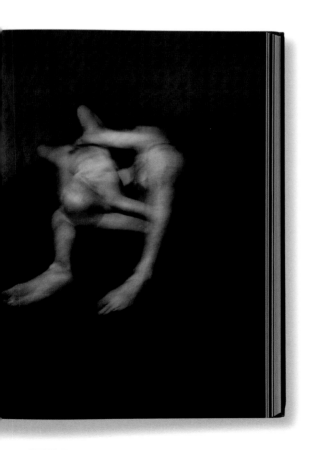

David Alan Harvey
Based on a True Story

Burn Books, New York, 2012
(limited edition of
600 copies)

245 x 170 mm (9 ⅗ x 6 ⅗ in),
132 pp

Hardback outer cover with
loose folded pages, folded
over a blue silk thread,
attached to cover through
holes and a bead at each
end. Book accompanied by
a poster, a roadmap for
original reassembling and
a postcard with 'clues',
with a printed slipcase
and an outer cardboard box

66 colour photographs

Photographs by David
Alan Harvey; design
by Bryan Harvey

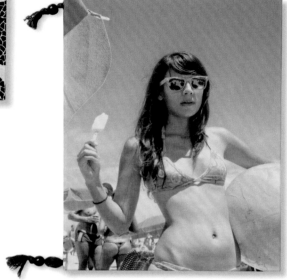

In 2008 David Alan Harvey spent three years on and off working in Rio de Janeiro on a journalistic assignment, building contacts with several groups including the police and drug dealers. After completing his assignments, he produced an entirely unconventional book, combining the tactile feel of a prayer book from the Middle Ages with a twenty-first century spirit, letting the reader be an active participant. The pictures are sequenced without explanation or transition, and there are no page numbers.

Designed by Harvey's son, Bryan Harvey, the book was influenced by the vignette-like structure of the film *Lost in Translation* (2003), with a mystery ending like the film. It is packaged in a large cardboard box that bears the signature wave-pattern found along the mosaicked pavements of Copacabana beach. The photographs inside are printed on loose pages held together by string, allowing them to be taken apart. An accompanying index postcard explains how to navigate the book, inviting the reader to interact with the story by mixing up the pages. The reader can pin it to the wall or spread it out on the floor; it is like a puzzle or a game of cards to be shuffled – a story that can have no end of conclusions. But in fact, closer examination reveals there's nothing random about the original edit and sequencing of the book. It is constructed as an intricate puzzle with only one right answer. Unrelated photographs are precisely paired in full-bleed diptychs, playing with scale and perspective to graphically merge in the middle, creating a new image, an entirely novel idea.

We follow Harvey moving through the unnamed city all day and all night: the name Rio was intentionally left out. The effect is both dynamic and cinematic – Bryan Harvey

is a filmmaker – and wholly unpredictable. Beautiful women – one of them a 'muse' whose story runs throughout – collide with papier-mâché skeletons or masked members of a paramilitary police force with automatic weapons; football and volleyball games follow images of the drug trade; high society balls clash with scenes from the favelas; the carnival contrasts with the sandy beaches of Copacabana and Ipanema. The clichés of modern day Brazil are all here, but turned on their heads and thrown together in an energetic montage, a kind of wordless *fotonovela* that makes tangible the city's essence, or mood, rather than a fixed sequence of lived experiences. In *The Photobook: A History (volume III*, 2014), Martin Parr and Gerry Badger say of Harvey's book that it 'takes its place as one of the best of the more extravagantly designed photobooks at a time when extravagant design is making a comeback'.

A member of Magnum since 1997, Harvey is the founder and editor of *Burn* magazine, featuring iconic and emerging photographers in print and online; in 2013 he gave away 2,500 copies of *Based on a True Story* printed in a larger magazine format, sharing his work with the residents of some of the poorest Rio neighbourhoods he had photographed. The book was the only photography book to be listed by *The New Yorker* in its Top Ten books of 2012.

It is important to Harvey that his work be accessible and seen outside the usual photojournalism readership. With this book, 'I just took it one step further by actually putting in a little novella on top of the documentary photography,' he says. 'This was an attempt to experiment and have a little fun, playing around with juxtapositions and making the story a bit of a mystery.'

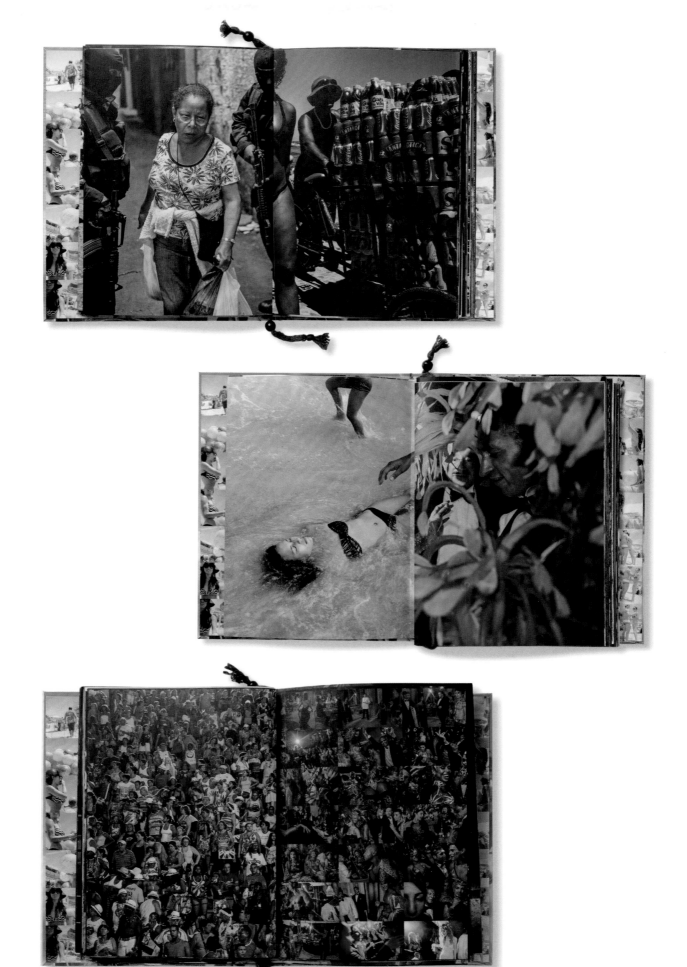

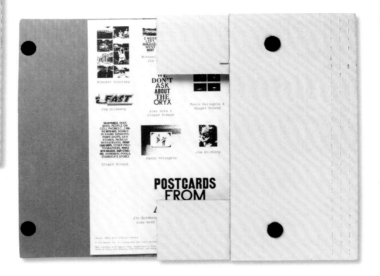

POSTC-ARDS FROM AM-ERICA

...San Antonio, TX

...Del Rio, TX ... Highway 90 ... El Paso, TX

Bisbee, AZ... Las Vegas, NV ... Fresno, CA

...Oakland, CA

Magnum Photographers
Postcards from America

Magnum Photos, London,
New York, Paris and Tokyo,
2012 (signed and numbered
edition of 500 copies)

Box dimensions 368 x 292 mm
(14 ½ x 11 ½ in)

Printed cardboard box,
including a book,
a newspaper, a poster,
two fold-outs, three cards,
five bumper stickers and
five zines

With contributions from
Jim Goldberg, Susan
Meiselas, Paolo Pellegrin,
Alec Soth and Mikhael
Subotzky; text by Ginger
Strand; design
by Michael Aberman and
Emmet Byrne

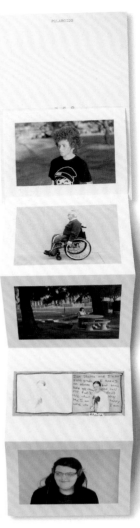

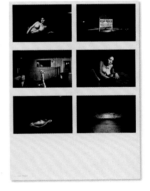

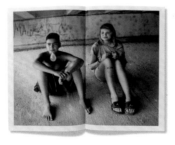

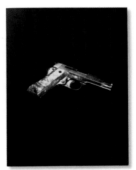

Printed in an edition of 500, the collaborative project
Postcards from America has the aim of 'to try to play like
a band, in search of a kind of polyphonic visual sound.'
It features photographic and literary documentation of
a road trip by five Magnum photographers – Jim Goldberg,
Paolo Pellegrin, Susan Meiselas, Alec Soth and Mikhael
Subotzky – and writer Ginger Strand took throughout the
American Southwest, following a route from San Antonio in
Texas to Oakland, California. Presented in a large white
box, it contains a visual index and a number of 'book'
elements: zines, bumper stickers, postcards, a newspaper,
a build-it-yourself-poster where pieces must be assembled

like a puzzle, a portfolio with twelve colour images, two
accordion books … The reader can look at and assemble these
elements in any order they want.

The six travellers piled into an RV and embarked on a two-
week, nearly 3,220-kilometre (2,000-mile) road trip. Their
goal was to document the Southwest, but also to improvise
ways to work collaboratively, each taking turns to act
as 'director', selecting a theme that individuals could
approach in their own way, separately – such as a 'zine'
of Polaroid colour portraits by Jim Goldberg or one by
Paolo Pellegrin featuring firearms on a black background –

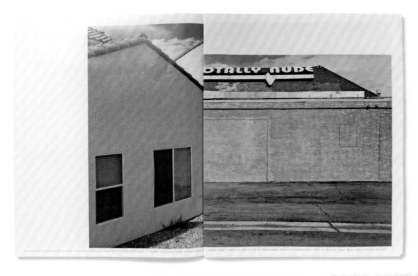

SOLAR PANELS, TEEN BOYS, PEOPLE ON CELL PHONES [...] PEOPLE WITH HATS, WOMEN IN STORE WINDOWS, PAWN SHOPS, GUN STORES, MEXICAN RESTAURANTS, PAYDAY LOAN SHOPS, OTHER PHOTOGRAPHERS, PEOPLE WITH WALKERS, BABY STROLLERS, SWIMMING POOLS, STARBUCKS STORES

or collaboratively: for instance, Jim Goldberg and Mikhael Subotzky collaborated on a 'zine' about the town of San Felipe Springs in Del Rio, Texas. On other days they would take up solo investigations, such as gun culture or sex trafficking — some picture stories within the 'book' are credited to individual photographers — or several photographers would shoot the same place, each from his or her own perspective.

Alec Soth, who instigated the project with Susan Meiselas and Jim Goldberg, has said of the project: 'In recent years, Magnum has been great about covering various journalist hot spots around the globe. But I think we've neglected the United States, a bit. A bunch of us were hungry to strip things down and work closely together like they did in the early days of Magnum.' *Postcards from America* is reminiscent of the 1935 Farm Security Administration (FSA) — the Depression-era project for photographers to document life in rural America — but with the difference that it is completely conceived and motivated by the photographers themselves, rather than a government or institution. This crucial characteristic gives the project the qualities of a trip with friends.

Lise Sarfati
She

Twin Palms Publishers, Santa
Fe, 2012 (edition of 2,000
copies; also available in
an edition of 25 signed
copies with an original
print in a clamshell box)

279 x 356 mm (11 x 14 in),
120 pp

Hardback with full grey
cloth and jacket

52 colour photographs

Essay by Quentin Bajac;
design by Jack Woody, Lise
Sarfati and François Adragna

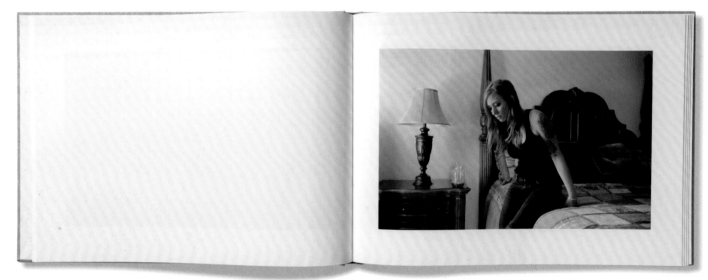

Lise Sarfati is an Algerian-born French photographer now based in California. Her main interest so far has been in colour portraits of adolescents, resembling film stills; she studied Russian literature and was deeply influenced by the films of Robert Bresson, Pasolini, Alain Resnais and Dziga Vertov. Sarfati began taking photographs at age thirteen, when she accompanied her mother, an academic who was then researching a novel on ageing, to the homes of old women who lived alone in Nice. As for the subjects in her photographs, Sarfati has referred to them as 'characters that might exist in a novel'.

Beautifully produced, Sarfati's book *She* features fifty-two single-person portraits made between 2005 and 2009. The images are set in a run-down area of Oakland, California and portray two middle-aged women — Christine and Gina — who are sisters, as are two younger subjects, Sloane and Sasha, Christine's daughters. Sarfati, who is self-taught as a photographer, wrote: 'I like doubles, like mothers and daughters, or sisters or reflections. This represents my research into women's identities … I am interested in fixing that instability.'

In his afterword for *She*, Quentin Bajac characterized the book as 'an anti family album'. And it is true that while Sarfati uses Kodachrome slide film, synonymous with family snapshots from the 1960s and 1970s (and Technicolor movies), the women are never photographed together and the book does not follow a narrative or trace relationships between them. The photographer's stance is that of neutrality. The images, though simple, have a mysterious quality that has to do with Sarfati's merging of portraiture and snapshot in arranged scenes that sometimes evoke Philip-Lorca diCorcia or Cindy Sherman. The four women seem equally suspicious of the photographer and the act of picture-taking.

Christine, the most dramatic character, seems to have had a hard life. She alternates between extremes in her costumes, from bride in a wedding dress and veil to topless dancer in the desert. Sloane seems to enjoy being photographed and often changes her appearance, posing with different wigs and makeup, while Sasha is pensive and melancholic, and retreats from the photographer's gaze.

The more we look at *She*, the more we feel the distance growing between us and Sarfati's models. She may be telling us that ultimately, the other is unknowable. 'The women in *She* reflect one another until you can no longer tell them apart. The only gaze possible is the gaze of the images between themselves,' she says. 'The sisters are isolated, they are alone. It's the fusion of these four solitudes that creates the series and the story.'

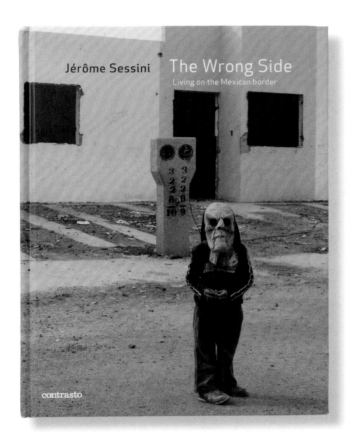

Jérôme Sessini
The Wrong Side: Living on the Mexican Border

Contrasto, Rome, 2012

249 x 186 mm (9 ¾ x 7 ⅜ in), 160 pp

Hardback

79 colour photographs

Text and afterword by Jérôme Sessini; design by Tania Russo

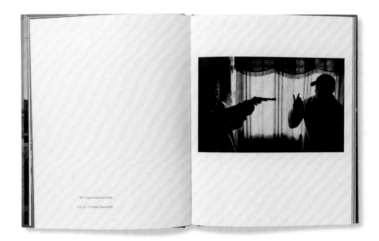

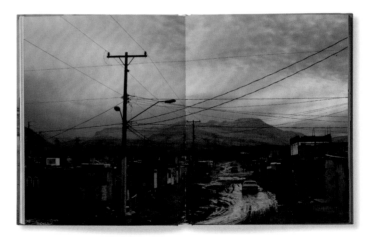

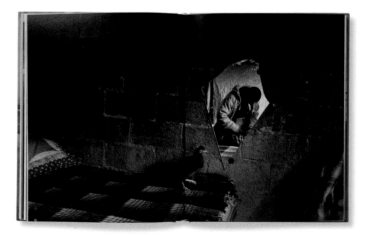

By the 'wrong side', Jérôme Sessini refers to both the Mexican side of the US-Mexico border and the wrong side of the law. For three years between November 2008 (the year he joined Magnum) and December 2011, Sessini made numerous trips to Ciudad Juarez, Culiacán and Tijuana, photographing the consequences of the 'war' between the Mexican government and the drug cartels. During his first stay in Ciudad Juarez there were seventy killings in one week. The city was consistently ranked the most dangerous place in the world outside of war zones. According to the Center for Investigative Reporting, 10,000 people have been killed in the last four years, an average of four people every day – the vast majority of the murders go unsolved and unpunished. Sessini noted, 'I found nothing there but despair, resignation and fear.'

The Wrong Side is a small format, sized between a novel and an illustrated book, with a loose narrative structure comprising both photographs and concluding diary entries in which Sessini describes some of his experiences without imposing a narrative on the earlier images of drugs, violence and prostitution. The subjects are bleak: gangs, police searches, arrests, crime scenes – both real and reconstructed – prostitutes, heroin addicts, executions, a funeral, gang prisoners … Even the images that do not relate directly to the drugs wars reflect their presence: haunting portraits of children in Ciudad Juarez, wide shots of the borderlands or surreal images, taken at night, of an old armchair set outside between two trees or a billboard of wanted drug cartel criminals against a swirling sky. Sessini explained of his subjects, 'Their life resembled a long expiatory calvary, for having committed the sin of being born in the wrong place at the wrong time.'

Sessini was awarded the F-Award for concerned photography and a Getty grant for his Mexican project. He noted: 'It is very easy to make photographs of violence, of the dead … But I wanted to create a deeper project about the social consequences of the violence and so I needed a lot of time to build up trust in people.'

Christopher Anderson
Stump

Editorial RM, Mexico City, 2013

302 x 234 mm (11 ¾ x 9 ¼ in), 96 pp

Paperback with cloth spine

74 colour and b&w photographs

Text by John Heilemann; creative direction by Christopher Anderson and Ramón Reverté; cover design by Aaron Amaro

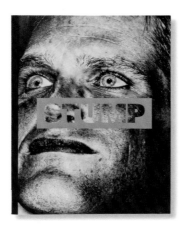

Such is Christopher Anderson's reputation as a political observer that he has behind-the-scenes access to politicians that other photographers can only envy. This privileged access is evident in *Stump*, Anderson's close-up view of American politics in action, shot on electoral campaign trails and at presidential primaries and political conventions between 1996 and 2012. The project originated from a year-long collaboration with *New York* magazine to create a body of work that would serve as a sort of family album of the American political scene.

The portraits, which Anderson calls 'X-ray icons', are presented as seventy-four black-and-white and color photographs, paired full-bleed on facing pages and interspersed with typical campaign-trail props such as fireworks and flags. Anderson captures his subjects in extreme close-ups, focusing on their too-white teeth, Botoxed or wrinkled faces, fake smiles, open mouths and clipped nose-hair. Quoting the book's introduction, ' … what's laid down on these pages is the bare essence of politics: not platforms or policies or ideologies … but the warts-and-all people who occupy the national stage'.

In a sense, the portraits can be viewed as rhetorical masks, such as those employed in ancient Greek theatre, rather than faces. They are reminiscent of the anti-Nazi photographs used by John Heartfield in the left-wing German magazine *AIZ* (*Arbeiter Illustriert Zeitung*) in the 1930s.

Removed from the context of reportage and sequenced according only to visual affinity (wrinkles with wrinkles, glasses with glasses …) Barack and Michelle Obama, Mitt and Josh Romney, Paul Ryan, Newt Gingrich, Bill Clinton, Jesse Jackson and others are made to seem in turn vain, greedy, ruthless, dishonest and self-centred.

Introduced by John Heilemann – a political journalist who co-wrote the best-selling book *Game Change*, about the 2008 American presidential election – *Stump* is a disabused, funny and cynical book. The relentless and wilfully monotonous accumulation of portraits, followed by hugs between politicians and audience members, leaves viewers feeling they have glimpsed an Orwellian nightmare. As Barack Obama once said, 'This shit would be really interesting if we weren't in the middle of it.'

Raghu Rai
Trees

PhotoInk, New Delhi, 2013
(second edition in colour
published by Art Alive
Gallery, New Delhi, 2015)

Hardback with beige cloth and
inset photograph

340 x 240 mm (12 ¼ x 9 ½ in),
108 pp

77 b&w photographs

Design by Rukminee Guha
Thakurta/Letterpress

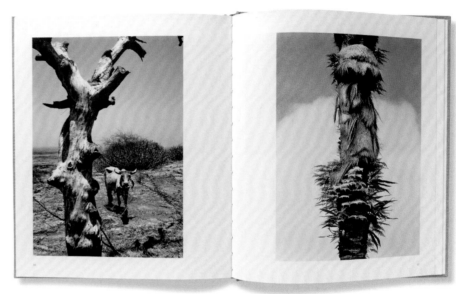

Trees are a life-long passion for the Indian photographer Raghu Rai, who is a nature lover and a gardener. In his farm near Mehrauli in India, he has planted shrubs and saplings of trees from all over India and abroad. Shot over forty-five years in India and other countries, the pictures in *Trees* were not made on assignment but over the years, as Rai was travelling. 'I wasn't looking for trees but I found them along the way. It was a much more intuitive and instinctive way of working,' he explains. His strong bond with trees becomes evident in an image where we see the tree growing out of the photographer's shadow, as if it were part of him.

Beautifully printed in black and white with a classic design (Rai has produced a second volume in colour), *Trees* stands apart from Rai's other work as a photojournalist – Rai, who has also worked as a photo editor, is especially interested in the photobook as a form and has authored more than fifty books, most of them documentaries about India, including an in-depth project on the 1984 chemical disaster in Bhopal and its effects on the victims' lives.

Trees is really a book of portraits: each tree possesses its own personality, its individuality, its character and particular energy. It is as if the photographer was pursuing a dialogue with his subjects: 'The trees communicate with you, articulating through their whispers.' Standing alone, their roots crawling over buildings, used by children as swings or witnessing ritual bathing in holy rivers, the trees become emblems of the sacred. In the last part of the book, Rai works during night storms, as the landscape is lashed with rain. He employs an inbuilt flash and a long exposure technique so that the trees, reduced to semi-abstract forms, seem to dance as light and water converge. 'If you make yourself available emotionally, spiritually and mentally, the situation speaks to you and tells what it wants you to do for it' says Rai, who became a Magnum associate in 1977. He adds: 'My affair with the trees will never end.'

As a student, the Belgian photographer Bieke Depoorter travelled around Russia armed only with a note in Russian asking to be allowed to sleep in people's homes. She found this a way to take intimate photographs of domestic life and published the resulting pictures in *Ou Menya* (2012). For her second book, *I Am About to Call it a Day*, Depoorter repeated the approach in the United States, making eight trips of a few weeks each beginning in 2010, again staying with and photographing strangers.

The book weaves together forty-two colour images of people and the places where Depoorter spent the night, with pictures of the snowy landscapes through which she drove during the day. Using thin and thick matte papers, the book is a series of bound full-bleed images inside a rough cardboard box. Depoorter wanted a large format, so that the details of people's homes could be seen, and without captions, wanting the viewer to supply his or own story.

For someone asking to be invited into the lives of strangers she met on the street, it is remarkable how much Depoorter got people to open up within each short, but intense, encounter. (Most pictures were taken in the evening because Depoorter liked the atmosphere of the night hour, when people go home, close their doors and become their true selves after the sun goes down.) One picture shows an older couple embracing in bed, another a woman sitting in the bathroom. There is an old suicide note in a journal, entitled 'My useless existence', that a senior woman had written but never previously shown anyone. A love letter fills another page.

'I think part of people letting me in has to do with the fact that they know I am going away the next day,' Depoorter says. 'I believe it's important that my work be shared through books, so that my pictures are seen in a completely different manner from when they are in an exhibition. In a way, a book is much more intimate. Within that format, I have opted for a pure simplicity, because I want to give the photos enough space. There are few texts and no subtitles. Readers are free to give the pictures whatever interpretation they feel like.'

Bieke Depoorter
I Am About to Call it a Day

Edition Patrick Frey, Zurich
and Hannibal, Belgium, 2014
(edition of 1500 copies)

420 x 280 mm (16 ¼ x 11 in),
43 pp

Cardboard cover/envelope,
with cloth-bound book inside

42 colour images

Text by Maarten Dings;
design by Armand Mevis

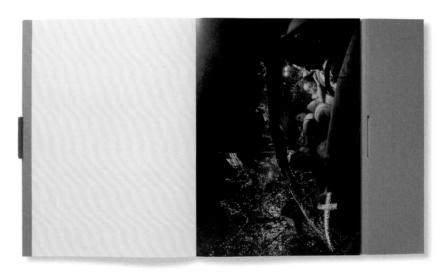

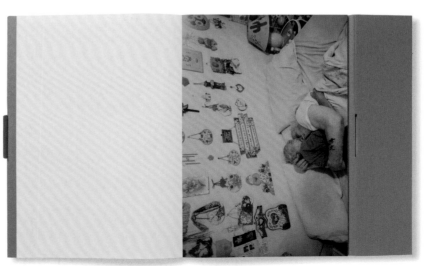

Peter van Agtmael
Disco Night Sept. 11

Red Hook Editions,
New York, 2014

264 x 215 mm (10 ½ x 8 ½ in),
276 pp including
19 gatefolds

Hardback with black cloth
and inset photograph

188 colour photographs

Text by Peter van Agtmael;
design by Yolanda Cuomo

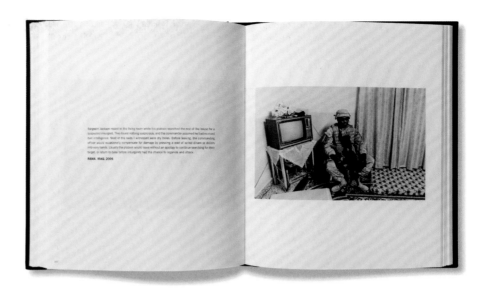

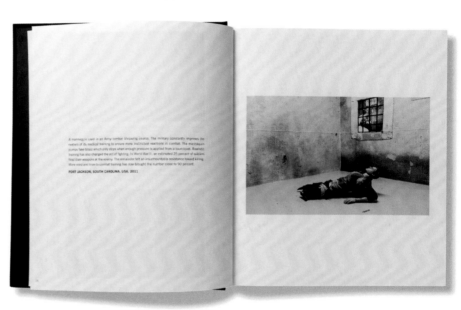

The traumatic pain acutely embedded within this book is signalled first by its cover, a heavy black vertical page without any type that displays a small horizontal colour photograph on top of it. The image appears detached and ironic, but quickly takes on a harsher, more apocalyptic meaning as one begins to absorb the implications of the odyssey detailed within the book's pages, vivisecting two fundamentally out-of-control and irrational wars in Iraq and Afghanistan and the agony that results for many of its participants. The book emphatically asserts a fundamental perversion that underlies this aggressive foreign policy – the disconnect with the great majority of Americans who have remained largely untouched by the severe violence and its repercussions.

Made in 2010, the cover photograph shows a solitary wooden house at night and a parking area with a single car in it, and a lit-up neon sign out front that says DISCO NIGHT SEPT 11. The sign is advertising, it turns out, 'a 1970s-style Disco Night' in Hopewell Junction, New York. For those who have personally experienced the wars that immediately followed the events of September 11, 2001, when van Agtmael's college roommate woke him in Connecticut to watch the Twin Towers as they crumbled on television, this image reveals what might be a parallel universe. Van Agtmael explores this split, acting on his own acknowledged

obsession to go to war, then following up with soldiers and their families as they came home.

The book is generally laid out with a single, concisely composed colour photograph of people and events on the right page, and a reflective, analytic, often acerbic text on the left. For example, one unassuming photograph of a cemetery in Corinth, Mississippi, where a veteran has just been buried, is paired with a text that reads: 'With the last light of day fading, hundreds of flowers were placed on Seth Ricketts's freshly dug grave. A car drove up with his in-laws and three-year-old son Aiden. Aiden posed like a ninja on the grave as his grandmother snapped pictures.'

The book also contains telling dialogues with the photographer's parents, deeply worried for his safety, questioning his choice to photograph war. One partial transcript before he first went to Iraq includes this excerpt: 'Dad: " … The risk factor … I understand what drives you. I am concerned about the fact that in my view you have not sufficiently analysed the element of obsession." Me: "Not sufficiently analysed? Of course I'm obsessed."' Unlike most photographic books of war which are told primarily in the third person, *Disco Night Sept. 11* articulates the first- and second-person as well. It is van Agtmael's second book, following *2nd Tour Hope I Don't Die* (2009).

Thomas Dworzak
#auschwitz

Artist's Scrap Book, 2014
(each an edition of
5 copies)

205 x 120 mm (8 x 4 ¾ in)
268 pp

Hardback

260 colour photographs

Other titles in series:
*#KZ, #K.R.A., #dprk,
#REARWINDOW, #GUN, #TOTAL:
107524.00, #aintnoheartinth
eheartofthecity, #siberianwin
tersarebrutal*

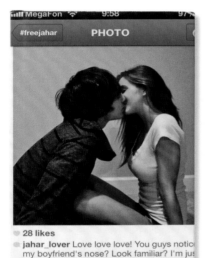

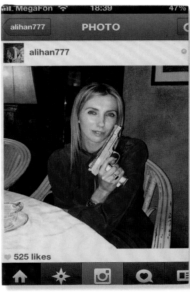

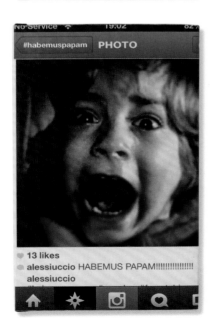

Like several of his Magnum colleagues, the German photographer Thomas Dworzak at times serves as a curator of other people's photographs. While on assignment in Afghanistan in 2002, he managed to acquire from Kandahar photo studios colourized, hand-painted images of Taliban soldiers with kohl-lined eyes posing in front of backdrops of painted scenery, even though photography had been publicly banned by the group. He published the results as *Taliban* (2002). In 2014 he produced nine self-published artist scrapbooks, in editions of only five copies each, that he had curated from the online platform Instagram.

Each book contains images culled from a specific hashtag, or a group of related ones, captured via screenshots on Dworzak's iPhone. His first book was on the election of Pope Francis, and he was delighted to find, among other discoveries, imagery of people dressing up their pets in papal style (*#habemuspapam*). Among his other books are one on the bombing of the Boston Marathon (*#bostonmarathon2013*) and another on the surprising campaign to liberate from prison one of its perpetrators, Dzhokhar Tsarnaev (*#freejahar*), by numerous adolescent girls who seemed to have been taken by his looks rather than by his politics. There is a volume featuring school trips to the concentration camp at Auschwitz, including images of those who see it as just another outing (*#auschwitz*); another on young people in northern Europe tanning themselves in solariums (*#siberianwintersarebrutal*); one on the Chechen leader, Ramzan Akhmadovich Kadyrov (*#K.R.A.*), smiling and playing with animals, trying to make himself seem warm and personable despite his brutal reputation; and another idiosyncratic series of images from someone apparently working at the North Korean embassy in Berlin (*#dprk*). Then there is a series on youth who are wealthy (*#rkoi*, or Rich Kids on Instagram), with evidence of heavy partying (*#receiptporn*).

Certainly any photographer covering world events is aware of the difficulties in getting access to events and sub-cultures – Dworzak was embedded with US and coalition troops in Afghanistan and Iraq between 2002 and 2008, and again with Georgian troops in Afghanistan in 2009–10, for example, forced to photograph under particular limitations. By mining specific veins of Instagram, Dworzak is exploring ways of being, and of self-representation, that readers would have known little about (while only five copies of each book have been printed, they have been widely publicized). And in doing so he is among the relative few to try to make sense of some of the billions of images that are now being uploaded daily.

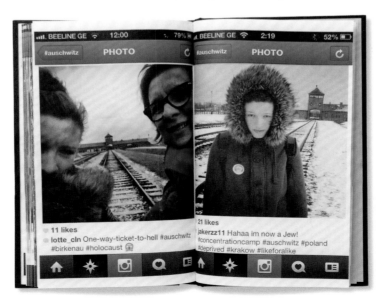

Olivia Arthur
Stranger

Fishbar, London, 2015
(edition of 1,000 copies)

190 x 252 mm (7 ½ x 9 ⅞ in),
224 pp

Hardback with translucent
pages

89 colour and b&w photographs

Edited by Olivia Arthur
and Philipp Ebeling;
design by Melanie Mues

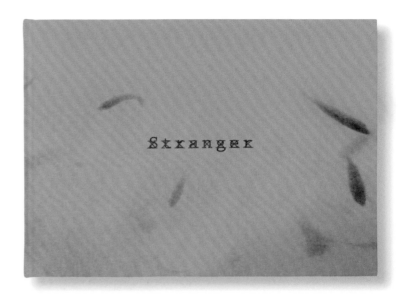

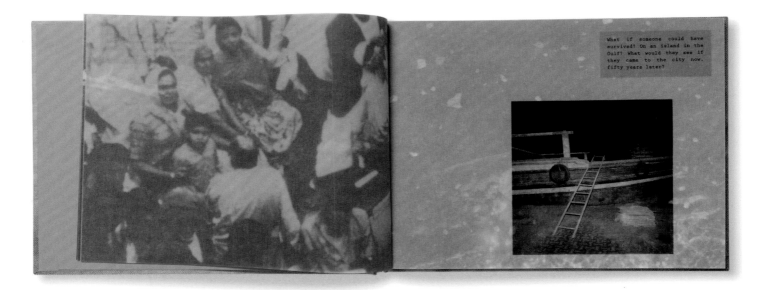

What if someone could have survived? On an island in the Gulf? What would they see if they came to the city now, fifty years later?

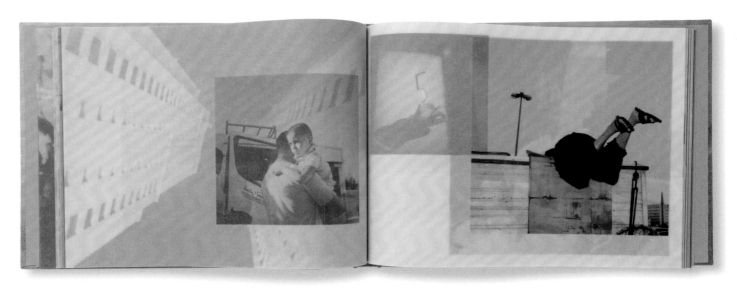

For British photographer Olivia Arthur, the photobook is such an important part of her practice that she has co-founded the imprint Fishbar to publish her own books and those of her colleagues. In 2012 Fishbar published Arthur's first book, *Jeddah Diary*, in which she won the trust of young women in Saudi Arabia in order to depict aspects of their lives rarely seen in the West. In 2015 Fishbar released *Stranger*, in which Arthur — who joined Magnum in 2013 as a twenty-two-year old — again explores the juxtaposition of East and West, this time in contemporary Dubai, a global city with a population of over 2.4 million that has metamorphosed from a fishing village into the ultimate playground of excess. As she was researching the history of Dubai, Arthur stumbled upon the story of a 1961 shipwreck that killed 238 people, including the son of a family who believed he had survived. She took that story as a starting point, imagining that she was that survivor visiting the city some fifty years later.

In its structure and design, *Stranger* is more of an artist's book than a traditional photobook, and reflects the city's visual contradictions: empty sand against new construction, old traditions against immense luxury, colossal shopping malls against minuscule human beings, the gulf between rich and poor. The images and text are printed on a translucent paper, allowing an image to appear reversed when one turns the page and other images to show underneath, as if submerged below the waves. 'I was looking for a way,' says Arthur, 'to have the words and images run together. I didn't want to separate them, but I also didn't want them to be captions. One of the biggest challenges when making photobooks is to get the balance of the images right with the text.'

With texts taken from interviews she conducted during her residency running through *Stranger* like snippets of conversations, things overheard and things remembered, the book captures both the sights and sounds of the city. Each page is recast by the images and text behind it, seeming to melt into each other like a dream or a flashback. Underwater views of the sunken ship bookend the narrative. Rather than a portrait of Dubai through time, *Stranger* feels more like a filmic narrative layering past and present.

Alex Majoli
& Paolo Pellegrin
Congo

Aperture, New York, 2015
(edition of 1,500 copies,
of which 100 copies were
a special edition with
a signed print by each
photographer; also published
in French)

292 x 387 mm (11 ½ x 15 ¼ in),
260 pp

Hardback with box and text
booklet (not shown)

202 b&w duotone photographs
and 56 colour images

Text by Alain Mabanckou;
edited by and collages
by Daria Birang; design
by Yolanda Cuomo

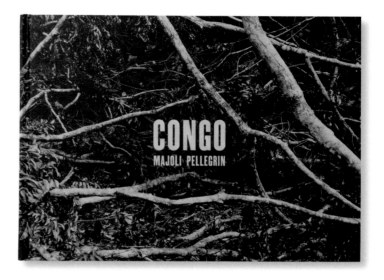

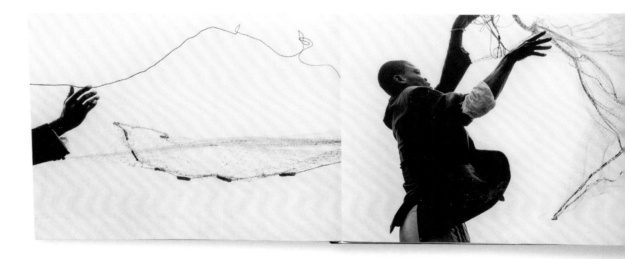

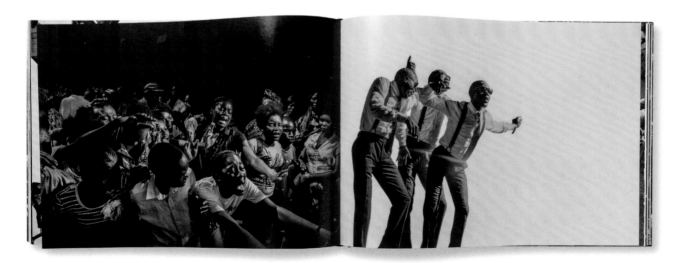

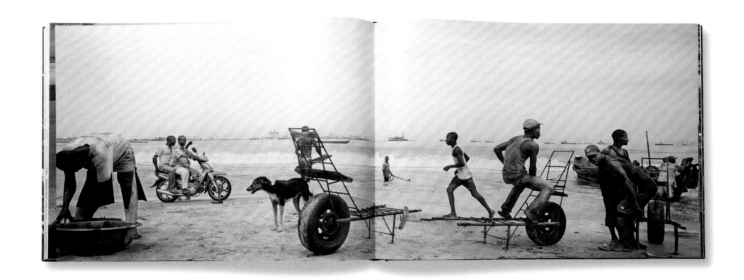

The collaboration between Italian photographers Alex Majoli and Paolo Pellegrin – members of Magnum from 2001 and 2005, respectively – resulted from an independent artistic commission by Cherry Tree Art Initiatives (CTAI) to freely document the Republic of Congo, a country little known to the rest of the world, over a period of two years, leading to the book's publication.

To create Congo, the two photographers made a handful of trips to the country, staying about three weeks each time. The pair photographed in Brazzaville and Point-Noire, the country's largest and second-largest cities, respectively. They also travelled in the more sparsely inhabited, jungle-filled northern part of the country. As Majoli put it, they were 'facing a massive wall of nature all the time'. Congo is a beautifully printed, very large format book – recalling nineteenth-century albums – with 202 duotones and 56 four-colour images presented on full-bleed pages, as gatefolds or as double-spread gatefolds. The book also features experimental forays into abstraction and collage.

Because of its layout and the sheer size of the pictures, looking at Congo becomes a silent and immersive experience. Taken in daylight and at night, in cities and tiny villages

and in the jungle, Majoli and Pellegrin's images are both compassionate and lyrical. The subjects range from prostitutes and the homeless – mysterious images often taken at night – to men at work in construction sites, unloading trucks or carrying loads in harbours. Traditional dances, religious gatherings and burials are also featured, and beautiful, often panoramic landscapes and still lifes help give a sense of place. We feel that Majoli and Pellegrin have shared the daily lives of their subjects. Writer Philip Gourevitch wrote of the images that 'the best of these compositions are presented in a cinematic scale and contain a Brueghel-like vastness and intricacy' (The New Yorker, 2015).

The images have no captions or individual credits, which adds to the mysterious feel of Congo. Says Majoli: 'We want to give the possibility to the viewers to build their own story, stimulate their own idea from what they see. I find it strange that in 2015 it's still an issue to leave photos without captions. How many "untitled" paintings are hanging in MoMa or the Met? The reason we don't want to identify the pictures probably comes from the same core discussion. For me, it is a sign of generosity toward the viewers rather than ourselves.'

Moises Saman
Discordia

Self-published, London, 2016

240 x 320 mm (9 ½ x 12 ⅝ in),
214 pp

Hardback with screenprinted
and embossed cloth

127 photographs, 4 collages
and 1 composite image

Text by Moises Saman; photo
collages by Daria Birang;
design by Daria Birang and
Moises Saman

Since 2011, the Spanish-American photographer Moises Saman, based in Cairo, has been chronicling the political upheaval of the 'Arab Spring' in a host of territories including Tunisia, Egypt, Libya, Syria and Jordan, with protests, demonstrations, riots and civil wars erupting across the Middle East and North Africa. Saman's project is ongoing – supported by a $5,000 fellowship from the W. Eugene Smith Memorial Fund and numerous awards, including the World Press Photo (2014), Pictures of the Year International (2012, 2014) and a Guggenheim Fellowship (2015) – but the book *Discordia* documents four years of Saman's personal journey through the region during a momentous period of Arab history.

Saman has a long career as a photojournalist, but the photographs in *Discordia* present a less linear and more symbolic narrative than traditional news photography. As Saman said, 'In order to tell this story the way I experienced it, I felt the need to transcend a linear journalistic language, and instead create a new narrative that combined the multitude of voices, emotions, and the lasting uncertainty I felt.'

While much of the work was shot on assignment for the *New York Times* magazine, Saman ultimately used many of their outtakes for the book. The screenprinted cloth cover of the book, blurry like a poorly adjusted television screen, includes the ambiguous image of a man that is perhaps either falling or throwing a projectile. Inside, *Discordia* features black-and-white and colour images on matte paper as well as collages by Daria Birang. Several gatefolds slow down the sequence's rhythm, one of them featuring a sequence of images of television screens, another a shot of a huge crowd praying outdoors in Cairo's Tahrir Square during the first anniversary of the Revolution. Saman superposed on the scene white photo cut outs that explore gestures he saw repeated over time. By cutting the images out of their context, the focus is brought on body language and expression.

Saman has chosen not to include captions under the images, listing them instead at the end, so that the reader first feels the impact of the photographs. 'For me, the editing process for an assignment is very different from that when I'm editing a longer narrative,' Saman wrote. 'A book needs rhythm, and, as such, I felt that *Discordia* needed to incorporate the quieter pictures that are sometimes overlooked because they capture moments just before or after the main event.'

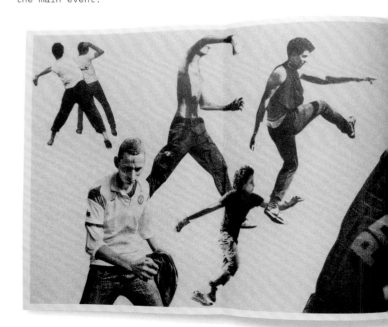

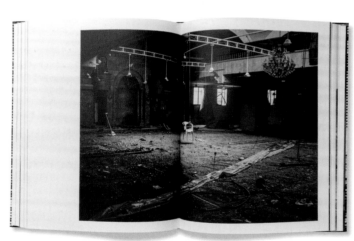

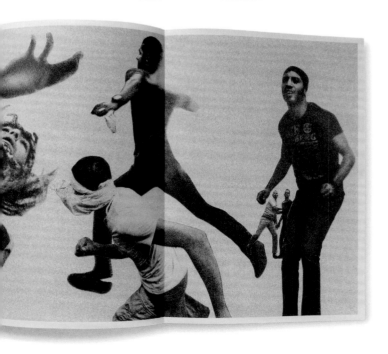

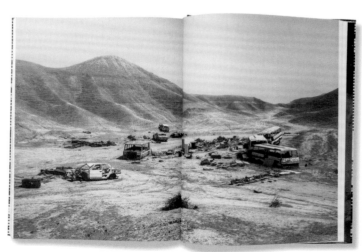

Michael Christopher Brown
Libyan Sugar

Twin Palms, Sante Fe,
New Mexico, 2016
(edition of 1,000 copies)

254 x 175 mm (10 x 6 ⅞ in),
412 pp

Hardback with cloth spine
and back cover

284 colour photographs

Text by Michael Christopher
Brown

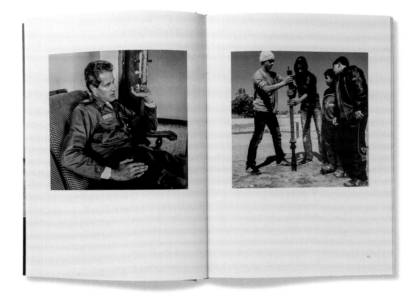

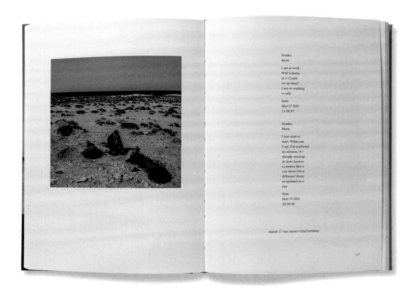

The size of a hardback novel, *Libyan Sugar* by Michael Christopher Brown records the revolution that led to the fall of the Libyan ruler, Colonel Muammar Gaddafi in 2011. Taken over a period of seven months, the book features 284 square-format colour pictures, mostly one picture per page but sometimes arranged as sequences of five or six images on a page. There are also numerous extracts from Brown's diaries, emails and texts with his family – his mother texts, 'I'm confused an anxious. 4 r already missing. At least borrow a camera that u can shoot frm a distance!' – letters, notes and sketches. In the prologue, Brown writes about his family's history of military service: his father, grandfather, great-great grandfather and seventh great-grandfather all served. He felt a mysterious attraction to Libya and identified with the values of the Arab Spring.

Some of Brown's pictures are raw, immediate, at times brutal: bloody imprints on a wall, an execution site, Gaddafi's body in a meat locker, a government fighter hit by a NATO incendiary round … while others are more about the in-between moments of war and the daily lives of the civilian population. With *Libyan Sugar*, Brown wanted to explore 'ethical distance and the iconography of warfare'. He wanted to use photography not as a photographer recording an event as part of his job, but more as a citizen living through the event. Therefore he recorded his experience using the same tool the Libyans used: a mobile phone, and he photographed not only action but offbeat moments in between events.

While in Libya, Brown was severely injured in a bombing that also wounded journalist Guy Martin and that killed fellow photographers, Tim Hetherington and Chris Hondros. 'Both Libya and I changed that year,' he writes. 'I came to see war and was awakened to mortality.' Brown, who became a Magnum associate in 2015, was also the subject of the HBO documentary *Witness: Libya*. His images form a series that, in his words 'moves beyond documentary realism and across the distinction between art and journalism.'

From the Archive:
Making Photobooks

1952
Henri Cartier-Bresson
The Decisive Moment

Henri Cartier-Bresson worked with French publisher
E. Tériade and Tériade's assistant Marguerite Lang to
conceive the design of his first book, *Images à la Sauvette*
(The Decisive Moment). A good friend of Cartier-Bresson,
Tériade was well entrenched in the Parisian art scene
as publisher of the art magazine *Verve*, with covers and
illustrations by artists such as Georges Braque, Marc
Chagall, Vasily Kandinsky, Henri Matisse and Pablo Picasso,
and texts by writers including Albert Camus, Ernest
Hemingway, James Joyce and Jean-Paul Sartre. After Cartier-
Bresson showed him a dummy copy, Matisse offered to design
the book's cover. Tériade sold the English-language rights
to Richard Simon of New York-based Simon & Schuster.
Both French and English editions were published in 1952.
>> pp.24–7

>> pp.24–7

1 Publisher E. Tériade
and Henri Matisse in the
garden of Tériade's villa
in Saint-Jean-Cap-Ferrat,
France, 1951.

2 Tériade holding a copy
of *The Decisive Moment*,
1952.

3 Publisher Richard
L. Simon, co-founder of
Simon & Schuster publishing
house, New York, with
his wife, 1952.

4 Cartier-Bresson's
handwritten quotes
for the epigraph for
The Decisive Moment.

5 Page of Cartier-Bresson's
title suggestions. The
French title, *Images à la
Sauvette*, translates as
'Images on the Run', but
The Decisive Moment was
settled upon as the title
for the English edition.

1

4

2

3

5

1957
Collective
Children's World

In 1953 Magnum co-founder Robert Capa coined the term 'Generation X' for a project about the young people around the world who had been born during World War II and the future they faced. The series was photographed by Magnum photographers and written by Bertrand Russell. Before its publication as the book *Children's World*, Capa sold the stories to *Holiday* magazine for $15,000 after an all-night poker game in Paris with Ted Patrick, the magazine's editor.
>> p.34

1 Printed maquette of *Children's World* and original caption sheets filed by photographers, with questionnaires completed by the children.

2 Spreads from a 1954 edition of *Holiday* magazine, which ran a story accompanied by the Children's World photographs.

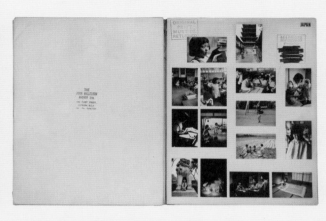

1

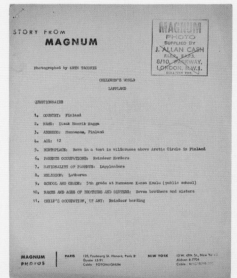

2

1954—6
Werner Bischof, Inge Morath and René Burri working with publisher Robert Delpire

1 Cover and interior spread from Werner Bischof's *Japan*, published by Robert Delpire Editions, Paris, 1954.

2 Cover of *Les Allemands* by René Burri (Editions Delpire, Paris, 1963).

3 Publisher Robert Delpire with a double exposure of Inge Morath, who is captured in the photograph behind her Leica camera, 1956.

4 Robert Delpire, Paris, 1956. Photograph by René Burri.

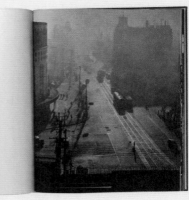

1

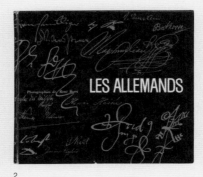

2

3

4

The influential French publisher Robert Delpire approached the Magnum office in Paris very early in his career. Having been nominated to run a university journal while a medical student, Delpire gained funding from pharmaceutical companies to produce a luxury magazine. Having read Henri Cartier-Bresson's *The Decisive Moment* (1952), a young Delpire nervously approached the Magnum office in the hope of acquiring images by Magnum photographers. Turning up without an appointment he simply knocked on the door — to be admitted by Robert Capa and introduced to Cartier-Bresson and Chim. The photographers looked through the few completed images of Delpire's journal, *Neuf*, judged it interesting and agreed to supply photographs (writers such as Sartre and André Breton were similarly amenable). Delpire struck up instant friendships with Cartier-Bresson and Capa and, soon afterwards, with Werner Bischof.

Bischof had worked extensively in Central Europe, documenting the wartime destruction and the postwar rebuilding. After Delpire discovered an enthusiasm for creating photobooks — he enjoyed working with collaborators on a project — Bischof approached him with a proposal to create a book about Japan. Sent to Japan on assignment for *LIFE* magazine, Bischof was drawn to the tranquillity of the traditional culture. Delpire noted: 'Bischof created it himself, because he knew exactly what he wanted to do with that book. My role was only to approve his suggestions. He knew how to make a book, how to create a sequence, to highlight strong moments, you see, so we did that together. It worked very well, we acquired a good reputation, and I had a continued good relationship with him…'.

Delpire also worked with Inge Morath, with whom he travelled for five weeks in Iran in 1956. As a result of the trip, Delpire produced the book *De la Perse à Iran* (1958). They also made *Fiesta en Pamplona* (1956). In 1963 Delpire worked with the young René Burri, like him close to the start of his career, on *Les Allemands* (1963), the French edition of *Die Deutschen*. The two men hit it off, as did Delpire and Cartier-Bresson, making *D'une Chine à l'Autre* together in 1954 (Delpire persuaded Sartre to write the text, although the writer had never been to China).

Delpire observed, 'In an artist's life, whether he is a photographer or painter, there is always going to be a moment where he gains notoriety, and this can happen with a book. A book is the best proof of a great work's quality. I can say, I never made a mistake. I have never thought of doing an important book with someone who was not important. I had many contacts with amazing people.'

'A book, if we are not careful with every detail — meaning the image quality, the print quality, the printing, the object itself — then it doesn't exist. Magnum today, as I see it, is still as it was yesterday — and I would like it to continue the same way, with a similar care for excellence and quality in all aspects. >> pp.35, 38—9

— Based on an interview with Robert Delpire by Marco Bischof, Paris, April 2010

1966
Marc Riboud
The Three Banners of China

Michel Sola was the 'eye' of *Paris Match* for over 35 years.
As director of the photography department he worked closely
with many of the contributing photographers, including
Marc Riboud, and they worked together on the creation of
this maquette for Riboud's book, *The Three Banners of
China*. These pages show Riboud's working notes in pencil
on the layout, positioning and sequencing the images.
It also includes the captions, which were stuck in place
with Sellotape. The finished book included 39 colour
and over 100 black-and-white photographs, varying in size
and layout, and each with an extended caption, detailing
Riboud's impressions and observations. >> pp.41–3

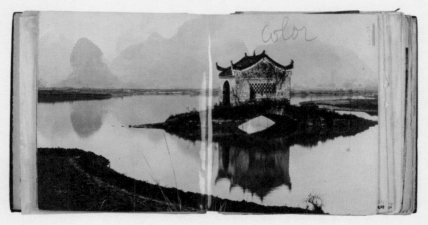

1971
Philip Jones Griffiths
Vietnam Inc.

From 1966 to 1968, and again in 1970, Philip Jones Griffiths travelled through Vietnam, documenting the war from the inside, sharing the conditions of soldiers and civilians and putting himself at immense personal risk. His reportage, which formed the content for *Vietnam Inc.*, played a key role in changing public perceptions of the conflict, especially in the United States. >> pp.50–1

1 Letter sent by Magnum to US authorities in Vietnam in 1966, confirming Philip Jones Griffiths's contract as a Magnum correspondent travelling to cover the Vietnam War.

2 Philip Jones Griffiths working on the sequence of *Vietnam Inc.* in his studio in Upstate New York, 1971.

1

2

1971
Danny Lyon
Conversations with the Dead

After photographing in six Texas prisons between 1967 and 1969, Danny Lyon received this letter from inmate Billy McCune, who expresses concern as to whether Danny is receiving all the letters and drawings that he has sent, 'because I hate to apply my effort in vain'. McCune's letters to Lyon and the drawings and paintings he made for the photographer permeate his book *Conversations with the Dead*, giving the reader an unsettling insight into the brutality, hopelessness and dispiriting existence of life in prison in 1960s' America. As Lyon says, 'I simply did not believe I could convey the reality of the prisons through my own writing alone. I wanted to drag the reader in with me. I wanted to put the reader through what I was experiencing emotionally. I wanted it to be real, and I became convinced the best way to do that was to use these documents and count on the basic humanity of my readers to respond.' >> pp.53–4

Letter from inmate Billy McCune to Danny Lyon, 1969. Lyon had just completed the principle photography for *Conversations with the Dead* and he was working to put the book together.

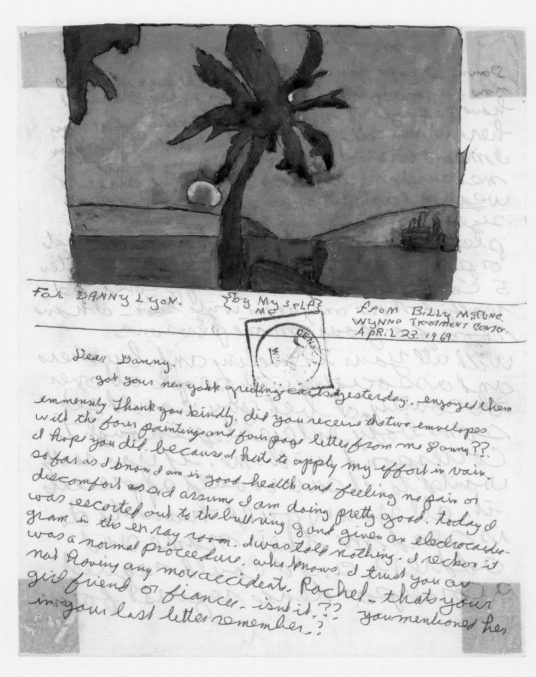

Original cover sketches drawn by Guy Le Querrec. His
notes annotating the illustration refer to the board game
design, which was inspired by the game *Jeu de l'oie*
(the French equivalent of Snakes and Ladders). The images
form a playful visual biography of the photographer's
life, with images relating to important moments, such
as acquiring his first camera (a Rolleiflex), his first
encounter with jazz and references to his family. >> pp.70

'Iran: La Révolution Confisquée was my first book on the revolution in Iran. Even as I was covering the events, from day to day, I knew that an event of such historical magnitude needed to be eventually portrayed in a book. As soon as the revolution was victorious, I began editing and sequencing the photographs. The book was published in the spring of 1980, while I was still in Iran, and I was lucky that it did not attract immediate attention by the Islamic regime. When it did, the ire of the mullahs was one of the reasons of my exile for 17 years.' >> pp.74–5

1 This contact sheet is made of two films, which had to be rolled up fast and hidden for fear of being confiscated by the Shah's army. The photos were taken on 25 January 1979 and filed by Abbas during his time in Iran, where he documented the revolution against Mohammad Reza Shah Pahlavi, which resulted in the overthrow of the Pahlavi dynasty. The woman, accused of being a supporter of the Shah was being lynched by an angry crowd of demonstrators. Abbas was running backwards as he was shooting and as he did so, someone shouted: 'Don't take pictures!' – it was clear that the revolution would be seen in an unfavourable light with young men turning violent on a middle-aged woman. Abbas answered in farsi, 'This is for history!'. The word history somehow meant the photos were not to be seen right away, with the SAVAK, the Shah's secret police, using them as evidence to arrest demonstrators.

2 Abbas in front of the American Embassy in Tehran, where diplomats were kept hostage during the revolution, 1980 (The full slogan read: 'Death to America'.)

3 Abbas's handwritten captions on hotel letterhead for Gamma, his agency at the time, referring to day one of the first President of the first (Islamic) Republic, Bani Sadr.

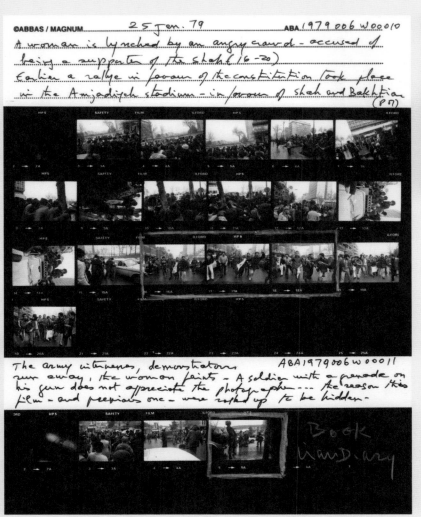

1

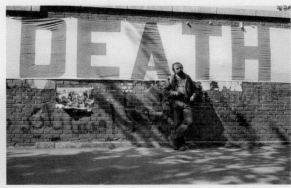

2

3

1981
Susan Meiselas
Nicaragua: June 1978–July 1979

The art critic and novelist John Berger once praised Susan Meiselas's photographs for their ability to 'take us right inside a revolutionary moment… Yet unlike most photographs of such material, these refuse all the rhetoric normally associated with such pictures: the rhetoric of violence, revolutionary heroism, and the glorification of misery.' When reflecting on her experience of making *Nicaragua*, Meiselas noted:

'When I went [to Nicaragua] it was quite a strange experience. The general impression I had was that everybody was waiting for something. And I was waiting for something that they were going to do. Increasingly, I felt that the kind of pictures I was taking gave maybe a small clue as to the texture of their lives, but very little. I spent six weeks there principally, because all I could feel was that I wasn't doing anything that gave a feeling for what in fact was going on there. Not going on in the world of events, but going on in terms of how people were feeling. And that still plagues me because I am not a war photographer in the sense that I didn't go there for that purpose. I'm really interested in how things come about and not just in the surface of what it is.

'I had been working in Nicaragua for nearly a year when the Sandinistas overthrew the Somoza dictatorship. Though many of my photographs had been published throughout the international media, I wanted to bring the pictures I took while there together to create a narrative that would live on as testimony to the passion of those times.

'Colour was not yet prevalent in documentary photography focused on social conflict, so the book was debated at the time of its release. The book placed my work in a world of photographic criticism that was expanding at that time. More importantly, the Nicaragua project has continued to be a significant point of my own engagement with questions about the nature of such photographs, moments frozen and ripped from history, as lives of people and places move on.'
- Susan Meiselas >> pp.80–2

1 Contact sheet of b&w images shot in Nicaragua. The finished book only featured colour photographs.

2 Annotated book page of the iconic photograph, 'Molotov Man', taken during Meiselas's trip to Nicaragua to make the film 'Pictures from a Revolution' in 1989.

3 Meiselas's notebook with her contact information.

4 Meiselas's handwritten notes, recorded at the time of preparing the book.

5 Meiselas's photograph taken in Masaya, Nicaragua, was used on the front cover of *The New York Times Magazine*, 30 July 1978. It was her first photograph published in the media as a cover.

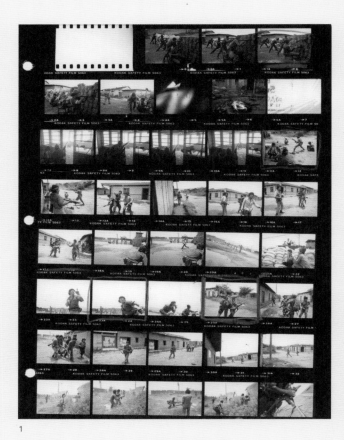

1

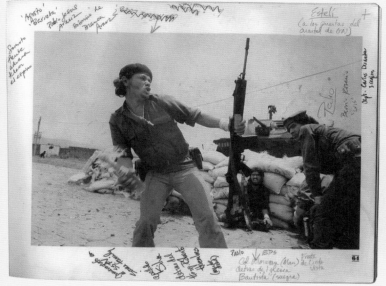

2

3

1.

photographs as souvenirs, evidence
- of a journey
- landmarks of the mind, mapping
 to memory

book -
- linear in structure in contrast to
 experience often circular, circuitous
- born in conflict between creating
 more or making coherent what's been done
- record of experience, laying of dots,
 connecting not knowing form
- not authoritative account, abstraction
 of process that has been evolving
- most of time couldn't photograph
 what I felt, saw, came to be
 understanding

Nicaragua.
- small
- ~~where every action, every day seems~~
 ~~to matter~~ censorship/martial law
- P.ch. assassination NyT (state siege lifted)
- identifying place I'd never known
- more read, more intertwined with
 US history:
 alternative canal / Ch-Bryan
 US marines
 Sandino
 Somoza GN US ally
 FSLN, P.ch, Morimbos
 20yrs.

4.

Cannot photograph what cannot see
- can only document expressive behavior
- things not photographed, not of visual
 importance but have value (in understanding
 (mtgs. FAO, Bowdler, situation)
- repression not witnessed
 (juliana) / results found 'evesto belgomo'

ear
burning formalism
 - making images of arbitrary visual
woman relationships
march - imposition of idea
 'some people passing moment,
 some people taking it'

 nts:
 - decision to go, having to be experienced
bullets? - knowing risks in going to 'center'
 & nothing there (combat ph. —
 never knowing what will find)
 - difference between life to be given
 to struggle vs. work was what
 made 'life of value'
 - Pomares "actions going unnoticed,
 brick by brick building" —
 • individual decisions weaving
 to become a force 'determining
 - being there, sense of 20yrs. history,
 of indiv. decisions

 — kxt
 Book — pix

I.

MASK (CU) with lies...

about poverty
statistics campesino in field

town with pig walking
~~about poverty~~ food seller front of bus

laundry on street carrying sack up ramp

FDR & telegram Somoza in white

BLN letter to NG boy looking at toy soldiers

EEBI of Tachito GN training in disassembly

 ~~BEGAT~~

Archbis. brand re alien
 violence corpse in landscape

bonfires bonfire in street

smoke of tear gas ~~lady walking past car burning~~
priest near coffin ~~smoke of tear gas~~
4 woman crying priest near coffin

death instilling more hate screaming near coffin
 ~~woman passing burning car~~

Arlen Siu demo funeral procession

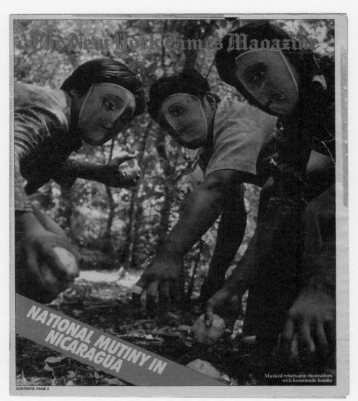

1993
Peter Marlow
Liverpool: Looking Out to Sea

Reflecting on his decision to present the photographs in
Liverpool: Looking Out to Sea in the form of a photobook,
Peter Marlow recalls: 'I felt the book format was an
appropriate way to show the work; books are so permanent,
unlike exhibitions or the commissioned magazine spreads
that I had done so much of at that time in my career… it
was my first experience of having complete responsibility
for a body of work.' When it came to sequencing the order
of images, Marlow was careful to avoid anything that
implied a narrative: 'Having the confidence just to let
the city unfold in front of me, I realised that what
I needed to do was to simply look and try to remove from
the equation the plans, the story line, the juxtapositions
that had become the standard toolbox of the photojournalist.
The fear of explaining was replaced by the excitement of
simply looking and discovering.' For Marlow this unique
style of 'authorship' – a lack of traditional authorship
– provided an enduring way of working on photobooks.
>> p.100

Miniature set of pages/
photographs included
in *Liverpool: Looking
Out to Sea*, numbered
by Marlow and annotated
for sequencing purposes.

1995
Jim Goldberg
Raised by Wolves

'In 1985 I received a Guggenheim Fellowship to photograph
runaway youth in the United States. My work has always
involved some form of dialectics: I had photographed
the rich, the poor and the elderly, so it made sense to
photograph young people. Reflecting on my own adolescent
alienation, I decided to photograph at-risk youth. I began
interacting with and photographing runaways on the streets
of San Francisco and Los Angeles. This was the first book
in which I began utilizing multi-dimensional storytelling
techniques. In a single body of work, I combined photographs,
text, collage, ephemera, drawings, snapshots, installation
elements and video. This way of working led me to think
more cinematically, pushing the boundaries of photography.
These strategies continue to drive my practice today.

Raised by Wolves laid the foundation for working
methodologies that became integral to my practice for
the years that followed. I wanted to explore the breadth
of documentary language and inspire more sensitive and
nuanced discussions about how we treat adolescents in
the United States… The long term project that followed
Raised by Wolves was *Open See*, which also grapples with
important and difficult subject matter: migration, human
trafficking, forced labor, etc. My approach to *Raised
by Wolves* significantly influenced the ways I worked in
Open See.

Raised by Wolves was both a book and an exhibition. I began
making the book in 1991 and worked on it for five years.
My approach to the book largely informed the exhibition.

The book seemed the best format for diverse media and
multiple narratives. It allowed me to consolidate a variety
of elements – photographs, text, home-movie stills, family
snapshots, drawings, diary entries, discarded belongings
– and combine them into a cohesive story. The stories
in *Raised by Wolves* are an essential part of the project;
there was something about the subjects that was lost –
their homes, their families. The book offered a way to
bring these lost parts together in a single place. Making
it came out of respect and necessity.' – Jim Goldberg
>> pp.104–5

Book maquettes made by
Goldberg when designing
Raised by Wolves.

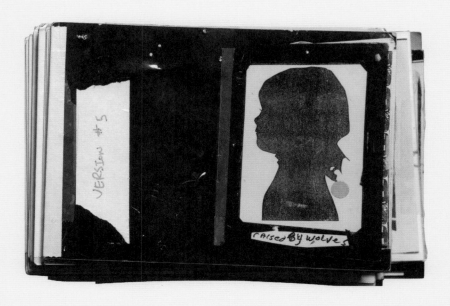

On 8 June 1968, Paul Fusco was assigned by his editor at *LOOK magazine* to accompany the train carrying Senator Robert F. Kennedy's body from New York to Arlington National Cemetery, following his assassination two days earlier. For eight hours, Fusco stood at an open window on the train, capturing the thousands of mourners who gathered along the train line to pay their respects as the train passed by.

LOOK's editors decided not to include Fusco's photographs and this remarkable body of work remained unpublished for 30 years. In 1998 Natasha Lunn, a photo editor at Magnum, was shown the work and the pictures were published in *GEORGE* magazine to coincide with the thirtieth anniversary of RFK's death. They were subsequently exhibited, with the support of Xerox, at The Photographer's Gallery, London in November 1999. To accompany the exhibition, a limited edition of 350 print-on-demand paperbacks were printed using a Xerox DocuColor 100 Digital Color Press – new technology at the time. This opened up new possibilities in terms of production and the book was produced with nine different covers.

The first edition of the book proved so popular that in 2001 it was republished by Umbrage Editions using more conventional book-making techniques for a wider audience, and in 2008 Aperture published an expanded and updated edition to mark the fortieth anniversary of Kennedy's assassination.

This note and letter from the Magnum archive reveal how closely Fusco was involved in the design of the original edition and also in the print-on-demand strategy.
>> pp.118–19

1999
Martin Parr
Common Sense

'I published *Common Sense* with Dewi Lewis, and we've collaborated on many book projects since. *Common Sense* is entirely image-filled: we decided early on that it would have no white paper in it at all, so the photographs are shown full bleed throughout, including on the endpapers. Even the opening title page has a photograph of my daughter blowing a chewing gum bubble — a deliberate choice of photograph as it allowed for a space for the book to be signed. The sequence, image pairings and overall layout was carefully thought out and considered, as you can see from our workings in the book's dummy shown here.'

Parr's book was published to coincide with a series of exhibitions in April 1999, for which he was awarded a Guinness World Record for staging the largest simultaneous photographic exhibition ever staged. A global project

realized by Magnum Photos with the British Council, laser copies of the *Common Sense* photographs were distributed internationally to forty-four different venues. The curators at each venue were given the freedom to create unique installations of the photographs resulting in exhibitions installed in car parks, abandoned shop windows and in the more traditional context of gallery spaces in cities across five continents.

'But the book is really "the legacy" of this project,' says Parr. 'The shows reached a wide audience but they came and went. Ultimately it's the book that lasts, and it still is lasting. Putting the work down on paper and presenting it in book form resulted in a lasting document that sums up the project — that's the beauty of the book.'
— Martin Parr >> pp.126–7

'Whenever I travel to a place, I photograph what interests
me, what strikes me visually. I create personal essays.
I have a singular type of vision and my work usually results
in a book – in fact, even when the work is shown in an
exhibition, the real culmination of a project is often
a book. In 1974 I saw the exhibition 'New Japanese
Photography' at MoMA in New York, and I was blown away.
It struck me that Japan would be a good place for me to
work, but it wasn't until 20 years later that I had the
opportunity to visit. The resulting book Go, features
images made in Tokyo and Osaka focusing on the Yakuza
(Japanese Mafia) and the Bosozoku (Japanese biker gangs),
and other street characters. After finishing the project,
I worked closely with designer Jonathan Ellery; it was
clear that we shared a similar vision of displaying
the photographs as full frames, bleeding off the page.
One key design element was the incorporation of Manga
illustrations, a known facet of Japanese popular culture.'
– Bruce Gilden >> pp.134–5

1 Jonathan Ellery with Bruce
Gilden and his daughter
Nina Gilden, New York City,
c.1999. Photograph by Sophie
Gilden

2 Handwritten note from
Bruce Gilden to Jonathan
Ellery, designer of Go.

3 Visual research and
ephemera collected while
in Japan.

4 Gilden's initial image
edit and captions for the
book in his distinctive
handwriting. This was repro-
duced in facsimile form on
the last page of the book.

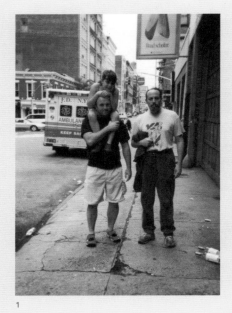

1

3

2

4

2015
Olivia Arthur
Stranger

'This was an unusual project for me because rather than straightforward documentary, I was trying to show a place from someone else's perspective. I found Dubai very alienating and disorientating, and I imagined that this character would be even more confused. I wanted to capture this feeling in the book and I decided to combine the images with snippets of conversations, like sights and sounds all spinning around together. I worked closely with the designer, Melanie Mues, and we looked at different transparent papers for the text. Melanie showed me a translucent paper from a Japanese illustration book – it was a good quality see-through paper and it allowed three drawings to be seen at once. I realized that it would be a brilliant way of recreating the sense of chaos and we decided to print the whole book on transparent paper. Of course, it is difficult to look at individual images through these layers – you end up sort of swimming through the book – but the overall effect it created was worth this sacrifice.

Selecting the images for inclusion in the book became extremely complicated because each picture affects how the three previous ones look and the three following, and you can't make a sequence in the normal way. I managed to put tracing paper through my laser printer and kept adjusting sizes and positions until things worked. Sometimes little gems would come out, like the guy in the sand with car doors for wings, or the fish turning into birds and flying off. Melanie's use of the crossed-out title graphic on the cover was inspired by invalidated passports and visas. I wanted to tell the story of working migrants who live in Dubai without the chance of citizenship.'
– Olivia Arthur >> pp.186–7

1

1 Editing and sequencing the book in Arthur's studio, 2013.

2 Maquette and handbound mock up testing the use of the translucent paper. Arthur wanted the images to fade in and out of view, and be interspersed with quotes, memories, and images of the shipwreck itself.

3 Transcript from interview with Sadik, Dubai. These formed the basis of the text in the book.

2

3

The Catalogue Raisonné &
Photographers' Biographies

Editorial Note

This catalogue raisonné includes all photobooks conceived, authored and published by Magnum photographers since the agency was founded in 1947. This bibliography does not include posthumous publications, series books, catalogues or monographs on the photographer's work created and authored by third parties. These are photobooks created by Magnum photographers.

The books listed and covers shown are first editions, with later formats and editions noted. Non-English language editions are detailed where this information is known and available, with publishers also listed in many instances. Later or revised editions are listed and pictured separately where the edition differs substantially from the first edition of the book.

For limited and artist's editions, the size of the edition is given where known - a limited edition is defined here as a book of 1,500 copies or less.

Publication dates are those printed in the books, and generally refer to the year of publication for the book's first edition.

With some exceptions, the images shown are of the book covers or jackets, as opposed to outer sleeves, slipcases or boxes. In a few instances, where it has not been possible to obtain a cover image, a graphic icon appears in its place.

All dimensions are shown as height by width using standard measurements, and these detail either the trimmed-page size or the book's cover dimensions; page counts are also open to interpretation, as many books are not paginated. The page counts listed here for the most part exclude endpapers.

While every endeavour has been made to standardize and ensure the accuracy of the technical book descriptions, cataloguing a publication is not as simple as it seems, with often the most basic aspects requiring interpretation. With non-English titles, for example, the decision regarding a book's English name is sometimes more a matter of personal interpretation than of simple translation. For reasons of space, only original titles are given, though titles in other languages are sometimes noted. When listing titles and subtitles, design credits and additional credits, we have opted for brevity in most instances.

Abbreviations

HB = Hardback
PB = Paperback
w/ jkt = with jacket
edn = edition
col = colour
b&w = black-and-white
illus = illustration

Abbas

An Iranian now living in Paris, Abbas (b. 1944; joined Magnum in 1981) is known for his photojournalism covering major events in Biafra, Vietnam, the Middle East and South Africa in the 1970s, and for his extensive essays on religions in later years. From 1978 to 1980, Abbas photographed the revolution in Iran, to which he returned in 1997 after seventeen years of voluntary exile. In 1986 he began a series of long-term projects on world religions and he is currently working on a large-scale project on Judaism.

Antoine d'Agata

D'Agata (b.1961; joined Magnum in 2004) left France in 1983 and remained overseas for the next ten years. In New York in 1990, he studied at the ICP, where his teachers included Larry Clark and Nan Goldin. In 1999 Galerie Vu began distributing his work and in 2001 he won the Niépce Prize for young photographers in France. In 2004 d'Agata shot his first short film, *Le Ventre du Monde*; this experiment led to his long feature film *Aka Ana*, shot in 2006 in Tokyo. In 2013 he staged a highly successful exhibition at Le Bal and was awarded the Photo Book Of The Year Award at Rencontres Internationales de la Photographie in Arles.

1 *Iran: La Révolution confisquée*. Editions Clétrat, Paris, 1980. PB, 245 x 250 mm, 96 pp, 70 b&w photos. Interview by Jean-Pierre Séréni.

2 *Retornos a Oapan*. Coleccion Rio De Luz/Fondo De Cultura Económica, Mexico City, 1986. PB, 210 x 275 mm, 88 pp, 55 b&w photos. Text by Abbas.

3 *Return to Mexico: Journeys Beyond the Mask*. W.W. Norton & Company, New York, 1992. HB, 255 mm x 215 mm, 128 pp, 83 b&w photos. Intro by Carlos Fuentes; text by Abbas.

4 *Allah O Akbar: A Journey Through Militant Islam*. Phaidon Press, London, 1994 (PB edn in 2002 and French edn in 2008; Italian edn: Contrasto, 2002). HB w/ jkt, 290 x 250 mm, 320 pp, 369 b&w photos. Text by Abbas.

5 *Voyage en chrétientés*. Editions de la Martinière, Paris, 2000 (published in English as *Faces of Christianity* by Abrams and in German as *Glaube-Liebe-Hoffnung?* by Knesebeck Verlag, 2000). HB, 305 x 245 mm, 328 pp, 264 b&w photos. Text by Abbas.

6 *IranDiary 1971-2002*. Editions Autrement, Paris, 2002 (Italian edn: *IranDiario*, Il Saggiatore, 2005). PB, 250 x 190 mm, 240 pp, 268 b&w photos. Text by Abbas.

7 *Visiones Del Islam*. Fundació 'La Caixa', Barcelona, 2002 (published in Catalan as *Visions de l'Islam*). PB, 300 mm x 240 mm, 142 pp, 60 b&w photos. Text by Abbas.

8 *Sur la route des esprits*. Editions Delpire, Paris, 2005. PB, 200 x 165 mm, 176 pp, 103 b&w photos. Text by Abbas.

9 *Children of Abraham/Les Enfants d'Abraham*. Editions Intervalles, Paris, 2006 (bilingual edn). PB, 230 x 175 mm, 240 pp, 138 b&w photos. Text by Abbas.

10 *In Whose Name? The Islamic World After 9/11*. Thames & Hudson, London, 2009 (published in French as *Au nom de qui?*, Les Editions du Pacifique, Paris). HB w/ jkt, 280 x 210 mm, 272 pp, 173 b&w photos. Text by Abbas.

11 *Ali, le combat*. Editions Sonatines, Paris, 2010 (also limited edn with a signed print). PB, 280 x 220 mm, 126 pp, 62 b&w photos and 5 illus. Text by Abbas.

12 *Les Enfants du Lotus/Voyage chez les bouddhistes*. Editions de La Martinière, Paris, 2011. HB, 280 mm x 220 mm, 286 pp, 204 b&w and 26 col photos. Text by Abbas.

13 *Gods I've Seen: Travels Among Hindus*. Phaidon Press, London, 2016 (also published in French). HB, 290 x 214 mm, 224 pp, 137 b&w and 10 col photos. Text by Abbas.

1 *De Mala Muerte*. Editions Point du Jour, Paris, 1998. PB w/ accordion folds, 160 x 120 mm, 10 pp, 9 photos. Text by Paco Ignacio Taïbo II.

2 *Mala Noche*. Editions En Vues, Nantes, 1998. HB, 260 x 200 mm, 104 pp, 62 b&w photos. Texts by Bruno Le Dantec & Jose Agustín.

3 *Antoine d'Agata*. Centro de Estudos Fotográficos, Vigo, 2001 (bilingual edn: French and Spanish; edn of 1000 copies). PB w/ acetate jkt, 110 x 150 mm, 56 pp, 40 b&w photos.

4 *Home Town*. Editions Point du Jour & Galerie du Théatre, Paris, 2002. PB, 240 x 265 mm, 80 pp, 38 b&w photos.

5 *Les carnets de la Création*. Editions de l'oeil, Paris, 2003. PB, 100 x 150 mm, 24 pp, 15 col photos. Text by Aïda Mady Diallo.

6 *Vortex*. Editions Atlantica, Biarritz, 2003. PB, 210 x 158 mm, 64 pp, 45 col and b&w photos. 8 photos by Morten Andersen; text by Christian Caujolle.

7 *Insomnia*. Images en Manoeuvres Editions, Marseille, 2003 (bilingual edn: English and French). PB, 270 x 220 mm, 192 pp, 130 col and b&w photos. Text by Christian Caujolle and Bruno Le Dantec.

8 *Stigma*. Editions Images en Manoeuvres, Marseille, 2004 (bilingual edn: English and French). HB, 300 x 225 mm, 64 pp, 37 col and b&w photos. Text by Philippe Azoury.

9 *Psychogéographie*. Editions Point du Jour, Paris, 2005. HB, 300 x 230 mm, 80 pp, 62 col photos. Text by d'Agata and Bruno Le Dantec.

10 *Manifeste*. Editions Point du Jour, Paris and Galerie Le Bleu de Ciel, Lyon, 2005. PB, 330 x 235 mm, 46 pp, 25 photos. Texts by d'Agata.

11 *Situations*. Rat Hole Gallery and Nobuhiko Kitamura, Tokyo, 2007 (trilingual edn: English, French and Japanese). HB w/ jkt, 275 x 220 mm, 80 pp, 62 col and b&w photos. Text by d'Agata and Guy Debord.

12 *Le Désir du Monde: Entretiens*. Éditions Téraèdre, Paris, 2008. PB, 197 x 133 mm, 122 pp, 2 col photos. Collaboration with Christine Delory-Momberger.

13 *Agonie*. Actes Sud/Atelier de Visu, Arles, 2009. HB, 240 x 180 mm, 252 pp, 62 col and b&w photos. Text by Rafael Garido.

14 *Cambodia*. Galería Rita Castellote, Madrid, 2010. PB, 200 x 150 mm, 24 pp, 12 photos. Text by Rafael Garido.

15 *Ice*. Editions Images en Manoeuvres, Marseille, 2012. HB, 226 x 168 mm, 288 pp, 151 col and b&w photos. Text by d'Agata; edited by Rafael Garido.

16 *Position(s)*. Avarie Editions, Paris, 2012 (trilingual edn: English, French and Italian). PB, 180 x 135 mm, 124 pp, 27 col and b&w photos. Text by d'Agata.

17 *Odysseia*. André Frère Editions, Marseille, 2013. HB, 212 x 165 mm, 192 pp, 100 col and b&w photos. Text by d'Agata, Bruno Le Dantec and Rafael Garido.

18 *Paraiso*. André Frère Editions, Marseille and FFIV, Valparaíso, 2013 (bilingual edn: English and Spanish). PB, 230 x 160 mm, 64 pp, 76 col photos. Text by d'Agata.

19 *Anticorps*. Editions Xavier Barral, Paris, 2013 (English edn: Prestel, London, 2014 and Japanese edn: Aka Aka Sha, Tokyo, 2013). HB, 260 x 190 mm, 560 pp, 503 col and b&w photos.

20 *Yama*. Super Labo, Kamakura, 2013 (English edn; limited edn of 500 copies). HB w/ slipcase, 300 x 200 mm, 88 pp, 80 col photos. Text by Rafael Garido.

21 *Actes: Antoine d'Agata Une présence Politique*. André Frère Editions, Marseille, 2014. HB w/ slipcase, 340 x 240 mm, 188 pp, 70 col photos. Text by Philippe Azoury, Léa Bismuth, François Cheval, Xavier Coton, Jean Baptiste Del Amo, Christine Delory-Momberger, Fannie Escoulen, Rafael Garido, Nan Goldin, Fabrice Guénier, Magali Jauffret, Bernard Marcadé, Bertrand Ogilvie, Paul Palacios-Dalens and André Rouillé.

22 *Noia*. Super Labo, Kamakura, 2014 (limited edn of 500). PB w/ slipcase, 396 x 297 mm, 36 pp. Text by d'Agata.

23 *Pornographia*. Editorial Cabaret Voltaire, Barcelona, 2014. PB, 160 x 120 mm, 256 pp, 62 photos. Novel by Jean-Baptiste Del Amo.

24 *Index*. André Frère Editions, Marseille and D. Books, Paris. 2014. PB, 180 x 135 mm, 256 pp. 1215 col photos. Text in French by d'Agata and Julio Cortazar.

25 *Angkor*. Editions JB and Editions Temple, Paris, 2014 (limited edn of 400 copies, including 73 copies with a signed print). PB, 185 x 135 mm, 192 pp, 73 photos.

26 *Fractal*. Amor Editions, Barcelona, 2014 (limted edn). HB, 250 x 340 mm, 192 pp, 96 grids of photos.

27 *Amoeba*. Super Labo, Kamakura, 2015 (limited edn of 500 copies). PB w/ slipcase, 147 x 105 mm, 16 pp, 2 photos.

28 *Fukushima*. Super Labo, Kamakura, 2015 (bilingual edn: Japanese and English; limited edn of 500 copies with signed certificates). HB w/ slipcase, 123 x 183 mm, 608 pp, 600 b&w photos. Text by d'Agata.

29 *Aithō*. Editions André Frères, Marseille, 2015. HB, 250 x 210 mm, 104 pp, 98 b&w photos. Text by Leopoldo Maria Panero and José Águedo Olivares.

30 *Eclipse*. Tbilisi Photo Festival Editions, Georgia,

2015 (bilingual edn: Georgian and English). PB, 150 x 220 mm, 220 pp, 98 col photos. Text by d'Agata.

31 *La propaganda del gesto*. Editions La Termica, Malaga, 2015. PB, 250 x 250 mm, 96 pp,

30 photos. Text by d'Agata, Bernard Marcadé, Fannie Escoulen and Rafael Garido.

32 *Désordres*. Editions Voies Off, Arles, 2015. HB, 320 x 240 mm, 144 pp, over 3,000 photos. Text and design by d'Agata.

Christopher Anderson

Anderson (b. 1970; joined Magnum in 2005) first gained recognition for his pictures in 1999 when he boarded a boat with Haitian refugees trying to sail to America. The boat sank in the Caribbean. In 2000 the images from that journey led to Anderson receiving the Robert Capa Gold Medal and they marked the emergence of an emotionally charged style that has characterized his work since. Anderson was *New York Magazine*'s first photographer-in-residence in 2012-13. His work spans the worlds of portraiture and documentary photography and directing.

8

11

3

5

1

2

3

4

1 *Nonfiction*. Consortium Book Sales, New York, 2003 (boxed paperback edn published by De.MO, Millbrook, 2004). HB, 179 x 196 mm, 104 pp, 54 col photos.

2 *Capitolio*. Editorial RM, Mexico City, 2009. HB, 298 x 332 mm, 132 pp, 89 b&w photos.

3 *Son*. Kehrer Verlag, Heidelberg, 2013. HB, 245 x 200 mm, 96 pp, 44 col photos.

4 *Stump*. Editorial RM, Mexico City, 2013. PB w/ cloth spine, 302 x 234 mm, 96 pp, 74 col and b&w photos. Text by John Heilemann.

Eve Arnold

Arnold (1912-2012; joined Magnum in 1951) first became interested in photography in 1946 while working in a photo-finishing plant in New York before later learning her skills from *Harper's Bazaar* art director Alexey Brodovitch. Arnold photographed many iconic figures in the second half of the twentieth century, yet she was equally comfortable documenting the lives of the poor and dispossessed. In 1980 she received the Lifetime Achievement Award from the American Society of Magazine Photographers and in 1993 she was made an Honorary Fellow of the Royal Photographic Society.

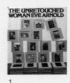

1

2

3

4

5

6

7

8

9

10

1 *The Unretouched Woman*. Alfred A. Knopf, New York, 1976. HB w/ jkt, 280 x 230 mm, 200 pp, 111 b&w and 44 col photos. Text by Arnold.

2 *Flashback! The 50's*. Alfred A. Knopf, New York, 1978. HB,

260 x 230 mm, 148 pp, 113 b&w photos. Text by Arnold.

3 *In China*. Alfred A. Knopf, New York, 1980. HB w/ jkt, 290 x 290 mm, 200 pp, 171 col photos. Text by Arnold.

4 *In America*. Alfred A. Knopf/ Secker & Warburg, New York, 1983. HB w/ jkt, 290 x 290 mm, 204 pp, 158 col photos. Text by Arnold.

5 *Marilyn Monroe: An Appreciation*. Alfred A. Knopf, New York, 1987 (also published by Hamish Hamilton, London, 1987;

in Spanish by Mondadori, Madrid, 1987; in Italian by Arnoldo Mondadori Editore, Milan, 1987; PB edn by Pan Books, London, 1989). HB w/ jkt, 285 x 239 mm, 140 pp, 70 col and b&w photos. Text by Arnold.

6 *All in a Day's Work*. Bantam Books, New York, 1989 (also published by Hamish Hamilton, London, 1990). HB w/ jkt, 275 x 235 mm, 164 pp, 150 col photos. Intro by Arnold.

7 *The Great British*. Alfred A. Knopf, New York, 1991 (published in PB as *In Britain* by Sinclair-Stevenson, London, 1991). HB w/ jkt, 280 x 235 mm, 144 pp, 25 col and 75 b&w photos. Intro by Arnold.

8 *In Retrospect*. Alfred A. Knopf, New York, 1995. HB w/ jkt, 280 x 228 mm, 288 pp, 47 col and 48 b&w photos. Text by Arnold.

9 *Ciné-Roman*. Cahiers du Cinéma, Paris, 2001 (published in English as *Film Journal* by Bloomsbury, London, 2002). HB w/ jkt, 250 x 179 mm, 256 pp, 122 b&w photos. Text by Arnold.

10 *Marilyn Monroe by Eve Arnold*. Washington Green Fine Art Publishing, Birmingham, 2005 (also published by Harry N. Abrams, New York, New York, 2005). HB w/ jkt, 280 x 280 mm, 160 pp, 98 col and b&w photos. Text by Arnold.

3 *Jewish Sites in Lebanon*. Moreshet Erets-Yisrael/Ariel Publishing, San Antonio, 1984. PB w/ jkt, 340 x 245 mm, 62 pp, 63 b&w photos.

4 *The Last War*. Keter Publishing House, Jerusalem, 1996 (Hebrew edn). HB w/ jkt, 315 x 253 mm, 256 pp, 133 b&w photos. Text by Michael Levin, Annabelle Melzer, Yeshayahu Nir and José Saramago.

5 *Israel: A Photobiography, the First Fifty Years*. Simon & Schuster, New York, 1998. HB w/ jkt, 336 x 260 mm, 200 pp, 140 b&w photos. Essay by Thomas Friedman.

6 *Our Daily Bread: Photographs from Israel*. University of Berkeley's Graduate School of Journalism Center for Photography, Berkeley, 2003. PB, 267 x 307 mm, 32 pp, 22 b&w photos and a contact sheet.

7 *Insight: Micha Bar-Am's Israel*. Walter König, Cologne, 2011. HB w/ jkt, 297 x 232 mm, 336 pp, 204 col and b&w photos. Edited and text by Alexandra Nocke; foreword by Gisela Dachs and Stef Wertheimer; intro by Ruthi Ofek.

8 *Southward*. The Negev Museum of Art, Beer Sheva, 2013 (Hebrew, English and Arabic edn). HB, 195 x 213 mm, 154 pp, 62 b&w and 12 col photos.

9 *Dividing Line: Photographs from the Yom Kippur War*. The Tel Aviv Museum of Art, Tel Aviv, 2013. HB, 220 x 165 mm, 92 pp, 30 b&w and 12 col photos.

10 *Seashore*. Haifa Museums/The National Maritime Museum, Haifa, Israel, 2015. PB, 215 x 240 mm, 48 pp, 35 b&w and 14 col photos.

Olivia Arthur

Based in London, Arthur (b. 1980; joined Magnum in 2008) began working as a photographer in 2003 after moving to Delhi. In 2006 she left for Italy to take up a residency with Fabrica, during which she began working on a series about women and the East-West cultural divide. This work has taken her to the border between Europe and Asia, Iran and Saudi Arabia. She is the co-founder of Fishbar, a publisher and photography space in London.

1　2

1 *Jeddah Diary*. Fishbar, London, 2012. HB, 221 x 180 mm, 120 pp, 63 col photos. Text by Olivia Arthur.

2 *Stranger*. Fishbar, London, 2015 (limited edn of 1,000 copies). HB w/ translucent pages, 190 x 252 mm, 224 pp, 89 col and b&w photos. Edited with Philipp Ebeling.

Micha Bar-Am

Micha Bar-Am (b.1930; joined Magnum in 1968) is an Israeli photographer. His images cover every aspect of life in Israel in the past sixty years, including the 1956 Sinai War and the Six-Day War in 1967. From 1968 to 1992, he was the *New York Times* photographic correspondent from Israel and from 1977 to 1993 he was curator of photography at Tel Aviv Museum. His work is held in numerous museums and collections throughout the world.

1　2　3　4

5　6　7　8

9　10

(bilingual edn: Hebrew and English). HB, 234 x 212 mm, 80 pp, 57 b&w photos. Photos by Micha Bar-Am and Azaria Alon; intro by Yohanan Aharoni and Azaria Alon.

2 *The Jordan*. Massada, Tel Aviv, 1981 (German edn: Der Jordan by Edition Erpf, Bern, 1983). HB w/ jkt, 260 x 260 mm, 100 pp, 44 b&w and 44 col photos.

1 *Across Sinai*. Hakibbutz Hameuchad Publishing House and Lamerhav, Tel Aviv, 1957

Bruno Barbey

Barbey (b. 1941; joined Magnum in 1964) studied photography and graphic arts at L'Ecole des Arts et Métiers in Vevey, Switzerland. In the 1960s, he photographed the Italians with the aim of capturing the nation's spirit, and in 1968 he documented the political unrest and riots in Paris and Tokyo. Rejecting the term 'war photographer', over five decades Barbey has travelled across continents and photographed numerous conflicts. Known for his free and harmonious use of colour, Barbey has frequently worked in Morocco, his childhood country, and books and exhibitions are a key part of his practice. The recipient of many awards, including the French National Order of Merit, in 2016 he was elected as member of the French Academy of Fine arts.

1　2　3　4

5　6　7　8

9　10　11　12

13　14　15　16

17　18　19　20

21 22 23 24

25 26 27 28

29 30

1 *Naples*. Editions Rencontre, Lausanne, 1964 (French edn). HB, 275 x 175 mm, 208 pp, 118 b&w photos. Text by Philippe Daudy.

2 *Camargue*. Editions Rencontre, Lausanne, 1965 (French edn). HB, 275 x 175 mm, 192 pp, 120 b&w and col photos. Text by Yvan Audouard.

3 *Bugey*. Editions Rencontre, Lausanne, 1965 (French edn). HB, 275 x 175 mm, 192 pp, 64 b&w and col photos. Text by Suzanne Tenand.

4 *Kenya*. Editions Rencontre, Lausanne, 1966 (French edn). HB, 275 x 175 mm, 192 pp, 120 b&w and col photos. Text by Claudine LaHaye.

5 *Portugal*. Editions Rencontre, Lausanne, 1966 (French edn). HB, 275 x 175 mm, 192pp, 123 b&w and col photos. Text by Gilbert Ganne.

6 *Koweit*. Editions Rencontre, Lausanne, 1967 (French edn). HB, 275 x 175 mm, 192pp, 140 b&w and col photos. Text by Meric Dobson.

7 *Ecosse*. Editions Rencontre, Lausanne, 1968 (French edn). HB, 275 x 175 mm, 192 pp, 120 b&w and col photos. Text by Paulette Decraene.

8 *Ceylan, Sri Lanka*. Editions André Barret, Paris, 1974. HB w/ jkt, 310 x 240 mm, 100 pp, 75 b&w and col photos. Text by Jacques Milley, Emmanuel Geais and André Barret.

9 *L'Iran pérennité et renaissance d'un empire*. Editions Jeune Afrique, Paris, 1976 (also published in English as *Iran: Rebirth of a Timeless Empire*). HB w/ jkt, 300 x 260 mm, 290 pp, 105 col photos. Text by René Maheu and Jean Boissel.

10 *Nigeria: Magic of a Land*. Editions Jeune Afrique, Paris, 1978 (published in French as *Nigeria du réel à l'imaginaire*). HB w/ jkt, 310 x 259 mm, 190 pp, 53 col photos. Text by Ola Balogun.

11 *Bombay*. Time Life Books, Amsterdam, 1979. HB w/ jkt, 300 x 240 mm, 200 pp, 33 col photos. Text by Dom Moraes.

12 *Pologne*. Editions Arthaud, Paris, 1982 (published in English as *Portrait of Poland* by Thames & Hudson, London; in German as *Polen* by Hoffmann & Campe, Hamburg; and PB edn, 1982). HB w/ jkt, 315 x 230 mm, 176 pp, 78 col photos. Collaboration with Bernard Guetta; preface by Czesław Miłosz; anthology compiled by Jan Krok-Paszkowski.

13 *Le Gabon*. Editions du Chêne, Paris, 1984. HB w/ jkt, 315 x 234 mm, 118 pp, 63 col photos.

14 *Portugal*. Collection Merian and Hoffmann & Campe, Hamburg, 1988 (German edn). HB, 280 x 205 mm, 54 pp, 39 col photos. Text by Stefan Reisner.

15 *FÈS: Immobile, Immortelle*. Editions Imprimerie Nationale, Paris, 1996. HB w/ jkt, 340 x 350 mm, 150 pp, 113 col photos. Text by Tahar Ben Jelloun and Mohamed Bennouna; commentary by Catherine and Ali Amahan.

16 *Gens des Nuages*. Editions Stock, Paris, 1997 (Korean edn published by Munhag, 2001). PB, 270 x 210 mm, 118 pp, 31 col photos. Text by Jemia and J.M.G. Le Clézio.

17 *Mai 68*. Galerie Beaubourg and Editions de la différence, Paris, 1998. PB, 240 x 210 mm, 168 pp, 36 b&w photos.

18 *Essaouira*. Editions du Chêne, Paris, 2001. HB w/ jkt, 250 mm x 250 mm, 176 pp, 87 col photos. Intro by Morgan Sportes.

19 *Le Paris de Sartre et Beauvoir: Photographies du Paris d'aujourd'hui*. Editions du Chêne, Paris, 2001 (published in German as *Simone de Beauvoir und Jean Paul Sartre in Paris*, Gerstenberg, Hidesheim, 2001). HB, 250 x 250 mm, 168 pp, 56 col and 12 b&w photos. Text by Jean-Luc Moreau.

20 *Les Italiens*. Editions de la Martinière, Paris, 2002 (published in English as *The Italians* by Harry N. Abrams, New York, 2002; and in paperback by Contrasto, Milan, 2015). HB w/ jkt, 280 x 285 mm, 120 pp, 96 b&w photos. Text by Tahar Ben Jelloun.

21 *Maroc* by Editions de la Martinière, Paris, 2003 (published in English as *My Morocco*, Thames & Hudson, London, 2003; in German as *Marokko* by Knesebeck, Munich, 2004). HB w/ jkt, 250 x 371 mm, 180 pp, 95 col photos. Text by Jemia and J.M.G. Le Clézio.

22 *Bruno Barbey 68*. Editions Cajasol, Córdoba, 2008 (also published in French by Creaphis, Paris, 2008). PB, 280 x 240 mm, 182 pp, 118 b&w and col photos. Text by Juan Bosco Diaz Urmeneta and Bernard Chambaz (coincided with a short film by Caroline Thienot Barbey).

23 *Bruno Barbey 1968*. Editions Fotografevi, Istanbul, 2008. PB, 240 x 300 mm, 184 pp, 107 b&w photos. Text by Roni Margulies, Igo Barbey, Ara Guler and Vedat Turkali.

24 *Oman 1971*. The Empty Quarter Gallery, Dubai, 2010. PB w/ jkt and fold-out pages, 286 x 205 mm, 126 pp, 67 col photos.

25 *Shanghai*. Editions C.D.P., Malakoff, 2010 (limited edn of 100 copies). HB w/ slipcase, 200 x 295 mm, 142 pp, 70 col photos. Preface by Serge Lipao.

26 *China in Kodachrome 1973-1980*. Beaugeste Photo Gallery, Shanghai and International Publishing House for China's Culture, Washington DC, 2012. PB, 210 x 140 mm, 120 pp, 61 col photos.

27 *Chine*. Les Editions du Pacifique, Paris, 2014. HB w/ jkt, 280 x 210 mm, 184 pp, 118 col photos. Intro by Jean Loh.

28 *Passages*. Editions de la Martinière, Paris, 2015 (published in Chinese by Post Wave Publishing, Beijing, 2016). HB, 590 x 320 mm, 384 pp, 347 b&w and col photos. Text by Carole Naggar; preface by Jean-Luc Monterosso.

29 *China: From Mao to Modernity*. Editions Didier Millet, Singapore, 2015. HB, 280 x 210 mm, 184 pp, 118 b&w and col photos. Foreword by Jonathan Fenby.

30 *China in Kodrachrome 1973-1989*. Poste Wave, Beijing, 2016. HB, 230 x 240 mm, 150 pp, 300 photos.

Jonas Bendiksen

Bendiksen (b.1977; joined Magnum in 2004) began his career at the age of 19 as an intern at Magnum's London office, before leaving for Russia to pursue his own work as a photographer. The recipient of numerous awards, including the 2003 Infinity Award from the International Center of Photography and first prize in the Pictures of the Year International Awards, Bendiksen has always enjoyed a mixture of his own personal long-term projects and commissions. His photographs have appeared in *National Geographic*, *Geo*, *Newsweek*, and the *Sunday Times Magazine*, among others. He lives in Oslo with his wife and two children.

1 2

1 *Satellites: Photographs from the Fringes of the Former Soviet Union*. Aperture, New York, 2006 (also Dutch edn by Mets & Schilt, Amsterdam; French edn by Editions Textuel, Paris; and Italian edn by Contrasto, Rome). HB, 235 x 176 mm, 152 pp, 62 col photos. Text by Jonas Bendiksen.

2 *The Places We Live*. Aperture, New York, 2008 (English edn; also published in Dutch, French, Italian, Norwegian, German and Swedish). HB, 151 x 194 mm, 196 pp, 130 col photos. Texts by Jonas Bendiksen and Philip Gourevitch.

Ian Berry

Berry (joined Magnum in 1962) made his reputation as a photojournalist reporting from South Africa, where he worked for the *Daily Mail* and *Drum* magazine. He documented the Sharpeville massacre in 1960 and his photographs were used in the trial to prove the victims' innocence. While based in Paris in 1962 he was invited to join Magnum by Henri Cartier-Bresson, before he moved to London to become the first contract photographer for the *Observer Magazine*. With numerous awards to his name, Berry has covered conflicts in Congo, Ireland and Vietnam, the famine in Ethiopia and apartheid in South Africa, and the political and social transformations in China and the former USSR.

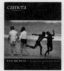
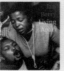
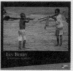

1 2 3 4

1 *The English*. Allen Lane, Penguin Books Ltd., London, 1978. HB w/ jkt, 245 x 225 mm, 112 pp, 100 b&w photos. Foreword by Ian Berry.

2 *Black & Whites: L'Afrique du Sud de Ian Berry*. Camera International, Paris, 1988. PB, 300 x 240 mm, 82 pp, 56 b&w photos. Text by François Mitterrand.

3 *Living Apart: South Africa under Apartheid*. Phaidon Press, London, 1996. HB w/ jkt, 290 x 250 mm, 254 pp, 218 b&w photos. Foreword by Archbishop Desmond M Tutu.

4 *Sold into Slavery*. Editions CDP, Malakoff, 2008. HB, 210 x 210 mm, 64 pp, 41 b&w photos.

Werner Bischof

Werner Bischof (1916–54; joined Magnum Photos in 1949) became a member of the Allianz group of artists and published his first major photo essays from 1943, and began to document post-war Europe between 1945 and 1950 under commission by Schweizer Spende. He gained international recognition by photographing the famine in Bihar, India, in 1951, and later travelled to Asia, South America and the US as a photographer for Magnum Photos and *LIFE* magazine. He died in 1954 in the Peruvian Andes.

1

2

3

4

5

3 *Mutter und Kind*. Migros Genossenschafts Bund, Zurich, 1949. PB, 225 x 200 mm, 190 pp, 109 b&w and col photos (32 photos by Bischof). Text by Walter Robert Corti.

4 *Das Eidgenössische Gestüt in Avenches*. Conzett & Huber, Zurich, 1954. HB w/ jkt, dimensions, 230 x 300 mm, 38 pp, 24 b&w photos. Text Jacques Baumann.

5 *Japon*. Editions Delpire, Paris, 1954 (English edn: Simon & Schuster, New York, 1954). HB w/ jkt, 278 x 223 mm, 158 pp, 109 b&w and col photos. Text by Robert Guillain.

1 *Das Kleine Spielzeugbuch*. Verlag Amstutz & Herdeg Zurich, Leipzig, 1945. PB, 178 x 128 mm, 48 pp, 38 b&w photos. Text by Alice Marcet.

2 *24 Photos*. L.M. Kohler, Bern, 1946. HB portfolio w/ ties, 305 x 236 mm, 46 pp, 24 b&w photos. Intro by Manuel Gasser.

Brian Brake

Brian Brake (1927–88; member of Magnum 1957–67) began his career as a portrait photographer in Wellington, New Zealand, and joined the National Film Unit in 1948. He moved to London in 1954, where he met Magnum photographers Ernst Haas and Henri Cartier-Bresson, joining the agency in 1957. Brake published internationally in *LIFE*, *Queen* and *Paris Match*, and in 1970 founded Zodiac Films in Hong Kong. In 1985 he helped to establish the New Zealand Centre for Photography.

1

2

1 *New Zealand: Gift of the Sea*. Whitcombe and Tombs, Christchurch, 1963 (second edn: Hodder & Stoughton, Auckland, 1990). HB w/ jkt, 292 x 229 mm, 150 pp, 104 b&w and col photos. Text by Maurice Shadbolt.

2 *Monsoon*. David Bateman, Albany, 2007. HB w/ jkt, 252 x 250 mm, 184 pp, 132 col photos. Foreword by Sir Edmund Hillary; afterword by Asoke Roy Chowdhury.

Michael Christopher Brown

Michael Christopher Brown (b.1978; joined Magnum in 2013) was raised in the Skagit Valley in Washington State, USA. Ongoing work explores the electronica music and youth scene in Havana, Cuba and the conflict in the Democratic Republic of Congo. In 2009–10 he made a photographic series from road and train trips in China, and in 2011 he worked on a project exploring the ethics and iconography of warfare while using a phone camera during the Libyan Revolution. A contributing photographer to *National Geographic* and *The New York Times Magazine*, among other publications, Brown was subject of the 2012 HBO documentary *Witness: Libya*.

1

1 *Libyan Sugar*. Twin Palms Publishers, Sante Fe, 2016 (limited edn of 1,000 copies). HB w/ cloth spine, 254 x 175 mm, 412 pp, 284 col photos. Text by Brown.

René Burri

Burri (1933–2014; joined Magnum in 1955) studied at the School of Arts and Crafts in Zurich. He first used a Leica camera during his military service. From 1953–55 he worked as a documentary filmmaker. His first reportage appeared in *LIFE* magazine and he subsequently worked for news magazines including *Look*, *Stern*, *Geo*, *Paris Match* and *Du*. Burri received the Dr Erich Salomon Prize in 1998 for his lifetime achievement in photojournalism.

1

2

3

4

5

6

7

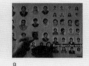
8

9

10

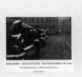
11

12

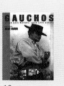
13

14

15

16

17

18

19

20

21

22

23

24

25 26 27 28

29 30

René Burri (continued)

1 *Die Deutschen*. Fretz & Wasmuth Verlag, Zurich/Stuttgart, 1962 (French edn: *Les Allemands* by Robert Delpire, Paris, 1963). HB w/ jkt, 185 x 210 mm, 168 pp, 88 b&w photos. Text extracts by Heinrich Böll, Bertolt Brecht, Max Frisch, Wolfgang Koeppen, Friedrich Sieburg, Diether Stolze and others.

2 *Brasilien*. Editions Rencontre, Lausanne, 1963. HB, 270 x 170 mm, 202 pp, 100 b&w photos. Text by Marcel Niedergang.

3 *The Gaucho*. Crown Publishers, New York, 1968 (also published by Macdonald, London, 1968; Spanish edn: *El Gaucho*, Muchnik Editores, Buenos Aires, 1968). HB w/ jkt, 295 x 238 mm, 176 pp, 125 b&w photos. Foreword by Jorge Luis Borges; text by José Luis Lanuza.

4 *La Grèce*. SNEP (Société Nouvelle Europe Promotion), Paris, 1974. HB w/ jkt, 240 x 240 mm, 128 pp, 115 col photos. Text by Jacques van den Bossche.

5 *Lost Pony*. San Francisco Book Company, San Francisco, 1976. HB w/ jkt, 190 x 250 mm, 110 pp, 60 b&w photos. Text by George Mendoza.

6 *Im Heiligen Land*. Reich Verlag, Lucerne, 1979 (also published in English and Spanish). HB, 250 x 190 mm, 158 pp, 104 col photos. Text by V.H. Morton and Odilo Kaiser.

7 *Mostra di Picasso*. Contrasto, Milan, 1983 (original edn by Burri in 1953; facsimile edn: *Fotografie1950/2000*, Palazzo dell' Arengario, Milan, 2005). PB, 260 x 210 mm, 48 pp, 26 b&w photos.

8 *René Burri: One World*. Benteli, Bern, 1984. HB, 234 x 292 mm, 210 pp, 134 b&w and 14 col photos. Text by René Burri, Guido Magnaguagno, Hans Puttnies, Hans Koning, Willy Rotzler and Charles-Henri Favrod.

9 *Von Photographen Gesehen: Alberto Giacometti*. Bündner Kunstmuseum, Chur, 1986 (French & German edns). PB, 270 x 210 mm, 152 pp, 159 b&w photos. Intro by Franz Meyer.

10 *Ein Amerikanischer Traum: Fotografien aus der Welt der NASA und des Pentagon*. Franz Greno, Nördlingen, 1986. PB, 260 x 270 mm, 140 pp, 110 col photos.

11 *Die Deutschen: Photographien 1957-1964* (revised edn). Schirmer/Mosel, Munich, 1986 (later and PB edns: 1990 and 1999). HB w/ jkt, 266 x 254 mm, 118 pp, 88 b&w photos. Text by Hans Magnus Enzenberger.

12 *Dialogue avec Le Corbusier*. Espace Art & Culture Ebel for Editions Glasnost, Basel, 1990. HB, 280 x 220 mm, 20 pp, 10 b&w photos. Text by Daniel Schwartz and René Burri.

13 *Gauchos* (revised edn). Takarajima, New York, 1994. HB w/ jkt, 298 x 220 mm, 112 pp, 60 b&w photos. Foreword by Jorge Luis Borges; text by José Luis Lanuza.

14 *77 Strange Sensations*. Edition Dino Simonett, Zurich, 1998 (part of a trilogy with *Berner Blitz* and *Nous Sommes Treize à Table*). HB, 304 x 228 mm, 72 pp, 54 b&w photos. Text by Barry Gifford.

15 *Le Corbusier: Photos by Rene Burri: Moments in the Life of a Great Architect*. Birkhäuser, Zurich, 1999. HB, 234 x 296 mm, 182 pp, 200 b&w and col photos. Edited and texts by Arthur Rüegg.

16 *Albert Jaquard Dall'Angoscia alla Speranza: Una Lezione di Ecologia Uman*. Mendrisio Academy Press, 1999. PB, 240 x 240 mm, 148 pp, 138 photos. Text by Albert Jacquard.

17 *Luis Barragán*. Phaidon Press, London, 2000. HB, 223 x 115 mm, 80 pp, 24 b&w photos; 27 col illus.

18 *Berner Blitz*. Edition Dino Simonett, Zurich, 2002 (edn of 3,000 copies; part of a trilogy with *77 Strange Sensations* and *Nous Sommes Treize à Table*). HB, 167 x 232 mm, 176 pp, 112 col photos.

19 *René Burri: Photographs*. Phaidon Press, London, 2004 (also published in French, German, Italian and Spanish; and PB, 2007). HB, 300 x 230 mm, 448 pp, 378 b&w photos, 44 col photos. Text by Hans-Michael Koetzle.

20 *Face à Face*. Museum Jean Tinguely, Basel and Benteli Verlag, Bern, 2005 (German edn). PB, 210 x 160 mm, 86 pp, 60 photos.

21 *Nous Sommes Treize à Table*. Edition Dino Simonett, Andeer, 2008 (part of a trilogy with *77 Strange Sensations* and *Berner Blitz*). HB, 295 x 225 mm, 64 pp, 13 b&w and 25 col photos, 12 illus. Text by Dino Simonett.

22 *Un Mundo*. Ediciones Aurelia, San Francisco, CA, 2008. PB, 300 x 240 mm, 124 pp, 97 b&w photos.

23 *Blackout New York*. Moser Verlag, Munich, 2009. HB, 342 x 249 mm, 80 pp, 40 b&w photos. Text by Hans-Michael Koetzle.

24 *Brasilia*. Scheidegger & Spiess, Zurich, 2011. HB, 310 x 230 mm, 224 pp, 118 b&w and 104 col photos. Text by Arthur Rüegg, René Burri and Clarice Lispector; edited by Arthur Rüegg.

25 *René Burri: Le Corbusier Intime*. Villa 'Le Lac' Le Corbusier, Corseaux, 2011. PB, 220 x 180 mm, 76 pp, 36 b&w photos.

26 *René Burri: Impossible Reminiscences*. Phaidon Press, London, 2013. HB w/ jkt, 315 x 280 mm, 240 pp, 172 col photos. Text by René Burri and Hans Michael Koetzle.

27 *René Burri: Utopia*. Editions de Penthes, Geneva, 2013. HB, 240 x 180 mm, 190 pp, 83 b&w photos and 15 col photos.

28 *Projet Corrida*. Editions de Penthes, Geneva, 2013. HB, 240 x 176 mm, 72 pp, 12 b&w and 72 col photos. Collaboration with Marco D'Anna.

29 *Dialogues 'The Iconic Photos'*. Projecto Group, Lausanne, 2014. HB, 245 x 180 mm, 138 pp, 85 b&w photos. Text by Hans-Michael Koetzle.

30 *Mouvement*. Steidl, Göttingen and Diogenes Verlag, Zurich, 2016. Two volumes w/ slipcase, 216 x 300 mm, 300 pp, 138 col and b&w photos.

Cornell Capa

Cornell Capa (1918-2008; joined Magnum in 1954) was born Cornell Friedmann to a Jewish family in Budapest. Capa moved to New York, where in 1938 he began working in the darkroom at *LIFE* magazine. Subsequently, he travelled to the UK, USSR and South America as a *LIFE* photographer. As both a photographer and photo editor, Capa mounted exhibitions and authored several books, including *Farewell to Eden* (1964), a study of the destruction of indigenous Amazon cultures, and *The Concerned Photographer* (1968). President of Magnum from 1956 to 1960, Capa also directed and founded the International Center of Photography in New York. In 1999 he received a Lifetime Achievement Award in Photography from the Aperture Foundation.

1 2 3 4

5 6 7

1 *Retarded Children Can Be Helped*. Channel Press, New York, 1957. HB, 206 x 130 mm, 160 pp, 115 b&w photos. Text by Maya Pines.

2 *Farewell to Eden*. Harper & Row, New York, 1964. HB w/ jkt, 280 x 216 mm, 244 pp, 148 b&w and col illus. Text by Matthew Huxley.

3 *Adlai Stevenson's Public Years*. Grossman Publishers, New York, 1966. HB w/ jkt, 280 x 214 mm, 160 pp, 82 b&w photos. Text by Adlai Stevenson; Walter Lippmann; w/ additional photos by John Fell Stevenson (23) and Inge Morath (6).

4 *The Emergent Decade: Latin American Painters and Painting in the 1960s*. Cornell University Press, Ithaca, NY, 1966. HB w/ jkt and PB, 340 x 240 mm, 172 pp, 14 col & 200 b&w illus. Text by Thomas M. Messer.

5 *New Breed on Wall Street*. Collier-Macmillan, New York, 1969. HB w/ jkt, 300 x 220 mm, 128 pp, 126 b&w photos. Text by Martin Mayer.

6 *Margin of Life: Population and Poverty in the Americas*. Grossman Publishers, New York, 1974. PB, 240 x 200 mm, 192 pp, 139 b&w photos. Text by J. Mayone Stycos.

7 *Cornell Capa: Photographs*. Bulfinch Press/Little, Brown & Co., Boston, 1992. HB w/ jkt, 279 x 248 mm, 116 pp, 163 b&w photos and 16 illus. Edited with Richard Whelan.

Robert Capa

Robert Capa (1913-54; co-founded Magnum in 1947) was born in Budapest to a Jewish family; he studied political science in Berlin and settled in Paris in 1933. His coverage of the Spanish Civil War, with Gerda Taro, appeared regularly in international magazines. His picture of a fatally wounded Loyalist soldier earned him an international reputation and became an iconic antiwar symbol. Capa travelled to China in 1938 and emigrated to New York a year later. As a correspondent in Europe, he documented the Second World War. In the postwar years, he travelled widely across Europe for American and European magazines, including a long stay in the USSR in 1947 and three trips to Israel in 1948-50. He died when he stepped on a landmine while photographing for *LIFE* in Thai-Binh, Indochina.

1

2

3

4

5

6

7

8

1 *Madrid*. Generalitat de Catalunya, 1937. PB, 298 x 235 mm, 96 pp, 110 b&w photos. Photos by Capa, Gerda Taro and David 'Chim' Seymour and others.

2 *Death in the Making*. Covici-Friede, New York, 1938. HB w/ jkt, 285 x 210 mm, 98 pp, 148 b&w photos. Preface by Jay Allen; photos by Capa, Gerda Taro and David 'Chim' Seymour.

3 *The Battle of Waterloo Road*. Random House, New York, 1941. HB w/ jkt, 304 x 224 mm, 124 pp, 111 b&w photos. Text by Diana Forbes-Robinson.

4 *Invasion!* Appleton-Century, New York, 1944. HB w/ jkt, 191 x 130 mm, 168 pp, 15 b&w photos. Text by Charles Christian Wertenbaker.

5 *Slightly Out of Focus*. Henry Holt, New York, 1947 (also various language edns; second edn

with an intro by Richard Whelan, Modern Library, New York, 1999). HB w/ jkt, 235 x 170 mm, 248 pp, 117 b&w photos. Text by Capa.

6 *A Russian Journal*. Viking Press, New York, 1948 (also various language edns published between 1948 and 1950). HB w/ jkt, 239 x 159 mm, 220 pp, 69 b&w photos. Text by John Steinbeck.

7 *This is Israel*. Boni and Gaer, New York, 1948. HB, 228 x 165 mm, 128 pp, 100 b&w photos & 7 maps. Foreword by Bartley C. Crum, text by I.F. Stone and photos by Capa, Jerry Cooke and Tim Gidal.

8 *Report on Israel*. Simon and Schuster, New York, 1950. PB, 269 x 170 mm, 144 pp, 91 b&w photos. Text by Irwin Shaw.

Henri Cartier-Bresson

After discovering the Leica in 1932, Henri Cartier-Bresson (1908-2004; co-founded Magnum in 1947) had his first exhibition in 1933 and pursued his photographic career in Europe and Mexico. He later collaborated with Jean Renoir to make three documentaries about the Spanish Civil War. Taken prisoner of war in 1940, he escaped in 1943. In 1944 he created a series of portraits of artists. He co-founded Magnum Photos in 1947 before travelling in the East for three years and in 1954 he became the first foreign photographer admitted into the USSR. One of the most influential photographers of the twentieth century, Cartier-Bresson's photography married both geometric abstraction and artful composition, with an intuitive and spontaneous style. He pioneered what became known as 'the decisive moment'. He began to reduce his photographic activities in 1974, concentrating on drawing. In 2003 he established the HCB Foundation in Paris.

1

2

3

4

5

6

7

8

9

10

11

12

13

14

15

16

17

18

19

20

21

22

23

24

25

26

27

1 *The Photographs of Henri Cartier-Bresson*. The Museum of Modern Art, New York, 1947. HB w/ jkt, 257 x 194 mm, 56 pp, 42 b&w photos. Text by Lincoln Kirstein.

2 *Beautiful Jaipur*. The Times of India Press, Bombay, 1948. HB w/ jkt, 243 x 165 mm, 76 pp, 64 b&w photos photos.

3 *Images à la Sauvette*. Editions Verve, Paris, 1952 (English edn: *The Decisive Moment*, Simon and Schuster, New York, 1952; facsimile edn: Steidl, Göttingen, 2014; with booklet with text by Clément Chéroux). HB w/ jkt, 370 x 274 mm, 158 pp, 126 b&w photos. Cover illus by Henri Matisse; intro by Cartier-Bresson and afterword by Richard Simon.

4 *Les Danses à Bali*. Editions Delpire, Paris, 1954. HB w/ jkt, 178 x 127 mm, 124 pp, 46 b&w photos. Text by Antonin Artaud.

5 *D'une Chine à l'Autre*. Editions Delpire, Paris, 1954 (English edn: *From One China to the Other*, Universe Books, New York, 1956). HB w/ jkt, 270 x 215 mm, 164 pp, 144 b&w photos. Text by Jean-Paul Sartre.

6 *Moscou: Vu par Henri Cartier-Bresson*. Editions Delpire, Paris, 1955 (English edn: *The People of Moscow: As Seen and Photographed by Henri Cartier-Bresson*, Simon and Schuster, New York, 1955). HB w/ jkt, 270 x 215 mm, 180 pp, 163 b&w photos. Foreword by Cartier-Bresson.

7 *Les Européens*. Editions Verve, Paris, 1955 (English edn: *The Europeans*, Simon and Schuster, New York, 1955). HB w/ jkt, 370 x 274 mm, 134 pp, 114 b&w photos. Cover designed by Joan Miró; text by Cartier-Bresson.

8 *Photographies d'Henri Cartier-Bresson*. Editions Delpire, Paris, 1963 (English edn: *Photographs by Cartier-Bresson*, Grossman Publishers, New York, 1963). HB, 230 x 190 mm, 66 pp, 47 b&w photos. Text by Cartier-Bresson.

9 *Flagrants Délits*. Editions Delpire, Paris, 1968 (English edn: *The World of Henri Cartier-Bresson*, The Viking Press, New York, 1968). HB, 305 x 280 mm, 210 pp, 210 b&w photos. Text by Cartier-Bresson.

10 *Man and Machine*. IBM World Trade Corporation, New York,

1969 (also published by Viking Press, New York, 1971). HB w/ jkt, 267 x 305 mm, 116 pp, 106 b&w photos.

11 *Vive La France*. Reader's Digest and Robert Laffont, Paris, 1970 (English edn: *Cartier-Bresson's France*, Thames & Hudson, London, 1970). HB w/ jkt, 315 x 250 mm, 288 pp, 245 b&w and 17 col b&w photos. Text by François Nourissier.

12 *The Face of Asia*. Weatherhill, New York and Orientations, Hong Kong, 1972 (also published by Viking Press, New York, 1972). HB w/ jkt, 292 x 216 mm, 206 pp, 175 b&w photos. Intro by Robert Shaplen.

13 *A Propos de l'U.R.S.S.* Editions du Chêne, Paris, 1973 (English edn: *About Russia*, Thames & Hudson, London, 1974). HB w/ jkt + PB, 267 x 245 mm, 180 pp, 141 b&w photos.

14 *Henri Cartier-Bresson: Photographe*. Editions Delpire, Paris, 1979 (English edn: *Henri Cartier-Bresson: Photographer*, Robert Delpire for the International Center of Photography, Paris, 1979). HB w/ jkt, 292 x 302 mm, 338 pp, 155 b&w photos. Foreword by Yves Bonnefoy.

15 *Paris à Vue d'Oeil*. Paris Audiovisuel and Association des Amis du Musée Carnavalet, Paris, 1984. PB, 240 x 220 mm, 52 pp, 133 b&w photos. Text by André Pieyre de Mandiargues and Véra Feyder.

16 *Henri Cartier-Bresson en Inde*. Centre National de la Photographie, Paris, 1985 (English edn: *Henri Cartier-Bresson In India*, Thames & Hudson, London, 1987). PB, 260 x 280 mm, 98 pp, 39 b&w photos. Intro by Satyajit Ray; text by Yves Véquaud.

17 *Henri Cartier-Bresson: Photoportraits*. Gallimard, Paris, 1985 (English edn: Thames & Hudson, London, 1985). PB, 290 x 250 mm, 288 pp, 255 b&w photos. Text by Andre Pieyre de Mandiargues.

18 *Henri Cartier-Bresson: The Early Work*. The Museum of Modern Art, New York, 1987 (also published in PB). HB w/ jkt, 248 x 260 mm, 152 pp, 87 b&w photos. Text by Peter Galassi.

19 *L'Amérique Furtivement*. Editions du Seuil, Paris, 1991 (English edn: *America in Passing*, Thames & Hudson, London, 1991).

20 *Paris à Vue d'Oeil*. Editions du Seuil, Paris, 1994 (English edn: *A propos de Paris*, Bulfinch Press, Boston, 1994; also published in PB). HB w/ jkt, 260 x 240 mm, 168 pp, 131 b&w photos. Texts by André Pieyre de Mandiargues and Véra Feyder.

21 *Carnets Mexicains 1934–1964*. Editions Hazan, Paris, 1995 (English edn: Thames & Hudson, London, 1995). HB w/ jkt, 215 x 235 mm, 88 pp, 54 b&w photos. Text by Carlos Fuentes.

22 *L'Art Sans Art d'Henri Cartier-Bresson*. Flammarion, Paris, 1995 (English edn: *Henri Cartier-Bresson and the Artless Art*, Thames & Hudson, London, 1996). HB w/ jkt, 345 x 248 mm, 328 pp, 289 b&w photos and drawings. Text by Jean-Pierre Montier.

23 *Henri Cartier-Bresson: des Européens*. Maison Européenne de la Photographie and Editions du Seuil, Paris, 1997 (English edn: *Henri Cartier-Bresson: Europeans*, Thames & Hudson, London, 1998). HB w/ jkt, 305 x 248 mm, 232 pp, 183 b&w photos. Text by Jean Clair.

24 *Tête à Tête: Portraits by Henri Cartier-Bresson*. Thames & Hudson, London, 1998. HB w/ jkt, 300 x 240 mm, 152 pp, 134 b&w photos and 8 drawings. Text by Sir Ernst H. Gombrich.

25 *Henri Cartier-Bresson: Paysages*. Editions Delpire Editeur, Paris, 2001 (English edn: *Henri Cartier-Bresson: Landscape Townscape*, Thames & Hudson, London, 2001). PB w/ jkt, 295 x 285 mm, 240 pp, 105 b&w photos. Texts by Erik Orsenna and Gérard Macé.

26 *Henri Cartier-Bresson: de qui s'agit-il?* Editions BnF and Gallimard, Paris, 2003 (English edn: *Henri Cartier-Bresson: The Man, the Image and the World. A Retrospective*, Thames & Hudson, London, 2003). HB w/ jkt, 260 x 280 mm, 432 pp, 476 b&w photos and 127 illus. Text by Philippe Arbaizar, Jean Clair, Claude Cookman, Robert Delpire, Jean Leymarie, Jean-Noël Jeanneney and Serge Toubiana.

27 *Cartier-Bresson Au Crayon*. Buchet/Chastel, Paris, 2004. PB, 280 x 220 mm, 160 pp, 5 b&w photos and 124 drawings. Text by Frédéric Pajak.

Chien-Chi Chang

Chien-Chi Chang (b.1961; joined Magnum in 1995) explores in his work the abstract concepts of alienation and connection. He draws on his own Taiwanese immigrant experience, both in the United States and Austria. For over 25 years, Chang has photographed the bifurcated lives of Chinese immigrants in New York's Chinatown, along with those of their wives and families back home in Fujian, China. Chang also incorporates sound into many of his projects.

1　2　3　4

1 *I do, I do, I do*. Ivy Liu and Premier Foundation, Taipei, 2001. HB, 254 x 254 mm, 120 pp, 55 b&w photos. Essay by Cheryl Lai; foreword by Sarina Yeh.

2 *The Chain*. Trolley Books, London, 2002. HB, leporello book in steel box, 188 x 127 mm, 104 pp, 48 b&w photos. Text by Cheryl Lai.

3 *Double Happiness*. Aperture, New York, 2005. HB, 160 x 235 mm, 144 pp, 125 b&w photos. Essay by Claudia Glenn Dowling.

4 *Jet Lag*. Hatje Cantz, Ostfildern, 2015. HB, 230 x 287 mm, 120 pp, 131 b&w and col photos. Essay by Chien-Chi Chang.

Bruce Davidson

Bruce Davidson (b.1933; joined Magnum in 1958) attended Rochester Institute of Technology and Yale University. He began working as a photographer for *LIFE* magazine in 1957. First gaining national recognition for his work on a Brooklyn gang and the civil rights movement in the early 1960s, he then produced his seminal work, *East 100th Street*, which was followed by his colour series of the New York Subway in the early 1980s and a black-and-white project on Central Park in the 1990s. He lives and works in New York.

1　2　3　4
5　6　7　8
9　10　11　12
13　14　15　16

1 *East 100th Street*. Harvard University Press, Cambridge, MA,1970 (also PB edn, 1971). HB, 271 x 230 mm, 130 pp, 123 b&w photos. Text by Davidson.

2 *Subsistence U.S.A.* Holt, Rinehart and Winston, New York, 1973. PB, 222 x 216 mm, 192 pp, 71 b&w photos. Text by Carol Hill.

3 *Bruce Davidson: Photographs*. Agrinde Publications, New York, 1978. PB, 278 x 289 mm, 164 pp, 114 b&w photos. Intro by Henry Geldzahler.

4 *Subway*. Aperture, New York, 1986. HB w/ jkt, 245 x 284 mm, 88 pp, 60 col photos. Text by Davidson; afterword by Henry Geldzahler.

5 *Central Park*. Aperture, New York, 1995. HB, 254 x 311 mm, 128 pp, 111 b&w photos. Text by Elizabeth Barlow-Rogers, Davidson and Marie Winn.

6 *Bruce Davidson: Portraits*. Aperture, New York, 1999. HB, 241 x 279 mm, 72 pp, 50 b&w photos.

7 *Brooklyn Gang: Summer of 1959.* Twin Palms Publishers, Santa Fe, 1998. HB, 305 x 254 mm, 96 pp, 67 b&w photos.

8 *Time of Change: Civil Rights Photographs 1961-1965.* St Ann's Press, Los Angeles, 2002. HB, 293 x 283 mm, 172 pp, 143 b&w photos. Foreword by US Congressman John Lewis; intro by Deborah Willis; afterword by Davidson.

9 *East 100th Street* (revised edn). St Ann's Press, Los Angeles, 2003. HB w/ jkt, 304 x 280 mm, 164 pp, 160 b&w photos. Interview by Barney Simon; text by Davidson and Mildred Feliciano.

10 *Subway* (revised edn). St Ann's Press, Los Angeles, 2003. HB w/ jkt, 247 x 300 mm, 124 pp, 102 col photos. Text by Fred Braithwaite, Arthur Ollman, Henry Geldzahler and Davidson.

11 *England/Scotland 1960.* Steidl, Göttingen, 2005 (revised edn in larger format, 2014). HB w/ jkt, 241 x 216 mm, 144 pp, 115 b&w photos. Text by Bruce Davidson; essay by Mark Haworth-Booth.

12 *Circus.* Steidl, Göttingen, 2007. HB, 291 x 291 mm, 102 pp, 80 b&w photos. Text by Davidson; essay by Sam Holmes.

13 *Outside Inside.* Steidl, Göttingen, 2010. HB, 3 vols w/ slipcase, each: 300 x 240 mm, 942 pp, 800 b&w photos. Text by Davidson.

14 *Bruce Davidson: In Color.* Steidl, Göttingen, 2014. HB, 295 x 290 mm, 264 pp, 228 col photos.

15 *Los Angeles 1964.* Steidl, Göttingen, 2015. HB, 295 x 290 mm, 56 pp, 25 b&w photos.

16 *Nature of Los Angeles 2008-2013.* Steidl, Göttingen, 2015. HB, 295 x 290 mm, 68 pp, 30 b&w photos.

Carl De Keyzer

Carl De Keyzer (b.1958; joined Magnum in 1990) likes to tackle large-scale projects. Much of his work examines the theme that in overpopulated communities everywhere, disaster has struck and systems are on the verge of collapse. His style is characterized by an accumulation of images that often interact with text. He has covered life in India, the collapse of the Soviet Union, political changes in Europe, religion in the USA, prison camps in Siberia, colonialism in the Congo, modern-day power and politics, and global warming.

CCCP). PB, 300 x 300 mm, 134 pp, 75 b&w photos. Text by De Keyzer.

4 *God, Inc.* Uitgeverij Focus, Amsterdam, 1992. PB, 300 x 295 mm, 74 pp, 70 b&w photos. Text by De Keyzer.

5 *East of Eden.* Ludion Press, Ghent, 1996. HB w/ jkt, 230 x 260 mm, 122 pp, 69 b&w photos. Intro by Ine Pisters.

6 *EVROPA.* Ludion Press, Ghent, 2000. HB, 276 x 166 mm, 180 pp, 159 b&w photos. Text by Immanuel Wallerstein.

7 *Tableaux d'Histoire.* Centro de Arte de Salamanca, Salamanca, 2002. PB, 274 x 240 mm, 64 pp, 24 col photos. Text by Dirk Lauwaert.

8 *Zona: Siberian Prison Camps.* Trolley Books, London, 2003 (also limited edn of 50 copies with a signed print). HB w/ jkt, 220 x 305 mm, 160 pp, 90 col photos. Text by De Keyzer.

9 *Trinity.* Mets & Schilt, Amsterdam, 2008 (Dutch edn: French, Flemish, German, Italian and Spanish edns also published). HB w/ jkt, 240 x 296 mm, 150 pp, 86 col photos. Text by Pete De Graeve, Lieven De Cauter and Katherine Derdarian.

10 *Congo (Belge).* Lannoo, Tielt, 2009 (also limited edn of 40 copies with a signed print; second edn, 2010). HB, 360 x 269 mm, 352 pp, 180 col photos. Text by David Van Reybrouck.

11 *Congo Belge en Images.* Lannoo, Tielt, 2009 (also limited edn of 40 copies with a signed print). HB, 360 x 269 mm, 192 pp, 94 b&w photos.

12 *Moments Before the Flood.* Lannoo, Tielt, 2012 (also limited edn of 50 copies with a signed print). HB, 330 x 330 mm, 272 pp, 146 col photos.

13 *Jacques Delors: Mein Leben für Europa, Gespräche/Carl De Keyzer: EVROPA.* Steidl, Göttingen 2013. HB, 235 x 154 mm, 152 pp, 92 b&w photos. Collaboration w/ Jacques Delors; preface by Hans-Dietrich Genscher.

14 *The First World War Now.* Hannibal, Veurne (Belgium), 2014 (also published as *The First World War: Unseen Glass Plate Photographs of the Western Front*, with University of Chicago Press; and French edn by Editions Mardaga, Brussels). HB, 325 x 243 mm, 240 pp, 88 b&w and 71 col photos. Preface by Geoff Dyer and intro by David Van Reybrouck.

15 *Album 14-18.* Hannibal, Veurne, 2014 (Dutch edn; also published in French and English). HB, 325 x 243 mm, 240 pp, 69 b&w and 30 col photos. Intro by David Van Reybrouck.

16 *Cuba La Lucha.* Lannoo, Tielt, 2016. HB, 310 x 220 mm, 176 pp, 80 col photos. Intro by Gabriela Salgado.

Luc Delahaye

Luc Delahaye (b.1962; member of Magnum 1994-2004) began his career as a war photographer, earning international acclaim. He has worked on several personal projects, including *L'Autre* (1999), a series of stolen photographs in the Paris subway, and *Winterreise* (2000), which examines the social consequences in Russia following the collapse of the Soviet Union. In 2001, he started making large-scale colour pictures depicting conflicts, news events or social issues, exploring the boundaries between art, history and information. He is a recipient of the Robert Capa Gold Medal, the Oskar Barnack Award, the ICP Infinity Award, Deutsche Börse Photography Prize and the Prix Pictet.

1

2

3
4

5
6
7

8

9
10
11
12

13
14
15
16

1
2
3
4

5
6
7

1 *Oogspanning: Fotografie Carl De Keyzer 1981-1984.* Self-published, Ghent, 1984 (limited edn of 200 copies). HB w/ jkt, 211 x 260 mm, 76 pp, 60 b&w photos. Text by Johan Anthierens.

2 *India.* Uitgeverij Focus, Amsterdam, 1987 (second edn, 1988). PB, 300 x 300 mm, 94 pp, 75 b&w photos. Text by Dirk van der Spek.

3 *Homo Sovieticus.* Uitgeverij Focus, Amsterdam, 1989 (edn of 2,000 copies; also a limited edn of 100 copies with a signed print; published in English as *USSR/1989/*

1 *Portraits/1.* Editions Sommaire, Paris, 1996. HB, 150 x 120 mm, 32 pp, 18 b&w photos.

2 *Mémo.* Editions Hazan, Paris, 1997 (French edn). HB, 180 x 140 mm, 168 pp, 81 b&w photos.

3 *L'Autre.* Phaidon Press, London, 1999. PB, 220 x 167 mm, 192 pp, 90 b&w photos. Text by Jean Baudrillard.

4 *Winterreise.* Phaidon Press, London, 2000 (also published in French; paperback edn published in 2003). HB w/ jkt & PB, 178 x

131 mm, 232 pp, 144 col photos. Text and design by Delahaye.

5 *History*. Chris Boot Ltd, London, 2003 (limited edn of 75 copies). HB in box, 292 x 425 mm, 32 pp, 13 col photos. Text by Eugenia Parry.

6 *Une Ville*. Xavier Barral, Paris, 2003 (French edn).

HB, 180 x 120 mm, 164 pp, 10 b&w and 50 col photos.

7 *Luc Delahaye: 2006–2010*. Steidl, Göttingen, 2011 (French edn). PB, 259 x 215 mm, 80 pp, 13 col photos. Text by Quentin Bajac.

Raymond Depardon

Raymond Depardon (b.1942; joined Magnum 1978) began his career as a photojournalist in the early 1960s, travelling to conflict zones including Algeria, Vietnam, Biafra and Chad. In 1966 he co-founded the photojournalism agency Gamma, and became its director from 1973–4. He was awarded the Pulitzer Prize in 1977. Depardon is also the creator of several documentary shorts and feature films influenced by *cinéma vérité* and direct cinema.

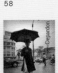
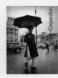
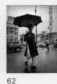
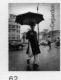
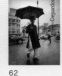
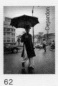

1 2 3 4
5 6 7 8
9 10 11 12
13 14 15 16
17 18 19 20
21 22 23 24
25 26 27 28
29 30 31 32
33 34 35 36
37 38 39 40
41 42 43 44
45 46 47 48
49 50 51 52
53 54 55 56
57 58 59 60
61 62

3 *Tchad*. Gamma, Paris, 1978 (French edn). PB, 314 x 236 mm, 24 pp, 5 contact sheets and 18 b&w photos. Text by Jérome Hinstin.

4 *Notes*. Editions Arfuyen, Paris, 1979 (French edn). PB, 250 x 190 mm, 44 pp, 33 b&w photos.

1 *Les Jeux Olympiques: Mexico 68*. Solar, Paris, 1968 (French edn). PB, 200 x 130 mm, 144 pp, 93 b&w photos.

2 *Chili: Special Reporter-Object*. Gamma/Photo Cinema, Paris, 1973 (French edn). PB, 300 x 288 mm, 64 pp, 82 b&w photos.

5 *Correspondance New-Yorkaise*. Editions de l'Etoile, Paris, 1981 (French edn; re-issued as *New York: Correspondance New-Yorkaise* by Cahiers du Cinéma, Paris, 2006). PB, 210 x 180 mm, 96 pp, 55 b&w photos. Text by Alain Bergala; preface by Christian Caujolle.

6 *Le Désert Américain*. Editions de l'Etoile, Paris, 1983 (French edn; re-issued by Editions Hazan, Paris, 2007). PB, 210 x 180 mm, 142 pp, 86 b&w photos and 32 illus. Intro by Serge Toubiana.

7 *San Clemente*. Centre National de la Photographie, Paris, 1984 (French edn). PB, 260 x 280 mm, 88 pp, 47 b&w photos.

8 *Les Fiancées de Saïgon*. Cahiers du Cinéma, Paris, 1986 (French edn). HB, 180 x 130 mm, 128 pp, 76 b&w photos.

9 *Hivers*. Editions Arfuyen and Magnum Photos Paris, 1987 (French edn). PB, 250 x 190 mm, 40 pp, 30 b&w photos.

10 *Vues*. Le Monde, Paris, 1988 (French edn). PB, 310 x 230 mm, 48 pp, 65 b&w photos. Preface by Bernard Franck.

11 *Pointe du Raz*. Marval, Paris, 1991 (French edn). PB, 220 x 240 mm, 22 pp, 19 b&w photos.

12 *Sites et Jeux*. Fondation Nationale de la Photographie, Lyon, 1992 (French edn). PB, 190 x 210 mm, 50 pp, 1 b&w and 35 col photos.

13 *Depardon/Cinéma*. Cahiers du cinema, Paris, 1993 (French edn). PB, 215 x 185 mm, 176 pp, 208 col photos; 50 b&w and 28 col illus. Text by Depardon and Frédéric Sabouraud.

14 *La Colline des Anges: Retour au Vietnam*. Editions du Seuil, Paris, 1993 (French edn). PB, 230 x 185 mm, 186 pp, 70 b&w photos. Text by Depardon and Jean-Claude Guillebaud.

15 *Return to Vietnam*. Verso, London, 1994. PB, 218 x 196 mm, 192 pp, 72 b&w photos. Text by Jean-Claude Guillebaud.

16 *La Ferme du Garet*. Editions Carré, Paris, 1995 (French edn; published in English as *Our Farm* by Actes Sud, France, 1997). PB, 200 x 152 mm, 320 pp, 246 b&w and 37 col photos and numerous illus and ephemera. Text by Depardon.

17 *La Porte des Larmes: Retour vers l'Abyssinie*. Editions du Seuil, Paris, 1996 (French edn). PB, 230 x 185 mm, 220 pp, 69 b&w photos. Text by Jean-Claude Guillebaud.

18 *En Afrique*. Editions du Seuil, Paris, 1996 (French edn). PB, 210 x 150 mm, 160 pp, 88 b&w photos.

19 *Silence Rompu*. Editions La Joie de Lire, Geneva, 1998 (French edn). HB, 230 x 215 mm, 62 pp, 31 b&w photos.

20 *La Solitude Heureuse du Voyageur*. Musées de Marseille, Marseille, 1998 (French edn). PB, 270 x 205 mm, 72 pp, 60 b&w photos.

21 *Depardon Voyages*. Editions Hazan, Paris, 1998 (French edn). PB, 195 x 134 mm, 604 pp, 527 b&w photos. Interview by Michel Butel.

22 *Corse*. Editions du Seuil, Paris, 1999 (French edn). HB, 180 x 170 mm, 96 pp, 41 b&w photos. Text by Jean-Noël Pancrazi.

23 *Errance*. Editions du Seuil, Paris, 2000 (French edn). PB, 246 x 163 mm, 160 pp, 77 b&w photos.

24 *Rêve de Déserts*. Gallimard, Paris, 2000 (French edn). HB, 285 x 285 mm, 72 pp, 48 b&w and col photos. Text by Titouan Lamazou.

25 *Détours*. Paris Audiovisuel, Paris, 2000 (French edn). HB, 232 x 160 mm, 336 pp, 177 b&w and 59 col photos, and 159 illus. Intro by Jacques Rancière.

26 *À Tombeau Ouvert*. Editions Autrement, Paris, 2000 (French edn). PB, 220 x 145 mm, 180 pp, 7 b&w photos. Text by Josée Landrieu, Chantal Delsol, Stéphane Callens and Alain Lipietz.

27 *Désert: Un homme sans l'Occident*. Editions du Seuil, Paris, 2002 (French edn). HB, w/ jkt, 160 x 245 mm, 200 pp, 116 b&w photos.

28 *Piemonte: Una Definizione Fotografica*. Agarttha Arte, Turin, 2003 (French edn). HB, w/ jkt, 320 x 240 mm, 84 pp, 32 b&w photos.

29 *06 Alpes-Maritimes*. Editions Xavier Barral and Magnum Photos, Paris, 2003. HB, 264 x 210 mm, 64 pp, 44 b&w photos.

30 *J.O.* Editions du Seuil, Paris, 2004 (French edn). PB, 230 x 159 mm, 352 pp, 224 b&w photos.

31 *Paroles Prisonnières*. Editions du Seuil, Paris, 2004 (French edn). PB, 185 x 130 mm, 80 pp, 36 b&w photos.

32 *Depardon 7x3*. Fondation Cartier, Paris and Actes Sud, Arles, 2004 (French edn). HB, 286 x 227 mm, 160 pp, 20 b&w and 141 col photos.

33 *Images Politiques*. La Fabrique Editions, Paris, 2004 (French edn). PB, 200 x 160 mm, 112 pp, 57 b&w photos.

34 *Paris Journal*. Editions Hazan, Paris, 2004 (French edn). HB, 226 x 195 mm, 538 pp, 500 b&w photos.

35 *Depardon: Afriques*. Editions Hazan, Paris, 2005 (French edn). HB, 280 x 185 mm, 300 pp, 335 b&w photos. Intro by Depardon.

36 *New York: 25 Ans Après le Dialogue*. Cahiers du Cinéma, Paris, 2006 (French edn). PB, 220 x 160 mm, 128 pp, 58 b&w and 3 col photos. Text by Depardon and Alain Bergala.

37 *PPP (Photographies de Personnalités Politiques)*. Editions du Seuil, Paris, 2006 (French edn; also published in PB, Editions Points, Paris, 2007). HB, 238 x 170 mm, 174 pp, 93 b&w photos. Intro by Jean Lacouture.

38 *8 Films*. Ministère des Affaires Etrangères, Paris, 2006

(French edn). PB, 241 x 167 mm, 80 pp, 13 b&w and 36 col photos. Text by Alain Bergala.

39 *La Solitude Heureuse du Voyageur*. Editions du Seuil, Paris, 2006 (revised French edn). PB, 180 x 105 mm, 106 pp, 100 b&w photos.

40 *Villes/Cities/Städte*. Actes Sud and Fondation Cartier, Paris, 2007 (trilingual edn: English, French and German). PB, 230 x 170 mm, 296 pp, 278 col photos.

41 *Le Désert Américain*. Editions Hazan, Paris, 2007 (revised French edn). PB, 200 x 135 mm, 160 pp, 80 b&w photos.

42 *Le Tour du Monde en 14 Jours, 7 Escales, 1 Visa*. Editions Points, Paris, 2008 (French edn). PB, 180 x 105 mm, 160 pp, 120 b&w photos.

43 *La Terre des Paysans*. Editions du Seuil, Paris, 2008 (French edn). HB, 250 x 200 mm, 160 pp, 120 b&w and col photos.

44 *Manhattan Out*. Steidl, Göttingen, 2008. HB, 203 x 295 mm, 120 pp, 98 b&w photos.

45 *Donner la Parole*. Steidl, Göttingen and Fondation Cartier, Paris, 2008 (French edn). HB, 210 x 150 mm, 164 pp, 93 col photos.

46 *Raymond Depardon 1968*. Editions du Seuil, Paris, 2008 (French edn). PB, 180 x 110 mm, 180 pp, 143 b&w photos.

47 *Terre Natale*. Fondation Cartier, Paris, 2008 (French edn). PB, 280 x 204 mm, 308 pp, 120 photos.

48 *Paysans*. Edition du Seuil, Paris, 2009 (French edn). PB, 180 x 110 mm, 128 pp, 80 b&w and col photos.

49 *Afrique(s)*. Editions Points, Paris, 2010 (French edn). PB, 180 x 110 mm, 160 pp, 80 b&w photos.

50 *Beyrouth Centre Ville*. Edition Points, Paris, 2010 (French edn). PB, 180 x 110 mm, 224 pp, 69 col and 55 b&w photos. Text by Claudine Nougaret.

51 *La France de Raymond Depardon*. Editions du Seuil, Paris, 2010 (expanded edn with text by Michel Lussault published by Editions Points, 2012). HB, 282 x 387 mm, 336 pp, 300 col photos.

52 *Un Aller pour Alger*. Editions Points, Paris, 2010 (French edn). PB, 180 x 110 mm, 228 pp, 147 b&w photos. Text by Louis Gardel.

53 *Terre Natale: Ailleurs Commence Ici*. Actes Sud, Arles and Fondation Cartier, Paris, 2010 (French edn). HB, 176 x 110 mm, 160 pp, 123 photos by Depardon; 80 photos by other photographers.

54 *Repérages*. Editions du Seuil, Paris, 2012 (French edn). PB, 200 x 235 mm, 100 pp, 72 b&w photos, 37 illus.

55 *Chile 1971*. LOM Ediciones, Santiago de Chile, 2013. HB, 240 x 170 mm, 124 pp, 119 b&w photos.

56 *Un Moment si Doux*. Réunion des Musées Nationaux, Paris, 2013 (French edn). HB, 240 x 220 mm, 176 pp, 150 col photos. Text by Hervé Chandès, Michel Cassé and Clément Rosset.

57 *Manicomio*. Steidl, Göttingen, 2014. PB, 203 x 295 mm, 208 pp, 218 photos.

58 *Méditerranée*. Editions Xavier Barral and MUCEM, Paris, 2014 (French edn). HB, clothbound, 310 x 250 mm, 112 pp, 82 b&w and col photos. Text by Claudine Nougaret.

59 *Berlin: Fragments d'une Histoire Allemande*. Editions du Seuil, Paris, 2014 (French edn; also published in German and English by Steidl, Göttingen, 2014). HB, 230 x 300 mm, 288 pp, 282 b&w photos.

60 *Le Désert Allers Retours*. La Fabrique Editions, Paris, 2014 (French edn). PB, 168 x 130 mm, 128 pp, 71 photos.

61 *Depardon, Loustal: Carthagène*. Editions Depuis, Paris, 2015 (French edn; also published in PB). HB and PB, 225 x 267 mm, 120 pp, 50 photos. Graphic novel by Jacques de Loustal.

62 *Adieu Saigon*. Editions du Seuil, Paris, 2015 (revised edn by Steidl, Göttingen). PB, 205 x 151 mm, 224 pp, 118 photos.

Bieke Depoorter

Bieke Depoorter (b.1986; joined Magnum in 2012) received her master's degree in photography from the Royal Academy of Fine Arts in Ghent in 2009. That year she travelled through Russia, photographing people in whose homes she had spent a single night for her series *Ou Menya*. A long-term project in the United States led to her second book *I Am About to Call It a Day*. Depoorter is working on several projects, including *In Between*, where she is photographing in the intimacy of Egyptian families.

1

2

2 *I Am About to Call It a Day*. Edition Patrick Frey, Zurich and Hannibal, Veurne, 2014 (limited edn of 1,500 copies). Cardboard cover, 420 x 280 mm, 43 pp, 42 col photos. Text by Maarten Dings.

1 *Ou Menya*. Lannoo, Tielt, 2012 (Trilingual edn: English, Dutch and French). PB, 326 x 241 mm, 128 pp, 48 col photos. Foreword by Paul Demets.

Thomas Dworzak

Born in Germany, Thomas Dworzak (b.1972; joined Magnum in 2000) lived in Tbilisi, Georgia in the 1990s, documenting the conflicts in the Caucasus region while working on a larger-scale project about its people. In the aftermath of 9/11, he covered wars in Iraq and Afghanistan and their impact on the USA. He has reported on conflicts in Haiti, Sri Lanka, Chad, Nigeria, Ukraine, Kyrgyzstan, Libya, Egypt and Russia. He continues to focus on the Caucasus, the Middle East and the former Soviet Union.

1

2

3

4

5

Benteli, Zurich, 2010). HB, 245 x 300 mm, 216 pp, 80 b&w photos.

4 *Beyond Sochi*. Editions Seriti, Paris, 2014. Box set of 15 maps and 72-pp text booklet, box: 250 x 110 mm, maps: 660 x 500 mm, 344 pp. Text by William Dunbar.

1 *Taliban*. Trolley Books, London, 2003 (German edn: Fotobuch Verlag, Freiburg, 2003). HB, 210 x 155 mm, 128 pp, 50 col and 6 b&w photos. Text by John Lee Anderson.

2 *MASH: IRAQ*. Trolley Books, London, 2007. HB, 210 x 295 mm, 96 pp, 80 col photos. Text by Mike Farrell.

3 *KAVKAZ (Kaukasus)*. Schilt Publishing, Amsterdam, 2010 (German and Russian edn w/ jkt:

5 *#auschwitz*. Artist's scrap book, 2014 (edn of 5 copies). HB, 205 x 120 mm, 268 pp, 260 col photos. One of nine books, each an edn of 5 copies: *#K.R.A.* (172 pp, 158 col photos); *#DPRK* (260 pp, 258 col photos); *#rearwindow* (86 pp, 83 col photos); *#aintnoheartintheheartof thecity* (212 pp, 100 col photos); *#solarium* (112 pp, 107 col photos); *#GUN* (83 pp, 77 col photos); *#TOTAL:107524.00* (197 pp, 193 col photos); *#habemuspapam* (197 pp, 260 col photos).

Nikos Economopoulos

Nikos Economopoulos (b.1953; joined Magnum in 1990) was born in Greece and became a Magnum member while photographing in the Balkans. Since then his work has focused on people caught at borders and crossings, including the 'Green Line' in Cyprus, Turkey and the Greek-Albanian border, the mass migration of ethnic Albanians fleeing Kosovo, as well as the Roma and other minorities. He began to photograph in colour in 2011 and now works on a long-term project entitled 'On-The-Road', focusing on Cuba and Ethiopia.

1

2

3

4

5

6

1 *In the Balkans*. Harry N. Abrams, New York and Libro, Athens, 1995 (bilingual edn: English and Greek). HB w/ jkt, 298 x 235 mm, 126 pp, 74 b&w photos. Intro by Frank Viviano.

2 *Lignite Miners*. Indiktos, Athens, 1998. HB w/ jkt, 300 x 240 mm, 104 pp, 51 b&w photos.

3 *Dance Ex Machina*. Difono, Athens, 2000. HB w/ jkt, 270 x 250 mm, 120 pp, 70 b&w photos.

4 *About Children*. Metaixmio, Athens, 2001. PB w/ jkt, 300 x 240 mm, 104 pp, 50 b&w photos.

5 *Economopoulos: Photographer*. Benaki Museum and Metaixmio, Athens, 2002. HB w/ jkt, 283 x 275 mm, 340 pp, 149 b&w photos

6 *Balkanlarda*. Fotografevi, Istanbul, 2007 (Turkish edn). HB w/ jkt, 350 x 280 mm, 164 pp, 156 b&w photos.

Elliott Erwitt

Elliott Erwitt (b.1928; joined Magnum in 1953) emigrated with his family to Los Angeles from Italy when he was 11 years old. While attending Hollywood High School he worked in a commercial darkroom. In 1948, Erwitt met Edward Steichen, Robert Capa and Roy Stryker in New York and the following year travelled to Europe as a professional photographer. Much of Erwitt's early work was for illustrated magazines such as *Holiday* and *LIFE*; in the 1970s and 80s he also turned to film, and produced documentaries and comedies. With a career spanning six decades, Erwitt is best known for his candid, often humorous, black-and-white shots of everyday settings, but also his ability to convey good-natured irony and to capture heartfelt moments of human sensibility.

1

2

3

4

5

6

7

8

9

10

11

12

13

14

15

16

17

18

19

20

21 22 23 24

25 26 27 28

29 30 31 32

33 34 35 36

37 38 39 40

41 42 43 44

45 46 47 48

49

1 *Photographs and Anti-Photographs*. The New York Graphic Society, New York, 1972. HB w/ jkt, 235 x 290 mm, 128 pp, 112 b&w photos. Intro by John Szarkowski; essay by Sam Holmes.

2 *Observations on American Architecture*. Viking Press, New York, 1972. HB w/ jkt, 287 x 250 mm, 144 pp, 124 col and b&w photos. Text by Ivan Chermayeff.

3 *The Private Experience: Personal Insights of a Professional Photographer*. Alskog and Thomas Y. Crowell, New York, 1974. HB w/ jkt, 280 x 205 mm, 88 pp, 64

4 *Son of Bitch*. Viking Press, New York, 1974. HB w/ jkt, 258 x 250 mm, 126 pp, 93 b&w photos. Text by P.G. Wodehouse.

5 *Recent Developments*. Simon and Schuster, New York, 1978. HB w/ jkt, 280 x 215 mm, 128 pp, 111 b&w photos. Intro by Wilfrid Sheed.

6 *The Angel Tree*. Alfred A. Knopf, New York, 1984. HB, 282 x 201 mm, 78 pp, 65 col photos.

7 *Personal Exposures*. W.W. Norton & Company, New York, 1988 (second edn published 2012; also published by Pacific Press, Tokyo, 1989). HB w/ jkt, 297 x 257 mm, 256 pp, 248 b&w photos. Foreword by Erwitt.

8 *Photographies 1946-1988*. Editions Nathan, Paris, 1988 (French edn). HB w/ jkt, 245 x 285 mm, 254 pp, 262 b&w photos.

9 *Hundstage*. Elert & Richer Verlag, Hamburg, 1988. HB, 285 x 215 mm, 120 pp, 55 b&w photos. Text by Volker Bartsch.

10 *Elliott Erwitt: On The Beach*. W.W. Norton & Company, New York, 1991. HB w/ jkt, 260 x 220 mm, 128 pp, 144 b&w photos.

11 *To the Dogs*. Distributed Art Publishers and Magnum Photos, Tokyo, 1992 (bilingual edn: English and Japanese). PB, 250 x 242 mm, 80 pp, 139 b&w photos. Text by Erwitt.

12 *To the Dogs*. Distributed Art Publishers and Scalo, New York, 1992. HB w/ jkt, 245 x 285 mm, 144 pp, 90 b&w photos. Text by Erwitt.

13 *The Angel Tree: A Christmas Celebration*. Harry N. Abrams, New York, 1993. HB w/ jkt, 262 x 239 mm, 88 pp, 109 col photos. Text by Linn Howard and Mary Jane Pool.

14 *Between the Sexes*. W.W. Norton & Company, New York, 1994. HB w/ jkt, 286 x 242 mm, 128 pp, 117 b&w photos. Text by Erwitt.

15 *Couples*. Magnum Photos, Tokyo, 1994. PB, 250 x 245 mm, 122 pp, 143 b&w photos.

16 *100+1*. Leonardo Arte, Milan, 1997 (Italian edn). PB, 242 x 282 mm, 124 pp, 101 b&w photos. Text by Erwitt.

17 *Dog Dogs*. Phaidon Press, London, 1998. PB, 185 x 123 mm, 512 pp, 500 b&w photos. Text by P.G. Wodehouse.

18 *Museum Watching*. Phaidon Press, London, 1999. HB w/ jkt, 245 x 210 mm, 160 pp, 160 b&w photos.

19 *¾ of a Second with Elliott Erwitt*. Magnum Photos, Tokyo, 2001. PB, 302 x 225 mm, 128 pp, 100 b&w photos.

20 *Elliott Erwitt: Snaps*. Phaidon Press, London, 2001 (also published in French, Italian and Spanish and three limited edns, 100-250 copies, each with a signed and numbered print; PB edn, 2003; abridged edn, 2011). HB w/ jkt, 270 x 190 mm, 512 pp, 508 b&w photos. Text by Murray Sayle and Charles Flowers.

21 *EE 60/60*. Ediciones Aldeasa and Museo Reina Sofía, Madrid, 2002 (Spanish edn). HB, 275 x 230 mm, 190 pp, 121 b&w photos. Foreword by Catherine Coleman.

22 *Elliott Erwitt's Handbook*. The Quantuck Lane Press, New York, 2002. HB w/ jkt, 216 x 152 mm, 128 pp, 100 b&w photos. Foreword by Charles Flowers.

23 *Flip-O-Rama: Italia*. De.MO, New York, 2003. 18 PB flipbooks in box, 121 x 176 mm, each book 58 pp, 1044 pp, in total, 497 b&w photos.

24 *The Japanese Friends of Elliott Erwitt*. Magnum Photos, Tokyo, 2004 (English and Japanese edn). PB, 260 x 240 mm, 104 pp, 120 col photos. Text by Erwitt.

25 *Friends (and Other Odd Combinations)*. PQ Publishers, Auckland, 2004. HB, 157 x 157 mm, 64 pp, 37 b&w photos.

26 *Lovers (and Other Extreme Optimists)*. PQ Publishers, Auckland, 2004. HB, 157 x 157 mm, 64 pp, 36 b&w photos.

27 *Dogs (and Other Curious Characters)*. PQ Publishers, Auckland, 2004. HB, 157 x 157 mm, 64 pp, 41 b&w photos.

28 *Woof*. Chronicle Books, San Francisco, 2005 (also published in German as *Wuff*, Gerstenberg, Hildesheim, 2007 with text by Erwitt). HB w/ jkt, 254 x 216 mm, 176 pp, 100 b&w photos. Foreword by Trudie Styler (English edn only).

29 *Icons*. NRW Forum, Düsseldorf, 2005. HB, 200 x 200 mm, 94 pp, 33 b&w photos.

30 *Personal Best*. teNeues, Kempen, 2006 (also published in small format paperback in 2011 and small format hardback in 2014). HB w/ jkt, 330 x 270 mm, 448 pp, 343 b&w photos. Intro by Sean Callahan.

31 *Elliott Erwitt Retrospectiva*. Casal Solleric, Palma, 2006. PB, 324 x 240 mm, 252 pp, 101 b&w photos.

32 *Personal Best, Personal Choice*. Chanel Nexus Hall, Tokyo, 2007. PB, 248 x 175 mm, 120 pp, 119 b&w photos.

33 *Unseen*. teNeues, Kempen, 2007. HB, 370 x 236 mm, 160 pp, 156 b&w photos. Text by Ferdinando Scianna.

34 *Elliott Erwitt's Dogs*. teNeues, Kempen, 2008 (also published in small format hardback in 2012). HB, 360 x 270 mm, 144 pp, 176 b&w photos. Foreword by Peter Mayle.

35 *Elliott Erwitt's New York*. teNeues, Kempen, 2008 (also published in paperback in 2011). HB, 360 x 270 mm, 144 pp, 134 b&w photos. Foreword by Adam Gopnik.

36 *Elliott Erwitt*. Kahitsukan and Kyoto Museum of Contemporary Art, Kyoto, 2008. PB w/ jkt, 298 x 225 mm, 120 pp, 95 b&w photos.

37 *Elliott Erwitt's Rome*. teNeues, Kempen, 2009 (also published by Contrasto, Rome). HB, 360 x 270 mm, 144 pp, 176 b&w photos. Foreword by Michelle Serra.

38 *The Art of André S. Solidor A.K.A. Elliott Erwitt*. teNeues, Kempen, 2009 (also published as a collector's edn of 200 copies with a signed digital print). HB w/ jkt, 360 x 270 mm, 96 pp, 76 b&w and col photos.

39 *Elliott Erwitt's Paris*. teNeues, Kempen, 2010. HB, 360 x 270 mm, 176 pp, 189 b&w photos. Foreword by Adam Gopnik.

40 *Sequentially Yours, Elliott Erwitt*. teNeues, Kempen, 2011. HB w/ jkt, 312 x 231 mm, 208 pp, 280 b&w photos. Text by Marshall Brickman.

b&w and col photos. Text by Sean Callahan.

41 *The Angel Tree: Celebrating Christmas at* The Metropolitan Museum of Art. Harry N. Abrams, New York, 2011 (revised edn). HB w/ jkt, 304 x 203 mm, 128 pp, 125 col photos.

42 *Elliott Erwitt XXL Special Edition.* teNeues, New York, 2012 (edn of 1500 copies; also published in as a collector's edn of 500 copies with a signed digital print). HB w/ jkt, 530 x 390 mm, 244 pp, 156 b&w photos. Text by Erwitt.

43 *Elliott Erwitt: Kids.* The Quantuck Lane Press, New York, 2012. HB w/ jkt, 225 x 162 mm, 128 pp, 111 b&w photos. Text by Charles Flowers.

44 *Le Petit Monde d'Elliott Erwitt.* Editions Tourbillon, Paris, 2013. HB, 225 x 230 mm, 96 pp, 91 b&w photos.

45 *Elliott Erwitt's Kolor.* teNeues, Kempen, 2013 (also published as a collector's edn of 300 copies with a signed digital print). HB w/ jkt, 365 x 273 mm, 448 pp, 420 col photos. Text by Sean Callahan

46 *Elliott Erwitt's Great Scottish Adventure.* The Macallan Distillers, Craigellachie, 2013 (limited edn of 2,030 copies, each with a bottle of Macallan whiskey and a signed print). HB, 322 x 232 mm, 192 pp, 158 b&w photos.

47 *Elliott Erwitt: Catalogo/ Catalogue.* Silvana Editoriale, Milan, 2013 (Italian, English and French edn). PB, 280 x 230 mm, 166 pp, 139 b&w photos. Text by Angela Madesani.

48 *Icons Gallery Collection.* Sudest57, Milan, 2014 (Italian edn). PB, 419 x 296 mm, 68 pp, 33 b&w photos. Text by Biba Giacchetti.

49 *Regarding Women.* teNeues, Kempen, 2014. HB w/ jkt, 360 x 270 mm, 304 pp, 369 b&w photos. Text by Charles Flowers.

Martine Franck

Martine Franck (1938–2012; joined Magnum in 1980) studied art history before discovering photography in the Far East in 1963. She worked in Paris for *Time Life* in 1964 and in 1970 she married Henri Cartier-Bresson, joined the agency Vu and, in 1972, helped to create the agency Viva. Her photography was socially concerned and humanitarian. In the 1990s she covered Ireland's Tory Island and the Tibetan Tulkus. In 2003 she established the Henri Cartier-Bresson Foundation with Cartier-Bresson and their daughter Mélanie.

1 *Etienne-Martin.* La Connaissance, Brussels, 1970 (French edn). HB w/ jkt, 331 x 241 mm, 142 pp, 58 b&w photos. Text by Michel Ragon.

2 *La sculpture de Cárdenas.* La Connaissance, Brussels, 1971 (French edn). HB w/ jkt, 327 x 243 mm, 146 pp, 268 b&w photos. Text by José Pierre.

3 *Les Lubérons.* Editions du Chêne, Paris, 1978 (French edn). HB, 250 x 233 mm, 84 pp, 60 col photos. Text by Yves Berger.

4 *Le Temps de Vieillir: Journal d'un Voyage,* 4. Editions Denoël and Filipacchi, Paris, 1980 (French edn). HB, 242 x 210 mm, 92 pp, 64 b&w photos. Intro by Robert Doisneau.

5 *Martine Franck.* Galerie Municipale du Château d'Eau, Toulouse, 1982 (French edn). HB, 209 x 208 mm, 22 pp, 21 b&w photos. Text by Jean Dieuzaide.

6 *Martine Franck: Des Femmes et la Création.* Maison de la Culture du Havre, Le Havre, 1983 (French edn). HB, 296 x 210 mm, 16 pp, 30 b&w photos. Intro by Vera Feyder.

7 *De Temps en Temps: Photographies de Martine Franck.* Les Petits Frères des Pauvres, Paris, 1988 (French edn). HB, 237 x 218 mm, 84 pp, 61 b&w photos. Preface by Claude Roy; text by Michel Christolhomme.

8 *Portraits d'Artistes: Collection Porte-Folios.* Editions Trois-Cailloux, Amiens, 1988 (French edn). HB portfolio in box, 300 x 240 mm, 22 pp, 18 b&w photos. Text by Yves Bonnefoy.

9 *Collège de France: Figures et Travaux.* Imprimerie Nationale and Paris-Audiovisuel, Paris, 1995 (French edn). HB, 300 x 230 mm, 160 pp, 76 b&w photos.

10 *The Man Who Planted Trees.* The Limited Editions Club, New York, 1995 (limited edn of 300 copies). HB, 440 x 365 mm (17 3/8 x 14 3/8 in.), 50 pp, 5 b&w photos. Text by Jean Giono.

11 *D'un jour, l'autre.* Editions du Seuil and Maison Européenne de la Photographie, Paris, 1998 (French edn; English edn: *One Day to the Next,* Thames & Hudson, London, 1998). HB w/ jkt, 270 x 215 mm, 168 pp, 104 b&w photos. Fax Foreword by John Berger and Martine Franck.

12 *Tory. Ile aux Confins de l'Europe.* Editions Benteli, Bern, 1998 (French edn; English edn: *Tory Island Images,* Wolfhound, Dublin, 1998). HB, 180 x 112 mm, 112 pp, 62 b&w photos. Text by Martine Franck.

13 *Tibetan Tulkus: Images of Continuity.* Anna Maria Rossi and Fabio Rossi, London, 2000. HB, 297 x 210 mm, 84 pp, 38 b&w photos. Preface by Anna Maria Rossi and Fabio Rossi; essay by David Seyfort Ruegg.

14 *Martine Franck, Photographies.* Galerie Claude Bernard, Paris, 2000 (French edn). HB, 200 x 200 mm, 72 pp, 74 b&w photos. Text by Ariane Mnouchkine.

15 *Martine Franck, Photographe.* Paris Musées and Editions Adam Biro, Paris, 2002 (French edn). HB, 240 x 167 mm, 144 pp, 110 b&w photos. Texts by Daniel Marchesseau and Gérard Macé.

16 *Fables.* Actes Sud, Arles, 2004 (French edn). HB, 263 x 200 mm, 98 pp, 39 col photos.

17 *Martine Franck.* Kahitsukan/ Kyoto Museum of Contemporary Art, Kyoto, 2008. HB, 290 x 225 mm, 120 pp, 86 b&w photos. Text by Yoshitomo Kajikawa.

18 *Women/Femmes.* Steidl, Göttingen, 2010 (bilingual edn). HB, 231 x 211 mm, 156 pp, 63 b&w photos. Intro by Richard Collasse.

19 *Martine Franck: Venus d'ailleurs.* Imprimerie Nationale Editions, Paris, 2011 (French edn; English edn: *From Other Lands: Artists in Paris*). HB, 276 x 245 mm, 156 pp, 62 b&w photos. Text by Germain Viatte.

1 2 3 4
5 6 7 8
9 10 11 12
13 14 15 16
17 18 19

Stuart Franklin

Stuart Franklin (b.1956; joined Magnum in 1985) is best known for his 1989 photograph from Tiananmen Square, China, featuring a man defying a tank, for which he won a World Press award. He has been awarded the Tom Hopkinson Award for published photojournalism and the Christian Aid prize for humanitarian photography while covering the Sahel famine in 1984–5. Since 1990, Franklin's work has focused on man's relationship with nature. He runs a programme in documentary photography in Norway and teaches worldwide.

1 2 3 4

5

6

7

8

9

1 *Tiananmen Square*. Black Sun, London, 1989. PB, 425 x 325 mm, 22 pp, 15 col photos. Intro by Tony Vines.

2 *The Time of Trees: A Photographic Essay by Stuart Franklin*. Leonardo Arte, Milan, 1999. HB w/ jkt, 335 x 270 mm, 164 pp, 172 b&w photos. Text by Franklin.

3 *La Città Dinamica*. Mondadori Electa, Milan, 2003. HB w/ jkt, 297 x 300 mm, 280 pp, 300 col and b&w photos.

4 *Sea Fever*. The Bardwell Press, Oxford, 2005, w/ National Trust and Magnum Photos. PB, 250 x 250 mm, 144 pp, 117 b&w photos. Text by Fiona Reynolds and Franklin.

5 *Hotel Afrique*. Dewi Lewis Publishing, Stockport, 2007. HB & PB, 328 x 240 mm, 48 pp, 48 col photos. Foreword by Mark Sealy.

6 *Footprint: Our Landscape in Flux*. Thames & Hudson, London, 2008. HB, 316 x 295 mm, 144 pp, 92 col photos. Texts by Franklin, Andrew Goudie, Tanja Pföhler and Heike Strelow.

7 *Saint-Petersburg*. Perlov Design Center, St Petersburg, 2012. HB, 290 x 252 mm, 108 pp, 100 b&w photos. Text by Charlotte Melville.

8 *Narcissus*. Hatje Cantz Verlag, Ostfildern, 2013. HB, 290 x 234 mm, 152 pp, 84 b&w photos. Text by Franklin.

9 *Dear Leonard: A Tribute to Leonard Cohen*. Silas Finch, London and New York, 2014 (artist's edn of 25 copies). HB w/ slipcase, 255 x 356 mm, 56 pp, 32 silver-gelatin prints and tip-in letter. Text by Franklin.

Leonard Freed

Leonard Freed (1929-2006; joined Magnum in 1970 and became a full member in 1972) began taking photographs in 1953. After trips through Europe and North Africa, he returned to his native United States in 1954, to study in Alexey Brodovitch's 'design laboratory'. Travelling widely, he photographed the Jewish community in Amsterdam (1957), blacks in America (1963-5), events in Israel (1967-8) and the Yom Kippur War (1973). He was famous for his work documenting the American civil rights movement (1963-5) and the NYC police department (1972-9).

1

2

3

4

5

6

7

8

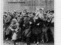
9

10

11

12

13

1 *Joden van Amsterdam*. Hooiberg, Epe, Amsterdam, 1958. HB, 170 x 150 mm, 104 pp, 54 b&w photos. Text by M. L. Snijders.

2 *Deutsche Juden Heute*. Rütten & Loening, Munich, 1965. HB, 250 x 205 mm, 94 pp, 48 b&w

photos. Text by Hans Hermann Köper, Robert Neumann, Alphons Silbermann, Ludwig Marcuse and Hermann Kesten.

3 *Black in White America*. Grossman Publishers, New York, 1967 (second edn published by Getty Publications, Los Angeles, 2010). PB, 255 x 216 mm, 206 pp, 169 b&w photos.

4 *Seltsame Spiele*. Bärmeier & Nikel, Frankfurt, 1970. PB, 278 x 201 mm, 102 pp, 92 b&w photos. Collaboration with Shinkichi Tajiri.

5 *Made in Germany*. Grossman Publishers, New York, 1970 (second edn published by Steidl, Göttingen, 2013). HB w/ jkt, 256 x 222 mm, 224 pp, 125 b&w photos.

6 *The Great Cities/Berlin*. Time Life Books, Amsterdam, 1977. HB, 300 x 228 mm, 200 pp, 121 col and b&w photos. Text by Frederic V. Grunfeld.

7 *Police Work*. Simon and Schuster, New York, 1980. PB, 278 x 215 mm, 126 pp, 124 b&w photos. Foreword by Studs Terkel.

8 *La Danse des Fidèles*. Editions du Chêne, Paris, 1984. HB w/

jkt, 251 x 281 mm, 106 pp, 79 b&w photos. Text by Freed.

9 *Leonard Freed: Photographies 1954-1990*. Nathan Image, Paris, 1991 (French edn; English edn: Cornerhouse Publications, Manchester, 1991). HB w/ jkt, 290 x 255 mm, 196 pp, 170 b&w photos. Intro by Stefanie Rosenkranz.

10 *Amsterdam: The Sixties*. Focus Publishing, Amsterdam, 1997. HB, 285 x 245 mm, 144 pp, 152 b&w photos. Text by Freed.

11 *Another Life*. ABP Public Affairs, The Netherlands, 2004 (bilingual edn: English and Dutch). HB, 290 x 240 mm, 452 pp, 198 b&w photos. Interview by Marcel Vleugels.

12 *Venice Venezia: Suspended between Past and Future*. Postcart Edizioni, Rome, 2006 (bilingual edn: English and Italian). HB, 340 x 250 mm, 272 pp, 99 b&w photos by Freed and 100 col photos by Claudio Corriveti.

13 *Worldview*. Steidl, Göttingen and Musée de l'Elysée, Lausanne, 2007. HB w/ jkt, 305 x 232 mm, 312 pp, 214 b&w photos. Text by William A. Ewing, Nathalie Herschdorfer, Wim van Sinderen.

Paul Fusco

Paul Fusco (b.1930; joined Magnum 1973) began taking photos with the US Army in Korea in 1951. In 1958, he began reporting for *LOOK* magazine on social issues including miners in Kentucky; Latino ghetto life in New York City; African-Americans in the Mississippi delta; and migrant labourers. Other subjects include people living with AIDS, the Zapatista uprising in the Mexican state of Chiapas and a major project documenting the radioactive fallout from Chernobyl. His latest project, 'Bitter Fruits' documents US families mourning soldiers killed in the Middle East wars as their bodies are returned home.

1

2

3

4

5

6

1 *Sense Relaxation: Below Your Mind*. Collier Books, New York, 1968 (also published in PB in 1969; published in French as *Le Relaxation Sensorielle*, De l'Homme, Montreal, 1972). HB and PB, 279 x 229 mm, 192 pp, 140 b&w photos. Text by Bernard Gunther.

2 *La Causa: The California Grape Strike*. Collier Books/ The Macmillan Company, New York, 1970. HB w/ jkt, 278 x 200 mm, 158 pp, 79 b&w photos. Intro by E. L. Barr; text by George D. Horwitz.

3 *What to Do Till the Messiah Comes*. Collier Books/The Macmillan

Company, New York, 1971. HB w/ jkt, 290 x 210 mm, 200 pp, 121 b&w photos. Text by Bernard Gunther.

4 *Marina & Ruby: Training a Filly with Love*. William Morrow & Company, New York, 1977. HB w/ jkt, 280 x 217 mm, 144 pp, numerous col photos. Text by Patricia Sayer Fusco and Marina Fusco.

5 *RFK Funeral Train*. Magnum Photos and The Photographers' Gallery, London, 1999 (artist's edn of 350 print-on-demand copies; first edn published by Umbrage Editions, New York, 2001; revised edn published by Aperture, New York, 2008). PB w/ nine different covers, individually numbered, 167 x 250 mm, 148 pp, 68 col photos. Intro by Norman Mailer.

6 *Chernobyl Legacy*. De.MO, New York, 2001. PB, 300 x 219 mm, 226 pp, 109 b&w and col photos. Collaboration with Magdalena Caris; intro by Michael Douglas.

Cristina García Rodero

Cristina García Rodero (b.1949; joined Magnum in 2005) studied painting before becoming a photographer. While working as a teacher in Spain she documented rural traditions in the form of secular and religious festivals, Christian and pagan, across Europe. In 1989 she won the W. Eugene Smith Foundation Prize. Her work has been widely published and exhibited internationally – her portraits and photo-documentation of voodoo rituals in Haiti were exhibited at the 2001 Venice Biennale.

1

2

3

4

5

1 *España Oculta*. Lunwerg Editores, Barcelona, 1989. HB w/ jkt, 290 x 290 mm, 134 pp, 126 b&w photos. Foreword by Julio Caro Baroja.

2 *Festivals and Rituals of Spain*. Harry N. Abrams, New York, 1994. HB w/ jkt, 330 x 250 mm, 220 pp, 187 col photos. Text by José Manuel Caballero Bonald.

3 *Rituales en Haití*. TF Editores, Madrid, 2001. HB w/ jkt, 330 x 250 mm, 218 pp, 101 b&w photos. Foreword by Christian Caujolle; text by Laënnec Hurbon.

4 *Maria Lionza: La Diosa de los Ojos de Agua*. Consejeria de Cultura y Turismo, Madrid, 2008. HB w/ jkt, 325 x 245 mm, 282 pp, 118 col and b&w photos.

5 *Cristina García Rodero: Transtempo*. La Fabrica, Madrid, 2011. HB w/ jkt, 279 x 197 mm, 260 pp, numerous photos.

Jean Gaumy

In 1975 Jean Gaumy (b.1948; joined Magnum in 1977) undertook two long works on subjects never before broached in France: *L'hôpital* and *Les Incarcérés*, both of which were later published in 1976 and 1983 respectively. His photographic and film works on human confinement have been coupled with a more contemplative photographic approach in recent years. His work has taken him from the arctic seas to the contaminated lands of Chernobyl and Fukushima. He received the Prix Nadar in both 2001 and 2010.

1

2

3

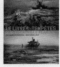
4

5

6

1 *L'hôpital*. Contrejour, Paris, 1976 (French edn). PB, 220 x 205 mm, 26 pp, 21 b&w photos.

2 *Les Incarcérés*. L'utopie pénitentiaire. Editions de l'Etoile, Paris, 1983 (French edn). PB, 220 x 190 mm, 94 pp, 38 b&w photos. Text by Yann Lardeau.

3 *Le Pont de Normandie*. La Cherche Midi, France, 1994 (French edn). HB w/ jkt, 300 x 262 mm, 100 pp, 107 b&w photos.

4 *Le Livre de Tempêtes à bord de l'Abeille Flandre*. Editions de Seuil, Paris, 2001 (French edn). HB w/ jkt, 323 x 236 mm, 186 pp, 65 b&w photos. Text by Hervé Hamon.

5 *Pleine Mer*. Editions de la Martinière, Paris, 2001 (also published as *Men at Sea*, Harry N. Abrams, New York; as *Mare Aperto*, Contrasto, Italy; and as *Auf hoher See*, Knesebeck, Germany, 2002). HB, 288 x 238 mm, 128 pp, 98 b&w and 7 blue-toned photos, 5 contact sheets and 1 illus. Text by Gaumy.

6 *D'après Nature*. Editions Xavier Barral, Paris, 2010 (trilingual edn in French, English and Italian; also published as a limited edn of 50 w/ box and print). HB w/ jkt, 312 x 378 mm, 98 pp, 40 b&w photos. Text by René Daumal.

Bruce Gilden

Bruce Gilden (b.1946; joined Magnum in 1998) was first attracted to his photographic subjects while growing up among the bustling streets of Brooklyn, New York. He first discovered photography in 1968 when he bought himself a cheap Miranda camera and began taking evening classes at the School of Visual Arts, New York – though he is primarily self-taught. Since then, Gilden has focused on strong 'characters', travelling all around the world to photograph them. His confrontational, graphic style and his use of flash render his images immediately recognizable, in both black-and-white film and in digital colour. Gilden received a Guggenheim Fellowship in 2013. He lives in Beacon, New York.

1

2

3

4

5

6

7

8

9

10

11

12

13

14

15

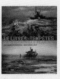
16

17

1 *The Small Haiti Portfolio*. Opus/P.S., Helsinki, 1990 (limited edn of 100 copies). HB, 165 x 152 mm, 24 pp, 12 b&w photos.

2 *Facing New York*. Cornerhouse Publications, Manchester, 1992. HB, 337 x 246 mm. 96 pp, 43 b&w photos.

3 *Bleus*. Mission Photographique Transmanche, Paris, 1994 (bilingual edn: French and English). PB, 300 x 235 mm, 40 pp, 22 b&w photos. Text by Pierre Devin.

4 *Haiti*. Dewi Lewis Publishing, Stockport, 1996. HB, 332 x 250 mm, 120 pp, 56 b&w photos. Intro by Ian Thomson.

5 *Ciganos*. Centro Português de Fotografia, Portugal, 1999. PB, 270 x 200 mm, 62 pp, 25 b&w photos. Intro by Teresa Siza.

6 *After the Off*. Dewi Lewis Publishing, Stockport, 1999. HB, 330 x 245 mm, 120 pp, 55 b&w photos. Short story by Dermot Healy.

7 *Go*. Trebruk, London, 2000 (limited edn of 3,000 copies, of which 100 w/ slipcase and print). HB w/ slipcase, 330 x 220 mm, 96 pp, 63 b&w photos and 3 manga illus.

8 *Coney Island*. Trebruk, London, 2002 (limited edn of 2,500 copies, of which 100 w/ slipcase). HB w/ slipcase, 320 x 240 mm, 108 pp, 54 b&w photos. Text by Gilden.

9 *A Beautiful Catastrophe*. PowerHouse Books, New York, 2005. HB, 320 x 240 mm, 140 pp, 86 b&w photos.

10 *Fashion Magazine by Bruce Gilden*. Magnum Photos, New York, 2006. Comprised of 5 PB inserts, each 390 x 278 mm: *Power*, 23 pp, 14 b&w photos; *Fame*, 28 pp, 14 b&w photos; *Addictions*, 48pp, 18 b&w photos; *Body*, 24pp, 18 b&w photos; *Fantasmes*, 28pp, 18 b&w photos; *Exclusive*, 24 pp, 16 b&w photos; *Illicit*, 23pp, 16 b&w photos.

11 *Bruce Gilden: Stern Fotographie Portfolio No. 64*.

Stern, Hamburg, 2011. HB, 360 x 270 mm, 96 pp, 58 b&w photos. Text in German and English.

12 *Foreclosures*. Browns edns, London, 2013 (standard & slipcase edn; edn of 500 copies). PB, 280 x 375 mm, 128 pp, 59 photos and 1 found postcard.

13 *A Complete Examination of Middlesex*. Archive of Modern Conflict, London, 2013. HB, 225 x 335 mm, 104 pp, 64 b&w and 12 col photos.

14 *American Made: S Magazine, Issue 07*. Leica Fotografie International, Hamburg, 2015. PB, 320 x 240 mm, 162 pp, 79 photos.

15 *Face*. Dewi Lewis Publishing, Stockport, 2015. HB, 370 x 247 mm, 104 pp, 52 col photos.

16 *Hey Mister, Throw Me Some Beads!* Kehrer Verlag, Heidelberg, 2015. HB, 320 x 240 mm, 110 pp, 52 b&w photos. Text by Gilden and Sophie Darmaillacq.

17 *Un Nouveau Regard sur la Mobilité Urbaine*. Editions de la martinière, Paris, 2015 (bilingual edn, English and French; limited edn of 500 copies). HB, 250 x 187 mm, 96 pp, 48 b&w photos.

Burt Glinn

Burt Glinn (1925–2008; joined Magnum in 1951) worked for *LIFE* magazine from 1949 to 1950 before first making his mark with a spectacular colour series on the South Seas, Japan, Russia, Mexico and California. His reportages have appeared in *Holiday, Esquire, Geo, Travel + Leisure, Fortune, LIFE* and *Paris Match*. He covered the Sinai War, the US Marine invasion of Lebanon and Fidel Castro's takeover of Cuba. In the 1990s he completed an extensive photo essay on the topic of medical science. He was president of Magnum between 1972 and 1975, and was re-elected to the post in 1987.

1 2 3

1 *A Portrait of All the Russias*. The Hogarth Press, London, 1967. HB w/ jkt, 277 x 206 mm, 176 pp, 56 col photos. Text by Laurens van der Post.

2 *A Portrait of Japan*. William Morrow & Company, New York, 1968. HB w/ jkt, 277 x 206 mm, 176 pp, 54 col photos. Text by Laurens van der Post.

3 *Havana: El Momento Revolucionario*. Umbrage Editions, New York, 2001 (English and Spanish edn). HB w/ jkt, 298 x 205 mm, 128 pp, 83 b&w photos. Intro by Rafael Acosta de Arriba; essays by Nan Richardson and Glinn.

Jim Goldberg

Jim Goldberg (b.1953; joined Magnum in 2002) lives and works in San Francisco. His innovative use of image and text contributes to his experimental storytelling practice. His major projects include *Rich and Poor* (1977–85), *Raised by Wolves* (1985–95), *Nursing Home* (1986), *Coming and Going* (1996–present), *Open See* (2003–9) and *Candy* (2013–15). He is the recipient of numerous awards, including three National Endowment for the Arts Fellowships, a Guggenheim Fellowship (1985), the Henri Cartier-Bresson Award (2007), and the Deutsche Börse Photography Prize (2011).

1 2 3 4

5 6 7 8

9 10 11 12

13 14

1 *Guest Register*. Self-published, New York, 1977. Spiralbound w/ silver gelatin prints and handwritten text, 235 x 298 mm, 54 pp, 50 photos.

2 *Rich and Poor*. Random House, New York, 1985. PB, 280 x 215 mm, 200 pp, 80 b&w photos.

3 *Raised by Wolves*. Scalo, Zurich, 1995. PB, 305 x 228 mm, 320 pp, 177 b&w and 53 col photos. Text by Goldberg.

4 *It Ended Sad, But I Love Where It Began*. TBW Books, Oakland, California, 2006 (Subscription Series #1, part of 4-book series; edn of 500 copies). PB, 178 x 127 mm, 20 pp, 18 b&w and col photos and text.

5 *War is Only Half the Story: The Aftermath Project Volume I*. Aperture, New York, 2008. PB, 300 x 245 mm, 128 pp, 40 b&w and col photos. Collaboration with and additional photos by Wolf Böwig.

6 *Open See*. Steidl, Göttingen, 2009. 4 PBs in slipcase, 165 x 216 mm, 244 pp, 179 b&w and col photos, polaroids with text and ephemera. Text by Armara Lakhouse.

7 *134 Ways to Forget*. Super Labo, Kamakura, 2011 (edn of 700 copies). Unbound PB, 225 x 145 mm, 64 pp, approx. 210 b&w and col photos, text and ephemera.

8 *Proof*. ICP, New York, 2013 (edn of 1000 copies). PB, 270 x 200 mm, 48 pp, 183 b&w and col photos with 5 hidden golden prize tickets.

9 *Polaroids from Haiti*. Nazraeli Press, Portland, Oregon, 2014 (*One Picture Book #84*: part of artists' book series). HB, 184 x 140 mm, 16 pp, 12 col photos.

10 *Rich and Poor*. Steidl, Göttingen, 2014 (redesigned and expanded edn). HB, 274 x 216 mm, 222 pp, 155 b&w photos with text and col insert.

11 *Prop Roots Vol. V*. Self-published, San Francisco, 2015. HB in clamshell case, 863 x 546 mm, 34 pp, 34 photos.

12 *The Last Son*. Super Labo, Kamakura, 2016. HB, 262 x 184 mm, 140 pp, approx. 210 b&w and col photos and mixed media collages.

13 *Ruby Every Fall*. Nazraeli Press, Paso Robles, California, 2016. HB, 305 x 381 mm, 32 pp, approx. 44 b&w and col photos, drawings and mixed media collages.

14 *Raised by Wolves (Bootleg)*. Self-published, Cotati, CA, 2016. PB, 306 x 228 mm, 320 pp, 214 b&w photos and 16 col photos, tipped in pictures and letter insert with original drawings.

Philip Jones Griffiths

Philip Jones Griffiths (1936–2008; joined Magnum in 1966) began his career photographing for the *Manchester Guardian* and the *Observer* newspapers while studying pharmacy. His book on the Vietnam War, *Vietnam Inc.*, where he had been from 1966 to 1971, crystallized public opinion and gave form to Western misgivings about American involvement in Vietnam. In 1973 he covered the Yom Kippur War, then worked in Cambodia in 1973–5. From 1980 to 1985 he was president of Magnum Photos. His work examines the unequal relationship between technology and humanity, summed up in his book *Dark Odyssey*. Faithful to the ethics of the Magnum founders, Griffiths believed in human dignity and in the capacity for improvement.

1 2 3 4

5 6

1 *Vietnam Inc*. Collier Books, New York, and Collier-Macmillan, London, 1971 (re-published by Phaidon Press, London, 2001, with an intro by Noam Chomsky). HB and PB, 280 x 202 mm, 224 pp, 266 b&w photos. Photography, text and design by Griffiths.

2 *Philip Jones Griffiths: Una Vision Retrospectiva (1952-1988)*. Organización Capital Europea de la Cultura, Madrid, 1992. PB, 270 x 238 mm, 126 pp, 100 b&w photos. Essay by William Messer.

3 *Dark Odyssey*. Aperture, New York, 1996. HB w/ jkt, 330 x 230 mm, 180 pp, 113 b&w photos. Intro by Murray Sayle.

4 *Agent Orange: 'Collateral Damage' in Vietnam*. Trolley Books, London, 2003. HB w/ jkt, 295 x 227 mm, 178 pp, 101 b&w photos. Text by Griffiths.

5 *Vietnam at Peace*. Trolley Books, London, 2005. HB w/ jkt, 248 x 335 mm, 312 pp, 550 b&w photos. Text by Griffiths.

6 *Recollections*. Trolley Books, London, 2008. HB w/ jkt, 297 x 210 mm, 240 pp, 130 b&w photos. Preface by Julian Stallabrass; text by Griffiths; extract from letter by Tony Benn.

Harry Gruyaert

Harry Gruyaert (b.1941; joined Magnum in 1981) has recorded the subtle chromatic vibrations of Eastern and Western light from Belgium to Morocco, India to Egypt. In his later work he abandoned the Cibachrome process in favour of digital print. Better suited to revealing the rich shades in his images, digital print brought his work one step closer to his original intention - to allow colour to assert itself.

1

2

3

4

5

6

7

8

9

10

11

1 *Lumieres Blanches: Photographies de Harry Gruyaert*. Centre Nationale de la Photographie, Paris, 1986 (French edn). PB, 260 x 272 mm, 102 pp, 45 col photos. Intro by Alain Macaire; text by Richard Nonas.

2 *Morocco*. Schirmer Art Books, Munich, 1990 (bilingual edn: French and English). HB w/ jkt, 296 x 318 mm, 112 pp, 52 col photos.

3 *Made in Belgium*. Editions Delpire, Paris, 2000 (French edn). HB, 204 x 287 mm, 90 pp, 73 col photos. Text by Hugo Claus.

4 *Rivages*. Les Editions Textuel, Paris, 2003 (French edn; English edn: Melts & Schilt; second edn: 2009). HB, 250 x 370 mm, 100 pp, 50 col photos. Preface by Brice Matthieussent.

5 *TV Shots*. Steidl, Göttingen, 2007. Flexibound, 284 x 192 mm, 152 pp, 104 col photos. Text by Jean-Philippe Toussaint.

6 *Marruecos*. Tres Culturas, Seville, 2009. HB, 298 x 298 mm, 62 pp, 53 col photos. Intro by Gerardo Ruiz-Rico Ruiz.

7 *Moscou*. Les Editions Be-Poles, Paris, 2010 (French edn). PB, 210 x 130 mm, 64 pp, 48 col photos.

8 *Roots*. Editions Xavier Barral, Paris, 2012 (French edn; Flemmish edn: Editions Hannibal) HB, 166 x 905 mm, 160 pp, 149 col and b&w photos. Text by Dimitri Verhulst.

9 *Maroc*. Les Editions Textuel, Paris, 2013 (French edn). HB, 255 x 340 mm, 120 pp, 80 col photos. Preface by Brice Matthieussent; text by Gruyaert.

10 *Harry Gruyaert*. Les Editions Textuel, Paris, 2015 (English edn: Thames & Hudson, London and Flemmish edn: Editions Hannibal, 2015). HB, 270 x 290 mm, 144 pp, 80 col photos. Foreword by François Hébel; afterword by Richard Nonas.

11 *Harry Gruyaert*. Hannibal Editions, Belgium, 2015 (French edn: Les Editions Textuel, Paris, 2015; English edn: Thames & Hudson, London, 2015). HB, 270 x 290 mm, 144 pp, 80 col photos. Foreword by François Hébel; afterword by Richard Nonas.

Ernst Haas

Ernst Haas (1921-86; joined Magnum in 1949) is considered one of the pioneers of colour photography. He moved from Vienna to the United States in 1951, and soon after began experimenting with Kodachrome colour film. In 1953 *LIFE* magazine published his groundbreaking, 24-page photo essay on New York City. In 1962 a retrospective of his work was the first colour photography exhibition held at New York's Museum of Modern Art. Haas received the Hasselblad Award in 1986, the year of his death.

1

2

3

4

1 *The Creation*. A Studio Book, Viking Press, New York, 1971 (French edn: Denoël, Paris, 1971; PB edn: Penguin Press, London, 1976; revised edn: Viking Press, New York, 1983). HB w/ jkt, 190 x 280 mm, 160 pp, 106 col photos.

2 *In America*. A Studio Book, Viking Press, New York, 1975. HB w/ jkt, 241 x 342 mm, 144 pp, 105 col photos.

3 *In Germany*. A Studio Book, Viking Press, New York, 1977. HB w/ jkt, 241 x 342 mm, 184 pp, 184 col photos.

4 *Himalayan Pilgrimage*. Viking Press, New York, 1978. HB w/ jkt, 230 x 332 mm, 142 pp, 141 col photos.

Philippe Halsman

Philippe Halsman (1906-79; joined Magnum in 1951) was born in Riga, Latvia, and began taking photographs in Paris in the 1930s, opening a portrait studio in Montparnasse in 1934. There he photographed writers and artists with an innovative, self-designed, twin-lens reflex camera. He arrived in the United States in 1940, the start of a prolific period of work producing reportage and covers for most major American magazines, including a record 101 covers for *LIFE* magazine.

1

2

3

4

5

6

1 *The Frenchman: A Photographic Interview*. Simon and Schuster, New York, 1949 (second edn: Taschen, Cologne, 2005). PB, 232 x 175 mm, 96 pp, 24 b&w photos.

2 *Dali's Mustache: A Photographic Interview*. Simon and Schuster, New York, 1954 (second edn: Flammarion, 1994). HB w/ jkt, 180 x 140 mm, 126 pp, 30 b&w photos. Collaboration with Salvador Dalí.

3 *Philippe Halsman's Jump Book*. Simon and Schuster, New York, 1959 (PB edn: Abrams, New York, 1986; second edn: Damiani, Bologna, 2015; French edn: Editions de la Martinière). HB w/ jkt, 178 x 210 mm, 96 pp, 180 b&w photos. Preface 'Jumpology' by Halsman.

4 *Halsman on the Creation of Photographic Ideas*. Ziff-Davis, New York, 1961. HB w/ jkt, 174 x 174 mm, 86 pp, 27 b&w photos. Text by Halsman.

5 *Halsman: Sight and Insight*. Doubleday & Company, New York, 1972. HB w/ jkt, 289 x 263 mm, 188 pp, 200 b&w photos. Text by Halsman.

6 *Halsman @ 79*. ICP, New York, 1979. PB, 304 x 229 mm, 76 pp, 80 b&w and col photos. Intro by Owen Edwards.

Hiroshi Hamaya

Hiroshi Hamaya (1915-99; joined Magnum in 1960) began his career photographing Tokyo from the air and the street, working as an aerial photographer and as a freelance contributor to magazines. In 1939 he travelled on assignment to the rural coast of Japan, where he became interested in documenting traditional customs and the austere environment. In the early 1950s he settled in the seaside town of Ōiso, where he produced books based on his earlier projects. Later in his career, Hamaya chronicled the massive demonstrations against the renewal of the US-Japan Security in Tokyo in 1960; and he also made studies of landscapes found in Japan and abroad.

1 *Yukunguni* (Snow Country). Mainichi Shimbun-Sha, Tokyo, 1956 (revised edn: Asahi Sonorama, 1977). HB w/ jkt and box, 300 x 260 mm, 140 pp, 126 b&w photos.

2 *Ura Nihon* (Japan's Black Coast). Shinchosha, Tokyo, 1957. HB, 374 x 277 mm, 116 pp, 74 b&w photos.

3 *Henkyo-no-machi Urumchi*. (Marginal Town Ürümqui). Heibnosha, Tokyo, 1957 (bilingual edn: Japanese and English). HB w/ jkt, 259 x 186 mm, 50 pp, 45 b&w photos.

4 *Mite Kita Chugoku* (China As I Saw It). Kawade Shobo Shinsha, Tokyo, 1958 (Japanese edn). HB w/ jkt and slipcase, 305 x 265 mm, 122 pp, 231 b&w photos.

5 *Kodomo Fudoki* (Children in Japan). Chuokoronsha, Tokyo, 1959 (Japanese edn). HB w/ jkt and case, 245 x 270 mm, 110 pp, 177 col and b&w photos.

6 *Ikari-to-Kanashimi-no-Kiroku* (Chronicle of Grief and Anger). Kawade Shobo Shinsha, Tokyo, 1960 (Japanese edn). PB, 257 x 180 mm, 100 pp, 92 b&w photos.

7 *Det Gömda Japan* (The Hidden Japan). Bonniers, Stockholm, 1960 (Swedish edn). HB, 250 x 188 mm, 160 pp, 30 b&w photos. Text by Bo Setterlind.

8 *Nihon Retto* (Landscapes of Japan). Heibonsha, Tokyo, 1964. HB w/ jkt, 220 x 350 mm, 146 pp, 111 col photos. Intro by Taro Tsujimura.

9 *Eye*. Self-published. 1968. HB, 251 x 271 mm, 34 pp, 33 b&w photos.

10 *American America*. Kawade Shobo, Tokyo, 1971. HB, 240 x 260 mm, 81 pp, 248 b&w photos.

11 *Senzo Zanso* (Latent Image/ After Image). Kawade Shobo Shinsha, Tokyo, 1971 (Japanese edn). HB w/ jkt, 186 x 125 mm, 256 pp, 66 b&w photos.

12 *Nihon-no-Shiika* (The poetry of Japan). Chuokoronsha, Tokyo, 1972 (Japanese; edn of 1,250 copies). HB, 300 x 260 mm, 160 pp, 156 col photos, 19 b&w photos.

13 *Aizu Yaichi*. Self-published, 1972. HB folio, 425 x 300 mm, 13 pp (unbound), 12 b&w photos.

14 *Nihon no Shizen* (Landscape of Japan). Kokusai Johosha, Tokyo, 1975 (Bilingual edn: Japanese & English; two volumes). HB w/ slipcase, 363 x 256 mm, vol.1: 160 pp, 77 col photos, vol.2: 164 pp, 83 col photos.

15 *Koho Fuji* (Mt. Fuji: A Lone Peak). Shueisha, Tokyo, 1978. Series, *Nihon no Bi* (Japanese Beauty), HB w/ jkt and box, text in Japanese, 364 x 258 mm, 134 pp, 55 colour photos.

16 *Nankyoku Hanto Natsu Keshiki* (Summer Shots Antarctic Peninsula). Asahi Sonorama, Tokyo, 1979 (bilingual edn: Japanese and English). PB, 210 x 299 mm, 108 pp, 99 col photos.

17 *Hamaya Hiroshi Syashin Syusei* (Corpus of Hiroshi Hamaya 1940-80). Iwanami Shoten, Tokyo, 1981 (Japanese edn; two volumes). HB w/ slipcase, 300 x 398 mm, vol.1: *Chi no Kao* (Aspects of Nature), 172 pp, 144 col photos, *Sei no Kao* (Aspects of Life), 194 pp, 176 b&w photos.

18 *Landscapes*. Harry N. Abrams, New York, 1982. HB w/ slipcase, 305 x 405 mm, 166 pp, 144 col photos.

19 *Tabi* (Travel). JTB, Nihon Kotsu Kosha, 1982. HB w/ slipcase and box, 252 x 365 mm, 305 pp, 601 b&w and col photos. Text by Hamaya.

20 *Gakugei Shoka* (Portraits of artists and scholars). Iwanami Shoten, Tokyo, 1983. HB w/ jkt, 310 x 323 mm, 140 pp, 120 b&w photos.

21 *Niji kiezu mata* (Rainbow Doesn't Disappear) (Private Photofolio commemorating the third anniversary after Daigaku Horiguchi's death). Self-published, Ōiso, 1983. PB, 195 x 212 mm, 48 pp, 40 b&w photos.

22 *Shiga Prefecture*. Shiga Prefectural Government, Shiga, 1983. HB, 247 x 265 mm, 130 pp, 85 col photos.

23 *Showa Nyoninsyu* (Women in the Showa Era). Asahi Shimbun Sha, Tokyo, 1985. HB, 253 x 269 mm, 204 pp, 340 b&w photos.

24 *Nyonin Rekijitu 1948-1950* (Calendar Days of Asaya Hamaya 1948-1950). Privately published, Ōiso, 1985 (edn of 1,000 copies). HB portfolio, 300 x 211 mm, 28 pp, 28 loose sleeves, 24 b&w photos.

25 *1930-1981 Hiroshi Hamaya: Fifty Years of Photography*. Self-published, Ōiso, 1986. 245 x 260 mm, 44 pp, 36 col and b&w photos

26 *Emergence de la Terre*. Editions Hologramme, Paris, 1986. HB, 310 x 405 mm, 168 pp. 144 col photos.

27 *Showa Dansei Shokun* (Men of the Showa Era). Asahi Shimbun Sha, Tokyo, 1989. PB, 253 x 269 mm, 204 pp, 338 b&w photos.

28 *Watashi* (Myself), *Shonan Bunko, Ōiso, 1991*. Shonan Bunko, Tokyo, 1991. HB, 240 x 261 mm, 122 pp, 165 b&w photos.

29 *Shashin no Seihi* (Century of Photography). Tokyo Metropolitan Museum of Photography, Tokyo, 1997 (bilingual edn: Japanese and English). PB, 239 x 258 mm, 192 pp, 118 b&w and 20 col photos.

30 *Fukuen Zuisho-no-Hitobito* (People with Lucky Relationships). Sojusha, Tokyo, 1998 (Japanese edn). HB w/ jkt, 297 x 218 mm, 206 pp, 192 b&w photos.

31 *Ichi-no-Oto* (Sounds of the Streets). Kawade Shobo Shinsha, Tokyo, 2009 (Japanese edn). HB w/ jkt, 257 x 184 mm, 128 pp, 96 b&w photos.

Charles Harbutt

Charles Harbutt (1935-2015; joined Magnum in 1963) was twice president of Magnum. He was a photojournalist for twenty years, working mostly for magazines in Europe, Japan and the United States, and from 1980 he pursued more personal interests. From 1992 until he died, Harbutt was an associate professor of photography at the Parsons School of Design in New York. He was also a guest artist at the Rhode Island School of Design, MIT and the Art Institute of Chicago, and he taught at Cooper Union, the Pratt Institute and Bard College. In 1989, he had a solo show at the Bibliotheque Nationale in Paris, which has a large collection of his prints. In 1997, his archives were acquired for the collection of the Center for Creative Photography, Tucson, Arizona.

1

2

3

4

5

x 230 mm, 144 pp. 110 b&w photos. Intro and epilogue by Harbutt.

3 *Kertész & Harbutt: Sympathetic Explorations*. Plains Art Museum, Fargo, North Dakota, 1978. PB, 254 x 229 mm, 68 pp, 51 b&w photos (24 by André Kertész, 24 by Harbutt, 2 by Joan Liftin and 1 by Richard Kalvar). Intro by Andy Grundberg.

4 *Progreso*. Navarin Editeur and Audiovisuel, Paris and Fondation Kodak-Pathe, New York, 1986 (French edn; published in English by Actuality Inc., New York, 1987). HB and PB, 305 x 230 mm, 93 pp, 86 b&w photos.

5 *Departure and Arrivals*. Damiani, Bologna, 2012. HB, 297 x 272 mm, 120 pp, 93 b&w photos.

1 *Plan for New York City: 1969 A Proposal*. MIT Press, Cambridge, Massachusetts, 1969. 3 vols, each vol: HB w/ jkt, oversize, 180 pp, c. 800 b&w photos. Additional photos by Burk Uzzle and Richard Kalvar; text by New York City Planning Commission.

2 *Travelog*. The MIT Press, Cambridge, Massachusetts and London, 1973. HB and PB, 203

Erich Hartmann

Erich Hartmann (1922-99; joined Magnum in 1951) worked for *Fortune* magazine in the 1950s and later produced numerous photo essays on the poetics of science, industry, architecture and technology for French, German and American *Geo* and other magazines. Personal projects included photographic interpretations with literary echoes: Shakespeare's England, Joyce's Dublin, Thomas Hardy's Wessex. He also explored abstract representations of ink-drops in water, patterns of laser light, and the beauty of tiny components of technology. In his later years he photographed the remains of the Nazi concentration camps. He was president of Magnum from 1985 to 1987.

1

2

3

1 *About OXO: In Its Jubilee Year 1965*. Spectator Publications, London, 1965. HB w/ jkt, 240 x 350 mm, 46 pp, 45 b&w photos. Text by Christopher Scarborough.

2 *Au Clair de la Terre*. Arcade, Paris, 1972 (also published in English as *Space: Focus Earth*, Arcade, 1972). PB w/ jkt, 280 x 203 mm, 124 pp, 67 b&w and col photos. Text by Georges Bardawil.

3 *In The Camps*. W.W. Norton & Company, New York and London, 1995 (French edn: *Dans le*

Silence des Camps, Editions de La Martinière, Paris, 1995; German edn: *Stumme Zeugen*, Schneider, Gerlingen, 1995; Italian edn: *Il Silencio dei Campi*, Contrasto, Rome, 1997). HB w/ jkt (PB for Italian edn), 277 x 252 mm, 112 pp, 76 b&w photos. Text by Hartmann; journal entry in Afterword by Ruth Bains Hartmann; quotes by Arthur Miller.

David Alan Harvey

David Alan Harvey (b.1944; joined Magnum in 1993) discovered photography aged 11 when he bought his first camera; in 1956 he began photographing his family and neighbourhood. His first book, *Tell It Like It Is* (1966), documented the lives of a black family in Norfolk, Virginia, his home state. He has worked and travelled extensively for *National Geographic*, producing over forty essays and two major books on the extensive Spanish cultural migration into the Americas. Other stories include one on French teenagers, the Berlin Wall and Maya culture. He is founder and editor of *Burn* magazine.

1

2

3

4

5

6

1 *Cuba*. National Geographic, Washington, DC, 1999. HB w/ jkt, 273 x 268 mm, 252 pp, 150 col photos. Text by Elizabeth Newhouse.

2 *Divided Soul*. Phaidon Press, London, 2003 (also published in French). HB w/ jkt, 220 x 330 mm, 166 pp, 104 col photos.

3 *Living Proof*. Powerhouse Books, New York, 2007. HB, 209 x 179 mm, 112 pp, c. 50 col photos. Text by Ruckus and Uptown.

4 *Based on a True Story*. Burn Books, New York, 2012 (limited edn of 600 copies). HB w/ slipcase, road map, postcard and printed cardboard box, 245 x 170 mm, 132 pp, 66 col photos.

5 *Tell It Like It Is*. Burn Books, New York, 2015 (also a special edn of 150 copies, with a replica book, 38 contact sheets and a signed print). PB, 381 x 267 mm, 76 pp, 46 b&w photos.

6 *Jeju Haenyeo: Sea Women*. Korean Arts Council, Seoul, 2015. HB, 254 x 254 mm, 148 pp, 70 b&w photos.

Tim Hetherington

Tim Hetherington (1970-2011; joined Magnum posthumously in 2011) first picked up a camera while travelling in Asia after graduating from Oxford in English and Classics. Frustrated by the limitations of any single medium, he described himself as a 'visual storyteller'. He was an early pioneer of experimental multimedia animated formats, as well as photography and video, his work culminating in a World Press Photo premiere award in 2008 and an Academy Award nomination in 2011. He worked extensively in West Africa, and with the American writer Sebastian Junger he made several visits to a single US Army platoon in Afghanistan, which culminated in the book *Infidel* and numerous films, including 'Restrepo' (2010). Hetherington was killed by shrapnel while covering the civil war in Libya in 2011.

1

2

1 *Long Story Bit by Bit: Liberia Retold*. Umbrage Editions, New York, 2009. HB, 310 x 232 mm, 193 pp, 136 b&w photos.

2 *Infidel*. Chris Boot Ltd, London, 2010. PB, 208 x 150 mm, 240 pp, 148 col photos. Intro by Sebastian Junger; text by Hetherington.

Abigail Heyman

Abigail Heyman (1942-2013; member of Magnum 1974-81) studied at Sarah Lawrence College in Bronxville, New York, before becoming a photographer; she held her first exhibition in Manhattan in 1972. Heyman's best-known book, *Growing Up Female: A Personal Photojournal* (1974), showed the limited lives of American women and became a key work of the feminist movement. She returned to a similar theme in books on women at work and on the institution of marriage. Heyman was also a widely published photojournalist and served from 1988 to 2000 as the director of photography and photojournalism at the International Center of Photography in Manhattan.

1

2

3

4

21

1 *Growing Up Female: A Personal Photojournal*. Holt, Rinehart, and Winston, New York, 1974. PB, 240 x 182 mm, 120 pp, 81 b&w photos. Intro by Heyman.

2 *Butcher, Baker, Cabinetmaker: Photographs of Women at Work*. Ty Crowell, New York, 1978. HB w/ jkt, 232 x 167 mm, 96 pp, numerous b&w photos. Text by Wendy Saul.

3 *Dreams & Schemes: Love and Marriage in Modern Times*. Aperture, New York, 1987 (second edn: Picture Project, New York, 1993). PB, 235 x 267 mm, 112pp, 70 b&w photos. Text by Heyman.

4 *Flesh & Blood: Photographers' Images of their Own Families*. Picture Project, New York, 1992. HB, 248 x 286 mm, 190 pp, numerous photos. Edited by Heyman, Ethan Hoffman and Alice Rose George. Essays by Ann Beattie and Andy Grundberg. Photos by numerous photographers.

1 *Yatun Papa*. W. Keller & Co., Stuttgart, 1963. HB, 300 x 235 mm, 112 pp, 52 b&w photos. Collaboration Rolf Winter.

2 *Berliner Wände: Bilder aus einer verschwundenen Stadt*. Carl Hanser Verlag, Munich, 1976. PB, 294 x 213 mm, 94 pp, 78 col photos. Text by Hoepker and Günter Kunert.

3 *Mack: Expedn in Künstliche Gärten*. Stern, Hamburg, 1977. HB, 300 x 275 mm, 188 pp, 146 col photos.

4 *Vienna*. Time/Life Books, Amsterdam, 1978. HB, 305 x 240 mm, 200 pp, 85 photos.

5 *Leben in der DDR*. Ein STERN-Buch, Wilhelm Goldman Verlag, Hamburg, 1980 (second HB edn: Gruner & Jahr, Hamburg, 1985). PB, 185 x 125 mm, 224 pp, 113 b&w photos. Text by Eva Windmöller.

6 *Die New York Story*. Geo, Hamburg, 1983. HB, 285 x 210 mm, 384 pp, 158 photos. Collaboration with Dankwart Grube.

7 *Ansichten: Fotos von 1960 bis 1985*. Edition Braus, Heidelberg, 1985. PB, 244 x 218 mm, 180 pp, 72 b&w and 94 col photos.

8 *Amerika: Die Geschichte der Eroberung von Florida bis Kanada*. Geo, Hamburg, 1986. HB, 279 x 213 mm, 347 pp, 87 col photos. Collaboration with Klaus Harpprecht.

9 *New Yorker*. Edition Stemmle, Schaffhausen, 1987. PB, 280 x 232 mm, 128 pp, 50 col photos. Text by Eva Windmöller.

10 *ROM*. Collection Merian Hoffman und Campe, Hamburg, 1988. HB, 280 x 210 mm, 50 pp, 38 col photos. Text by Martin Mosebach.

11 *Land der Verzauberung*. Ellert & Richter, Hamburg, 1991. PB, 290 x 237 mm, 146 pp, 63 col photos. Text by Freddy Langer.

12 *Return of the Maya*. Dewi Lewis Publishing, Stockport and Henry Holt, 1998. HB w/ jkt, 279 x 211 mm, 146 pp, 108 col photos.

13 *Photografien 1955-2005*. Schirmer/Mosel, Munich, 2005. HB w/ jkt, 292 x 280 mm, 260 pp, 194 b&w and col photos. Text by Ulrich Pohlmann and Christian Schaernack, et al.

14 *Cate*. Self-Published, 2010. HB, 290 x 210 mm, 50 pp, 47 col photos.

15 *Champ*. Peperoni Books, Berlin, 2011. (second edn; 2012). HB, 279 x 237 mm, 96 pp, 80 b&w and col photos. Foreword by Hoepker.

16 *DDR Ansichten: Views of a Vanished Country*. Hatje Cantz, Ostfildern, 2011. HB, 285 x 268 mm, 256 pp, 82 b&w and 117 col photos. Text by Wolf Biermann, Gunter Kunert, Eva Windmoller and Hoepker.

17 *Berliner: Kaleidoskop*. Verlag Thomas Reche, Neumarkt, 2011. HB, 282 x 214 mm, 68 pp, 10 b&w and 21 col photos. Text by Gunter Kunert.

18 *Landscapes*. Bookfactory Bubu, Zurich, 2012. HB, 420 x 300 mm, 80 pp, 82 photos. Text by Norbert Denkel.

19 *New York*. teNeues, Kempen, 2013. HB w jkt, 315 x 233 mm, 120 pp, 76 b&w and col photos.

20 *Heartland: An American Road Trip in 1963*. Peperoni Books, Berlin, 2013. HB, 216 x 240 mm, 84 pp, 68 b&w and 8 col photos. Text by Hans-Michael Koetzle and Hoepker.

21 *Wanderlust*. teNeues, Kempen, 2014. HB, 320 x 240 mm, 304 pp, 275 b&w and col photos.

Thomas Hoepker

Thomas Hoepker (b.1936; joined Magnum in 1989) studied art history and archeology in Göttingen and Munich before beginning a career as a photojournalist for magazines including *Münchner Illustrierte* and *Kristall*. He was art director for *Stern* in 1987-9, and collaborated with his then wife, the journalist Eva Windmöller, in East Germany and New York. From 1978 to 1981 he was Director of Photography for the American edition of *Geo*. President of Magnum Photos from 2003 to 2006, Hoepker specializes in reportage and stylish colour features. He has also shot and produced several TV documentaries with his second wife Christine Kruchen.

1

2

3

4

5

6

7

8

9

10

11

12

13

14

15

16

17

18

19

20

David Hurn

David Hurn (b.1934; joined Magnum in 1967) established his international reputation with an intensely personal coverage of the late 1950s and 1960s. In the 1970s he returned to his native Wales to explore the way the Welsh live, who its people are, its landscape and culture. In addition to his photobooks, Hurn has written a narrative book with Bill Jay, *On Being a Photographer* (1997).

1

2

3

4

5

6

1 *David Hurn: Photographs 1956-1976*. Arts Council of Great Britain, London, 1979. HB w/ jkt, 199 x 211 mm, 64 pp, 49 b&w photos. Intro by Tom Hopkinson.

2 *Wales: Land of my Father*. Thames & Hudson, London, 2000. HB w/ jkt, 228 x 240 mm, 120 pp, 92 b&w photos. Intro by Patrick Hannan.

3 *Living in Wales*. Seren, Bridgend, 2003. HB w/ jkt, 238 x 225 mm, 132 pp, 101 b&w photos. Foreword by Anthony Jones.

4 *Cardiff: Rebirth of a Capital*. Cardiff Council, Cardiff, 2005. HB w/ jkt, 279 x 237 mm, 192 pp, 116 b&w and col photos, 2 illus. Foreword by Shirley Bassey.

5 *Writing the Picture*. Seren, Bridgend, 2010. HB w/ jkt, 239 x 220 mm, 110 pp, 65 b&w photos. Intro and poems by John Fuller.

6 *The 1960s: Photographed by David Hurn*. Reel Art Press, London, 2015. HB, 290 x 245 mm, 228pp, 240 b&w and col photos. Intro by Peter Doggett.

Richard Kalvar

Richard Kalvar (b.1944; joined Magnum in 1975) studied literature at Cornell University before becoming assistant to the French fashion photographer Jérôme Ducrot. A long visit to Europe in 1966-7 made him decide to become a photographer and shortly afterward he moved to Paris, helping found the Viva agency in 1972. As a member of Magnum, Kalvar has done extensive personal work around the world, notably in France, Italy, England, Japan and the United States, supporting himself with journalistic and commercial assignments. His photographs frequently play on the juxtaposition of the mundane and a feeling of strangeness created by a particular choice of timing and framing.

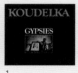

1

2

3

1 *Portrait de Conflans-Saint-Honorine*. Editions P.O Calmann-Lévy, France, 1993 (French edn). HB, 290 x 145 mm, 82 pp, 60 b&w photos. Preface by Alain Decaux.

2 *Earthlings*. Flammarion, Paris, 2007 (also published in French as *Terriens*). HB w/ jkt, 310 x 238 mm, 192 pp, 88 b&w photos. Preface by Seloua Luste Boulbina.

3 *Drôles de vies!* Editions Autrement, Paris, 2008 (French edn). HB, 200 x 200 mm, 22 pp, 10 b&w photos.

Josef Koudelka

Born in Moravia, Czechoslovakia, Koudelka (b.1938; joined Magnum in 1971) began his career as an aeronautical engineer, photographing in his free time. He became a full-time photographer in the 1960s and his photographs of Prague's 1968 Soviet invasion were published in 1969. Helped by Magnum, Koudelka left Czechoslovakia for asylum in the UK in 1970. Based in Paris and Prague, he has concentrated on panoramic photos of landscapes since 1986.

1

2

3

4

5

6

7

8

9

10

11

12

13

14

15

16

17

18

19

20

21

22

23

24

25

26

27

28

29

1 *Gypsies*. Aperture, New York, 1975 (also special PB edn for MoMA, New York; French edn: *Gitans: La Fin du Voyage*, Editions Delpire, Paris, 1977; and PB edn: Aperture, New York, 1985). HB w/ jkt, 270 x 295 mm, 136 pp, 60 b&w photos. Text by Anna Fárová, Willy Guy and John Szarkowski (text in French edn by Robert Delpire and Willy Guy).

2 *Exils*. Centre National de la Photographie, Paris, 1988 (French edn; English HB edn: Thames & Hudson, London and Aperture, New York, 1988). PB, 260 x 279 mm, 144 pp, 61 b&w photos. Text by Robert Delpire, Alain Finkielkraut and Danièle Sallenave (text in English edn by Czesław Miłosz).

3 *Josef Koudelka: Mission Photographique Transmanche, cahier 6*. Éditions de la Différence/Centre Régional de la Photographie Nord Pas-de-Calais, Douchy-les-Mines, 1989. PB in slipcase, 235 x 295 mm, 30 pp, 15 b&w photos. Texts by Michel Guillot and Bernard Latarjet.

4 *Animal*. Trois Cailloux and Maison de la Culture d'Amiens, Amiens, 1990 (edn of 700 copies). Portfolio, 318 x 248 mm, 36 pp, 18 b&w photos. Text by Ludvík Vaculík.

5 *Josef Koudelka: Fotografie, Divadlo za Branou 1965-1970*. Vytiskl Editpress, Prague, 1993. PB, 260 x 210 mm, 64 pp, 42 b&w photos. Text by Otomar Krejča and Anna Fárová.

6 *Černý Trojúhelník-Podkrušnohoří: Fotografie, 1990-1994* (The Black Triangle: The Foothills of the Ore Mountains, Photos 1990-1994). Vesmír, Prague, 1994. PB w/ slipcase, 233 x 293 mm, 74 pp, 34 b&w photos. Text by Josef Vavroušek; extract from a speech by Václav Havel.

7 *Josef Koudelka: Periplanissis*. Organisation for the Cultural Capital of Europe Thessaloniki 1997, International Thessaloniki Film Festival and Foundation for Hellenic Culture, Thessaloniki, 1995 (edn of 2000 copies). PB, 210 x 293 mm, 76 pp, 43 b&w photos. Text by Alain Bergala and Margarita Mandas.

8 *Exils* (second edn). Editions Delpire, Paris, 1997 (English edn with text by Czesław Miłosz: Aperture, New York and Thames & Hudson; Italian edn: Alinari, Florence, 1997). HB w/ jkt, 273 x 305 mm, 154 pp, 65 b&w photos. Text by Robert Delpire and Czesław Miłosz.

9 *Reconnaissance: Wales*. Fotogallery/Cardiff Bay Arts Trust/National Museums and Galleries of Wales/Magnum Photos, Cardiff, 1998 (edn of 1000 copies). HB w/ accordion folds, 235 x 284 mm, 48 pp, 16

b&w photos and 16 b&w thumbnails with captions. Text by Derrick Price and Christopher Coppock.

10 *Chaos*. Editions Nathan and Editions Delpire, Paris, 1999 (French edn; English edn: Phaidon Press, London, 1999; Italian edn: Motta, Milan, 1999). HB w/ jkt, 300 x 430 mm, 112 pp, 108 b&w photos. Text by Bernard Noel; afterword by Robert Delpire.

11 *Lime Stone*. Lhoist, 2001 (limited edn of 2000 copies; second edn: Editions de la Martinière, Paris, 2001). HB w/ clamshell box, 232 x 302 mm, 88 pp, 36 b&w photos. Text by Jean-Pierre Berghmans and Gilles A. Tiberghien.

12 *En Chantier: Une université et un quartier, Paris 13e, Masséna*. Textuel, Paris, 2002 (French edn). HB, 195 x 400 mm, 28 pp, 21 b&w photos. Collab. with Aymeric Fouquez.

13 *Josef Koudelka*. Torst, Prague, 2002 (also published in Spanish by Torst, Prague, 2003). PB, 179 x 158 mm, 188 pp, 82 b&w photos. Text by Anna Fárová, Interview with Josef Koudelka by Karel Hvížďala.

14 *Teatro del Tempo*. Peliti Associati, Rome, 2003 (also published by Actes Sud, Arles and in Greek by Apeiron, Athens). HB w/ slipcase, 213 x 294 mm, 56 pp, 24 b&w photos. Text by Erri de Luca and Diego Mormorio.

15 *L'Epreuve Totalitaire*. Editions Delpire, Paris, 2004. PB, 200 x 165 mm, 168 pp, 97 b&w photos. Essay by Jean-Pierre Montier.

16 *Koudelka*. Editions Delpire, Paris, 2006 (French edn; also English, Czech, German, Spanish, Greek and Italian edns). HB w/ jkt, 283 x 302 mm, 276 pp, 166 b&w photos. Text by Robert Delpire, Dominique Eddé, Anna Fárová, Michel Frizot, Petr Král, Otomar Krejča and Gilles A. Tiberghien.

17 *Koudelka: Camargue*. Actes Sud and Conservatoire du Littoral, Arles, 2006. PB, 230 x 294 mm, 54 pp, 22 b&w photos. Text by Jean Giono.

18 *Invasion 68*. Aperture, New York, 2008 (also Czech, Greek, German, Italian, Spanish, French, Dutch, Japanese, Hungarian and Russian edns). PB, 320 x 247 mm, 296 pp, 248 b&w photos. Essays by Jiří Hoppe, Jiří Suk and Jaroslav Cuhra; afterword by Irena Šorfová.

19 *Josef Koudelka: Retrospektif/ Retrospective*. Pera Müszesi, Istanbul, 2008 (bilingual edn: English and Turkish). PB, 280 x 240 mm, 140 pp, 70 b&w photos. Text by Koudelka, Romeo Martinez, Hervé Guibert, Robert Delpire, Stuart Alexander and Karel Hvížďala.

20 *Piemonte*. Editions Xavier Barral, Paris, 2009 (French edn; English edn: Thames & Hudson, London, 2009; Italian edn: Contrasto, Rome, 2009). HB, 205 x 330 mm, 160 pp, 76 b&w photos. Intro by Giuseppe Culicchia.

21 *Gypsies* (revised edn). Thames & Hudson, London and Aperture, New York, 2011 (also published in French, German edn: Steidl, Gottingen; Italian edn: Contrasto, Rome; Czech edn: Torst, Prague; Greek edn: Apeiron, Athens; and Spanish edn: Lunwerg Editores, Madrid, all 2011). HB w/ jkt, 325 x 247 mm, 224 pp, 109 b&w photos. Text by Willy Guy (and by Robert Delpire in French edn).

22 *Lime*. Editions Xavier Barral, Paris, 2012. HB w/ slipcase, 242 x 345 mm, 248 pp, 170 b&w photos. Essay by Jacqueline de Ponton D'Amécourt.

23 *Wall*. Aperture, New York, 2013 (French edn: Editions Xavier Barral, Paris, 2013; German edn: Prestel Verlag, Munich, 2013). HB, 264 x 374 mm, 120 pp, 54 b&w photos.

24 *Koudelka Decreazione*. Contrasto, Rome, 2013. PB w/ slipcase, 222 x 295 mm, 22 pp, 9 b&w photos.

25 *Josef Koudelka: Retrospective*. National Museum of Modern Art, Tokyo, 2013. PB w/ jkt, 253 x 242 mm, 192 pp, 103 b&w photos. Text by Rei Masuda; interview by Karel Hvížďala.

26 *Josef Koudelka: Nationality Doubtful*. The Art Institute of Chicago in assoc. w/ The J. Paul Getty Museum, Chicago, 2014 (HB Spanish edn: Edicion de Matthew S. Witkovsky, Fundacion MAPFRE, Madrid, 2015). PB, 310 x 240 mm, 226 pp, 121 b&w photos, 37 illus and 32 text illus. Edited by Matthew S. Witkovsky; essays by Stuart Alexander, Amanda Maddox, Gilles A. Tiberghien and Matthew S. Witkovsky.

27 *Vestiges/Sledi 1991-2014*. Galerija Jakopic Gallery, Ljubljana, 2014 (second edn: Forte Di Bard Editore, Aosta, Italy, 2014; and Pont du Garde, Vers Pont-du-Gard, 2015). HB w/ slipcase, 100 x 250 mm, 22 pp 22 b&w photos.

28 *Exils*. Editions Delpire, Paris, 2014. (third edn; also published by Aperture, New York and Thames & Hudson, London). HB w/ jkt, 265 x 298 mm, 188 pages. 75 b&w photos. Essay by Czesław Miłosz, Text by Robert Delpire.

29 *Josef Koudelka: Twelve Panoramas, 1987-2012*. Pace/ MacGill Gallery, New York, 2015. HB w/ slipcase, 100 x 300 mm, 34 pp, 12 b&w photos. Text by Julian Cox.

Hiroji Kubota

Hiroji Kubota (b.1939; joined Magnum in 1971) met Magnum photographers René Burri, Burt Glinn and Elliott Erwitt when they visited Japan in 1961 and after graduating from Tokyo's University of Waseda in 1962, he moved to the United States to begin his career in photography. After becoming a freelance photographer in 1965, he returned to Japan in 1968, refocusing his attention on Asia (he witnessed the fall of Saigon at the end of the Vietnam War in 1975). Between 1979 and 1984, Kubota embarked on a 1,000-day tour of China, producing a book and exhibition in 1985. In 2004 he completed *Japan*, a book on his homeland.

1　2　3　4

5　6　7　8

9　10　11　12

13

1 *Taigano Nagare, Chugoku no Fudo to Rekishi* (The Flow of the Great River, People and Land in China). Geibunsha, Japan, 1981. HB w/ jkt, 304 x 230 mm, 144 pp, 99 col photos.

2 *Keirin Mugen* (Guilin Fantasy). Iwanami Shoten, Tokyo, 1982. HB w/ jkt, 350 x 259 mm, 94 pp, 27 col photos.

3 *Yukyuno Daichi, Chugoku* (Eternal Earth, China). Kyoikusha, Japan, 1985. PB, 275 x 213 mm, 202 pp, 146 col photos.

4 *Kozan Senkyo* (Mount Huangshan). Iwanami Shoten Publishers, Tokyo, 1985. HB, 260 x 350 mm, 106 pp, 32 col photos.

5 *Chugoku Banka*. TBS-Britannica, Tokyo, 1986 and W.W. Norton & Company, New York, 1985; William Collins Sons and Co Ltd, London, 1986; Hologram, Paris, 1987; Hoffman und Campe, Hamburg, 1987; White Press, Italy, 1987 and Joint Publishing Co., Hong Kong, 1987. HB w/ jkt, 289 x 300 mm, 180 pp, 186 col photos.

6 *Chosen Meiho, Hakutozan, Kongozan* (Korean Mountains, Baegdusan and Geumgangsan). Iwanami Shoten Publishers, Tokyo, 1988. HB, 260 x 350 mm, 56 pp, 56 col photos.

7 *Chōsen Sanju Hachidosen no Kita* (North of the 38th Parallel). Kyoikusya, Tokyo, 1988. PB w/ jkt, 210 x 150 mm, 224 pp, 106 col photos.

8 *From Sea to Shining Sea: A Portrait of America*. W.W. Norton & Company, New York, 1992 (English edn; also published by Hoffman und Campe, Hamburg, 1992 and Shueisha, Tokyo, 1992). HB w/ jkt, 292 x 303 mm, 204 pp, 173 col photos. Intro by Kubota.

9 *Ichiban To-i Kuni Kitachosen Annnai*. North Korea. Takarajimasha, Tokyo, 1994. PB, 210 x 145 mm, 223 pp, 200 col photos. Foreword by Bruce Cumings.

10 *Out of the East: Transition and Tradition in Asia*. W.W. Norton & Company, New York, 1999. HB w/ jkt, 303 x 222 mm, 304 pp. 200 col photos. Foreword by Lucio A. Noto.

11 *Ajia to Shokuryo* (Asia and Food). Iye no Hikari Kyokai, Tokyo, 1999 (also published as *Can We Feed Ourselves?*, Magnum Photos, New York, 2000). PB, 198 x 204 mm, 138 pp, 92 col photos. Foreword by Lester R Brown; intro by Gordon R. Conway.

12 *Japan*. W.W. Norton & Company, New York, 2004 (English edn). HB w/ jkt, 292 x 300 mm, 228 pp. 173 col photos. Foreword by Elliott Erwitt.

13 *Hiroji Kubota: Photographer*. Aperture, New York, 2015. HB w/ jkt, 305 x 229 mm, 512 pp, 400 b&w and col photos. Preface by Elliot Erwitt; foreward by Mark Lubell; intro by Alison Nordstrom.

Sergio Larraín

Sergio Larraín (1931–2012; Magnum member 1959–2012) grew up in Chile, in a family where books and culture were very important. He first began to take photographs with a Leica camera. After studying in the United States, he began to travel, working as a freelance photographer. Invited to join Magnum by Henri Cartier-Bresson after a six-month stay in London, he then spent two years based in Paris, reporting for news magazines before travelling around Europe and the Middle East, returning to Chile in 1963. It is here that he collaborated with the poet Pablo Neruda which led to the publication of his book *Valparaiso*. In later years commercial photography became problematic for him and he stopped taking photographs. Withdrawing to the Chilean countryside, he devoted himself to yoga, writing, drawing and mysticism.

1 2 3 4

5 6 7

1 *El Rectangulo en la Mano*. Cadernos Brasileiros, Santiago, 1963 (Spanish edn). PB, 180 x 123 mm, 44 pp, 17 b&w photos.

2 *In the Twentieth Century*. Lord Cochrane. Chile, 1965. PB, 350 x 260 mm, 28 pp, 34 b&w photos.

3 *Una Casa en la Arena*. Editorial Lumen, Barcelona, 1966 (Spanish edn). HB, 220 x 210 mm, 98 pp, 34 b&w photos. Text by Pablo Neruda.

4 *Chili*, Editions Rencontre, Lausanne, 1968 (French edn). HB, 275 x 175 mm, 190 pp, 85 b&w photos. Text by Jean Mayer.

5 *Valparaiso*. Editions Hazan, Paris, 1991. PB, 234 x 164 mm, 64 pp, 38 b&w photos. Text by Pablo Neruda.

6 *Londres*. Editions Hazan, Paris, 1998 (French edn; English edn: *London 1958-59*, Dewi Lewis Publishing, Stockport). PB, 236 x 164 mm, 64 pp, 40 b&w photos. Intro by Mike Seaborne; text by Alain Bergala and Londra Peliti associati.

7 *Sergio Larrain*. IVAM Centre, Valencia, 1999. PB, 292 x 222 mm, 174 pp, 117 b&w photos. Text by Robert Bolano, René Burri and Josep Vincent Monzo.

Guy Le Querrec

Guy Le Querrec (b.1941; joined Magnum in 1976) was brought up in Paris, where he took his first photographs of jazz musicians; jazz has remained a constant theme in his work - he envisages everyday life as a musical score. In 1969 he was hired by the weekly *Jeune Afrique* as picture editor and photographer, and did his first reportages in Francophone Africa. He joined *Vu* in 1971, then co-founded the co-operative Viva in 1972 before joining Magnum. In the late 1970s he co-directed two films, and in 1980 directed the first photographic workshop organized by the City of Paris. His interest in music is reflected in shows in which he projects photographs next to live musicians.

5 6 7 8

9 10 11 12

13 14 15

1 2 3 4

1 *Quelque Part*. Edition Contrejour, Paris, 1977 (French edn). PB w/ jkt, 240 x 204 mm, 72 pp, 68 b&w photos. Text by Arnaud Claass and Roméo Martinez.

2 *Tête à Tête: Un Sculpteur et Ses Modèles*. Editions Carrère, Paris, 1988 (French edn). HB, 210 mm x 280 mm, 150 pp. 31 b&w photos.

3 *Musicales: Le Porte-folios de Guy Le Querrec*. Editions Trois Cailloux, Amiens, 1991 (French edn). PB folio in slipcase, 305 x 240 mm, 24 pp, 18 b&w photos. Text by Enzo Cormann.

4 *Jazz Comme une Image*. Scanéditions, Paris, 1993 (French edn). PB, 270 x 235 mm, 142 pp, 180 b&w photos. Intro by Stéphane Ollivier.

5 *Carnet de Routes*. Label Bleu. France, 1995 (French edn). PB w/ box and CD, 125 x 140 mm, 96 pp, 77 b&w photos. Texts by Guy Maurette and Jean-Jacques Mandel. Collaboration with Aldo Romano, Louis Sclavis and Henri Texier.

6 *JAZZ de JÂZZ*. Editions Marval, Paris, 1996 (French edn). HB w/ jkt, 283 x 283 mm, 224 pp, 385 b&w photos. Text by Philippe Carles.

7 *François Mitterrand: Des Temps de Poses à l'Elysée*. Editions Marval, Paris, 1997 (French edn). PB, 160 x 125 mm, 78 pp. 37 b&w photos. Text by Daniel Druet.

8 *Carnet de Routes: Suite Africaine*. Label Bleu, France, 1998 (French edn). Box w/ PB and CD, 125 x 140 mm, 96 pp, 95 b&w photos. Intro by Michel Orier. With Aldo Romano, Louis Sclavis and Henri Texier.

9 *Nuits Atypiques*. Éditions Confluences, Bordeaux, 1998 (French edn). PB, 220 x 220 mm, 90 pp, 66 b&w photos. Text by Philippe Méziat.

10 *Sur la Piste de Big Foot*. Editions Textuel, Paris, 2000 (French edn). HB w/ jkt, 329 x 254 mm, 130 pp, 98 b&w and col photos. Intro by Jim Harrison.

11 *Jazz: Light and Day*. Federico Motta Editore, Milan, 2001 (French edn). PB, 185 x 125 mm, 398 pp, 380 b&w photos.

12 *African Flashback*. Label Bleu, France, 2005 (French edn). HB w/ box and CD, 185 x 130 mm, 42 pp, 101 b&w photos. Collaboration with Aldo Romano, Louis Sclavis, Henri Texier.

13 *D'Jazz à Nevers: Chemins Croisés*. Éditions de l'Armançon, Précy-sous-Thil, 2006 (French edn). HB, 278 x 236 mm, 86 pp, 129 b&w photos.

14 *Géométrie de l'Instant*. Créaphis Editions, Paris, 2009 (French edn). PB, 225 x 165 mm, 44 pp, 15 b&w photos.

15 *Lobi*. Le Bec en l'Air, Marseille, 2015 (French edn). HB, 220 x 165 mm, 96 pp, 45 b&w photos. Intro by François Bazzoli.

Erich Lessing

Erich Lessing (b.1923; joined Magnum in 1951) was born into a Jewish family, the son of a dentist and a concert pianist. In 1939 he was forced to leave Austria due to the rise of Hitler's power; he escaped to Palestine and began working as a photographer. On his return to Austria in 1947, Lessing became a photojournalist for the American news agency Associated Press. His photos were published in renowned magazines including *LIFE*, *Paris Match* and *Picture Post*. From the 1960s, Lessing shifted his professional focus to cultural and historical subjects, museum photography, landscape and science. He has taught in Arles, France, at the Venice Biennale, at the Salzburg Summer Academy and at the Academy of Applied Arts in Vienna. His work has been exhibited throughout the world.

1 *Szene*. Verlag der Österreichischen Staatsdruckerei, Vienna, 1954. HB w/ jkt, 305 x 235 mm, 170 pp, 188 b&w and 31 col photos.

2 *Imago Austriae*. Herder, Vienna, 1963. HB w/ jkt, 300 x 260 mm, 304 pp, 142 col photos and 60 b&w photos.

3 *Die Wiener Schatzkammer*. Hallwag, Bern, 1964. HB, 195 x 127 mm, 48 pp, 217 col photos. Text by Anton J. Walter.

4 *Die Odyssee: Homers Epos in Bildern erzählt von Erich Lessing*. Herder, Freiburg im Breisgau, 1964 (also published in English by Macmillan, London, 1966; in Dutch by H.J.W. Becht, Amsterdam, 1966; in Italian by Editioni Paoline, Alba, 1969; and in Swedish by Allhems Förlag, Malmö, 1969). HB w/ jkt, 300 x 260 mm, 300 pp, 115 col photos. Text by Karl Kerényi, Michel Gall and Hellmut Sichtermann.

5 *Römisches Erinnerungsbuch: mit Farbbildern von Erich Lessing*. Herder, Freiburg im Breisgau, 1966 (also published in English by Burns & Oates, London/Herder & Herder, New York, 1969; in Italian by Edizioni Paoline, Alba, 1969; second edn: 1986). HB w/ jkt, 300 x 270 mm, 182 pp 40 col photos, 57 engravings by G.B. Piranesi. Text by Werner Bergengruen.

6 *Entdecker des Weltraums: mit Farbbildern von Erich Lessing*. Vorwort und Ausblick von Wernher von Braun. Herder, Freiburg im Breisgau, 1967 (also published in English as *Discoverers of Space*, Burns & Oates, London and Herder & Herder, New York, 1969). HB w/ jkt, 300 x 270 mm, 172 pp, 47 col photos. Preface by Wernher von Braun; text by Karl Bednarik and Udo Becker.

7 *Roma*. Herder Editrice e Libreria, Rome, 1968 (trilingual edn: Italian, English and German text). PB, 295 x 260 mm, 48 pp, 40 col photos. Text by Norbert von Kaan.

8 *Die Arche Noah*. Fritz Molden, Zurich, 1968 (also published in Swedish by P. A. Norstedt & Söners Förlag, Stockholm, 1968; in Dutch by Elsevier, Amsterdam, 1968; and in English by Time-Life Books, New York, 1968). HB w/ jkt, 260 x 230 mm, 117 pp, 65 col photos.

9 *Die Abenteuer des Odysseus: Homers Epos in Bildern erzählt von Erich Lessing*. Herder, Freiburg im Breisgau, 1969 (also published in Spanish by Editorial Herder, Barcelona, 1969; and in Dutch by Nederlandse Boekenclub, The Hague, 1970). HB w/ jkt, 245 x 217 mm, 80 pp, 71 col photos. Text by Karl Kerényi.

10 *Vérité et Poésie de la Bible*. Editions Hatier, Paris, 1969 (Herder, Freiburg im Breisgau, 1969; also published in Italian by Edizioni Paoline, Alba, 1969; and in English by Macmillan, London, 1970). HB w/ jkt, 300 x 262 mm, 320 pp, 115 col photos. Intro by Henri Cazelles; text by Jean Bottéro, Marie Joseph Steve, Jean Koenig, Penuel Peter Kahane and Pierre Amiet.

11 *Deutsche Reise: mit Farbbildern von Erich Lessing*. Herder, Freiburg im Breisgau, 1969. HB w/ jkt, 266 x 294 mm, 178 pp, 45 col photos. Intro by Carl Burckhard; text by Werner Bergengruen.

12 *Ravenna: Steine Reden*. Herder, Freiburg im Breisgau, 1970. HB w/ jkt, 246 x 187 mm, 80 pp, 42 col photos. Intro by Wolfgang Stadler.

13 *Der Mann aus Galiläa*. Herder, Freiburg im Breisgau, 1971 (also published in English by Herder & Herder, New York, 1971; and in Dutch by H. J. W. Becht, Amsterdam, 1972). HB w/ jkt, 300 x 260 mm, 312 pp, 104 col photos. Intro by Karl Kerényi; text by Karl Kerényi, David Flusser, Josef Blank, Heinrich Lützeler,

Peter P. Kahane and Dorothee Rondorf.

14 *Die Spanische Hofreitschule zu Wien*. Fritz Molden, Vienna, 1972 (also published in English by McGraw-Hill, New York, 1972; in French by Editions Albin Michel Stock, Paris, 1972; and in Dutch by C. A. J. van Dishoeck, Brussels, 1972). HB w/ jkt, 320 x 245 mm, 264 pp, 50 col photos. Text by Hans Handler.

15 *Die Botschaft Jesus*. Herder, Freiburg im Breisgau, 1972. HB w/ jkt, 300 x 267 mm, 224 pp, 46 col photos. Text by P. Bernhard Paal and Wolf Stadler.

16 *Traumstraßen durch Deutschland*. Fritz Molden, Vienna, 1973. HB w/ jkt, 275 x 215 mm, 272 pp, 186 col photos. Text by Janko Musulin.

17 *Jesus Gottessohn: Begegnung und Bekenntnis*. Herder, Freiburg im Breisgau, 1974 (also published in Italian by Edizioni Paoline, Rome, 1980). HB w/ jkt, 242 x 217 mm, 160 pp, 80 col photos. Text by Eugen Weiler and Wolfgang Stadler.

18 *Die K. (u.) K.-Armee 1848-1914*. C. Bertelsmann, Munich, 1974. HB w/ jkt, 325 x 245 mm, 256 pp, 200 col photos and b&w illus. Text by Johann Christoph Allmayer-Beck.

19 *L'Opéra de Paris*. Editions Hatier, Paris, 1975 (French edn). HB w/ jkt, 280 x 230 mm, 224 pp, 42 b&w and col photos, 259 illu/s. Text by Olivier Merlin.

20 *Traumstraße Donau*. Fritz Molden, Vienna, 1975 (French edn). HB w/ jkt, 275 x 215 mm, 296 pp, 136 col photos. Text by Ernst Trost.

21 *Brauer Bunte Mauer*. Bruckmann, Munich, 1975. HB, 245 x 232 mm, 90 pp, 27 b&w and 10 col photos.

22 *Gott sprach zu Abraham: die Geschichte des biblischen Volkes und seines Glaubens*. Herder, Freiburg im Breisgau, 1976 (German edn). HB w/ jkt, 240 x 210 mm, 152 pp, 70 col photos. Text by Claus Westermann.

23 *Le Message de l'Espérance*. Editions Hatier, Paris, 1976 (also published in French by Editions du Club France Loisirs; and English by The Seabury Press, New York, 1976). HB w/ jkt, 243 x 213 mm, 80 pp, 72 col photos. Text by J. Dheilly.

24 *Deutsche Ritter Deutsche Burgen*. C. Bertelsmann, Munich, 1976 (German edn). HB w/ jkt, 318 x 232 mm, 250 pp, 174 b&w and col photos, and 52 illus. Text by Werner Meyer.

25 *Die griechischen Sagen*. C. Bertelsmann, Munich, 1977 (German edn). HB w/ jkt and sleeve, 326 x 244 mm, 296 pp, 152 col photos. Text by Ernest Borneman, Wolfgang Oberleitner and Egidius Schmalzriedt.

26 *Traumstraßen durch Frankreich*. Fritz Molden, Vienna, 1978 (also

published in French by Arthaud, Paris, 1978). HB w/ jkt, 275 x 220 mm, 288 pp, 165 col photos. Text by Pierre Gascar.

27 *Die Kaiserlichen Kriegsvölker: Von Maximilian I. bis Prinz Eugen 1479-1718*. C. Bertelsmann, Munich, 1978 (German edn). HB w/ jkt, 325 x 245 mm, 256 pp, 250 col photos and b&w illus. Text by Johann Christoph Allmayer-Beck.

28 *Ephesos*. Ueberreuter, Vienna, 1978. HB w/ jkt, 305 x 245 mm, 280 pp, 169 col and b&w photos. Text by Wolfgang Oberleitner.

29 *Les Celtes*. Editions Hatier, Paris, 1978 (also published in Dutch by Standaard Uitgeverij, Antwerp, 1979; and in German by Jugend & Volk, Vienna, 1979). HB w/ jkt, 320 x 280 mm, 254 pp, 116 col photos. Preface by Paul-Marie Duval; text by Venceslas Kruta and Miklós Szabó.

30 *Judaica: Die Sammlung Berger - Kult und Kultur des europäischen Judentums*. Jugend & Volk, Vienna, 1979 (German edn). HB w/ jkt, 310 x 245 mm, 298 pp, 104 col photos. Text by Wolfgang Häusler and Max Berger.

31 *Ludwig van Beethoven*. Herder, Freiburg im Breisgau, 1979 (German edn). HB w/ jkt, 240 x 215 mm, 120 pp, 48 col photos. Text by Kurt Dieman.

32 *Hallstatt: Bilder aus der Frühzeit Europas*. Jugend & Volk, Vienna, 1980 (German edn). HB w/ jkt, 310 x 246 mm, 284 pp, 160 col photos. Text by Wilhelm Angeli, Fritz Eckart Barth, Jörg Biel, Walter Drack, Mikulás Dusek, Markus Egg, Alexandrine Eibner-Persy, Otto-Herman Frey, Stane Gabrovec, Jean-Jacques Hatt, Hans-Jürgen Hundt, René Joffroy, Wolfgang Kimmig, Karl Kromer, Walter Modrijan, Friedrich Moosleitner, Jindra Nekvasil, Elisabeth Patek, Ernst Penninger and Hartwig Zürn.

33 *Paulus: The Travels of Saint Paul*. Herder, Freiburg im Breisgau, 1980 (also published in Dutch by H. J. W. Becht, Amsterdam, 1980; in French by Editions Hatier, Paris, 1980; and in English, Herder & Herder, New York, 1980). HB w/ jkt, 300 x 240 mm, 288 pp, 114 col photos. Text by David Flusser, Edward Schillebeeckx and Eduard Schweizer.

34 *Deutsche Schlösser, Deutsche Fürsten*. C. Bertelsmann, Munich, 1980 (German edn). HB w/ jkt, 325 x 245 mm, 240 pp, 92 col photos. Text by Ludwig Hüttl.

35 *Wolfgang Amadeus Mozart*. Herder, Freiburg im Breisgau, 1980 (German edn). HB w/ jkt, 240 x 215 mm, 118 pp, 48 col photos. Text by Géza Rech.

36 *Hausbibel*. Herder, Freiburg im Breisgau, 1981 (German edn). HB w/ jkt, 208 x 130 mm, 1476 pp, 49 col photos.

37 *Joseph Haydn*. Herder, Freiburg im Breisgau, 1981

(German edn). HB w/ jkt, 240 x 215 mm, 120 pp, 48 col photos. Text by Rudolf Klein.

38 *Das Heer unter dem Doppeladler: Habsburgs Armeen 1718-1848*. C. Bertelsmann, Munich, 1981 (German edn). HB w/ jkt, 325 x 245 mm, 264 pp, 91 col photos. Text by Johann Christoph Allmayer-Beck.

39 *Paulus. Der Völkerapostel: Bildbiographie mit 72 Farbtafeln*. Herder, Freiburg im Breisgau, 1982 (also published in English by The Crossroad Publishing Company, New York, 1983). HB w/ jkt, 240 x 215 mm, 135 144 pp, 72 col photos. Text by Edward Schillebeeckx.

40 *Die Donau*. Ringier, Munich, 1982. HB w/ jkt, 288 x 217 mm, 272 pp, 254 col photos. Text by Dieter Maier.

41 *Die Italienische Renaissance in Bildern erzählt von Erich Lessing*. C. Bertelsmann, Munich, 1983 (also published in French by Hatier, 1985). HB w/ jkt, 325 x 240 mm, 332 pp, 155 col photos. Text by Karl Otmar von Aretin and Friedrich Piel.

42 *Wiener Rathausbuch*. Jugend & Volk, Vienna, 1983 (German edn). HB w/ jkt and sleeve, 308 x 247 mm, 128 pp, 88 col photos. Text by Felix Czeike, Ulrike Planner-Steiner and Karlheinz Roschitz.

43 *Die Niederlande: Die Geschichte in den Bildern ihrer Maler erzählt von Erich Lessing*. C. Bertelsmann, Munich, 1985 (German edn). HB w/ jkt, 325 x 250 mm, 336 pp, 178 col photos. Text by Karl Schütz and Georg Kugler.

44 *Der Wiener Musikverein*. Verlag Edition Wien, Vienna, 1987 (German edn). HB w/ jkt, 310 x 240 mm, 152 pp, 106 col photos. Text by Franz Endler.

45 *Die Bibel: Das Alte Testament in Bildern erzählt von Erich Lessing*. C. Bertelsmann, Munich, 1987 (special edn published as *Das Heilige Land: Landschaften, Archäologie, Religion Orbis*, Munich, 2000). HB w/ jkt, 325 x 255 mm, 408 pp, 214 col photos. Text by Franz Kardinal König, Rainer Albertz, Frank Crüsemann, Jürgen Ebach and Manfred Görg.

46 *La Grece*. Editions Payot, Paris, 1987 (also published in German as *Griechenland* by Kohlhammer Verlag, Stuttgart, 1988). HB w/ jkt, 336 x 223 mm, 168 pp, 137 col photos. Text by A. Lemaître.

47 *Edles Porzellan*. Falken, Niedernhausen, 1989 (German edn). HB w/ jkt, 325 x 235 mm, 160 pp, 163 col photos. Text by Margot Lutze.

48 *Die Geschichte Frankreichs*. C. Bertelsmann, Munich, 1989 (German edn). HB w/ jkt, 325 x 250 mm, 352 pp, 172 col photos. Text by Franz Herre.

49 *Immortelle Egypte*. Editions Nathan, Paris, 1990

(also published in German by Bechtermünz, Augsburg, 1991). HB w/ jkt and sleeve, 310 x 237 mm, 260 pp, 228 col photos. Text by Christian Delacampagne.

50 *Les Mythes Grecs*. Editions Nathan, Paris, 1991. HB w/jkt and sleeve, 310 x 237 mm, 260 pp, 167 col photos. Text by Claude Mossé.

51 *Florence et la Renaissance*. Editions Terrail, Paris, 1992. (French edn; also published in English by Editions Terrail, Paris, 1993). PB, 300 x 240 mm, 222 pp, 173 col photos. Text by Alain J. Lemaitre.

52 *La Gloire de Venise*. Editions Terrail, Paris, 1993 (French edn; also published in English by Editions Pierre Terrail, Paris, 1994). PB, 300 x 240 mm, 208 pp, 137 col photos. Text by Daniel Huguenin.

53 *Schinkel: An Architecture for Prussia*. Rizzoli, New York, 1994. HB, 310 x 238 mm, 240 pp, 63 col photos. Text by Barry Bergdoll.

54 *Femmes Mythologies*. Imprimerie Nationale Éditions, Paris, 1994 (also published in German by Metamorphosis Verlag, Munich, 1994; and in Italian by Istituto Poligrafico e Zecca dello Stato, Rome, 1994). HB w/ jkt, 330 x 250 mm, 416 pp, 260 col photos. Text by Philippe Sollers.

55 *Erich Lessing. Photographie. Die ersten 50 Jahre.* Historisches Museum der Stadt Wien, Vienna, 1994 (also published in English, French and Spanish by Austrian Federal Ministry of Foreign Affairs, Vienna, 1995). PB, 275 x 215 mm, 172 pp, 51 col and 86 b&w photos. Interview by Angelica Bäumer.

56 *Pompéi*. Editions Terrail, Paris, 1995 (also published in German and English by Editions Terrail, Paris, 1996). PB, 298 x 247 mm, 208 pp, 160 col photos. Text by Antonio Varone.

57 *Dieux de l'Egypte*. Imprimerie Nationale Editions, Paris, 1998 (also published in English by George Brazillier, New York, 1998). HB w/jkt, 329 x 270 mm, 202 pp, 179 col photos. Text by Pascal Vernus.

58 *Dieu en ses Anges*. Les Editions du Cerf, Paris, 2000 (French edn). HB, 325 x 265 mm, 238 pp, 132 col photos. Text by Dominique Ponnau.

59 *Erich Lessing: Vom Festhalten der Zeit Reportage-Fotografie 1948-1973.* Christian Brandstätter, Vienna, 2002 (also published in French by Editions Hazan, Paris, 2003; and in English by The Quantuck Lane Press, New York, 2005). HB w/jkt, 320 x 230 mm, 454 pp, 678 b&w photos. Text by Alistair Crawford.

60 *Au Louvre: Les Arts Face à Face*. Editions Hazan, Paris,

2003 (French and English edns). HB w/ jkt, 315 x 250 mm, 280 pp, 469 col photos. Text by Adrian Goetz.

61 *1001 Peintures au Louvre*. Musée du Louvre Éditions, Paris and 5 Continents Editions, Milan, 2005 (also published in English by Musée du Louvre Éditions, Paris and 5 Continents Editions, Milan, 2005; and in German by Michael Imhof, Petersberg, 2006). HB w/ jkt, 288 x 252 mm, 590 pp, 1020 col photos. Text by Vincent Pomarède and Delphine Trébosc.

62 *From Liberation to Liberty: An Austrian Photo Album 1945-1960.* Verlag der Metamorphosen, Vienna, 2005. PB, 300 x 291 mm, 252 pp, 235 b&w photos. Text by Gerd Bacher, Alexander Giese, Hugo Pepper, Friedrich Steinbach, Ludwig Steiner, Peter Weiser, Karl Zemanek.

63 *Budapest 1956: la Révolution.* Biro Editeur, Paris, 2006 (also published in English by Thames & Hudson, London, 2006; in German by Christian Brandstätter, Vienna, 2006; in Italian by Marietti Editore, Genoa, 2006; in Hungarian by Intézet, Budapest, 2006). HB, 310 x 310 mm, 148 pp, 190 b&w photos. Text by Lessing, Francois Fejtö, György Konrád and Nicolas Bauquet.

64 *Naissance de la Figure.* Editions Hazan, Paris, 2007 (also published in Italian by Editoriale Jaca Book, Milan, 2007). HB w/ jkt 305 x 265 mm, 208 pp, 191 col photos. Text by Jean-Paul Demoule.

65 *Herbert von Karajan.* Böhlau, Vienna, 2008 (German edn; also published by Verlag der Metamorphosen, Vienna and Biro Editeur, Paris, 2008). HB w/ CD, 300 x 300 mm, 228 pp, 185 b&w photos. Text by Rainer Bischof (German edn) and Eve Ruggieri (French edn).

66 *Joseph Haydn und seine Zeit in Bildern.* Lesethek Verlag, Vienna, 2009 (also published in English by Verlag der Metamorphosen, Vienna, 2009). HB, 300 x 300 mm, 256 pp, 215 col photos. Texts by Johann Christoph Allmayer-Beck and Rudolf Klein.

67 *Menschenbilder.* Thomas Reche, Neumarkt, 2010. HB, 282 x 214 mm, 68 pp, 37 b&w photos.

68 *The Louvre: All the Paintings.* Black Dog & Leventhal, New York, 2011 (also published in Italian by Mondadori Electa, Milan, 2011; in German by Dumont, Cologne, 2012; and in French by Flammarion and Musée du Louvre Editions, Paris, 2012). HB w/ jkt, sleeve and DVD, 272 x 276 mm, 766 pp, 3022 col photos. Preface by Henri Loyrette; edited and intro by Vincent Pomarède; text by Anja Grebe.

69 *Fünfzehn Stimmungen.* Thomas Reche, Neumarkt, 2011 (German edn). HB, 300 x 204 mm, 88 pp, 25 b&w photos. Interview and letters by Václav Havel.

70 *Anderswo.* Nimbus Kunst und Bücher, Wädenswil, 2014 (German edn). HB w/ jkt, 300 x 210 mm, 168 pp, 112 b&w photos. Text by Thomas Reche.

71 *Von der Befreiung zur Freiheit: Österreich nach 1945.* Tyrolia, Innsbruck, 2015 (German edn). HB, 295 x 235 mm, 384 pp, 277 b&w photos. Text by Michael Gehler.

72 *Ungarn 1956.* Tyrolia, Innsbruck, 2015 (German edn). HB, 297 x 234 mm, 272 pp, 196 b&w photos. Text by Michael Gehler.

Herbert List

Herbert List (1903-75; Magnum contributor 1951-75) studied art history in Germany. In 1930 he discovered the Rolleiflex camera and quickly developed a style influenced by the Bauhaus and Surrealism. Leaving Nazi Germany in 1936, he worked from Paris and Athens shooting aspects of Greece and Italy: from antiquities, and landscapes, to the Mediterranean way of life. The German invasion of Greece forced him back to Germany, where he was not allowed to work. After the war he was finally able to publish a series of books. His work became more spontaneous; influenced by Italian Neo-Realist film. List stopped taking photographs in the mid 1960s and slowly lost interest in photography before he died in 1975.

1 *Le Voyage en Grèce*. Cahiers Périodiques, Paris, 1938. PB, 220 x 275 mm, 24pp, 12 b&w photos. Text by Aeschylus, Plutarch, Homer and others.

2 *Frühe Kunst Amerikas*. Amerika Haus, Munich, 1950. PB, 240 x 170 mm, 72 pp, 34 b&w photos. Intro by Stefan P. Munsing.

3 *Kunst der Südsee*. Prestel, Munich, 1952. PB, 252 x 180 mm, 47 pp, 20 b&w photos. Text by Andreas Lommel.

4 *Licht über Hellas*. Georg D. W. Callwey, Munich, 1953. HB, 360 x 295 mm, 244 pp, 160 b&w photos. Intro by Walter-Herwig Schuchhardt.

5 *Rom*. Hanns Reich, Munich, 1955. HB w/ jkt, 280 x 220 mm, 100 pp, 83 b&w photos. Text by Hans Mollier.

6 *Plastik der Südsee*. Hans E. Günther, Stuttgart, 1956. HB w/ jkt, 280 x 198 mm, 64 pp, 55 b&w photos. Text by Werner Schmalenbach.

7 *Nigeria: 2000 Jahre Plastic*. Städtische Galerie München, Munich, 1961. PB w/ jkt, 275 x 205 mm, 102 pp, 75 b&w photos.

8 *Caribia*. Rowohlt, Hamburg, 1958. HB w/ jkt, 249 x 206 mm, 96 pp, 96 b&w photos. Intro by List.

9 *Napoli*. Sigbert Mohn, Gütersloh, 1962 (German edn; also Italian edn: Rizzoli, Milan, 1968). HB w/ jkt, 295 x 235 mm, 204 pp, 192 b&w photos. Text by Vittorio de Sica.

10 *Nigerian Images*. Lund Humphries, London and Praeger, New York, 1963 (German edn: *Bildwerke aus Nigeria*, Prestel, Munich, 1963; French edn: *Merveilles de l'art nigérien*, Edition du Chêne, Paris, 1963). HB w/ jkt, 282 x 230 mm, 124 pp, 158 b&w photos. Text by William Fagg.

11 *Martin Mayer: Bronzeplastiken und Zeichnungen*. Karl Thiemig, Munich, 1972. HB, w/ jkt, 270 x 215 mm, 168 pp, 82 b&w photos. Text by Konrad Roethel.

Danny Lyon

Danny Lyon (b.1942; Magnum Associate 1967-74) pioneered the style of photographic 'New Journalism' as he rebelled against *LIFE* magazine style photographs, instead immersing himself as a participant with his documented subjects. He produced his major bodies of work in this way: joining the Chicago outlaw motorcycle club for *The Bikeriders*, and spending fourteen months of near daily visits inside the Texas prison system for *Conversations with the Dead*. Lyon has produced over fifteen photobooks and mounted exhibitions at The Whitney Museum of American Art, The Art Institute of Chicago, The Corcoran Gallery in Washington DC, and won two Guggenheim Fellowships, a Rockefeller Fellowship, and numerous National Endowment for the Arts awards. Lyon lives in the state of New Mexico.

1 2 3 4

5 6 7 8

9 10 11 12

13 14 15 16

17

1 *The Bikeriders*. Macmillan, New York, 1968 (second edn published by Twin Palms Publishers, Santa Fe, 1998; third PB edn by Chronicle Books, San Francisco, 2003; facsimile edn published by Aperture, New York, 2014). HB w/ jkt, 236 x 164 mm, 94 pp, 49 b&w photos.

2 *The Destruction of Lower Manhattan*. Macmillan, New York, 1969 (also published by Powerhouse Books, New York, 2005). HB, 284 x 277 mm, 160 pp, 83 b&w photos. Text by Lyon.

3 *Conversations with the Dead: Photographs of Prison Life with the Letters and Drawings of Billy McCune #122054*. Holt, Rinehart and Winston, New York, 1971 (facsimile English and French edns published by Phaidon Press, London, 2015 with a new afterword by Lyon). HB w/ grey cloth and jkt, 205 x 279 mm, 196 pp, 75 b&w photos, 5 col illus and 6 b&w identity photos. Foreword by Lyon; intro, letters and drawings by Billy McCune.

4 *The Paper Negative*. Bleak Beauty Books, Bernalillo, New Mexico, 1980. PB, 279 x 204 mm, 62 pp, 29 b&w photos. Text by Lyon.

5 *Pictures from the New World*. Aperture, New York, 1981. HB, 220 x 290 mm, 142 pp, 160 col and b&w photos. Texts by Lyon.

6 *Merci Gonaïves: A Photographer's Account of Haiti and the February Revolution*. Bleak Beauty Books, Bernalillo, New Mexico, 1988. PB, 279 x 225 mm, 62 pp, 35 b&w photos. Text by Lyon.

7 *I Like to Eat Right on the Dirt: A Child's Journey Back in Space and Time*. Bleak Beauty Books, Bernalillo, New Mexico, 1989. Spiralbound PB, 279 x 357 mm, 52 pp, 178 b&w photos. Text by Lyon.

8 *Memories of the Southern Civil Rights Movement*. University of North Carolina Press, North Carolina, 1992 (also published by Twin Palms Publishers, 2010). PB, 305 x 220 mm, 192 pp, 93 b&w photos.

Foreword by Julian Bond; text by Lyon and afterword by Congressman John Lewis.

9 *Bushwick: Let Them Kill Themselves*. Editions Le Point du Jour, Paris, 1996 (bilingual edn: French and English). PB, 210 x 140 mm, 48 pp, 22 b&w photos. Text by Carlos Ferreria.

10 *Knave of Hearts*. Twin Palms Publishers, California, 1999 (also published as a limited slipcased edn). HB w/ jkt, 305 x 250 mm, 148 pp, 64 col and b&w photos. Text by Lyon.

11 *Indian Nations: Pictures of American Indian Reservations in the Western United States*. Twin Palms Publishers, California, 2002 (also published as a limited slipcased edn). HB, 305 x 254 mm, 164 pp, 84 tritone photos. Intro by Larry McMurtry.

12 *Like A Thief's Dream*. Powerhouse Books, New York, 2007. HB w/ jkt, 209 x 159 mm, 190 pp, 24 b&w and col photos. Letters with James Ray Renton and Lyon.

13 *Memories of Myself*. Phaidon Press, London, 2009. HB w/ jkt, 290 x 245 mm, 208 pp, 152 col and b&w photos. Text by Lyon.

14 *Deep Sea Diver: An American Photographer's Journey in Shanxi, China*. Phaidon Press, London, 2011 (signed and numbered limited edn of 2,200 copies). HB w/ slipcase, 280 x 330 mm, 136 pp, 85 b&w photos.

15 *Danny Lyon: The Seventh Dog*. Phaidon Press, London, 2014. HB w/ jkt, 275 x 275 mm, 240 pp, 200 col and b&w photos, original photo collages, letters and other ephemera. Afterword by Elisabeth Sussman.

16 *Burn Zone*. Bleak Beauty Books, 2016. PB, 280 x 215 mm, 54 pp, 4 col and 8 b&w photos. Text by Lyon and Josephine Fiorelli.

17 *Story of Sam*. Bleak Beauty Books, 2016. HB, 230 x 146 mm, 88 pp, 15 col and 5 b&w photos.

Alex Majoli

Alex Majoli (b.1971; joined Magnum in 1996) attended the Art Institute in Ravenna, in his native Italy. In 1991, he joined the Grazia Neri agency, for which he photographed the Balkan wars. His interest in psychiatric care took him to Greece, where he photographed the closing of the notorious insane asylum on the island of Leros, the subject of his first book. He then travelled to Brazil, where he began a 20-year, ongoing project about the extremes found in the darker side of that society. His work explores the theatre within our daily lives: in front of his lens, people perform in their natural settings as on a film set or a stage, illustrating the thin line between reality and theatre, documentary and art, human behavior and acting.

1 2 3 4

1 *Leros*. Westzone Publishing, London, 1999. PB, 210 x 155 mm, 96 pp, 47 b&w photos. Intro by Laura Facchi and text by Majoli.

2 *Leros* (revised edn). Trolley Books, London, 2002. HB w/ jkt, 175 x 245 mm, 112 pp, 68 b&w photos. Intro by Laura Facchi and text by Majoli.

3 *One Vote*. Filigranes Editions and Magnum Photos, Paris, 2004 (bilingual edn: English and French). PB, 165 x 120 mm, 32 pp, 20 b&w photos.

4 *Libera Me*. Trolley Books, London, 2010. HB, 235 x 340 mm, 64 pp, 27 b&w photos.

Constantine Manos

Constantine Manos (b. 1934; joined Magnum in 1963) was the son of Greek immigrants in South Carolina, where he joined the school camera club at age thirteen. At the age of nineteen he became the official photographer for the Boston Symphony at its summer music festival at Tanglewood. After completing his military service, Manos worked for *Esquire*, *LIFE* magazine and *Look* in New York. He then spent two years in Greece before moving back to Boston. He first published his colour images in *American Colour* (1995), followed by *American Color 2* in 2010. In 2003 he won the Leica Medal of Excellence for his *American Color* images.

 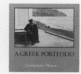 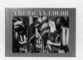

1 2 3 4 13 14 15 16

5

1 *Portrait of a Symphony*. Basic Books, New York, 1960. HB w/ jkt, 279 x 212 mm, 128 pp, 131 b&w photos. Foreword by Aaron Copland.

2 *A Greek Portfolio*. Viking Press, New York, and Secker and Warburg, London, 1972 (also published in French as *Suite Grecque*, Editions du Chêne, Paris, 1972; in German as *Griechische Impressionen*, Bucher, Luzern, 1972; second edn w/ insert in English, French, German and Chinese: W.W. Norton & Company, New York, 1999). HB w/ jkt, 265 x 265 mm, 166 pp, 116 b&w photos. Text by Manos.

3 *Bostonians*. Cambridge Seven Associates, Massachusetts, 1975. PB, 260 x 260 mm, 84 pp, 84 b&w photos. Text by Manos; intro by Brooks Johnson.

4 *American Color*. W.W. Norton & Company, New York, 1995. HB w/ jkt, 227 x 300 mm, 96 pp, 93 col photos. Text by Manos.

5 *American Color 2*. W.W. Norton & Company, New York, 2010 (special edn set in slipcase of *American Color* and *American Color 2*, 2012). HB w/ jkt, 225 x 293 mm, 142 pp, 138 col photos. Text by Manos; intro by Alison Nordstrom.

1 *Passport*. Lustrum Press, New York, 1974. PB, 305 x 230 mm, 56 pp, 93 b&w photos.

2 *Ward 81*. Simon and Schuster, New York, 1979 (second edn published by Damiani, Bologna, 2008). HB w/ jkt and PB, 210 x 280 mm, 96 pp, 85 b&w photos. Intro by Milos Forman; text by Karen Folger Jacobs.

3 *Falkland Road: Prostitutes of Bombay*. Alfred A. Knopf, New York and Thames & Hudson, London, 1981 (also published in PB; revised edn: Steidl, Göttingen, 2005). HB w/ jkt, 276 x 254 mm, 124 pp, 65 col photos.

4 *Photographs of Mother Teresa's Missions of Charity in Calcutta: Untitled 39*. The Friends of Photography, Carmel, California, 1985. PB, 260 x 210 mm, 48 pp, 36 b&w photos. Intro by David Featherstone.

5 *Streetwise*. University of Pennsylvania Press, Philadelphia, 1988 (also Aperture, New York, 1991). HB, 279 x 254 mm, 80 pp, 58 b&w photos. Intro by John Irving.

6 *Mary Ellen Mark: 25 Years*. Bulfinch Press, Boston, 1991. PB, 280 x 240 mm, 200 pp, 130 b&w photos. Text by Marianne Fulton.

7 *Indian Circus*. Chronicle Books, San Francisco, 1993 (also published in Japanese by JICC, Tokyo, 1993). HB w/ jkt, 286 x 254 mm, 108 pp, 74 b&w photos. Foreword by John Irving.

8 *A Cry For Help: Stories of Homelessness and Help*. Simon and Schuster, New York, 1996. PB, 241 x 241 mm, 104 pp, 50 b&w photos. Text by Andrew Cuomo, Robert Coles and Mark's subjects.

9 *Mary Ellen Mark: American Odyssey 1963-1999*. Aperture, New York, 1999. HB, 311 x 267 mm, 152 pp, 144 photos.

10 *Twins*. Aperture, New York, 2003. HB, 330 x 267 mm, 96 pp, 80 b&w photos. Interviews by Mary Ellen Mark.

11 *Exposure: The Iconic Photographs*. Phaidon Press, London, 2005 (also published in French as *Exposer*; PB edns 2006 and 2007). HB, 322 x 260 mm, 288 pp, 135 b&w and col photos. Intro by Weston Naef.

12 *Undrabörn: Extraordinary Child*. National Museum of Iceland, Reykjavik, 2007. PB, 380 x 305 mm, 176 pp, 85 b&w photos. Intro by Margaret Hallgrmsdottir and text by Einar Falur Ingolfsson.

13 *Seen Behind the Scene: Forty Years of Photographing on Set*. Phaidon Press, London, 2008 (also published in French, Spanish and Italian, 2009; PB edn: 2013). HB w/ jkt, 290 x 214 mm, 264 pp, 168 b&w photos.

14 *Prom: Portraits from Proms Across the United States*. J. Paul Getty Museum, Los Angeles, 2012. HB, 325 x 255 mm, 164 pp, 128 b&w photos.

15 *Man and Beast: Photographs from Mexico and India*. University of Texas Press, Austin, Texas, 2014. HB, 305 x 305 mm, 168 pp, 129 b&w photos. Text by Mark and Melissa Harris.

16 *Tiny: Streetwise Revisited*. Aperture, New York, 2015. HB, 305 x 254 mm, 176 pp, 145 b&w photos. Text by Isabel Allende and John Irving.

Mary Ellen Mark

Mary Ellen Mark (1940-2015; Magnum member 1977-81) studied painting and art history at the University of Pennsylvania before taking a masters in photojournalism in 1964. A Fulbright Scholarship allowed her to spend several months photographing in Turkey, and she also visited numerous European countries. Living in New York in the late 1960s she concentrated on US society, following protests against the Vietnam War and the Women's Liberation movement. Much of her career was spent photographing people at the edge of society, documenting the homeless, the isolated and drug addicts with a high degree of empathy for publications such as *The New York Times Magazine* and *LIFE* magazine. She worked frequently in India, photographing circus performers and Bombay prostitutes. Mark also worked widely in advertising and photographed on many film sets. After leaving Magnum, she co-founded the agency, Archive Pictures, with Charles Harbutt and Abigail Heymann, before establishing her studio (Falkland Road Inc.) in 1986.

1 2 3 4

5 6 7 8

9 10 11 12 1 2 3 4

Peter Marlow

Peter Marlow (1952-2016; joined Magnum in 1980) studied psychology at Manchester University and joined the Sygma agency in 1976. In the late 1970s he travelled internationally as a photojournalist before returning to Britain in the 1980s. He was responsible for some of the most iconic images that defined Britain under the divisive government of Prime Minister Margaret Thatcher. Marlow and Chris Steele-Perkins founded the Magnum office in London in 1987, and he was twice president of Magnum. In later years, Marlow explored a more poetic approach, working more extensively in colour and concentrating on physical and personal landscapes.

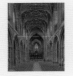

5 6 7 8

1 *Liverpool: Looking Out to Sea.* Jonathan Cape, London, 1993. HB w/ jkt and PB, 244 x 330 mm, 112 pp, 85 b&w photos. Intro by Ian Jack.

2 *Universale dei Diritti Umani.* Arte, Bologna, 1998. HB, 215 x 197 mm, 72 pp, 60 b&w photos. Text extracts from the Declaration and Kofi Annan.

3 *Concorde: The Last Summer.* Thames & Hudson, London, 2006. HB, 219 x 181 mm, 144 pp, 104 col photos. Foreword by A.A. Gill; intro by Mike Bannister.

4 *Somebody.* Self-published, London, 2010. HB, 290 x 298 mm, 92 pp, 45 b&w and col photos.

5 *Point of Interest.* Self-published, London, 2011. HB, 300 x 300 mm, 98 pp, 47 col photos. Intro by Jules Wright.

6 *The English Cathedral.* Merrell, London, 2012. HB w/ jkt, 346 x 280 mm, 128 pp, 45 col photos. Text by Martin Barnes and John Goodall.

7 *Undercover Spitalfields: Market Stories.* Magnum Photos, London, 2013. HB, 300 x 225 mm, 62 pp, 101 col photos. Text by Jonathan Glancey.

8 *English National Ballet: Breaking New Ground.* Magnum Photos, London, 2015. HB, 299 x 219 mm, 78 pp, 92 b&w and col photos.

Steve McCurry

Steve McCurry (b.1950; joined Magnum in 1985) began his career when, after two years of working at a newspaper, he made his first trip to India in 1978. Travelling with little more than a bag of clothes and film, he made his way across the subcontinent to Pakistan, where he met a group of Afghan refugees who smuggled him across the border to travel with the Mujahedeen and record their uprising, just as the Russian invasion was closing the country to journalists. Since then McCurry has become one of the most iconic figures in contemporary photography and has been recognized with scores of prestigious awards, including the Robert Capa Gold Medal for courage and enterprise.

1 *The Imperial Way: By Rail from Peshawar to Chittagong.* Houghton Mifflin Harcourt, Boston, 1985. HB w/ jkt, 265 x 210 mm, 142 pp, 96 col photos. Text by Paul Theroux.

2 *Monsoon.* Thames & Hudson, New York, 1995 (second edn: Thames & Hudson, London, 1998). HB w/ jkt and PB, 235 x 265 mm, 112pp, 84 col photos. Text by McCurry.

3 *Portraits.* Phaidon Press, London, 1999 (also French, Italian, German and Japanese edns; second edn: 2013). HB, 185 x 123 mm, 512 pp, 255 col photos. Foreword by McCurry.

4 *South Southeast.* Phaidon Press, London, 2000 (also French, Italian, German and Spanish edns). HB w/ jkt, 380 x 275 mm, 156 pp, 67 col photos. Text by McCurry.

5 *Sanctuary: The Temples of Angkor.* Phaidon Press, London, 2002 (also French and Japanese edns; PB edn published 2005). HB w/ jkt, 189 x 270 mm, 144 pp, 89 col photos. Intro by John Guy.

6 *The Path To Buddha: A Tibetan Pilgrimage.* Phaidon Press, London, 2003. HB w/ jkt and PB, 250 x 250 mm, 144 pp, 100 col photos. Intro by Robert Thurman.

7 *Looking East.* Phaidon Press, London, 2006 (also published in French as *Regards d' Orient*, Phaidon Press, Paris, 2012). HB w/ jkt, 380 x 275 mm, 128 pp, 75 col photos. Foreword by McCurry.

8 *In the Shadow of Mountains.* Phaidon Press, London, 2007 (also published in French as *Dans l'Ombre des Montagnes*, Phaidon Press, Paris, 2007). HB, 297 x 258 mm, 152 pp, 100 col photos. Text by Kerry William Purcell.

9 *The Unguarded Moment.* Phaidon Press, London, 2009 (also French, Spanish, German and Italian edns). HB w/ jkt, 380 x 270 mm, 156 pp, 75 col photos.

10 *100 Photos de Steve McCurry pour la Liberté de la Presse.* Editions Reporters sans Frontières, Paris, 2012. PB, 260 x 200 mm, 144 pp, 100 col photos. Preface by Agnès B.

11 *Steve McCurry: The Iconic Photographs.* Phaidon Press, London, 2011 (limited edn of 2000 copies with a signed and numbered print in a clothbound slipcase; smaller format standard edn published in 2012; also published in Chinese and Spanish, 2013). HB w/ slipcase, 500 x 375 mm, 264 pp, 165 col photos. Texts by Kerry William Purcell and Anthony Bannon.

12 *Steve McCurry Untold: The Stories Behind the Photographs.* Phaidon Press, London, 2013 (published in French as *Inédit; Les histoires à l'origine des photographies*, Phaidon Press, Paris, 2013; Chinese edn: Chinese Photographic Publishing House, 2013; German edn: Edel, 2013; Dutch edn: Lannoo, 2013; Italian edn: Mondadori, 2013; Taiwan edn: Chinese Complex My House Publications, 2015; and Korean edn: Sigongsa, 2015). HB w/ jkt, 345 x 245 mm, 264 pp, 270 col photos and 151 illus.

13 *From These Hands: A Journey Along the Coffee Trail.* Phaidon Press, London, 2015. HB, 214 x 290 mm, 144 pp, 70 col photos. Text by Adam Leith Gollner.

14 *India.* Phaidon Press, London, 2015 (French and English edns; Italian edn: Mondadori, 2015). HB, 380 x 275 mm, 208 pp, 150 col photos. Text by William Dalrymple.

15 *Steve McCurry: On Reading.* Phaidon Press, London, 2016 (English, French and Spanish edns). HB, 214 x 290 mm, 144 pp, 66 col photos. Intro by Paul Theroux.

Susan Meiselas

Susan Meiselas (b.1948; joined Magnum in 1976) was teaching photography in New York public schools when she took the pictures for her first book, *Carnival Strippers* (1976), documenting striptease dancers at country fairs in New England. Joining Magnum that same year, Meiselas became a freelance photographer. She is best known for her documentation of human rights issues in Latin America, beginning in Nicaragua in 1978-9. In 1997 she created a book of a 100-year visual history of Kurdistan. She has co-edited two other books: *El Salvador, Work of 30 Photographers* (1983) and *Chile from Within* (1990); she has also co-directed two films: *Living at Risk* (1985) and *Pictures from a Revolution* (1991). In 1992 she was made a MacArthur Fellow and she received a Guggenheim Fellowship in 2015.

1 2 3 4

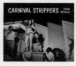

5 6 7 8

1 *Carnival Strippers*. Farrar, Strauss & Giroux, New York, 1976 (limited edn of 75 copies w/ print also published; French edn: *Striptease Forain*, Edition du Chêne, Paris, 1976; also published in paperback). HB w/ jkt, 254 x 222 mm, 150 pp, 73 b&w photos.

2 *Nicaragua: June 1978-July 1979*. Pantheon Books, New York, 1981 (also published in paperback; French edn: Herscher, Paris, 1981; Spanish edn: Educa, Costa Rica, 1983; reissued by Aperture and ICP, with additional DVD, New York, 2008; Spanish edn: Instituto de Historia de Nicaragua y Centroamericana, 2008). HB w/ jkt and PB, 215 x 175 mm, 120 pp, 71 b&w photos. Text by various writers.

3 *Kurdistan: In the Shadow of History*. Random House, New York, 1997 w/ jkt (second edn: University of Chicago Press, Chicago, 2008; also published in PB). HB w/ jkt, 305 x 245 mm, 408 pp, 410 illus. Text by Martin Van Bruinessen.

4 *Pandora's Box*. Trebruk and Magnum Photos, London, 2001 (limited edn of 1650 copies, of which 150 copies were signed and w/ slipcase). HB, 198 x 300 mm, 92 pp, 63 col photos.

5 *Encounters with the Dani*. Steidl, Göttingen and ICP, New York, 2003. HB, 280 x 210 mm, 196 pp, 147 illus.

6 *Carnival Strippers* (revised edn). Steidl, Göttingen and Whitney Museum, New York, 2003. HB w/ jkt, 273 x 234 mm, 164 pp, 78 b&w photos. Text by Meiselas, Sylvia Wolf and Deirdre English.

7 *In History*. Steidl, Göttingen and ICP, New York, 2008. HB, 260 x 206 mm, 356 pp, 173 b&w and col photos; 97 illus. Text by Meiselas, Caroline Brothers, Edmundo Desnoes, Elizabeth Edwards, David Levi-Strauss, Lucy Lippard, Kristen Lubben, Allan Sekula, Abigail Solomon-Godeau and Diana Taylor.

8 *Prince Street Girls*. Yellow Magic Books, Paris, 2013 (limited edn of 200 copies). PB, 219 x 162 mm, 46 pp, 26 b&w photos.

Wayne Miller

Wayne Miller (b.1918-2013; joined Magnum in 1958) studied photography at the Art Center School of Los Angeles from 1941-42. Miller served in the United States Navy, where he was assigned to Edward Steichen's Naval Aviation Unit. In 1946-48, he won two consecutive Guggenheim Fellowships and photographed African-Americans in Chicago, Illinois. Miller worked with *LIFE* magazine and other photo magazines until 1953. He was Edward Steichen's assistant on the Museum of Modern Art's historic exhibition, 'The Family of Man' (1955) and in 1958 he became a member of Magnum Photos, serving as its president from 1962-66. His ambition was, in his words, to 'photograph mankind and explain man to man'. Active in environmental issues in the 1960s, Miller went on to work with the National Park Service. He retired from professional photography in 1975, devoting himself to sustainable forestry in California.

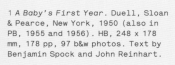

1 2 3 4

1 *A Baby's First Year*. Duell, Sloan & Pearce, New York, 1950 (also in PB, 1955 and 1956). HB, 248 x 178 mm, 178 pp, 97 b&w photos. Text by Benjamin Spock and John Reinhart.

2 *The World is Young*. Ridge Press, New York, 1958 (also published in paperback). HB, 275 x 216 mm, 192 pp, 300 b&w photos.

3 *Chicago's South Side; 1946-1948*. University of California Press, Berkeley, 2000. HB w/ jkt, 280 x 252 mm, 112 pp, 103 b&w photos. Text by Orville Schell, Gordon Parks and Robert B. Stepo.

4 *Wayne F. Miller: Photographs 1942-1958*. Powerhouse, New York, 2008. HB w/ jkt, 292 x 273 mm, 256 pp, 190 b&w photos. Text by Fred Ritchin, Kerry Tremain, Paul Berlanga, Gordon Parks and Amy Dru Stanley.

Inge Morath

Inge Morath (1923-2002; joined Magnum in 1953) was the Austrian editor for the picture magazine *Heute* before joining Magnum as an editor and researcher in 1949 and then as a photographer four years later. Morath worked extensively in Europe, North Africa and the Middle East. Her special interest in the arts found expression in photographic essays published by a number of leading magazines. She settled in New York and Connecticut in 1962, after her marriage to playwright Arthur Miller, with whom she collaborated on several books.

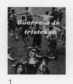

1 2 3 4

5 6 7 8

9 10 11 12

13 14 15 16

17 18 19 20

21 22 23 24

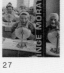

25 26 27 28

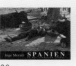

29 30 31

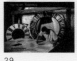
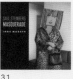

1 *Guerre à la tristesse*. Editions Robert Delpire, Paris, 1955 (also published as *Fiesta in Pamplona*, Manesse Verlag, Zurich, 1955; as *Fiesta in Pamplona*, Universe Books, New York, 1956; and as *Fiesta in Pamplona*, Photography Magazine, London, 1956). HB w/ jkt, 286 x 230 mm, 148 pp, 82 b&w and col photos. Edited by Robert Delpire; text by Dominique Aubier.

2 *Venice Observed*. Editions G. & R. Bernier and Reynal & Co., Paris and New York, 1956 (also published as *Venise, Connue et Inconnue*, Editions de l'Oeil, Lausanne, 1956). HB w/ jkt, 317 x 247 mm, 200 pp, numerous b&w and col photos. Text by Mary McCarthy; photos by Morath and others.

3 *De la Perse ó l'Iran*. Editions Robert Delpire, Paris, 1958 (also published as *From Persia to Iran*, Viking Press, New York, 1960; as *Persien*, Manesse Verlag and Conzett & Huber, Zurich, 1960 and PB edn: Nouvel Observateur/ Delpire, Paris, 1980). HB w/ jkt, 279 x 220 mm, 138 pp, 37 b&w and 25 col photos. Edited by Robert Delpire; text by Edouard Sablier.

4 *Bring Forth the Children*. McGraw-Hill, New York, 1960. HB w/ jkt, 258 x 185 mm, 160 pp, 90 b&w photos. Text by Yul Brynner.

5 *Tunisie*. Editions Delpire, Paris, 1961 (English edn: *Tunisia*, Orion Press, New York, 1961). HB w/ jkt, 285 x 220 mm, 164 pp, numerous photos. Texts by Claude Roy and Paul Sebag; photos by Morath and others.

6 *Le Masque*. Maeght Editeur, Paris, 1967. HB w/ jkt, 270 x 320 mm, 202 pg, 22 b&w photos and drawings by Saul Steinberg. Text by Michel Butor and Harold Rosenberg.

7 *In Russia*. Editions A Studio Book/Viking Press, New York, 1969 (also published by Martin Secker & Warburg, London, 1969; and as *I Russland*, Grondhal & Sons, Oslo, 1970; in PB by Penguin Group, New York, 1969; and as *En Russie*, Bücher Verlag, Lucerne, 1974). HB w/ jkt, 248 x 197 mm, 240 pp, 133 b&w and col photos. Text by Arthur Miller.

8 *East West Exercises*. Simon Walker & Co., 1973. Numerous photos. Text by Ruth Bluestone; photos by Morath.

9 *Grosse Photographen unserer Zeit: Inge Morath*. C.J. Bücher Verlag, Lucern, 1975 (also published in French). HB, 275 x 225 mm, 90 pg, 82 b&w photos. Text by Olga Carlisle.

10 *My Sister, Life and other poems*. Editions Harcourt Brace Jovanovich and A Helen and Kurt Wolf book, New York, 1976 (also published as *Meine Schwester-das Leben*, Reich Verlag and Harcourt Brace Jovanovich, Lucerne, 1976). HB w/ jkt, 240 x 193 mm, 119 pp, 47 b&w and col photos. Poems by Boris Pasternak; text by Olga Andreyev Carlisle.

11 *In the Country*. Viking Press, New York, 1977 (also published by Martin Secker & Warburg, London, 1977; and as *Country Life*, Reich Verlag, Lucerne, 1977). HB w/ jkt, 260 x 224 mm, 192 pp, 114 b&w and col photos. Text by Arthur Miller.

12 *Inge Morath: Photographs of China*. Grand Rapids Art Museum, Grand Rapids, 1979. Numerous photos. Intro by Robert M. Murdoch.

13 *Chinese Encounters*. Editions Farrar Straus & Giroux, New York, 1979 (also published in paperback by Penguin Books, Middlesex, 1981; and as *In China*, Reich Verlag, Lucerne, 1981). HB w/ jkt, 248 x 197 mm, 256 pp, 178 b&w photos. Text by Arthur Miller.

14 *Der Liebe Augustin: Bilder aus Wien*. Reich Verlag, Lucerne, 1981. HB w/ jkt, 215 x 280 mm, 152 pp, 105 b&w and col photos. Texts by Andre Heller, Barbara Frischmuth, Pavel Kohout and Arthur Miller.

15 *Salesman in Beijing*. Editions Viking Press, New York, 1984 (also published by Methuen, London, 1984; and in PB by Penguin, London, 1984). HB w/ jkt, 214 x 145 mm, 272 pp, 36 b&w photos. Text by Arthur Miller.

16 *Portraits*. Aperture, New York, 1986. HB w/ jkt, 295 x 250 mm, 94 pg, 74 b&w photos. Intro by Arthur Miller; afterword by Morath.

17 *Russian Journal*. Editions Aperture, New York, 1991 (also published by Sinclair Stevenson, London, 1991; and as *Russisches Tagebuch*, Christian Brandstaetter Verlag, Wien, 1991). HB w/ jkt, 245 x 293 mm, 132 pp, 120 b&w and col photos. Intro by Yevegeny Yevtushenko; text by Andrei Voznensky and Olga Andreyev Carlisle.

18 *Salzburg - An Artist's View*. Fotohof/Otto Müeller Verlag, Salzburg, 1991 (bilingual edn: English and German). HB w/ jkt, 245 x 305 mm, 111 pp, 19 b&w photos. Text by Harald Waitzbauer; photos by Morath and 3 others.

19 *Inge Morath: Fotografien 1952-1992*. Editions Fotohof/ Otto Müller Verlag, Salzburg, 1992 (bilingual edn: English and German; 3rd enlarged edn published by Fotohof/Otto Müller Verlag, Salzburg, 2000). HB w/ jkt, 246 x 284 mm, 156 pp, 116 b&w photos. Text by Morath, Kurt Kaindl and Margit Zuckriegl.

20 *Inge Morathová*. Výstava Fotografií Porándaná pod Zástitou prezidenta Repubky Václava Havla, Prague Castle Gallery, Prague, 1993. Loose pages in folder, without pagination, 240 x 235 mm. Text by Anna Farova.

21 *Inge Morath: España Años 50*. Editions Lola Garrido Armendáriz Arte con texto, Madrid, 1994 (PB edn published by Fundación Caixa Galicia, Santiago-La Coruña-Lugo, 1995/1996). HB w/ jkt, 248 x 314 mm, 144 pp, 95 b&w photos. Edited and intro by Lola Garrido Armendáriz; text by Morath.

22 *Donau*. Fotohof/Otto Müller Verlag, Salzburg, 1995. (bilingual edn: English and German) HB w/ jkt, 247 x 286 mm, 142 pp, 132 b&w and col photos. Text by Karl-Markus Gaub; afterword by Morath.

23 *Women to Women*. Magnum Photos, Tokyo, 1996. PB, 245 x 250 mm, 96 pp, numerous b&w photos. Photos by Eve Arnold and Inge Morath.

24 *San Fermin Años 50*. I.G.A., Pamplona, 1997. HB w/ jkt, 302 x 219 mm, 176 pp, 100 b&w photos. Texts by Arthur Miller, Inge Morath and Ramón Irigoyen.

25 *Inge Morath*. Universidad Pública de Navarra, Madrid, 1997. PB, 206 x 169 mm, 200 pp, 88 b&w photos. Text by Joaquin Pascal, Arthur Miller and Lola Garrido Armendáriz.

26 *Camiño de Santiago*. Universidade de Santiago de Compostela, 1998. HB w/ slipcase, 210 x 297 mm, 164 pp, 89 b&w photos. Edited by Lola Garrido Armendariz; text by Manuel Rivas.

27 *Inge Morath: Life as a Photographer*. Editions Gina Kehayoff, Munich, 1999. (German PB edn: Gina Kehayoff, Munich, 1999). HB w/ jkt, 270 x 225 mm, 184 pp, 145 b&w photos. Intro by Sabine Folie and Gerald Matt; text by Morath, Rolf Sachsse, Sabine Folie, Olivia Lahs-Gonzales and Gerald Matt.

28 *Portraits*. Fotohof / Otto Müller Verlag, Salzburg, 1999. HB w/ jkt, 281 x 242 mm, 128 pp, 104 b&w photos. Texts by Arthur Miller, Anna Farova and Robert Delpire.

29 *Regensburg: Der Blick von aussen*. Stadt Regensburg, Regensburg, 2000. PB, 210 x 277 mm, 72 pp, 55 b&w photos. Edited by Martin Angerer; conceived by Kurt Kaindl; text by Ulrich Pohlmann.

30 *Spanien: In Den Fünfziger Jahren*. Editions Batuz Foundation, Altzella, 2000 (PB edn: Batuz Foundation, Altzella, 2000). HB w/ jkt, 247 x 315 mm, 120 pp, 78 b&w photos.

31 *Saul Steinberg: Masquerade*. Viking Studio, New York, 2000. HB w/ jkt, 185 x 185 mm, 80 pp, 63 b&w photos. Text by Morath.

James Nachtwey

James Nachtwey (b.1948; Magnum member 1986-2001) studied art history and political science in Massachusetts before deciding to become a photographer, partly influenced by seeing images of the Vietnam War and the Civil Rights movement. Since his first overseas assignment - covering the IRA hunger strike in Northern Ireland in 1981 - he has travelled to most of the world's major conflicts and trouble spots, often as a contract photographer for *Time* magazine, an association that began in 1984. Nachtwey argues, 'I have been a witness and these pictures are my testimony. The events I have recorded should not be forgotten and must not be repeated.' Having been associated with Black Star and Magnum, in 2001 he was one of the founders of the VII photo agency. He has received numerous honours for his work and is a member of the Royal Photographic Society.

1 2 3

1 *Deeds of War*. Thames & Hudson, London, 1989. HB w/ jkt, 314 x 258 mm, 166 pp, 75 col photos. Intro by Robert Stone.

2 *Inferno*. Phaidon Press, London, 1999 (also published in French and German). HB, 380 x 275 mm, 480 pp, 382 b&w photos. Intro by Luc Sante; afterword by Nachtwey.

3 *Pietas*. Contrasto, Rome, 2013. PB, 208 pp, numerous col and b&w photos.

Lu Nan

Lu Nan (b.1962; joined Magnum in 1994). He began his series documenting Chinese psychiatric wards in 1989, followed in 1992-96 by his work on China's underground Catholics. He - like his subjects - risked arrest and prosecution for this work. From 1996 to 2004 he documented the life of Tibetan peasants, and in 2006 he created a photo series on the prisons of northern Burma (Myanmar).

1 2 3 4

5 6

edn by China Tushu Publishing Ltd., Hong Kong, 2008 and as part of a trilogy by China Nationality Art Photography Publishing House, Beijing, 2014/2016). HB, 291 x 315 mm, 132 pp, 60 b&w photos. Text by Li Xianting

1 *Wasure Rareta Hitobito (The Forgotten People: The State of Chinese Psychiatric Wards)* Daisan Shokan, Tokyo, 1993 (Japanese edn; second edn 2006). HB w/ jkt, 210 x 300 mm, 136 pp, 63 b&w photos. Text by Ma Xiaohu and Zhang Dake.

2 *Four Seasons: Everyday Life of Tibetan Peasants.* Sichuan Fine Arts Publishing House, Chengdu, 2007 (bilingual edn: English and Chinese; also published as part of a trilogy by China Nationality Art Photography Publishing House, Beijing, 2014/2016). HB, 284 x 304 mm, 224 pp, 109 b&w photos.

3 *On the Road: The Catholic Church in China.* China Tushu Publishing Ltd., Hong Kong, 2008 (Chinese edn; also published as a bilingual English and Chinese

4 *The Forgotten People: The State of Chinese Psychiatric Wards.* China Tushu Publishing Ltd., Hong Kong, 2008 (bilingual edn: English and Chinese; edn of 1000 copies; also published as *The Forgotten People: The Condition of China's Psychiatric Wards*, China Nationality Art Photograph Publishing House, Beijing, 2014/2016 as part of a trilogy). HB w/ jkt, 285 x 303 mm, 124 pp, 56 b&w photos.

5 *Prison Camps in Northern Myanmar.* China Tushu Publishing Ltd., Hong Kong, 2008 (bilingual edn: English and Chinese). PB, 322 x 242 mm, 136 pp, 63 b&w photos.

6 *Prisons of North Burma.* China National Art Photograph Publishing House, Beijing, 2015 (bilingual edn: English and Chinese). HB w/ jkt, 283 x 273 mm, 144 pp, 63 photos. Preface by Lu Nan.

Trent Parke

Trent Parke (b.1971; joined Magnum in 2002) began taking photographs in his native Australia as a young teen, using his mother's camera (a Pentax Spotmatic) and a darkroom converted from the family laundry. After joining Magnum, Parke set off on an ambitious project with his wife and fellow photographer Narelle Autio, driving almost 90,000 kilometres around Australia visiting a wide variety of communities. The photographs were published as *Minutes to Midnight*, a somewhat disturbing view of contemporary Australia that was later bought by the National Gallery of Australia. Parke, Magnum's only Australian member, specializes in street photography.

1 2 3 4

5 6

1 *Dream/Life.* Hot Chilli Press, Sydney, 1999 (also published as a limited edn of 500 copies for Newsltd, 1999). HB w/ jkt, 244 x 289 mm, 144 pp, 104 b&w photos.

2 *The Seventh Wave.* Hot Chilli Press, Sydney, 2000 (also published in paperback). HB, 244 x 287 mm, 128 pp, 69 b&w photos. Collaboration with Narelle Autio; essay by Robert Drewe.

3 *Bedknobs and Broomsticks.* Little Brown Mushroom, Minnesota, 2010 (edn of 1,000 copies). HB, 200 x 168 mm, 40 pp, 22 b&w photos.

4 *Minutes to Midnight.* Steidl, Göttingen, 2013. HB, 250 x 288 mm, 96 pp, 45 b&w photos.

5 *The Christmas Tree Bucket.* Steidl, Göttingen, 2013. HB, 250 x 295 mm, 128 pp, 62 col photos.

6 *The Black Rose.* Art Gallery of South Australia, Adelaide, 2015. HB, 240 x 318 mm, 168 pp, 104 col and b&w photos. Text by Parke.

Martin Parr

Martin Parr (b.1952; joined Magnum in 1994) studied photography at Manchester Polytechnic from 1970 to 1973. His work bridges the divide between art and documentary photography. His studies of the idiosyncrasies of mass culture and consumerism around the world, his innovative imagery and his prolific output have placed him firmly at the forefront of contemporary art. Parr is an avid collector of books and a world authority on the photobook. He has simultaneously developed an interest in filmmaking, and has started to use his photography within different conventions, such as fashion and advertising.

1 2 3 4

5 6 7 8

9 10 11 12

13 14 15 16

17 18 19 20

21 22 23 24

25 26 27 28

29 30 31 32

33 34 35 36 69 70 71 72

37 38 39 40 73 74 75 76

41 42 43 44 77 78 79 80

45 46 47 48 81 82 83 84

49 50 51 52 85 86 87 88

53 54 55 56 89 90 91 92

57 58 59 60 93 94 95 96

61 62 63 64 97 98 99

65 66 67 68

1 *Home Sweet Home*. Self-published, 1974 (edn of less than 50 copies). PB, 159 x 107 mm, 16 pp, 4 c-type col prints, 10 b&w prints and a postcard. Text by Parr, Val Williams and R.D. Laing.

2 *Bad Weather*. A. Zwemmer Ltd, London, 1982 (also revised edn: 2014). PB, 209 x 297 mm, 64 pp, 56 b&w photos. Texts by Michael Fish and Peter Turner.

3 *Calderdale Photographs*. Calderdale Museums Service, West Yorkshire, 1984. PB, 219 x 208 mm, 14 pp, 13 b&w photos.

4 *Prescot Now and Then*. Metropolitan Borough of Knowsley Leisure Services Department, Wallasey, 1984. PB, 199 x 210 mm, 48pp, 20 b&w photos by Parr; 20 b&w photos by others. Text by Loraine Knowles.

5 *A Fair Day: Photographs from the West of Ireland*. Promenade Press, Merseyside, 1984. PB, 209 x 248 mm, 92 pp, 75 b&w photos. Text by Fintan O'Toole.

6 *The Last Resort: Photographs of New Brighton*. Promenade Press, Wallasey, 1986 (edn of 2,000; second HB edn: Dewi Lewis Publishing, Stockport, 1998). PB, 230 x 300 mm, 88 pp, 40 col photos. Text by Ian Walker.

7 *The Cost of Living*. Cornerhouse Publications, Manchester, 1989. PB, 224 x 284 mm, 80 pp, 62 col photos. Text by Robert Chesshyre.

8 *One Day Trip*. Editions de la Difference, Paris, 1989. PB w/ jkt, 299 x 234 mm, 52 pp, 25 col photos. Text by Robert Chesshyre.

9 *Signs of the Times: A Portrait of the Nation's Tastes*. Cornerhouse Publications, Manchester, 1992 (French HB edn: *Signes des Temp*, Éditions Textuel, Paris, 2006). PB, jkt added to remaining copies in 1994, 228 x 233 mm, 72 pp, 59 col photos. Text by Nicholas Barker.

10 *Bored Couples*. Edition Galerie du Jour Agnès B, Paris, 1993. PB, 239 x 245 mm, 36 pp, 22 col photos.

11 *Home and Abroad*. Jonathan Cape, London, 1993. PB, 259 x 286 mm, 78 pp, 58 col photos, 1 b&w photo. Intro by Ian McEwan.

12 *From A to B: Tales of Modern Motoring*. BBC Books, London, 1994. PB, 229 x 234 mm, 72 pp, 60 col photos. Text by Nicholas Barker.

13 *Small World*. Dewi Lewis Publishing, Stockport, 1995 (also French edn: *Quel Monde*, Marval, France, 1995). HB, 261 x 288 mm, 96 pp, 69 col photos. Text by Simon Winchester (intro by Roland Topor in French edn).

14 *British Food*. Galerie du Jour Agnès B, Paris, 1995 (second edn: 1998). PB, 180 x 249 mm, 44 pp, 48 col photos.

15 *Benidorm*. Self-published, 1997-99 (edn of 8 albums + APs, each signed and numbered). HB photo album, 214 x 154 mm, 20 pp, 40 col photos.

16 *West Bay*. The Rocket Press, Oxfordshire, 1997 (edn of 250 copies, each signed and numbered. Numbers 1-25 were accompanied by an original signed photo). HB w/ clothbound slipcase, 310 x 420 mm, 60 pp, 24 tipped-in col photos. Text by Fergus Allen, Philip Gross, Sophie Hannah, Geoffrey Hoare, Alice Oswald, Vicki Raymond, Kate Clanchy and Roger McGough.

17 *Japonais endormis*. Galerie du Jour Agnès B, Paris, 1998. PB, 168 x 234 mm, 48 pp, 24 col photos.

18 *Benidorm*. Sprengel Museum, Hannover, 1999. PB, 239 x 205 mm, 36 pp, 23 col photos. Text by Gerry Badger.

19 *Common Sense*. Dewi Lewis Publishing, Stockport, 1999. HB, 203 x 292 mm, 160 pp, 158 col photos.

20 *Boring Postcards*. Phaidon Press, London, 1999. HB (PB edn: 2004), 150 x 210 mm, 176pp, 120 col and 35 b&w photos.

21 *Sguardi Gardesani*. Edizioni Charta, Milan, 1999 (Italian and English edn). PB, 240 x 298 mm, 96 pp, 29 col photos; 29 b&w by John Davies. Text by Franco Rella.

22 *Flowers*. Munkedals AB Paper Company Sweden, 1999 (edn of 2,500). HB, 179 x 250 mm, 84 pp, 50 col photos.

23 *Autoportrait*. Dewi Lewis Publishing, Stockport, 2000. HB, 147 x 104 mm, 120 pp, 45 col

and 12 b&w photos. Text by Marvin Heiferman.

24 *Think of England*. Phaidon Press, London and Paris, 2000 (English and French edns; PB edn: 2004). HB w/ jkt, 269 x 190 mm, 148 pp, 133 col photos. Jkt text by Gerry Badger.

25 *Boring Oregon*. Self-published, 2000 (edn of 18 albums), each signed and numbered). HB photo album, 340 x 380 mm, 78 pp, 456 col photos.

26 *Boring Postcards USA*. Phaidon Press, London, 2000. HB (PB edn: 2004), 150 x 210 mm, 176 pp, 160 col photos.

27 *Flowers* (revised edn). Galerie du Jour Agnès B, Paris, 2001. HB, 139 x 200 mm, 96 pp, 49 col photos.

28 *Langweilige Postkarten*. Phaidon Press, London, 2001. HB, 150 x 210 mm, 176 pp, 92 col and 68 b&w photos.

29 *Cherry Blossom Time in Tokyo*. Eyestorm, London, 2001 (edn of 30 copies). HB w/ box 258 x 270 mm, 42 pp, 20 c-type col photos.

30 *Souvenir du Maroc*. Self-published, 2001 (edn of 10 albums). Plastic photo album with original c-type photos, 165 x 120 mm, 20 pp, 20 col photos.

31 *Stars and Stripes*. Self-published, 2001 (edn of 5 albums, each signed and numbered). HB photo album, 157 x 105 mm, 100 pp, 100 c-type col photos.

32 *Martin Parr*. Phaidon Press, London, 2002 (first edn in English, French and German; Italian edn: Contrasto, Rome, 2002; also collector's edns with a signed and numbered print; published in PB in 2004). HB, 248 x 288 mm, 356 pp, Numerous col and b&w photos by Parr and others. Text by Val Williams.

33 *The Phone Book: 1998-2002*. The Rocket Press, London, 2002 (blue cover edn) and 20.21, Essen, 2002 (pink cover edn). Limited edn of 2002 copies, of which 35 copies are a deluxe edn w/ 12 loose prints in a box: 1001 copies w/ blue cover, including 20 deluxe copies; and 1001 copies w/ pink cover, including 15 deluxe copies. PB, 290 x 196 mm, 192 pp, 143 col photos.

34 *Cruise Memories*. Self-published, 2002 (edn of 8 albums, each signed and numbered). HB photo album, 255 x 210 mm, 24 pp, 24 c-type col photos.

35 *Knokke*. Franck Bordas, Paris, 2002 (edn of 30 copies, each signed and numbered). Folio of 16 loose prints in solander box, 297 x 400 mm, 16 pp, 15 col photos.

36 *From our House to your House*. Dewi Lewis Publishing, Stockport, 2002. HB, 175 x 175 mm, 96 pp, 91 col illus.

37 *7 Communist Still Lifes*. Nazraeli Press, Tucson, Arizona,

2003 (edn of 500). HB, 181 x 138 mm, 20 pp, 6 col photos with an original c-print tipped in.

38 *Bliss*. Chris Boot Ltd, London, 2004. PB, 230 x 165 mm, 128 pp, 128 col illus.

39 *Saddam Hussein Watches*. Chris Boot Ltd, London, 2004. PB w/ plastic bag, 380 x 300 mm, 40 pp, 38 col photos.

40 *7 Colonial Still Lifes*. Nazraeli Press, Tucson, Arizona, 2005 (edn of 500). HB, 181 x 139 mm, 16 pp, 6 col photos with an original c-print tipped in.

41 *Martin Parr: vu par*. Editions Points de vues, Bonsecours, France, 2005. Spiralbound PB, 164 x 243 mm, 138 pp, 17 col and 2 b&w photos. Text by Diane Dufour and Marie-Christine Biebuyck.

42 *Road Trip 2005: Martin Parr and Friends*. Sony Ericsson, London, 2005. PB, 164 x 194 mm, 96 pp, 204 col photos (116 by Martin Parr).

43 *A8*. John McAslan and Partners, London, 2005. Newspaper format, 395 x 280 mm, 34 pp, 28 col photos. Text by John McAslan.

44 *Fashion Magazine*. Magnum Photos, Paris, 2005 (edn of 50: also limited edn w/ box and 6 c-type prints). PB, 320 x 225 mm, 216 pp, 205 col photos, 2 illus. Texts by Violaine Binet, Paul Smith, Sonia Rykiel, Tamsin Blanchard, Christian Lacroix, Jean Charles de Csatlbajac and others.

45 *Mexico*. Chris Boot Ltd, London, 2006. HB, 209 x 292 mm, 92 pp, 80 col photos. Text by Rogelio Villarreal.

46 *Parrjektif: Istanbul'da Stil Peşinde*. Mavi Jeans, Istanbul, 2006. HB, 315 x 238 mm, 132 pp, 100 col photos.

47 *Tutta Roma*. Contrasto, Rome, 2006. PB, 239 x 194 mm 96 pp, 67 col photos and 7 illus. Text by Ivana della Portella.

48 *Small World* (updated edn with 30 new images). Dewi Lewis Publishing, Stockport, 2007 (French edn: *Petite Planete*. Hoëbeke, France, 2008). HB w/ jkt, 240 x 295 mm, 96 pp, 74 col photos. Text by Geoff Dyer.

49 *Parking Spaces*. Chris Boot Ltd, London, 2007 (edn of 1000). HB in box, 330 x 248 mm, 86 pp, 63 col photos.

50 *Witness Number Three*. Joy of Giving Something Inc., 2007. HB, 304 x 240 mm, 84 pp, 30 col photos by Parr with additional photos by Kohei Yoshiyuka, Keizo Kitajama, Osamu Kanemura, Mark Neville, Rob Hornstra and Bart Sorgedrager; text by Parr, Rob Hornstra, Mark Neville, Bart Sorgedrager and Susie Parr.

51 *Martin Parr Retrospective 1971-2000*. Seoul Arts Centre, Seoul, 2007. PB, 295 x 210 mm, 64 pp, 26 col photos, 6 b&w photos.

52 *Love Cube*. Gun Art, Stockholm, Sweden, 2007. Boxed set, 200 x 200 mm, 27 picture cards of b&w photos, with 8-pp stapled booklet. Text by Johan Croneman.

53 *Fashion Newspaper*. Magnum Photos and Paul Smith, London, 2007 (English and Japanese edn). Newspaper format, 417 x 304 mm, 64 pp, 57 col photos. Text by Parr and Paul Smith.

54 *Postcards*. Chris Boot Ltd, London, 2008 (also published in a slipcase with *Objects* in 2008). HB, 310 x 190 mm, 332 pp, 682 col illus. Intro by Thomas Weski.

55 *Objects*. Chris Boot Ltd, London, 2008. (also published in a slipcase with *Postcards* in 2008). HB 310 x 190 mm, 176 pp, 682 col photos. Intro by Parr.

56 *Guardian Cities Project*. The Guardian, London, 2008. Newspapers in box, 468 x 315 mm, 16 pp each. Cardiff: 29 col photos; Manchester: 29 col photos; Belfast: 27 col photos; Cambridge: 28 col photos; Bristol: 26 col photos; Liverpool: 32 col photos; Newcastle: 29 col photos; Edinburgh: 34 col photos; Brighton: 30 col photos; Leeds: 28 col photos. Texts by Parr.

57 *Correspondencia*. AFA edns, Chile, 2008. PB, 200 x 154 mm, 64 pp, 28 col photos (14 by Parr), 2 b&w photos (1 by Parr).

58 *Everybody Dance Now*. Editions 2wice, New York, 2009. PB, w/ metallic cover, 292 x 210 mm, 96 pp, 107 col photos, 8 b&w photos. Foreword by Patsy Tarr and Abbott Miller; intro by Andy Grundberg.

59 *Playas*. Chris Boot Ltd, London, and Editorial RM, Mexico, 2009. HB, 205 x 132 mm, 68 pp, 59 col photos. Text by Susie Parr.

60 *The Last Resort* (revised edn). Dewi Lewis Publishing, Stockport, 2009 (German edn: Kehrer Verlag, Heidelberg, 2009; French edn: Images en Manoeuvres Editions, Marseille, 2009). HB, 242 x 297 mm, 84 pp, 40 col photos. Text by Gerry Badger.

61 *Luxury*. Chris Boot Ltd, London, 2009 (French edn: Editions Textuel, France, 2009; Spanish edn: RM, Mexico; 2009, also special edn in HB w/ leatherette cover and accompanied by a signed and numbered c-type print). HB, 249 x 248 mm, 116 pp, 83 col photos. Introductory text by Paul Smith.

62 *Joachim Schmid Is Martin Parr, Martin Parr Is Joachim Schmid*. Joachim Schmid, London, 2009; Joachim Schmid/Blurb. HB w/ jkt, 168 x 175 mm, 40 pp, 16 col photos by Schmid, 16 col photos by various photographers selected by Parr.

63 *Assorted Cocktail*. Casal Solleric, Palma, Mallorca, 2009 (also published as a small format PB edn by Dox, Prague, 2011). HB, 219 x 235 mm, 252 pp, 204 col photos. Text by Thomas Weski, Aina Calvo Sastre and Vicente Sala Bello.

64 *Sweet Memory: Chinese Wedding Album*. Self-published, 2009. HB w/ slipcase, 294 x 210 mm, 20 pp, 20 col photos.

65 *Martin Parr in India 1984-2009*. Photoink, New Delhi, 2010. (trilingual edn: English, Hindi and Urdu). HB, 210 x 132 mm, 70 pp, 25 col and 11 b&w photos.

66 *The Real World*. Kaunas Photography Gallery, Kaunas, . 2010. PB (published as part of a two-volume set in a slipcase), 209 x 238 mm, 84 pp, 40 col photos. Text by Thomas Weski.

67 *Parr by Parr*. Éditions Textuel, Paris, 2010 (English edn: Schilt Publishing, Amsterdam, 2010; Italian edn: Contrasto, Rome, 2012; Russian edn: Treemedia Content, Russia, 2012). PB, 209 x 155 mm, 128 pp, 40 col and 5 b&w photos, 12 illus. Text by Quentin Bajac and Parr.

68 *A Book of Kings*. Third Millennium Information, London, 2010 (edn of 2,300). HB w/ jkt, 280 x 210 mm, 224 pp, 44 col photos by Parr, plus various other photos and illus. Foreword by Karl Sabbagh and additional texts by various contributors.

69 *Machu Piccu*. Nazraeli Press, Portland, OR, 2010 (edn of 100). HB w/ jkt, 360 x 385 mm, 32 pp, 23 col photos, 1 col print. Text by Parr.

70 *One Day: 10 Photographers*. Kehrer Verlag, Heidelberg, 2010. HB (10-volume set in a slipcase), 218 x 163 mm, 36 pp, 15 col photos.

71 *Japan*. Super Labo, Kanagawa (Japan), 2011. HB, 200 x 146 mm, 52 pp, 32 col photos.

72 *Urban Outfitters Summer Preview 2011*. Urban Outfitters, Philadelphia, PA, 2011. PB, 356 x 236 mm, 52 pp, 31 col photos.

73 *7 Cups of Tea*. Nazraeli Press, Portland, OR, 2012 (edn of 500). HB, 180 x 138 mm, 16 pp, 6 col photos and 1 c-type print.

74 *No Worries*. T&G Publishing, Sydney, 2012 (special edn in clamshell box w/ c-type print: T&G Publishing, Sydney, 2012). HB w/ jkt, 236 x 259 mm, 132 pp, 93 col photos. Text by Robert Cook and Parr.

75 *Up and Down Peachtree: Photographs of Atlanta*. Contrasto, Rome, 2012. Clothbound HB, 279 x 223 mm, 160 pp, 99 col photos and 16 illus.

76 *Souvenir*. CCCB, Barcelona, 2012. PB, 240 x 170 mm, 176 pp, 88 col photos, 1 b&w photo, 1 illus, 37 photos of Parr's collection. Texts by Salvador Esteve i Figueras and Marçal Sintes, Horacio Fernández.

77 *Made in Italy*. Pazzini Editore, Rimini, 2012. 8 PBs in slipcase, 210 x 250 mm, 16 pp, 12 col photos.

78 *Life's a Beach*. Xavier Barral, Paris and Aperture, New York, 2012 (French edn: 1000 copies and English edn: 1000 copies). Clothbound HB in slipcase, 240 x 320 mm, 72 pp, 98 col photos. Foreword by Parr.

79 *Life's a Beach*. Aperture, London, 2013. HB, 152 x 206 mm, 124 pp, 98 col photos. Foreword by Parr.

80 *The Non-Conformists*. Aperture, New York, 2013 (special edn: Aperture, New York, 2013 including book in slipcase and gelatin-silver print). HB w/ jkt, 240 x 200 mm, 168 pp, 124 b&w photos. Text by Susie Parr.

81 *Instant Parr*. Goliga, Tokyo, 2013. PB, 207 x 297 mm, 20 pp, 21 c-type prints tipped in.

82 *Signs of the Times* (revised edn). Beetles + Huxley, London, 2014. PB, 208 x 210 mm, 68 pp, 28 col photos.

83 *Grand Paris 2014*. Xavier Barral, Paris, 2014. Vinyl lexi-cover, 297 x 210 mm, 132 pp, 39 col photos.

84 *Voewood Festival*. Voewood Publications, Norfolk, 2014. HB, 300 x 300 mm, 72 pp, 45 col photos. Text by DBC Pierre.

85 *Hong Kong Parr*. GOST Books and Blindspot Gallery, London, 2014. Vinyl flexi-cover, 261 x 198 mm, 112 pp, 54 col photos w/ 24 pp booklet tipped in with 11 col photos.

86 *Black Country Stories*. Dewi Lewis Publishing, Stockport, 2014. HB, 315 x 228 mm, 140 pp, 105 col photos. Text by Parr.

87 *We Love Britain!* Schirmer/Mosel, Munich and Sprengel Museum Hannover, 2014. PB w/ plastic jkt, 271 x 208 mm, 128 pp, 71 col photos. Texts by Georg Fahrenschon and Inka Schube.

88 *The Amalfi Coast*. Studio Trisorio, Napoli, 2014 (English and Italian; revised edn, 2015). PB, 209 x 204 mm, 36 pp, 25 col photos. Text by Fabrizio Tramontano.

89 *Bad Weather* (revised edn). Errata Editions, New York, 2014. HB w/ jkt, 239 x 176 mm, 92 pp, 77 b&w and col photos, a poster and 2 contact sheets). Text by Thomas Weski.

90 *Martin Parr*. Phaidon Press, London, 2014 (revised edn). HB, 248 x 290 mm, 476 pp, numerous col and b&w photos by Parr and others. Text by Val Williams.

91 *Chinatown, 1984*. Café Royal Books, Southport, 2015 (edn of 250). Zine format, 200 x 140 mm, 34 pp, 18 b&w photos.

92 *A Place in the Sun*. Barbado, Lisbon, 2015. PB, 147 x 213 mm, 64 pp, 25 col photos. Text by Agnès de Gouvion-Saint-Cyr.

93 *Be Bold with Bananas*. Salon Verlag, Cologne, 2015 (edn of 100; special edn w/ clamshell box and additional c-print: Salon

Verlag, Cologne, 2015). HB, 241 x 174 mm, 62 pp, a col photo by Parr, 1 col print by Parr. 30 photos by others.

94 *Kassel Menu*. FBF-Books & Kasseler Fotografie Festival gUG, Kassel, 2015 (limited edn of 350 copies). HB in cardboard box, 235 x 328 mm, 22 pp, 20 col photos and 26 loose photos.

95 *Autoportrait 1996-2015*. Dewi Lewis, Stockport and Xavier Barral, Paris, 2015 (revised edn). HB, 155 x 110 mm, 142 pp, 84 col photos, 4 b&w photos.

96 *The Rhubarb Triangle*. The Hepworth Wakefield, Wakefield, 2016 (also special edn in slipcase w/ col pigment print). HB, 215 x 278 mm, 84 pp, 40 col photos. Text by Simon Wallis and Susie Parr.

97 *Real Food*. Phaidon Press, London, 2016 (also published in French as *Des Goûts*, Phaidon Press, Paris, 2016). HB, 150 x 208 mm, 208 pp, 209 col photos. Text by Fergus Henderson.

98 *Yates*. Cafe Royal Books, Southport, 2016 (edn of 500). PB, 200 x 140 mm, 34 pp, 19 b&w photos.

99 *Cakes and Balls*. Anzenberger Edition, Vienna (edn of 1,200, of which 50 were collector's edn). HB, 219 x 219 mm, 80 pp, 56 col photos.

Paolo Pellegrin

Paolo Pellegrin (b. 1964; joined Magnum in 2001) studied architecture at L'Università la Sapienza in Rome before studying photography at l'istituto Italiano di Fotografia in Rome. He became a full member of Magnum in 2005. He was a contract photographer for *Newsweek* for ten years and currently has a contract with the German magazine *Zeit*. Pellegrin has won many awards, including ten World Press Photo awards and numerous Photographer of the Year awards, a Leica Medal of Excellence, an Olivier Rebbot Award, the Hansel-Meith Prize, and the Robert Capa Gold Medal Award. In 2006, he was assigned the W. Eugene Smith Grant in Humanistic Photography. He lives in London.

1

2

3

4

5

6

7

8

1 *Bambini*. Sinnos, Milan, 1997. PB, 300 x 240 mm, 88 pp, 32 b&w photos.

2 *Kukes*. SSU, Stockholm, 1999. HB, 232 x 158 mm, 48 pp, 20 b&w photos.

3 *L'au-Delà est Là*. Edition Point du Jour, Paris, 2000. PB, 160 x 120 mm, 11 b&w photos. Text by Régis Jauffret.

4 *Kosovo 1999-2000 The Flight of Reason*. Trolley Books, London, 2002. HB w/ jkt, 235 x 235 mm, 148 pp, 60 b&w photos. Text by Pellegrin, Tim Judah and Thomas Rees.

5 *As I Was Dying*. Dewi Lewis Publishing, Stockport, 2007 (also

published in French by Actes Sud, Arles and in Italian by Peliti Associati, Rome). HB, 301 x 244 mm, 140 pp, 70 b&w photos.

6 *Double Blind*. Trolley Books, London, 2007. PB, 230 x 210 mm, 144 pp, 80 b&w photos. Text by Scott Anderson and Patti Smith.

7 *Fashion Magazine: Storm*. Magnum Photos, Paris, 2010. PB, 300 x 216 mm, 320 pp, 147 b&w and col photos. Text by Bruce Mau, Marc Augé, John Elkington and Underground Resistance.

8 *Dies Irae*. Contrasto, Rome, 2011. HB, 300 x 240 mm, 208 pp, 130 b&w photos. Text by Robert Koch and Pellegrin.

Gilles Peress

Gilles Peress (b.1946; joined Magnum in 1971) began working with photography in 1970, having previously studied political science and philosophy in Paris. One of Peress' first projects examined immigration in Europe, and he has since documented events in Northern Ireland, Lebanon, Palestine, Iran, the Balkans, Rwanda, the United States, Afghanistan and Iraq. His work has been widely exhibited and is collected by museums and collections all over the world. Peress has received numerous awards and fellowships, including the Guggenheim Fellowship, the W. Eugene Smith Grant for Humanistic Photography and the International Center of Photography Infinity Award. He is Professor of Human Rights and Photography at Bard College, NY and Senior Research Fellow at the Human Rights Center, UC Berkeley. He lives in Brooklyn.

1

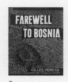
2

3

4

1 *Telex Persan*. Contrejour, Paris, 1984 (also published in English as *Telex Iran: In the Name of Revolution*, Aperture, New York; re-published in HB by Scalo, New York, 1997). PB, 378 x 266 mm, 104 pp, 100 b&w photos. Text by Gholam-Hossein Sa'edi.

2 *Farewell to Bosnia*. Scalo, Zurich and New York, 1994. HB, 365 x 270 mm, 168 pp, 150 b&w photos.

3 *The Silence*. Scalo, Zurich and New York, 1995 (published in French as *Le Silence*). PB, 228 x 160 mm, 208 pp, 100 b&w photos.

4 *The Graves: Srebrenica and Vukovar*. Scalo, Zurich and New York, 1998 (published in French as *Les Tombes*). HB, 206 x 136 mm, 334 pp, 150 b&w photos. Text by Eric Stover.

Gueorgui Pinkhassov

Gueorigui Pinkhassov (b.1952; joined Magnum in 1988) was interested in photography at school but studied cinematography in Moscow before working at the Mosfilm studio, where he worked as a cinematographer before becoming a set photographer. He raised his profile by becoming a member of the Moscow Union of Graphic Artists, and his work was noticed by the renowned filmmaker Andrei Tarkovsky, who invited Pinkhassov to photograph a reportage about his film *Stalker* (1979). Pinkhassov moved to Paris in 1985, shortly before he joined Magnum and built a career as a photojournalist specializing in what has been termed art-reportage, in which mundane subjects take on an almost abstract quality. He has worked regularly for publications such as *Geo*, *Actuel* and the *New York Times Magazine*.

1

2

3

4

1 *Sightwalk*. Phaidon Press, London, 1998. HB w/ textured cover, 286 x 293 mm, 40 pp, 25 col photos. Text by Pinkhassov.

2 *Carnet d'Opéra, regards en coulisses*. Editions Xavier Barral, Paris, 2003 (French edn). HB, 175 x 255 mm, 110 pp, 71 col photos. Text by Hugues R. Gall.

3 *Nordmeer*. Mare Verlag, Hamburg, 2006. HB w/ jkt, 266 x 306 mm, 136 pp, 100 col photos.

4 *Un Nouveau Regard Sur La Mobilité Urbaine*. Editions de la Martiniere, Paris, 2015. HB w/ illustrated cover, 187 x 250 mm, 96 pp, 60 col photos.

Mark Power

Mark Power (b.1959; joined Magnum in 2002) studied painting at art school but decided to become a photographer while travelling following his graduation (one of his temporary jobs was running the camera department in an Australian chemists). His photographic career was

a decade old when, in 1992, he began teaching photography. This, together with large-scale commissions in the industrial sector, enabled him to concentrate on long-term, self-assigned projects usually based in Britain or central Europe, particularly Poland. He has published eight books and is currently Professor of Photography at the University of Brighton, UK.

1

2

3

4

5

6

7

8

1 *The Shipping Forecast*. Zelda Cheatle Press (in association with Network Photographers), London, 1996 (first edn of 1,700 copies and 300 paperback copies; second and third edns published in hardback and paperback, 1997). HB w/ jkt, 286 x 245 mm, 88 pp, 66 b&w photos. Intro by David Chandler.

2 *Superstructure*. Harper Collins Illustrated, London, 2000 (edn of 2,000 copies). HB w/ jkt, 282 x 310 mm, 208 pp, 135 col and b&w photos. Text by David Chandler.

3 *The Treasury Project*. Photoworks, Brighton, 2002 (edn of 1,500 copies, of which 500 copies were for public sale; special limited edn of 50 copies in a box with a signed and numbered print also published). HB w/ acetate jkt, 316 x 200 mm, 120 pp, 113 col photos. Text by Power.

4 *26 Different Endings*. Photoworks, Brighton, 2007 (edn of 1,000 copies; also limited edn of 26 copies, each with a different print). HB w/ jkt, 290 x 365 mm, 64 pp, 26 col photos. Text by David Chandler.

5 *The Sound of Two Songs*. Photoworks, Brighton, in association with Photomonth Kraków, Brighton, UK, 2010 (edn of 2,000 copies). HB w/ full red cloth and screen-printed bird motif on front cover, 310 x 250 mm, 168 pp, 73 col photos. Text by Gerry Badger, Wojciech Nowicki, Marek Bieńczyk and Power.

6 *Mass*. GOST Books, London, 2013 (edn of 750 signed and numbered copies). HB, 250 x 202 mm, 118 pp, with 18 fold-out pages, 36 col photos.

7 *Die Mauer ist Weg!* Self-published, Globtik Books, Brighton, 2014 (edn of 1,000 copies). HB, 380 x 282 mm, 96 pp, 44 b&w photos. Text by Power.

8 *Destroying the Laboratory for the Sake of the Experiment*. Self-published, Globtik Books, Brighton, 2016 (edn of 1,500 copies). HB w/ jkt, 245 x 155 mm, 228 pp, 59 col photos, 17 illus. Poems by Daniel Cockrill.

Raghu Rai

Raghu Rai (b.1942; joined Magnum in 1977) took up photography in 1965 and a year later he joined *The Statesman* newspaper as chief photographer. In 1971 he was awarded the 'Padmashree', one of the highest civilian awards ever given to a photographer. From 1976 to 1991 he worked for news magazines *Sunday* and *India Today*, and he also contributed ground-breaking photo essays on social, political and cultural themes to *Time*, *LIFE*, *GEO*, *The New York Times*, *The Sunday Times*, *Newsweek* and the *New Yorker*. Based in Delhi, Rai has covered India extensively and he continues to be an associate of Magnum Photos.

1

2

3

4

1 *The Face of Despair*. The Statesman, New Delhi, 1971. PB, 268 x 210 mm, 46 pp, 54 b&w photos. Intro by Kuldip Nayar.

2 *A Life in the Day of Indira Gandhi*. Nachiketa Publications and Macmillan, New Delhi, 1974. HB, 205 x 275 mm, 116 pp, 116 b&w photos. Text by Raghu Rai.

3 *Delhi: A Portrait*. Oxford University Press, Oxford, 1983. HB 295 x 220 mm, 160pp, 98 b&w and col photos. Text by Khushwant Singh

4 *Taj Mahal*. Time Books International, New Delhi, 1984 . HB, 324 x 377 mm, 156 pp, 99 b&w and col photos.

5 *India*. Times Book International, New Delhi, 1988 (also published as *Dreams of India*, Time Books, International, New Delhi, 1988). HB w/ jkt, 254 x 356 mm, 190 pp, 117 b&w photos. Intro by John Kenneth Galbraith.

6 *Calcutta*. Time Books International, New Delhi, 1989. HB w/ jkt, 280 x 337 mm, 130 pp, 91 b&w photos. Intro by Dominique Lapierre.

7 *Tibet in Exile*. Time Books International, New Delhi, 1990 (English and French edns; second edn: Edition Didier Millet and Penguin Books India, New Delhi, 2009). HB w/ jkt, 376 x 264 mm, 144 pp, 187 col photos. Intro by the Dalaï Lama; text by Jane Perkins.

8 *Khajuraho: Sanctuaire de l'Amour en Inde*. Time Books International, New Delhi, 1991 (bilingual edn: French and English; revised English edn: Niyogi Books, New Delhi, 2016). HB, 358 x 252 mm, 160 pp, 97 col photos. Text by Louis Frederic.

9 *Forever In Bloom: The Lotus of Bahapur*. Time Books International, New Delhi 1992. HB, 250 x 345 mm, HB w/ jkt, 126pp, 92 col photos. Text by Roger White.

10 *Raghu Rai's Delhi*. Indus, New Delhi, 1993. HB w/ jkt, 315 x 410 mm, 128 pp, 118 b&w and col photos. Text by Pavan K. Varma.

11 *Mother Teresa Faith and Compassion: The Life and Work of Mother Theresa*. Element Books, London, 1996. HB, 320 x 259 mm, 190 pp, 89 b&w photos. Intro by Navin Chawla.

12 *My Land & Its People*. Vadehra Art Gallery, New Delhi, 1997. HB w/ jkt, 246 x 350 mm, 112 pp, 104 b&w photos. Intro by Linda Joffee and Arun Vadehra.

13 *Man, Mettle & Steel*. Steel Authority of India Limited, New Delhi, 1998. HB w/ jkt, 290 x 340 mm, 128 pp, 113 b&w photos. Text by Usha Rai.

14 *Maghya Pradesh: Images Beyond Surface*. Madhya Pradesh Govt, Bhopal, 2000. HB w/ jkt, 250 x 335 mm, pp, 96 col photos. Text by Ashok Vajpeyi, Anil Sharma.

15 *Lakshadweep*. Lakshwadeep Administration, 2000. HB, 285 x 350 mm, pp, 97 col photos. Intro by Rajiv Talwar.

16 *Raghu Rai's India: A Retrospective*. Asahi Shimbun, Tokyo, 2001 (Japanese edn). PB, 298 x 225 mm, 224 pp, 202 b&w photos. Texts by Raghu Rai, Tomio Tada and Michael E. Hoffman.

17 *The Sikhs*. Roli Books, New Delhi, 2001 (second edn: 2005). HB w/ jkt, 305 x 305 mm, 144 pp, 96 col photos and 38 illus. Text by Khushwant Singh.

18 *Éxposure: Portrait of a Corporate Crime* (also published in French by La Martinière and in English by Abrams). Greenpeace International, Amsterdam, 2002. PB w/ jkt, 294 x 294 mm, 84 pp, 57 b&w photos. Intro by Anil Sharma.

19 *Saint Mother: A Life Dedicated*. Timeless Books, New Delhi, 2004 (revised edn). HB, 311 x 309 mm, 128 pp, 95 b&w photos.

20 *Indira Gandhi: A Living Legacy*. Timeless Books, New Delhi, 2004. HB w/ jkt, 305 x 305 mm, 144 pp, 121 b&w photos.

21 *Earthscapes*. Bodhi Art, New Delhi, 2006. PB, 300 x 235 mm, 56 pp, 55 col photos.

22 *Just By the Way: Rocks, Clouds and Nudes*. Tasveer, New Delhi, 2006. PB, 305 x 300 mm, 74 pp, 50 b&w photos. Interview by Anita Kaul Basu.

23 *Raghu Rai's India: Reflections in Black & White*. Penguin Books, Haryana, 2007. HB, 294 x 403 mm, 168 pp, 106 col photos. Intro by Rai.

24 *India Notes.* Editions Intervalles, Paris, 2007. HB, 230 x 250 mm, 142 pp, 21 col photos. Texts by Tiziano Terzani.

25 *Delhi: Contrasts & Confluences.* OM Books International, New Delhi, 2007 (also published as *Raghu Rai's Delhi* by Thames & Hudson, London, 2009). HB, 305 x 405 mm, 160 pp, 70 b&w photos, 84 col photos. Intro by William Dalrymple.

26 *Raghu Rai's India: Reflections in Colour.* Penguin Books India, Haryana, 2008 (also published by Haus). HB, 294 x 403 mm, 168 pp, 140 col photos. Text by Raghu Rai and Tiziano Terzani.

27 *Calcutta/Kolkata.* Timeless Books, New Delhi, 2008. HB, 298 x 428 mm, 150 pp, 113 b&w photos. Intro by Dominique Lapierre.

28 *Varanasi: Portrait of a Civilization.* Harper Collins, New Delhi, 2010. HB, 300 x 330 mm, 162 pp, 48 b&w and 82 col photos.

29 *The Indians: Portraits from My Album.* Penguin Books, Haryana, 2010. HB w/ jkt, 304 x 287 mm, 160 pp, 140 b&w and col photos. Preface by Raghu Rai; intro by John Falconer.

30 *Bombay, Mumbai: Where Dreams Don't Die.* OM Books International, London, 2010. HB, 305 x 330 mm, 192 pp, 77 b&w and 81 col photos. Intro by Vir Sanghvi.

31 *India's Great Masters: A Photographic Journey into the Heart of Classical Music.* Harper Collins, New Delhi, 2010. HB w/ jkt, 340 x 310 mm, 168 pp, 154 b&w photos. Text by Ashok Vajpeyi.

32 *The Journey of a Moment in Time.* Chandigarh Lalit Kala Akademi, Chandigargh, 2011. PB, 240 x 232 mm, 70 pp, 22 col photos, 28 b&w photos.

33 *Outside the Margins.* Save the Children, Haryana, 2012. PB, 250 x 321 mm, 72 pp, 61 col photos. Intro by Raghu Rai & Aruna Roy.

34 *Pushkar Ji.* Timeless Books, New Delhi, 2012. PB, 241 x 226 mm, 96 pp, 77 col photos. Text by Raghu Rai.

35 *Taj Mahal.* Timeless Books, New Delhi, 2012 (published in two collectors edns). HB, 330 x 400 mm, 156 pp, 101 photos. Intro by Usha Rai.

36 *Raghu Rai: Divine Moments.* Tasveer, Bangalore, 2012. PB, 223 x 292 mm, 52 pp, 26 b&w photos. Text by Raghu Rai and Saleem Arif Quadri.

37 *Taj Mahal.* Timeless Books, New Delhi, 2012. HB, 228 x 228 mm, 112 pp, 67 photos.

38 *Trees.* Photoink, New Delhi, 2013. HB, 340 x 240 mm, 108 pp, 77 b&w photos. Intro by Rai.

39 *Mahakumbh: A Spectacle of Divine Design.* Raghu Rai Center For Photography, Gurgaon, 2013. HB w/ jkt, 292 x 292 mm, 110 pp, 92 col photos. Intro by Celia Mercier.

40 *Bangladesh: The Price of Freedom.* Niyogi Books, New Delhi, 2013. HB, 240 x 295 mm, 116 pp, 93 b&w Photos. Intro by Shahidul Alam.

41 *Raghu Rai's Kolkata.* Team Future Impressions, Calcutta, 2014. HB, 295 x 300 mm, 124 pp, 5 b&w and 77 col photos. Foreword by Aparna Sen.

42 *Acharya Tulsi: The Aura.* Dharam Sajjan Trust, Jaipur, 2014. HB, 345 x 320 mm, 128 pp, 97 b&w photos. Foreword by the Dalai Lama.

43 *Vijayanagara Empire: Ruins To Resurrection.* Niyogi Books, New Delhi, 2014. HB, 295 x 295 mm, 140 pp, 58 b&w and 42 col photos. Text by Usha Rai.

44 *The Tale of Two: An Outgoing and an Incoming Prime Minister.* Raghu Rai Center For Photography, Gurgaon, 2014. HB w/ jkt, 279 x 211 mm, 80 pp, 54 b&w photos. Intro by Rai.

45 *Husain Doshi Gufa.* Vadehra Art Gallery, Delhi, 2014. HB w/ jkt, 287 x 287 mm, 106 pp, 43 b&w and 37 col photos. Intro by Balkrishna Doshi.

46 *India through the Eyes of Raghu Rai.* Gionee, New Delhi, 2015. PB, 305 x 280 mm, 92 pp, 31 b&w and 57 color photos.

47 *The Album: Family & Friends.* Raghu Rai Foundation for Art and Photography and Delhi Photo Festival, New Delhi, 2015. PB, 225 x 240 mm, 168 pp, 170 b&w photos. Intro by Raghu Rai.

48 *Picturing Time: the Greatest Photos of Raghu Rai.* Aleph Book Company, New Delhi, 2015. HB, 240 x 170 mm, 192 pp, 121 b&w photos. Text by Raghu Rai.

49 *Refugees in India.* UNHCR India, New Delhi, 2015. HB, 253 x 305 mm, pp, 72 b&w and 8 col photos. Intro by Dominik Bartsch.

50 *Gujarat.* Navjeevan Trust, Ahmedabad, 2015. HB, 292 x 292 mm, 144 pp, 117 col photos. Foreword by Esther David.

51 *Raghu Rai: Trees (Whispers).* Art Alive Gallery, 2015. HB, 245 x 300 mm, 108 pp, 62 col photos. Intro by Raghu Rai.

Eli Reed

Eli Reed (b. 1946; joined Magnum in 1983) began work as a freelance photographer in 1970, following completion of studies and graduation in 1969 from the Newark School of Fine and Industrial Arts. He was a Harvard Nieman Fellow from 1982–3 and took a number of classes at Harvard's Kennedy School of Government. His work from El Salvador, Guatemala and other Central American countries attracted the attention of Magnum in 1982 and he joined the agency a year later, becoming a full member in 1988. His long-form work has covered child poverty in America, a study of Beirut and, most notably, the African-American experience along with many other social issues. He has lectured and taught on photography, and currently works as Clinical Professor of Photojournalism at the University of Texas in Austin while continuing to work on various projects, including filmmaking, that interest him.

1

2

3

1 *Beirut: City of Regrets.* W.W. Norton & Company, New York, 1988. HB w/ jkt, 215 x 251 mm, 110 pp, 128 col photos. Text by Fouad Ajami; poetry by Reed.

2 *Black in America.* W.W. Norton & Company, New York, 1997. HB w/ jkt, 278 x 248 mm, 174 pp. 162

b&w photos. Foreword by Gordon Parks and poetry by Reed.

3 *Eli Reed: A Long Walk Home.* University of Texas Press, Austin, 2015. HB, 267 x 330 mm, 352 pp, 261 b&w photos. Intro by Paul Theroux and text by Reed.

Marc Riboud

Marc Riboud (b.1923; joined Magnum in 1953) took his first pictures with a Kodak Vest-Pocket camera given to him by his father for his 14th birthday. After studying engineering in Lyon, he decides to become a photographer in 1951, joining Magnum when, in 1953, his photo-story 'Eiffel Tower's Painter' was published in *LIFE* magazine. In 1955 he travelled to India via the Middle East, then on to China in 1957. Riboud was one of the few photographers allowed to travel in South and North Vietnam between 1968 and 1969. He became renowned for his images of Asia, where he continued to work into the 1990s. His work has been exhibited in numerous museums and galleries in Paris, New York, Shanghai and Tokyo, and he has received numerous awards, including two prizes from the Overseas Press Club, the ICP Infinity Award and the Nadar prize for his book *Into the Orient*.

1 2 3 4

5 6 7 8

9 10 11 12

13 14 15 16

 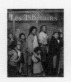

17 18 19 20

21 22 23 24

25

1 *Vrouwen van Japan.* Bruna & Zoon, Utrecht, 1959 (Dutch edn; also published as *Women of Japan*, André Deutsch, London, 1959). PB, 175 x 114 mm, 160 pp, 96 b&w photos. Text by Christine Arnothy.

2 *The Three Banners of China.* Macmillan, New York, 1966 (French edn: Robert Laffont, Paris, 1966; German edn: Helmut Kossodo, Genève, 1966). HB w/ jkt, 260 x 211 mm, 216 pp, 109 b&w and 39 col photos. Intro by Han Suyin and text by Riboud.

3 *Face of North Vietnam.* Holt, Rinehart & Winston, New York, 1970. HB and PB, 282 x 221 mm, 140 pp, 122 b&w photos. Text by Philippe Devillers.

4 *Bangkok.* WeatherHill/Serasia, New York, 1972 (second edn: 1976). HB, 222 x 305 mm, 174 pp, 110 b&w and col photos. Text by William Warren.

5 *Chine: Instantanés de Voyage.* Editions Arthaud, Paris, 1980 (English edn: Pantheon Books, New York, 1981; second edn by Editions Arthaud, Paris, 1986). HB, 290 x 260 mm, 118 pp, 102 b&w photos. Text by Riboud.

6 *Gares et Trains.* Editions Ace, Paris, 1983. PB, 283 x 195 mm, 128 pp, 80 b&w and col photos. Text by Jacques Réda.

7 *Images de Villeurbanne: Images des Gratte-Ciel.* Fondation Nationale de la Photographie, Lyon, 1985. PB, 221 x 212 mm, 44 pp, 32 b&w photos. Intro by Christian Caujolle.

8 *Marc Riboud. Journal.* Editions Denoël, Paris, 1986 (English edn: Harry N. Abrams, New York, 1988; second edn: La Martinière, Paris, 2000 and Knesebeck,

Munich, 2001). HB w/ jkt, 280 x 290 mm, 120 pp, 93 b&w photos. Text by Claude Roy and Riboud.

9 *L'Embarras du Choix.* Centre National de la Photographie, Paris, 1988 (English edn: International Center of Photography, New York and Thames & Hudson, London, 1988). PB, 302 x 270 mm, 24 pp, 19 b&w photos. Text by Riboud.

10 *Capital of Heaven.* Doubleday, New York, 1989 (French edn: Editions Arthaud, Paris, 1989; German edn: Hoffmann und Campe, Hamburg, 1989; second French edn: Flammarion, Paris, 2004.). HB w/ jkt, 350 x 250 mm, 142 pp, 95 col photos. Intro by François Cheng.

11 *Angkor: Sérénité Boudique.* Imprimerie Nationale, Paris, 1992 (English edn: Thames & Hudson, London, 1992). HB, 333 x 242 mm, 152 pp, 75 b&w photos. Text by Jean Lacouture, Jean Boisselier, Madeleine Giteau and Riboud.

12 *Daya Bay: Une Centrale Nucléaire en Chine* (Daya Bay: A Nuclear Power Plant in China). Editions EDF, Paris, 1994. HB w/ jkt, 350 x 255 mm, 94 pp, 59 col photos. Text by Jean Lacouture.

13 *Quarante Ans de Photographie en Chine.* Editions Nathan, Paris, 1996 (English edn: Thames & Hudson, London and Harry N. Abrams, New York, 1996). HB, 300 x 236 mm, 176 pp, 133 b&w photos. Intro by Jean Daniel; text by Riboud.

14 *Istanbul.* Imprimerie Nationale, Paris, 2003. HB, 312 x 253 mm, 151 pp, 73 b&w photos. Text by Jean-Claude Guillebaud.

15 *Demain Shanghai.* Editions Delpire, Paris, 2003. HB w/ jkt, 300 x 240 mm, 160 pp, 104 b&w photos. Preface by Caroline Puel; calligraphy by Feng Xiao-Min.

16 *Marc Riboud: 50 Ans de Photographie.* Flammarion, Paris, 2004 (French and English edns).

HB, 308 x 247 mm, 174 pp, 138 b&w photos. Preface by Robert Delpire; text by Annick Cojean, Riboud and Catherine Chaine.

17 *Sous les Pavés.* Editions La Dispute, Paris, 2008. PB, 300 x 210 mm, 126 pp, 67 b&w photos. Intro by Seloua Luste Boulbina.

18 *Les Tibétains.* Imprimerie Nationale, Paris, 2009. HB, 325 x 240 mm, 166 pp, 100 b&w and col photos. Text by André Velter.

19 *Algérie Indépendance.* Le Bec en l'Air Editions, Marseille, 2009. HB, 290 x 215 mm, 192 pp, 96 b&w photos. Preface by Jean Daniel; text by Seloua Luste Boulbina and Malek Alloula.

20 *I comme Image.* Editions Gallimard Jeunesse and Les Trois Ourses, Paris, 2010 (French edn; also published in English as *I for Imagine*, Tara Books, Chennai, 2011). PB, 185 x 136 mm, 104 b&w photos. Intro by Catherine Chaine.

21 *1. 2.. 3... Image.* Editions Gallimard Jeunesse and Les Trois Ourses, Paris, 2011. PB, 185 x 136 mm, 83 pp, 57 b&w photos. Intro by Catherine Chaine.

22 *Choses Vues.* Imprimerie Nationale, Paris, 2012 (Chinese edn: Post Wave Publishing Consulting, Beijing, 2014). HB, 240 x 180 mm, 288 pp, 165 b&w photos. Intro by André Velter.

23 *Paroles d'un Taciturne: Entretiens avec Bertrand Eveno.* Editions Delpire, Paris, 2012. PB, 200 x 165 mm, 168 pp, 164 photos. Interviews with Bertrand Eveno.

24 *Vers l'Orient.* Editions Xavier Barral, Paris, 2012 (bilingual edn: French and English; also published by BPG Art Media, Beijing, 2012). 5 HB volumes w/ slipcase, 200 x 187 mm, each 64pp, 220 b&w photos. Text by Riboud and Catherine Chaine.

25 *Marc Riboud: 60 Ans de Photographie* (Marc Riboud: 60 Years of Photography). Flammarion, Paris, 2014. HB, 320 x 250 mm, 200 pp, 142 b&w photos. Intro by Robert Delpire; text by Annick Cojean, Catherine Chaine and Riboud.

Eugene Richards

Eugene Richards (b.1944; Magnum member 1978-1995 and 2002-2005) is a filmmaker, writer, and author of seventeen books, several under his own imprint, Many Voices Press. After joining Magnum, he worked increasingly as a freelance magazine photographer, undertaking assignments on such diverse topics as the American family, drug addiction, emergency medicine, breast cancer and poverty in America. In 1992, he directed and shot 'Cocaine True, Cocaine Blue', the first of eleven films he has made. He is the recipient of a Guggenheim Fellowship, the W. Eugene Smith Memorial Award and the Kraszna-Krausz Book Award for Photographic Innovation. Richards's photographs are held in the collections of the Metropolitan Museum of Art, MoMA and Centre Pompidou, among others.

1 *Few Comforts or Surprises: The Arkansas Delta*. MIT Press, Cambridge, Massachusetts and London, UK 1973. HB w/ jkt, 228 x 280 mm, 124 pp, 108 b&w photos. Text by Richards.

2 *Dorchester Days*. Many Voices Press, Wollaston, Massachusetts, 1978 (edn of 1000 copies). PB, 305 x 227 mm, 64 pp, 76 b&w photos. Text by Richards; postscript by Dorothea Lynch.

3 *50 Hours*. Many Voices Press, Wollaston, Massachusetts, 1983. PB w/ jkt, 275 x 210 mm, 48 pp, 27 b&w photos. Design by Richards; text by Dorothea Lynch.

4 *Exploding Into Life*. Aperture, New York, 1986. HB w/ jkt, 266 x 196 mm, 168 pp, 49 b&w photos. Design by Richards; Text by Dorothea Lynch.

5 *Below the Line: Living Poor in America*. Consumer Reports Books, New York, 1987. HB w/ jkt, 280 x 236 mm, 218 pp, 143 b&w photos. Design and interviews by Richards.

6 *The Knife and Gun Club: Scenes from an Emergency Room*. Atlantic Monthly Press, New York, 1989. HB w/ jkt, 267 x 203 mm, 240 pp, 105 b&w photos. Design and text by Richards.

7 *Cocaine True, Cocaine Blue*. Aperture, New York, 1994. HB w/ jkt, 305 x 229 mm, 160 pp, 93 b&w photos. Design and text by Richards; afterword by Dr. Stephen W. Nicholas.

8 *Americans We*. Aperture, New York, 1994. HB w/ jkt, 280 x 264 mm, 132 pp, 94 b&w photos. Text by Richards.

9 *Dorchester Days*. Phaidon Press, London, 2000 (revised and expanded edn; also published in French). HB w/ jkt, 305 x 216 mm, 110 pp, 100 b&w photos. Text by Richards.

10 *Stepping Through the Ashes*. Aperture, New York, 2002. HB w/ jkt, 292 x 210 mm, 192 pp, 99 b&w photos. Design and postscript by Richards; interviews by Janine Altongy.

11 *The Fat Baby: Stories by Eugene Richards*. Phaidon Press, London, 2004 (also published in French). HB w/ jkt, 290 x 214 mm, 432 pp, 279 b&w photos. Text and design by Richards.

12 *A Procession of Them*. University of Texas Press, Austin, Texas, 2008. HB w/ jkt, 216 x 165 mm, 152 pp, 71 b&w photos. Design and photographer's notes by Richards.

13 *The Blue Room*. Phaidon Press, London, 2008. HB w/ jkt, 280 x 400 mm, 168 pp, 78 col photos. Working notes and design by Richards.

14 *War is Personal*. Many Voices Press, Brooklyn, New York, 2010. HB w/ jkt, 280 x 210 mm, 240 pp, 101 b&w photos. Text and design by Richards; afterword by Dr. Andrew J. Bacevich.

15 *Red Ball of a Sun Slipping Down*. Many Voices Press, Brooklyn, New York, 2014. HB w/ jkt, 242 x 298 mm, 112 pp, 52 col and b&w photos. Design and text by Richards.

Miguel Rio Branco

The son of diplomats, Miguel Rio Branco (b.1946; joined Magnum in 1980) had a peripatetic childhood growing up in Portugal, Switzerland, Brazil and the United States. He has variously been a painter, a photographer, a filmmaker and an installation maker. His first painting exhibition was in Bern in 1974. Two years later, he moved to New York for his studies, returning to Rio de Janeiro in 1967, where he had a solo exhibition of his drawings before launching a career in photography and film. He is best known for the dramatic quality of his colour work as well as his photo collages, artworks and books.

1 *Dulce Sudor Amargo*. Fondo de Cultura Económica, Mexico City, 1985 (Portuguese edn). PB, 210 x 270 mm, 104 pp, 79 col photos. Text by Jean-Pierre Nouhaud.

2 *Nakta*. Fundacao Cultural de Curitiba, Curitiba, 1996 (Portuguese edn). HB, 280 x 280 mm, 120 pp, 45 col photos. Poem 'Nuit Close' by Louis Calaferte.

3 *Silent Book*. Cosac & Naify Editions, São Paulo, 1997. HB, 190 x 190 mm, 92 pp, 75 col photos. Design by Jean Yves Cousseau.

4 *Miguel Rio Branco*. Aperture, New York, 1998. HB, 293 x 242 mm, 144 pp, 145 col and b&w photos. Text by David Levi Strauss, Léila Warnick Salgado and Sebastião Salgado.

5 *Entre Els Ulls*. Fundacio La Caixa, Barcelona, 1999 (Catalan edn; also published in Spanish as *Entre los Ojos*, Phillip Galgiani, New York, 2000). PB, 265 x 240 mm, 110 pp, 95 col photos. Text by Adriano Pedrosa and interview with Marta Gili.

6 *Broyer du Noir*. Galerie 1900-2000, Paris, 2000 (French edn). PB, 140 x 100 mm, 34 pp, 17 col photos.

7 *Pele do Tempo*. Centro de Arte Hélio Oiticica, Rio de Janeiro, 2000 (Portuguese and English edn). HB w/ CD-Rom, 150 x 150 mm, 52 pp, 34 col photos and illus. Text by Paulo Sergio Duarte.

8 *Entre os Olhos: O Deserto*. Cosac & Naify, São Paulo, 2001 (Portuguese edn). HB and DVD, 135 x 140 mm, 240 pp, 216 col photos. Text by David Levi Strauss.

9 *Gritos Surdos*. Centro Português de Fotografia, Porto, 2002. HB w/ DVD, 215 x 165 mm, 144 pages, 68 photo collages. Text by Maria do Carmo Serén.

10 *Gran Canaria*. Gobierno de Canarias, Santa Cruz de Tenerife, 2003 (Spanish edn).

HB, 267 x 215 mm, 96 pp, 96 col photos.

11 *Plaisir La Douleur*. Editions Textuel, Paris, 2005 (French edn). HB, 270 x 270 mm, 144 pp, 116 b&w and col photos. Text by Paulo Herkenhoff.

12 *Notes on the Tides*. Groninger Museum, Groningen, 2006. HB, 150 x 110 mm, 184 pp, 108 col photos, 62 illus. Poem by Paulo Herkenhoff.

13 *Tokyo*. Taka Ishii Gallery and Getsuyosha, Tokyo 2008 (Japanese, English and Spanish edn). Two PB in slipcase, 250 x 177 mm, 82 pp, 46 col photos. From a collaborative exhibition with Daido Moriyama.

14 *Miguel Rio Branco*. Lazuli Editora, São Paolo, 2008 (Portuguese edn). PB, 175 x 125 mm, 120 pp, 65 photos. Text by Simonetta Persichetti.

15 *Ponto Cego*. Santander Cultural, Porto Alegre, 2012. HB, 270 x 270 mm, 120 pp, 88 photos. Text by Paulo Herkenhoff.

16 *Você está Feliz?*. Cosac Naify, São Paulo, 2012. HB, 195 x 145 mm, 384 pp, 190 b&w and col photos.

17 *Out of Nowhere*. Luste Editores, São Paulo, 2013. HB, 240 x 240 mm, 160 pp, 237 photos. Text by Ligia Canongia and Miguel Rio Branco.

18 *Miguel Rio Branco: Gritos Surdos*. Casa França Brasil Secretaria de Cultura Estado, Rio de Janeiro, 2014. PB, 255 x 200 mm, 144 pp, 58 photos by Antonio Garcia Couto. Text by Luisa Duarte.

19 *Teoria da Cor*. Pinacoteca do Estado, São Paulo, 2014. HB and PB w/ slipcase, 210 x 170 mm, 134 pp (HB) and 32 pp (PB), 110 illus and one photo by Isidora Gajic.

20 *Maldicidade*. Cosac Naify, São Paulo, 2014. HB, 215 x 155 mm, 400 pp, 277 photos.

George Rodger

George Rodger (1908–1995; Magnum member 1947–1995) began working as a photographer in the 1930s. His photographs of London during the Blitz persuaded *LIFE* magazine to hire him as a war correspondent, for whom he travelled widely during World War II. In April 1945, he became the first photographer to enter the Bergen-Belsen concentration camp. As a reaction to the trauma of wartime, Rodger embarked on a 45,000-kilometre journey through Africa and the Middle East, exploring ways of life that brought people close to nature. After becoming a founder member of Magnum in 1947, Rodger concentrated on Africa for over thirty years. Among his most celebrated images were those he took in 1951 of the Kordofan Nuba tribe.

1

2

3

4

5

6

7

8

1 *Red Moon Rising*. Cresset Press, London, 1943. HB, 246 x 163 mm, 126 pp, 82 b&w photos. Text by Rodger.

2 *Desert Journey*. Cresset Press, London, 1944. HB w/ jkt, 240 x 155 mm, 150 pp, 76 b&w photos. Text by Rodger.

3 *Le Village des Noubas*. Delpire, Paris, 1955 (second edns published in French and English by Phaidon Press, London, 1999). HB w/ jkt, 178 x 128 mm, 124 pp, 38 b&w photos. Text by Rodger.

4 *George Rodger*. Gordon Fraser, Arts Council of Great Britain, London, 1975. PB, 289 x 225 mm, 70 pp, 68 b&w photos. Intro by Inge Bondi.

5 *George Rodger en Afrique*. Editions Herscher, Paris, 1984. HB w/ jkt, 311 x 242 mm, 190 pp, 131 b&w photos.

6 *George Rodger Magnum Opus: Fifty Years in Photojournalism*. Dirk Nishen Publishing, London, 1987. HB w/ jkt, 274 x 220 mm, 110 pp, 105 b&w photos. Text by Martin Caiger-Smith.

7 *The Blitz: The Photography of George Rodger*. Penguin Books, London and New York, 1990 (HB edn w/ jkt also published by Bloomsbury Books, London, 1994). PB, 240 x 255 mm, 176 pp, 156 b&w photos. Intro by Tom Hopkinson.

8 *Humanity and Inhumanity: The Photographic Journey of George Rodger*. Phaidon Press, London, 1994 (PB edn: 1995). HB, 290 x 250 mm, 320 pp, 230 b&w photos. Foreword by Henri Cartier-Bresson; text by Bruce Bernard.

Sebastião Salgado

The Brazilian documentary photographer Sebastião Salgado (b. 1944; Magnum member 1979–94) worked as an economist before becoming a photographer in 1973. Initially he worked on news stories before undertaking self-assigned long-term projects. Working with Sygma and Gamma photo agencies, before joining Magnum, he later founded Amazonas Images in 1994, with his wife Lélia Wanick Salgado. His best-known work focuses on overlooked sections of society, including industrial workers and displaced peoples; his Genesis project documented parts of the planet and its inhabitants still living in a pristine state largely unaffected by modern civilization. Salgado, who became a UNICEF Goodwill Ambassador in 2001, also founded with his wife Lélia, The Instituto Terra, an organization devoted to rainforest conservation.

1

2

3

4

5

6

7

8

9

10

11

12

13

14

15

16

17

18

1 *Autres Amériques*. Editions Contrejour, Paris, 1986 (also published as *Other Americas*, Pantheon Books, New York; as *Otras Americas*, Ediciones ELR Madrid, 1986; and as *Outras Américas*, Companhia das Letras, São Paulo, 1999; revised HB edn, Aperture, New York, 2015). PB, 300 x 240 mm, 112pp, 48 b&w photos. Intro by Alan Riding.

2 *Sahel: L'Homme en Détresse*. Prisma Presse, Lyon and Centre National de la Photographie for Médicins sans Frontière, 1986 (also published as *Sahel: El Fin del Camino*, Comunidad de Madrid, for Medicos Sin Fronteras, Madrid, 1988; and as *Sahel: The End of the Road*, Berkeley, 2004). PB, 360 x 270 mm, 106 pp, 94 b&w photos. Intro by Jean Lacouture; text by Xavier Emmanuelli.

3 *Les Cheminots*. Comite. Central D'Entreprise de la SNCF, Paris, 1989. PB, 304 x 225 mm, 104 pp, 82 b&w photos.

4 *An Uncertain Grace*. Aperture, New York, 1990 (also published by Thames & Hudson, London and Sygma Union, Japan, 1990; as *Une Certaine Grâce*, Nathan, France, 1990; as *Um Incerto Estado de Graça*, Editorial Caminho, Alfragide, 1995; and as *Un Incerto Stato di Grazia*, Contrasto, Rome, 2002). PB, 327 x 279 mm, 154 pp, 108 b&w photos. Text by Eduardo Galeano and Fred Ritchin.

5 *Workers: An Archaeology of the Industrial Age*. Aperture, New York, 1993 (also published by Phaidon Press, London, 1993; as *La Main de l'Homme*, Éditions de La Martinière, Paris, 1993; as *Trabalho*, Editorial Caminho, Alfragide, 1993; as *Trabajadores*, Lunwerg Editores, Barcelona, 1993; *Arbeiter*, Zweitausendeins, Leipzig, 1993; as *Workers*, Iwanami Shoten, Japan, 1993; as *La Mano dell'Uomo*, Contrasto, Rome, 1994; and as *Trabalhadores*, Companhia das Letras, São Paulo, 1996). HB w/ jkt, 329 x 245 mm, 400 pp, 350 b&w photos.

6 *Terra*. Éditions de La Martinière, Paris, 1997 (also published by Editorial Caminho, Alfragide; Zweitausendeins, Leipzig; Contrasto, Rome; Phaidon Press, London; Companhia das Letras, São Paulo; and Alfaguara, Madrid). HB, 30 x 245 mm, 144 pp, 99 b&w photos. Preface by José Saramago; poetry by Chico Buarque.

7 *Um Fotografo em Abril*. Editorial Caminho, Alfragide, 1999. HB, 209 x 136 mm, 47pp, numerous photos.

8 *Exodes*. Éditions de La Martinière, Paris (also published as *Éxodos*, Editorial Caminho, Alfragide; as *Migranten*, Zweitausendeins, Leipzig; as *In Cammino*, Contrasto / Leonardo Arte, Rome; as *Migrations*, Aperture, New York; as *Êxodos*, Companhia das Letras, São Paulo; and as *Éxodos*, Fundacion Retevision, Madrid), 2000. HB w/ jkt, 335 x 253 mm, 432 pp, numerous photos.

9 *Les Enfants de l'Exode*, Éditions de La Martinière, Paris (also published as *Retratos de Crianças do êxodo*, Editorial Caminho, Alfragide; as *Kinder*, Zweitausendeins, Leipzig; as *Ritratti*, Contrasto / Leonardo Arte, Rome; The Children, Aperture, New York; *Retratos de Crianças do êxodo*, Companhia das Letras, São Paulo; and as *Retratos*, Fundacion Retevision, Madrid), 2000. HB, 333 x 248 mm, 112 pp, numerous photos.

10 *Malpensa: La Città del Volo*, SEA Aeroporti di Milano, 2000. HB, 320 x 240 mm, 140 pp, 90 b&w photos. Text by Allesandro Mauro.

11 *Salgado, Parma*. Contrasto, Rome, 2002. PB, 315 x 231 mm, 96 pp, numerous photos. Edited by Alessandra Mauro; preface by Bernardo Bertolucci; intro by Pino Cacucci and Jose Saramago.

12 *The End of Polio: A Global Effort to End a Disease.* Bulfinch Press, New York, 2003 (also published as *La Fine della Polio*, Contrasto, Rome; as *O Fim da Pólio*, Companhia das Letras, São Paulo; as *O Fim da Pólio*, Editorial Caminho, Alfragide; & as *L'Eradication de la Polio*, Éditions du Seuil / Turner & Turner, Paris). HB, 264 x 212 mm, 160 pp, numerous photos. Text by Kofi Annan, Siddharth Dube, Mark Dennis and Christine McNab.

13 *L'Homme et l'Eau.* Editions Terre Bleue, Paris, 2005. HB, 305 x 240 mm, 157 pp, numerous photos. Text by Salgado and Cristovam Buarque.

14 *O berço da desigualdade/The cradle of inequality/La cuna de la desigualdad/Le berceau de l'inégalité.* UNESCO, São Paulo, 2006. (multilingual edn: Portuguese, English, Spanish and French). HB w/ jkt, 290 x 250 mm, 192 pp, numerous photos. Text by Cristovam Buarque.

15 *Africa.* Taschen, Cologne, 2007. HB, 367 x 258 mm, 336 pp, numerous photos. Text by Mia Couto; edited by Lélia Wanick Salgado.

16 *Les Voies du Bonheur.* Éditions de La Martinière, Paris, 2010. HB, 316 x 259 mm, 180 pp, numerous photos. Text by Jean-Marie Pelt.

17 *Genesis.* Taschen, Cologne, 2013 (also published as a limited edn of 2,500 copies in two volumes w/ cloth case, book stand and box). HB 355 x 245 mm, 520 pp, Numerous photos. Text by Lélia Wanick Salgado.

18 *The Scent Of A Dream: Travels In The World Of Coffee.* Harry N. Abrams, New York, 2015. HB, 355 x 240 mm, 320 pp, 150 b&w photos.

Moises Saman

Moises Saman (b.1974: joined Magnum in 2010) spent his youth in Barcelona and studied Communications and Sociology at California State University. In 2000 Moises joined *Newsday* as a staff photographer until 2007, during which time he focused on the fallout of 9/11, travelling across the Middle East. In 2007 he became freelance and a contributor to *The New York Times, Newsweek* and *Time magazine*, among others. His work has received awards from the World Press Photo and the Overseas Press Club. In 2015 he received a Guggenheim Fellowship for his work on the Arab Spring.

1

2

3

1 *This is War: Witness of Man's Destruction.* Charta, Milan, 2004. PB, 165 x 241 mm, 100 pp, 75 photos.

2 *Afghanistan: Broken Promise.* Charta, Milan, 2007. PB, 211 x 272 mm, 112 pp. 78 b&w photos. Preface by Rory Stewart.

3 *Discordia.* Self-published, 2016. HB, 320 x 240 mm, 214 pp, 127 col and b&w photos, 4 collages and 1 composite image. Text by Moises Saman.

Alessandra Sanguinetti

Alessandra Sanguinetti (b.1968; joined Magnum in 2007) grew up in Argentina from 1970 until 2003. Her first major book, *On the Sixth Day* (2005), was a fable-like story of the world of farm animals. Since 1999, she has documented the lives of two young cousins on a farm outside Buenos Aires, exploring their emotions and dreams through their childhood into young adulthood and family life. The resulting book, *The Adventures of Guille and Belinda and the Enigmatic Meaning of their Dreams*, was published in 2010 and she is currently working on a sequel. Sanguinetti has received numerous awards for her work, including a Guggenheim Foundation fellowship, a Hasselblad Foundation grant, a MacDowell Fellowship and the Rencontres d'Arles Discovery Award.

1

2

3

1 *On the Sixth Day.* Nazraeli Press, Tuscon, Arizona, 2005. HB, 328 x 308 mm, 80 pp, 61 col photos. Afterword by Robert Blake.

2 *The Adventures of Guille and Belinda and the Enigmatic Meaning of their Dreams.* Nazraeli Press, Portland, Oregon, 2010 (edn of 2,000 copies). HB, 277 x 277 mm, 120 pp, 60 col photos.

3 *Sorry, Welcome.* TBW Books, Oakland, California, 2013. HB w/ jkt, 300 x 230 mm, 40 pp, 21 b&w photos.

Lise Sarfati

Lise Sarfati (b.1958; Magnum member 1997–2011) was awarded a Master's degree in Russian studies by the Sorbonne in Paris before becoming official photographer to the Académie des Beaux Arts in Paris. She went on to spend ten years living and photographing in Russia before moving to the United States and concentrating on creating novelistic photographic series about women, particularly those on the fringes of society. In 2011 she left Magnum to pursue her interest in art photography rather than social documentary.

1

2

3

4

5

1 *Acta Est.* Phaidon Press, London, 2000 (also PB in French). HB and PB, 297 x 198 mm, 104 pp, 46 col photos. Intro by Olga Medvedkova.

2 *Lise Sarfati.* Fundacion Salamanca Ciudad de Cultura, Salamanca, 2004. PB, 240 x 290 mm, 98 pp, 39 col photos. Text by Olga Medvedkova and Javier Panera Cuevas.

3 *The New Life.* Twin Palms Publishers, Santa Fe, 2005 (also limited edn of 50 copies w/ signed print in a clamshell box). HB w/ jkt, 265 x 330 mm, 120 pp, 50 col photos. Essay by Olga Medvedkova.

4 *Fashion Magazine: Austin, Texas.* Magnum Photos, Paris, 2008. PB, 270 x 197 mm, 216 pp, 99 col photos. Essay by Quentin Bajac.

5 *She.* Twin Palms Publishers, Santa Fe, 2012 (edn of 2000 copies; also limited edn of 25 copies w/ signed print in a clamshell box). HB w/ jkt, 279 x 356 mm, 120 pp, 52 col photos. Essay by Quentin Bajac.

Ferdinando Scianna

Ferdinando Scianna (b.1943; joined Magnum in 1982) began his photographic career while a student at the University of Palermo and he photographed widely in his native Sicily, including for his book *Feste Religiose in Sicilia* (1965), which included an essay by Leonardo Sciascia. Moving to Milan, Scianna became a photojournalist and reporter, covering subjects such as politics and literature. In the late 1980s he took up fashion photography and published a retrospective, *Le Forme del Caos* (1989), while continuing to explore religious rituals - *Viaggio a Lourdes* (1995) - and returning to Sicily for *Quelli di Bagheria* (2002), a reconstruction of the atmosphere of his home town in his youth.

1

2

3

4

5

6

7

8

9 10 11 12

13 14 15 16

17 18 19 20

21 22 23 24

25

1 *Feste Religiose in Sicilia.*
Leonardo da Vinci Editrice, Bari,
1965 (Italian edn). HB w/ jkt, 186
x 128 mm, 224 pp, 106 b&w photos.
Text by Leonardo Sciascia.

2 *Il Glorioso Alberto.* Editphoto,
Milan, 1971 (Italian edn). PB,
210 x 200 mm, 70 pp, 59 b&w
photos. Text by Annabella Rossi.

3 *Les Siciliens.* Editions Denoël,
Paris, 1977 (French edn). HB
clothbound w/ jkt, 231 x 299 mm,
164 pp, 49 b&w photos. Text by
Dominique Fernandez and Leonardo
Sciascia.

4 *La Villa Dei Mostri.* Einaudi,
Turin, 1977 (Italian edn).
PB, 205 x 195 mm, 102 pp, 72
b&w photos. Intro by Leonardo
Sciascia.

5 *Il Grande Libro Della Sicilia.*
Arnoldo Mondadori Editore, Milan,
1984 (Italian edn). 260 x 185 mm,
176 pp, 101 col photos. Intro by
Leonardo Sciascia.

6 *L'instante e la Forma.* Ediprint,
Siracusa, 1987. PB, 243 x 209 mm,
44 pp, 33 b&w photos.

7 *Feste Religiose in Sicilia.*
L'Immagine Editrice, Palermo,
1987 (revised Italian edn). HB w/
slipcase, 342 x 255 mm, 189 pp,
83 b&w photos. Text by Leonardo
Sciascia.

8 *Kami: Minatori Sulle Ande
Boliviane.* L'immagine Editrice,
Milan, 1988 (Italian edn). PB, 320
x 240 mm, 139 pp, 60 b&w photos.

9 *La Scoperta Dell'America.*
Centro Culturale Pasolini,
Casarsa della Delizia, 1988.
PB, 220 x 230 mm, 20 pp, 13 b&w
photos. Intro by Giuliana Scimé.

10 *Citta del Mondo.* Bompiani,
Milan, 1988 (Italian edn). PB, 280
x 205 mm, 94 pp, 80 b&w photos.

11 *Ore di Spagna.* Pungitopo,
Messina, 1988. PB, 210 x 150 mm,
124 pp, 44 b&w photos. Text by
Leonardo Sciascia.

12 *Maglia.* Franco Sciardelli,
Milan, 1989. PB, 286 x 202 mm,
116 pp, 59 b&w photos.

13 *Le Forme del Caos.* Art & Srl,
Udine, 1989. HB, 305 x 245 mm,
260 pp, 191 b&w photos. Text by
Manuel Vazquez Montalban and
Leonardo Sciascia.

14 *Men and Trucks.* Iveco, Turin,
1990. PB, 229 x 263 mm, 58 pp,
48 col photos. Intro by Scianna.

15 *In Ireland, Connemara.*
Yamamoto, Tokyo, 1993. HB, 260
x 180 mm, 40 pp, 25 b&w photos.

16 *Marpessa.* Leonardo, Milan,
1993 (Italian edn; also
published by Contrejour, Paris,
1993). PB, 414 x 312 mm, 108 pp.
59 b&w photos.

17 *Altrove: Reportage di Moda.*
Federico Motta Editore, Milan,
1995 (Italian edn). HB w/ jkt
and slipcase, 300 x 237 mm, 200
pp, 111 b&w photos.

18 *Viaggio a Lourdes.* Mondadori,
Milan, 1996. PB, 300 x 230 mm,
120 pp, 100 b&w photos.

19 *Dormire Forse Sognare.* Art&
Temi, Udine, 1997 (PB English
edn: *To Sleep, Perchance to
Dream*, Phaidon Press, London,

1997). HB w/ jkt, 310 x 250 mm,
128 pp, 83 b&w photos.

20 *Ninos del Mundo.* Ayuntamiento
de la Coruña, Coruña, 2000
(published in Italian as *Mondo
Bambino* by L'Arte a Stampa,
Milan, 2002). HB, 270 x 220 mm,
110 pp, 96 b&w photos. Texts
by Jesus Garrido and Oliva María
Rubio.

21 *Altre Forme del Caos.*
Contrasto, Rome, 2000 (Italian
edn). PB, 265 x 210 mm, 80
pp, 59 b&w photos. Text by
Alessandra Mauro.

22 *Sicilia Ricordata.* Libreria
Rizzoli, Milan, 2001. HB, 340

x 240 mm, 158 pp, 93 col photos.
Text by Dacia Maraini.

23 *Quelli di Bagheria.* Peliti
Associati, Rome, 2002 (also
published by i quaderni
dell'Ortigia). PB, 240 x 170 mm,
384 pp, 392 b&w photos. Text
by Ferdinando Scianna.

24 *La Geometria e la Passione.*
Contrasto, Rome, 2009. HB w/
jkt, 320 x 245 mm, 252 pp, 170
b&w photos.

25 *Lettori.* Edizioni Henry
Beyle, Milan, 2015 (edn of 575
signed copies). HB, 185 x 125
mm, 92 pp, 28 b&w photos.

Jérôme Sessini

Jérôme Sessini (b.1968; joined Magnum in 2012) began taking
documentary photographs around his home in eastern France after a
friend showed him some photobooks. Moving to Paris in 1998, he was
sent by the Gamma photo agency to cover the conflict in Kosovo,
beginning a career as a photojournalist that has seen him cover
conflicts in Palestine, Iraq, Lebanon and Somalia, and the 2004
revolution in Haiti. In 2008 Sessini began an ongoing project on
the wars of the drug cartels in Mexico. Sessini's sometimes graphic
realism is harnessed to a simple message: 'Ordinary people are always
the losers, whether it's Iraq, Mexico or France.'

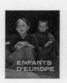

1

1 *The Wrong Side: Living on the
Mexican Border.* Contrasto, Rome,
2012. HB, 249 x 186 mm, 160 pp,
79 col photos. Text and afterword
by Sessini.

David 'Chim' Seymour

David 'Chim' Seymour (1911–1956; co-founder of Magnum in 1947) turned
to photography in 1933 while studying at the Sorbonne in Paris.
He then covered political events for leading magazines including
LIFE, beginning with the Spanish Civil War. After founding Magnum
in 1947, he was commissioned by UNICEF to photograph the children
of Europe after the war. His photo essays include iconic portraits
of Ingrid Bergman, Audrey Hepburn, Sophia Loren and Pablo Picasso.
He was killed by an Egyptian machine-gunner in Suez in 1956, while
photographing for *Newsweek*.

1 2 3 4

1 *Krieg in Spanien.* Yiddish
Universal Library, Warsaw, 1938.
HB, 150 x 190 mm, 166 pp, 7 b&w
photos. Text by S.L. Shneiderman.

2 *Enfants d'Europe* (Children
of Europe). UNESCO, Paris, 1949
(also Spanish and English edns:
1949). Spiralbound PB, 224 x 180
mm, 60 pp, 54 b&w photos. Intro
by Seymour; captions in French,
English and Spanish.

3 *The Vatican.* Farrar, Straus
and Company, New York, 1950.
HB w/ jkt, 250 x 190 mm, 190 pp,
numerous photos. Text by
Ann Carnahan.

4 *Chiisana Inochi / Little Ones.*
Heibonsha, Tokyo, 1957. HB, 274
x 183 mm, 53 pp, 44 b/w photos.

Marilyn Silverstone

Marilyn Silverstone (1929-99; joined Magnum in 1964) was an associate editor for art and design magazines during the 1950s, as well as working on a series of films about painters. In 1955 she began to photograph professionally. In 1959 she was sent on a three-month assignment to India, and she lived in New Delhi until 1973. Silverstone became an ordained Buddhist nun in 1977 and lived in Kathmandu, where she later died at the Shechen Monastery.

1 2 3 4

1 *Bala: Child of India*. Methuen & Co, London, 1962 (second edn: Hastings House, New York, 1968). HB, 48 pp, numerous b&w photos. Text by Luree Miller.

2 *Gurkhas and Ghosts: The Story of a Boy in Nepal*. Methuen & Co, London, 1964 (also published by Criterion Books, New York, 1970). HB w/ jkt, 240 x 160 mm, 144 pp, 65 b&w photos. Text by Luree Miller.

3 *Ocean of Life: Visions of India and the Himalayan Kingdoms*. Aperture, New York, 1985. HB w/ jkt, 292 x 235 mm, 70 pp, 55 col photos. Preface by Haven O'More; afterword by Theven Khampo Thupten.

4 *The Black Hat Dances: Two Buddhist Boys in the Himalayas*. Dodd, Mead & Company, New York, 1987. HB w/ jkt, 227 x 188 mm, 86 pp, 52 b&w photos. Text by Luree Miller.

W. Eugene Smith

William Eugene Smith (1918-78; joined Magnum in 1955) took his first photographs aged 15 for two local newspapers and began working for *Newsweek* in 1937. He then worked as a war correspondent for *Flying* magazine and *LIFE*, but was injured while following the American offensive against Japan. He worked for *LIFE* again between 1947 and 1955. Smith was fanatically dedicated to his mission as a photographer. He died of a stroke in 1978, but his legacy lives on through the W. Eugene Smith Fund to promote humanistic photography.

1 2

1 *W. Eugene Smith: His Photographs and Notes*. Aperture, New York, 1969. PB, 255 x 215 mm, 148 pp, 120 b&w photos. Afterword by Lincoln Kirstein.

2 *Minamata: Words and Photographs*. Holt, Rinehart and Winston, New York, 1975 (second edn: Centre National de la Photographie, Paris, 1991; third edn: Aperture Grossman, New York 1995). PB, 293 x 238 mm, 192 pp, 150 b&w photos. Collaboration with Aileen Smith.

Jacob Aue Sobol

Jacob Aue Sobol (b. 1976; joined Magnum in 2007) is a Danish photographer who studied photography under the tutelage of Morten Bo. Based in Copenhagen, he has worked in East Greenland, Guatemala, Tokyo, Bangkok, Russia, Yakutia, China, the United States and Denmark. A key influence on his strong aesthetic style is the grainy, off-kilter work of Danish photographers such as Anders Petersen and Christer Strömholm. Sobol's work has been widely exhibited, including at Yossi Milo Gallery in New York, Polka Gallerie in Paris and the Museum of Modern Art in San Francisco. In 2008 he won the European Publishers Award for his book, *I, Tokyo*.

1 2 3 4

5 6 7 8

9 10

1 *Sabine*. Politiken, Copenhagen, 2004 (Danish edn of 700 copies and Greenlandic edn of 200 copies; also self-published English edn of 200 copies). HB, 228 x 336 mm, 112 pp, 55 b&w photos. Text by Sobol and foreword by Finn Thrane.

2 *I, Tokyo*. Dewi Lewis Publishing, Stockport, 2008 (language edns published by Actes Sud, Paris, 2008; Apeiron, Athens, 2008; Edition Braus, Berlin, 2008; Lunwerg Editores, Barcelona, 2008; Mets & Schilt, Amsterdam, 2008; and Peliti Associati, Rome, 2008). HB, 320 x 225 mm, 112 pp, 73 tritone photos. Text by Sobol.

3 *Fortællinger*. Fotografisk Center, Copenhagen, 2011. HB, 180 x 120 mm, 46 pp, 22 b&w photos.

4 *Avec Toi*. Maison du Danemark, Paris, 2013. PB, 420 x 280 mm, 20 pp (pages unfold as posters), 17 b&w photos.

5 *Arrivals and Departures*. Leica Gallery, Warsaw, 2013 (1st and 2nd edn). PB, 315 x 230 mm, 50 pp, 40 b&w photos.

6 *Veins*. Dewi Lewis Publishing, Stockport, 2013. HB, 247 x 166 mm, 144 pp, 97 b&w photos. Collaboration with Anders Peterson; intro by Gerry Badger.

7 *With You*. La Bottega Gwalleria, Sienna, 2015 (limited edn of 150 copies). PB, 315 x 220 mm, 22 pp, 16 photos.

8 *By the River of Kings*. Super Labo, Kamakura, Japan, 2016. HB, 286 x 228 mm, 152 pp, 109 tritone photos.

9 *12 Months of Winter (#1)*. Brothas, Copenhagen, 2016 (limited edn of 1,000 copies; part of a series of 12 books). PB, 320 x 240 mm, 36 pp, 16 tritone photos.

10 *12 Months of Winter (#2)*. Brothas, Copenhagen, 2016 (limited edn of 1,000 copies; part of a series of 12 books). PB, 320 x 240 mm, 32 pp, 15 tritone photos.

Alec Soth

Alec Soth (b. 1969; joined Magnum in 2004) is an American photographer based in Minneapolis. His photographs are rooted in the distinctly American tradition of 'on-the-road photography', and have been featured in the 2004 Whitney and São Paulo Biennials, as well as in the San Francisco Museum of Modern Art, the Museum of Fine Arts, Houston, and the Walker Art Center, Minneapolis. He has received the Guggenheim Fellowship (2013), published a number of books, and started his own publishing company, Little Brown Mushroom.

1 2 3 4

5 6 7 8

9a 9b 9c 10

11 12 13 14

15 16 17 18

19 20 21 22

23 24 25 26

27 28 29 30

31

1 *Sleeping by the Mississippi*. Self-published, Minneapolis, Minnesota, 2003 (two limited edns of 30 and 25 copies each). HB, 272 x 212 mm, 60 pp, 45 col photos.

2 *Sleeping by the Mississippi*. Steidl, Göttingen, 2004 (first edn; second edn also 2004 and third edn published in 2008; edns all have different covers). HB, 275 x 285 mm, 118 pp, 47 col photos. Text by Patricia Hampl and Anne Wilkes Tucker.

3 *Niagara*. Steidl, Göttingen, 2006. HB, 320 x 275 mm, 96 pp, 39 col photos. Text by Philip Brookman and Richard Ford.

4 *Fashion Magazine by Alec Soth: Paris Minnesota*. Magnum Photos, Paris, 2007. PB, 301 x 239 mm, 190 pp, 116 col photos.

5 *Dog Days Bogotá*. Steidl, Göttingen, 2007. HB w/ jkt, 224 x 214 mm, 60 pp, 50 col photos. Text by Alec Soth.

6 *The Last Days of W*. Little Brown Mushroom, Minnesota, 2008. Unbound newsprint, 419 x 305 mm, 48 pp, 36 col photos. Text by Lester B. Morrison.

7 *Lost Boy Mountain*. Little Brown Mushroom Books, Minnesota, 2009 (edn of 1,000 copies). PB, 216 x 140 mm, 24 pp, 11 mixed media works. Text by Lester B. Morrison.

8 *Allowing Flowers*. Macroom Books, 2009. HB w/ slipcase, 279 x 305 mm, 32 pp, 12 col photos. Text by Denny Haley.

9a–c *3 Zines by Lester B. Morrison*. Little Brown Mushroom Books, Minnesota, 2009. 3 zines (edn of 500 copies): *Library for Broken Men*, PB, 223 x 172 mm, 20 pp, 15 mixed media works; *Lonely Bearded Men*, PB, 223 x 172 mm, 20 pp, 18 drawings; *Lester Becomes Me*, PB, 223 x 172 mm, 20 pp, 10 col photos.

10 *Sheep*. TBW Books, Oakland, California, 2009 (edn of 800 copies). PB, 203 x 152 mm, 48 pp, 20 col and b&w photos.

11 *From Here to There: Alec Soth's America*. The Walker Art Center, 2010. HB, 258 x 208 mm, 224 pp, 75 b&w and 162 col photos. Edited by Siri Engberg; text by Geoff Dyer, Siri Engberg, August Kleinzahler, Bartholomew Ryan, Britt Salvesen, Barry Schwabsky; design by Emmet Byrne.

12 *Ash Wednesday, New Orleans*. Super Labo, Kamakura, 2010 (edn of 500 copies). PB, 256 x 182 mm, 32 pp, 39 col photos.

13 *Brighton Picture Hunt*. Photoworks, Brighton, 2010 (edn of 1,000 copies). HB, 205 x 165 mm, 64 pp, 43 col photos. Collaboration with Carmen Soth.

14 *One Mississippi: One Picture Book #63:*. Nazraeli Press, Manchester, 2010. HB 180 x 140 mm, 16 pp, 12 col photos.

15 *Rodarte, Catherine Opie, Alec Soth*. JRP Ringier, Zurich, 2011. HB, 280 x 215 mm, 176 pp, 125 col photos. Text by John Kelsey; edited by Brian Phillips; design by Patrick Li.

16 *La Belle Dame Sans Merci*. Punctum Press, Rome, 2011. HB, 299 x 388 mm, 52 pp, 19 col photos.

17 *The Auckland Project*. Radius Books, Santa Fe, 2011. 2 volume HB, 290 x 228 mm, 160 pp, 98 col photos. Collaboration with *John Gossage*.

18 *Broken Manual*. Steidl, Göttingen, 2011 (edn of 300 copies). PB w/ slipcase, 297 x 210 mm, 136 pp, 51 b&w and col photos. Intro by Lester B. Morrison.

19 *Looking for Love, 1996*. Kominek Books, Berlin, 2012. HB, 222 x 200 mm, 56 pp, 42 b&w photos.

20 *Ohio (LBM Dispatch #1)*. Little Brown Mushroom, Minnesota, May 2012 (edn of 2,000 copies). Zine, 382 x 292 mm, 48 pp, 37 b&w photos. Text by Brad Zellar; design by Jenny Tondera.

21 *Upstate (LBM Dispatch #2)*. Little Brown Mushroom, Minnesota, August 2012 (edn of 2,000 copies). Zine, 382 x 292 mm, 48 pp, 41 b&w photos. Text by Brad Zellar; design by Jenny Tondera.

22 *Michigan (LBM Dispatch #3)*. Little Brown Mushroom, Minnesota, November 2012 (edn of 2,000 copies). Zine, 382 x 292 mm, 48 pp, 45 b&w photos. Text by Brad Zellar; design by Jenny Tondera.

23 *House of Coates*. Little Brown Mushroom, Minnesota, 2012 (edn of 1,000 copies). HB, 222 x 171 mm, 118 pp, 68 col photos. Text by Brad Zellar and Alec Soth; design by Hans Seeger.

24 *Three Valleys (LBM Dispatch #4)*. Little Brown Mushroom, Minnesota, March 2013 (edn of 2,000 copies). Zine, 382 x 292 mm, 48 pp, 38 b&w photos. Text by Brad Zellar; design by Meredith Oberg.

25 *Colorado (LBM Dispatch #5)*. Little Brown Mushroom, Minnesota, June 2013 (edn of 2,000 copies). Zine, 382 x 292 mm, 48 pp, 41 b&w photos. Text by Brad Zellar; design by Meredith Oberg.

26 *Ping Pong Conversations*. Contrasto, Rome, 2013. HB, 210 x 150 mm, 182 pp, 78 col photos. Interview with Francesco Zanot.

27 *Texas Triangle (LBM Dispatch #6)*. Little Brown Mushroom, Minnesota, December 2013 (edn of 2,000 copies). Zine, 382 x 292 mm, 48 pp, 41 b&w photos. Text by Brad Zellar.

28 *Georgia (LBM Dispatch #7)*. Little Brown Mushroom, Minnesota, November 2014 (edn of 2,000 copies). Zine, 382 x 292 mm, 48 pp, 36 b&w photos. Text by Brad Zellar.

29 *Bogotá Funsaver: One Picture Book #88*. Nazraeli Press, Manchester, 2014. HB, 180 x 140 mm, 16 pp, 12 col photos, 1 original signed print.

30 *Songbook*. Mack, London, 2015. HB, 285 x 273 mm, 144 pp, 73 b&w photos.

31 *Gathered Leaves*. Mack, London, 2015. 4 PB w/ box and 29 postcard prints (*Broken Manual*, *Sleeping by the Mississippi*, *Niagara* and *Songbook*): 228 x 223 mm, 211 b&w and col photos. Text by Aaron Schuman and Kate Bush.

Chris Steele-Perkins

Chris Steele-Perkins (b.1947; joined Magnum in 1979) moved from Rangoon, where he was born, to London, where he started working as a freelance photographer in 1971. From 1973, he undertook travel assignments for international relief organizations and worked with groups dealing with social problems in Europe. His first book, *The Teds*, was published in 1979, the same year he joined Magnum Photos and began working extensively in the Third World. Since then, he has published eleven more books on Afghanistan, Japan, England and British centenarians.

1 2 3 4

5

6

7

8

9
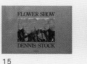
10

11

12

9

10

11

12
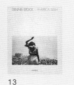
13
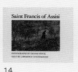
14

15
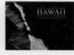
16

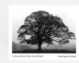
13

17

18

19

7 *The Teds.* Dewi Lewis Publishing, Stockport, 2002 (revised edn; also large format edn, 2016). HB, 235 x 170 mm, 128 pp, 84 b&w photos. Text by Richard Smith.

8 *Echoes.* Trolley Books, London, 2003. HB, 210 x 145 mm, 128 pp, 69 col photos. Text by Steele-Perkins.

9 *Tokyo, Love, Hello.* Editions Intervalles, Paris, 2006. HB, 171 x 226 mm, 224 pp, 102 col photos. Text by Steele-Perkins and Donald Richie.

10 *Northern Exposures.* Northumbria University Press, Newcastle upon Tyne, 2007. PB, 242 x 250 mm, 120 pp, 96 b&w photos. Intro by Steele-Perkins.

11 *England, My England.* Northumbria University Press, Newcastle upon Tyne, 2009. HB w/ jkt, 255 x 260 mm, 224 pp, 125 b&w and col photos. Intro by David Elliott.

12 *Fading Light: Portraits of Centenarians.* McNidder & Grace, Carmarthen, 2012. HB, 240 x 240 mm, 96 pp, 56 b&w photos. Intro by Steele-Perkins.

13 *A Place in the Country.* Dewi Lewis Publishing, Stockport, 2015. HB w/ jkt, 240 x 300 mm, 120 pp, 83 col photos.

1 *The Teds.* Travelling Light/Exit, London, 1979. PB, 229 x 201 mm, 128 pp, 72 b&w photos. Text by Richard Smith.

2 *Survival Programmes: In Britain's Inner City.* Open University Press, Maidenhead, 1982. PB, 210 x 260 mm, 224 pp, 93 b&w photos. Collab. w/ Nicholas Battye and Paul Trevor.

3 *Beirut: Frontline Story.* Pluto Press, London, 1983. PB, 160 pp, 26 b&w photos. Text by Sélim Nassib and Caroline Tisdall.

4 *The Pleasure Principle.* Cornerstone, Manchester, 1989. PB, 275 x 225 mm, 61 pp, 61 col photos. Intro by Steele-Perkins.

5 *Afghanistan.* Marval, Paris, 2000 (second edn: Westzone, London, 2001). HB, 312 x 229 mm, 128 pp, 79 b&w photos. Text by André Velter, Sayd Bahodne Majrouh and Steele-Perkins.

6 *Fuji.* Umbrage Editions, New York, 2001 (second edn: 2009). HB w/ jkt, 280 x 273 mm, 136 pp, 104 col photos. Intro by Steele-Perkins.

Dennis Stock

Dennis Stock (1928–2010; joined Magnum in 1951) became an apprentice to *LIFE* magazine photographer Gjon Mili in 1947. In the 1950s he produced iconic portraits of Hollywood stars, most notably James Dean, and of jazz musicians, which were published in his 1960 book *Jazz Street*. In 1968 Stock took a leave of absence from Magnum to establish Visual Objectives, a film production company, shooting several documentaries. He photographed Californian hippy culture in the late 1960s and nature and landscape in his later years.

1

2

3

4

5

6

7

8

1 *Portraits of a Young Man, James Dean.* Kadokawa Shoten, Tokyo, 1956. PB w/ jkt, 252 x 180 mm, 82 pp, 65 b&w photos.

2 *Plaisir du Jazz.* Le Guide du Livre, Lausanne, 1959. HB, 280 x 220 mm, 144 pp, 130 b&w photos. Text by Michel-Claude Jalar.

3 *Jazz Street.* André Deutsch, London and Doubleday, New York, 1960. HB, 280 x 220 mm, 62 pp, 130 b&w photos. Text by Nat Hentoff.

4 *The Alternative: Communal Life in New America.* Collier-Macmillan, New York, 1970. HB w/ jkt, 277 x 200 mm, 190 pp, 70 b&w photos. Text by William Hedgepeth.

5 *California Trip.* Grossman, New York, 1970. HB, 277 x 342 mm, 98 pp, 99 b&w photos.

6 *Edge of Life: The World of the Estuary.* Sierra Club, San Francisco, 1972. HB, 304 x 257 mm, 128 pp, 34 col photos. Intro by Paul Brooks; text by Peggy Wayburn.

7 *Brother Sun: A Photographic Appreciation.* Sierra Club, San Francisco, 1974. HB w/ jkt (also published in PB), 260 x 260 mm, 86 pp, 40 col photos. Intro by J. G. Mitchell.

8 *The Circle of Seasons.* Viking Press, New York, 1974. HB, 282 x 254 mm, 104 pp, 64 col photos. Text by Josephine W. Johnson.

9 *California: The Golden Coast.* Viking Press, New York, 1974. HB, 213 x 267 mm, 110 pp, 60 col photos. Text by Philip L. Fradkin.

10 *Made in USA.* Hatje Cantz, Ostfildern, 1975. HB, 305 x 254 mm, 180 pp, 140 b&w photos. Text by Dennis Stock and Richard Whelan.

11 *This Land of Europe: A Photographic Exploration by Dennis Stock.* Kodansha International, New York, 1976. HB w/ jkt, 284 x 284 mm, 132 pp, 58 col photos. Intro by Hugh

Trevor-Rope; essays by Konrad Lorenz, Kai Curry-Lindahl, Roger Callois, Emil Egli and Julián Marías.

12 *James Dean Revisited.* Viking Press, New York, 1978. HB w/ jkt, 252 x 200 mm, 128 pp, 92 b&w photos. Text by Stock.

13 *America Seen.* Editions Contrejour, Paris, 1980. PB 268 x 210 mm, 72 pp, 68 b&w photos. Text by Stock.

14 *Saint Francis of Assisi.* Harper & Row, New York, 1981 (second edn: 1989). HB w/ jkt, 300 x 250 mm, 126 pp, 13 col photos. Text by Laurence Cunningham.

15 *Flower Show.* Rizzoli, New York, 1986 (Italian edn: Magnus Edizioni, Udine; French edn: Editions Menges, Paris, 1982). HB w/ jkt, 285 x 410 mm, 110 pp, 76 col photos. Text by Monica Cossardt.

16 *Hawaii: Photographs by Dennis Stock.* Harry N. Abrams, New York, 1988. HB w/ jkt, 305 x 380 mm, 160 pp, 159 col photos.

17 *Provence Memories.* NY Graphic Society, New York, 1988. HB w/ jkt, 290 x 410 mm, 106 pp, 80 col photos. Intro by Philip Conisbee.

18 *New England Memories.* Bulfinch Press, London, 1989. HB w/ jkt, 275 x 400 mm, 102 pp, 80 col photos. Intro by Noel Perrin.

19 *James Dean: Fifty Years Ago.* Harry N. Abrams, New York, 2005. HB, 303 x 250 mm, 128 pp, 83 b&w photos. Intro by Joe Hyams.

Mikhael Subotzky

Mikhael Subotzky (b. 1981; joined Magnum in 2007) has focused his work on social, historical and political narratives at home in South Africa and abroad. Executed in a variety of mediums, including photographs, film and video installations, collages and drawings, Subotzky's works have been widely exhibited. His major photographic series have looked at South Africa's prison system, the town of Beaufort West, and Ponte City, a residential skyscraper in Johannesburg. His most recent work, WYE (2016), explores the relationship between the United Kingdom and two of its former colonies South Africa and Australia.

1 2 3 4

1 *Beaufort West*. Chris Boot Ltd, London, 2008. HB, 280 x 350 mm, 80 pp, 45 col photos. Text by Mikhael Subotzky and Jonny Steinberg.

2 *Retinal Shift*. Steidl, Göttingen, 2012. HB, 260 x 190 mm, 488 pp, 541 b&w and col photos. Text by Anthea Buys and Sean O'Toole.

3 *Ponte City*. Steidl, Göttingen, 2014. HB w/ box, 365 x 237 mm, 192 pp. 91 col photos. Collaboration with Patrick Waterhouse.

4 *WYE*. Sherman Contemporary Art Foundation, Paddington, 2016. HB, 200 x 250 mm, 286 pp, 135 col photos. Preface by Gene Sherman; essay by Nina Miall.

Larry Towell

Larry Towell (b. 1953; joined Magnum in 1988) grew up in a large family in rural Ontario and his experience as a poet and folk musician have shaped his photographic style. He has completed projects on the Nicaraguan Contra war, on relatives of the disappeared in Guatemala, the conflict in El Salvador and a thirteen-year-long project in the Palestine. His fascination with landlessness led him to a major reportage on the Mennonite migrant workers of Mexico. In 2008, when he began to photograph the Afghan conflict, he also finished a project on his family in Ontario, where he sharecrops a 75-acre farm. He is also the author of several music and poetry CDs.

1 2 3 4

5 6 7 8

9 10 11 12

13

1 *Burning Cadillacs*. Black Moss Press, Windsor, Ontario, 1983. PB, 225 x 178 mm, 102pp, 30 b&w photos.

2 *Gifts of War*. Coach House Press, Toronto, Ontario, 1988. PB, 215 x 146 mm, 110 pp, 52 b&w photos.

3 *Somoza's Last Stand: Testimonies from Nicaragua*. Williams-Wallace Publishers, Ontario, 1990. PB, 214 x 132 mm, 208 pp, 27 b&w photos. Text by Towell.

4 *The Prison Poems of Ho Chi Minh*. Cormorant Books, Ontario, 1992. PB, 200 x 150 mm, 108 pp, 26 b&w photos. Intro by Towell.

5 *House on Ninth Street: Interviews and Photographs from Guatemala*. Cormorant Books, Ontario, 1994. PB, 214 x 130 mm, 196 pp, 19 b&w photos. Text by Towell.

6 *El Salvador*. W.W. Norton & Company, New York 1997. PB, 279 x 210 mm, 126 pp, 62 b&w photos. Intro by Mark Danner.

7 *Then Palestine*. Marval, Paris, 1998 (English edn: Aperture, New York, 1998). PB, 313 x 232 mm, 114 pp, 64 b&w photos. Text by Mahmoud Darwich and René Backmann.

8 *The Mennonites*. Phaidon Press, London, 2000. HB w/ jkt and slipcase, 250 x 190 mm, 292 pp, 119 b&w photos. Text by Towell.

9 *No Man's Land*. Chris Boot Ltd and Archive of Modern Conflict, London, 2005. HB, 262 x 378 mm, 144 pp, 126 b&w photos. Intro by Robert Delpire.

10 *In the Wake of Katrina*. Chris Boot Ltd and Archive of Modern Conflict, London, 2006 HB, 295 x 224 mm, 144 pp, 44 b&w photos. Intro by Timothy Prus; afterword by Ace Atkins.

11 *The World from My Front Porch*. Chris Boot Ltd and Archive of Modern Conflict, London, 2008. HB, 315 x 244 mm, 224 pp, 235 b&w and col photos. Text by Towell.

12 *The Cardboard House: MSF Peru – Action on Aid*. Trolley Books, London, 2008. PB, 220 x 170 mm, 128 pp, 57 b&w photos. Preface by Piero Gandini.

13 *Afghanistan*. Aperture, New York, 2014. HB, 382 x 280 mm, 192 pp, 350 b&w and col photos. Text by Towell.

Burk Uzzle

A protégé of Henri Cartier-Bresson, Burk Uzzle (b.1938; member of Magnum 1967-1982) began his photographic career in documentary – LIFE magazine hired him at the age of twenty-three, their youngest photographer ever – before moving on to revealing studies of small-town America, where he used a combination of split-second impressions to reflect the human condition. President of Magnum in 1979 and 1980, Burk also produced iconic images of the Woodstock festival, the assassination and funeral of Martin Luther King, Jr., and refugees from the Cambodian war.

1 2 3 4

5

1 *Landscapes*. Magnum Photos/Light Impressions Corp., New York, 1973. PB, 203 x 228 mm, 96 pp, 87 b&w photos. Intro by Ron Bailey.

2 *All American*. Aperture, New York, 1984. HB w/ jkt, 305 x 250 mm, 128 pp, 94 b&w photos. Intro by Martha Chahroudi.

3 *A Progress Report on Civilization*. Chrysler Museum, Norfolk, Virginia, 1992. PB, 152 x 305 mm, 22 pp, 27 col photos.

4 *A Family Named Spot*. Five Ties Publishing, New York, 2006. HB w/ jkt, 290 x 240 mm, 172 pp, 77 b&w photos. Preface by Charlie Rose; short story by Allan Gurganus.

5 *Just Add Water*. Five Ties Publishing, New York, 2007. HB w/ jkt, 305 x 380 mm, 120 pp, 60 col photos. Intro by Vicki Goldberg.

Peter van Agtmael

Peter van Agtmael (b.1981; joined Magnum in 2008) studied history at Yale University, graduating with honors in 2003. Since 2006 he has primarily covered the wars following 9/11 and their consequences, working extensively in Iraq, Afghanistan and the United States. He has won numerous awards including the W. Eugene Smith Grant and the ICP Infinity Award for Young Photographer. In 2008 he helped organize the book and exhibition *Battlespace*, a retrospective of largely unseen work by 22 photographers covering Iraq and Afghanistan.

1

2

1 *2nd Tour Hope I Don't Die.* Photolucida, Portland, Oregon, 2009. PB, 254 x 215 mm, 112 pp, 74 col photos. Text by van Agtmael.

2 *Disco Night Sept. 11.* Red Hook Editions, New York, 2014. HB, 264 x 215 mm, 276 pp, 188 col photos. Text by van Agtmael.

John Vink

John Vink (b. 1948; joined Magnum in 1993) studied photography at L'École de la Cambre in Brussels in 1968, before he began working as a freelance journalist three years later. He joined Agence Vu in 1986 and won the Eugene Smith Award that year. Between 1987 and 1993 he compiled a major body of work on refugees around the world. He created and published *Themes*, a photography magazine dedicated to documentary photography. Based in Cambodia since 2000, Vink covers political and social issues through self-assigned stories. He has published several e-books including *30 Years for a Trial* (2013), *Quest for Land* (2014) and *Hearths of Resistance* (2015).

1

2

3

4

1 *Réfugiés: Photographies de John Vink (1987-1994).* Centre National de la Photographie and Médecins sans Frontières, Paris, 1995. PB, 190 x 120 mm, 128 pp, 99 b&w photos. Intro by Rony Brauman.

2 *Avoir 20 ans à Phnom Penh.* Editions Alternatives, Paris, 2000. PB, 241 x 172 mm, 96 pp, 57 b&w photos. Preface by Rithy Panh; text by Kong Sothanrith and Frédéric Amat.

3 *Peuples d'en Haut: Laos, Guatemala, Géorgie, La Montagne est leur royaume.* Editions Autrement, Paris, 2004. PB, 248

x 189 mm, 208 pp, 141 b&w photos. Text by Christian Culas, Jesús García Ruiz, Bernard Outtier and John Vink.

4 *Poids Mouche.* Les Editions du Mékong, Phnom Penh, 2006. HB, 205 x 185 mm, 80 pp, 69 col and b&w photos. Text by Christophe Macquet.

Alex Webb

Alex Webb (b. 1952; joined Magnum in 1976) became interested in photography during high school and attended the Apeiron Workshops in Millerton, New York, in 1972. He majored in history and literature at Harvard University, while also studying photography at the Carpenter Center for the Visual Arts. In 1974 he began working as a photojournalist. During the mid-1970s he photographed small-town life in the American south in black and white, and began working in the Caribbean and Mexico. In 1978 he started to photograph in colour, which he continues to do. He has exhibited widely in the United States and Europe, and has received numerous awards for this work.

1

2

3

4

5

6

7

8

9

10

11

12

1 *Hot Light/Half-Made Worlds: Photographs from the Tropics.* Thames & Hudson, London and New York, 1986. HB w/ jkt, 267 x 305 mm, 96 pp, 76 col photos.

2 *Under a Grudging Sun: Photographs from Haiti Libéré 1986-1988.* Thames & Hudson, London, 1989. PB, 310 x 244 mm, 85 96 pp, 59 col photos. Text by Webb.

3 *Fotografias: From the Tropics.* Comunidad de Madrid, Madrid, 1989. PB, 260 x 210 mm, 98 pp, 67 photos.

4 *From the Sunshine State: Photographs of Florida.* Monacelli Press, New York, 1996. HB w/ jkt, 292 x 239 mm, 128 pp, 103 col photos.

5 *Amazon: From the Floodplains to the Clouds.* Monacelli Press, New York, 1998. HB w/ jkt, 274 x 309 mm, 144 pp, 112 col photos.

6 *Dislocations: Photographs by Alex Webb.* Film Study Center at Harvard University, Cambridge, 1998 (limited edn of 40). HB, 210 x 258 mm, 56 pp, 60 col photos.

7 *Alex Webb Crossings: Photographs from the US-Mexico Border.* Monacelli Press, New York, 2003. HB w/ jkt, 292 x 239

mm, 152 pp, 85 col and 10 b&w photos. Text by Tom Miller.

8 *Alex Webb: Yours Gallery Portfolio.* Yours Gallery, Warsaw, 2005. 360 x 270 mm, 60 pp, 24 photos. Intro by Anrzej Wajda.

9 *Istanbul: City of a Hundred Names.* Aperture, New York, 2007 (Dutch edn: Mets En Shilt, Culemborg, 2007). HB w/ jkt, 250 x 294 mm, 136 pp, 77 col photos. Text by Orhan Pamuk.

10 *Violet Isle.* Radius Books, Santa Fe, 2009. PB w/ slipcase, 254 x 285 mm, 144 pp, 70 col photos. Collaboration with Rebecca Norris Webb; text by Pico Iyer.

11 *The Suffering of Light: Thirty Years of Photographs.* Aperture, New York and Thames & Hudson, London, 2011 (Italian edn: Contrasto, Milan, 2011; French edn: Editions Textuel, Paris, 2011). HB, 305 x 330 mm, 204 pp, 115 col photos. Text by Geoff Dyer.

12 *Memory City.* Radius Books, Santa Fe, 2014 (also published by Thames & Hudson, London, 2014). HB w/ booklet and sleeve, 305 x 248 mm, 152 pp, 65 b&w and col photos. Collaboration with Rebecca Norris Webb.

Donovan Wylie

Donovan Wylie (b.1971; joined Magnum in 1992) was born in Belfast. He was still a teenager when he published his first book, *32 Counties*, of images taken on a three-month journey around Ireland. The political and social upheaval of the Irish troubles formed the backdrop to and subject of many of his works over the next two decades, although his concern with the 'architecture of conflict' has also taken him to locations in the Middle East and North America.

1 2 3 4

5 6 7 8

9 10 11

1 *32 Counties: Photographs of Ireland*. Secker & Warburg, London, 1989. HB w/ jkt, 280 x 236 mm, 288 pp, 60 b&w photos. Text by 32 Irish writers.

2 *The Dispossessed*. Picador, London, 1992. PB, 192 x 130 mm, 181 pp, 104 b&w photos. Text by Robert Wilson.

3 *Notes from Moscow: Photographs by Donovan Wylie*. Picador, London, 1994. PB, 194 x 225 mm, 128 pp, 64 b&w photos.

4 *Ireland: Singular Images*. Andre Deutsch, London, 1994. PB, 200 x 240 mm, 80 pp, 50 b&w photos.

5 *Losing Ground*. Fourth Estate, London, 1998. PB, 209 x 145 mm, 64 pp, 41 b&w photos. Afterword by Andrew O'Hagan.

6 *The Maze*. Granta Books, London, 2004. HB w/ jkt, 229 x 277 mm, 110 pp, 81 col photos. Text by Wylie and Louise Purbrick.

7 *British Watchtowers*. Steidl, Göttingen, 2007 (also published as a trilogy with *Outposts and North Warning System*, 2014). HB, 230 x 295 mm, 72 pp, 60 col photos. Text by Louise Purbrick.

8 *Maze* (revised edn). Steidl, Göttingen, 2009. Two HB and one PB in slipcase, 235 x 295 mm, 186 pp, 135 col photos. Text by Louise Purbrick.

9 *Scrapbook*. Steidl, Göttingen, 2009. PB, 295 x 200 mm, 112 pp, 224 col photos.

10 *Outposts: Kandahar Province*. Steidl, Göttingen, 2011 (also published as a trilogy with *British Watchtowers and North Warning System*, 2014). HB, 230 x 295 mm, 62 pp, 26 col photos. Afterword by Gerry Badger.

11 *North Warning System*. Steidl, Göttingen, 2014 (also published as a trilogy with *British Watchtowers and Outposts*, 2014). HB, 230 x 295 mm, 40 pp, 17 col photos.

1 *Madonna!*. Éditions de l'Étoile, Paris, 1983. PB, 208 x 180 mm, 106 pp, 64 b&w photos. Text by Claude Klotz.

2 *Enquête d'Identité: Un Juif à la Recherche de sa Mémoire*. Editions Contrejour, Paris, 1987. HB w/ jkt, 290 x 200 mm, 112 pp, 75 b&w photos. Text by Zachmann and Brigitte Dyan.

3 *20 Ans de Rêves*. Syria Editions, Paris, 1993. PB, 180 x 165 mm, 118 pp, 101 b&w photos. Text by Jean Louis Jacquet.

4 *W. ou l'Oeil d'un Long-nez*. Marval, Paris, 1995. HB w/ jkt, 270 x 190 mm, 248 pp, 250 col and b&w photos. Text by Zachmann.

5 *Maliens: Ici et Là-bas*. Editions Plume, Paris, 1997. HB, 160 x 242 mm, 116 pp, 92 col and b&w photos. Text by Zachmann.

6 *Chili: Les Routes de la Mémoire*. Marval, Paris, 2002. HB, 127 x 219 mm, 112 pp, 52 b&w photos.

7 *Good Nights*. Biro Editeur, Paris, 2008. PB, 195 x 165 mm, 46 pp, 16 col photos. Text by Martin Winckler.

8 *Ma Proche Banlieue: Photographies de Patrick Zachmann*. Éditions Xavier Barral, Paris, 2009. PB w/ jkt and DVD, 240 x 170 mm, 352 pp, 188 b&w and col photos. Preface by Souâd Belhaddad; text by Zachmann.

9 *Mare Mater: Journal Méditerranéen*. Actes Sud, Paris, 2014. HB w/ DVD, 240 x 170 mm, 312 pp, 238 b&w and col photos. Intro by François Cheval; text by Zachmann.

10 *So Long, China*. Editions Xavier Barral, Paris, 2016. HB, 230 x 170 mm, 592 pp, 345 b&w and col photos. Text by Zachmann.

Patrick Zachmann

Patrick Zachmann (b. 1955; joined Magnum in 1985) has been a freelance photographer since 1976, focusing on cultural identity, memory and immigration in different communities. From 1982 to 1984, he documented the challenges of integration facing young immigrants in Marseilles. He has also worked in film; most recently, *Mare Mater* (2013) explores young North African illegal migrants' experience of separation from their mothers, and focuses on Zachmann's own mother, who migrated seventy years previously from Algeria to France.

1 2 3 4

5 6 7 8

9 10

Magnum Photographers

These photobooks are group projects created and featuring photographs by two or more photographers. If fewer than six photographers contributed to the book, they are listed as part of the book's technical description. Many of these books feature photographs by numerous photographers, sometimes even all members of Magnum Photos at the time of publication.

 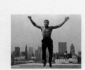

1 *Children's World*. Heibonsha, Tokyo, 1957. HB, 253 x 180 mm, 59 pp, 59 b&w photos.

2 *The First 100 Days of the Kennedy Administration: Let Us Begin*. Simon & Schuster, New York, 1961 (also published in PB). HB, 267 x 211 mm, 144 pp, 115 b&w photos. Edited by Martin Agronsky.

3 *Creative America*. Trident Press, New York, 1962. HB w/ jkt, 280 x 219 mm, 128 pp, 131 b&w and col photos.

4 *The Concerned Photographer*. Grossman, New York, 1968. PB, 240 x 202 mm, 162 pp, 174 b&w photos. Edited by Cornell Capa.

5 *America in Crisis*. Holt, Rinehart & Winston, New York, 1969. HB w/ jkt, 292 x 210 mm, 192 pp, 171 b&w photos. Edited by Charles Harbutt and Lee Jones; text by Harbutt, Jones and Mitchel Levitas.

6 *The Concerned Photographer 2*. Grossman, New York, 1972. HB w/ jkt, 240 x 202 mm, 142 pp, 110 b&w photos. Edited by Cornell Capa.

7 *Front Populaire*. Magnum Photos and Editions du Chêne, Paris, 1976. PB, 280 x 220 mm, 124pp, 117 b&w photos. Photos by Robert Capa and David 'Chim' Seymour; text by Georgette Elgey.

8 *Les Grandes Photos de la Guerre d'Espagne*. Jannink, Paris, 1980. HB, 285 x 224 mm, 176 pp, 111 b&w photos. Photos by Robert Capa and David 'Chim' Seymour; text by Georges Soria.

9 *Paris Magnum Photographs 1935-1981*. Aperture, New York, 1981. HB w/ jkt, 304 x 224 mm, 110 pp, 87 b&w photos. Text by Irwin Shaw; intro by Inge Morath.

10 *The Fifties: Photographs of America*. Pantheon, New York, 1985. PB, 249 x 251 mm, 163 pp, 150 b&w photos.

11 *Bons Baisers*. Editions Contrejour, Paris, 1987. PB, 200 x 125 mm, 62 pp, 45 b&w photos.

12 *China: A Photohistory 1937-1987*. Thames & Hudson, London, 1988. HB, 265 x 240 mm, 200 pp, 153 b&w photos. Text by W.J.F. Jenner and intro by Jonathan D. Spence.

13 *In Our Time: The World as Seen by Magnum Photographers*. W.W. Norton & Company, New York, 1989. HB w/ jkt, 329 x 237 mm, 456 pp, 304 b&w and col photos. Edited by William Manchester; text by Jean Lacouture and Fred Ritchin.

14 *A l'Est de Magnum: 1945-1990*. Arthaud, Paris, 1990. PB, 310 x 250 mm, 262 pp, 195 photos.

15 *Magnum Cinema: Photographs from 50 Years of Movie-making*. Phaidon Press, London, 1995 (first published by Cahiers du Cinéma Livres, Paris, 1994). HB w/ jkt, 280 x 230 mm, 360 pp, 450 b&w photos. Intro by Alain Bergala.

16 *Magnum Landscape*. Phaidon Press, London, 1996 (first published by Editions Plume, Paris, 1996; also published in

PB, 2005). HB w/ jkt, 150 x 210 mm, 184 pp, 101 b&w photos. Foreword by Ian Jeffrey.

17 *Guerras Fratricidas.* Fundación La Caixa de Pensiones, Barcelona, 1996 (bilingual edn: English and Spanish). HB and PB, 192 pp, numerous photos. Text by Agnès Sire and Marta Gill.

18 *Israel: 50 Years As Seen by Magnum Photographers.* Aperture, New York, 1998. HB w/ jkt, 311 x 227 mm, 198 pp, 193 b&w and col photos.

19 *1968: Magnum Throughout the World.* Editions Hazan, Paris, 1998. HB w/ jkt, 280 x 230 mm, 268 pp, 240 b&w photos. Texts by Eric Hobsbawm and Marc Weitzmann.

20 *Magna Brava: Magnum's Women Photographers.* Prestel, Munich, 1999. HB w/ jkt, 300 x 236 mm, 238 pp, 224 b&w and col photos. Text by Isabella Rossellini, Christiane Amanpour and Sheena McDonald.

21 *The Misfits: Chronique d'un tournage, par les photographes de Magnum.* Cahiers du Cinéma Livres, Paris, 1999 (also published by Phaidon Press, London, 2000 and in PB, 2001). HB, 255 x 190 mm, numerous photos, 189 pp. Text by Serge Toubiana and an interview with Arthur Miller.

22 *GMT 2000: A Portrait of Britain at the Millennium.* HarperCollins Illustrated, London, 2000. PB, 182 x 122 mm, 384 pp, 375 b&w and col photos.

23 *Magnum°.* Phaidon Press, London, 2000 (also published in PB, 2003; French and German, 1999; Spanish, 2004; and Italian, 2007). HB, 250 x 250 mm, 536 pp, 345 b&w and 175 col photos.

24 *New York September 11.* Powerhouse Books, New York, 2001. HB, 318 x 232 mm, 144 pp, 20 b&w and 74 col photos. Intro by David Halberstam.

25 *Arms Against Fury: Magnum Photographers in Afghanistan 1941–2004.* Powerhouse Books, New York, 2002. HB 224 x 286 mm, 240 pp, 132 b&w and 110 col photos. Edited by Robert Dannin.

26 *Magnum Football.* Phaidon Press, London, 2002 (also published in French, German, Italian, Spanish and Japanese; published in PB, 2005). HB w/ jkt, 150 x 210 mm, 184 pp, 59 col photos and 79 b&w photos.

27 *New Yorkers As Seen by Magnum Photographers.* Powerhouse Books, New York, 2003. HB, 260 x 260 mm, 176 pp, 143 b&w and 42 col photos. Edited by Max Kozloff.

28 *Magnum Stories.* Phaidon Press, London, 2004 (French edn: 2005; PB edn: 2014). HB w/ jkt, 276 x 276 mm, 512 pp, 545 b&w and 235 col photos. Edited by Chris Boot.

29 *Muhammad Ali.* Harry N. Abrams, New York, 2004. HB w/ jkt, 203 x 254 mm, 160 pp, numerous col and b&w photos.

30 *Magnum Ireland.* Thames & Hudson, London, 2005. HB w/ jkt, 260 x 258 mm, 256 pp, 236 b&w and col photos. Edited by Brigitte Lardinois and Val Williams; intro by John Banville; text by Anthony Cronin, Nuala O'Faolain, Eamonn McCann, Fintan O'Toole, Colm Tóibín and Anne Enright.

31 *Euro Visions.* Steidl, Göttingen, 2005. PB, 234 x 168 mm, 206 pp, 380 col photos. Text by Caroline Mille, Bruno Racine, Diane Dufour and Quentin Bajac.

32 *Venedig.* Mare, Hamburg, 2005. HB, 255 x 230 mm, 136 pp, 64 col photos. Photos by Martin Parr, Paolo Pellegrin, Gueorgui Pinkhassov, Mark Power & Robert Voit; text by Zora del Buono.

33 *The Image to Come: How Cinema Inspires Photographers.* Steidl, Göttingen, 2007. HB, 204 x 280 mm, 280 pp, 406 b&w and col photos, 44 illus. Text by Serge Toubiana and Diane Dufour.

34 *Ces Images Qui Nous Racontent Le Monde.* Albin Michel, Paris, 2007. HB, 228 x 218 mm, 256 pp, 340 b&w and col photos. Text by Eric Godeau.

35 *Magnum Magnum.* Thames & Hudson, London, 2007. HB w/ jkt, 291 x 236 mm, 568 pp, 413 b&w and col photos. Edited by Brigitte Lardinois; intro by Gerry Badger.

36 *Magnum's First.* Hatje Cantz, Ostfildern, 2008. HB, 325 x 246 mm, 212 pp, 83 col photos. Edited by Peter Coeln, Achim Heine and Andrea Holzherr; text by Christoph Schaden.

37 *Magnum Korea As Seen by Magnum Photographers.* W.W. Norton & Company, New York, 2008. HB w/ jkt, 300 x 315 mm, 304 pp, 248 col photos. Text by Bruce Cumings.

38 *Pop Sixties.* Abrams, New York, 2008. HB w/ jkt, 260 x 213 mm, 192 pp, 150 col photos. Intro by Anthony Decurtis.

39 *Access to Life.* Aperture, New York, 2009. HB w/ DVD, 286 x 241 mm, 310 pp, 468 b&w and col photos. Edited by Annalyn Swan and Peter Bernstein; preface by Desmond Tutu; essay by Jeffrey D. Sachs.

40 *A Magnum Journal: Georgian Spring.* Chris Boot Ltd, London, 2009. HB w/ jkt, 292 x 254 mm, 252 pp, 70 b&w and 170 col photos. Foreword by Dworzak; text by Wendell Steavenson.

41 *Witness: Magnum Photographs from the Front Line of World War II.* Flammarion, Paris, 2009. HB, 240 x 304 mm, 192 pp, 179 photos. Text by Rémy Desquesnes.

42 *Magnum Am Set.* Schirmer Mosel, Munich, 2010 (also published in Spanish and Italian). HB, 280 x 230 mm, 140 pp, 128 b&w and col photos. Edited by Isabel Siben and Andrea Holzherr; text by Hans Helmut Prinzler.

43 *The Mexican Suitcase.* Steidl, Göttingen, 2010. PB, 307 x 254 mm, 750 pp, numerous photos. Photos by Robert Capa, David 'Chim' Seymour and Gerda Taro. Text by Paul Preston, Simon Dell, David Balsells i Solé and others.

44 *Magnum Contact Sheets.* Thames & Hudson, London, 2011. HB w/ jkt, 342 x 280 mm, 508 pp, 205 b&w and 230 col photos. Edited by Kristen Lubben.

45 *Magnum Revolution: 65 Years of Fighting for Freedom.* Prestel, Munich, 2012. HB w/ jkt, 300 x 240 mm, 256 pp, 150 b&w and 100 col photos. Text by Jon L. Anderson and Paul Watson.

46 *Marilyn by Magnum.* Prestel, Munich, 2012. HB w/ jkt, 260 x 225 mm, 144 pp, 80 col photos. Text by Gerry Badger.

47 *Unknown Quantities.* Fishbar Books, London, 2012. PB w/ slipcase, 160 x 240 mm, 96 pp, 82 col photos. Photos by Olivia Arthur, Moises Saman, Peter Van Agtmael and Dominic Nahr.

48 *Algérie: De la guerre à l'indépendance 1957–1962.* Editions Ouest, Rennes, 2012. HB, 220 x 235 mm, 128 pp, 93 photos. Text by Jean-Jacques Jordi.

49 *Postcards from America.* Magnum Photos, London, New York, Paris and Tokyo, 2012 (signed and numbered edition of 500 copies). Printed cardboard box w/ book, newspaper, poster, two fold-outs, three cards, five bumper stickers and five zines. Dimensions of box: 368 x 292 mm. Photos by Jim Goldberg, Susan Meiselas, Paolo Pellegrin, Alec Soth and Mikhael Subotzky; text by Ginger Strand.

50 *Paris Magnum.* Flammarion, Paris, 2014. HB w/ jkt, 318 x 249 mm, 302 pp, 241 b&w and col photos. Edited by Éric Hazan.

51 *Rochester 585/716: A Postcard from America Project.* Aperture, New York, 2015. PB, 279 x 216 mm, 452 pp, 1000 b&w and col photos. Text by Cornelius Eady, Marie Howe, Chris Klatell, Nathan Lyons and Laura Wexler.

52 *Odyssee Europa.* Magnum Photos and Zeitenspiegel-Reportageschule Günter Dahl, Reutlingen, 2015. HB, 265 x 215 mm, 148 pp, 50 photos.

53 *Congo.* Aperture, New York, 2015. HB w/ box and text booklet, 292 x 387 mm, 260 pp, 202 b&w photos and 56 col photos. Photos by Alex Majoli and Paolo Pellegrin; collages by Daria Birang and text by Alain Mabanckou.

Index

Page numbers in bold refer to the main entry; page numbers in *italic* refer to illustrations.

Picture credits

All book photography on pages 6-192 is by Ian Bavington Jones. Additional credits are as follows:

Courtesy Abbas/Magnum: 203; Courtesy Olivia Arthur: 211; Photo by Ian Bavington Jones: 198 (fig 1); © Henri Cartier-Bresson/Magnum Photos/Courtesy Fondation Henri Cartier-Bresson: 196; Courtesy Jonathan Ellery/Browns and Bruce Gilden: 210; Collection Fondation Henri Cartier-Bresson: 6 (fig 2); Courtesy Jim Goldberg: 207; © Heather Holden 1971 Upstate New York, USA: 200; Courtesy Guy Le Querrec: 202; © Danny Lyon/Dektol.wordpress.com/Bleakbeauty.com: 201; Magnum Photos: 7 (fig 3), 197, 198 (fig 3 and 4), 199, 208; Courtesy Peter Marlow: 206; Courtesy Susan Meiselas: 204-5; Courtesy Martin Parr/Photos by Ian Bavington Jones: 209; © Sebastiao Salgado/Amazonas/nbpictures: 10 (fig 11); photo by Magnum Photos), 87.

Acknowledgements

We are deeply indebted to the book's authors: Fred Ritchin for his introductory essay and texts on individual photographers' books on the following pages: 18; 25; 45-6; 51; 60; 61; 62; 66; 70; 74-5; 79; 81-2; 84; 87; 105; 120; 168; 183; and 185.

And to Carole Naggar who wrote all remaining texts on individual photographers' books, as shown on pages 18-192.

Many people have helped with this book in terms of research, feedback, ideas and collating information for the bibliography. We would like to thank all the photographers, their representatives and photographers' Estates, for both members past and present, for their invaluable contribution to the project. In addition, several individuals deserve special mention for their work on this book:

Deb Aaronson
Stuart Alexander
Ian Bavington Jones
Eva Bodinet
Julia Bolus, Arthur Miller Trust
Neil Burgess
Victoria Clarke
Sophie Compton
Tim Cooke
Adela Cory
Ellen Christie
Diane Fortenberry
Jian Gao
Daniel Goode
Tianna Greham
Emily Graham
David Hurn
Hannah Kaspar
Kurt Kaindl, Fotohof
David Kogan
Paul Hayward
Louis Little
Sana Manzoor
Eva Mitterndorfer
Melanie Mues
Matt Murphy
Josephine New
Junko Ogawa
Megan Parker
Martin Parr
Rosie Pickles
Coline Plançon
Eriko Shimazaki
Tilly Slight
Jenni Smith
Alec Soth
Norbu Verhagen
Sophie Wright
Cynthia Young

Phaidon Press Limited
Regent's Wharf
All Saints Street
London N1 9PA

Phaidon Press Inc.
65 Bleecker Street
New York, NY 10012

phaidon.com

First published 2016
© 2016 Phaidon Press Limited

ISBN 978 0 7148 7211 7

A CIP catalogue record from this book
is available from the British Library
and the Library of Congress.

Commissioning Editor:
Victoria Clarke
Production Controller:
Adela Cory

Designed by Melanie Mues,
Mues Design, London

Printed in Hong Kong

Fred Ritchin is Dean of the School at the International Center of Photography in New York. Prior to joining ICP as Dean, Ritchin was professor of Photography and Imaging at New York University's Tisch School of the Arts from 1991-2014, where he co-directed the NYU/Magnum Foundation Photography and Human Rights program. Previously he was the picture editor of the *New York Times Magazine* (1978-82), Executive Editor of *Camera Arts magazine* (1982-83), and in 1999 became founding director of PixelPress. Ritchin has written and lectured internationally about the challenges and possibilities implicit in the digital revolution, and has authored numerous books on photography, including *After Photography* (2008) and *Bending the Frame: Photojournalism, Documentary, and the Citizen* (2013). His historical essay, 'What is Magnum?' was published in 1989 in *In Our Time: The World as Seen by Magnum Photographers*.

Carole Naggar has worked as a poet, artist, curator, educator and photography historian since 1971. She is a co-founder and Special Projects Editor of PixelPress, as well as a regular contributor to *Aperture* and *Time Lightbox*. Among her published works are biographies of David 'Chim' Seymour, George Rodger and Werner Bischof, and texts for *Dennis Stock: Time is on Our Side* (2013) and *Bruno Barbey: Passages* (2015). In 2015 she published two books of poetry: *Haiku by Night* and *Voyage à Kyoto*. Naggar is the series editor for the Magnum Legacy Biography series, published in conjunction with the Magnum Foundation. Two volumes have been published to date: *Eve Arnold* (2014) and *Bruce Davidson* (2016), with a volume on Inge Morath planned for 2017.